PICASSO

in The Metropolitan Museum of Art

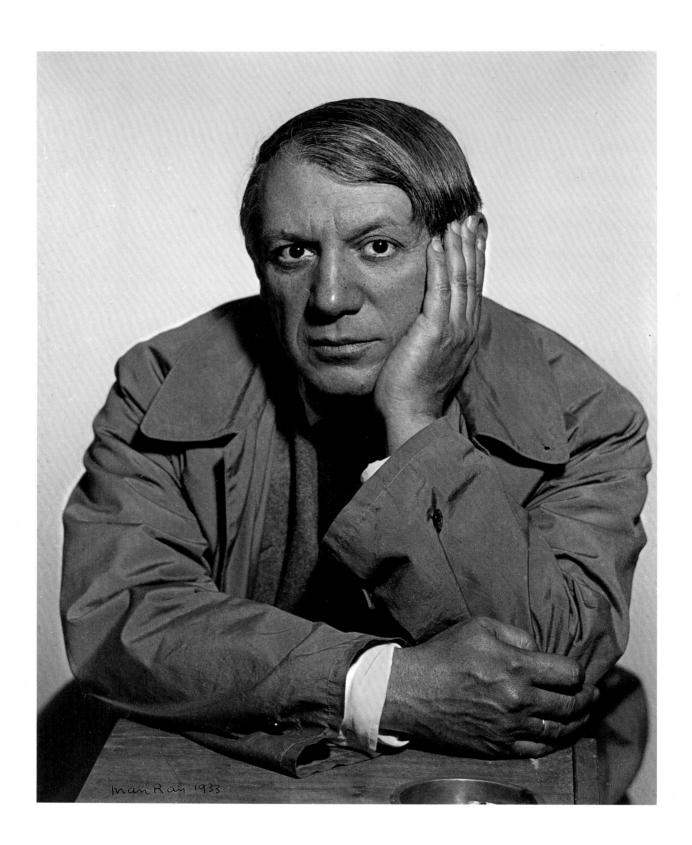

PICASSO
in The Metropolitan Museum of Art

Edited by Gary Tinterow and Susan Alyson Stein

Essays and entries by Magdalena Dabrowski, Lisa M. Messinger,
Asher Ethan Miller, Marla Prather, Rebecca A. Rabinow, Sabine Rewald,
Samantha Rippner, and Gary Tinterow

Technical notes by Lucy Belloli, Shawn Digney-Peer,
Isabelle Duvernois, Rachel Mustalish, and Kendra Roth

Documentation by Christel Hollevoet-Force

The Metropolitan Museum of Art, New York
Yale University Press, New Haven and London

In Memory of
William S. Lieberman
and
John P. O'Neill

This catalogue is published in conjunction with the exhibition
"Picasso in The Metropolitan Museum of Art," on view at
The Metropolitan Museum of Art, New York, April 27–August 1, 2010.

The exhibition and the catalogue are made possible by the
Iris and B. Gerald Cantor Foundation.

Published by The Metropolitan Museum of Art, New York
Gwen Roginsky, General Manager of Publications
Margaret Rennolds Chace, Managing Editor
Peter Antony, Chief Production Manager
Dale Tucker, Senior Editor
Bruce Campbell, Designer
Christopher Zichello, Production Manager
Robert Weisberg, Assistant Managing Editor
Jane S. Tai, Image Research and Permissions
Jean Wagner, Bibliographic Editor

Typeset in Optima and Garamond
Printed on Cartiere Burgo 130 gsm R-400
Separations by Professional Graphics, Inc., Rockford, Illinois
Printed and bound by Conti Tipocolor, s.p.a., Florence, Italy

Jacket/cover illustration: Detail of *Seated Harlequin* (cat. 17)
Frontispiece: Man Ray, *Picasso*, 1933. Gelatin silver print, 13⅞ × 11 in. (35.2 ×
27.9 cm). The Metropolitan Museum of Art, New York, Ford Motor Company
Collection, Gift of Ford Motor Company and John C. Waddell, 1987 (1987.1100.18)
Illustration, p. 259: Lucien Clergue, *Picasso at the Feria de Nîmes*, May 1958, printed
ca. 1981. Gelatin silver print, image: 9¹³⁄₁₆ × 11¹⁵⁄₁₆ in. (24.9 × 30.4 cm), sheet: 12 ×
8 in. (30.5 × 20.3 cm). The Metropolitan Museum of Art, New York, Gift of Peter
Riva, 1981 (1981.1188.4)

Cataloging-in-Publication Data is available from the Library of Congress.

ISBN 978-1-58839-370-8 (hc: The Metropolitan Museum of Art)

ISBN 978-1-58839-371-5 (pbk: The Metropolitan Museum of Art)

ISBN 978-0-300-15525-9 (hc: Yale University Press)

Contents

Sponsor's Statement

Picasso! A life force, an artist who changed the world, a creator of artworks that remain endlessly fascinating. In 1999 the Iris and B. Gerald Cantor Foundation sponsored at the Met a glorious exhibition of Picasso works in clay. This extraordinary show ignited our interest in seeing the full range of Picassos in the Museum's large and important collection—paintings, drawings, watercolors, terracottas, and prints that illuminate the art of our times. Thus, we are delighted to be the sponsor of "Picasso in The Metropolitan Museum of Art." We congratulate all who have contributed to the exhibition and to this scholarly catalogue. Together they represent a significant undertaking, and we are proud to play a role in sharing them with the public.

Iris Cantor

Iris Cantor
President and Chairman
Iris and B. Gerald Cantor Foundation

Director's Foreword

I always wanted to be historical," wrote Gertrude Stein, "from almost a baby on, I felt that way about it." Perhaps that statement best explains Stein's decision to leave her most precious possession—her portrait by Pablo Picasso—to The Metropolitan Museum of Art, a museum with which she had had no previous connection. When her now iconic portrait arrived here in 1947, it was exhibited in the Great Hall, testimony to the power of her celebrity. The Metropolitan had been slow to embrace Picasso's art, and it did little to rectify that before receiving Stein's portrait, the first painting by the artist to enter the collection. But Stein's surprising legacy proved to be just the first in a remarkable series of gifts and bequests of Picassos to the Metropolitan that punctuated the second half of the twentieth century. This period of extraordinary generosity culminated in a crescendo of collections that arrived in the 1980s and 1990s, which together helped to make the Metropolitan's holdings of Picasso's art the second largest in the United States and, therefore, one of the largest in the world.

More than a dozen members of our curatorial and conservation staff devoted the last year to an intensive study of the Museum's works by Picasso, and a comparable number in other departments endeavored to produce this catalogue and the exhibition that it accompanies. The result is a fascinating look at the work of one of the most protean artists of the recent past, proof that even an artist as well known as Picasso still has much to reveal. Thanks to these extensive studies, for example, we have been able to confirm the authorship of one painting and to better establish the early ownership and exhibition history of many other works. Our understanding of Picasso's working methods has also been expanded through extensive technical examinations, from X-radiography and infrared reflectography to analysis of media samples. In short, we now know much more about our paintings and works on paper by Picasso, how they were created, who bought them, and where they were seen in Europe and America in the first decades of the twentieth century. The stories behind these works are endlessly fascinating, illuminating in each case how artists, dealers, collectors, and journalists discovered Picasso and his art.

I am grateful to Gary Tinterow and Susan Alyson Stein, Engelhard Chairman and curator, respectively, in the Department of Nineteenth-Century, Modern, and Contemporary Art, for leading this project and orchestrating the contributions of their colleagues. They and I are especially cognizant of the efforts of the staff of the Editorial Department in producing this important volume. All of us, in turn, wish to reiterate our gratitude and respect for the extraordinary collectors who decided to share their passion with the public. As recounted in the introduction to this volume, the Metropolitan's collection is the aggregate of gifts and bequests made by a number of remarkable figures—from Alfred Stieglitz, Georgia O'Keeffe, and Gertrude Stein to Scofield Thayer, Mr. and Mrs. Charles Kramer, Mr. and Mrs. Isidore M. Cohen, Walter H. and Leonore Annenberg, Florene M. Schoenborn, Mr. and Mrs. Klaus G. Perls, and Natasha Gelman. We hope that their friends and all who marvel at Picasso's art will find their generosity rewarded by this book. This exhibition and publication have benefited from the enduring support of the Iris and B. Gerald Cantor Foundation and its benevolent foresight in establishing an endowment fund to allow the Museum to achieve the highest quality programming.

Thomas P. Campbell
Director, The Metropolitan Museum of Art

Acknowledgments

Soon after the arrival of the Scofield Thayer collection in 1984, William S. Lieberman, then chairman of the department of twentieth-century art, began planning an exhibition of the Metropolitan's Picasso holdings. The project underwent many metamorphoses over the next twenty years, as new gifts and bequests transformed the collection in ways unimaginable in 1984. Mr. Lieberman mounted four Picasso exhibitions during his twenty-five-year tenure at the Met, but, like several of Picasso's early compositions, his grand project was never realized. Now we know why.

Eight curators, five conservators, five research scientists, and eight researchers have devoted nearly a year to an extensive study of the Museum's Picasso holdings. Contributing authors are named on the title page: we are deeply grateful to each of them. This was a cross-departmental collaboration almost unprecedented in the Metropolitan's history, exhausting and rewarding in equal measure. Picasso's work has inspired more books than perhaps any other artist in history, and yet after consulting hundreds, if not thousands of them, there remains much to be learned about nearly everything he made. We cannot pretend to have discovered every last detail, but we are very pleased to be able to share the fruit of our research in the hope of inspiring a fresh and more nuanced appreciation of Picasso's astounding achievement.

Without question, the most gratifying aspect of the exhibition has been the collaboration, cooperation, and support we have received from colleagues within the building and without. It is impossible to adequately acknowledge all these contributions, but, knowing who you are and what you have done, we hope that it will please you nonetheless to see your names printed below. Etiquette demands that we single out a few for special recognition. First thanks go to our director, Thomas P. Campbell, for providing access to the necessary resources—staff, material, financial—to realize the project in its proper dimensions. Without the support of Iris Cantor—longtime friend of the department—and the Iris and B. Gerald Cantor Foundation, this book would not have been possible. Emily Rafferty, president, and Nina Diefenbach, vice president of Development, have helped in myriad ways. This publication began to take form under the caring aegis of John P. O'Neill, the Museum's publisher and editor in chief. Illness prevented him from seeing it through to the end, but his devoted staff maintained his legendary standards. We are especially grateful to Dale Tucker for his dedication to the project as well as to the other members of the Editorial Department team who brought the book to print, especially Gwen Roginsky, Cynthia Clark, Jean Wagner, Jane Tai, Christopher Zichello, Robert Weisberg, and the designer, Bruce Campbell, along with Ellyn Childs Allison, Peter Antony, Alexandra Bonfante-Warren, Margaret Chace, Marcie Muscat, Richard Slovak, and Elizabeth Zechella. The accompanying exhibition was designed by Michael Langley and Sophia Geronimus and benefited from the support of Linda Sylling, Taylor Miller, and Andrey Kostiw. Samantha Rippner very generously collaborated on the project, assuming responsibility for the cataloguing and display of Picasso's graphic work. We are indebted to Malcolm Daniel and Christopher Noey for enriching the documentary and didactic components of the exhibition.

Conservators and scientists in four departments embraced the project enthusiastically, closely examining the works and undertaking treatments where necessary. As a result, the Museum's Picassos look better than ever, and our understanding of their physical properties has increased many fold. We are very grateful indeed to Lucy Belloli, Shawn Digney-Peer, Isabelle Duvernois, Rachel Mustalish, and Kendra Roth as well as to Julie Arslanoglu, Silvia A. Centeno, Tony Frantz, Adriana Rizzo, and Mark Wypyski. With good grace and enthusiasm Cynthia Iavarone coordinated the preparation, mounting, and reframing of several hundred works, a gargantuan task in which she was assisted by Tony Askin, Martin Bansbach, Jeff Elliott, Russell Gerlach, David Del Gaizo, Sandie Peters, Rachel Robinson, and Brooks Shaver. Kay Bearman and Nykia Omphroy stood ready to assist at all times.

Christel Hollevoet-Force constructed provenance and exhibition histories as well as bibliographic references for nearly one hundred works, often from confusing and conflicting evidence, resulting in fascinating conclusions that enrich the early history of the diffusion of Picasso's art. It was a daunting task, but she, like all the authors, benefited from the copious research of Ian Alteveer, Marci Kwon, Jessica Murphy, Emily Navratil, Alison Strauber, and Emily Zandy. Many of the discoveries and connections in this book derive from the work of

these fine researchers; especial thanks to Marci Kwon, who brought her keen intellect and resourcefulness to the final stages of editing.

Susan Stein coordinated with tireless dedication this vast research operation. Maintaining control of innumerable details from the beginning through to the final proofreading, she made this book much more accurate, consistent, and readable than it might have been, and she brought the same high standards to bear on every aspect of the organization of the exhibition. It could not have been done without her; I am infinitely grateful for all that she did.

On behalf of all of my collaborators, I am pleased to acknowledge the contributions of our friends in the field: Laura Albans, Ramona Bannayan, MacKenzie Bennett, Sarah M. Berman, Julia May Boddewyn, Emily Braun, Esther Braun-Kalberer, Janet Briner, Heather Brodhead, Leslie Cade, Alex Corcoran, Margarida Cortadella i Segura, Kathy Curry, Kate Dalton, Virginie Devillez, Marian Dirda, Roland Dorn, Emily Down, Inge Dupont, Flavie Durand-Ruel, Michelle Elligott, Ken Fernandez, Michael FitzGerald, Valerie Fletcher, Megan Fontanella, Christopher P. Gardner, Elizabeth L. Garver, Carmen Giménez, Nadia Granoff, Michelle Harvey, Günther Herzog, Chris Hightower, Ay-Whang Hsia, Hans Janssen, Anne Jean-Richard, Maria Reyes Jimenez-Garcia, Jane Joe, Lewis Kachur, Pepe Karmel, Hélène (Seckel) Klein, Stefan Koldehoff, Fanny Lambert, Patricia Leighton, Deb Lenert, Renzo Leonardi, Elena Llorens, Robert Lubar, Cristina Masanés, Marilyn McCully, Maureen Melton, Cristina Mendoza, Ferran Lahoz Miralles, Dominique Morelon, Erika Mosier, Kristie Meehan, Linda Briscoe Myers, Andres Neufert, Marshall C. Olds, Robert McDonald Parker, Diana Widmaier Picasso, Antoni Pichot, Thierry Pin, Christine Pinault, Charlotte Priddle, Donald Prochera, Núria Peiris Pujolar, John Richardson, Bernice Rose, Elaine Rosenberg, Jae Jennifer Rossman, Jennifer Schauer, Manuel Schmit, Lucian Simmons, Michael Simonson, Ann Simpson, Veerle Soens, Elizabeth Sterling, Markus H. Stoetzel, Jeanne Sudour, Cherie Summers, Verane Tasseau, Jennifer Tobias, Lilian Tone, and Joy Weiner.

At the Metropolitan, we are pleased to acknowledge Kit Basquin, David Bressler, Barbara Bridgers, Rebecca Capua, Sharon Cott, Katherine Dahab, Barbara File, Robyn Fleming, George R. Goldner, Charlotte Hale, Rebecca Herman, Catherine Jenkins, Carol Lekarew, Marilyn Mandel, Patrice Mattia, Mark Morosse, Nadine Orenstein, Majorie Shelley, Elyse Topalian, and Elizabeth Zanis.

Finally, I speak for all of us as I express our gratitude for the privilege of working with such extraordinary works of art. That is possible only because of the generosity of the collectors who conveyed their treasures to this Museum. We are reminded of this generosity every day, and it continues to astonish.

G T

Contributors

Lucy Belloli (LB)
Conservator, Paintings Conservation

Magdalena Dabrowski (MD)
Special Consultant, Nineteenth-Century, Modern,
and Contemporary Art

Shawn Digney-Peer (SD-P)
Assistant Conservator, Paintings Conservation

Isabelle Duvernois (ID)
Assistant Conservator, Paintings Conservation

Lisa M. Messinger (LMM)
Associate Curator, Nineteenth-Century, Modern,
and Contemporary Art

Asher Ethan Miller (AEM)
Research Associate, Nineteenth-Century, Modern,
and Contemporary Art

Rachel Mustalish (RM)
Conservator, Paper Conservation

Marla Prather (MP)
Senior Consultant, Nineteenth-Century, Modern,
and Contemporary Art

Rebecca A. Rabinow (RAR)
Associate Curator and Administrator, Nineteenth-
Century, Modern, and Contemporary Art

Sabine Rewald (SR)
Jacques and Natasha Gelman Curator,
Nineteenth-Century, Modern, and Contemporary Art

Samantha Rippner
Associate Curator, Drawings and Prints

Kendra Roth (KR)
Conservator, Objects Conservation

Gary Tinterow (GT)
Engelhard Chairman, Nineteenth-Century,
Modern, and Contemporary Art

Note to the Reader

The dimensions of works of art are given in inches and centimeters, with height preceding width, followed by depth (for three-dimensional objects). Unless otherwise noted, all translations are by the authors or editors.

Works that appear in the checklists of prints and ceramics are designated by "P" and "C" numbers respectively (for example, cat. P10, or cat. C10). Figure illustrations that appear within a catalogue entry are identified by the catalogue number, followed by an image number corresponding to its order within the text (for example, fig. 17.1 appears as the first image reproduced under cat. 17).

Exhibitions and references are cited in abbreviated form in the essay and entries. In the provenance for each work of art, the use of brackets denotes a period of ownership by an art dealer. Abbreviations used for catalogues raisonnés are listed at the beginning of the bibliography and the checklist of prints.

The spellings of Spanish and Catalan proper names generally follow current usage unless determined otherwise by new scholarship or research.

TECHNICAL EXAMINATIONS

The analytical techniques described below were used in the examination of the works in this catalogue.

Autoradiography

Neutron activation autoradiography is a nondestructive technique used to examine underlying paint layers. The painting is placed in a beam of thermal neutrons for a period of time and Beta particles (electrons) emitted during the process are recorded on photographic film. A series of consecutive exposures, of varying duration, are made. Because the radioactive elements within a painting have varying decay times, different images are produced within the series. With this information conservators can often reconstruct a chronology of the painting process, including the sequence in which certain pigments were applied.

X-radiography

X-radiography is a nondestructive technique whereby radiation is used to analyze certain aspects of a work of art—structure, technique, and condition—that are not visible to the naked eye. Materials of low atomic weight, which are less dense (such as carbon-based paint, iron pigments, or canvas), allow X-rays to pass through easily and appear dark on the film; those of high atomic weight (such as paint mixed with lead white or metal hardware) appear white. Although X-radiographs require careful interpretation because they show all of the layers of a work superimposed (paint layers, ground, support, and stretcher), they are particularly valuable in revealing changes in composition beneath the surface of a painting. The X-radiographs illustrated in this catalogue were digitally assembled using Adobe Photoshop. Stretcher bars and hardware were digitally minimized to allow maximum legibility of all underlying paint layers.

Infrared Reflectography

Infrared reflectography uses infrared (IR) radiation to study underlayers and underdrawing invisible to the naked eye. IR radiation penetrates certain colors and reveals images that result from the contrast between materials that either absorb or reflect the radiation. Unlike X-radiographs, infrared reflectography shows carbon-based underdrawing (in charcoal or graphite, for example) or sketches in carbonaceous paints, allowing one to see through paint layers, even lead white. The Museum's Picassos were examined with an Indigo Systems Merlin Near Infrared camera with a solid-state InGaAs (Indium Gallium Arsenide) detector sensitive to wavelengths from 0.9 to 1.7 microns. The camera was used in conjunction with a customized macro lens optimized for this range. The resulting images (infrared reflectograms) were digitally assembled using Adobe Photoshop.

PICASSO

in The Metropolitan Museum of Art

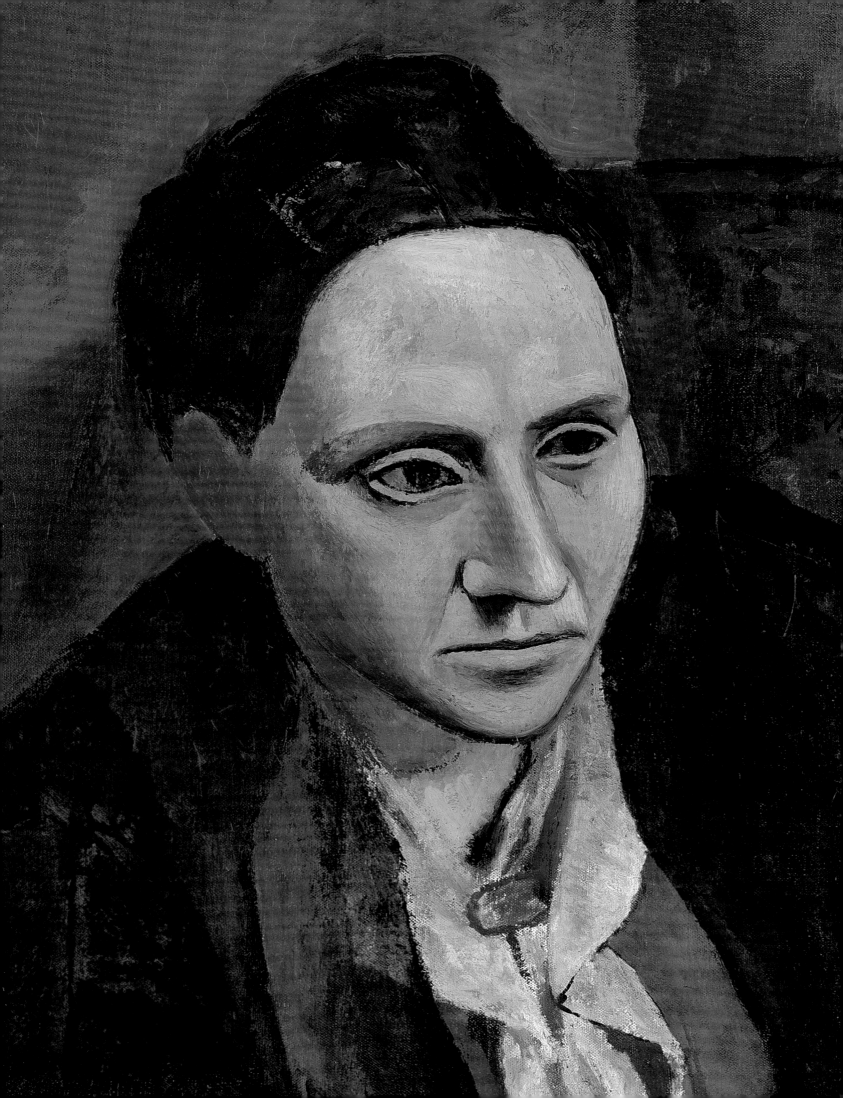

Picasso in The Metropolitan Museum of Art

GARY TINTEROW

"Y̶ou can be a museum, or you can be modern, but you can't be both."[1] It was thanks to that famous dictum that the Metropolitan Museum received, in 1947, its first and arguably most famous painting by Pablo Picasso (1881–1973), the 1906 portrait of Gertrude Stein, as a bequest of the sitter (figs. 1, 2). For reasons one can only speculate about, Stein, the most celebrated American collector in Paris, did not like New York's Museum of Modern Art, founded in 1929, nor its director, Alfred H. Barr, Jr.[2] And while there were fine museums in each of the cities to which she had ties—San Francisco, Pittsburgh, and Baltimore, not to mention Paris—she clearly wanted to associate herself with the grandest museum in her native country, and in 1946, the year she wrote her will, that could only be the Met.

Ironically, from its founding in 1870 the Metropolitan was a museum that exhibited works by living artists, albeit in ways that might have disappointed such a devout modernist as Gertrude Stein. And while it was slow to own examples by the artists whom the Stein siblings patronized, principally Henri Matisse and Picasso, some of the individuals associated with the Museum—officers, trustees, and above all the New York collectors and art dealers who became donors—recognized from very early on Picasso's particular genius. It was only a matter of time (about fifty years) before the Metropolitan could be called one of the great repositories of Picasso's work. Unlike the much larger and well-balanced collection of the artist's work at the Museum of Modern Art, which was nurtured by three generations of curators and donors and is unquestionably the most comprehensive anywhere, the Metropolitan's collection developed by happenstance rather than by design. The result is that it is strongly skewed toward Picasso's early work—especially the Blue and Rose Periods—as well as paintings, pastels, and drawings in his neoclassical style of the early 1920s. Long a favorite with the public, Picasso's work before 1907 and his sweet neoclassicism of the 1920s was also preferred by some of the tastemakers at the Metropolitan—Bryson Burroughs in the years before World War II and Theodore Rousseau, Jr., in the years after—as well as by the collectors in their circles. Today, the Metropolitan

cares for thirty-four paintings, fifty-eight drawings, watercolors, and pastels, two sculptures, ten ceramic plaques, and almost four hundred prints by Picasso. Many are incomparable masterpieces. Excepting the purchase of four paintings, five drawings, and twenty-seven prints, all were gifts or bequests of individuals with ties to the Museum. Here, briefly, is an account of how the Metropolitan came to possess the particular objects in its collection.

Although Gertrude Stein gave but one painting to the Museum, she can be held responsible for many more. Indeed, that Picasso found financial support in his early years in Paris was largely thanks to the championship of Gertrude and her brother Leo. Because of their encouragement, the influential art dealer Ambroise Vollard bought twenty-seven canvases from Picasso in May 1906, the first of what would be twice-yearly purchases through 1911.[3] (Many of the prints and at least two paintings, a drawing, and possibly a bronze now at the Metropolitan passed through Vollard's hands.)[4] At the time Picasso's paintings sold for only a few hundred francs a canvas, a pittance, but the Steins' purchases, combined with Vollard's, constituted the majority of Picasso's income until he signed a contract with Daniel-Henry Kahnweiler in December 1912. Although the Russian collectors Ivan Morozov and Sergei Shchukin would outstrip them just before World War I, the Steins' group of Picassos was the largest in private hands until Gertrude and Leo split up their joint collection in the winter of 1913–14.[5] The Metropolitan's enigmatic *Bust of a Man* of 1908 (cat. 46) hung in their studio until that winter, while the 1906 *Self-Portrait* (cat. 39) remained with Gertrude until her death in 1946.

It was the extraordinary collection of pictures that the Steins had assembled, perhaps more than the erudite conversation, that attracted so many young artists and collectors to the studio at 27, rue de Fleurus, near the Luxembourg gardens (fig. 3). Germans such as the dealer Wilhelm Uhde (who may have handled *Seated Harlequin* and *Young Woman of Gósol* [cats. 17, 33]) and his protegé Edwin Suermondt (who owned *Seated Harlequin*) mixed with Americans like the Baltimore sisters Dr. Claribel and Etta Cone or the Philadelphia collector Albert C. Barnes at the Steins' Saturday evening open house. It was there that nearly every young American

Fig. 1. Detail of *Gertrude Stein* (cat. 38)

3

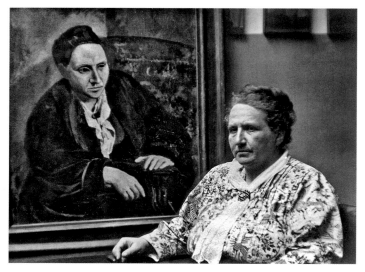

Fig. 2. Man Ray, photograph of Gertrude Stein in front of her portrait at 27, rue de Fleurus, 1922. May Ray Trust

artist visiting Paris before the First World War learned of Picasso and saw his paintings and drawings. Starting with Max Weber and extending through Arthur Davies, Charles Demuth, Arthur Dove, Marsden Hartley, Walter Pach, Edward Steichen, the Mexican-born New Yorker Marius de Zayas, and countless others, American artists returned to New York filled with enthusiasm for the exciting new developments in France. Several of these artists acted as agents for dealers such as Alfred Stieglitz (fig. 5) and collectors like John Quinn and Albert Barnes; they arranged for introductions to the Steins and, through them, to Picasso. As a result of hearing Leo Stein's impassioned lecture at the Steins' studio in 1909, Stieglitz gave Picasso his first show in America—at the Little Galleries of the Photo-Secession at 291 Fifth Avenue, New York—from March 28 through May 1911 (fig. 4).[6] Only a few of the works in the show have been identified,[7] but one seems to have

been a last-minute addition to the lot of forty-nine drawings Picasso had agreed to send to New York. Numbered "49 bis" in Picasso's hand on the verso, the 1910 *Standing Female Nude* (cat. 52) is a scintillating charcoal drawing in a crystalline Cubist style that continues to astound viewers today. Stieglitz bought it for himself. According to the note he inscribed on the back of the frame, "This drawing was the finest of the series shown [at 291] & according to P[icasso] himself is one of the most beautiful things he ever did." Confirmation of Stieglitz's remark can be found in the prominence of the drawing in contemporary photographs of Picasso's studio at 11, boulevard de Clichy, where it hung in a place of honor (see fig. 52.1).

The 1911 show was a commercial failure, but as a succès d'estime it put in motion a series of events that guaranteed an almost constant presence of Picasso's work in publications and in shows in advanced New York galleries during the coming years. After a visit to Picasso in the summer of 1911, Stieglitz compared him to Matisse and concluded: "Picasso appears to me the bigger man. He may not yet have fully realized it in his work the thing that he is after, but I am sure he is the man that will count."[8] *Camera Work,* the house organ of Stieglitz's gallery 291, published reproductions of works by Picasso and Matisse and essays by Gertrude Stein in 1912 and 1913.[9] Eight works by Picasso were shown in the 1913 International Exhibition of Modern Art (the Armory Show), including the 1910 *Standing Female Nude.*[10] With France and Germany at war beginning in August 1914, most art dealing ceased in Europe; for the next five years, New York, not Paris, was the place to see Picassos.[11] Although another dealer, Michael Brenner, had signed an exclusive contract with Kahnweiler to represent Picasso in New York, Kahnweiler was exiled from France as a result of the hostilities and alienated from his business; hence

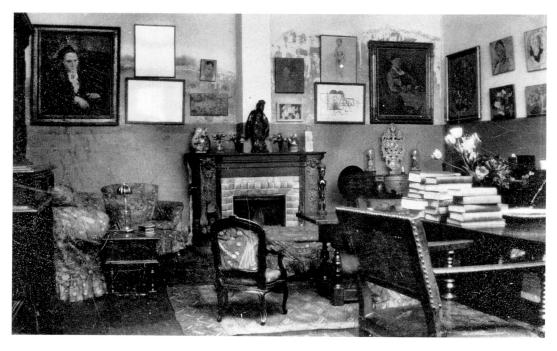

Fig. 3. Gertrude Stein's studio at 27, rue de Fleurus, Paris, early 1920s (?), with Picasso's *Gertrude Stein* (cat. 38) and Cézanne's *Madame Cézanne with a Fan* (see fig. 38.3) hanging on opposite sides of the fireplace. Yale Collection of American Literature, Beinecke Rare Book and Manuscript Library, New Haven, Connecticut

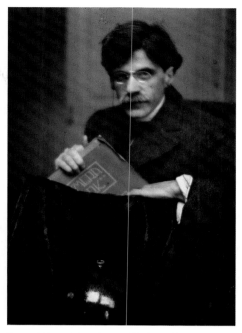

Fig. 4. Alfred Stieglitz, a 1915 installation view of 291, New York, with *Bottle and Wine Glass on a Table* (cat. 58) on wall at left. Platinum print, 7⅝ × 9⅝ in. (19.4 × 24.4 cm). The Metropolitan Museum of Art, New York, Alfred Stieglitz Collection, 1949 (49.55.36)

Fig. 5. Edward Steichen, *Alfred Stieglitz*, 1907. Autochrome, 9 × 6³⁄₁₆ in. (22.9 x 15.7 cm). The Metropolitan Museum of Art, New York, Alfred Stieglitz Collection, 1955 (55.635.10)

in 1914–15 Stieglitz was able to mount another two shows. One display was consigned by Francis and Gabrielle Picabia, artists who, like Marcel Duchamp, acted as dealers and agents for avant-garde French artists in New York during the war;[12] another consisted of nine works lent by the Parisian dealer Adolphe Basler, seven of which are now at the Metropolitan (cats. 24, 47–49, 53, 56, and 57).[13] Among them are several exceptional, very large drawings of 1908–9 that can be characterized as presentation drawings on account of their scale and clarity. One, a still life (cat. 47), stands out as an unusual representational composition from a period when Picasso was rapidly developing the fractured forms of Cubism. From the works consigned by the Picabias, Stieglitz bought the exceptional 1912 papier collé *Bottle and Wine Glass on a Table* (cat. 58), which he called "the most complete 'abstraction' of the modern movement."[14]

During this period the curator of modern art at the Metropolitan was Bryson Burroughs. A painter from Cincinnati who became enthralled in Paris by his teacher, Pierre Puvis de Chavannes, Burroughs had been hired as an assistant by Roger Fry, the brilliant English aesthete and promoter of the French Post-Impressionists. Fry was curator of paintings at the Metropolitan in 1906 and 1907. His tenure was cut short after he locked horns with J. Pierpont Morgan, at the time the Museum's most powerful trustee. Although Burroughs remained, he did not pursue the modernist artists, like Picasso, who fascinated Fry. Stieglitz had hoped to sell the unsold work from his 1911 show to the Metropolitan, but as Stieglitz remembered at the end of his life, Burroughs "saw nothing in

Picasso and vouched that such mad pictures would never mean anything to America."[15] Two years later, and with great difficulty, Burroughs succeeded in persuading the trustees to purchase their first Cézanne—the very tame landscape *View of the Domaine Saint-Joseph* (13.66)—from the 1913 Armory Show. Already chastened by the opposition to buying Renoir's gracious family portrait, *Madame Charpentier and Her Children* (07.122), in 1907, Burroughs found himself in the awkward position of taking uncontroversial positions, so as to avoid trustee displeasure, only to be lambasted by avant-garde artists, collectors, and dealers. Stieglitz, for one, chided the Metropolitan in a 1911 letter to the *Evening Sun*, saying that the Museum should mount an exhibition of Post-Impressionism that would extend to "the work of Matisse and Picasso, two of the big minds of the day expressing themselves in paint."[16] No matter that the work of these two "big minds" was featured in Stieglitz's gallery; in time, others took up his cause.

A letter signed on January 26, 1921, by the artists Arthur Davies and Gertrude Vanderbilt Whitney and the collectors Lillie P. Bliss and John Quinn urged the Metropolitan to organize a "special exhibition illustrative of the best of Modern French art."[17] The signatories promised to secure the loans. Burroughs, who originally hoped to focus the exhibition on five artists—Cézanne, Degas, Pissarro, Redon, and Renoir—was forced to broaden the selection. A letter from Quinn to Burroughs illuminates the pressure that was exerted: "I do not think the inclusion of three blue things by Picasso . . . without the inclusion of any pictures by him of the pink period

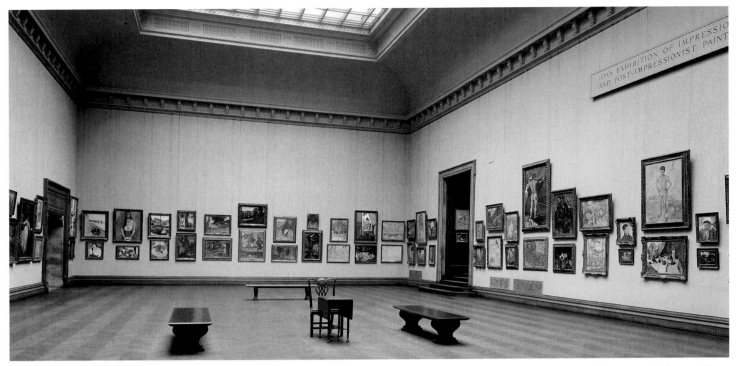

Fig. 6. Installation view of "Loan Exhibition of Impressionist and Post-Impressionist Paintings" at The Metropolitan Museum of Art, New York, 1921. This exhibition marked the first display of Picasso's work at the Museum.

and the later cubistic ones would be at all representative of Picasso . . . particularly as you apparently do not want to include any of Picasso's abstract work, beautiful and decorative though it is."[18] Burroughs relented and included Quinn's Picasso, *Woman Combing Her Hair* (1906, The Museum of Modern Art, New York) in addition to a 1919 landscape lent by the antiquities dealer Dikran Kelekian,[19] who had just lent seven of his Picassos to an exhibition of his private collection of modern pictures at the Brooklyn Museum.[20] That exhibition closed immediately before the Metropolitan's opened on May 2, 1921.

As Burroughs might have predicted, the presentation of truly modern art, at Brooklyn and then at the Metropolitan, unleashed a firestorm of invective in the press, with accusations of Bolshevik plots, and worse. Although it was the first public museum anywhere to own works by Manet (1889) and the first in America to buy a Cézanne (1913), the Metropolitan had been notoriously slow in coming around to modern art in any significant way. The 1921 exhibition constituted Picasso's debut in the building (fig. 6). The ensuing cause célèbre galvanized some individuals to act. Gertrude Vanderbilt Whitney offered her collection of American art and an endowment to the Metropolitan in 1929, the same year that Lillie P. Bliss and six friends founded The Museum of Modern Art; Whitney eventually founded her eponymous museum after the Met refused her offer. One would think that the creation of these two museums would have obviated the need for contemporary art at the Metropolitan, but that was not the case. The

receipt in 1929 of the enormous Havemeyer Bequest, with its dozens of Cézannes, Courbets, Degases, Manets, and Monets, only underscored the absence of Picasso, Matisse, and modernist painting in general. (The premature death of John Quinn in 1924 and the dispersal of his extraordinary collection was a huge blow to New York's cultural community.) So when the soon-to-be director of the Metropolitan, Herbert Winlock, attended the opening of the Modern's new building in 1931, he asked, "When the so-called 'wild' creatures of today are regarded as the conservative standards of tomorrow is it too much to hope that you will permit some of them to come to the Metropolitan Museum of Art, leaving space on your walls for the new creations of the new day?"[21] And when Winlock read Alfred Barr's introduction to the catalogue of the Bliss Collection at the Modern, he was surprised to learn that "among Cézanne's European successors the Metropolitan collection contains no works by Gauguin, Seurat, Toulouse Lautrec, Rousseau, Matisse, Derain, Picasso . . . all of whom are now represented at the Museum of Modern Art." Winlock later wrote to Burroughs to ask: "Do you not think it would be a good idea if we got some?"[22]

In 1947, as arrangements were being made to ship the portrait of Gertrude Stein from Paris to New York, representatives of the Whitney, the Modern, and the Metropolitan signed the Tripartite Agreement (see fig. 7). This contract rationalized the collecting of contemporary art—European at the Modern, American at the Whitney—so that the Metropolitan could buy it (at market value less twenty percent) from her sister

museums when the art was no longer current. The agreement lasted but a year with the Whitney because of clashes over acquisitions and plans for a new Whitney wing at the Metropolitan. However, over the course of the full five years of its association with the Modern, the Metropolitan was able to purchase forty important works, including Picasso's *La Coiffure* (cat. 30) and *Woman in White* (cat. 72). It helped that the Metropolitan's new director, Francis Henry Taylor, considered Picasso a painter of "unearthly power" and "the towering genius of our day."[23] Yet the agreement created difficulties that continue to have ramifications in our time. According to the terms, a work such as Picasso's *Gertrude Stein* was meant to hang at the Modern, so the Metropolitan sent it there after a brief showing in the Great Hall. But when Gertrude's companion, Alice B. Toklas, heard of the move, she objected vociferously, and the painting was brought back to the Metropolitan, where it languished in storage when it was not out on extensive tours.[24] Another, more significant contretemps revolved around *La Coiffure*, which was donated to the Modern, anonymously, by Stephen C. Clark in 1937.[25] A founding trustee of the Modern in 1929, Clark also served on the board of the Metropolitan from 1932 to 1945 and from 1950 until his death, in 1960. As part of the agreement, in 1953 the Modern sold *La Coiffure* to the Metropolian, a transaction that must have

met Clark's approval. However, his dismay over the kind of advanced abstract art that Alfred Barr was buying with the proceeds of the sale of a number of works—including two Picassos, three Matisses, two Cézannes, two Rouaults, three Seurats, and five Maillols—led to Clark's resignation from the Modern's acquisition committee and, further, to the Modern losing the Stephen C. Clark collection, which was eventually divided among the Metropolitan, Yale University Art Gallery, and the New York State Historical Association.

Nonetheless, the Tripartite Agreement—and the arrival of *Gertrude Stein*—gave new momentum to the Metropolitan's curators. The superb Ingresque portrait of Ambroise Vollard (cat. 61) handily won board approval in 1947; young Cézanne scholar John Rewald acted as the intermediary. Two years later, Georgia O'Keeffe distributed the collection of her former husband, Alfred Stieglitz, to museums across the country, and a windfall of Picassos arrived at the Metropolitan—not to mention dozens of masterpieces by American modernists. Encouraged by this development, curator Theodore Rousseau, Jr., set to work improving the Metropolitan's collection of early modern painting. Having returned from service on the Army's Roberts Commission repatriating looted art in Europe, he had a special appreciation of modern French painting. He bought the quintessential Blue Period painting *The Blind Man's Meal*

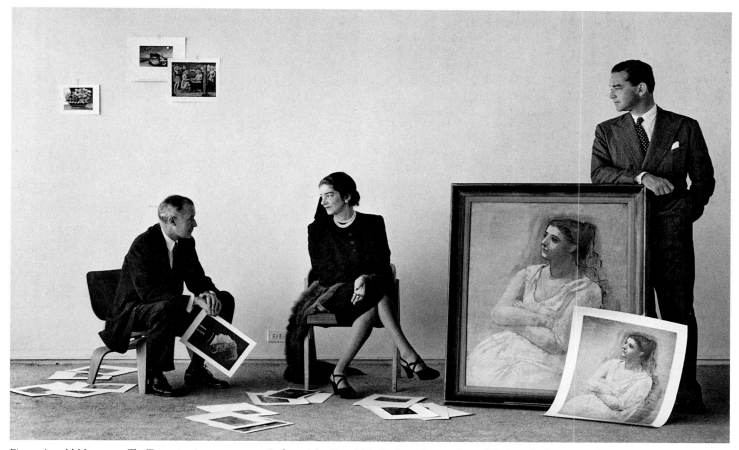

Fig. 7. Arnold Newman, *The Tripartite Agreement,* 1947. Left to right: Ronald L. Redmond, president of the board of trustees, The Metropolitan Museum of Art; Flora Whitney Miller, president, Whitney Museum of American Art; and John Hay "Jock" Whitney, president, The Museum of Modern Art, holding *Woman in White* (cat. 72). Arnold Newman/Getty Images

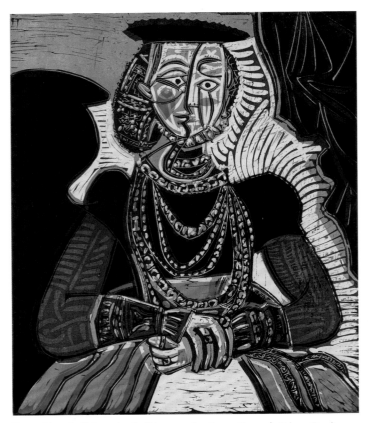

Fig. 8. Detail of *Portrait of a Woman, after Lucas Cranach II* (cat. P121)

(cat. 22) in 1950 with funds given by Enid Annenberg Haupt and her husband, Ira. Ten years later he purchased an early masterpiece, *Seated Harlequin* (cat. 17), with funds given by Frances Lehman Loeb and John Loeb. Rousseau advised a number of New York collectors, including Frances Lehman Loeb's sister and brother-in-law, Mr. and Mrs. Richard J. Bernhard,[26] and Rita Hillman, thereby contributing to the general appreciation of Picasso's early work, while collectors associated with Alfred Barr and the Museum of Modern Art gravitated toward Picasso's later, more challenging and modernist pictures.

That changed in 1979, when Metropolitan director Philippe de Montebello hired William S. Lieberman to head the department of twentieth-century art at the Museum. Lieberman, most recently director of the department of drawings at the Modern and a specialist in Picasso's graphic work, had the advantage of having worked at Alfred Barr's side for nearly twenty years. By coincidence and design the Metropolitan's Picasso collection mushroomed, and to mark the transformation Lieberman organized four Picasso exhibitions during his twenty-five-year tenure.[27] Mr. and Mrs. Charles Kramer and Mr. and Mrs. Isidore Cohen gave large and comprehensive collections of Picasso's colorful postwar prints (see fig. 8)—149 from the Kramers and 175 from the Cohens—spirited and charming works that express the artist's newfound joy with his second wife, Jacqueline Roque. Raymonde Paul, the executor of the estate of her brother C. Michael Paul,

gave the Museum a lively Lautrec-like poster design (cat. 14) as well as the set of eleven caricatures Picasso made of the habitués of the Barcelona café Els Quatre Gats when he was only nineteen (cats. 1–11). But even these copious gifts pale in comparison to the bequest, in 1982, of the collection of Scofield Thayer.

In 1919, Scofield Thayer (fig. 9), heir to a New England textile fortune, and James Sibley Watson bought America's foremost literary review, *The Dial*. Having attended Harvard with ee cummings and Oxford with Ezra Pound, Thayer moved to Europe in 1921 with a taste for avant-garde literature and art and the money to patronize both. The first in America to publish T. S. Eliot's *The Waste Land* (1922), he was also the first to extensively collect Picasso's new neoclassicism, sometimes directly from the artist. One senses the thrill of discovery in Thayer's bragging letters: "Mr. Seldes took me to see Picasso in his studio, where I found him even more charming than upon the previous evening. As I presume you know, I admire him more than any other living artist. He had many wonderful things in his studio, but none of them, unfortunately, buyable."[28] Ever loathe to miss a sale, Picasso quickly rectified the situation. Two weeks later, Thayer wrote to Picasso's dealer Paul Rosenberg, "I bought a large female head with hair streaming out behind [fig. 10] for which today

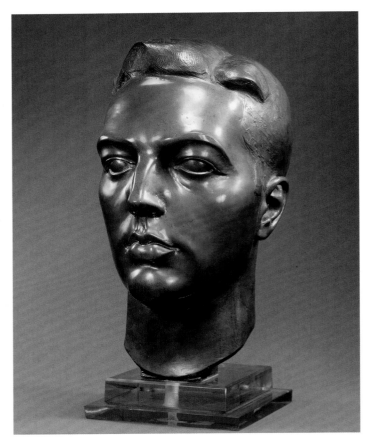

Fig. 9. Gaston Lachaise, *Scofield Thayer*, 1923. Bronze, 12⅝ × 6¼ × 9⅜ in. (32.1 × 15.9 × 23.8 cm). The Metropolitan Museum of Art, New York, Bequest of Scofield Thayer, 1982 (1984.433.30)

Fig. 10. Detail of *Head of a Woman* (cat. 69)

I sent my cheque to Monsieur Picasso."[29] With just a few exceptions, the sixteen Picassos in Thayer's collection belong to either Picasso's first neoclassical period, about 1905–6 (cats. 26, 29, 31, 32, 34, and 37), or the second, about 1920–23 (cats. 64–69, 71). Thayer's aim was to publish not just the best in modern literature but the best in European and American art as well, and most of the works that he bought were selected specifically for their ability to be reproduced accurately in *The Dial* and a folio he called *Living Art*: hence the preponderance of drawings, pastels, and watercolors.[30] With these publications

in mind, Thayer justified his conservative taste; as he wrote to Gilbert Seldes, an editor at *The Dial*, "Picasso is a man of whom one cannot have too much provided always one avoids, in publishing a magazine with our deficit—his pure cubistic stuff. That I, at least, cannot afford to do."[31]

Thayer settled in Vienna, where he sought treatment from Sigmund Freud and accumulated a significant cache of drawings by Egon Schiele and Gustave Klimt. His frequent mental breakdowns began to escalate in 1926, however, and following several institutionalizations he remained in seclusion

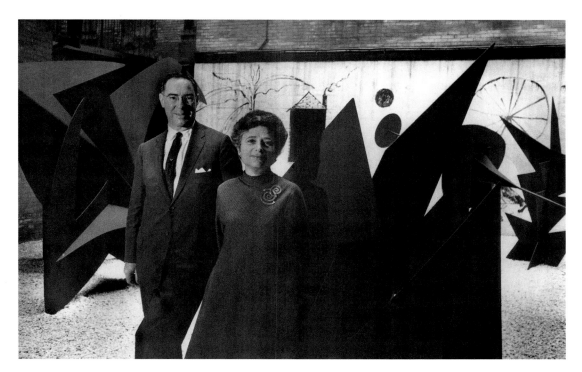

Fig. 13. Ugo Mulas, photograph of Klaus and Dolly Perls in their New York apartment, with stabiles by Alexander Calder and Dolly wearing a Calder brooch, ca. 1965

from the late 1920s until his death, in 1982. The nature of Thayer's troubles are not well understood—we know that his marriage failed and his wife went on to have a child with ee cummings—but perhaps some hint can be found in the character of the art that he bought while abroad, which included a cache of explicitly erotic scenes by Schiele and Klimt as well as the notorious *Erotic Scene* (cat. 20) by Picasso. Beginning in 1931, Thayer's guardians placed his collection, which had grown to hundreds of works, on loan to the Worcester Art Museum, Massachusetts, but following Thayer's death it was discovered that in his will he had given the majority of his extraordinary ensemble to the Metropolitan.

After the Thayer bequest was received, the Metropolitan's Picasso collection continued to grow apace. Late works finally began to augment the Museum's sole postwar painting, the 1955 *Faun with Stars* (cat. 90), given by Joseph Hazen in 1970. Mr. and Mrs. Leonard S. Field gave their 1960 painting of Jacqueline Roque (cat. 92) in 1990, and Mr. and Mrs. A. L. Levine donated the jaunty 1968 *Standing Nude and Seated Musketeer* (cat. 94) in 1981, when the painting was barely thirteen years old. Early works were also added, such as the drawings donated by the Tarnopol brothers (cats. 27 and 70) and the Oenslagers' moving *Mother and Child on a Bench* (cat. 15). Without question, however, the most important of the early pictures was *At the Lapin Agile* (cat. 25), the donation of Ambassador and Mrs. Walter Annenberg (fig. 11), who bought it at auction from the heirs of former Metropolitan trustee Joan Whitney Payson.[32] The first self-portrait of Picasso as Harlequin—and a striking admission of his affair with Germaine (Laure Gargallo), the lover of his doomed friend, Carles Casagemas—*At the*

Lapin Agile continues to resonate as a representation of the young artist's *vie bohème* in turn-of-the-century Paris.

Three extraordinary, transformative gifts and bequests came to the Museum at the end of the century. William Lieberman had worked long and hard to secure these prizes; with them, the Metropolitan's collection finally achieved representation across the full length of Picasso's career. Florene M. Schoenborn, daughter of the founder of the May Company stores, began collecting with her husband, the influential Chicago architect Samuel Marx, in 1939 (fig. 12). Focusing on the School of Paris, and patronizing the dealer Pierre Matisse, they eventually acquired eleven Picassos[33] along with many other exceptional works. "What gives the Marx collection its character," wrote Alfred Barr, "is the dozen or so magnificent paintings that even ten years ago would have seemed, to most collectors, too big, too aggressive, and too strong to live with."[34] Every one of their paintings added a new dimension to the Metropolitan's collection: the standouts include the magnificent 1915 *Guitar and Clarinet on a Mantelpiece* (cat. 62), the Surrealist *Nude Standing by the Sea* of 1929 (cat. 77), and the touching 1934 *Reading at a Table* (cat. 79). Widowed in 1964, Florene Marx later married Wolfgang Schoenborn, a German-born Mexican real-estate developer; he died in 1986. When Mrs. Schoenborn died in 1995, she left twenty paintings and sculptures to the Metropolitan, including marvelous Braques (1996.403.11, 1996.403.12, 1996.403.13) and its first Juan Gris (1996.403.14). She left fourteen other works, including her greatest painting, Matisse's incomparable *The Moroccans*, to the Museum of Modern Art. Mrs. Schoenborn and William Lieberman had been close friends. As Metropolitan director

Philippe de Montebello commented at the time, "Mrs. Schoenborn's extremely generous gift comes out of that flawless relationship between collector and curator."[35]

The gift of six Picassos by Klaus and Dolly Perls, in the late 1990s, arrived with the aura of the artist's early days in Paris very much intact (fig. 13). Klaus Perls' parents were the Berlin art dealers Hugo and Käte Perls. Like Wilhelm Uhde, Alfred Flechtheim, and Heinrich Thannhauser, the Perls bought French art to sell to German collectors; among the works now at the Metropolitan, Klaus's parents had owned or sold *Jardin de Paris*, *The Actor*, *La Coiffure*, *Guitar and Clarinet on a Mantelpiece*, and both versions of *Man with a Lollipop* (cats. 14, 23, 30, 62, 83, and 84). As Klaus recalled, "They were friends of Kahnweiler and those people. . . . They put these things on the walls in Zehlendorf and people, friends came and [said] 'Oh that's nice, I would like to have something like that.' And they said 'well, by all means if you want to have it, here I'll sell it to you and I'll go back to Paris and buy some more.'"[36] Klaus, who studied art history in Munich and Basel and wrote a dissertation on the Renaissance French artist Jean Fouquet, moved to the United States in the late 1930s. With his wife, he became a dealer in School of Paris painting as well as the sculpture of Alexander Calder. Their Picasso gift comprised two Cubist paintings and four Surrealist works. Although difficult to read at first glance, the 1910 *Woman in an Armchair* (cat. 51) emerges over time as a remarkable recasting by Picasso of Cézanne's portrait of his wife, also now at the Metropolitan (see fig. 51.1). *Pipe Rack and Still Life on a Table* (cat. 55) is a rare

surviving overdoor from a never-realized Cubist library for the Brooklyn house of Hamilton Easter Field. Together, they were the first paintings in the high Cubist style to come to the Met. Moreover, the four Surrealist works in the Perls gift chart with remarkable clarity Picasso's journey from unhappy husband (*Harlequin*, 1927; cat. 75) to enraptured lover (*The Dreamer*, 1932; cat. 78) to perplexed father of a new child (*Woman Asleep at a Table*, 1936; cat. 81) to head-over-heels lover once again (*Dora Maar in an Armchair*, 1939; cat. 86).

The 1998 Gelman bequest of eighty-five works, including fourteen Picassos, finally brought to the Metropolitan the kind of Cubist masterpieces that John Quinn had written to Bryson Burroughs about in 1921. A Russian-born producer of films in Mexico, Jacques Gelman (fig. 15) was a partner of Cantinflas, Latin America's greatest comedian. Natasha Gelman (fig. 14), who was born in Czechoslovakia, "traveled the world in a sophisticated and fearless way [and] finally landed in Mexico, where she lived for the rest of her life."[37] For the Gelmans, who bought in tandem, filmmaking was so lucrative that money was never a problem; rather, the limiting factor was the difficulty obtaining works of sufficient quality. Their first picture was their toughest—Picasso's brutal 1927 caricature of his wife Olga, *Head of a Woman* (cat. 76)—and one can see that they applied the most rigorous standards to the rest of their purchases (fig. 16). Excepting the showy and virtuosic *Woman in Profile* (cat. 13), the Gelman Picassos are never pretty; they are, instead, the perfect corollary to Scofield Thayer's taste for elegant neoclassicism. Perhaps the most difficult of

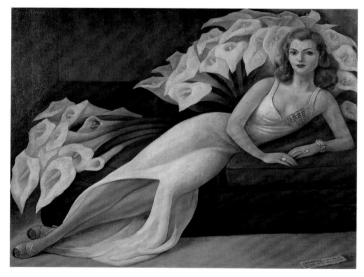

Fig. 14. Diego Rivera, *Natasha Gelman*, 1943. Oil on canvas, 47¼ × 61¼ in. (120 × 155.5 cm). Jacques and Natasha Gelman Collection, Mexico

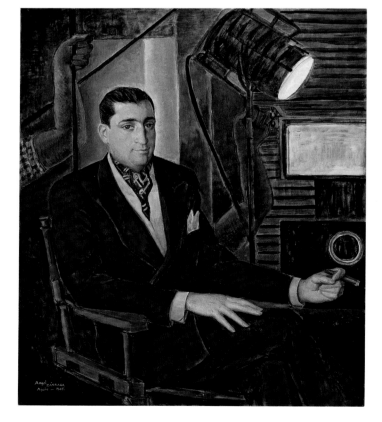

Fig. 15. Angel Zárraga, *Jacques Gelman*, 1945. Oil on canvas, 51 × 43½ in. (129.5 x 110 cm). Jacques and Natasha Gelman Collection, Mexico

them all is the *Still Life with a Bottle of Rum* (cat. 54). Painted in the company of Georges Braque at Céret, in southwest France, in the summer of 1911, this still life represents Picasso approaching the brink of abstraction. Never again would his work be so hermetic and difficult to decipher, and rarely are his paintings so continuously compelling. That summer Braque and Picasso were linked together like mountain climbers, as they liked to say, and the Gelmans also bought Braque's *Still Life with Banderillas* (1999.363.11), painted simultaneously with their Picasso, to demonstrate this remarkable moment of collaboration. The artists later joked that even they could not identify which work of that summer had been painted by whom—nor can most visitors to the Gelman galleries at the Metropolitan—but that is almost beside the point. Even casual observers are drawn to this pair of pictures, first wondering what they represent, then guessing how they were

painted, and, finally, recognizing that the artists provoke us as viewers to self-consciously analyze our own act of perception and to test our relationship to the world of art and objects.

Marvelous works on paper in the Gelman collection, such as the three drawings of 1907–8 (cats. 41, 43, and 44) and the enormous 1912 papier collé *Man with a Hat and a Violin* (cat. 59), are a welcome complement to the ensemble of Cubist drawings in the Alfred Stieglitz collection. Thanks to the Cubist pictures in the Perls gift and the Gelman bequest, it need no longer be said, as it was in 1911 and again in 1921, that the Metropolitan does not show the most advanced and difficult of Picasso's work. But the complete story of the development of Cubism—one of the seminal movements in twentieth-century art—remains to be told at the Metropolitan, and Picasso's extraordinary work as a sculptor, with the exception of the Cubist *Head of a Woman* (cat. 50), is missing

entirely. If history provides any indication of the future, passionate collectors will continue to acquire the best they can find, and, eventually, some of those remarkable individuals will turn over that art for public enjoyment at the great city museums that flourish through their support.

1. John Hightower wrote in *Four Americans in Paris* (New York–Baltimore–San Francisco 1970–71, p. 8) that Gertrude Stein said this to "one of my predecessors as Director of The Museum of Modern Art." That could only be Alfred H. Barr, Jr.

2. "Gertrude—as you will remember by my having told you several times always with an increasing violence—loathed and despised The Museum of Modern Art and all its little ways." Letter from Alice B. Toklas to W. G. Rogers, September 27, 1947 (Burns 1973, p. 77).

3. See Tinterow 2006, pp. 105–7.

4. These works include *The Blind Man's Meal* (cat. 22), *La Coiffure* (cat. 30), *Ambroise Vollard* (cat. 61), and, possibly, the bronze *Head of a Woman* (cat. 50). See also cats. 13, 15.

5. Excepting, of course, the stock of the dealers Vollard and Kahnweiler.

6. In his lecture Leo Stein declared Picasso "the leading genius of the age." Stieglitz, who later recalled that he "had never heard more English nor anything clearer" (quoted by FitzGerald in New York–San Francisco–Minneapolis 2006–7, p. 22), offered Leo an opportunity to publish his statement in *Camera Work*, but Leo never took him up on the offer. The exhibition in New York, formally titled "Exhibition of Early and Recent Drawings and Water-Colors by Pablo Picasso of Paris," was originally supposed to close on April 25 but was extended until May.

7. According to Julia May Boddewyn in New York–San Francisco–Minneapolis 2006–7, p. 329. See also p. 150, n. 1.

8. Letter from Stieglitz to Sadakichi Hartmann, December 22, 1911, quoted in Washington 2000, p. 124.

9. *Camera Work* 34–35 (April–July 1911) featured an article by Marius de Zayas on Picasso, and *Standing Female Nude* (cat. 52) was reproduced in *Camera Work* 36 (October 1911, p. 63). In addition, Stieglitz devoted the August 1912 issue of *Camera Work* to essays by Gertrude Stein on Matisse and Picasso and reproduced *Acrobat Standing on a Ball* (1905, The Pushkin State Museum of Fine Arts, Moscow), *Head of Woman in a Mantilla* (1909, private collection; z II.171), *The Reservoir at Horta de Ebro* (1909, The Museum of Modern Art, New York), *Portrait of Kahnweiler* (1910, The Art Institute of Chicago), and *Standing Female Nude* (cat. 52); see, respectively, pp. 31, 33, 35, 37, and 63 of that issue. Finally, *Gertrude Stein* (cat. 38), *Woman with Mandolin* (1910, The Museum of Modern Art, New York), and *Standing Female Nude* (cat. 52) were reproduced in the June 1913 issue (pp. 49, 51, 53, respectively). See New York–San Francisco–Minneapolis 2006–7, p. 329.

10. These included *Nature morte No. 1* (unidentified), *Nature morte No. 2* (unidentified), *Landscape (Two Trees)* (1908, Philadelphia Museum of Art), *Mme. Soler* (1903, Staatsgalerie Moderner Kunst, Munich), *Tête d'homme* (1912, unidentified), *La Femme au pot de moutarde* (1910, Gemeentemuseum, The Hague), *Standing Female Nude* (cat. 52), and *Head of a Woman* (cat. 50). See New York–San Francisco–Minneapolis 2006–7, p. 329, which omits the bronze.

11. My account follows the remarkable history by Michael FitzGerald in New York–San Francisco–Minneapolis 2006–7.

12. "An Exhibition of Recent Drawings and Paintings by Picasso and Braque, of Paris" (December 9, 1914–January 11, 1915). See New York–San Francisco–Minneapolis 2006–7, p. 329.

13. The remaining two Basler/Stieglitz works are likely at The Art Institute of Chicago: the 1909 drawing *Head of a Woman* (1949.578) and the print *The Frugal Repast* (1949.904), even though early invoices referred to all nine as "Zeichnungen." See Pepe Karmel in Washington 2000, p. 505, n. 11.

14. Written in Stieglitz's hand on the back of the original mount (NCMC archives).

15. Stieglitz 1939.

16. Stieglitz 1911. Burroughs eventually organized that exhibition ten years later.

17. Here I follow the account by Rebecca A. Rabinow in "Modern Art Comes to the Metropolitan" (Rabinow 2000).

18. John Quinn to Bryson Burroughs, March 24, 1921. Office of the Secretary Records, The Metropolitan Museum of Art Archives.

19. In addition to *Woman Combing Her Hair* (no. 80), Quinn also lent *Woman with a Chignon* (1901, Harvard Art Museum/Fogg Museum, Cambridge, Massachusetts; exhibited as "Woman at a Table," no. 79). The 1919 landscape (no. 81) was exhibited under the title "Landscape" and is presently titled *Landscape with Dead and Live Trees* (1919, Bridgestone Museum of Art, Tokyo). Kelekian also lent *Woman with a Cape* (1901, The Cleveland Museum of Art; exhibited as "Portrait of a Lady," no. 82). Quinn owned cat. 17.

20. "Paintings by Modern French Masters Representing The Post Impressionists and Their Predecessors," March 26–April 1921; Kelekian's works were nos. 167–73.

21. Quoted in Tomkins 1970, p. 305.

22. H. E. Winlock to Bryson Burroughs, September 25, 1934. Office of the Secretary Records, The Metropolitan Museum of Art Archives. Winlock added, "Bill [Ivins] is up in the air because we have 133 prints and three drawings of those artists, of whom Barr says we have no 'works' although he has included lithograph drawings and wood-cuts of those artists among the works in the Bliss Collection." In 1922–23 William Ivins, Jr., acquired five important prints by Picasso (including *The Frugal Repast* [cat. P1] and *The Watering Place* [cat. P11]). During the same period the Museum received as a gift of Paul Sachs ten pochoirs (color stencil reproductions of gouaches by Picasso), a limited edition signed by the artist. Though reproductions, they constitute the first works by Picasso to enter the Metropolitan's collection. Ivins had habitually acquired works on paper by artists whose paintings proved to be less palatable to the trustees.

23. Quoted in Tomkins 1970, p. 305.

24. "And to think that they [The Museum of Modern Art] have acquired the portrait. It is unbearable—but that isn't the worst—in the same agreement between the two museums which gives the portrait to the Modern the Metropolitan buys two Picassos from the Modern and furthermore the Modern has the right to sell their acquisitions so the portrait may be acquired by Barnes or Chrysler or God knows who. It's unthinkable and I'm very upset and sad that such a thing can be. [. . .] If the *Times* has reported this correctly I'll certainly protest. . . ." Letter from Alice B. Toklas to W. G. Rogers, September 27, 1947 (Burns 1973, p. 77). Toklas then wrote Roland Redmond, president of the board of the Metropolitan: "Miss Gertrude Stein very deliberately chose the Metropolitan Museum—having decided to leave it to a museum in her mind there was no choice—if there had been one the Museum of Modern Art would not have been an alternative. . . . It is now very sad to see her wishes so disregarded—so miscarried. It is an ethical question. And I appeal to you to reconsider your decision to lend the picture to the Museum of Modern Art . . . so that the painting remains at the Metropolitan Museum." Letter from Alice B. Toklas to Roland Redmond, October 6, 1947. Office of the Secretary Records, The Metropolitan Museum of Art Archives.

25. Clark gave the Modern two other Picassos the same year: *Guitar and Fruit Dish on a Table* (1924; z v.268) and *Seated Woman* (1926–27, Art Gallery of Ontario). The Modern deaccessioned both, in 1944 and 1964, respectively. His last gift to the Modern was in 1953: Maillol's sculpture *The Mediterranean* (1902–5). Between 1954 and 1958 he gave three Picassos to Yale, including *Dog and Cock* (1921), which Clark had bought from the Modern in 1942 to help fund the purchase of Picasso's *Three Musicians* (1921). Clark was elected to the Metropolitan's board in 1932 and was vice president from 1941 to 1944; he resigned in 1945 over staffing decisions and returned in 1950. A founding trustee from 1929, from 1939 to 1946 Clark was the first chairman of the board of the Modern. He asked Barr to resign in 1944, and he himself resigned from the acquisitions committee in 1951 but remained a member of the board until his death in 1960. See Williamstown–New York 2006–7.

26. Frances and Adele Lehman, the daughters of Mr. and Mrs. Arthur Lehman, were granddaughters of Adolph Lewisohn, the distinguished collector of modern French pictures.

27. "Picasso Linoleum Cuts: The Mr. and Mrs. Charles Kramer Collection" (New York [MMA/Kramer] 1985); "Picasso and the Weeping Women: The Years of Marie-Thérèse Walter and Dora Maar" (Los Angeles–New York–Chicago 1994–95); "Picasso and the Engraver: Selections from the Musée Picasso, Paris" (New York [MMA] 1997); "Picasso, Painter and Sculptor in Clay" (London–New York 1998–99). Upon Lieberman's death, in 2005, he bequeathed the Metropolitan eight works by Picasso; two others had previously been given to the Museum in his honor (cats. 28, 79) and one he donated himself (cat. P117).

28. Letter from Thayer to his mother, July 17, 1923. Copies of letters in notes 28–30 in the NCMC archives.

29. Letter from Thayer to Paul Rosenberg, July 19, 1923.

30. Thayer wrote of this preference in a letter to Gilbert Seldes: "As far as possible I have not used oil paintings even among the paintings because oil paintings cannot be well reproduced. Thus I have succeeded in finding a superb Picasso tempera. . . ." Letter from Thayer to Gilbert Seldes, October 24, 1922. The "superb tempera" to which he refers is *The Watering Place* (cat. 29), which Thayer reproduced in *The Dial* (vol. 78 [June 1925], facing p. 455). Other works illustrated in *The Dial* include *Three Bathers Reclining by the Shore* (cat. 65; vol. 76 [June 1924], ill. after p. 492), *Three Bathers by the Shore* (cat. 64; vol. 76 [June 1924], after p. 492), *Head of a Woman* (cat. 68; vol. 81 [September 1926], frontis. [as "A Head"]), and *Head of a Woman* (cat. 69; vol. 86 [March 1929], ill. p. 181).

31. Letter from Thayer to Gilbert Seldes dated January 15, 1922.

32. Ambassador Annenberg's sisters, Enid Haupt and Lita Hazen, had already made important contributions to the collection.

33. Four of these went to the Museum of Modern Art.

34. Alfred H. Barr, Jr., in New York and other cities 1965–66, preface, unpaginated.

35. Vogel 1996b, p. C12.

36. Hadler and Perls 1993.

37. Russell 1998, p. D23.

CATALOGUE

1. Self-Portrait "Yo"

Barcelona, early 1900

Ink and essence on wove paper
3¾ × 3⅜ in. (9.5 × 8.6 cm)
Inscribed in ink, upper left: YO
Gift of Raymonde Paul, in memory of her brother, C. Michael Paul, 1982
1982.179.18

In February 1899, the seventeen-year-old Picasso returned to Barcelona after some eighteen months in Madrid. Exactly one year later, he had his first one-man show—an exhibition of drawings—at the fashionable bohemian tavern Els Quatre Gats,[1] which he began frequenting shortly after his return. Els Quatre Gats was created as a meeting place for the artists, writers, and progressive intellectuals who proclaimed themselves adherents of so-called Modernisme: a combination of native Catalan traditions, French Art Nouveau, and Symbolism that was regarded at the time as the most avant-garde tendency in Catalan art, literature, and architecture. The café itself was inspired by the Parisian cabaret Le Chat Noir (The Black Cat), a popular venue among the international artistic set in Montmartre. It was founded by four friends, artists of a generation slightly older than Picasso—Ramon Casas, Santiago Rusiñol, Pere Romeu, and Miquel Utrillo—who had all lived for some time in Paris and become acquainted with the latest trends in art. Upon returning to Spain, they felt that Barcelona, in order to become an important cultural center, needed a clublike environment to foster the exchange of new aesthetic views and to attract creative individuals.

Els Quatre Gats opened on June 12, 1897, on the ground floor of the Casa Martí, a neo-Gothic residential and commercial building in the heart of old Barcelona.[2] Until it closed in 1903, it was a vital center of innovative thought, musical evenings, and an exhibition space for young Modernista artists. Picasso's show there, which opened on February 1, 1900, was effectively a response to the well-publicized exhibition by Casas—a highly respected Catalan society portraitist—at the Sala Parés in October 1899.[3] Purportedly challenged by his friends to "out-do" Casas, Picasso included some 150 drawings of different sizes and pinned them directly to the walls of the tavern, unmounted and unframed. They were primarily portraits of the members of his *tertulia*—a term referring to his circle of artists, admirers, and supporters—and other café regulars. Although reviewed rather poorly and by only a handful of critics, the exhibition nonetheless marked a significant moment in the artist's development.

Picasso's drawings of this period fall primarily into one of two categories: the large works, generally about 2 feet tall, and the very small ones, which are no bigger than 5–6 inches square. Their subjects are depicted either full length, posed against an urban or landscape background, or are presented simply as head portraits. Among the small drawings is a series of some twelve vignette-size head portraits, eleven of which are in the collection of the Metropolitan Museum (cats. 1–11). The twelfth is in the Museu Picasso, Barcelona (see fig. 6.1). Although the portraits were traditionally believed to have been included in Picasso's exhibition at Els Quatre Gats, according to the latest research they were instead likely made in the months following it.[4]

The works in the series, including this striking self-portrait, were executed primarily in ink and essence (an oil diluted with turpentine). Picasso defined the heads in heavy black outlines and set them within lightly colored pictorial fields; most are surrounded by a dark, framelike border that follows the contours of the support sheet. As Picasso biographer John Richardson has pointed out,[5] the portraits verge on caricature, capturing in rapid, vivid strokes and flat areas of color the personalities and idiosyncrasies of their subjects.

Self-Portrait "Yo" is imposing despite its small format and relative simplicity of composition and expressive means. Unlike the other works in the series, it is fundamentally a study in chiaroscuro. It is also not a true self-portrait but Picasso's embellished, somewhat romantic vision of himself as a bohemian dandy, particularly the bushy hair, nonchalant tilt of the head,

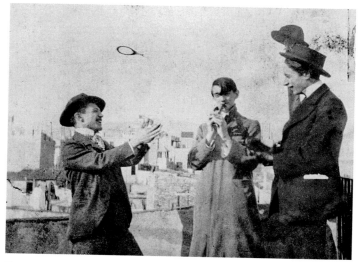

Fig. 1.1. Mateu de Soto, Picasso, and Carles Casagemas on the terrace at 3, rue de la Merced, Barcelona, ca. 1900. Musée National Picasso, Paris

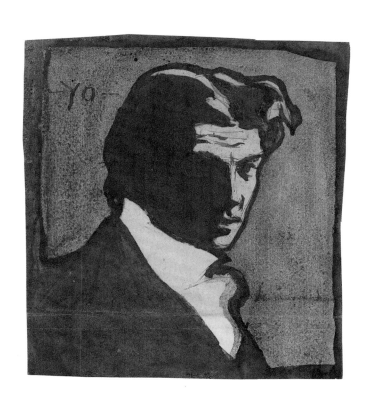

and modish outfit. The dark jacket and the right side of his face, which is cast in deep shadow, contrast dramatically with the collar and fashionable cravat, emphasized in white against a purplish blue background. The inscription, which means "I" in Spanish, was added to leave no doubt as to the identity of the sitter. M D

1. The name "Els Quatre Gats" (The Four Cats) has a double meaning: it reflects the number of its founders, but it also echoes a Catalan phrase meaning "us-four cats," or a small number of like-minded people. See Mendoza 2006, pp. 80–81.
2. The building itself reflects the desire of Catalan architects to revive the greatness of Catalonia's medieval past. It was designed by Josep Puig i Cadafalch (1867–1956), a young architect who shortly thereafter was regarded as one of the eminent figures of Modernista architecture. See ibid. The café, which still exists in the same location, was recently renovated but now caters mostly to tourists.
3. At the time, Sala Parés was considered the most serious gallery in Barcelona presenting recognized masters of modern art from both Catalonia and elsewhere in Europe.
4. See Mendoza 2006, pp. 86–89.
5. Richardson 1991–2007, vol. 1 (1991), pp. 143–49.

PROVENANCE
Santiago Juliá, Barcelona (by 1955); C. Michael Paul, New York (until d. 1980); his sister, Dr. Raymonde Paul, New York (1980–82; her gift to the Metropolitan Museum, 1982)

EXHIBITIONS
Possibly Barcelona 1900, no cat.; Barcelona 1955, no. 22; Bern 1984–85, no. 84, pp. 20 (ill.), 71, 138 (ill.), 320; Charleroi 1985, no. 8, pp. 119, 130 (ill.); Barcelona 1995–96, no. 71, pp. 81 (ill.), 175, 309–10 (Eng. ed.); Cleveland–New York 2006–7, no. 3:11, pp. 86–87 (ill.), 500; Amsterdam 2007–8, pp. 146 (ill.), 189

REFERENCES
Rodríguez Codolà 1900 (2006 ed., pp. 265–66) (on the series); Palau i Fabre 1966, pp. 67 (fig. 32), 238; Zervos 1932–78, vol. 21 (1969), p. 44 (ill.), no. 109; Palau i Fabre 1970, pp. 42–43 (ill.), 161, no. 11; New York 1980, p. 19 (fig. d); Palau i Fabre 1981a, p. 23 (ill.); Palau i Fabre 1981b, pp. 190 (ill.), 529, no. 427; Messinger 1986, pp. 73 (fig. 1), 74–75; Anon., October 26, 1991, p. 148 (ill.); Richardson 1991–2007, vol. 1 (1991), p. 148 (ill.); Varnedoe 1996, p. 120 (ill.) (both eds.); Léal, Piot, and Bernadac 2000, pp. 38 (fig. 47), 502 (both eds.)

TECHNICAL NOTE

In the series of small portraits that includes *Self-Portrait "Yo,"* Picasso used intricate mixtures of inks and paints, which he applied with pen and brush on a variety of paper types. Although the portraits have some techniques and materials in common, in their variations they highlight the artist's experimental nature.

The appearance of the ink in each drawing depends on the method of application, the type of paper, and the condition of the work. All of the portraits were first sketched with a metal nib pen used quickly and with sufficient force to scratch and roughen the paper, to varying effect. (In *Self-Portrait "Yo"* the lines have not significantly roughened the surface.) Picasso then accentuated the major lines of the portraits, the hair and head of the sitters, and the borders of the papers using a rich, brush-applied dark brown ink. It should be noted that both the pen- and brush-applied inks were probably darker, even near black, when first used. They contain iron, which causes them to be corrosive to the paper, as well as other components such as chromium[1] that are consistent with the composition of writing and artists' inks commercially available at the time. This particular ink is thin and penetrates the papers easily, the extent of which can be seen on the verso of all of the drawings. In *Self-Portrait "Yo"* the brown ink has nearly obliterated the pen lines, and the dark ink fields appear smooth and even.

All of the portraits have brush-applied washes of color, which are generally intense, thin, and in uneven layers, as seen in the blue background of *Self-Portrait "Yo."* The washes were applied over nearly the entire surface of the portraits; their appearance, interaction with their paper supports, observation under ultraviolet light, and analytical testing[2] suggest that most are a manipulated and thinned oil paint known as essence, made by using turpentine to remove most of the oil from the paint. In the drawings the essence was further diluted, allowing it to be used very thinly and to impart a washy matte effect closely resembling the appearance of watercolor. The essence has caused the paper to become transparent in many instances, and discoloration from the oil and turpentine has caused some of the papers to yellow and darken. Other components found in some of the drawings include gum and wax.

The papers in the series comprise a variety of textures and thicknesses, and while it seems Picasso made use of many types, he clearly favored white papers, as is the case with *Self-Portrait "Yo."* Although the surfaces are almost entirely covered by ink and wash, small areas left in reserve reveal the color of the sheet. Picasso used the paper reserve selectively in many of the drawings to create highlights. In *Self-Portrait "Yo"* there is a prominent crease running along the bottom of the image where the drawing was folded. The lower part of the white of the shirt, which is paper reserve, was protected from light and has not darkened, showing the white original tone. Many of the portraits have pinholes at the top and evidence of former mountings. On those without them, these could have been trimmed off.

 R M

1. Nondestructive analysis done by X-ray fluorescence.
2. Analytical testing on these small drawings is difficult owing to the nature of the media, which exist in small quantities and, generally, as a mixture and little or no sampling is possible. However, the results from Fourier Transform Infrared Reflectography and Attenuated Total Reflectance are used in tandem with the evidence garnered from close conservation examination.

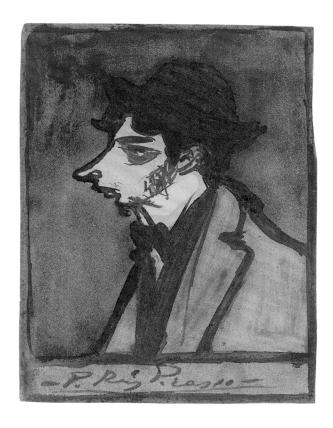

2. Carles Casagemas

Barcelona, early 1900

Ink and essence on wove paper
4⅛ × 3⅛ in. (10.5 × 7.9 cm)
Signed in ink, at bottom: –P. Ruiz Picasso–
Gift of Raymonde Paul, in memory of her brother, C. Michael Paul, 1982
1982.179.19

The painter and poet Carles Casagemas i Coll (1880–1901), son of the United States consul general in Barcelona, met Picasso at Els Quatre Gats café, which both frequented. Between January and September 1900 they also shared a studio in Barcelona. In the autumn of that year, Casagemas accompanied Picasso on his first trip to Paris, where they visited the Exposition Universelle together with several other Catalan artists. While in Paris, Casagemas developed an obsession with Laure Gargallo, known as Germaine, the future wife of Ramon Pichot, another Quatre Gats friend (see cat. 7). In despair over their failed love affair, Casagemas committed suicide in a café on February 17, 1901, after first attempting to kill Germaine. Remorseful that he was not in Paris when his friend died, Picasso later insisted that it was because of Casagemas's suicide that he began painting in blue, heralding his Blue Period. Among several haunting canvases he made at the time are a portrait of Casagemas, evocative burial scenes (see figs. 14.3, 14.4), and the 1903 masterpiece *La Vie* (see fig. 22.4).

The present drawing emphasizes Casagemas's eccentric profile, particularly his long nose, small head, and short neck. Like many of the other drawings in the series, it is signed "P. Ruiz Picasso," the signature used by the artist throughout 1900.

MD

PROVENANCE
Santiago Julía, Barcelona (by 1955); C. Michael Paul, New York (until d. 1980); his sister, Dr. Raymonde Paul, New York (1980–82; her gift to the Metropolitan Museum, 1982)

EXHIBITIONS
Possibly Barcelona 1900, no cat.; Barcelona 1955, no. 24; Bern 1984–85, no. 85, pp. 138 (ill.), 320–21; Charleroi 1985, no. 14, pp. 119, 136 (ill.); Barcelona 1995–96, no. 73, pp. 83 (ill.), 176, 310 (Eng. ed.); Cleveland–New York 2006–7, no. 3:18, pp. 86–87 (fig. 17), 501; Amsterdam 2007–8, pp. 148 (ill.), 189

REFERENCES
Rodríguez Codolà 1900 (2006 ed., pp. 265–66) (on the series); Palau i Fabre 1966, pp. 66 (fig. 30), 238; Zervos 1932–78, vol. 21 (1969), p. 45 (ill.), no. 116; Cabanne 1975a, ill. between pp. 56 and 57; New York 1980, p. 19 (fig. i); Palau i Fabre 1981a, p. 35 (ill.); Palau i Fabre 1981b, pp. 191 (ill.), 530, no. 438; Alley 1986, p. 16 (fig. 21); Messinger 1986, p. 77 (fig. 12); Mailer 1995, p. 46 (ill.); McCully 1996, pp. 236 (ill.), 238; Palau i Fabre 2006, pp. 93–95, 125–31, and passim, ill. facing p. 97; Joseph J. Rishel in S. Stein and Miller 2009, pp. 278, 279 (fig. 212)

TECHNICAL NOTE

The metal nib pen Picasso used to make the underlying sketch heavily roughened the wove paper. The colored washes are essence, an oil paint diluted and thinned with turpentine. The roughened areas swelled and absorbed the blue wash more readily and were easily disturbed by the action of the brush. This accounts for the streaky, intensely colored media that has soaked the paper, penetrating to the verso but also bleeding sideways to create visible halos in the paper reserve.

RM

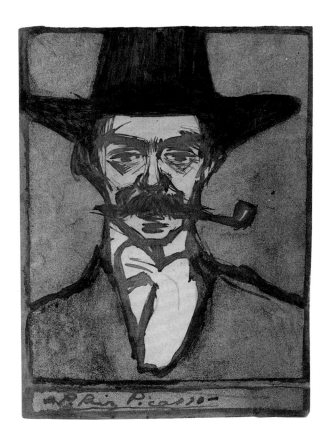

3. Frederic Pujulà

Barcelona, early 1900

Ink and essence on wove paper
5 × 3⅝ in. (12.7 × 9.2 cm)
Signed in ink, at bottom: –P. Ruiz Picasso–
Gift of Raymonde Paul, in memory of her brother, C. Michael Paul, 1982
1982.179.20

PROVENANCE
Santiago Juliá, Barcelona (by 1955); C. Michael Paul, New York (until d. 1980); his sister, Dr. Raymonde Paul, New York (1980–82; her gift to the Metropolitan Museum, 1982)

EXHIBITIONS
Possibly Barcelona 1900, no cat.; Barcelona 1955, no. 23; Bern 1984–85, no. 91, pp. 138 (ill.), 321; Charleroi 1985, no. 9, pp. 119, 131 (ill.); Barcelona 1995–96, no. 75, pp. 85 (ill.), 175, 310 (Eng. ed.); Cleveland–New York 2006–7, no. 3:19, pp. 86–87 (ill.), 501; Amsterdam 2007–8, pp. 147 (ill.), 189

REFERENCES
Rodríguez Codolà 1900 (2006 ed., pp. 265–66) (on the series); Palau i Fabre 1966, pp. 66 (fig. 29), 238; Zervos 1932–78, vol. 21 (1969), p. 44 (ill.), no. 110; New York 1980, p. 19 (fig. a); Palau i Fabre 1981b, pp. 191 (ill.), 530, no. 436; Messinger 1986, p. 76 (fig. 5); Richardson 1991–2007, vol. 1 (1991), p. 154 (ill.); Palau i Fabre 2006, p. 119

The journalist and dramatist Frederic Pujulà i Vallès (1877–1963), whom Picasso befriended at Els Quatre Gats, belonged to a group of Catalan enthusiasts of Esperanto who met at the café.[1] He contributed frequently to the Catalan literary magazine *Joventut* (Youth) and in early 1900 was an art critic for another magazine, *La veu de Catalunya*. He also wrote the first Catalan science-fiction novel, *Homes artificials* (Artificial Men), in 1912.

Picasso depicted Pujulà frontally, giving him an imposing presence in which the subject stares out at the viewer from beneath his bushy eyebrows. This aspect is emphasized by the heavy outlines, the large, wide-brimmed dark hat, and the white cravat juxtaposed against the deep blue vest. MD

1. Esperanto is an international auxiliary language devised in 1877 by Dr. Ludovic Lazar Zamenhof (1859–1917), a Polish-born ophthalmologist.

TECHNICAL NOTE

The metal pen ink lines are thick and strong compared to the pale, brush-applied lines that emphasize the form. Picasso appears to have diluted or mixed the ink with a resinous material, which has caused a golden brown halo to surround each of the strokes. He colored the hat using a thick, uneven, grainy pigment. The contrast between the pen lines and brushstrokes and the thin and thick media creates the texture and pattern in the hat. The smooth texture of the paper is visible where the wash settled in the wove marks left by the papermaking process.

RM

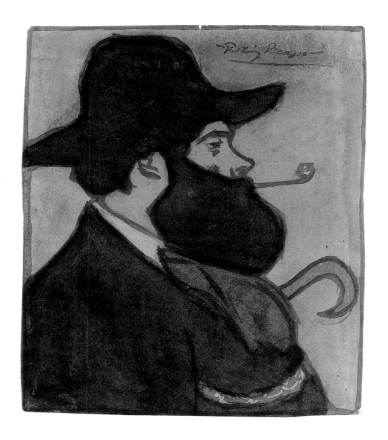

4. Hermen Anglada-Camarasa
Barcelona, early 1900

Ink, essence, and mixed-media paint on wove paper
4¾ × 3⅞ in. (12.1 × 9.8 cm)
Signed in ink, upper right: –P. Ruiz Picasso–
Gift of Raymonde Paul, in memory of her brother, C. Michael Paul, 1982
1982.179.21

The Catalan painter Hermenegildo Anglada i Camarasa
(1871–1959) was a regular at Els Quatre Gats and, like Picasso,
an alumnus of La Llotja, an art school housed in Barcelona's old
stock exchange building. After moving to Paris in 1894 to study
painting at the Académie Julian and the Académie Colarossi,
Anglada divided his time between Barcelona and Paris, choosing
as his primary subject Parisian nightlife. In 1900 he had his first
solo exhibition, at Barcelona's Sala Parés, in which his style
oscillated between Modernisme and Noucentisme, the latter a
Catalan cultural movement that advocated a return to Catalan
folkloric themes, the region's classical Mediterranean past, and
more pronounced figuration. In 1914 Anglada settled in Majorca,
where he specialized in highly decorative depictions of the sur-
rounding landscape. He later exhibited widely in Europe and
the United States.

Picasso met Anglada in 1899 and the following year painted
this portrait of him in a style reminiscent of that seen in *Self-
Portrait "Yo"* (cat. 1). Shown in bust-length profile, Anglada
sports a black, bushy beard, a black round hat with a wide brim,
his characteristic pipe, and a black jacket and vest. These

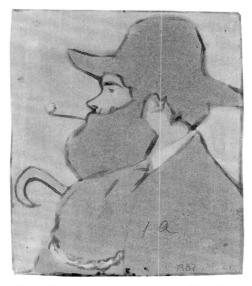

Verso of cat. 4, showing penetration of the oil-
based medium

dark forms project dramatically against the pale orange back-
ground, resonating with the gold chain of his pocket watch and
blue ascot. Anglada's figure looms large within the drawing,
which, despite its small size, manages to convey a sense of his
overwhelming personality. M D

PROVENANCE
Santiago Julía, Barcelona (by 1955); C. Michael Paul, New York (until d. 1980);
his sister, Dr. Raymonde Paul, New York (1980–82; her gift to the Metropolitan
Museum, 1982)

EXHIBITIONS
Possibly Barcelona 1900, no cat.; Barcelona 1955, no. 21; Bern 1984–85, no. 93, pp. 139 (ill.), 321; Charleroi 1985, no. 4, pp. 119, 126 (ill.); Barcelona 1995–96, no. 87, pp. 92 (ill.), 175, 311 (Eng. ed.); Cleveland–New York 2006–7, no. 3:13, pp. 86–87 (ill.), 500; Amsterdam 2007–8, pp. 149 (ill.), 189

REFERENCES
Rodríguez Codolà 1900 (2006 ed., pp. 265–66) (on the series); Palau i Fabre 1966, pp. 66 (fig. 38), 238; Zervos 1932–78, vol. 21 (1969), p. 44 (ill.), no. 105; New York 1980, p. 19 (fig. e); Palau i Fabre 1981b, pp. 190 (ill.), 529, no. 430; Messinger 1986, p. 75 (fig. 2); Léal, Piot, and Bernadac 2000, pp. 38 (fig. 46), 502 (both eds.); Palau i Fabre 2006, pp. 111, 167, and passim (on Anglada)

TECHNICAL NOTE

Picasso made this portrait on very thin, smooth-wove commercial paper. Although he made a pen sketch, as with the other portraits in the series, he did so lightly and did not scratch the surface, preserving the smooth nature of the paper. He created textural contrast between the thinly painted background, which he tinted red with essence, and the rougher, mottled, and lumpy black hat, beard, and coat, which he painted with a mixture of media that includes gum (likely from watercolor) and highly particulate ivory or bone black pigment.[1] The high quantities of medium and the thinness of the paper have caused the entire sheet to become translucent and darker in color. This is visible on the verso (ill.), as is the degree to which the media penetrated the sheet. RM

1. Determined by Annuated Total Reflectance Infrared Analysis conducted by Julie Arslanoglu, Department of Scientific Research.

5. Benet Soler

Barcelona, early 1900

Ink and mixed-media paint on wove paper
4⅛ × 3¼ in. (10.5 × 8.3 cm)
Signed in ink, upper left: –P. Ruiz Picasso–
Verso: *Portrait of a Man (Pere Romeu?)*, charcoal
Gift of Raymonde Paul, in memory of her brother, C. Michael Paul, 1982
1982.179.22a, b

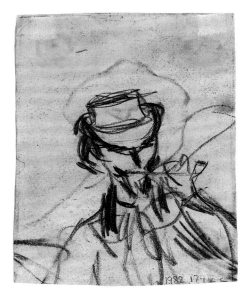

Verso of cat. 5, *Portrait of a Man (Pere Romeu?)*
(1982.179.22b)

Benet Soler Vidal (1874–1945), known as Retalls ("Scraps"), was a Barcelona tailor whose shop was situated in Plaça Santa Ana at the Portal de l'Angel, near Els Quatre Gats tavern. Habitually elegant and a bon vivant, Soler was a regular of Els Quatre Gats, where he met Picasso in 1899. The artist eventually painted several portraits of Soler and his family, frequently in exchange for custom-made clothing. As a result, Soler came to own numerous works from Picasso's early period.

Picasso depicted Soler in a few rapid strokes of ink and paint, capturing his fashionable demeanor and easy charm. The portrait is the only one in the series with another work on the verso (ill.): an unfinished charcoal sketch of a head. Although this frontal head recalls the portrait of Frederic Pujulà (cat. 3), it most likely depicts Pere Romeu, one of the founders of Els Quatre Gats (see cat. 11). MD

PROVENANCE
Santiago Julía, Barcelona (by 1955); C. Michael Paul, New York (until d. 1980); his sister, Dr. Raymonde Paul, New York (1980–82; her gift to the Metropolitan Museum, 1982)

EXHIBITIONS
Possibly Barcelona 1900, no cat.; Barelona 1955, no. 24; Bern 1984–85, no. 92, pp. 139 (ill.), 321; Charleroi 1985, no. 12, pp. 119, 134 (ill.); Barcelona 1995–96, no. 82, pp. 88 (ill.), 175–76, 310 (Eng. ed.); Cleveland–New York 2006–7, no. 3:20, pp. 86–87 (ill.), 501; Amsterdam 2007–8, pp. 147 (ill.), 189

REFERENCES
Rodríguez Codolà 1900 (2006 ed., pp. 265–66) (on the series); Palau i Fabre 1966, pp. 66 (fig. 36), 238; Zervos 1932–78, vol. 21 (1969), p. 45 (ill.), no. 113; Palau i Fabre 1981b, pp. 190 (ill.), 529, no. 429; Messinger 1986, p. 76 (fig. 7); Palau i Fabre 2006, pp. 103–4 and passim (on Soler)

TECHNICAL NOTE

Picasso began this portrait with a pen and ink drawing, in a manner similar to several of the others in the series, and reinforced the major lines with brush-applied ink. He then painted the yellow background and brown jacket with an unusual mixed-media paint that is bubbly, transparent, and waxy, and which has dried in a pattern indicating that it was very fluid when applied. Although analytical testing could not determine the definitive composition of this material,[1] the traces of certain identified compounds, including wax and fatty acids, indicate that this is clearly not a standard artists' material but, rather, something manipulated by the artist to produce the working properties and texture he desired. RM

1. Analysis conducted by Julie Arslanoglu, Department of Scientific Research.

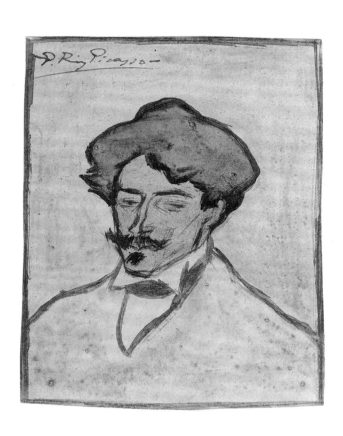

23

6. Santiago Rusiñol

Barcelona, early 1900

Ink and essence on wove paper with partial watermark ("A")
at lower right of beard
4¼ × 4 in. (10.8 × 10.2 cm)
Signed in ink, lower left: –P. Ruiz Picasso–
Gift of Raymonde Paul, in memory of her brother, C. Michael Paul, 1982
1982.179.23

Santiago Rusiñol i Prats (1861–1931), a painter, poet, art critic, and writer, was one of the four co-founders ("four cats") of Els Quatre Gats. In his time considered one of the most important painters of the nineteenth century, he was also a leading spirit in the birth of Modernisme. In 1887 Rusiñol went to Paris with two other Catalan friends, Ramon Casas and Miquel Utrillo, and together they enjoyed the bohemian life in Montmartre during the 1880s and 1890s. They were habitués of the cabaret Le Chat Noir, the inspiration for Els Quatre Gats, where Rusiñol met and befriended Picasso in 1899. A generation older than Picasso, Rusiñol recommended the young artist to his friend Ignacio Zuloaga when Picasso decided to travel to Paris.

Between 1890 and 1894 Rusiñol shared his Montmartre studio with Casas, a respected portraitist, and counted among his French friends the painter Suzanne Valadon (1865–1938) and the musician and composer Erik Satie (1866–1925). Among his favorite subjects were the local cafés and dance halls, their interiors, and their patrons; his influences included Eugène Carrière (1849–1906), Pierre Puvis de Chavannes (1824–1898), and the expatriate American painter James Abbott McNeill Whistler (1834–1903). In his later career Rusiñol resided primarily in the Mediterranean coastal town of Sitges—his house there, Cau Ferrat, is now a museum—where he organized "Festes Modernistes" (celebrations of Modernista art and music) and focused his creative energies on landscapes and garden scenes. In this austere frontal portrait, Picasso captured Rusiñol's diginity and seriousness with a minimum of expressive means, notably through the dark, mostly flat areas of black and blue in the upper torso, and the large, wide-brimmed hat. Placed against a transparent background, Rusiñol's figure appears particularly massive and domineering (compare to fig. 6.1). MD

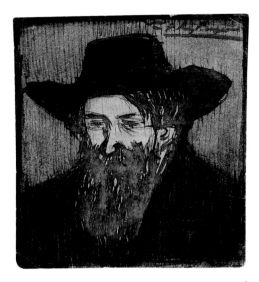

Fig. 6.1. Pablo Picasso, *Portrait of Santiago Rusiñol*, 1900. Ink and essence on paper, 4 × 3⅝ in. (10.3 × 9.2 cm). Museu Picasso, Barcelona (MPB 110.433)

EXHIBITIONS
Possibly Barcelona 1900, no cat.; Barcelona 1955, no. 23; Bern 1984–85, no. 87, pp. 139 (ill.), 321; Charleroi 1985, no. 10, pp. 119, 132 (ill.); Barcelona 1995–96, no. 85, pp. 91 (ill.), 175, 311 (Eng. ed.); Cleveland–New York 2006–7, no. 3:16, pp. 86 (ill.), 500; Amsterdam 2007–8, pp. 149 (ill.), 189

REFERENCES
Rodríguez Codolà 1900 (2006 ed., pp. 265–66) (on the series); *Pèl & ploma* 2, no. 65 (December 1900), p. 4 (ill.); Palau i Fabre 1966, pp. 66 (fig. 31), 238; Zervos 1932–78, vol. 21 (1969), p. 44 (ill.), no. 111; New York 1980, p. 19 (fig. c); Palau i Fabre 1981a, p. 48 (ill.); Palau i Fabre 1981b, pp. 191 (ill.), 529, no. 435; Messinger 1986, p. 75 (fig. 4); Léal 1996, vol. 1, p. 34 (fig. 6); Palau i Fabre 2006, pp. 109–10 and passim (on Rusiñol)

TECHNICAL NOTE

The black ink Picasso used to define the hat, shoulders, hair, and beard was found to contain carbon black[1] and is compositionally distinct from the brown ink he used to create the initial drawing. While the blue background is made from a wash of essence—a thin and underbound preparation of oil paint—the jacket is a brush-applied ink wash, most likely a thinned version of the black ink used to define the forms. The washes have settled into the waffle-like pattern of the watermarked wove paper, increasing its visibility. The collar and signature space also reveal the bright white color of the paper. RM

1. The presence of carbon was confirmed by Silvia A. Centeno, Department of Scientific Research, using Raman Spectroscopy.

PROVENANCE
Santiago Juliá, Barcelona (by 1955); C. Michael Paul, New York (until d. 1980); his sister, Dr. Raymonde Paul, New York (1980–82; her gift to the Metropolitan Museum, 1982)

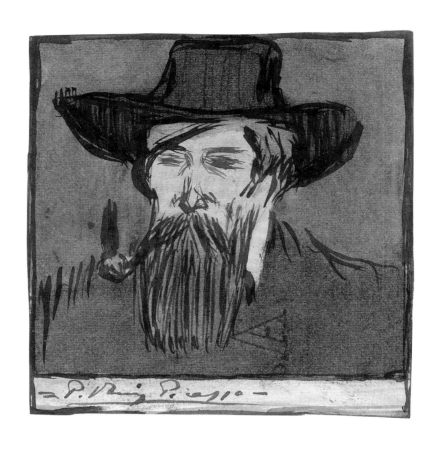

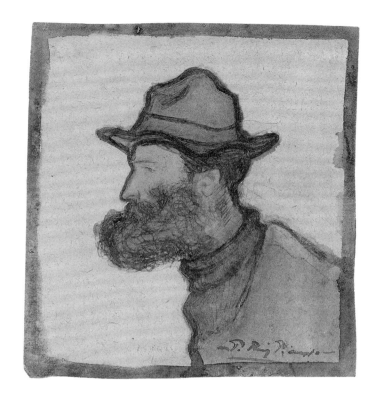

7. Ramon Pichot

Barcelona, early 1900

Ink and essence on wove paper
3⅞ × 3⅝ in. (9.8 × 9.2 cm)
Signed in ink, lower right: –P. Ruiz Picasso–
Gift of Raymonde Paul, in memory of her brother, C. Michael Paul, 1982
1982.179.24

The Modernista painter, printmaker, and illustrator Ramon Pichot i Gironès (1869–1925)[1] was another member of Picasso's Quatre Gats *tertulia*: his group of friends and companions who met regularly at the café. Pichot, who came from a musical and artistic background, was one of the younger of the Modernista painters; he had a one-man show at Els Quatre Gats in late February 1899, just about the time Picasso returned to Barcelona from Madrid. Picasso was close to the Pichot family and frequently spent time at their various residences.

In about 1900 Pichot traveled to Paris and became one of the devoted "bande à Picasso" residing in Montmartre, who together decorated the cabaret Le Zut. He later married Laure Gargallo, known as Germaine, whose failed affair with Picasso's friend Carles Casagemas drove the latter to commit suicide in 1901 (see cat. 2). Pichot divided his time between Montmartre and Barcelona, where he often exhibited at the Galeries Dalmau, an important venue for avant-garde artists. His death in 1925 was commemorated by Picasso in the painting *The Three Dancers* (1925, Tate, London).

MD

1. See p. 73, note 4.

PROVENANCE
Santiago Juliá, Barcelona (by 1955); C. Michael Paul, New York (until d. 1980); his sister, Dr. Raymonde Paul, New York (1980–82; her gift to the Metropolitan Museum, 1982)

EXHIBITIONS
Possibly Barcelona 1900, no cat.; Barcelona 1955, no. 22; Bern 1984–85, no. 89, pp. 138 (ill.), 321; Charleroi 1985, no. 7, pp. 119, 129 (ill.); Barcelona 1995–96, no. 77, pp. 89 (ill.), 175, 310 (Eng. ed.); Cleveland–New York 2006–7, no. 3:12, pp. 86 (ill.), 500; Amsterdam 2007–8, pp. 148 (ill.), 189

REFERENCES
Rodríguez Codolà 1900 (2006 ed., pp. 265–66) (on the series); Palau i Fabre 1966, pp. 67 (fig. 35), 238; Zervos 1932–78, vol. 21 (1969), p. 44 (ill.), no. 108; New York 1980, p. 19 (fig. f); Palau i Fabre 1981b, pp. 190 (ill.), 529, no. 432; Alley 1986, p. 16 (fig. 22); Messinger 1986, p. 77 (fig. 11); Richardson 1991–2007, vol. 1 (1991), p. 141 (ill.); Palau i Fabre 2006, pp. 75–77 (ill.), 98, 171–72, and passim (on Pichot)

TECHNICAL NOTE

Picasso delicately defined the patterns of the sitter's beard and turtleneck sweater in thin pen lines; in some places the lines are nearly devoid of ink, leaving only scratches to define the form (fig. 7.1). This drawing is unique in the series in that it has an unpainted background. Picasso reinforced the perimeter of the figure with a white pigment, which has created a slight haze. He did this freely and, it seems, not to obscure existing lines but to soften the color and shape of the hard pen and brush lines.

RM

Fig. 7.1. Photomicrograph (detail) of cat. 7

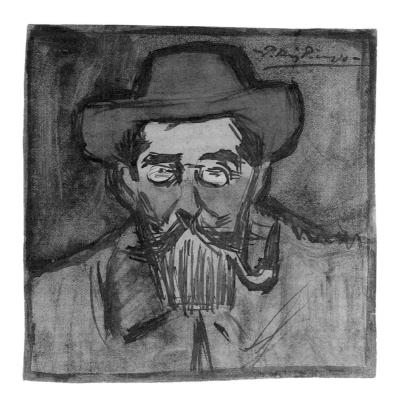

8. Ramon Casas
Barcelona, 1900

Ink and essence on wove paper
4¼ × 4⅛ in. (10.8 × 10.5 cm)
Signed in ink, upper right: –P. Ruiz Picasso–
Gift of Raymonde Paul, in memory of her brother, C. Michael Paul, 1982
1982.179.25

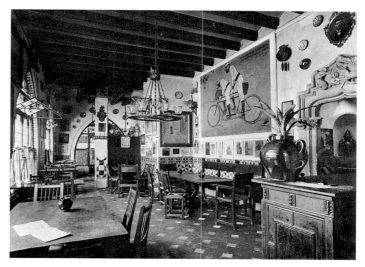

Fig. 8.1. Interior of Els Quatre Gats, 1899. Casas's painting *Ramon Casas and Pere Romeu on a Tandem* is visible at right

Arguably the most outstanding portraitist among Catalan painters, Ramon Casas i Carbó (1866–1932) was also one of the leading figures of the avant-garde movement known as Modernisme. Educated in Barcelona and Paris, Casas shared a studio in Montmartre with Santiago Rusiñol (see cat. 6), another key Modernista artist, from 1890 to 1894, when they versed themselves in the latest trends in French art, particularly Art Nouveau and Symbolism. Upon returning to their native Barcelona, they introduced aspects of what they had learned in Paris to the local artistic community, which was eager for news of the Parisian avant-garde. As part of their effort to make Barcelona a center of European modernism, Casas and Rusiñol helped found the bohemian Els Quatre Gats café. They produced a magazine under the same name, and Casas also contributed to *Pèl & ploma*, another Modernista publication. One of the highlights of Casas's early creative period was a decorative painting for the largest wall of Els Quatre Gats, *Ramon Casas and Pere Romeu on a Tandem* (fig. 8.1). In 1901 the painting was replaced by *Ramon Casas and Pere Romeu in a Car*, at the time frequently said to depict the nineteenth versus the twentieth century.[1]

Besides being a skilled portraitist, Casas was also a talented poster designer. He excelled in figural genre scenes notable for their use of bright light to suggest an atmosphere of comfort and leisure. Most of his later works—landscapes as well as portraits—were commissions for wealthy clients. Casas's exhibition of some 230 portrait drawings at Sala Parés in October 1899 stimulated Picasso to create his own series, which was intended to show that what Casas did well, Picasso could do better.

Picasso crammed this frontal image of Casas into an almost square border and emphasized the subject's deep pink cheeks. The work has an overall somber appearance despite the fairly light colors that define the coat and the delicate purple-blue

background behind Casas's projecting hat. Unlike in several of the other portraits, where Picasso's virtuosic, sinuous line is the primary expressive force, here straight lines and color convey the essential aspects of Casas's appearance. M D

1. See Mendoza 2006, pp. 80–85.

PROVENANCE
Santiago Juliá, Barcelona (by 1955); C. Michael Paul, New York (until d. 1980); his sister, Dr. Raymonde Paul, New York (1980–82; her gift to the Metropolitan Museum, 1982)

EXHIBITIONS
Possibly Barcelona 1900, no cat.; Barcelona 1955, no. 2; Bern 1984–85, no. 88, pp. 139 (ill.), 321; Charleroi 1985, no. 6, pp. 119, 128 (ill.); Barcelona 1995–96, no. 78, pp. 86 (ill.), 175, 310 (Eng. ed.); Cleveland–New York 2006–7, no. 3:14, pp. 86 (ill.), 500; Amsterdam 2007–8, pp. 148 (ill.), 189

REFERENCES
Rodríguez Codolà 1900 (2006 ed., pp. 265–66) (on the series); Palau i Fabre 1966, pp. 66 (fig. 37), 238; Zervos 1932–78, vol. 21 (1969), p. 44 (ill.), no. 107; New York 1980, p. 19 (fig. g); Palau i Fabre 1981b, pp. 191 (ill.), 529, no. 433; Messinger 1986, p. 75 (fig. 3); Léal 1996, vol. 1, p. 34 (fig. 5); Palau i Fabre 2006, passim (on Casas) and ill. facing p. 65

TECHNICAL NOTE
The even, translucent color in the area of the hat shows the ability of the brush-applied ink to produce smooth, even passages when it is not applied over pen-drawn lines. This is in contrast to most of the other drawings in the series, where the combination of pen lines and brush-applied media creates textures and enhances details. The streaky background and smooth, pink cheeks are both manifestations of essence: diluted oil media. Picasso left the eyes without a layer of wash to make them stand out more brightly against the surrounding pale yet intentionally toned face.

R M

9. Juli Vallmitjana

Barcelona, early 1900

Ink, essence, mixed-media paint, and pastel on wove paper
4⅞ × 3⅝ in. (12.4 × 9.2 cm)
Signed in ink, upper left: –P. Ruiz Picasso–
Gift of Raymonde Paul, in memory of her brother, C. Michael Paul, 1982
1982.179.26

The Catalan artist Juli Vallmitjana i Colominas (1873–1937), another Els Quatre Gats regular, excelled in performances of *sombras artísticas*, a type of shadow-puppet theater modeled on the Chinese shadow theater made popular by the Parisian cabaret Le Chat Noir. Vallmitjana, who had been a painter before becoming a writer, was particularly fascinated by the combination of puppetry, music, words, and set designs.[1] In this portrait, Picasso varied the pose from most of the others in the series, shifting from a profile or frontal view to a vantage from above, in which the bulk of the sitter's body occupies a larger portion of the pictorial field. He also emphasized the angularity of Vallmitjana's chiseled face, contrasting it with the curvilinear aspects of his bushy mass of dark hair. To make the figure stand out, Picasso restricted his palette to brownish tones placed against a blue-green background. The delicate lines of yellow and blue pastel that define the outline of the ascot add a touch of light. M D

1. See Messinger 1986, p. 76; see also Mendoza 2006, p. 87.

PROVENANCE
Santiago Juliá, Barcelona (by 1955); C. Michael Paul, New York (until d. 1980); his sister, Dr. Raymonde Paul, New York (1980–82; her gift to the Metropolitan Museum, 1982)

EXHIBITIONS
Possibly Barcelona 1900, no cat.; Barcelona 1955, no. 23; Bern 1984–85, no. 90, pp. 138 (ill.), 321; Charleroi 1985, no. 11, pp. 119, 133 (ill.); Barcelona 1995–96, no. 72, pp. 82 (ill.), 176, 309 (Eng. ed.); Cleveland–New York 2006–7, no. 3:21, pp. 86–87 (ill.), 501; Amsterdam 2007–8, pp. 147 (ill.), 189

REFERENCES
Rodríguez Cordolà 1900 (2006 ed., pp. 265–66) (on the series); Palau i Fabre 1966, pp. 67 (fig. 34), 238; Zervos 1932–78, vol. 21 (1969), p. 44 (ill.), no. 112; Palau i Fabre 1981b, pp. 191 (ill.), 529, no. 434; Messinger 1986, pp. 75, 76 (fig. 6); Palau i Fabre 2006, pp. 114–15, ill. facing p. 129

TECHNICAL NOTE
In addition to the metal nib pen sketch, brush-applied ink lines, and essence typical of the works in this series, Picasso embellished this portrait with pastel to depict the colorful tie. A cloud of fixative applied by the artist to limit the disturbance of the friable pastel makes the surface glossy and the colors more saturated. Picasso created the sitter's jacket with a mixed-media paint that is streaky and bubbly, similar in appearance to the media used in *Benet Soler* (cat. 5). This area, which may be a mixture of essence, watercolor, turpentine, and wax, underscores Picasso's penchant for experimentation.

R M

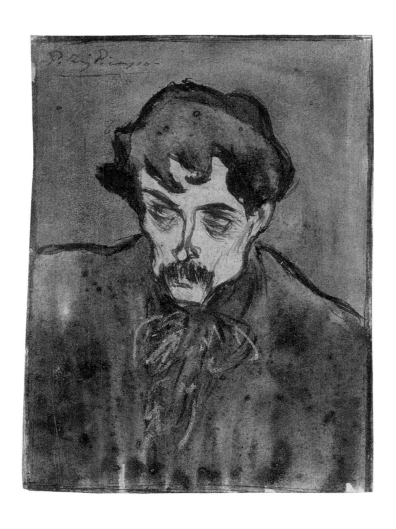

29

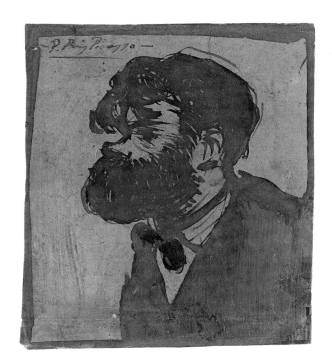

10. Joaquim Mir

Barcelona, early 1900

Ink and essence on wove paper
3½ × 3⅛ in. (8.9 × 7.9 cm)
Signed in ink, upper left: –P. Ruiz Picasso–
Verso: two stray pen marks at right edge
Gift of Raymonde Paul, in memory of her brother, C. Michael Paul, 1982
1982.179.27

Joaquim Mir i Trinxet (1873–1940), another of Picasso's Els
Quatre Gats companions, was considered one of the most
important landscapists of the Modernista movement. After
exhibiting at the Sala Parés in Barcelona, Mir moved to Majorca,
where he painted his most accomplished and, at times, almost
abstract works. Picasso presents Mir in a manner similar to that
seen in the portrait of Hermen Anglada-Camarasa (cat. 4),
although here the profile is in reverse. He emphasized the broad
areas of dark color, particularly the coat, hair, and beard, by set-
ting them against a pale orange background. This economy of
form and color endows the drawing with its expressive force,
succinctly conveying the sitter's gruff personality.

MD

PROVENANCE
Josep Graells, Barcelona; Santiago Juliá, Barcelona (by 1955); C. Michael Paul,
New York (until d. 1980); his sister, Dr. Raymonde Paul, New York (1980–82; her
gift to the Metropolitan Museum, 1982)

EXHIBITIONS
Possibly Barcelona 1900, no cat.; Barcelona 1955, no. 22; Bern 1984–85, no. 95,
pp. 140 (ill.), 321; Charleroi 1985, no. 13, pp. 119, 135 (ill.); Barcelona 1995–96,
no. 79, pp. 86 (ill.), 175, 310 (Eng. ed.); Cleveland–New York 2006–7, no. 3:15,
pp. 86 (ill.), 500; Amsterdam 2007–8, pp. 149 (ill.), 189

REFERENCES
Rodríguez Codolà 1900 (2006 ed., pp. 265–66) (on the series); Pèl & ploma 3,
no. 81 (October 1901), ill., unpaginated; Cirici-Pellicer 1946, ill. facing p. 32; Zervos
1932–78, vol. 6 (1954), p. 15 (ill.), no. 121; Palau i Fabre 1966, pp. 66 (fig. 28), 238;
Palau i Fabre 1981a, p. 57 (ill.); Palau i Fabre 1981b, pp. 191 (ill.), 530, no. 437;
Messinger 1986, pp. 76 (fig. 10), 77; Palau i Fabre 2006, pp. 111–12, 167, and passim
(on Mir)

TECHNICAL NOTE

Picasso formed large areas of the portrait, including the hair, beard, and jacket, with
brush-applied ink. The corrosive quality of the ink has deteriorated the paper and
further compromised the drawing's condition, which suffered in the past from poor
housing and handling. During application, larger amounts of ink collected at the
edges of the strokes, revealing the darker shade that the ink may have been when
first applied. The drawing has a double crease mark along the bottom edge, similar
to Self-Portrait "Yo" (cat. 1).

RM

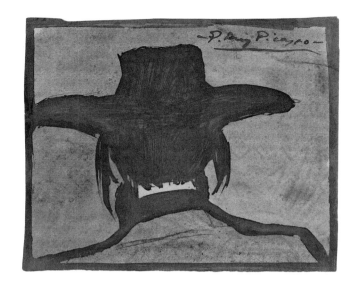

11. Pere Romeu

Barcelona, early 1900

Ink and essence on wove paper watermarked with fragment of emblem
2¾ × 3⅜ in. (7 × 8.6 cm)
Signed in ink, upper right: –P. Ruiz Picasso–
Gift of Raymonde Paul, in memory of her brother, C. Michael Paul, 1982
1982.179.28

Following an encounter with the noted Catalan portraitist Ramon Casas (see cat. 8), Pere Romeu i Borràs (1862–1908) initially intended to become a painter. Yet after moving to Paris in 1893, where he indulged in the bohemian life of Montmartre and performed in the shadow-puppet theater of the famous cabaret Le Chat Noir, he was inspired to take a more entrepreneurial direction. Romeu became the primary founder of Barcelona's Els Quatre Gats, one of the "four cats" of the café's name. He also initiated literary and musical evenings and exhibitions by the Modernista artists who frequented the tavern, giving many of them, including Picasso, their first one-man shows.

With longish hair that framed his face down to his chin and a dark, wide-brimmed hat, the lanky Romeu was the very picture of a Modernista bohemian. Here Picasso masterfully conveys that personality in a somewhat simplified manner, showing Romeu's large brown hat from behind, with long locks of uncombed hair hanging down over his ears. Romeu's slightly stooped shoulders and dangling limbs are well known from other portraits of him, including one by Ramon Casas that occupied a large wall of Els Quatre Gats (see fig. 8.1). Picasso executed several drawings and paintings of Romeu and in 1902 also painted a portrait of his wife, Corina. The present portrait, with its exceptional economy of expressive means and large areas of color, some outlined in heavy ink contours, projects with great immediacy Romeu's renowned quirkiness. MD

PROVENANCE
Santiago Juliá, Barcelona (by 1955); C. Michael Paul, New York (until d. 1980); his sister, Dr. Raymonde Paul, New York (1980–82; her gift to the Metropolitan Museum, 1982)

EXHIBITIONS
Possibly Barcelona 1900, no cat.; Barcelona 1955, no. 21; Bern 1984–85, no. 86, pp. 139 (ill.), 321; Charleroi 1985, no. 5, pp. 119, 127 (ill.); Barcelona 1995–96, no. 81, pp. 87 (ill.), 175, 310 (Eng. ed.); Cleveland–New York 2006–7, no. 3:17, pp. 86 (ill.), 500; Amsterdam 2007–8, pp. 149 (ill.), 189

REFERENCES
Rodríguez Codolà 1900 (2006 ed., pp. 265–66) (on the series); Blunt and Pool 1962, p. 29, pl. 5; Palau i Fabre 1966, pp. 67 (fig. 33), 238; Zervos 1932–78, vol. 21 (1969), p. 44 (ill.), no. 106; Jane Fluegel in New York 1980, pp. 19 (fig. b), 28; Palau i Fabre 1981b, pp. 190 (ill.), 529, no. 431; Messinger 1986, p. 76 (fig. 8); Richardson 1991–2007, vol. 1 (1991), p. 141 (ill.); Palau i Fabre 2006, pp. 110–11 and passim (on Romeu)

TECHNICAL NOTE

A fragment of a watermark and the texture of the wove paper are accentuated where the thin, diluted, brush-applied essence has settled into the paper. Picasso enhanced the texture of the hat and the hair on the back of the sitter's head by layering the ink wash over a series of pen lines. As in many of the small portraits, the action of the pen significantly disturbed the fibers and roughened the paper, which as a consequence holds subsequent layers of ink and wash in an uneven manner. This is in contrast to the smooth appearance of the hat in *Ramon Casas* (cat. 8), where the ink was applied to the sheet where there are no pen lines.

RM

12. Woman in Green
Madrid, Spring 1901

Pastel on tan paper board
20⅜ × 14¼ in. (51.8 × 36.2 cm)
Signed in black pastel, upper left: <u>P. Ruiz Picasso</u>
Purchase, Mr. and Mrs. John L. Loeb Gift, 1961
61.85

After celebrating New Year's of 1901 in Barcelona, Picasso moved to Madrid, where he intended to stay for at least a year. On February 4 he signed a lease on a commodious though spartan apartment and devoted himself to work on two new, high-minded publications: *Arte joven* and *Notas d'arte*. Although the latter was never realized, *Arte joven* appeared like a brilliant comet on the Madrid scene before it disappeared from view in June 1901. With articles by writers on the political left and illustrations principally by Picasso, it brought to Madrid a youthful, anarchic sensibility well known in Barcelona but infrequently encountered in the staid capital, home to Spain's teetering monarchy, attenuated aristocracy, and intransigent bureaucrats.

Although confusion has surrounded Picasso's production in Madrid that spring, it can now be determined that in addition to his illustrations for the two magazines he created a group of pictures—at least one large and one smaller canvas and about a dozen pastels[1]—depicting women dressed in theatrical costumes more elaborate than elegant. The larger painting, lost for some fifty years and now in Madrid, was a highly finished picture submitted to the Exposición General de Bellas Artes (fig. 12.1). It is without doubt the most commanding product of his brief stay in Madrid—a work, with its references to Goya's portraits of Queen María Luisa, intended to cement Picasso's reputation as the new "pequeño Goya."

The pastels, less impressive than the painting, are hasty in execution and not as incisive in their observation. It may be that toward the end of the spring Picasso felt pressured to produce material for his two upcoming June exhibitions: at Sala Parés, Barcelona, and Galerie Vollard, Paris. The subject matter is clearly Parisian: female denizens of the demimonde dressed to the nines in cheap confections that announce the wearer as a performer—theatrical, sexual, or both. Related paintings by Picasso that were shown at Ambroise Vollard's, such as the Metropolitan's *Woman in Profile* (cat. 13), may have been painted in Madrid as well. As many writers have observed, the sharp nose, black brow, and pointed chin of the *Woman in Green* appear in several of the pastels, but it is not known if Picasso based these features on a particular individual or whether he used them to express a type. It is impossible, however, to agree with Josep Palau i Fabre that they are portraits of actual figures from Madrileño high society: these women would not have been welcome in any proper drawing room.

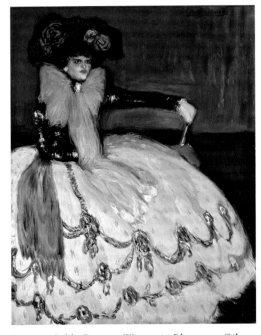

Fig. 12.1. Pablo Picasso, *Woman in Blue*, 1901. Oil on canvas, 52½ × 39¾ in. (133.5 × 101 cm). Museo Nacional Centro de Arte Reina Sofía, Madrid (ASO1618)

Although Picasso had clearly seen reproductions of works by Edgar Degas (1834–1917) and Henri de Toulouse-Lautrec (1864–1901) during his first stay in Paris (autumn 1900), his pastel technique in Madrid does not betray close observation of the work of those two masters. Instead, Picasso seems to have used pastel here as a simple and expedient means of enhancing his works with color. As June 25, the opening date of the Vollard show, loomed ever larger, he may have felt that he did not have time to wait for oils to dry for safe transport to Paris. He left Madrid in early May for a brief stay in Barcelona and sent this work to the small exhibition sponsored by the review *Pèl & ploma* at the Sala Parés in June.[2] It was probably bought there by Delmiro de Caralt, the Barcelona textile magnate, whose son of the same name, a well-known cineast, inherited the work from his father.

GT

1. DB III.3–12.
2. Picasso must have transported this pastel in the same portfolio as another pastel, *Castillian Village* (private collection, New York; DB V.51): as Metropolitan conservator Rachel Mustalish recently observed, a ghost image of *Woman in Green* was impressed on the verso of *Castillian Village*, which entered a Barcelona collection at an equally early date. Thus, neither work was likely exhibited at Vollard's in Paris.

33

PROVENANCE
Delmiro de Caralt, Barcelona, and his son (1901–61; sold to Knoedler); [M. Knoedler & Co., New York, 1961; sold in May for $60,000 to the Metropolitan Museum (purchased with funds donated by Mr. and Mrs. John L. Loeb)]

EXHIBITIONS
Possibly Barcelona 1901, no cat.; New York (MMA) 1961, no cat.; New York (MMA) 1962, no cat.; New York (MMA) 1963, no cat.; New York (MMA) 1964, no cat.; New York (MMA) 1965, no cat.; New York (MMA) 1966, no cat.; New York (MMA) 1968, no cat.; New York (MMA) 1990, no cat.; Cleveland–New York 2006–7 (not shown in Cleveland), hors cat.

REFERENCES
Pincell 1901, pp. 15–17; Daix and Boudaille 1967, pp. 34, 133 (ill.), no. III.7; Sterling and Salinger 1967, p. 227 (ill.); Zervos 1932–78, vol. 21 (1969), p. 85 (ill.), no. 216; Palau i Fabre 1981b, p. 221 (ill.), no. 542; Messinger 1983, p. 70

TECHNICAL NOTE
Picasso created a variety of textures by using different techniques. For the sitter's face, he applied smooth strokes of white pastel that blended the underlying pink layer to create a blush, while he roughened the paper in the area of the sofa to create the effect of upholstery fabric. This is in contrast to the light, loose loops of diffuse white strokes that make up the sitter's wrap, which in turn are texturally distinct from the voluminous skirt. In the skirt, the artist combined broad strokes of pastel with very thin, hard lines, possibly made with charcoal, which slightly indented the surface of the support. For the jewelry and other bright highlights, Picasso added thick impasto dabs of yellow and white pastel.

The support is a hard board made from an unrefined paper pulp. Although very flat, it has enough surface texture to give it sufficient tooth to be used successfully with pastel, which has a fine particulate nature. It is tan in color and may have darkened slightly over time. The board was also cut down, as seen from the jagged cut along the left edge and the crease marks along the top edge. The rosettes on the sitter's skirt have faded to a lavender from a brighter, redder shade of purple.

RM

13. Woman in Profile
Madrid, Spring 1901

Oil on paper board mounted on particle board
20½ × 13¼ in. (52.1 × 33.7 cm)
Signed, lower left: –Picasso–
Jacques and Natasha Gelman Collection, 1998
1999.363.58

This painting belongs to a small group of pictures Picasso made of extravagantly dressed women that were meant to evoke the demimonde of dance halls and brothels. The electric palette and broad dabs of paint relate it to other works he is thought to have made in Madrid in the spring of 1901, in anticipation of his upcoming show at the Galerie Vollard, Paris, which opened on June 25. Like *The Dwarf Dancer* (Museu Picasso, Barcelona), *The Spanish Dancer* (formerly Rodgers collection, New York; DB IV.3), and *Old Woman* (Philadelphia Museum of Art), it is painted in oil on paper board and was thus easily transported; Picasso biographer John Richardson believes the artist may have begun these works in Madrid and finished them in Paris.[1] The group is characterized by a similar treatment of backgrounds and dress, with brightly colored dabs of paint in imitation of Divisionism, and they bear the artist's new signature—"Picasso" preceded and followed by dashes—which is found on all of the works now thought to have been exhibited at Vollard's. A related watercolor, called *At the Moulin Rouge* (fig. 13.1), which is signed and dated 1901, shows a woman with similar features strutting past a crowd of admiring women, but it is not possible to determine whether that watercolor preceded or, more likely, was made after this painting.

Picasso arrived in Paris in May 1901 with a good number of paintings, pastels, and drawings, but not enough for his show. He installed himself at 130, boulevard de Clichy, in the former Montmartre apartment of his friend Carles Casagemas, who

Fig. 13.1. Pablo Picasso, *At the Moulin Rouge*, 1901. Watercolor, gouache, graphite, and charcoal on paper, 24¾ × 18⅞ in. (63 × 48 cm). Private collection

had committed suicide just a few months before (see cat. 2). Picasso's then dealer, a Catalan named Pedro Mañach (Pere Manyac), shared the apartment with him and footed the bills. Writers have tended to exaggerate the number of pictures Picasso painted each day in order to achieve the sixty-three catalogued items—and these were in addition to dozens of drawings as well

as portraits of the organizers, including Mañach, Vollard, Francisco Iturrino (a co-exhibitor), and Gustave Coquiot, the author of the catalogue essay (and the frivolous titles). But Richardson agrees with the assessment of eyewitness Félicien Fagus that Picasso may have indeed made as many as three a day.[2] Given the short period of time and the artist's chameleon-like changes of style, it is now impossible to identify with certainty which of the pictures exhibited at Vollard's were painted in Madrid and Barcelona in early 1901 and which were painted in Paris in the days before the opening.

Woman in Profile, though likely exhibited at Vollard's, cannot be identified with a particular catalogue number. According to Josep Palau i Fabre and Pierre Daix,[3] it might have been number 13, entitled "La Fille du Roi d'Egypte" (slang, according to Daix, for a Gypsy girl). Daix and Georges Boudaille have also suggested it was catalogue number 54 ("Chanteuse") or 55 ("L'Amoureuse"). For that matter, it could have been any one of the works called "Fille," "Vieille Fille," or "Femme de Nuit." The exhibition itself was informal to the point of disorganization. Picasso later recalled that the canvases were "on top of one another almost to the ceiling and unframed, while some were not even on stretchers but in large folders."[4] Nonetheless, the show was a decided though minor success both critically and financially. The poet Max Jacob (1876–1944) remembered how Picasso "was accused of imitating Steinlen, Lautrec, Vuillard, Van Gogh, etc., but everyone recognized that he had fire, a real brilliance, a painter's eye."[5] Indeed, the venture succeeded in exposing Picasso to a group of French cognoscenti and opinion makers: Jacob was sufficiently impressed to ask to be introduced to the artist, and they quickly became fast friends.[6] Picasso's facility, moreover, immediately became the stuff of legend, as Fagus wrote in *La Revue blanche*: "Besides the great masters, one easily unravels many likely influences. . . . Each one fleeting, eluding us as soon as it is grasped: one can see that his vehemence has not yet allowed him the opportunity to forge a personal style; his personality lies in this vehemence; this juvenile, impetuous spontaneity (they say that he's not twenty yet, that he painted up to three canvases per day)."[7]

Following his habit, Vollard did not buy any of the unsold work, and he did not keep for long, if it all, his own portrait by Picasso (1901, Foundation E. G. Bührle Collection, Zürich).[8] Presumably, Picasso's unsold pictures became Mañach's property in exchange for the monthly stipend of 150 francs he had been paying the artist; in 1902 a number of them were exhibited in a show arranged by Mañach, without Picasso's participation, at Berthe Weill's Paris gallery. Several of the canvases thought to have been exhibited at Vollard's were later overpainted by Picasso, proof that the artist did manage to keep some of them.

The first owner of *Woman in Profile* was the Basque painter Ignacio Zuloaga (1870–1945), who bought works directly from Picasso in Barcelona as early as 1900.[9] According to Zuloaga's son, Picasso traded this work for one by his father, but no work by Zuloaga has emerged among Picasso's possessions; the date

and circumstances thus remain unknown. It is possible that the transfer occurred as late as 1905, when Ignacio arranged for Picasso to submit a work, *Acrobat and Young Harlequin* (DB XII.9), to the Spanish pavilion at the Venice Biennale, although in the end it was not exhibited. GT

1. Richardson 1991–2007, vol. 1 (1991), p. 182. This painting shows indications of having been transported while still wet, but not of subsequent work.
2. Ibid., p. 193.
3. Palau i Fabre 1981b, p. 249; Daix 1993, p. 473.
4. Recounted in Palau i Fabre 1981b, p. 246.
5. Jacob 1927, p. 199, trans. in McCully 1982, p. 37.
6. Richardson 1991–2007, vol. 1 (1991), p. 204.
7. "On démêle aisément, outre les grands ancêtres, mainte influence probable…. Chacune passagère, aussitôt envolée que captée: On voit que son emportement ne lui a pas laissé le loisir encore de se forger un style personnel; sa personnalité est dans cet emportement, cette juvénilement impétueuse spontanéité (on conte qu'il n'a pas vingt ans, qu'il couvrit jusqu'à trois toiles par jour)." Fagus 1901, pp. 464–65.
8. This portrait was previously thought to depict Gustave Coquiot.
9. Richardson 1991–2007, vol. 1 (1991), p. 153.

PROVENANCE
Ignacio Zuloaga, Elgueta and Paris (acquired from the artist, probably by exchange, ca. 1903/5–d. 1945); his son, Antonio Zuloaga, Paris (1945–52; sold in March 1952 for $10,000 to Gelman); Jacques and Natasha Gelman, Mexico City and New York (1952–his d. 1986); Natasha Gelman, Mexico City and New York (1986–d. 1998; her bequest to the Metropolitan Museum, 1998)

EXHIBITIONS
Probably Paris 1901; Paris 1950, no. 79; New York 1962 (shown at Knoedler), no. 5, ill.; Tokyo–Kyoto–Nagoya 1964, no. 4, pp. 28 (ill.), 137; New York–London 1989–90, pp. 68–69 (ill.), 309 (ill.); Martigny 1994, pp. 23 (ill.), 92–93 (ill.), 331 (ill.); New York–Chicago–Paris 2006–7 (shown in New York only), no. 142, pp. 103 (fig. 109), 314, 385 (ill.)

REFERENCES
Zervos 1932–78, vol. 6 (1954), p. 174 (ill.), no. 1461; Daix and Boudaille 1967, pp. 42, 159, 182 (ill.), no. V.60; Palau i Fabre 1981b, pp. 245 (ill.), 249 (ill.), no. 636; Chevalier 1991, p. 25 (ill.); *Impressionist and Modern Art*, sale, Christie's, London, June 25, 2002, p. 32 (ill.)

TECHNICAL NOTE

Picasso painted the composition in oil medium directly on bare paper board—with no isolating ground layer—in free, vigorous, thick brushstrokes that create a texture resembling an open weave. The color of the board, now light brown but probably beige originally, served as an undertone. There is no drawing under the paint layer; instead, Picasso outlined the woman's profile with thin strokes of blue paint on top of her flesh tones, a technique he used repeatedly over the years. He also did not blend the paint. The individual strokes bear the fresh imprint of his flat brush (about 2 centimeters wide), and the paper board shows through the composition. This technique contributes to the distinctive blurry effect of the paint layer, while the high-contrast, bright palette gives the painting an intense luminosity. The paint texture is thick in places, but the finish is fairly dry, reminiscent of pastel, with the exception of the black hair, which displays a soft sheen. Some of the high impastos show gouge marks made when the paint was still fresh, most likely from casual handling. The paint layer was never varnished, allowing for a full appreciation of its subtle textures and sheens.

The original paper board was subsequently glued on to a compressed-fiber board, and a cradle made of vertical and horizontal wooden strips was glued to the back, a traditional conservation treatment often seen on panel paintings. This was also frequently done to disguise works on paper and make them appear as if they were actually painted on panel. The numerous fine cracks and broken impastos on the surface were most likely induced during this process.

 ID

14. Jardin de Paris (Design for a Poster)

Paris, Summer (late July?) 1901

Ink and watercolor on wove paper
25½ × 19½ in. (64.8 × 49.5 cm)
Signed in ink, lower right: –Picasso–; inscribed, at top: –JARDIN /
PARIS–
Verso: *Study for "The Mourners" and "Evocation (Burial of Casagemas)"*
Paris, Summer or early Autumn, 1901, charcoal
Gift of Raymonde Paul, in memory of her brother, C. Michael Paul, 1982
1982.179.17a, b

As an ambitious young artist on the prowl for advancement and income, Picasso availed himself of every opportunity for commercial work, whether in Barcelona, Madrid, or Paris. From menus for his Barcelona café, Els Quatre Gats, to illustrations for artistic reviews (*Pèl & ploma*, *Arte joven*) and satirical revues in Paris (*Le Frou-Frou*), Picasso could work in a range of styles easily identified with more famous artists, be it social realism in the manner of Steinlen, Casas, or Nonell, or a festive poster design in the manner of Lautrec and Chéret.

During his early stays in Paris, Picasso lived and worked in Montmartre, known then and now as a locus of nocturnal pleasures both innocent and guilty. The streets were plastered with posters for the big establishments (Le Moulin Rouge, Le Moulin de la Galette) as well as smaller nightclubs and cafés, while the sidewalks were crowded with revelers, prostitutes, hustlers, beggars, and bums. In a bid to capitalize on the reputation of his adopted neighborhood, Picasso made Montmartre's nightlife and its peculiar denizens the theme of many of the works he exhibited in his first Parisian show, held in June and July 1901 at the Galerie Vollard. Perhaps because of that show, or, more prosai-

cally, through Catalan connections in Paris, Picasso executed this design for a Parisian dance hall, Le Jardin de Paris.

Located near the Champs-Élysées, the Jardin de Paris was the summer outpost of the Moulin Rouge; unlike that sexual bazaar up in Montmartre, however, the Jardin was said to have been relatively guileless. Both establishments were managed by Josep Oller (1839–1922), a Catalan who was the inventor of the pari-mutuel betting system.[1] In addition to the Jardin, which opened in 1896, he owned the Nouveau Cirque (1886), the Moulin Rouge (1889), and the Olympia (1893). It is easy to imagine Picasso being introduced to Oller through one of his Catalan friends: bohemian Montmartre was a kind of center for Catalan artists in Paris,[2] and some of Picasso's older acquaintances from Barcelona—the artists Ramon Casas, Santiago Rusiñol, and Miquel Utrillo—had shared an apartment above La Galette and must have known Oller. Several art historians, including Marilyn McCully, John Richardson, and Barbara Shapiro, have written that Picasso was commissioned by Oller to make a poster for the Jardin de Paris, which Enrique Mallen dates to late July 1901. No proof of an actual commission has

Fig. 14.1. Henri de Toulouse-Lautrec, *Jane Avril* (at the Jardin de Paris), 1893. Lithograph printed in five colors, 50¹³⁄₁₆ × 36¹³⁄₁₆ in. (129.1 × 93.5 cm). The Metropolitan Museum of Art, New York, Harris Brisbane Dick Fund, 1932 (1932.88.15)

Fig. 14.2. Henri de Toulouse-Lautrec, *La Troupe de Mlle Églantine*, 1896. Lithographed poster, 24¼ × 31¼ in. (61.6 × 79.4 cm). The Metropolitan Museum of Art, New York, Harris Brisbane Dick Fund, 1932 (1932.88.5)

Fig. 14.3. Pablo Picasso, *The Mourners*, 1901. Oil on canvas, 39⅜ × 35½ in. (100 × 90.2 cm). Private collection

Verso of cat. 14, *Study for "The Mourners" and "Evocation (Burial of Casagemas)"* (1982.179.17b)

Fig. 14.4. Pablo Picasso, *Evocation (Burial of Casagemas)*, 1901. Oil on canvas, 59¼ × 35⅝ in. (150.5 × 90.5 cm). Musée d'Art Moderne de la Ville de Paris

emerged, however, and no printed poster has been found; Picasso kept this maquette, later using the verso (ill.) for an informal sketch. Although some historians have taken the existence of the maquette as proof of a commission, Picasso could have easily made it as a speculative venture to entice Oller into a lucrative arrangement. In any event, the present work could not have been mechanically reproduced; it is a presentation piece showing how the poster might have looked. Had Picasso received the commission, separate lithographic stones would have been prepared for each of the four colors he proposed: blue, yellow, rust red, and black. Knowing that, Picasso carefully kept each of the colors to specific areas of the composition in order to simplify the printing process. Liberally borrowing from Lautrec's imagery—in particular the two posters *Jane Avril* and *La Troupe de Mlle Églantine* (figs. 14.1, 14.2)—Picasso also borrowed Lautrec's signature tonal shading, achieved using seemingly random splotches of color that function much like modern Ben Day dots.[3]

Given that Lautrec was already inactive—he had suffered a cerebral hemorrhage in April 1901, six months before his death at thirty-six—Picasso may well have hoped to position himself as Lautrec's successor or, at the minimum, a low-cost alternative to the master lithographer. As the gambit failed, Picasso found himself with a large, unsaleable composition. In the summer or early autumn of 1901 he used the back of his poster design (ill.) to sketch a preliminary composition for *The Mourners* and *Evocation (Burial of Casagemas)* (figs. 14.3, 14.4).[4] The latter was the magnum opus dedicated to the memory of his friend Carles Casagemas, in whose apartment he was living and whose lover, Germaine, was now his own. GT

1. In 1864 Oller had founded several betting agencies. After he invented the pari-mutuel (pool) method of betting, he obtained a patent for the machine used to perform the calculations, called a *compteur totalisateur*. Pari-mutuels were suppressed by the French government in 1875 before being officially authorized in 1887. Oller also created the racecourses at Maisons-Laffitte and Saint Germain. See Anon., April 22, 1922, p. 12, and *Encyclopaedia Britannica Online*, 2009, s.v. "pool."

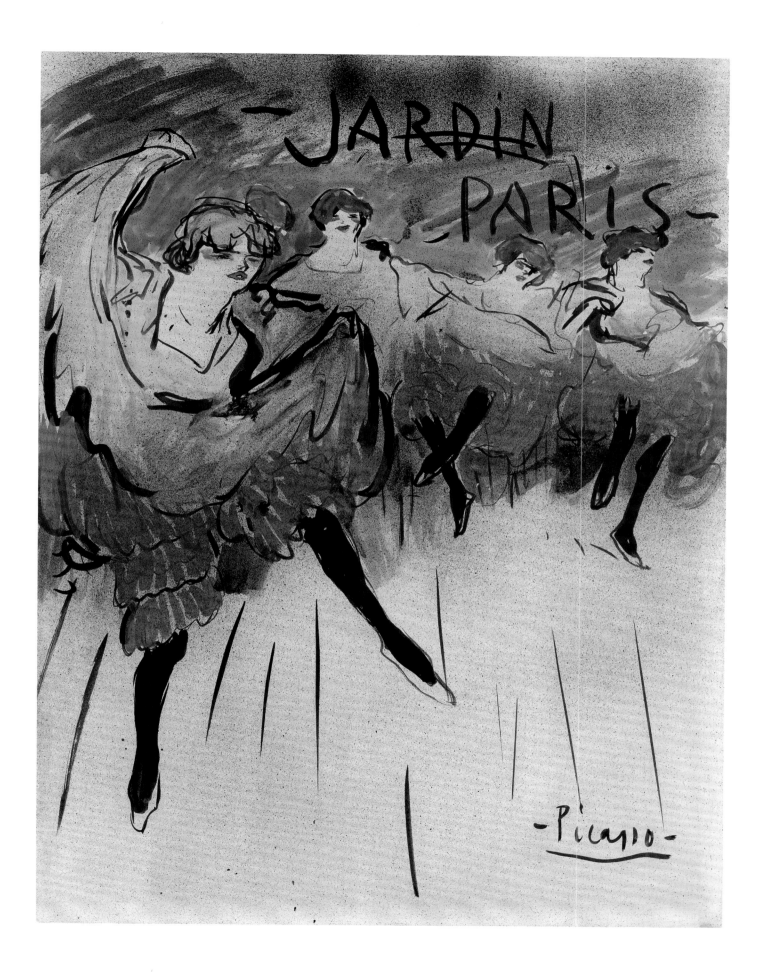

2. The first large composition created by Picasso after his arrival in Paris in the autumn of 1900 was a picture of La Moulin de la Galette (Solomon R. Guggenheim Museum, New York).

3. Lautrec's *Jane Avril* (made to advertise her cabaret show at Le Jardin de Paris) and Chéret's poster *Le Jardin de Paris* (1890) were reissued in smaller format for subscribers to *Les Maîtres de l'affiche*, published by L'Imprimerie Chaix. Chéret was the artistic director. His *Le Jardin de Paris* was republished in 1897, Lautrec's *Jane Avril* in 1898.

4. This sketch appears related to several known studies for *Burial of Casagemas*, in which the horizontal figure of Casagemas is surrounded by hunched and seated mourners. Daix (DB 46) has dated these studies to the summer of 1901. In all of them, the scene is framed on each side of the composition by a standing figure, and these framing figures are connected by a row of closely huddled mourners. In the Metropolitan's sketch, Picasso is still grappling with how to define the body of Casagemas and the bed on which he is laid out. In a related conté crayon work (z VI.328), the body appears laid out on the ground, while in a pen drawing (z VI.329), a similar coffin-shaped box is sketched, and there is a figure similar to the one standing at far left in the painting. The figure seated near Casagemas's feet appears in several of the studies as well as the final painting. The triangular shape at top center seems related to the trees in the conté crayon work noted above.

PROVENANCE

Alphonse Bellier, Paris; Georges Lévy (probably Léon Georges Levy), Paris (his sale, Hôtel Drouot, Paris, December 20, 1934, no. H; sold for 1,900 francs); [Galerie Käte Perls, Paris, by 1937]; [Perls Galleries (Klaus and Frank Perls), New York, 1937–1938 or 1939; sold to Chrysler]; Walter P. Chrysler, Jr., New York and Warrenton, Virginia (probably 1938/by March 1939–1950; his sale, Parke-Bernet Galleries, New York, February 16, 1950, no. 28, sold for $950); private collection (1950–61; sale, Parke-Bernet Galleries, New York, April 26, 1961, no. 19); Colonel C. Michael Paul (by 1966–d. 1980); his sister, Dr. Raymonde Paul, New York (1980–82; her gift to the Metropolitan Museum, 1982)

EXHIBITIONS

Paris (Perls) 1937, no. 5; New York (Perls) 1937, no. 2; New York 1938, no. 4; Chicago 1939, no. 135; New York and other cities 1939–41 (shown only in New York, Chicago, Saint Louis, and Boston), no. 14, p. 28 (ill.); Richmond–Philadelphia 1941, no. 194, p. 111; on view at MMA, February 16–March 28, 1983; Bern 1984–85, no. 114, pp. 223 (ill.), 322; New York 1985, no cat.; New York 1990–91, no cat.; Boston–New York 1991, no. 149, ill. on cover and p. 151; Paris 1998–99, fig. 6; Washington–Chicago 2005, no. 174, pp. 139, 166 (ill.)

REFERENCES

Anon., January 1939, p. 7 (ill.); Frankfurter 1941, p. 12 (ill.); Barr 1946, p. 20 (ill.); Zervos 1932–78, vol. 6 (1954), p. 45 (ill.), no. 367; Elgar and Maillard 1956, pp. 10, 13; D. Cooper 1968, p. 341, fig. 23; Messinger 1983, p. 70; Tinterow 1987, pp. 80 (ill.), 81; Daix and Boudaille 1967, p. 145 (ill.), no. IV.15; Palau i Fabre 1981b, pp. 234 (ill.), 534, no. 590; Richardson 1991–2007, vol. 1 (1991), p. 201; advertisement for Boston–New York 1991, *New York Times Magazine*, October 20, 1991, p. 21 (ill.); Washington–Boston 1997–98, p. 36 (fig. 22); Léal, Piot, and Bernadac 2000 (both eds.), pp. 40 (fig. 50), 41, 502; Julia May Boddewyn in New York–San Francisco–Minneapolis 2006–7, pp. 346, 347, 348, 350, 356

TECHNICAL NOTE

Picasso used a calendered paper, which is dampened and passed through heated rollers to give it a smooth, hard surface. The ink and the watercolor sit on the surface of the sheet, which does not provide any texture itself. The paper has yellowed slightly and would have originally been a bright white; however, the colors remain vivid. The spatter technique Picasso used to modulate the tones of the background is analogous to (and done in the same manner as) the spatter pattern given to lithographic prints to create tones and atmosphere. A charcoal sketch on the verso is partially obscured by the adhesive of a former mounting.

RM

15. Mother and Child on a Bench

Paris, second half of 1901 (possibly by June 1901)

Pastel on wove paper
22½ × 19⅜ in. (57.2 × 49.2 cm)
Signed in blue pastel, lower right: –Picasso–
Bequest of Donald M. and Mary P. Oenslager, 1996
1996.441

Despite the febrile gaiety of much of the work Picasso exhibited at the Galerie Vollard in June and July 1901, by the end of the summer a dark cloud had settled over his production. The predilection was already in place: in 1900 he inscribed a self-portrait drawing "Paul Ruiz Picasso Pictor en Misere Humane [*sic*]."[1] As he said to his friend, the poet Jaime Sabartés, "Grief is at the basis of life. . . . If we demand sincerity of the artist, sincerity is not found outside the realm of grief."[2]

The politics of Picasso's circles in Barcelona and Madrid were decidedly anarchistic, and his sympathies were unquestionably with workers, the downtrodden, and all those at the margins of society. Years later, Picasso told Josep Palau i Fabre that the summer of 1901 was when he visited the prison of Saint-Lazare in Paris, a site—infamous in song and verse—that would provide the artist with imagery for several years to come. Saint-Lazare, an enormous compound in the 10th arrondissement, not far from Montmartre, was the headquarters of Saint Vincent de Paul's Congregation of the Mission to the poor in the seventeenth century. It was later used by the City of Paris as a prison for

Fig. 15.1. Henri-Gabriel Ibels, *La Chanson du rouet*, ca. 1893. Lithograph, 13¾ × 10⅞ in. (35 × 27.6 cm). Musée du Prieuré, Saint-Germain-en-Laye (PMD 992.7.1)

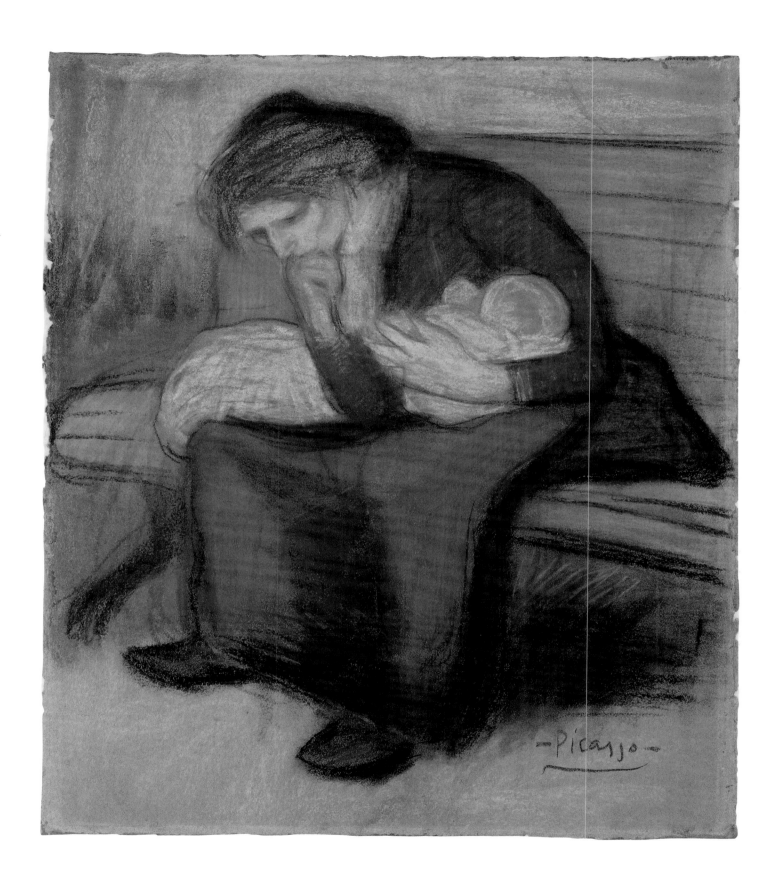

female prostitutes and as a hospital for venereal disease. Infected inmates were required to wear a distinctive white bonnet, in shape reminiscent of the revolutionary "Phrygian cap," which shows up in Picasso's pictures in 1901 and 1902. "Les deux risques" of prostitution were considered to be disease and pregnancy.[3] Some women brought a child with them to Saint-Lazare; others gave birth there. By all accounts the hospital and prison were clean and safe, yet regardless of the small comforts these were unhappy women: for many their child was a burden, a stigmata of failure. Not until 1904 would Picasso illustrate the unmitigated joy of motherhood.

The precise date of this pastel is not known. It is possible the work was made for Picasso's June 1901 exhibition at the Galerie Vollard, but the grim sensibility points to the second half of the year. The strong contours and graphic use of pastel betray Picasso's close study of Théophile-Alexandre Steinlen (1859–1923) and Henri-Gabriel Ibels (1867–1936), two French illustrators who specialized in social realism and often drew on the imagery of Montmartre and its street culture. A lithograph by Ibels, *La Chanson du rouet* (fig. 15.1), shows a seated woman nursing a swaddled baby. Like Picasso, Ibels exhibited at Vollard's gallery. Both Steinlen and Ibels, moreover, modeled their art on the vast repertoire of social commentary in the work of Honoré Daumier (1808–1879), which was much in evidence in Paris that summer after a vast retrospective of his work opened at the École des Beaux-Arts.[4] It is worth noting as well that Käthe Kollwitz (1867–1945), who recognized a kindred social consciousness in Picasso, bought a picture, "La Bête" (unidentified), from the show at Vollard's. GT

1. Richardson 1991–2007, vol. 1 (1991), p. 217.
2. Sabartés 1946a, p. 65.
3. Leja 1985.
4. "Exposition, Daumier, par le Syndicat de la presse artistique," Palais de l'École des Beaux-Arts, through May 1901. The exhibition included numerous scenes of a mother and child (see, for example, nos. 43, 44, 100, 119, 149, 222, 226, 232, 269, and 272).

PROVENANCE
Donald M. Oenslager (d. 1975) and Mary P. Oenslager (d. 1995), New York (their bequest to the Metropolitan Museum, 1996)

EXHIBITION
Possibly Paris 1901, no. 64

REFERENCES
Zervos 1932–78, vol. 1 (1932), p. 56 (ill.), no. 111; Blunt and Pool 1962, p. 30, pl. 83; Daix and Boudaille 1967, p. 163 (ill.), no. V.8; Palau i Fabre 1981b, pp. 300 (ill.), 538, no. 753; Leja 1985, fig. 29 (between pp. 168 and 169); Rebecca A. Rabinow in New York–Chicago–Paris 2006–7, p. 314

TECHNICAL NOTE
The textured artists' paper has darkened and become warmer than its original cool gray, but it retains the mottled tone created by the colored fibers in the sheet. Picasso made a rough sketch of the design in blue pastel, visible in the delineation of the hands and at the edges of the various shapes of the composition. After building up the colors and forms with subsequent layers of pastel, he reemphasized details and outlines in strokes of black. Picasso applied the pastel heavily, layering colors for depth of tone. In some areas he blended the layers to create shadows, as in the features of the face; in others he used layering and a heavy application of pastel to roughen the paper, resulting in surface effects such as the texture of the hair. The pale pink pastel in the foreground and in the infant has sunk into the paper, creating a contrast between the paper and pastel that is different from the drawing's original appearance. RM

16. Mother and Child by a Fountain
Paris, Autumn/Winter 1901

Oil on canvas
16⅛ × 12⅞ in. (41 × 32.7 cm)
Signed in black paint, lower right: <u>Picasso</u>
On verso, at right: several thin, mostly vertical strokes of paint
Bequest of Scofield Thayer, 1982
1984.433.23

Between 1900 and 1903 Picasso made three trips to Paris; he settled there permanently in 1904. The autumn of 1901, during his second stay (May 1901–January 1902), saw the beginning of what came to be known as his Blue Period, a time of introspection and darkness for Picasso precipitated by the death of his close friend Carles Casagemas (see cat. 2). The subject of this canvas, a mother and child, is one that appears frequently in works from the Blue Period. On the surface an essentially tender theme, it was in fact inspired by Picasso's visits to the

Fig. 16.1. Henri-Gabriel Ibels, *Les Petites Mères*, ca. 1803. Lithograph, 14⅝ × 10¾ in. (37.2 × 27.2 cm). Musée du Prieuré, Saint-Germain-en-Laye (PMD 992.7.3)

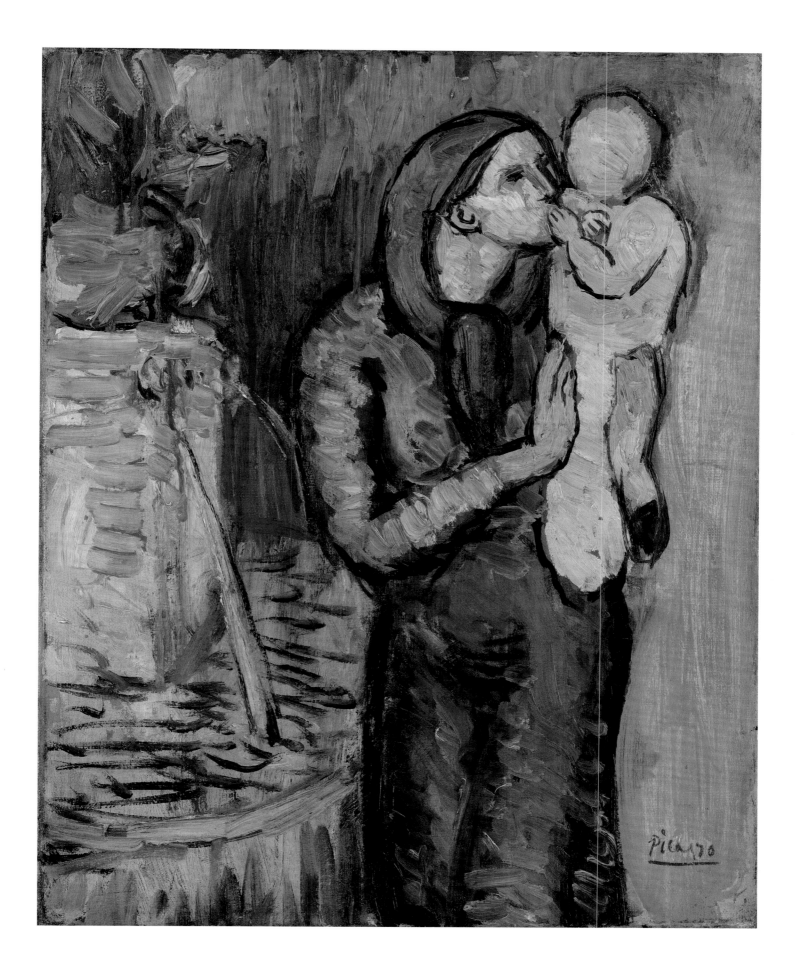

women's prison and hospital of Saint-Lazare, in the Faubourg-Saint-Denis section of Paris. Instead of sentimentality, the subjects represent the opposite end of the emotional spectrum: a harsh everyday reality of dismaying poverty, disease, and homelessness. His portrayals thus invite comparison to the biting social commentary implicit in the graphic works of artists such as Henri-Gabriel Ibels, in particular his illustration for the songbook "Les Petites Mères" (fig. 16.1).

Many of the inmates of Saint-Lazare were prostitutes or criminals infected with venereal disease who had either given birth at the prison or, after being arrested, were allowed to keep their children with them as long as they were being nursed. Picasso began visiting the prison sometime about the late summer or early autumn of 1901 through Dr. Louis Jullien, a prominent venereologist who was a consulting physician there.[1] The visits, which provided the artist with models at no cost, turned him into a "painter of human misery."[2] Picasso was particularly taken aback by the presence of children amid the prison's cavernous spaces, which were imbued with the smell of disinfectant and an almost overwhelming gloom.

Saint-Lazare was unique among Parisian penal institutions: a combination of convent, soup kitchen, laundry, and pharmacy where the inmates were charged with the spotless upkeep of the facilities. Located in a seventeenth-century building, it was turned into a prison during the French Revolution, and in 1824 it became a women's penitentiary run by an order of nuns, the Sisters of Saint Joseph. Picasso was fascinated by the inmates' attire, in particular their ugly black-and-blue-striped jackets and their so-called Phrygian bonnets, or *bonnets d'ordonnance* (regulation caps), which were either brown or white, the latter distinguishing a syphilitic.[3] In *Mother and Child by the Fountain* and similar works, Picasso stylized and idealized this attire, transforming the drab jackets into dark blue El Greco–like habits and the bonnets into cowl-neck head coverings or hoodlike shawls. He thus turned images of dejected whores or drunkards into symbols of motherhood or the Madonna and Child, full of sweetness and sorrow. The overall blue tonality, from which the Blue Period derives its name, emphasizes the sadness of the world being depicted as well as the artist's melancholy. Ironically, we are also reminded of the sanctified atmosphere of some religious depictions of the Madonna and Child.

Within the fairly small format of the painting Picasso relied on a diversity of brushstrokes to explore the nuances of the nearly monochromatic color scale. The horizontal strokes of the mother's dress, outlined in black, and the heavy white impasto of the baby's figure stand out against the loosely painted background at right and the large shape of the fountain in the prison courtyard, at left. The dominant cool blues and the sharply delineated figures enhance the mood of physical and emotional isolation, while the energetically drawn yellow contour of the fountain's edge reverberates in the yellowish green of the vertical section between the woman's head and the top of the fountain. The compositional structure gives a sense of intimacy to the

woman's surroundings and brings her figure and that of the child closer to the viewer even as the exact context of their milieu remains obscure. MD

1. For details of Picasso's visits to Saint-Lazare, see Richardson 1991–2007, vol. 1 (1991), pp. 218–24.
2. Ibid., p. 219, quoting Picasso (see cat. 15).
3. Ibid., p. 221.

PROVENANCE
Frank Burty Haviland, Paris (by ca. 1905, until at least 1909; probably acquired from the artist); Roger Dutilleul, Paris (by 1912); Baron Napoléon Gourgaud, Paris; Scofield Thayer, Vienna and New York (ca. 1923–d. 1982; on extended loan to the Worcester Art Museum, Massachusetts, 1931–82, inv. 31.755; his bequest to the Metropolitan Museum, 1982)

EXHIBITIONS
New York 1924, no. 29; Worcester 1924, no. 29; Northampton 1924, no cat.; New York (Seligmann) 1936, no. 6, p. 14, and ill.; Worcester 1959, no. 74, p. 84; Worcester 1965, no cat., unnumbered checklist; Worcester 1971, no cat.; Worcester 1981, no. 114; Yokohama 1989, no. 160, p. 198 (ill.); Washington–Boston 1997–98, no. 72, pp. 171 (ill.), 357; Paris 1998–99, fig. 26; Tokyo 2000, no. 19, vol. 1, p. 58, vol. 2, pp. 57, 58 (ill.); Hannover–Berlin 2000, no. 1, pp. 66–67 (ill.); Houston 2007, no. 124, pp. 166 (ill.), 244; Berlin 2007, p. 248 (ill.)

REFERENCES
Raynal 1921, pl. 2; Raynal 1922, pl. 2; *The Dial* 80 (May 1926), ill. facing p. 357; Taylor 1932, p. 70; Zervos 1932–78, vol. 1 (1932), no. 107, p. 54 (ill.); Cirici-Pellicer 1946, pl. 52, unpaginated; Sutton 1955, fig. 2; Blunt and Pool 1962, pp. 20, 31, fig. 107; Kay 1965, p. 48 (ill.); Daix and Boudaille 1967, p. 195 (ill.), no. VI.9; Anon., May 19, 1972, pp. 1 (ill.), 38; Cabanne 1975a, p. 117; Palau i Fabre 1981b, pp. 277 (ill.), 537, no. 698; Brenson 1982, pp. A1, C18 (ill.); Leja 1985, p. 72; Daix 1995, pp. 9, 109, 361–62, 566, 588, 685, 808; Julia May Boddewyn in New York–San Francisco–Minneapolis 2006–7, pp. 333, 344

Fig. 16.2. Infrared reflectogram of cat. 16, showing an arch in the top-left quadrant and the initial position of the legs

On the verso of the canvas, which is medium-weight linen, one can glimpse the white, commercially prepared ground through the open weave. Picasso began the painting by outlining the figures in blue paint, which is visible at the top of the child's head, along the proper left side of the child, around the back, and down past the mother's proper left hand. He further developed the composition in quick, direct strokes. Touches of green and brown from this preliminary stage can be seen through skips in the paint film, such as beneath the figures and along the proper left wrist of the mother. Picasso quickly settled on a different palette, however, composed predominantly of blue and white. He added local passages of green (top left), yellow (bottom right), and red (mixed with white for flesh tones) late in the painting process, and he continually reinforced outlines with blue and black paint.

There is much evidence of Picasso using the wet-in-wet technique (in which the oil paint remains wet throughout subsequent applications), especially in the impastoed areas. Several drips in the blue and green in the top-left quadrant indicate that he applied these colors in a thin consistency. Areas of pale lavender paint beneath the present composition can be seen through skips in the paint film. As this layer is visible in broad areas throughout the work, it is possible that Picasso was covering an earlier application of paint, perhaps even a previous composition. This is also suggested by the fact that losses in the paint layer reveal underlying pigmented layers, such as green through the water at the base of the fountain and red along the left edge of the canvas. X-radiography indicates concentrations of lead white that appear unrelated to anything in the visible paint film; it is unclear whether these details reflect changes made to the present composition or if they relate to an earlier composition by either Picasso or another artist. Infrared reflectography (fig. 16.2) reveals that in the initial linear underpainting the mother was standing with her legs apart; it also shows an archway in the top-left quadrant, and it enhances the sculpted head from which the water is spouting on the right side of the fountain. On the verso of the canvas are strokes of red, green, purple, brown, and white paint, which is unusual for Picasso and may be additional evidence that the canvas was first used by another artist.

In 1963, in order to treat a series of distortions in the canvas, the work was removed from its strainer and put on to a stretcher, which was better able to support the canvas and accommodate any necessary adjustments of tension. In 1986, shortly after entering the Metropolitan's collection, the work was cleaned. A layer of wax and two synthetic surface coatings that were muting the tones of the work were removed, revealing a brighter, higher-keyed palette.

SD-P

17. Seated Harlequin

Paris, Autumn 1901

Oil on canvas, lined and mounted to a sheet of pressed cork
32¾ × 24⅛ in. (83.2 × 61.3 cm)
Signed and dated in red paint, lower left: P̲icasso̲/1901[1]
Purchase, Mr. and Mrs. John L. Loeb Gift, 1960
60.87

After experimenting with a bewildering variety of styles in the year following his first arrival in Paris, in the autumn of 1901 Picasso was able to coalesce his thinking into a series of remarkably cogent pictures: what may be the first in a style properly called his own. He painted six canvases, all about the same size, with a single figure or a couple seated at a café table, that together constitute one of the greatest achievements the prodigious twenty-year-old artist had yet accomplished.[2] Each of them is a masterpiece; *Seated Harlequin* is arguably the best of the bunch.

The paintings—their format, subject, palette, and handling—derive from a heady list of prototypes: the 1870s café scenes of Degas and Manet as reworked by Van Gogh, Gauguin, and Lautrec in the 1880s and 1890s. Picasso may not yet have seen many Degases or Manets in the flesh, but he was surrounded by their progeny in the posters of Lautrec. He must have seen canvases by Gauguin at Vollard's, and he might have spied works by Cézanne and Van Gogh there as well: Van Gogh's 1889 portrait of Madame Roulin, *La Berceuse* (fig. 17.1), which has similar floral wallpaper, was bought by Vollard in 1900.[3] The muted, glaucous palette of *Seated Harlequin* has been compared to Gauguin's suite of Tahitian paintings shown at Vollard's in 1898, while the Harlequin costume appeared in paintings of the 1890s by Cézanne. Above all, the epigrammatic concision of Picasso's new style suggests that he had absorbed the graphic impact of Lautrec's lithographed posters and translated it into oil on canvas, arriving at a result that was close to Gauguin and Van Gogh without being imitative.[4] The pose of the figure may derive, improbably enough, from an 1894–95 painting by Georges de Feure (1868–1943) titled *Voix du Mal*, which was reproduced in black and white in the February 1900 issue of *Figaro illustré* (fig. 17.2).[5] The decorative style—notably the emphasis on pattern, large areas of flat color, and lack of shadow or modeling—resembles the work of Maurice Denis and the Nabis in general, also available to Picasso at Vollard's. But the result, in Picasso's hands, is a synthesis that transcends its sources to become something original and powerful.

The image did not spring directly from Picasso's mind onto the canvas. Technical examination reveals that Picasso revised the painting a great deal before settling on the final arrangement (see figs. 17.3, 17.4). The floral background was originally more extensive and not cut off by the banquette; there were several alternative contours for the head, shoulders, and proper right arm; and there was a large, overscaled drinking glass on the table where the match striker now appears. In addition, Picasso first painted the Harlequin properly—without a ruff at the neck and cuff—and Harlequin's bicorne hat once rested behind his right hand.

Fig. 17.1. Vincent van Gogh, *La Berceuse*, 1889. Oil on canvas, 36½ × 29 in. (92.7 × 73.7 cm). The Metropolitan Museum of Art, New York, The Walter H. and Leonore Annenberg Collection, Gift of Walter H. and Leonore Annenberg, 1996, Bequest of Walter H. Annenberg, 2002 (1996.435)

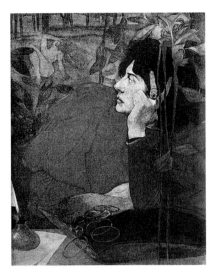

Fig. 17.2. Georges de Feure, *Voix du Mal*, 1894–95. Reproduced in *Figaro illustré*, February 1900, p. 35

The commedia dell'arte character Harlequin was by 1901 a ubiquitous figure in popular entertainment, seen at masked balls, the opera, street fairs, the circus, and the Moulin Rouge. His costume, a patchwork of black and red lozenges separated by white bands, was established by the mid-sixteenth century, and he usually carried a baton, or slapstick, and wore a black mask. Although the stock figures of the commedia—four young lovers (two male and two female), one or two authority figures, and a couple of servants (male or female)—had been absorbed into popular culture throughout Europe, the commedia was revived as an antique art form in mid-nineteenth century France, with a new emphasis on authenticity. For this reason, it is especially odd that in revising his picture Picasso would give his Harlequin a white face and a ruffled collar and cuffs, for these are the attributes of Pierrot, the melancholy, cuckolded clown who inevitably loses his love, Columbine, to the nimble and lusty Harlequin. For Picasso to conflate Harlequin and Pierrot therefore confounds convention.

Many writers have suggested that the pensive mood of this picture and the series to which it belongs was the result of Picasso's brooding on the suicide of his friend Carles Casagemas, who, like Pierrot, was unrequited in love.[6] Four years later, in

At the Lapin Agile, Picasso painted himself as Harlequin alongside his Columbine, Germaine, the woman who drove Casagemas to suicide. Perhaps Picasso gave this Harlequin the ruffs and white face of Pierrot to signal melancholy; more likely he added them simply because he wanted to, just as the blue and black squares of the leotard are his own invention. (He originally colored the costume yellow and light blue—the same light blue seen in *The Two Saltimbanques (Harlequin and His Companion)* [The Pushkin State Museum of Fine Arts, Moscow]—before settling on medium blue and black.) Although Picasso would take on Harlequin as one of his alter egos, there is no indication of self-identification in this picture, which may mark the first appearance of Harlequin in his work.[7]

Seated Harlequin has had an impressive career as an important representative of Picasso's early work, which in the mid-twentieth century was often called his "stained-glass" or "cloisonné" period. It was acquired, perhaps as early as 1906, by an Oxford-educated German aesthete from Aachen, Edwin Suermondt, a protégé and client of the dealer Wilhelm Uhde. Uhde introduced Suermondt to Picasso and Braque and brought him to Gertrude Stein's salons.[8] Suermondt lent it to an exhibition in Cologne in 1912, but the young German seems to have sold it by 1913, when it was seen in exhibitions in Munich and Cologne and purchased shortly thereafter by Heinrich Thannhauser. (Thanks to the dealers Vollard, Uhde, Thannhauser, Flechtheim, and Kahnweiler, Picasso's work was shown more often in Germany than in France in the years just prior to World War I.) The voracious American collector John Quinn bought it in 1922. In the 1930s it was owned by the young Philadelphian Henry McIlhenny and his sister, Bonnie Wintersteen, who sold it to another Philadelphian, Henry Clifford. The New York collectors Mr. and Mrs. John L. Loeb funded the Museum's purchase of the work in 1960.

G T

1. According to Douglas Cooper (letter to Theodore Rousseau, July 17, 1962, NCMC archives), Picasso recalled that the painting was sent to him in the late 1930s, when he signed it at the request of the owner.
2. The others are: *Portrait of Sabartés* (DB VI.19); *The Two Saltimbanques* (DB VI.20); *Woman with a Chignon* (DB VI.29); *L'Apéritif* (DB VI.24); and *The Absinthe Drinker* (DB VI.71).
3. Vollard purchased this work from the sitter and her husband, Joseph Roulin, in 1900, and it was with Amédée Schuffenecker by 1905 (see provenance in S. Stein and Miller 2009, p. 204). Vollard also had two versions of Van Gogh's *L'Arlésienne* with the pink background but sold both in February 1900 (stock nos. 161813 and 17161). The first one came back to him, however, in exchange for a Gauguin, although it is not clear on what date; the next references to the paintings in his stock book are after 1901. One of the versions was included in the Bernheim-Jeune exhibition in 1901; see note 4 below. My thanks to Susan Stein and Roland Dorn for these observations.
4. Picasso probably missed the important showing of paintings by Van Gogh at Bernheim-Jeune, Paris (March 15–31, 1901), "Exhibition d'oeuvres de Vincent van Gogh," which included two Arlésiennes: no. 14, "L'Arlésienne (fond rose)," lent by Vollard (now Museu de Arte de São Paulo or Galleria Nationale d'Arte Moderna, Rome), and no. 50, "L'Arlésienne," lent by Émile Schuffenecker (now Musée d'Orsay, Paris). It is worth noting that there were several paintings at the 1901 Salon (April 22–June 30) called "Rêverie" or "Mélancolie" that share a pose and mood with Picasso's *Seated Harlequin*, especially *Mélancolie* (no. 1721) by Tony Robert-Fleury (1837–1911) and *Rêverie* (no. 718) by Allan Osterlind (1855–1938).

51

19. Seated Figure
Barcelona, Spring 1902

Ink and wax crayon on a paper card
5¼ × 3⅝ in. (13.3 × 9.2 cm)
Signed in black ink, lower right: <u>Picasso</u>
Bequest of Joan Whitney Payson, 1975
1976.201.29

Fig. 19.1. Pablo Picasso, *Sketch of a Female*, from *Sketchbook #30*, 1903. Brown ink on paper, 23 × 12 in. (58.4 × 30.5 cm). Private collection

Picasso's line drawings of the early Blue Period, exemplified by this small sketch, reflect the artist's remarkable ability to capture through a limited vocabulary of strokes the introspective mood and aura of isolation so palpable in his paintings from that time. Drawing, a medium with which Picasso had exceptional facility, even in childhood, became his tool for testing stylistic possibilities and compositional options. By its very nature the most direct and immediate expression of an artist's creative thoughts, drawing allows for innumerable changes in form, subject matter, and composition, frequently helping the development of new ideas and pictorial notations that are eventually transferred, or transformed, into a painting. In Picasso's case, intense periods of drawing often alternated with feverish painting activity.

In the present drawing, Picasso rendered the androgynous nude seated on a rock or boulder using a quick, thin line. He used delicate shading in black ink and blue wax crayon to emphasize the top part of the figure's back, slightly curved neck, left cheek, underside of the arms, and back of the legs; broader strokes define the rock. The drawing was executed on the verso of a business card from the cotton factory Suari y Juñer, in Barcelona (ill.), which belonged to the family of Picasso's good friends Juan and Sebastián Juñer-Vidal. Josep Palau i Fabre, in his book *Picasso en Cataluña*,[1] describes Picasso's relationship with the brothers following his return from Paris in January 1902 and before his subsequent trip there with Sebastián in October of that year: "[H]e had dinner in the house of the brothers Juan and Sebastián Juñer-Vidal, who had a cotton factory with the office in the Calle de la Platería, at no. 21. He spent long hours in the back room of this office, drawing almost constantly—drawings which were kept jealously by the Junyer [Juñer] brothers, until they finally possessed quite a collection."

Picasso must have considered this drawing—part of the collection formed by Sebastián Juñer-Vidal—relatively important, because he selected it for inclusion in the first volume of the catalogue raisonné of his works compiled by Christian Zervos in 1932.[2] Stylistic analysis of the figure in the context of other works from the period seems to indicate that the delicate, androgynous body, slender feet, and long, equally slender arms and thighs as well as the chignonlike hairdo belong to a woman (fig. 19.1). In particular, the high cheekbones, straight nose, and deeply set eyes bring to mind Germaine, the source of Picasso's friend Carles Casagemas's suicidal obsession and later an occasional mistress of the artist. The pose of the figure, especially the

Verso of cat. 19

right arm, which is raised in a mannered gesture of peace or, perhaps, to signal a pause in conversation, reappears in *Woman with a Fan* (National Gallery of Art, Washington, D.C.), a painting executed in Paris in the autumn of 1905, about a year after Picasso had settled permanently in the French capital. The two figures also share the same type of hieratic pose, which imbues them with authority as well as a quiet dignity.

MD

1. Palau i Fabre 1966, pp. 100–108. Another drawing from this group was sold at Sotheby's New York, *Impressionist & Modern Art, Part Two*, sale no. 7892, May 7, 2003, lot 187.
2. Zervos 1932–78, vol. 1 (1932), p. 72 (ill.), no. 152. There it was titled "Woman with Right Arm Raised"; subsequently it was also known as "Nude Circus Figure" as well as "Seated Male Nude."

PROVENANCE

Sebastián Juñer-Vidal, Barcelona (probably acquired from the artist, ca. 1902 until at least 1932); by descent to Carlos Juñer-Vidal, Barcelona; [Knoedler & Co., New York; sold in 1960 to Payson]; Joan Whitney Payson (Mrs. Charles Shipman Payson), Manhasset, New York (1960–d. 1975; her bequest to the Metropolitan Museum, 1975)

EXHIBITIONS

Kyoto–Tokyo 1980, no. 64, ill.; Bern 1984–85, no. 163, pp. 274 (ill.), 324–25; Paris 1998–99, ill. on back cover; Balingen 2000 (Eng. ed.), no. 24, ill.; Liège 2000–2001, not in cat.

REFERENCES

Anon., October 5, 1902, p. 1 (ill.); Zervos 1932–78, vol. 1 (1932), p. 72 (ill.), no. 152; Cirici-Pellicer 1946, p. 152 (ill.); Camón Aznar 1956, pp. 539 (fig. 405), 728; Maria Teresa Ocaña in Barcelona–Bern 1992, p. 23 (ill.)

TECHNICAL NOTE

As the support is a commercial paper, stiffened for use as a business card, it has a smooth texture. It was white when new; over time the card has become slightly darker and browner. There are pinholes in the upper corners, indicating, as with many works on paper, that it was pinned to a support either while it was being made or for subsequent viewing.

Visual examination and X-ray fluorescence (XRF) indicate that the pen-applied ink, as in many of Picasso's drawings, is likely a commercial writing ink that was originally black, dark brown, or even blue-black and has altered over time; inks of the period were often mixtures and could vary highly in appearance and durability. To emphasize shadow, Picasso reinforced the back of the figure's head in a second, darker type of ink that remains darker today. He used blue wax crayon for the coloring and shading of the drawing. Overall, considering the white card and the black and blue media, the drawing would once have had a cooler tonality.

<div align="right">RM</div>

20. Erotic Scene (known as "La Douleur")

Paris, Autumn 1902, or Barcelona, 1903

Oil on canvas
27⅝ × 21⅞ in. (70.2 × 55.6 cm)
Bequest of Scofield Thayer, 1982
1984.433.22

Picasso returned to Paris from Barcelona in October 1902, within a few days of his twenty-first birthday. The trip was impromptu, perhaps occasioned by his desire to avoid military service in Spain. No longer under contract to Pedro Mañach, Picasso soon found himself in the City of Lights without money, lodging, or clients. It was, he later recalled, the most difficult time he would ever experience. The Catalan sculptor Auguste Agero offered to share a squalid room at the Hôtel du Maroc, on the rue de Seine, and Picasso, in desperation, accepted for a month or so; by the end of his stay he had left the hotel to share a room with the poet Max Jacob.

During the short sojourn, Picasso produced several powerful drawings of hieratic figures expressing torment or pain, inspired in part by Poussin. This graphic but deflatingly unerotic canvas was, according to John Richardson, the sole painting he made during this stay. Richardson posits that it was either a commission or, worse, that the desperate young painter was pressured to paint erotica. Picasso may well have been unable to afford painting supplies; his despair over his material circumstances, as evidenced by the absence of contact with the extended network of Catalans in Paris, may have been another factor inhibiting his work. Years later, when Pierre Daix showed him a photograph of this painting, Picasso denied it was his and prohibited him from including it in his catalogue raisonné.[1] Alan Riding recounted in 2001 that Picasso told Daix, "It's not mine. I've done worse. But it was a joke by friends."[2]

The eyewitness accounts of Picasso's life in the autumn of 1902 were written by Max Jacob and Jaime Sabartés, the artist's good friend and, later, secretary and biographer. However, as Richardson has shown, Jacob is unreliable and Sabartés was disappointingly discreet about this period; neither refers to this painting. Richardson uses one clue to cast a hypothesis regarding its origin: Sabartés wrote that Picasso could not "stomach some grotesque incidents and the pettiness of persons known to him and Max. Picasso refused to speak about this matter and the vile and repugnant egoism of the individuals concerned…at the Hôtel du Maroc."[3] Richardson suggests that the "disgusting Spaniards," as Picasso referred to them in a letter to Max Jacob, extracted this painting in exchange for money or materials.[4] Perhaps one of those Spaniards then sold it to Picasso's friend Benet Soler, who consigned it to Galeries Dalmau, Barcelona, in 1912, where it was photographed by Adolf Mas and bought by the dealer Daniel-Henry Kahnweiler. More likely, Picasso had traded the salacious picture for clothes from Soler, a tailor.

It is difficult to account for Picasso's rejection of the picture when reminded of it by Daix in the 1960s. While the subject is unique in his painted oeuvre, Picasso made dozens if not hundreds of explicitly sexual watercolors and drawings in his early years, especially between 1902 and 1903; toward the end of his career eroticism became one of his principal subjects. As a young man Picasso made no secret of his promiscuity, and in his paintings and drawings (especially the latter) he frequently depicted himself in the company of courtesans, showgirls, and prostitutes. This painting, however, remains unusual for its patent lack of quality; it has none of the erotic intensity that characterizes the slightest of his pornographic doodles, and the immature point of view is surprising coming from a young man so extensively experienced in sex. Even Picasso himself—for that is indeed Picasso on the bed—does not look at the abject woman fellating him; instead, he lifts his head with both hands to view the act reflected in a mirror across the room, adopting the pose of Goya's Majas at the Prado (fig. 20.1). The figure of

Fig. 20.1. Francisco de Goya y Lucientes, *The Nude Maja*, ca. 1800. Oil on canvas, 38¼ × 74¾ in. (97 × 190 cm). Museo del Prado, Madrid (P74)

Fig. 20.2. Pablo Picasso, *Woman with Mirror*, 1903. Charcoal on paper, 9 × 8⅝ in. (22.9 × 21.9 cm). Musée National Picasso, Paris (MP476)

the woman does not display Picasso's typical fascination for the bodies of his lovers, although the pose does resemble an autograph drawing of 1903 (fig. 20.2). The summary execution of the entire work—careless handling of the drapery, crude realization of the female nude, unfinished lower quarter of the canvas—is likewise atypical of Picasso. Hence his characterization of the painting as a joke by someone else rings true: one could easily imagine a friend teasing Picasso with an embarrassing picture in his own style. One could also see a friend embellishing an abandoned picture by him by painting the artist's face on the male figure. Why else would Picasso have denied making this work unless he truly believed it was not by him?

Until now, it was thought that *Erotic Scene* disappeared from view after 1912 and resurfaced in the 1960s. New research has revealed that it in fact belonged to the Parisian art dealer Paul Guillaume, who acquired it from the Paris auction of Daniel-Henry Kahnweiler's stock in 1923. (In 1914, all of the art belonging to Kahnweiler, a German national resident in Paris who was Picasso's dealer at the time, had been seized by the French government as property of an enemy alien. After much debate, it was sold in a series of auctions in Paris in 1922 and 1923.) Lot 360 of the fourth Kahnweiler sale included the following note in the catalogue: "Hidden by a shutter hinged to the back of this canvas is a painting, *Erotic Scene*, that, due to its libidinous subject, cannot be exhibited."[5] The title, media, and dimensions of the described work conform to the Metropolitan's painting—and to no other known work in Picasso's oeuvre.[6] In a letter of September 13, 1912, confirming the purchase through Josep Dalmau, Kahnweiler called it his "tableau obscène."[7] The painting must therefore be authentic: if by some fluke Kahnweiler had acquired a misattributed work, it would have been denounced as such at the time by Picasso or, later, the experts who organized the 1923 sale.

Erotic Scene was first reproduced in 1969. Robert Rosenblum discussed it in a 1970 article, and it has been frequently illustrated since Richardson's discussion of it in a 1987 essay.[8] All modern writers except Daix accept the painting as autograph, and technical examination has shown that the physical properties of the picture are consistent with Picasso's work of the time. The peculiar title by which it was formerly known, "La Douleur" (pain or agony), appears on an early twentieth-century label on the stretcher and may derive from a mistranscription of "La Douceur," meaning a reciprocal gift for services rendered, which comfortably suits the subject.

GT

1. Daix related this story to Lewis Kachur on November 9, 1989, per note in NCMC archives.
2. Riding 2001, p. E2.
3. Sabartés 1946a, p. 91, quoted in Richardson 1991–2007, vol. 1 (1991), p. 258.
4. Richardson 1991–2007, vol. 1 (1991), p. 258.
5. "Au dos du tableau, masqué par un volet monté sur charnières, une peinture 'scène galante' qui, en raison de son sujet libidineux, ne peut être exposée." Kahnweiler sales 1921–23, part 4 (May 7–8, 1923), p. 24.
6. Only two of the three digits of the lot number ("36...") were visible in a blue crayon inscription on the stretcher of the canvas; the final digit was once obscured by a label but has recently been revealed. The Kahnweiler sale catalogue indicates that this composition was attached to the back of a still life that was bought by Paul Guillaume. X-radiography does show another composition under the present surface, but it cannot be determined whether it is under the erotic scene or on the back of the canvas, which is obscured by a modern lining. My thanks to Christel Hollevoet-Force, Lucy Belloli, and Shawn Digney-Peer for their observations and research on this matter.
7. Dalmau Archives, Barcelona.
8. Richardson 1987, p. 160.

PROVENANCE
Probably Benet Soler, Barcelona (until 1912, on consignment with Galeries Dalmau, Barcelona; sold in September, through Dalmau, for 300 francs, to Kahnweiler); [Galerie Kahnweiler, Paris, 1912–14]; sequestered Kahnweiler stock (1914–23; sale, "Vente de biens allemands ayant fait l'objet d'une mesure de Séquestre de Guerre: Collection Henri Kahnweiller [*sic*]: Tableaux modernes, quatrième et dernière vente," Hôtel Drouot, Paris, May 7–8, 1923, no. 360 [as "Nature morte" and "Scène galante"] for 5,000 francs to Guillaume); [Paul Guillaume, Paris, 1923; sold to Thayer]; Scofield Thayer, Vienna and New York (ca. 1923–d. 1982; in storage, ca. 1931–82; his bequest to the Metropolitan Museum, 1982)

EXHIBITIONS
Possibly Barcelona 1912, no cat. (perhaps shown upon request); Paris 1998–99, fig. 41; Paris–Montreal–Barcelona 2001–2 (not shown in Barcelona), pp. 90 (fig. 40), 181 (pl. 40), and brochure, p. 4 (ill.); London 2007–8, pp. 173 (ill), 249

REFERENCES
Anon., May 10, 1923, p. 1 (no. 360); Anon., May 17, 1923, unpaginated (no. 360); Desnos 1923; Brusendorff and Henningsen 1969, p. 112 (ill.); Rosenblum 1970, p. 337 n. 1; Richardson 1987, p. 160; Richardson 1991–2007, vol. 1 (1991), p. 258 (ill.); Mailer 1995, p. 74 (ill.); Rosenbaum 1996, text and ill.; R. Johnson 1997, p. 8; Trincia 1997, p. 20; Martí 1998, p. 39; Anon., September 3, 2001; Dupuis-Labbé 2001, p. 25; Richardson 2001, pp. 18 (ill.), 23; Riding 2001, p. E2; Hurd 2004, p. 102 (ill.); Marks 2006; Durrant 2007, ill.; Goldstein 2007, pp. 29–30 (ill.); Higgins 2007a; Higgins 2007b; Hoyle 2007; Lewis-Jones 2007; Reynolds 2007; F. Wilson 2007

The painting is on medium-weight linen canvas commercially prepared with a white ground. It appears that Picasso painted primarily wet-in-wet and the oil paint had not yet dried before subsequent applications of paint, causing colors to blend. Glimpses of pink within the figure of the woman suggest that she may have started out with warmer flesh tones.

Examination in raking light reveals slightly textured brushstrokes, some of which appear unrelated to the present composition. This may indicate that, as with many Blue Period paintings, there is another composition underneath the *Erotic Scene*; however, examinations with infrared reflectography and X-radiography have proved inconclusive.

At some point before the painting entered the Metropolitan's collection the canvas was stiffly lined with a glue-paste adhesive. In 1986 a thick, discolored, and glossy varnish was removed, and the paint film was lightly varnished in order to adequately saturate the surface.

SD-P

21. Head of a Woman

Barcelona, Spring–Summer 1903

Oil on canvas
15⅞ × 14 in. (40.3 × 35.6 cm)
Signed in dark blue paint, upper left: Picasso
Signed and dated on verso in blue paint, at center: Picasso/1903 [following date is a large circular swirl of blue paint that extends under the stretcher bar, possibly added to cross out an inscription]
Bequest of Miss Adelaide Milton de Groot (1876–1967), 1967
67.187.91

In January 1903, following his third trip to Paris, Picasso returned to Barcelona and moved back into the studio on Calle Riera de San Juan he had originally shared with his late friend, Carles Casagemas. He remained in Barcelona for the next fourteen months, a fruitful period when he produced numerous drawings and some fifty paintings, among them such Blue Period masterpieces as the allegorical *La Vie* (see fig. 22.4), *Celestina* (Musée Picasso, Paris), and *The Blind Man's Meal* (cat. 22), as well as this small portrait.

The painting depicts an attractive young woman in a shoulder-length format. Her head, a graceful oval, is gently tilted, and her delicate features and widely set, dark blue-black eyes give the subject an almost coquettish appearance. A touch of reddish pigment on the full mouth adds an element of sensuousness, while the beautiful eyes, fixed on some unknown point in the viewer's space, are thoughtful and sad. It has been suggested that the work might have been painted directly from a model.[1] Other research indicates that it depicts the same person, though in reverse and nude, seen in the 1902–3 canvas *Head of a Woman (Portrait of Geneviève)*, now in the Hermitage (fig. 21.1),[2] whose eyes, nose, mouth, and rather heavyset neck strongly resemble those of our model. Here, however, in addition to the overall blue tones, Picasso highlighted the proper right shoulder with delicate pink touches of pigment and thickly articulated the bridge of the nose with white. According to John Richardson, the sitter was a twenty-year-old doll dressmaker known variably as Cécile Acker or Geneviève (or Germaine) Pfeipfer (Peifer). She was also briefly a mistress of Picasso's and through him met Max Jacob, with whom she lived for eight months, until their

relationship ended.[3] Perhaps Picasso, having painted the Hermitage portrait, took up the subject again after his return to Barcelona and produced this much more flattering image.

Technical examination has revealed the presence of a different composition underlying the present portrait: a horizontal landscape depicting a country road bordered by several trees and large stones (see the technical note accompanying this entry). The landscape is inscribed "A J.TORRES. / GONZALEZ" (fig. 21.2). Although microscopic magnification of the canvas surface allows limited insights into the palette of the landscape, it is difficult to determine the author of the overpainted work on stylistic grounds. One could conjecture that it was executed

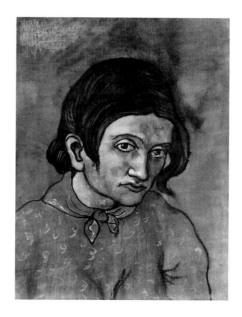

Fig. 21.1. Pablo Picasso, *Head of a Woman (Portrait of Geneviève)*, 1902–3. Oil on canvas on cardboard, 19⅝ × 14⅜ in. (49.7 × 36.5 cm). The State Hermitage Museum, Saint Petersburg (GE-6573)

and then discarded by Joan González (1868–1908), the older brother of sculptor Julio González (1876–1942). Joan's paintings from 1902–3 include a number of oils and gouaches that employ the same motifs of trees with abundant foliage and rocks.[4] The dedication to "J. Torres" by "Gonzalez" likely refers to Joaquín Torres García (1874–1949), with the last name shortened to "Torres," in accordance with Spanish tradition, a plausible scenario given that all three artists were friends and members of the same bohemian circle at Els Quatre Gats.

The González family settled in Paris in 1900, and Picasso was a frequent visitor. On the verso of the Museum's *Study of a Harlequin* (cat. 24) is a long list of addresses of his friends in Paris, including that of the González family: 22, avenue du Maine. Julio returned to Barcelona in 1902, possibly together with Picasso, but on October 19 of that year he left for Paris again along with Picasso and another artist-friend, Josep Rocarol.[5] While there they visited the González house often, and Picasso—always in need of funds for both survival and supplies—might have been offered one of their discarded or unfinished paintings so he could reuse the canvas. — MD

1. See Yokohama 1989, p. 200, no. 162.
2. See the discussion by Albert Kostenevich (2008, vol. 1 , p. 454, vol. 2, pp. 117–18).
3. Richardson 1991–2007, vol. 1 (1991), pp. 260–62. According to Richardson she was Jacob's one and only heterosexual affair.
4. For examples, see Barcelona 1998, figs. 117–19.
5. See *El Liberal*, October 20, 1902.

PROVENANCE
Baron Shigetaro Fukushima, Paris and Tokyo; [Galerie Alfred Flechtheim, Düsseldorf and Berlin, by 1932]; Adelaide Milton de Groot, New York (by 1933–d. 1967; on extended loan to the Metropolitan Museum, from 1936 [inv. L.3346.33]; her bequest to the Metropolitan Museum, 1967)

EXHIBITIONS
Zürich 1932, no. 8, p. 2; New York (MMA) 1936, no cat., unnumbered checklist; on view at MMA, February 25–April 29, 1941, March 19–November 1942, March 24–February 1944, May 24, 1944–May 29, 1946, and September 29–November 17, 1947; New York (MMA) 1950, no cat.; New York (Perls) 1958, no. 21, ill.; Columbus 1958–59, no. 29; on view at MMA, September 12–October 14, 1963, and October 28, 1963–February 20, 1964; Portland (Ore.) 1970, no. 6, p. 17 (ill.); Bellingham 1976–77, no. 82, pp. 112 (ill.), 113; on view at MMA, November 3, 1977–October 31, 1978; Saitama 1982, no. 76, pp. 115 (ill.), 211; Bern 1984–85, no. 198, pp. 296 (ill.), 326; Charleroi 1985, no. 24, pp. 120, 147 (ill.); Yokohama 1989, no. 162, p. 200 (ill.); Okayama and other cities 1990, no. 1, p. 32 (ill.); Paris 1998–99, fig. 34; Houston 2007, no. 125, pp. 167 (ill.), 244 (ill.), 245; Berlin 2007, p. 249 (ill.)

REFERENCES
Barr 1946, p. 282; Zervos 1932–78, vol. 6 (1954), p. 67 (ill.), no. 548; Daix and Boudaille 1967, p. 224 (ill.), no. IX.16; Lecaldano 1968, pp. 92 (ill.), 93, no. 69; Boudaille 1969, p. 14; Palau i Fabre 1981b, pp. 349 (ill.), 542, no. 906; Glozer 1988, pl. 31

TECHNICAL NOTE

Picasso applied paint thinly in a limited palette of blue, white, and red (mixed with white for flesh tones), on plain-weave, medium-weight canvas commercially prepared with a white ground. He then reinforced outlines and details in blue. Areas of texture from brushstrokes that appear to be unrelated to the present composition, such as flat semicircular passages near the jaw, shoulder, and proper left ear, suggest the presence of an underlying composition, which X-radiography and infrared examination (fig. 21.2) confirm. This underlying composition, a landscape oriented 90 degrees counterclockwise from the portrait, is inscribed and signed in paint at lower right. It includes a path bordered by a fallen stone wall and several trees whose foliage accounts for some of the textural differences noted above. Based on what can be seen under magnification through skips in the overlying blue paint, the palette of the landscape includes reddish brown, warm green, and black.

On the reverse (fig. 21.3), which Picasso signed and dated in blue paint, is a circular swirl of blue paint that may have been added to cover something, such as an inscription from the previous artist. Infrared reflectography reveals a drawn circle that is covered by the blue swirl, but the crossbar prevents further examination. In 1982 a discolored layer of natural resin varnish was removed and a thin varnish was added to adequately saturate the paint film. — SD-P

Fig. 21.2. Infrared reflectogram of cat. 21, showing underlying landscape inscribed and signed "A J. Torres. / Gonzalez" at lower right corner

Fig. 21.3 Reverse of cat. 21

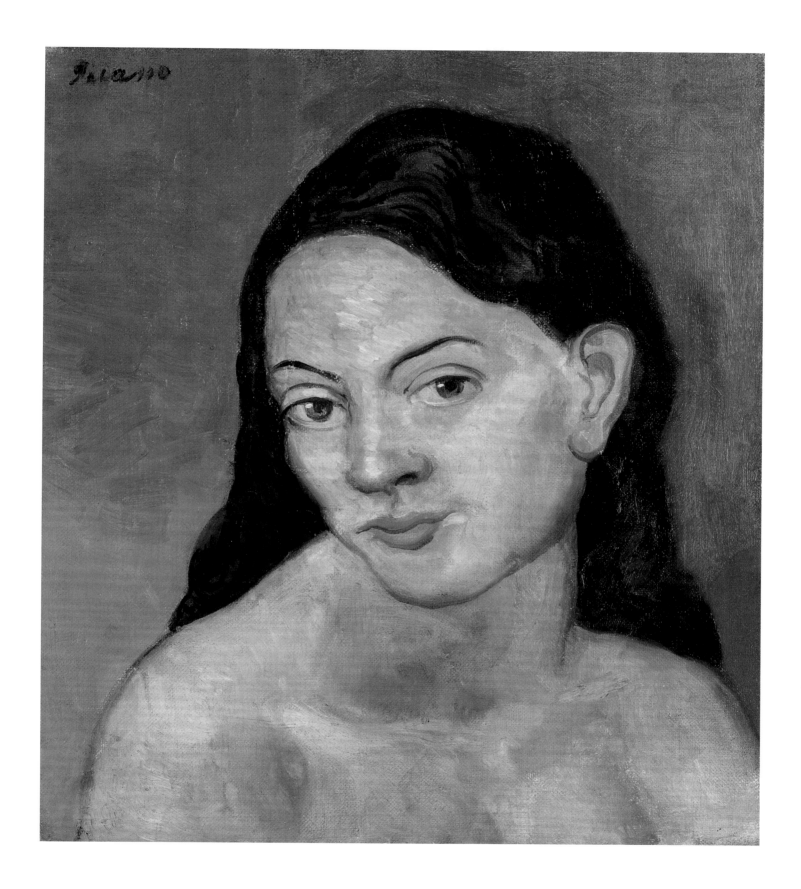

22. The Blind Man's Meal
Barcelona, late Summer–early Autumn 1903

Oil on canvas
37½ × 37¼ in. (95.3 × 94.6 cm)
Signed in blue, upper right: Picasso
Purchase, Mr. and Mrs. Ira Haupt Gift, 1950
50.188

This haunting painting is one of five considered by many to be the most accomplished of Picasso's Blue Period.[1] It depicts a gaunt blind man against an almost monochromatic background of diverse shades of blue, which impart to the composition a mood of melancholy and misery, desolation and loneliness. The all-pervading blue also creates a darkly symbolic alternate world of dejection and despair. In portraying the old, destitute, blind, and homeless, the almost mannerist paintings of the Blue Period represent what Pierre Daix has described as Picasso's "secular translation of the dramatic and religious tensions of El Greco into poverty and unhappiness."[2]

The Blind Man's Meal, painted in Barcelona in the late summer to early autumn of 1903, summarizes the stylistic characteristics of the Blue Period: rigorous drawing that expresses essentials only; a simple, hieratic composition; and a palette dominated by intense shades of blue. A letter by Picasso to the poet Max Jacob, written in the artist's idiosyncratic French, gives a precise description of the composition: "I am painting a blind man at the table. He holds a piece of bread in his left hand and with his right hand reaches for a jug of wine. There is a dog nearby that is looking at him. I am quite happy with it. It is not finished yet."[3] The letter includes a sketch of the described painting in which the head of a dog is clearly drawn at lower left (fig. 22.1). In the final painting the dog has disappeared, his

head replaced by an empty bowl, and the edge of the table closely parallels the lower edge of the canvas.

As discussed in the technical note below, X-radiography reveals another work beneath the present composition: a figure of a nude woman with long dark hair flowing down over her knee and calf, crouched in a pose redolent of dejection and misery (fig. 22.2). In the upper left corner, above her head, are traces of three flowers—either lilies or amaryllises—perhaps symbolizing the girl's deflowering, a motif used frequently by the French Symbolists and by Picasso himself, as in the 1901 satiric charcoal and color wash of Jaime Sabartés, *The Decadent Poet* (Museu Picasso, Barcelona). Infrared reflectography (see fig. 22.5) also indicates that several other objects were repositioned to create what is essentially a still-life arrangement on the table.

More than a mere portrait, the painting is Picasso's comment on human misery in general and, more specifically, on the suffering of the underclass of society. The man's evident blindness, slightly contorted figure—especially his concave torso and long, thin, El Greco–esque hands—and the way Picasso has underscored his poverty, make his disenfranchisement all the more poignant. White highlights on the face, neck, hands, bread, and napkin set the figure in relief against the austere background. The meager meal of bread and wine invites a symbolic reading of the figure as Christ and of the bread and wine as the sacrament

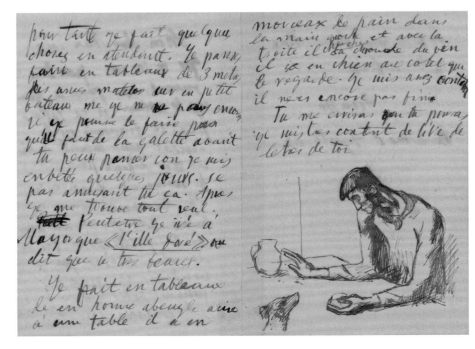

Fig. 22.1. Letter from Picasso to Max Jacob, with preliminary sketch of cat. 22, ca. 1903. Ink on wove paper, 8 × 10⅜ in. (20.3 × 26.4 cm). The Barnes Foundation, Merion, Pennsylvania (BF714)

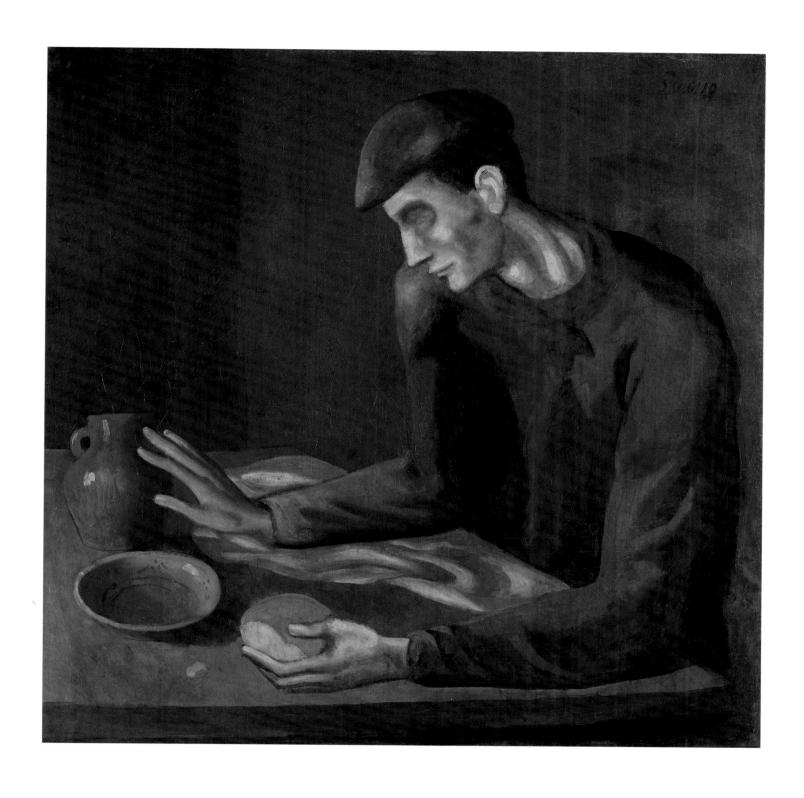

of Christ's body and blood, eucharistic associations with which Picasso, both as a Spaniard and the son of a devout mother, would have been acutely aware. The work also reflects Picasso's own situation when he painted it: a time when, impoverished and depressed, he closely identified with the less fortunate and downtrodden. Note should also be made of the painting's kinship with the work of Picasso's other Catalan friends, particularly Isidre Nonell (1873–1911), but also Xavier Gosé (1876–1915) and Ricard Opisso (1880–1966), all of whom likewise focused on the disenfranchised and those on the margins of the society.

MD

1. As described by Pierre Daix and Georges Boudaille (1967, p. 62). The other four, all from 1903, are: *The Ascetic* (The Barnes Foundation, Merion, Pennsylvania), *The Old Jew* (The Pushkin State Museum of Fine Arts, Moscow), *The Blind Man* (Harvard Art Museum / Fogg Art Museum, Cambridge, Massachusetts), and *The Old Guitarist* (The Art Institute of Chicago).
2. See ibid.
3. Picasso, letter to Max Jacob, August 6, 1903 (The Barnes Foundation, Merion, Pennsylvania); translation by Magdalena Dabrowski.

PROVENANCE

[Galerie Vollard, Paris, by 1906/7–1912, stock no. 5456; probably purchased from the artist; sold on December 11, 1912, for 3,000 francs and shipped on January 10, 1913, to Moderne Galerie]; [Moderne Galerie (Heinrich Thannhauser), Munich, 1912–13, stock no. 3272; sold in February 1913 to Koenig]; Hertha Koenig and her brother, Helge Siegfried Koenig, Munich (1913–50; consigned by November 16, 1949, until November 1950 to Justin K. Thannhauser, New York; sold in November 1950, through Thannhauser, for $38,500 to the Metropolitan Museum [purchased with funds given by Mr. and Mrs. Ira Haupt]); the Metropolitan Museum, 1950

EXHIBITIONS

Munich 1913, no. 10, ill.; Buenos Aires 1934, no. 3, ill.; Hempstead 1952, no cat., checklist no. 29; New York (MMA) 1956, no cat.; New York–Chicago 1957, p. 19 (ill.); Philadelphia 1958, no. 12, p. 15, ill.; London 1960, no. 18, p. 16 (pl. 6b); New York (Knoedler) 1962, no. 13, ill.; New York 1980, pp. 47, 53 (ill.), and checklist p. 7; Melbourne–Sydney 1984, pp. 27 (pl. 19), 208, 241, 246; London 1985–86, no. 183, pp. 40, 44 (fig. 43), 321; Cleveland–Philadelphia–Paris 1992, p. 41 (ill.); Washington–Boston 1997–98, no. 94, pp. 41, 87, 99, 191 (ill.), 200, 291, 293, 299, 359; Paris 1998–99, fig. 29; New York 2000, pp. 17 (ill.), 124; Kyoto–Tokyo 2002–3, pp. 29, 38–39 (ill.), 168; Cleveland–New York 2006–7, no. 4:16, pp. 137 (fig. 3), 139, 501; New York–Chicago–Paris 2006–7 (shown in Paris only), no. 147, pp. 238 (fig. 248), 239, 387 (ill.)–88 (French ed: pp. 246 [ill.], 336)

REFERENCES

Anon., February 18, 1913, p. 11; Rohe 1913, p. 382; Zervos 1932–78, vol. 1 (1932), pp. xxiv, 78 (ill.), no. 168; Zervos et al. 1932, unpaginated ill.; Cirici-Pellicer 1946, pp. 151, 154, 158–59, pl. 129; Lieberman 1954, pl. 19; Anon., May 27, 1957, pp. 80–81 (ill.); Coates 1957, p. 127; Vallentin 1957, pp. 87–88; Penrose 1958, p. 91, pl. II.8; Pool 1960, p. 387; Blunt and Pool 1962, p. 21; Palau i Fabre 1966, pp. 102 (pl. 9), 242; Daix and Boudaille 1967, pp. 58, 62, 229 (ill.), no. IX.32; Sterling and Salinger 1967, pp. 230–31 (ill.); Lecaldano 1968, pp. 94 (ill.), 95, no. 94, pl. 16; Boudaille 1969, p. 14; Rubin 1972, p. 190 (fig. 5); Penrose and Golding 1973, pp. 175 (fig. 296), 176, 279; Gordon 1974, p. 663 (Munich 1913, no. 10); Johnson 1976, pp. 19–20, 199 (fig. 21); Chevalier 1978, p. 55; Christ 1980, pp. 21–22 (ill.); Palau i Fabre 1981b, pp. 352, 354 (ill.), 355, 358, 542, no. 920; Penrose 1981, pp. 88–89, pl. II.8; Piot 1981, p. 61; Larson 1986, pp. 40–41 (ill.), 48; Topalian 1986, p. 363 (pl. 18); Daix 1987a, p. 48; Tinterow 1987, pp. 112–13 (fig. 89); Glozer 1988, p. 16, pl. 32; Leighten 1989, p. x, fig. 20; Chevalier 1991, pp. 38, 51 (ill.); Richardson 1991–2007, vol. 1 (1991), pp. 277–79 (ill.); Koenig 1992, pp. 22, 25, 104 n. 3; Núria Rivero and Teresa Llorens in Barcelona–Bern 1992, p. 126; Warncke 1992, pp. 92, 103 (ill.); Geelhaar 1993, pp. 57, 73 (fig. 63), 77, 83, 270 n. 19, 278 n. 264; Seckel and Weiss 1993, p. 192 (fig. 1); Daix 1995, pp. 59, 215, 470, 547, 553, 686, 698, 782–83, 895; Mailer 1995, p. 86 (ill.); Martí 1998, p. 39; Léal, Piot, and Bernadac 2000, pp. 63 (fig. 116), 503 (English ed.: pp. 60, 63 [fig. 116], 503); Schapiro 2000, pp. 1 (fig. 1), 186; Drutt 2001, p. 9 (ill.); Cowling 2002, pp. 105–7 (fig. 82); González López 2004, p. 77; Anon., October 27, 2005, p. B13; Holtmann, Herzog, and Jacobs van Renswou 2006, pp. 16–17, 58 (fig. 3); Julia May Boddewyn in New York–San Francisco–Minneapolis 2006–7,

Fig. 22.2. X-radiograph of cat. 22

Fig. 22.3. Pablo Picasso, *Seated Old Woman*, 1903. Charcoal and pastel on paper, 23⅝ × 15¾ in. (60 × 40 cm). Museu Picasso, Barcelona (MPB 110.015)

p. 375; Gloria Groom and Asher E. Miller in New York–Chicago–Paris 2006–7, pp. 238 (fig. 248), 239, 387 (ill.), 388, no. 147; Sabina Rewald in Tinterow et al. 2007, pp. 202 (ill.), 287 (ill.), 288, no. 187; Emily D. Bilski in Munich 2008, pp. 28, 39 n. 48; Rilke 2009, pp. 18–19, 25–26, 67, 139, 145, 154–57, 159–60

TECHNICAL NOTE

Picasso applied paint to the canvas in a succession of thin layers, so that colors from below are visible. He subtly varied the Prussian blue, the most prominent color, by adding white in some cases and ocher or yellow in others. X-radiography (fig. 22.2) reveals another work beneath the present composition: a crouching female figure whose legs bear a resemblance to the figure in the June 1903 drawing *Seated Old Woman* (fig. 22.3) and whose general posture is close to that seen in the painting resting on the floor in the 1903 canvas *La Vie* (fig. 22.4). Indeed, it is likely that this painting was in the artist's studio at the time he painted *La Vie*. The nude figure is in an attitude of great dejection. Placed tightly within the square, it differs from the spacious placement of the nude in the painting on the floor in *La Vie*. The X-radiograph indicates that the sides of this painting have been cropped, so it is possible that the dimensions may have been closer to those of the lower painting in *La Vie*. In any case, it would seem that Picasso was only interested in including an image of a huddled woman in *La Vie*, not a precise representation of this specific canvas.

The numerous lines resembling cross-hatching are areas in which the artist tried to eliminate the earlier painting by scraping. This is unusual for Picasso, who customarily painted directly over a previous composition, not bothering to remove an earlier one. It explains why *The Blind Man's Meal*, despite having another painting underneath the present surface, is so flat and smooth. (The scraping also allowed Picasso to begin a new painting soon after completing the crouching woman.) It is possible that the woman may have had an arm resting on her knee, but the scraping in that area makes it impossible to say this with certainty. Infrared reflectography (fig. 22.5) shows that Picasso shifted the third finger of the right hand upward and lowered the pitcher, thus painting over what originally was either a handle or, more likely, a spoon in the dish, as seen in two contemporaneous watercolors of beggars eating (DB X.1, Z 1.209; DB X.2, Z 1.210). The head of the dog mentioned in the letter to Max Jacob can be seen in the bottom-left corner.

The painting was glue lined, varnished, and retouched prior to entering the Metropolitan's collection. In 1980 the discolored varnish was removed and another varnish was applied to integrate the work and to mask surface burns, which possibly occurred during the glue lining. L B

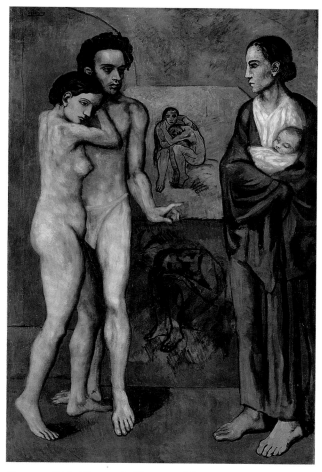

Fig. 22.4. Pablo Picasso, *La Vie*, 1903. Oil on canvas, 77⅜ × 50⅞ in. (196.5 × 129.2 cm). The Cleveland Museum of Art, Gift of Hanna Fund (1945.24)

Fig. 22.5. Infrared reflectogram of cat. 22, showing previous compositional elements, with outline of dog's head

23. The Actor

Paris, December 1904–January 1905

Oil on canvas
77¼ × 45⅜ in. (196.1 × 115.1 cm)
Signed, lower right: Picasso
Gift of Thelma Chrysler Foy, 1952
52.175

Simple yet haunting, *The Actor* is one of the major works with which Picasso announced a definitive departure from his Blue Period obsession with the wretched. The large format is nearly identical to that of *La Vie* (see fig. 22.4) and only a few centimeters narrower than the Soler family portrait (1903, Musée des Beaux-Arts, Liège), ranking it as one of the largest pictures he had produced since leaving Spain. This is significant, because for Picasso the dimensions of a work always related to the importance he attached to it. In this instance, it appears that he wished to make a large picture to inaugurate his shift in the late autumn of 1904 from painting street people, tattered beggars, and blind musicians in blue and ocher to depicting the theatrical world of acrobats and saltimbanques dressed in dusty pink and blue costumes from the commedia dell'arte.[1] Although the attenuated figure and the extraordinary play of expressive hands in *The Actor* recall the El Greco–inspired mannerism of the Blue Period,[2] the painting can be seen as the prologue to a series of works culminating in the enormous canvas *Family of Saltimbanques*, completed in the autumn of 1905 (see fig. 26.1), often and rightly considered the greatest achievement of the artist's early maturity.

This new subject matter, palette, and sensibility coincided with the arrival of Picasso's new lover, the model and sometime artist Fernande Olivier (1881–1966). They met at the Bateau Lavoir (the "Laundry Boat"), a ramshackle warren of studios on the rue Ravignan, in Montmartre. Picasso recorded the beginning of their relationship in an ink drawing that shows them making love, and which he inscribed for posterity "Agusto 1904" (DB XI.13; not in Zervos). Picasso continued to see other women, however, and Fernande's face does not appear in his paintings until the spring of 1905. A marvelous sheet of studies for *The Actor* (fig. 23.1) that includes two profiles of Fernande has been associated with New Year's Eve 1904, which Picasso spent with her.[3] If this dating proves correct, then the painting can also be dated to December 1904–January 1905.[4] Interestingly, the sheet shows the same correction to the placement of the actor's left leg and foot that is visible in pentimenti to the painting.

Picasso painted *The Actor* on the back of a previously used canvas. He reversed the canvas to paint *The Actor* and then obliterated the earlier composition with gray, red, and blue paint. Examination shows that the earlier picture had a Symbolist palette of gold, mauve, and cerulean blue laid with vigorous, Divisionist-style brushwork in swirling patterns (see fig. 23.4).

Fig. 23.1. Pablo Picasso, *Study for "The Actor,"* 1904. Graphite on paper, 19 × 12½ in. (48.3 × 31.7 cm). Private collection

Opinion has been divided on the subject of that composition and whether or not it is by Picasso. John Richardson hoped that Picasso's missing 1901 *Virgin with Golden Hair* might be behind *The Actor*;[5] Metropolitan Museum conservator Hubert von Sonnenburg thought that perhaps it was instead a stage decoration by someone else. More recently, close examination with Metropolitan conservator Lucy Belloli suggested a new possibility. The composition on the back appears to be a landscape: one with a rippled body of shimmering gold water with stones at bottom left, rocky palisades at upper left, and a large looming figure at right. Although it could be related to a little-known group of pictures Picasso painted in Barcelona in the spring of 1901, including two seascapes that still belong to the Picasso estate,[6] the antinaturalist, Symbolist palette of unusual tertiary colors argues against Picasso and points instead to an artist such as Santiago Rusiñol (see cat. 6) or Isidre Nonell. In these early years Picasso often reused canvases, especially large ones—the 1905 *Young Acrobat on a Ball* (The Pushkin State Museum of Fine Arts, Moscow) conceals his 1901 *Portrait of Iturrino*,[7] while the Metropolitan's *La Coiffure* (cat. 30) was painted over three earlier compositions—but he also painted on canvases and panels by others: the small *Head of a Woman* (cat. 21) was painted over a landscape signed "Gonzalez."[8]

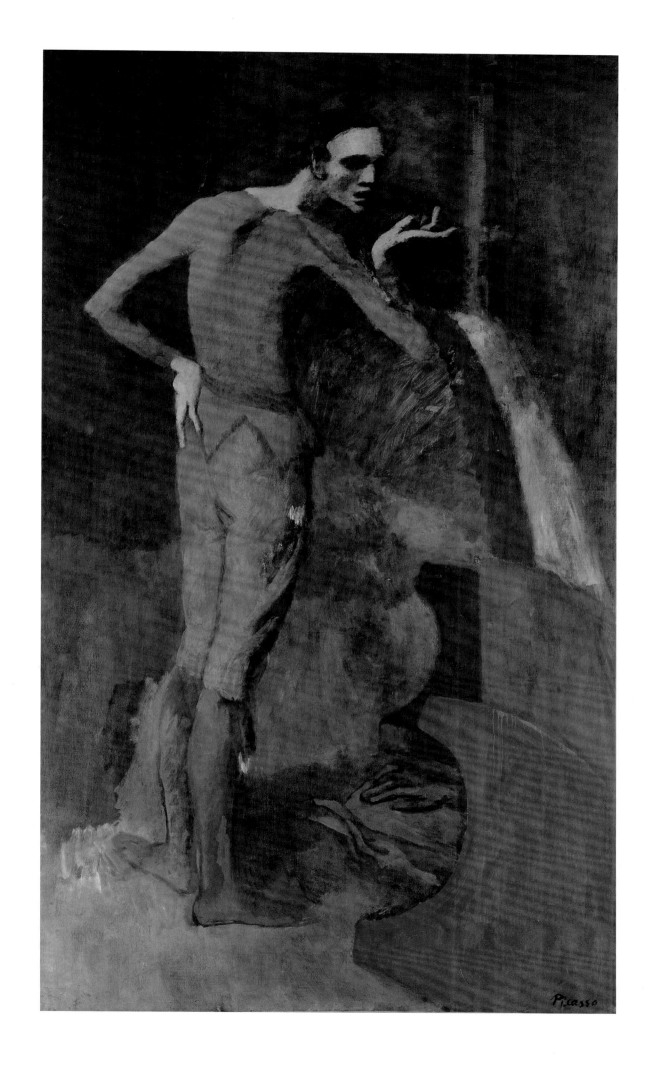

Curiously, Picasso did not include *The Actor* in his exhibition at Galeries Serrurier, Paris, which opened on February 25, 1905.[9] Perhaps it was not yet finished. This exhibition brought the young artist his most significant recognition since his 1901 showing at Vollard's as well as a new friendship with the admiring critic and poet Guillaume Apollinaire. When Paul Rosenberg sold the painting in 1941, he stated that Vollard had bought it directly from the artist, but in fact the first owner was Frank Burty Haviland, who almost certainly acquired it from Picasso. We know that Haviland—a wealthy Franco-American painter whose brother, Paul, backed Alfred Stieglitz's New York gallery 291—knew Picasso by 1905: Gertrude Stein recounted that when Picasso and Fernande first dined at her home on rue de Fleurus, in 1905, Picasso mentioned him.[10] Haviland and Picasso were in fact quite close, a friendship that led to the unusual commission of a Cubist library for Haviland's cousin, Hamilton Easter Field—including the Metropolitan's *Pipe Rack and Still Life on a Table* (cat. 55)—as well as Picasso's first solo show in America, in 1911. It also resulted in Picasso summering at Haviland's house, in his adopted village of Céret, the same year.

After Haviland found that he could not paint in Picasso's presence, he decided to rid himself of his collection of works by the artist.[11] By 1912 *The Actor* was in Germany, already the property of Paul Leffmann, who lent it to the Cologne exhibition society the Sonderbund. Picasso was distressed that such a conspicuous early work had been chosen for exhibition rather than his more recent, and very different, Cubist work, which had already found a following among German collectors. He complained to Daniel-Henry Kahnweiler, his dealer: "Why did the Sonderbund people reproduce my painting that Haviland had before instead of another better and more recent one?"[12] Leffmann then lent it to two more exhibitions, in Cologne and Berlin, in 1913.

There has been much speculation about the model for *The Actor*. Picasso's British friend Roland Penrose claimed, without evidence, that he was a neighbor in Montmartre.[13] Richardson noted that the two hands in the prompter's box indicate that the setting is in a theater or opera house, which Picasso was able to attend after giving several works to the violinist Henri Bloch and his sister Suzanne, a Wagnerian opera singer. (Picasso also frequented the Théâtre Montmartre, which was only a five-minute walk from his rue Ravignan studio.)[14] Richardson further hypothesizes that the specific inspiration might have been the tragic figure of Canio/Pagliaccio, the protagonist in the 1892 opera *Pagliacci* by Ruggero Leoncavallo, which had premiered in Paris in 1902.[15] Yet Picasso could easily have known the Catulle Mendès story that inspired the opera, about a jealous actor/clown who murders his wife. More than anything else, in *The Actor* Picasso established a rapport with Jean-Auguste-Dominique Ingres's *Oedipus and the Sphinx* (fig. 23.2), which had been at the Louvre since 1878. Indeed, this painting may be Picasso's opening in his lifelong investigation of the mysterious power of Ingres's art. G T

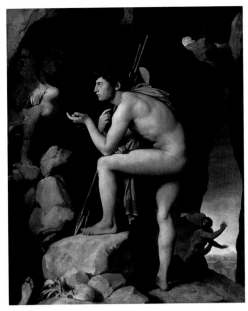

Fig. 23.2. Jean-Auguste-Dominique Ingres, *Oedipus and the Sphinx*, 1808–27. Oil on canvas, 74⅜ × 56¾ in. (189 × 144 cm). Musée du Louvre, Paris (RF 218)

1. E. A. Carmean (in Washington 1980–81, p. 37) has suggested that "The warm red of the background, the 'rose' of the Rose Period … probably originated in—and thus serves to refer to—the actual rose color of the tent of the Medrano circus in Paris, which Picasso often visited."
2. The pose recalls the figure in Gauguin's woodcut *A Fisherman Drinking Beside His Canoe* (1894, The Art Institute of Chicago), which belonged to Paco Durrio, a friend of Picasso's, by 1902. Saltimbanques were the subjects of drawings by Daumier shown at a 1901 exhibition at the École des Beaux-Arts. (Max Jacob also gave Picasso his collection of Daumier lithographs to seal their friendship; Cowling 2002, p. 119.)
3. See Daix 1995, pp. 9, 646: "On connaît un dessin d'étude de *L'Acteur* (DB XII.2) intéressant parce qu'il contient des profiles de Fernande, sans doute parmi les plus anciens. On sait qu'elle a passé avec Picasso le réveillon de la fin 1904."
4. In the Galerie Kahnweiler archives, *The Actor* (photograph no. 56) is dated "hiver 1904."
5. Richardson 1991–2007, vol. 1 (1991), p. 502 n. 31.
6. *Les roches* (z XXI.150) and *La Méditerranée* (OPP 01.285).
7. Richardson 1991–2007, vol. 1 (1991), p. 498 n. 8.
8. Nonell is known to have given Picasso and Casagemas his studio supplies when he left Paris in October 1900, so Nonell may be the most likely author of the landscape on the verso.
9. According to Richardson (ibid., p. 355), the show included thirty paintings and gouaches, three engravings, and an album of drawings; works by the artists Albert Trachsel (1863–1929) and Auguste Gérardin (b. 1849) were also included.
10. Richardson 1991–2007, vol. 1 (1991), p. 400. According to a letter from Pepe Karmel to Sabine Rewald (March 10, 1995, NCMC archives), Haviland was close to Picasso from 1905 through 1914. Karmel elaborates in his book (2003, p. 137) that Haviland had been introduced to the artist by the composer Déodat de Séverac, although he does not provide a date. Karmel notes, however, that Haviland was part of a small number of collectors who supported Picasso from 1905 to 1909 and was one of the few collectors who continued to buy from him during this period (including DR 343, which he bought directly from the artist).
11. According to Richardson (1991–2007, vol. 2 [1996], p. 6), Haviland disposed of all of his Picasso canvases "after urging his hero to spend the summers of 1911 and 1913 at Céret." He "fell so heavily under his influence that he felt constrained to rid himself of his remaining Picassos, by way of exorcism." According to a letter from Pepe Karmel to Sabine Rewald (March 10, 1995, NCMC archives), Haviland owned four works by Picasso: *Mother and Child by a Fountain* (cat. 16), *Le Bock* (1909; DR 312), *Factory at Horta d'Ebro* (1909, The State Hermitage Museum, Saint Petersburg; DR 279), and *Seated Female Nude* (1910, Tate, London; DR 343). Corroborating this, the Haviland provenance appears in DR 312, 279, and 343. See also Karmel 2003, p. 209 n. 61.
12. "Pourquoi les tipes du Sonderbund ont reproduit mon tableau celui de Haviland avant au lieu de un autre mieux et plus recent et dans le catalogue on aurait pu

mettre dans le tableau de Matisse (Marguerite) *apartenant à Monsieur Picasso.*"
Picasso to Kahnweiler, July 15, 1912, reprinted in Geelhaar 1993, p. 47, and p. 274,
n. 134, where it is indicated that the letter can be found in the Kahnweiler-Leiris
Collection, Musée Nationale d'Art Moderne, Centre Pompidou, Paris.
13. Penrose 1958, p. 107.
14. P. Read 1997, p. 216. Peter Read also points out a pencil drawing from this
period that depicts hands emerging from a prompter's box. He identifies this
sketch as a scene from *Henri III et sa cour* (1904–5, private collection; z xxii.102)
but does not mention whether the play was staged at Théâtre Montmartre or at
another venue; see ibid., pp. 217–18.
15. Richardson 1991–2007, vol. 1 (1991), p. 338.

Fig. 23.3. X-radiograph of cat. 23 (reverse), with outlines of a figure

PROVENANCE
Frank Burty Haviland, Paris and Céret (ca. 1905–1911 or 1912; probably acquired
from the artist); Paul Leffmann, Cologne (by 1912–13); private collection, Germany
(1913–38); [Hugo Perls, Berlin, Paris, and New York, in shares with Paul Rosenberg,
Paris, London, and New York, stock no. 4014, June 1938–1941; sold by Rosenberg
on November 15, 1941, for $20,000 to Knoedler]; [M. Knoedler, New York, 1941];
Thelma Chrysler Foy (Mrs. Byron C. Foy), New York (1941–52; her gift to the
Metropolitan Museum, 1952)

EXHIBITIONS
Cologne 1912, no. 216, p. 40, pl. 28; Cologne 1913, no. 5; Berlin 1913, no. 160;
New York and other cities 1939–41 (shown in New York, Chicago, Saint Louis, Bos-
ton, San Francisco, and Cincinnati), no. 29, pp. 37, 39 (ill.); Los Angeles 1941,
no. 31, p. 18 (ill.); New York 1973, hors cat.; New York 1975, unpaginated, ill.;
New York 1980, pp. 54 (ill.), 56, and checklist p. 9; New York 2000, pp. 20 (ill.), 124

Fig. 23.4. Reverse of cat. 23 (detail), showing palette samples of the paint-
ing later obscured by Picasso

REFERENCES
Anon., March 27, 1913, p. 1; Hildebrandt 1913, p. 378; Scheffler 1913, p. 202 (ill.);
Dekorative Kunst, January–February 1921, pp. 79, 83 (views of the painting in the
Leffmann home in Cologne); *The Dial* 85 (October 1928), unpaginated ill.; Zervos
1932–78, vol. 1 (1932), p. 124 (ill.), no. 291; Raynal 1921, pl. 18; Raynal 1922, pl. 18;
Schürer 1927, pl. 2; Soby 1939, pp. 8 (ill.), 10; Barr 1946, p. 33 (ill.); Lassaigne 1949,
pl. 12; Gaya Nuño 1950, pl. 12; Lieberman 1954, pls. 21, 22; Elgar and Maillard 1955,
pp. 18, 265 (ill.); Sutton 1955, fig. 23; Elgar and Maillard 1956, p. 22, and ill.; Vallen-
tin 1957, p. 113; Penrose 1958, p. 111, pl. III.1 (1959 ed., pp. 10, 107, pl. III.1); Blunt
and Pool 1962, p. 21; Daix and Boudaille 1967, pp. 65, 67–68, 70, 74, 254, 256 (ill.),
no. XII.1; Sterling and Salinger 1967, pp. 231–32 (ill.); Fermigier 1969, pp. 46, 47
(fig. 28), 392; Lecaldano 1968 (both eds.), no. 154, p. 99 (ill.), pl. 27; Boudaille 1969,
pl. VI; Penrose 1971a, p. 111, pl. III.1; Gordon 1974, p. 593 (Cologne 1912, no. 216);
Cabanne 1977, pp. 94, 97, 211; Chevalier 1978, pp. 40 (ill.), 64, 69; Christ 1980,
pp. 21–22 (ill.); Cabanne 1981, p. 60; Palau i Fabre 1981b, pp. 396 (ill.), 399, 403,
544–45, no. 1017; Penrose 1981, pp. xii, 108, pl. III.1; Piot 1981, p. 61; Perry 1982,
p. 110; Isabelle Monod-Fontaine in Paris 1984–85, p. 169; Haruki Yaegashi in Tokyo
1985, p. 72 (ill.); Bernadac and Du Bouchet 1986, p. 33 (ill.); Daix 1987a, p. 56; Daix
and Boudaille 1988, pp. 67, 69–70, 256 (ill.), 257, no. XII.1; Boone 1989, p. 12;
Chevalier 1991, pp. 62 (ill.), 63, 73; Richardson 1991–2007, vol. 1 (1991), pp. 248,
315, 337–38 (ill), 502 n. 31; Michèle Richet in Paris–Nantes 1991–92, p. 112; Pierre
Daix in Barcelona–Bern 1992, pp. 34, 48 n. 23; Seckel 1992, p. 11, pl. 1; Warncke
1992, p. 114 (ill.); Ziffer 1992, p. 211 (fig. 398); Boone 1993, p. 12; Geelhaar 1993,
pp. 47 (fig. 39), 57, 237 (fig. 268), 274 n. 133; Karmel 1993, vol. 1, p. 18 n. 4; Richard-
son 1994, p. 26; Daix 1995, pp. 9, 286, 416, 646, 763; Anne Baldassari in Paris 1997,
pp. 124 (fig. 113), 128; P. Read 1997, pp. 44, 217–18 (fig. 6); Léal, Piot, and Bernadac
2000, pp. 76 (fig. 149), 504 (English ed.: pp. 72, 76 [fig. 149], 89, 504); Cowling
2002, pp. 118, 119 (fig. 93); Julia May Boddewyn in New York–San Francisco–
Minneapolis 2006–7, pp. 350, 355; P. Read 2008, p. 14

TECHNICAL NOTE

Picasso painted *The Actor* on the back of a previously used canvas. After applying a
traditional white ground, he continued with an overall light gray coat, which
accounts for the work's somber tone. He worked quickly, using dilute oil paint,
which in some places drips into adjacent color areas (note the pale pink of the top
of the prompter's box bleeding into the red of the side, or the thin gray that covers
the arch of the stage). This dilution allows colors from beneath to be visible, adding
depth throughout. Picasso heavily reworked other areas, however, including the right
hand, which was originally closer to the chin. Other changes to this hand as well as
to the head—which is remarkably similar to that seen in the study (fig. 23.1)—may
have been made, but it is not possible to decipher them. In addition, the left calf
and foot were initially farther to the left, and the left foot was parallel to the right

foot; the ghost of this earlier position is readily visible. (Interestingly, a similar
change occurred in the study.) He then moved the right foot more to the right, as
necessitated by the final position of the left calf and foot.

The overall texture of *The Actor* reflects the dramatic surface texture of the painting
on the reverse, which Picasso obscured with red, gray, and blue paint. Remnants of
the composition and the handling can be seen in the X-radiograph (fig. 23.3). Indi-
cations of the palette are visible in the photograph of the top quarter of the reverse,
where the obscuring overpaint has been removed (fig. 23.4). It is not possible to
determine what this prior composition was. As noted above, Hubert von Sonnen-
burg, longtime conservator of paintings at the Metropolitan, thought that it might
be a stage decoration, but stage sets were almost always painted in glue-based, fast-
drying paints, and this painting was done in oil, heavily applied with much impasto.

In 1952, when *The Actor* entered the Metropolitan's collection, it had a thick,
discolored, natural resin varnish. It was cleaned in 1973 and revarnished; this var-
nish, in turn, was removed in 1980 with the hope of leaving the work unvarnished.
Although this was not possible (the unvarnished surface appeared extremely dry and
dull), the new varnish put on at that time is very thin, allowing for the appreciation
of matte and glossy variations in the paint intended by the artist.

LB

24. Study of a Harlequin
Paris, late Summer 1904–early 1905

Ink on ledger paper
5⅝ × 3⅝ in. (14.3 × 9.2 cm)
Inscribed on verso with list of names and addresses
Alfred Stieglitz Collection, 1949
49.70.32

Picasso, a prolific draftsman, often carried a small notebook in his pocket for making quick sketches. Although this drawing does not seem to be a direct study for a particular painting or etching, it does relate generally to the extended series of Harlequins, saltimbanques, and circus performers that populated the artist's work between 1900 and 1909 and dominated much of his Paris production in 1904–5, including the Metropolitan's painting *At the Lapin Agile* (cat. 25).[1]

With just a few strokes of the pen, Picasso deftly conveys Harlequin's status as an isolated figure existing outside the norms of society. The spare, taut lines emphasize Harlequin's gaunt, angular physique and facial features, the latter shown in strict profile. Many other figures in Picasso's work from this period (and even earlier) display similar characteristics: for example, the mannerist elongations and profile heads in *The Blind Man's Meal* (cat. 22), *The Frugal Repast* (cats. P1, P2), where the man's face bears an exceptional likeness to this Harlequin's, and *The Actor* (cat. 23).

Establishing a precise chronology for Picasso's undated drawings is difficult given that his imagery often evolved over several years and underwent many metamorphoses. The Museum's Harlequin study seems to fall between the etching *The Frugal Repast* (late summer 1904) and the painting *At the Lapin Agile* (1905), where the artist assumed the identity of Harlequin for the first time; dressed in the character's colorful motley, he wears the same knotted white neckerchief seen in this sketch. The painting and the drawing are also related through the strong resemblance of the profile heads. The sketch, however, contains several elements that seem extraneous to *Lapin Agile* and may relate instead to a large gouache of 1905, *The Harlequin's Family* (z 1.298). Hidden within the drawing's lines are two single legs drawn down the center of the sheet. The barefoot leg on top is particularly close in shape and foot angle to those of the nude woman in the gouache, while the other, slippered foot relates generally to Picasso's depictions of Harlequins and circus performers.

As the randomness of these overlapping jottings suggests, Picasso produced such sketches on the spur of the moment and on whatever paper he had at hand, be it napkin, newspaper, envelope, or trade card. In this instance, the support is a page torn out of a small ledger book meant for recording financial accounts.[2] Both sides are printed with thin graph lines and red vertical lines that form columns, which Picasso ignored in his sketches. However, on the verso he generally respected the horizontal lines when he compiled a list of names and addresses of friends and associates in Paris (ill.). Among the names (some misspelled) are the Spanish artists Paco Durrio ("Dourio–sculpt."), Ricard Canals, Julio and/or Joan González as well as the well-known paper supplier Maunoury-Wolff & Cie. Other names, some more legible than others, invite speculation. The fifth name from the bottom, for example, could be the French author Eugène Marsan (known as Sandricourt), who in 1906 praised the young Picasso's genius—and his Harlequin paintings—in the preface to his novel *Sandricourt: Au pays des firmans*.[3] LMM

1. See Washington 1980–81.
2. Although many of Picasso's notebooks have survived intact (twenty-nine full or partial books are in the Musée Picasso, Paris), others are known only from individual sheets or, as in this case, a single sheet. The ledger book this sheet was taken from is similar but not identical to one owned by Picasso that was given out by an insurance company as advertising; that book is catalogued in Léal 1996, vol. 1, pp. 199–201, no. 14. For another ledger book, owned by Picasso's friend Max Jacob, see Quimper–Paris 1994, pp. 298–317.
3. Marsan 1906, pp. 12–13; passage printed in translation in Richardson 1991–2007, vol. 1 (1991), pp. 372, 511 n. 12.

PROVENANCE
[Probably with Moderne Galerie (Heinrich Thannhauser), Munich, by 1913 and sold on March 31, 1914, to Basler]; [Adolphe Basler, Paris, 1914–15; left with Stieglitz in December 1914 as collateral for a loan and acquired on August 15, 1915, upon default of loan]; Alfred Stieglitz, New York (1915–d. 1946); his estate (1946–49; gift to the Metropolitan Museum, 1949)

EXHIBITIONS
Probably Munich 1913, hors cat.; New York 1915, no cat.; Philadelphia 1944, no. 88; New York (MMA) 1997, hors cat.; Paris 1998–99, fig. 4; Balingen 2000, no. 41, ill.

REFERENCES
Hamilton 1970, p. 379; Richardson 1991–2007, vol. 1 (1991), p. 372 (ill.); Karmel 2000, pp. 186, 188, 505 n. 11; Julia May Boddewyn in New York–San Francisco–Minneapolis 2006–7, pp. 329, 359; Joseph J. Rishel in S. Stein and Miller 2009, p. 278 (fig. 211)

TECHNICAL NOTE

Picasso used a steady outline of ink, articulating forms with quick strokes to create light and shadow. Two stronger dark lines along the edges of the strokes reveal how the nib of the pen separated under the pressure of his mark making. The brown ink sank into the commercial ledger paper and has faded; the red ledger lines on the recto are also faded. RM

At left, verso of cat. 24, list of names and addresses transcribed below:

Dourio. sculpt. 3 rue Constantin Pecqueur / H [?] Khan. 65 rue Caulaincourt / Canals 18 rue Girardon / Perrette / Dourliac}. 91 rue Lepic / Maunoury Wolff. / patrons de Savigny. 110 rue St Martin. / Fubini – ~~Lorando~~ 6 rue des Goncourt. / Gonzalès 22 avenue du Maine / Marsan. [?] 4 bis impasse du Maine / Berge[r?]–Raux { Champigny sur Marne (Seine) / rue de Brétigny / Mon Daÿdé- / Mme Gauthiez ~~64 ou 25~~ rue Philippe de Girard. / Bd de la Chapelle / Edgard David - 15 rue de Chateaudun. / March bistro [?] popular 5 rue de Chateaudun [?]

25. At the Lapin Agile
Paris, 1905

Oil on canvas
39 × 39½ in. (99.1 × 100.3 cm)
The Walter H. and Leonore Annenberg Collection, Gift of Walter H. and
Leonore Annenberg, 1992, Bequest of Walter H. Annenberg, 2002
1992.391

From 1905 until 1912, *At the Lapin Agile* was the only work by Picasso on continuous public view in Paris. After it was painted, the canvas was removed from its original stretcher and nailed to the wall of the popular Montmartre cabaret it summarily depicts (fig. 25.1).[1] Paintings by Picasso were worth little at the time, and this one may have been commissioned by the cabaret's proprietor, Frédéric Gérard, in exchange for meals.[2] A charismatic bohemian figure (fig. 25.2), Frédé (as he was known) was widely recalled by his patrons for leading them in ribald sing-alongs.[3] Here, in a reversal of the typical visual relationship between patron and painter, Picasso camouflaged the caricatured, diminutive Frédé against the back wall and positioned his own likeness prominently in the foreground. The woman between them, seen in profile, is the artist's friend Germaine.[4]

The Lapin Agile was founded as early as 1860 as the tavern Le Cabaret des Assassins. It soon became a favorite haunt of artists and other marginal types, who perpetuated an atmosphere of off-the-cuff entertainment and creativity. A signature example of this esprit was the slow transition of its very name: in 1875 the caricaturist André Gill (1840–1885) painted a sign for the building's exterior, which depicted a nimble rabbit (*lapin*) jumping out of a saucepan. The sign thus came to be referred to as "Le Lapin à Gill," and in due course the tavern became known by the punning name it bears today.[5] The Lapin Agile proved a canny vehicle for the enterprising young Picasso. In 1903, soon after Frédé married its new proprietress, Berthe "la Bourguignonne," the building was threatened with demolition. To the rescue came Aristide Bruant, who purchased the building and leased it to the couple.[6] Bruant, a singer and impresario immortalized in posters by Henri de Toulouse-Lautrec, had attained renown at an establishment of a similar artistic and literary cast, Le Chat Noir.[7]

Picasso admired Lautrec, whose work was so influential to the artists of Els Quatre Gats. Although café scenes were common from the last quarter of the nineteenth century onward, Lautrec's precedent was the strongest, particularly in works such as the poster for *Le Divan Japonais* (fig. 25.3), which served as a model for a portrait of Germaine by Picasso's friend Carles Casagemas and for this painting as well.[8] The café setting had previously been explored by Picasso, notably in works made in Paris in 1901, including *Absinthe Drinker* (z 1.62, DB v.12), *Seated Harlequin* (cat. 17), and *The Two Saltimbanques (Harlequin and His Companion)* (The Pushkin State Museum of Fine Arts, Moscow; z 1.92, DB vi.20); the unusual square format both

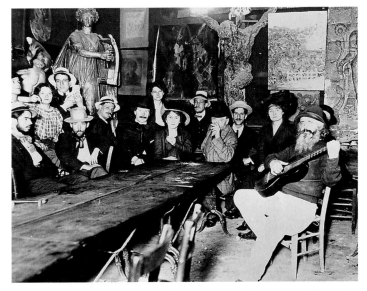

Fig. 25.1. Interior of the Lapin Agile, ca. 1905–12, with cat. 25 visible in the background at center; the proprietor, Frédé Gérard, is seated at right.

Fig. 25.2. Pablo Picasso, *Frédé Gérard*, 1905. Pen and ink on paper, 6¾ × 6 in. (17 × 15.5 cm). Private collection

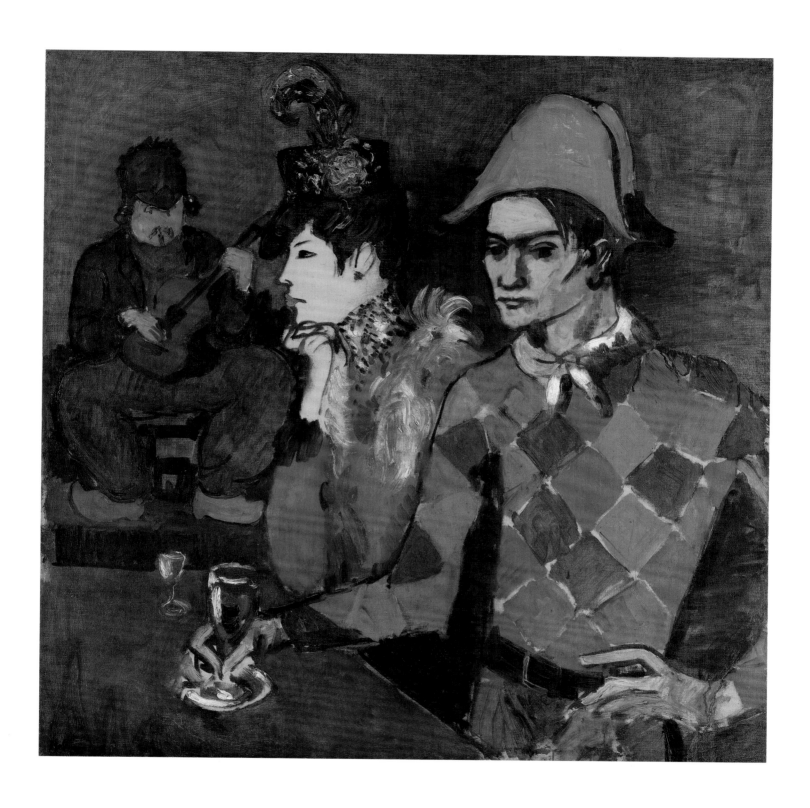

Fig. 25.3. Henri de Toulouse-Lautrec, *Le Divan Japonais*. Lithograph printed in four colors on wove paper, 31⅞ × 24 in. (80.8 × 60.8 cm). The Metropolitan Museum of Art, New York, Bequest of Clifford A. Furst, 1958 (58.621.17)

looks back to *The Blind Man's Meal* (cat. 22) and anticipates *Les Demoiselles d'Avignon* of 1907 (see fig. 40.1).

Picasso had executed an earlier project for Frédé—the decoration of a room in his prior establishment, Le Zut, in the autumn of 1901.[9] The artist's friend Jaime Sabartés provided an eyewitness account of that commission:

> With the tip of the brush dipped in blue, he drew a few female nudes in one stroke. Then, in a blank area which he had purposely left, he drew a hermit. As soon as one of us shouted: "Temptation of Saint Anthony," he stopped the composition. Evidently, as far as he was concerned, this was enough, but more than half the wall was still unpainted, and in order to finish it as quickly as possible he tackled it without uttering a word, without lifting his brush except for taking more color....[10]

Features of this anecdote prefigure *At the Lapin Agile*, not least the drama of a man striving to ignore the temptations of a woman, a theme that was recognized in the painting from the time it was first displayed. In his eccentric utopian novel *Sandricourt: Au pays des firmans* (1906), Eugène Marsan wrote of the couple: "They aren't looking at one another, but I know they are in love."[11]

Picasso's close-fitting diamond-patterned costume and bicorne are emblematic of Harlequin, who together with Pierrot and Columbine were central characters of the traditional commedia dell'arte. Picasso's depiction of himself in the guise of the lusty Harlequin has given rise to speculation about the nature of the self-image he constructs here. The elongated fingers of the left hand at his hip and the extended right arm impart a bearing commensurate with aristocratic portraiture from Bronzino to Ingres. Picasso himself identified the woman sitting beside him as Germaine, a crucial figure of his formative years in Paris.[12] Describing her as she appeared two years later, in late 1907, Gertrude Stein wrote: "She was quiet and serious and spanish, she had the square shoulders and the unseeing fixed eyes of a spanish woman."[13] Indeed, Germaine experienced an extraordinary degree of intimacy with a succession of four Spanish men—all close friends of one another—in a brief span of time. She is most often remembered for her involvement with the unfortunate Casagemas (see cat. 2) in the autumn of 1900, but by the time Picasso arrived in Paris for his second stay, in mid-May 1901, Germaine had taken up with the artist Manolo (Manuel Martínez Hugué, 1872–1945), whom she then forsook for Picasso. Shortly thereafter she became attached to yet another artist, Ramon Pichot (see cat. 7), whom she eventually married.

This last connection, to one of his oldest and most supportive friends, is what enabled Picasso's friendship with Germaine to endure. He depicted her on a number of occasions,[14] but her presence in this work of 1905 is curious given that it was painted during his courtship of Fernande Olivier. Picasso said that the fact that Fernande was then still married precluded him from depicting her in *Lapin Agile*.[15] In fact, the inclusion of Germaine in this slice of narrative, which presents a moment of detachment between two erstwhile companions, is entirely apropos. Since Germaine and Fernande could hardly have been unaware of one another—and of their respective histories—the presence of the former lover may be considered a vanitas intended specifically for the new one.[16] Picasso's jealousy over Fernande was notorious: in the spring of 1906 he slapped her in the Lapin Agile upon finding her there unaccompanied in the middle of the day.[17] Nearly four decades later, Picasso took the very young Françoise Gilot to see Germaine on one of their first outings. As Gilot recounted:

> We made our way up the hill again until he found the Rue des Saules. We went into a small house. He knocked at a door and then walked inside without waiting for an answer. I saw a little old lady, toothless and sick, lying in bed. I stood by the door while Pablo talked quietly with her. After a few minutes he laid some money on her night table. She thanked him profusely and we went out again. Pablo didn't say anything as we walked down the street. I asked him why he had brought me to see the woman.
>
> "I want you to learn about life," he said quietly. But why especially that old woman? I asked him. "That woman's name is Germaine Pichot. She's old and toothless and poor and unfortunate now," he said. "But when she was young she was very pretty and she made a painter friend of mine suffer so much that he committed suicide.... She turned a lot of heads. Now look at her."[18]

AEM

1. This is what struck André Salmon when he saw *At the Lapin Agile* in the exhibition devoted to otherwise previously unexhibited works by Picasso organized by Douglas Cooper at Marseilles in 1959: "Now it's in a frame, as it ought to be for the masters. I saw it without its stretcher attached to a wall of the Lapin" ("C'est maintenant dans un cadre comme il faut pour les maîtres. J'ai vu ça à l'état de toile sans châssis fiché à un mur du Lapin") Salmon 2004, p. 912 (author's trans.).

2. See Richardson 1991–2007, vol. 1 (1991), pp. 371–74.

3. Frédé was described in the newspaper *Le Figaro* as "a Parisian full of flair, in the picturesque getup of a peasant from Abruzzi" ("C'est le père Frédéric, sous son accoutrement pittoresque de paysan des Abruzzes, est un Parisien plein de finesse") Anon., October 3, 1911, p. 1 (author's trans.).

4. Germaine was the nickname of the French-born Laure Florentin, née Gargallo (1880–1948), who married Ramon Pichot in 1908. I am grateful to Cristina Masanés and Antoni Pichot for sharing biographical details about the Pichots, including his birthdate, that appear here and elsewhere in this volume.

5. On the Lapin Agile's eclectic decor, including a plaster Christ by Léon John Walsey (d. 1914/18) that served as a coatrack, see fig. 25.1 and the description by Francis Carco (1919, pp. vii–viii).

6. There remains no comprehensive history of the Lapin Agile; see Marc 1989, pp. 131–32; Hillairet 1997, vol. 2, p. 504; Roussard 2001, pp. 197–99; and especially Richardson 1991–2007, vol. 1 (1991), the chapter entitled "*Au Lapin Agile,*" pp. 368–87, and notes on pp. 510–12.

7. On Lautrec and Bruant, see Chapin 2005, especially pp. 91–94.

8. Casagemas's drawing was first published in Palau i Fabre 1971, p. 12, as *At the café*, adjacent to a photograph of Germaine dated to 1900.

9. "Zut" is a mild French expletive whose English equivalent is "damn!," which gives some indication of its ambience.

10. Sabartés 1948, chap. 8, "Group at the Zut," pp. 70–81 (see especially pp. 76–77); see also Richardson 1991–2007, vol. 1 (1991), pp. 224–25.

11. "Ils ne se regardent point; mais je sais qu'ils s'aiment." Marsan 1906, pp. 12–13 (author's trans.). Marsan (1882–1936), a contributor to periodicals including *La Plume*, may have made the artist's acquaintance through either Apollinaire or Salmon. His name and address may appear on the verso of *Study of a Harlequin* (cat. 24). Perhaps he aspired to have a frontispiece for *Sandricourt* like *Two Saltimbanques* (GB 1.6), the etching Picasso produced for Salmon's *Poëmes* in early 1905; the description of *At the Lapin Agile* that appears in Marsan's preface surely serves as the etching's literary equivalent. The theme of travel, which is intrinsic to *Sandricourt*, is in keeping with the itinerant lifestyle of the saltimbanques— and of Picasso's—up to that time.

12. See John Richardson in New York 1962, no. 16 (unpaginated).

13. G. Stein 1933, p. 29, and see also pp. 30, 33.

14. These include two works of 1901: a portrait dedicated to the sitter by the artist (sale, Sotheby's, New York, May 6, 2009, no. 24; z XXI.153) and *Woman Ironing* (cat. 18), as well as *Woman with a Headscarf,* 1902 (private collection; z XXI.410, DB VII.8). She features in the allegory *La Vie* (fig. 22.4), painted in Barcelona in 1903, which notably included Picasso's only major self-portrait between 1901 and 1905, although in completing the picture the artist replaced his own visage with that of Casagemas. She is also present in *The Three Dancers*, 1925 (Tate, London; z v.426): see Alley 1986, passim.

15. As cited by Richardson 1991–2007, vol. 1 (1991), pp. 371–72.

16. In the etching known as *Sheet of Sketches*, which was possibly begun in December 1904 and finished in 1905 (GB 1.8), Picasso, dressed as a Harlequin, holds up a skull; looking back at it from the opposite direction is Fernande, seen in profile and wearing what may be described as an Egyptian tiara.

17. Olivier 2001a, p. 177.

18. Gilot and Lake 1964, pp. 78, 82.

PROVENANCE

Frédéric (Frédé) Gérard, Paris (acquired from the artist in 1905; sold in 1912); Alfred Flechtheim, Düsseldorf (1912–14; sold in August 1914 for 7,000 marks, through Nils Dardel, to de Maré); Rolf de Maré, Hildesborg, Sweden, and Paris (1914–52; sold in 1952 for $40,000); [César Mange de Hauke, New York, and Hector Brame, Paris (June 10–August 5, 1952; sold to Knoedler)]; [Knoedler and Co., New York (August 5–September 1952; sold, reportedly for $60,000, to Payson)]; Joan Whitney Payson (Mrs. Charles Shipman Payson), Manhasset, New York (1952–d. 1975); her daughter, Mrs. Vincent (Lorinda) de Roulet, Manhasset (1975–89; sale, Sotheby's, New York, November 15, 1989, no. 31, for $40.7 million to Annenberg); Walter H. and Leonore Annenberg, Rancho Mirage, California (1989–92; owned jointly with the Metropolitan Museum, 1992–his d. 2002; his bequest to the Metropolitan Museum)

EXHIBITIONS

Displayed in the Lapin Agile, 22, rue des Saules, Paris, 1905–12; Munich 1913, no. 15; Cologne 1913, no. 15, ill.; Berlin 1913, no. 163; Stockholm 1947, no. 70, p. 18; New York (MMA) 1957; New York (MMA) 1958, checklist no. 102, p. 9; Marseilles 1959, no. 6, ill.; New York (MMA) 1960, no. 86; New York 1962 (shown at Knoedler), no. 16, ill.; Fort Worth–Dallas 1967 (shown in Dallas only), no. 8, p. 93; New York 1968, no. 148; New York 1976, no. 94, pp. xviii (fig. 13), 127–29 (ill.), 194–95; Wellesley 1978, no. 53; Kyoto–Tokyo 1980, no. 66, ill.; Philadelphia–Washington– Los Angeles–New York 1989–91 (not shown in Philadelphia), unnumbered cat., pp. 118–19, 206–7; New York 2008–9, unnumbered online cat.

REFERENCES

Marsan 1906, pp. 5–14; Anon., October 3, 1911, p. 1; Anon., March 27, 1913, p. 1; Einstein 1913, pp. 1186–89; Hildebrandt 1913, p. 376; Rohe 1913, pp. 381 (ill.), 382; Michel 1913–14, p. 374 (ill.); Carey 1915, p. SM11; Carco 1919, p. vii; Asplund 1923, pp. 45, 50–51, pl. 22; *The Dial*, September 1927, p. 6 (ill.); Carco 1928, p. 35; Zervos 1932–78, vol. 1 (1932), p. 120 (ill.), no. 275; Girieud [1936–48], unpaginated; Palmgren 1947, unpaginated; Anon., February 21, 1947, unpaginated; Anon., February 28, 1947, unpaginated; *La Biennale di Venezia*, no. 13–14 (April–June 1953), p. 10, ill.; Sutton 1955, fig. 38; Roland Penrose in London 1956, p. 33 (fig. 71), under no. 101 (not in exhibition); Penrose 1957, p. 33 (fig. 71); Penrose 1958, pp. 117–18, pl. I-7; Buchheim 1959, pp. 43–44; Cogniat 1959, p. 54, frontis.; Blunt and Pool 1962, pp. 22, 32, fig. 137; Mollet 1963, pp. 36–37; Jaffé 1964, pp. 72–73, pl. 73; Olivier 1964, p. 157; Berger 1965, p. 44 (pl. 20); Daix and Boudaille 1967, pp. 253 (ill.), 263 (ill.), 336, no. XII.23; D. Cooper 1968, pp. 16, 34 (pl. 35), 342; Lecaldano 1968 (both eds.), p. 103 (ill.), no. 197, pl. 40; Sieberling 1968, p. 123 (ill.); Crespelle 1969, p. 63; Palau i Fabre 1970, pp. 138–39 (ill.), 165, no. 59; Leymarie 1971a, pp. 210 (ill.), 292; Penrose 1971b, p. 37 (fig. 71); Reff 1971, pp. 36 (fig. 10), 38; Flechtheim 1972, pp. 48, 54; Rubin 1972, pp. 33, 193; Warnod 1972, pp. 96 (ill.), 98–99; Reff 1973, pp. 26 (pl. 33), 33–34, 274; Gordon 1974, p. 663 (as Munich 1913, no. 15); Thomas 1975, p. 29; Johnson 1976, p. 34; Cabanne 1977, p. 99; Daix 1977, pp. 62, 66 n. 22, fig. 13; Johnson 1977, pp. 91 (ill.), 92–93; Crespelle 1978, pp. 162–63; Lecaldano 1979, p. 103, no. 197, pl. 40; Jane Fluegel in New York 1980, p. 57; Gedo 1980, pp. 63, 65; E. A. Carmean Jr. in Washington 1980–81, pp. 29, 50, 87 (under no. 33), 94, pl. 2; Cabanne 1981, pp. 64–65 (pl. 16); Gottlieb 1981, pp. 15–16; Kodansha 1981, pl. 15; Palau i Fabre 1981b, pp. 393 (ill.), 408, 544, no. 1012; Penrose 1981, p. 109, pl. I-9; Rodriguez 1984–85, p. 50; Alley 1986, pp. 20–21 (fig. 35), 27 n. 36; M. Green and Swan 1986, p. 167; Daix 1987a, pp. 42, 55, fig. 14; Littlewood 1987, fig. 17; Magdalena Moeller in Düsseldorf–Münster 1987–88, pp. 40 (ill.), 41–42 under n. 23; Jaffé 1988, pl. 55; Olivier 1988, p. 197; Boone 1989 (both eds.), p. 15; Reif 1989a, p. C16 (ill.); Reif 1989b, p. C23 (ill.); Assouline 1990, pp. 65, 369 n. 31; Chevalier 1991, p. 72 (ill.); Coignard 1991, p. 65; Richardson 1991–2007, vol. 1 (1991), pp. 368 (ill.), 369, 371–73 (ill.), 510 nn. 8–9, 511 n. 12, vol. 2 (1996), pp. 314, 322, 330; Tinterow 1991, pp. 36, 39 (ill.); Pierre Daix, Núria Rivero, and Teresa Llorens in Barcelona–Bern 1992, pp. 39–41, 126; Poggi 1992, pp. 32, 261 n. 10; Seckel 1992, pp. 17–18, pl. 6; Warncke 1992, vol. 1, p. 128 (ill.); Daix 1993, pp. 29, 47–48 (fig. 14); Geelhaar 1993, pp. 55, 57, 60 (fig. 50), 275 n. 156; S. Rewald 1993, p. 62 (ill.); Warncke 1993, vol. 1, p. 128 (ill.); Cardwell 1994, pp. 258–59, 277, 280 (fig. 3); Richardson 1994, pp. 13 (ill.), 23; Daix 1995, pp. 18, 40, 65–66, 276, 379, 393, 693, 698; FitzGerald 1995, p. 277 n. 55; Mailer 1995, p. 168 (ill.); Lubar 1996, pp. 43, 45 (fig. 39), 48 (fig. 48); Varnedoe 1996, pp. 130–31 (ill.), 176 n. 20; Marilyn McCully and Jeffrey Weiss in Washington–Boston 1997–98, pp. 45, 46 (fig. 39), 202 (fig. 7), 203; Berkow 1998, pp. 144, 145 (ill.); Saltzman 1998, p. 297; Volta 1998, pp. 90 (ill.), 92 n. 31; Karmel 2000, pp. 188, 507 n. 43; Léal, Piot, and Bernadec 2000, pp. 80 (fig. 160), 504; Franck 2001, p. 63; Olivier 2001, p. 173; Roussard 2001, p. 198; Daniel Bonthoux and Bernard Jégo in Paris 2002, p. 44 (ill.); Cowling 2002, pp. 27–28 (fig. 5), 29–30, 117–18, 131; Appignanesi 2004, pp. 80–82 (ill.); Jean Clair in Paris–Ottawa 2004, pp. 145, 373; *Impressionist and Modern Art*, sale, Christie's, New York, November 3, 2004, p. 38, under no. 9; Salmon 2004, p. 912; Michael FitzGerald in New York–San Francisco–Minneapolis 2006–7, pp. 315, 327 n. 175; Asher E. Miller in New York–Chicago–Paris 2006–7, p. 386, under no. 145; Daix 2007, pp. 56, 88, 119, 567 n. 8; Sabine Rewald in Tinterow et al. 2007, pp. 203 (ill.), 288, no. 188; Pierre Daix in Paris 2007–8, pp. 9–10 (fig. 1); Näslund 2008, pp. 102 (ill.), 103 (ill.), 106, 160–61 (ill.), 480 (ill.), 481, 595 n. 1, 603 nn. 40–45, 604 (under 1914); Wilkin 2008, p. 6; Yve-Alain Bois in Rome 2008–9, p. 19; Joseph J. Rishel in S. Stein and Miller 2009, pp. ix, xii, 276–80 (ill.), no. 52

Everything about this painting points to speed of execution: it is a perfect example of the wet-in-wet painting technique, whereby the artist works so quickly that the oil paint remains wet throughout subsequent applications and thus the colors blend. First, Picasso outlined the composition in Prussian blue paint. Using mixed brown paint thinned with turpentine, he then blocked in the background, the table, the figure of Frédé, and Harlequin's face. So thin was this color that it dripped onto Harlequin's shoulder and wrist, carrying with it the outlining blue. Next he painted the costumes, alternating between his outfit and Germaine's. As he continued to paint he reinforced the blue outline, by turns sharp or soft-edged, depending on whether it overlay or yielded to the colored area he wanted it to define. This outline remains clearly visible, giving all of the figures a blue halo.

Picasso was never systematic in building up a painting; rather, he kept moving from figure to background, from one area to another, letting what appeared on the canvas influence the direction of the next strokes. He chose early on to use the stark white surface of the commercial priming for Germaine's face and hands, and in the final strokes of the painting he quickly filled the space between Harlequin's right arm and body with black paint to emphasize his flatness and leanness. There are indications that Picasso considered depicting Germaine's other forearm, meaning that both of her arms would have been visible. Examination under high magnification reveals hints of a blue outline flowing down from the second hand. Infrared reflectography and X-radiography were inconclusive on this issue, however, and it is possible that, having started that line, Picasso simply changed his mind.

Considering that this painting was tacked unstretched to the wall of the bar Le Lapin Agile for many years, it is in remarkably good condition. The square format, unusual in the artist's oeuvre, is in fact not perfectly square, most likely a result of careless cutting of the tacking edges prior to lining. In 1912, after the painting was purchased from the owner of the bar, it was stretched and subsequently cleaned, lined, and varnished. Some areas of impasto were flattened in the lining and the edges have been retouched, but the exposed priming is pristine. A stamp on the stretcher (GALERIE KAHNWEILER/PHOTO 207) indicates that the painting was photographed by Picasso's dealer Daniel-Henry Kahnweiler before 1914. It is possible that the conservation of the painting was arranged by Kahnweiler on behalf of the work's new owner, Alfred Flechtheim. Certainly the work was stretched in Paris before being shipped to Germany to join Flechtheim's collection, and given the presence of Kahnweiler's stamp on the stretcher, it is reasonable to surmise that it was he who had the work restored. The painting was cleaned again in 1947 for an exhibition of modern paintings from the collection of Rolf de Maré.[1]

L B

1. Näslund 2008, pp. 480–81, and see Stockholm 1947, no. 70.

26. Saltimbanque in Profile

Paris, late 1905

Essence on paper board
31¼ × 23½ in. (79.4 × 59.7 cm)
Signed in blue, lower left: Picasso
Bequest of Scofield Thayer, 1982
1984.433.269

Although identified by some writers as one of the eight Saltimbanques shown at the Galeries Serrurier, Paris, in February and March 1905, this handsome and hieratic picture was more likely painted at the end of that year. The figure exhibits none of the attenuation present in *The Actor*, a work that was in progress at the beginning of 1905, and it has all of the confidant ease and expression of the later Saltimbanque pictures. For Picasso, 1905 was the year of the saltimbanque— from the works shown in February-March, to the suite of eight etchings perhaps conceived to illustrate his new friend Apollinaire's poems, to the magisterial *Family of Saltimbanques* completed in the autumn (fig. 26.1). These itinerant circus acrobats provided Picasso with a subject that fed his continued interest in those who were outcasts, poor, and rootless, even as their lithe, well-honed figures were a scaffold for his newfound interest in classicism.

Concurrently, 1905 was also the year when Picasso assimilated essential characteristics of Jean-Auguste-Dominique Ingres's work. Scholars have been slow to recognize the impact of Ingres (1780–1867) on Picasso in the years from 1904 to 1908.[1] Many of the telltale signs—such as the half-round figures frozen in shallow, relief-like space and the simple, classical clothing—have been attributed instead to Picasso's study of Egyptian art or to the influence of works by Puvis de Chavannes and Gauguin, all of which were the subject of renewed interest in Paris about 1904.[2] Yet Picasso surely recognized that the

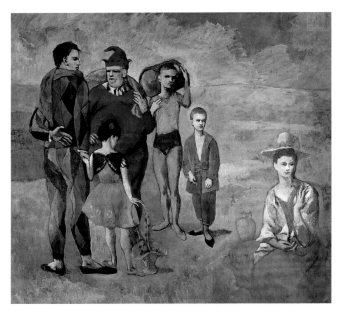

Fig. 26.1. Pablo Picasso, *Family of Saltimbanques*, 1905. Oil on canvas, 83¾ × 90⅜ in. (212.8 × 229.6 cm). National Gallery of Art, Washington, D.C., Chester Dale Collection (1963.10.190)

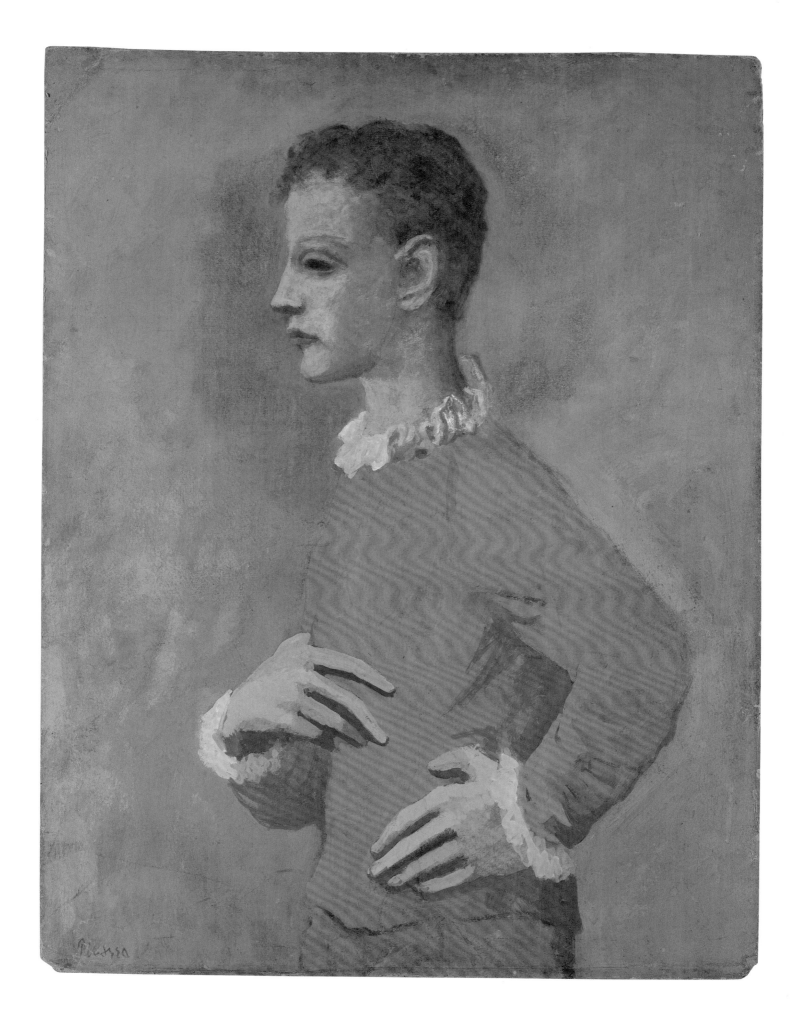

source of much of the authority conveyed by Puvis and Gauguin derived from Ingres, and indeed he seems to have made an effort to see as much Ingres as possible. In April 1904 he stopped in Montauban, not far from Toulouse, in southwestern France, to visit the Musée Ingres, which still contains the thousands of drawings Ingres left in his studio. It is likely that in June 1905, en route to the Netherlands, he also visited the Royal Museums in Brussels, where Ingres's *Virgil Reading the Aeneid* is displayed.[3] Moreover, the 1905 Salon d'Automne (October 18–November 25) mounted a special exhibition of sixty-eight works by Ingres, primarily drawings.[4] All of this coincided with a new flush of publications on Ingres, many of them illustrated.[5] As Fernande Olivier, Picasso's Rose Period companion, wrote, "In painting, his predilection at the time inclined him toward El Greco, Goya, the primitives, and above all Ingres, whom he loved to study at the Louvre."[6] While Ingres would never recognize Picasso's broad painting technique in *Saltimbanque in Profile* as his own, he might see affinities with the portrait style and sensibility. The hand-on-hip pose, for example, derived from Bronzino's *Portrait of a Young Man* (1530s, The Metropolitan Museum of Art, New York), which Ingres knew in Rome; he used it often in his portraits and drawings, most notably the grand portrait in oil of the Comte de Pastoret (fig. 26.2).[7]

Picasso originally made the head of the young performer appear much more sculptural and unnatural, with deeply cut curls and heavily lidded eyes that anticipate his primitivizing sculptural style of 1906 (see fig. 26.3).[8] The Parisian dealer Paul Guillaume likely had the work altered in the early 1920s,

washing away the curls and smoothing the flesh of the face in order to create a more conventional, naturalistic head.[9] Picasso's first cataloguer, Christian Zervos, was the first to decry the alteration, publishing before and after photographs in 1932 and attributing the damage to "a picture dealer."[10] Although the early history of the gouache is not known, during World War I it belonged to two successive Swiss collectors who lent it to exhibitions in Zürich and Basel. GT



1. Meyer Schapiro was the first to argue extensively for the impact of Ingres on the Rose Period. See Schapiro 1976. The subject was subsequently given a full airing in Laurence Madeline's exhibition "Picasso—Ingres" (Paris–Montauban 2004).
2. See Blunt and Pool 1962 and S. Mayer 1980.
3. Schapiro wrote, "Picasso had made a trip from Paris to Holland earlier that year, but did not see the original canvas then, I have been told." He cites Jean Leymarie, director, Centre Pompidou, Paris, for this information (Schapiro 1976 [1978 ed., pp. 113, 118 n. 3]). Picasso certainly knew the other version in Toulouse. Madeline (in Paris–Montauban 2004, p. 11) notes that a study for *Virgil Reading the Aeneid* was exhibited at the 1905 Salon d'Automne (October 18–November 25), although no specific study is listed on the checklist. It could be one of the various studies listed under the title *dessins* (see, for example, nos. 18–21, 27–29, 57, 59, and 60).
4. In his essay "Ingres chez les Fauves," Roger Benjamin notes that the Salon d'Automne included eighteen studies in graphite and one oil sketch (*La Femme aux trois Bains*, 1851, Musée Ingres, Montauban) of *The Turkish Bath* (1862, Musée du Louvre, Paris). These sketches were drawn from Montauban's collection of fifty-nine drawings of this subject (see Vigne 1995, nos. 2305–2363). The curator at Montauban, Jules Mommeja, organized the Ingres presentation at the Salon d'Automne. Benjamin 2001, pp. 99, 118 n. 24.
5. These include: Lapuze 1905a and 1905b; Bouyer 1905, p. 271; Alexandre 1905 (with 24 illustrations); G. Kahn 1905; Doucet 1905 (8 illustrations). Additionally, a sale at Galerie Georges Petit on May 26, 1905, included Ingres's painting *The Martyrdom of Saint Symphorian* (1865), lot 10.
6. "En peinture, ses gouts d'alors le portaient vers le Greco, Goya, les primitifs, et surtout vers Ingres, qu'il se plaisait à aller étudier au Louvre." Olivier 1933, p. 182.
7. Picasso also played with this pose in a series of sketches (DB XIV.3–6) that culminated in the painting *Boy Leading a Horse* (DB XIV.7).
8. Picasso seems to have had a specific model in mind, one he used for DB XIII.13, 15–21. The same saltimbanque appears in a drawing dated December 24, 1905 (see fig. 30.5), and the pose appears in *At the Lapin Agile* (cat. 25).
9. In 1923 Guillaume sold the work to the American collector Scofield Thayer (see also cats. 16, 20, 26, 29, 31, 32, 34, 37, 42, 64–69, 71, P2, P6, P10, P22–24).
10. Z I.276 and 277, p. 121, XLII.

Fig. 26.2. Jean-Auguste-Dominique Ingres, *Amédée-David, the Comte de Pastoret*, 1823–26. Oil on canvas, 40½ × 32¾ in. (103 × 83.5 cm). The Art Institute of Chicago, Estate of Dorothy Eckhart Williams; Robert Allerton, Bertha E. Brown, and Major Acquisitions funds (1971.452)

PROVENANCE
Dr. Paul Linder, Basel (by April 1914); Mr. "N. N.," Basel (by April 1916); [Paul Guillaume, Paris, until 1923; sold to Thayer]; Scofield Thayer, Vienna and New York (1923–d. 1982; on extended loan to the Worcester Art Museum, Massachusetts, 1931–82 [inv. 31.768]; his bequest to the Metropolitan Museum, 1982)

EXHIBITIONS
Zürich 1914, no. 1; Basel 1916, no. 208; New York 1924, no. 32; Worcester 1924, no. 27; Northampton 1924, no cat.; New York (Seligmann) 1936, no. 20, p. 19, ill.; Chicago (Art Institute) 1937, no. 114; New York (Wildenstein) 1945, no. 52, ill.; Atlanta–Birmingham 1955, no. 47; Worcester 1959, no. 76, p. 85, frontis.; New York 1962 (shown at Knoedler), no. 24, ill.; Worcester 1965, no cat., unnumbered checklist; Worcester 1971, no cat., unnumbered checklist; Worcester 1981, no. 108; New York (MMA) 1997, hors cat.; Paris 1998–99, fig. 8; Barcelona–Martigny 2006–7 (both eds.), no. 40, pp. 107 (ill.), 331

REFERENCES
Trog 1914, p. 1; *The Arts* 6, no. 2 (August 1924), ills. facing p. 92; *The Dial* 79, no. 6 (December 1925), ill. facing p. 445; F. Taylor 1932, pp. 65 (ill.), 70; Zervos 1932–78, vol. 1 (1932), p. 121 (ills.), nos. 276, 277; Cott 1948, p. 90 (fig. 128); Benet 1953, ill. facing p. 146, cover ill.; Elgar and Maillard 1955, pp. 26 (ill.), 30, 45; Sutton 1955, no. 36, ill.; Elgar and Maillard 1956, pp. 30 (ill.), 34; Daix and Boudaille 1967, pp. 82, 280 (ill.), no. XIII.19; Lecaldano 1968 (both eds.), pp. 16, 104–5 (ill.), no. 213, pl. 45; Schapiro 1968, p. 119 n. 6, Elgar and Maillard 1972, no. 18, pp. 25 (ill.), 26; Gordon 1974, p. 119 (Galeries Serrurier, Paris, 1903, possibly nos. 1–8, 19,

Fig. 26.3. Photograph of cat. 26, prior to alteration, as published in Zervos (vol. 1, no. 276, p. 121)

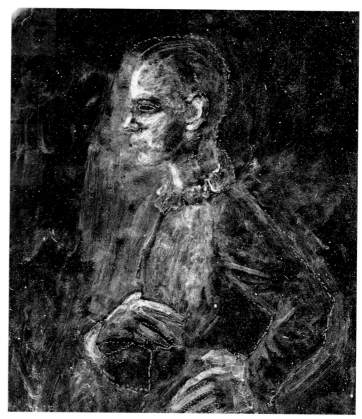

Fig. 26.4. X-radiograph of cat. 26, showing previous position of compositional elements

or 20); Schapiro 1976, p. 251 n. 6 (1978 ed.: p. 119 n. 6); Chevalier 1978, p. 83 (ill.); Kodansha 1981, pl. 26; Palau i Fabre 1981b, pp. 428, 429 (ill.), 548, no. 1170; Donker 1982, p. 1 (ill.); Messinger 1985, pp. 48–49 (ill.); Daix and Boudaille 1988, p. 280 (ill.), no. XIII.19; Núria Rivero and Teresa Llorens in Barcelona–Bern 1992, p. 264 n. 1; Seckel 1992, pl. 18; Geelhaar 1993, pp. 60–61 (fig. 51), 62, 276 nn. 199–200; Giraudon 1993, p. 19 (ill.); *Impressionist and Modern Paintings, Drawings, and Sculpture,* part 1, sale, Christie's New York, November 7, 1995, p. 66 (fig. 3); Belloli 2005, pp. 156–57 (fig. 12); Julia May Boddewyn in New York–San Francisco–Minneapolis 2006–7, pp. 333, 334, 344, 345, 360

TECHNICAL NOTE

Picasso layered colors to form the figure and placed lighter and darker tones over flat planes of red to create light and shadows. In thin brushstrokes of umber he defined the outline of the figure and added small details such as the fingernails. For the slate gray background, he made fast, sketchy strokes, mostly with a broad brush. Although the paint has the matte characteristics of gouache, certain aspects of its craquelure and finish did not support a definitive identification of the paint. (We also know that Picasso mixed and experimented with media.) Although only minute amounts of media were available for analysis, Pyrolysis Gas Chromatography-Mass Spectrometry (Py-GC-MS) and Fourier Transform Infrared Reflectography (FTIR)[1] indicate that the samples contain fatty acids and sandarac, a natural tree resin. The presence of fatty acids and the appearance of the paint indicate that Picasso was using what is called essence, which is made by removing much of the oil in the paint with turpentine, leaving a washy matte paint behind. Picasso manipulated traditional oil paints in other works, such as his series of small portraits on paper from 1900 (cats. 1–11). In many cases the essence is a thin transparent wash, but in *Saltimbanque in Profile* the paint was made thicker and opaque through admixtures of lead white, a siccative (drying agent) that creates a chalkier paint, increasing its vulnerability to abrasion and sensitivity to water and solvents.

The presence of sandarac may be the result of a varnish layer that was applied to the paper board. While it could have been added by Picasso (artists of the time would have been familiar with sandarac), it also may have been on the board Picasso chose: functional paper items such as boxes and screens were commonly coated with san-

darac varnish to increase their durability and impart water resistance. The sandarac may account for the yellow cast of the support, visible in thinly painted areas such as in the figure's right hand and the left side of the torso. This coating also allows the paint to sit on the surface of the support and retain its body. The sandarac varnish and the underbound paint account for the delicacy of the paint layer and the cracking evident on the surface.

The support board, made from unrefined paper pulp, contains numerous fiberous, mineral, and metal inclusions that have pushed through the surface of the board and paint layer. The board also has numerous deep scratches that appear to have been on the board before Picasso used it. Around the head and face of the figure the surface is abraded and mottled. Prior to the work's entering the collection of the Metropolitan Museum, an attempt by a dealer to "clean" the surface resulted in significant changes to the head of the figure. In an earlier photograph (fig. 26.3) we can see that this wiping removed the well-defined curls from the hair and abraded the highlighted planes of the face, disturbing the original contour effects. The hands may more accurately represent the intended appearance of the flesh, with well-defined islands of shades of pale pink. This intervention also left a film of taupe paint over the collar, face, and hair, and striations created a strong halo effect around the figure. Subsequent treatment was undertaken to mitigate the appearance of this damage,[2] but a haze of smeared paint remains in the hair and parts of the head.

To the left and right of the figure, some of the pink of the vestment is visible under the slate-colored background. Although the high lead content of the relatively thick paint layers made penetration with infrared reflectography (IR) impossible, X-radiography (fig. 26.4) reveals beneath the visible paint layer an echo of the profile of the head. Neither the outline stroke that circles the figure nor the streaking from the "cleaning" accounts for the well-defined profile seen in the X-ray, indicating that this was another position of the head that Picasso sketched or painted sometime during the development of the portrait. He also seems to have changed the position of the figure's right shoulder. RM

1. Executed by Julie Arslanoglu, Department of Scientific Research.
2. Information about the condition of the object when it entered the Metropolitan's collection and subsequent treatment from M. H. Ellis, unpublished examination and treatment report, 1985, Department of Paper Conservation.

27. Three Studies of an Acrobat

Paris, late 1905

Ink on wove paper
9½ × 12⅜ in. (24.1 × 31.4 cm)
Signed in graphite, lower center: <u>Picasso</u>
Bequest of Gregoire Tarnopol, 1979, and Gift of Alexander Tarnopol, 1980
1980.21.21

Picasso used the acrobat as Degas used the dancer: to understand the architecture of the human figure and the mechanics of support and balance. Here, with just a few deft marks of a nibbed pen, Picasso jotted his impressions of a circus performer balancing on one hand while rotating her hips and splayed legs. He made three sequential, alternative views of the same figure, as if he were moving around her while drawing. More likely, he drew her from memory in his studio, playing back in his mind's eye the scene that he had studied so intently.

"At this time," Gertrude Stein recalled of late 1905, "they all met at least once a week at the Cirque Médrano and there they felt very flattered because they could be intimate with the clowns, the jugglers, the horses and their riders."[1] As Picasso told the photographer Brassaï, "I was really under the spell of the circus… Sometimes I came three or four nights in one week."[2] Fernande Olivier wrote that Picasso "admired [the circus performers] and had real sympathy for them,"[3] but he seemed most attracted to the traveling acrobats, or saltimbanques, of the lowest order: "the so-called 'postiches'"— according to Theodore Reff—"who have neither tent nor platform for mounting a sideshow, but must perform on a poor rug laid down in a city square or suburban fair."[4]

This sketch seems to have been made at about the same time as another sheet (fig. 27.1), but there is insufficient information in the brief notations to assign a specific date. Both may have been preparatory to, but not specific studies for, the large oil on canvas *Young Acrobat on a Ball* (1905, The Pushkin State Museum of Fine Arts, Moscow). Of this painting, wrote Meyer Schapiro, "the experience of a balance vital to the acrobat, his very life, in fact is here assimilated to the subjective experience of the artist, an expert performer concerned with the adjustment of lines and masses as the essence of his art."[5] The equation of acrobat with artist is also found in contemporaneous French literature. In 1905 André Salmon, the poet who, along with Guillaume Apollinaire, reigned over Picasso's life at this time, published a poem that includes the stanza "I am the acrobat who dances on the cord / Happy with his dizziness and his tattered finery."[6] This, Salmon's first published verse, was graced with a Saltimbanque by Picasso as a frontispiece. GT

Fig. 27.1. Pablo Picasso, *The Acrobats*, 1905. Graphite on paper, 9¼ × 11¼ in. (23.5 × 28.5 cm). Private collection

1. G. Stein 1938, p. 25, as quoted in Reff 1971, p. 33.
2. Quoted in Brassaï 1966, p. 20, as quoted in Reff 1971, p. 33.
3. Olivier 1933 p. 127, quoted in Reff 1971, p. 33.
4. Reff 1971, p. 33.
5. Schapiro 1937, p. 92.
6. Salmon 1906, quoted in Reff 1971, p. 42.

PROVENANCE
[Galerie Kahnweiler, Paris, by 1914, stock no. 1741]; sequestered Kahnweiler stock (1914–23; sale, "Vente de biens allemands ayant fait l'objet d'une mesure de Séquestre de Guerre: Collection Henri Kahnweiller [*sic*]: Tableaux modernes, quatrième et dernière vente," Hôtel Drouot, Paris, May 7–8, 1923, possibly no. 90, 91, 93, 94, or 95); [Saidenberg Gallery, New York, after 1950]; Gregoire Tarnopol, New York (by 1965–d. 1979; his bequest to the Metropolitan Museum, 1979) and his brother Alexander Tarnopol, New York (his gift to the Museum, 1980)

REFERENCES
Zervos 1932–78, vol. 22 (1970), p. 103 (ill.), no. 275; Reff 1976, p. 238

TECHNICAL NOTE

Using a metal nib pen, Picasso defined the forms of the drawing with thin strokes and the darker passages, such as the torso of the central figure, with multiple lines. He allowed more ink to escape from the pen by lingering in a spot, and by applying slight pressure he made marks that are wider than the nib, as seen in the shadows of the acrobat's heels. The ink, now a light brown color, originally would have been darker. As in many other of his drawings, Picasso used a secondary ink to expand the range of tones. This darker ink—seen in the shadows under the arm and hand of the middle figure and at the hand of the right figure—is clearly thicker but also has a blue-black coloration. Picasso applied it in a puddle to intensify the color, and this has prevented the pooled ink from altering at the same rate as the thin strokes. X-ray fluorescence (XRF) analysis confirms that these two inks are different and that both were probably commercial inks.

The drawing was adhered to a secondary support (now lost or removed) with a now highly discolored adhesive, which has partially soaked into the sheet and remains visible on the verso. This has caused the thin sheet to become brown and mottled and may have hastened the alteration in the color of the ink.

RM

28. Blue Vase
Paris, Winter 1905–Spring 1906[1]

Wax crayon and ink on wove paper, mounted to paper board
12⅞ × 9¼ in. (32.7 × 23.5 cm)
Signed in graphite, lower right (on vase): <u>Picasso</u>
Gift of Douglas Dillon, in honor of William S. Lieberman, 1998
1998.455

In 1906 the dealer Ambroise Vollard decided to resurrect the art of painting on ceramics. He claimed the inspiration came from an exhibition he attended,[2] although surely his enthusiasm was bolstered by the opening of the Musée des Arts Décoratifs, in May 1905, and the opportunities created by the death of Siegfried Bing, the famous purveyor of modern decorative art, a few months later. Vollard invited the participation of a handful of artists whose work he had recently displayed in his gallery. The idea was that they—André Derain, Jean Puy, Ker-Xavier Roussel, Maurice de Vlaminck, and others—would paint designs onto simple earthenware forms prepared by the master ceramicist André Methey.[3] Methey fervently believed that the art of ceramics was due for a revival and had already begun collaborating with some of the same artists whose work intrigued Vollard.[4] Picasso drew *Blue Vase* at exactly this moment. While it is usually considered an isolated example of his early interest in ceramics, Gary Tinterow believes that Picasso could have created *Blue Vase* specifically to attract Vollard's attention.

Picasso and Vollard met in late 1900 when the Spanish teenager first traveled to Paris. The dealer thought enough of Picasso's work to feature him in a joint exhibition the following June.[5] After the artist returned to Paris from Spain in 1904, he struggled financially and by all accounts was delighted and relieved when Vollard purchased twenty-seven of his pictures in May 1906. Over the next few years the dealer visited him every few months, spending thousands of francs on his paintings and drawings. Given their multiple interactions at the time and the insular nature of the Parisian art community, Picasso was undoubtedly aware of Vollard's ceramic project.

Vollard's archives are incomplete, but they do reveal that on July 12, 1906, he paid 500 francs to Methey for "a group of stoneware and porcelain."[6] Vollard's payments to Methey continued over the next few years. A receipt dated October 2, 1907, shows that Vollard paid Methey directly for ceramics painted by Derain (fig. 28.1), Puy, Roussel, Vlaminck, and Methey himself. On average, platters were sold to Vollard for 20 francs apiece, plates for 7, and small vases for 15. Pricier items included a tea service decorated by Derain for 50 francs and a large vase painted by Roussel for 100 francs.[7] To the dealer's disappointment, even after being showcased at the 1907 Salon d'Automne,[8] the brightly colored and highly decorative ceramics did not catch the public's fancy and ultimately generated little demand.

Many of these painted plates, vases, and bowls feature simplified representations of humans, animals, and vegetation,

Fig. 28.1. André Derain, *Tall Vase with Figures*, ca. 1906. Tin-glazed ceramic, H. 21¼ in. (54 cm). Musée d'Art Moderne de la Ville de Paris, Gift of Ambroise Vollard, 1937 (AMOA 128)

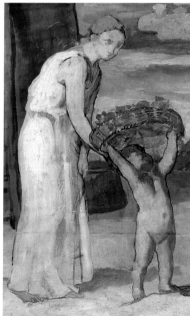

Fig. 28.2. Pierre Puvis de Chavannes, *Cider* (detail), ca. 1865. Oil on paper laid down on canvas, 51 × 99¼ in. (129.5 × 252.1 cm). The Metropolitan Museum of Art, New York, Catharine Lorillard Wolfe Collection, Wolfe Fund, 1926 (26.46.1)

elements found in Picasso's *Blue Vase* as well. The figures in the upper register of Picasso's drawing—a nude couple holding a garland over their heads and a putto prancing with a basket of fruit—are common decorative motifs.[9] In the early years of the twentieth century, figures with garlands were familiar images in Paris, appearing in magazines, paintings, and all types of decorative arts, from fine china to bas-reliefs. The figures traditionally symbolize fecundity and abundance, as does the motif of a

putto bearing a basket of fruit. Picasso's inspiration for this passage—as well as a closely related work (DB D.XIV.5)—may have come from any number of classical sculptures (or a line drawing after one, illustrated in a reference book Picasso is thought to have consulted[10]), the painted decorations on the walls and ceilings of the Louvre, and the work of Puvis de Chavannes (fig. 28.2).[11] Six years after his death, Puvis (along with Cézanne, Lautrec, Redon, and Renoir) was honored with a monographic display at the 1904 Salon d'Automne. According to the accompanying catalogue, more than fifty-two paintings and drawings by Puvis were on view. Picasso, like many of his peers who visited the display, was impressed and influenced by what he saw.

Examination of *Blue Vase* under a microscope reveals that Picasso lightly sketched the trio of figures and then added heavier strokes of ink for emphasis, followed by wax crayon.[12] All three figures are colored yellow (which is difficult to see with the naked eye now that the paper has darkened), and they and the garlands and basket are shaded with purple. After drawing the human figures, Picasso added the lower band of animals. He may have sensed just how much his putto, with its upraised arms and bent leg, resembled the circus equestrians he had repeatedly sketched in 1905 (see cat. P9).[13] The galloping horse, centered precisely under the boy's foot, was the first animal added. It is framed by a sinuous peacock or swan at left (consistently overlooked in descriptions) and, at right, an elephant, which may relate to several small sketches of elephants he drew during the same period.

The whimsical design of *Blue Vase* was never translated to another medium. While Vollard continued to visit Picasso and make purchases from him, there is no indication that he ever encouraged the artist to join in the work being done at Methey's studio, in the Parisian suburb of Asnières. Some forty years would pass before Picasso truly embraced ceramic design, and when he did, it became a passion that would stimulate him for the rest of his life.

RAR

1. Pierre Daix and others have mistaken an ink squiggle on the lower right side of the drawing for the number "6." The drawing, signed in graphite, is undated.
2. Vollard 1936, p. 249.
3. Methey later changed the spelling of his name to Metthey, but his publications and invoices from this period are all signed "Methey." Already in 1902, critics were signaling Methey as one of the most innovative and interesting ceramists of the day. See, for example, Klingsor 1902, p. 213.
4. Methey 1907.

5. For more detailed information on Picasso's relationship with Vollard, see Tinterow 2006.
6. Bibliothèque et Archives des Musées Nationaux, Paris, Fonds Vollard, MS 421 (5, 1), fol. 123.
7. Ibid., MS 421 (2, 3), fols. 126–27.
8. The 1907 Salon d'Automne, held at the Grand Palais from October 1–22, featured a selection of Methey's work, created in collaboration with Denis, Laprade, Maillol, Matisse, Puy, Rouault, Valtat, and Vlaminck. All of the tin-glazed ceramics on view belonged to Vollard.
9. Vollard owned several vases decorated with groups of nude figures whose joined hands encircle the ceramic, among them Mary Cassatt's *Vase: The Children's Circle* (Petit Palais, Paris) and Matisse's *Green and White Vase with Nude Figures* (Musée d'Art Moderne de la Ville de Paris).
10. See, for example, the thousands of line drawings in Reinach 1897–1931, vol. 2, *Sept mille statues antiques* (1897) and vol. 3, *Deux mille six cent quarante statues antiques* (1904).
11. The Metropolitan Museum's *Cider* (26.46.1) is Puvis's study for the left side of the mural *Ave Picardia Nutrix* (Musée de Picardie, Amiens). It is possible that Picasso saw the canvas, as it was owned in the early years of the twentieth century by Louis-Alexandre Berthier, prince de Wagram, who then sold it back to the Galerie Durand-Ruel by 1905. The work remained in Paris through at least 1912.
12. My thanks to Rachel Mustalish for examining this drawing with me on several occasions.
13. Picasso also drew other itinerant circus performers: strongmen, jesters, and acrobats. In this light, the nude male with upraised arms in *Blue Vase* recalls a similarly posed saltimbanque in leotard and tights (1905, *Groupe de quatre saltimbanques*; OPP 05.336).

PROVENANCE
[G. & L. Bollag, Zürich, by 1925; sale, "Gemälde und Handzeichnungen, Die Bestände des frühern Salon Bollag," G. & L. Bollag, Zürich, April 3, 1925, no. 163, probably bought in]; [Galerie Suzanne Bollag, Zürich, by 1965–68; sale, "Impressionist and Modern Paintings, Drawings and Sculpture," Sotheby & Co., London, April 24, 1968, no. 122, for £8,000 ($19,600) to Orton]; D. R. Orton (from 1968); The Honorable and Mrs. Douglas Dillon, New York (until 1998; their gift to the Metropolitan Museum, 1998)

EXHIBITIONS
Frankfurt–Hamburg 1965, no. 22, ill.; London–New York 1998–99, pp. 29–30 (fig. 19)

REFERENCES
Daix and Boudaille 1967, p. 290 (ill.), no. D.XIV.6; Lecaldano 1968, p. 106 (ill.), no. 242; Zervos 1932–78, vol. 22 (1970), p. 123 (ill.), no. 341; Johnson 1976, pp. 51, 209 (fig. 41); Richardson 1991–2007, vol. 1 (1991), p. 457 (ill.); Jean Sutherland Boggs in Cleveland–Philadelphia–Paris 1992, pp. 42, 43 n. 17

TECHNICAL NOTE

Picasso first made a quick pen sketch, which acts as an underdrawing. He then reinforced the design with stronger pen strokes and wax crayon in three colors: blue, yellow (which he mixed and layered to create the green), and purple (to define the shadows). The colors vary in their intensity, depending on the pressure of application. In some areas the crayon scratched away the color, creating a series of white lines that reinforce the action of the drawing. The colors appear strong and are probably only slightly altered from their original appearance, but the contrast with the support has changed as the wove tan paper has darkened to brown.

RM

29. The Watering Place
Paris, Winter 1905–Spring 1906

Gouache on tan paper board
14⅞ × 22⅞ in. (37.8 × 58.1 cm)
Signed in black ink, lower left: Picasso
Bequest of Scofield Thayer, 1982
1984.433.274

Following the completion of *Family of Saltimbanques* in late 1905 (see fig. 26.1), Picasso planned another ambitious, multifigure composition scholars refer to as *The Watering Place*. Although it does not exist in a definitive version, and it is not known whether Picasso ever committed it to canvas, the studies for the project suggest a grand, elegiac painting on a very large scale. The Metropolitan's sketch is the most impressive of the existing studies for the entire composition. It shows a group of nude adolescents washing and watering their horses in an arid, mountainous landscape. The relationship between *The Watering Place* and the *Family of Saltimbanques* cannot be overstated: not only do the two compositions share a similar dusty palette and landscape, it could be said that *The Watering Place* is a temporal sequel to the other, with the circus figures having stripped to wash themselves as well as their horses. (The principal boy leading a horse first appears in studies wearing a saltimbanque's costume.)[1] The androgynous mood is another similarity, one that Apollinaire evoked in his review of Picasso's spring 1905 show at Galeries Serrurier, Paris: "These impuberate adolescents reveal the restless searching of innocence, the animals teach them religious mysteries. The Harlequins accompany the glory of women, resemble them; they are neither men nor women."[2]

Picasso relied on a number of specific sources to conceive his composition. He probably saw at Vollard's in 1903 Gauguin's *Riders on a Beach* (fig. 29.1), which the artist had based on a Degas jockey scene, but reversed. It is unlikely that Picasso knew Degas's jockey pictures in the original, but he might have recognized that Degas and, following him, Gauguin had both quoted from the Parthenon frieze.[3] The mounted boy seen from the back may have derived from a William Holman Hunt drawing that Picasso could have known from a magazine article;[4] the frescolike palette of grayed pinks, ocher, and pale blue bears the imprint of Puvis de Chavannes, whose work was celebrated in Paris in 1904; and the insistent contours and arcadian vision point to Cézanne, whose work had been featured at the 1905 Salon d'Automne—that is to say, just prior to Picasso's beginning this composition.[5]

While all of these sources have been discussed before by scholars, it appears to have escaped notice that in *The Watering Place* Picasso quite self-consciously refers to the early Renaissance Italian practice of showing the same figures reversed in the same composition: here seen in the boy on the horse at left, who is mirrored by the mounted boy at right. Picasso could have observed this in any number of compositions—especially

Pisanello's frescoes in Verona and related drawings at the Musée du Louvre—but it was a conspicuous feature of Andrea Mantegna's *Crucifixion* (1456–59) and *Parnassus (Mars and Venus)* (1497), both also at the Louvre. Could Picasso's new acquaintance, Leo Stein, have sparked his interest in Mantegna, the subject of Stein's obsessive focus?[6] Although the disposition of figures and landscape also seems closely related to Degas's *Young Spartans* (ca. 1860–62, reworked until 1880, The National Gallery, London), Picasso could not have seen it without an (unlikely) entrée to the old artist's inner sanctum.[7] However, *Young Spartans* and Ingres's *L'Âge d'Or* (1862, Château de Dampierre) both quote the circle of dancing figures in Mantegna's *Parnassus*, hence Mantegna could be the link that binds all of these works together.

Picasso's friendship with Leo Stein and his sister, Gertrude, is inextricably linked to *The Watering Place*, for they encouraged Picasso's hybrid neoclassicism in the most direct way possible: they bought his canvases, and they sent others to his studio to do so as well, most notably Ambroise Vollard.[8] Although Picasso did not need the Steins to see and think about Cézanne, it would have been impossible for Leo not to convey to the young Spaniard his excitement over the display at the 1905 Salon d'Automne. When Picasso excerpted one of the figural groups from *The Watering Place* for *Boy Leading a Horse* (fig. 29.2) and completed it in a manner indebted to Cézanne, the Steins immediately acquired it.

Because so much of Picasso's work at Gósol, Spain, in the summer of 1906 featured nude male adolescents (see cats. 31, 32), it

Fig. 29.1. Paul Gauguin, *Riders on a Beach*, 1902. Oil on canvas, 28½ × 35⅞ in. (73 × 92 cm). Private collection

was long thought that the all-male world of *The Watering Place* was conceived there as well. Most scholars now recognize that, instead, the Gósol pictures follow a mood established in this work, which was made in Paris over the winter or spring of 1906. It is not known why Picasso did not follow through with a large canvas, but that has not deterred speculation. Some imagine that he was derailed by Matisse's *Le bonheur de vivre* (The Barnes Foundation, Merion, Pennsylvania),[9] which was exhibited at the spring 1906 Salon des Indépendants[10] and acquired by the Steins soon thereafter and, like *The Watering Place*, was indebted to Ingres and Mantegna. Far from being neoclassical, however, Matisse's work was dramatically free of convention, unhinged from all known styles.

In addition to *Boy Leading a Horse*, Picasso made several studies of isolated figures from *The Watering Place*, among them an exquisite drawing of the mounted boy seen from behind (private collection; DB XIV.11). The Metropolitan's gouache was preceded by a pencil drawing and a watercolor, each with a different number of figures and horses (DB XIV.14, 15). He later memorialized the composition in a drypoint published in the Saltimbanques suite (see cats. P10, P11). GT

Fig. 29.2. Pablo Picasso, *Boy Leading a Horse*, 1906. Oil on canvas, 86⅞ × 51⅝ in. (220.6 × 131.2 cm). The Museum of Modern Art, New York, The William S. Paley Collection (575.1964)

1. DB XIV.3, 4.
2. Apollinaire 1905 (reprint ed., pp. 482–83).
3. Susan Mayer (1980, p. 199) cites the rider at the far left and the horse eating grass at far right as quotations from the west frieze of the Parthenon, which Picasso knew from engravings, photographs, and plaster casts, as did Degas and Gauguin.
4. Richardson 1980, unpaginated.
5. The 1905 Salon d'Automne, held in Paris from October 18 to November 25, featured ten paintings by Cézanne (nos. 314–23), who had been given a one-man show there the previous year. Picasso may have seen "Watercolors by Paul Cézanne," held at Galerie Vollard through June 17, 1905 (See New York–Chicago–Paris 2006–7, p. 317), and a dozen works at "Paintings by Paul Cézanne," held at Vollard's through March 13, 1906 (see ibid.). Émile Bernard's article "Paul Cézanne" was published in *L'Occident* 6 (July 1904), pp. 17–30.
6. Leo went to Tuscany in late September 1900 intending to study Mantegna. Additionally, his favorite painting in the Louvre was said to be Mantegna's *Crucifixion*: "it was this picture that prepared him, he claimed, for Cézanne" (Wineapple 1996, p. 87).
7. Although I do not think Picasso could have visited Degas's studio, much less have been shown Degas's collection of his early work and canvases by modern masters, they did know some of the same people. It has been said that Picasso's companion Fernande Olivier may have modeled for Degas, and Picasso later knew Suzanne Valadon, of whom Degas was quite fond.
8. See Tinterow 2006.
9. Richardson 1991–2007, vol. 1 (1991), p. 424.
10. March 20–April 30, no. 2289.

PROVENANCE
[Galerie Alfred Flechtheim, Düsseldorf and Berlin, by 1913–23; sold in May 1923 for $1,000 to Thayer]; Scofield Thayer, Vienna and New York (1923–d. 1982; on extended loan to the Worcester Art Museum, Massachusetts, 1931–82, inv. 31.765; his bequest to the Metropolitan Museum, 1982)

EXHIBITIONS
Munich 1913, no. 17; Cologne 1913, no. 13, ill.; possibly Vienna 1914, no. 43; Hannover 1919, no. 116; New York 1924, no. 30; Rochester 1924, no. 68; Worcester 1924, no. 26; Northampton 1924, no cat.; Hartford 1934, no. 13; Chicago (Art Institute) 1937, no. 115; New York and other cities 1939–41 (shown in New York only), no. 52, p. 48 (ill.); Boston 1946, no. 44; Worcester 1959, no. 75, pp. 84–85; Worcester 1965, no cat., checklist; Worcester 1971, no cat.; New York 1980, pp. 59, 69 (ill.); Worcester 1981, no. 113; Tübingen–Düsseldorf 1986, no. 33, p. 275, ill.; New York 1993, no cat.; Washington–Boston 1997–98 (shown in Boston only), no. 142, pp. 48, 311 (ill.)

REFERENCES
Thayer 1923, paintings section, pl. 6; Bell 1924, p. 56 (ill.); Carey 1924, p. SM10; Craven 1924, p. 182; McBride 1924, pp. 207–9; *The Dial* 78 (June 1925), ill. facing p. 445; F. Taylor 1932, pp. 67 (ill.), 70; Zervos 1932–78, vol. 1 (1932), p. 118 (ill.), no. 265; McCausland 1934, unpaginated (1944 reprint, p. 15); Barr 1946, p. 42 (ill.); Merli 1948, p. 599, fig. 133; Breeskin 1952, p. 107; Nef 1953, pp. 138 (ill.), 139; Elgar and Maillard 1955, pp. 27, 34 (ill.); Elgar 1956, pl. 10; Elgar and Maillard 1956, p. 38 (ill.); Vallentin 1957, p. 119; Jacqueline Bouchot-Saupique in New York 1959, p. 137; Blunt and Pool 1962, p. 26; Jean Sutherland Boggs in Toronto–Montreal 1964, p. 45; Joost 1964, pp. 229, 237; Pool 1965, pp. 123–25 (ill.) (reprint ed., pp. 141–42, fig. 3); Reff 1966, p. 267; Daix and Boudaille 1967, pp. 87, 90, 92–94, 96–97, 274, 284, 286–88 (ills.), no. XIV.16; Lecaldano 1968 (both eds.), p. 106 (ill.), no. 239, pls. 52, 53; Boudaille 1969, ill.; Fermigier 1969, p. 74; Joost 1971, pp. 493 (fig. 10), 494; Broude 1972, pp. 86 (fig. 6), 87; Elgar and Maillard 1972, pp. 23–24 (fig. 17); Mahar 1972, pp. 395, 401–2; Rubin 1972, pp. 34, 192 (fig. 10), 193; Gordon 1974, pp. 663 (Munich 1913, no. 17), 794 (possibly Vienna 1914, no. 43); Cabanne 1975, pp. 12, 213, 177; Hilton 1975, pp. 60, 62; Carlson 1976, pp. xiv, xvi, xvii, 44, 104 (fig. 19); Cabanne 1977, p. 104; Chevalier 1978, pp. 71, 76 (ill.); Itsuki and Yaegashi 1978, pl. 33; Combalia Dexeus 1979, fig. 3; Carol Hynning Smith in New York and other cities 1979–80, p. 80; Gedo 1980, p. 70; S. Mayer 1980, sect. VI figs. 17, 18 (detail), 20 (detail); Richardson 1980; Kodansha 1981, pl. 30; Palau i Fabre 1981b, pp. 434, 435 (ill.), 444, 549, no. 1197; Penrose 1981, p. 117; Gary Tinterow in Cambridge–Chicago–Philadelphia 1981, p. 66; Coünter Metken in Munich and other cities 1981–82, p. 39; Perry 1982, p. 126; Brigitte Baer in Dallas and other cities 1983–84, p. 34; Messinger 1985, pp. 48 (ill.)–49; Magdalena M. Moeller in Hannover 1986–87, p. 11 (ill.); Daix 1987a, p. 70; Tinterow 1987, p. 114 (fig. 90); Daix and Boudaille 1988, pp. 87, 90, 92–94, 96–97, 274, 284, 288 (ill.), no. XIV.16; Huffington 1988, fig. 17; Leighten 1989, pp. xi, 78, fig. 50; Podoksik 1989, pp. 47, 50 (ill.), 158 (ill.); Chevalier 1991, pp. 80 (ill.), 85; Richardson 1991–2007, vol. 1 (1991), pp. 424, 425 (ill.), 427, 441, 511 n. 37; William Rubin in New York 1991, pp. 101, 102, 166 (fig. 48); Daix 1992a, p. 60; Pierre Daix, Marilyn McCully, and Josep Palau i Fabre in Barcelona–Bern 1992, pp. 43, 49 (nn. 56, 58), 59, 76, 77 (ill.), 93, 282, 284, 288, 290–92; K. Farrell

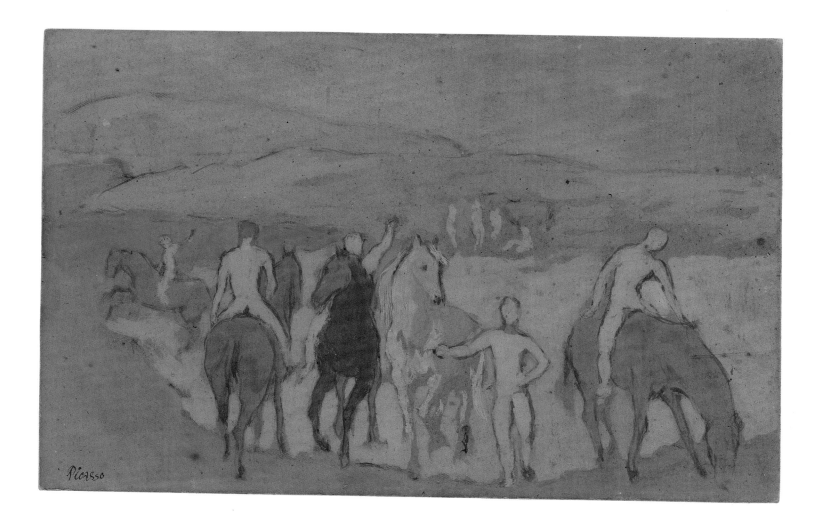

1992, p. 88 (ill.); Seckel 1992, pl. 21; Marilyn McCully in Málaga 1992–93, pp. 78, 79 (fig. 5), 321, 322; Geelhaar 1993, p. 275 n. 156; Brigitte Léal in Barcelona 1994–95, p. 243; Daix 1995, pp. 1, 2, 84, 186, 583, 694–95; Podoksik 1996, pp. 64, 65, ill.; Boardingham 1997, pp. 67 (ill.), 80; Kirk Varnedoe in Atlanta–Ottawa–Los Angeles 1997–99, p. 42; Léal, Piot, and Bernadac 2000 (both eds.), pp. 91, 94 (fig. 190), 505; Llorens Serra 2001, pp. 36 (fig. 10), 102; Tomàs Llorens in Madrid 2001–2, p. 66 (fig. 13); Cowling 2002, pp. 141, 142 (fig. 117), 194; Elderfield 2004, pp. 111, 508 n. 1; Maria Dolores Jiménez-Blanco in Madrid (Thyssen-Bornemisza) 2004–5, p. 95; José Álvarez Lopera in Madrid 2006, pp. 96, 98 (fig. 4.1), 99; Julia May Boddewyn in New York–San Francisco–Minneapolis 2006–7, pp. 333, 334, 340, 345, 350; Pierre Daix in Paris 2007–8, pp. 11–12 (fig. 5); Pierre Daix in Paris 2008–9, pp. 74 (fig. 2), 75; On-line Picasso Project 2009, no. OOP.06.061

TECHNICAL NOTE

The paper board Picasso chose for this drawing is made from nonhomogeneous fibers and is rough and mottled in appearance; it also has a subtle weave pattern on the surface, an artifact of its commercial manufacture, that is punctuated with lumps and dark spots, a result of the debris and unrefined materials caught in the pulp. Picasso gave the surface additional texture by working with wet media on the board, which caused it to pill, most noticeably at lower right. He almost entirely covered the board with brush-applied color. Many of the figures, such as the blue

horse at center, were sketched in thin pale blue lines; these may be under all of the figures, but the blue media cannot be seen beneath other layers, even by using infrared reflectography, owing to its physical and chemical nature. Picasso further defined the figures and landscape elements with brown brush lines. Several of the central figures have a thicker layer of paint that solidifies and opacifies their forms. Although the slightly yellow color of the support can be seen around the figures, Picasso painted the negative space with a variety of pale shades of thin washes, which have soaked into the board, rather than employ the paper reserve as a background color.

The visual characteristics of this work suggest the artist used gouache: the paint is very matte, appears to have been worked in water in some areas, and there is no staining, haloing, or bleeding that would be associated with drained and turpentine-thinned oil paint, known as essence. However, because Picasso is known to have used essence (see cats. 1–11, 26), *The Watering Place* was analyzed using Fourier Transfer Infrared Reflectography (FTIR),[1] which indicated that there is no oil component in the media but that it does contain some type of material not usually associated with pure gouache. This may be an indication of the proprietary mixtures that were part of the commercial paints purchased by Picasso; it could also reflect an unusual mixture of media, characteristic of the artist's experimentation in drawings made during this period.

RM

1. Executed by Julie Arslanoglu, Department of Scientific Research.

30. La Coiffure

Paris, Spring (–Autumn?) 1906

Oil on canvas
68⅞ × 39¼ in. (174.9 × 99.7 cm)
Signed, lower left: <u>Picasso</u>
Wolfe Fund, 1951; acquired from The Museum of Modern Art, New York,
Anonymous Gift
53.140.3

The impact of Pierre Puvis de Chavannes (1824–1898) on the early work of Picasso has long been recognized.[1] Not only was Puvis revered as a modern classicist in Paris, he was respected by the Modernistas of Barcelona. Picasso knew Puvis's murals at the Panthéon in Paris,[2] he would have seen works on display at the 1900 Exposition Universelle,[3] and he clearly studied the special exhibition of Puvis's works at the 1904 Salon d'Automne, which included *La Toilette* (fig. 30.1).[4] The Ingres exhibition at the 1905 Salon d'Automne[5] seems to have revived Picasso's interest in modern classicism, because soon afterward he was prompted to begin this essay on a theme dear to Ingres, Puvis, and younger classical acolytes such as Renoir and Degas.

Although today art historians associate a woman at her toilette with Degas's famous series of nude bathers, shown in Paris at the 1886 Impressionist exhibition and repeated in his oeuvre until he stopped working, about 1910, it is unlikely that Picasso could have seen many examples by Degas apart from the occasional display in a gallery window.[6] One that he might have known is *Woman Having Her Hair Combed* of about 1886–88 (fig. 30.2), which was reproduced by George William Thornley in an 1888 lithograph that was admired in the studios of Montmartre.[7] Ingres's great nudes and bathers gave Degas license to develop a modern pretext for exploring the female nude, and that same license was used by Puvis and Renoir in their development of the theme.[8] In an odd twist, Picasso, in his picture, chose to suppress the eroticism that normally attends the subject. Instead, as Sabine Rewald has noted,[9] he turns the picture into a contrapuntal variation on the Holy Family, similar in mood to Leonardo's *Virgin and Child with Saint Anne* at the Louvre.

As Lucy Belloli recounts below, Picasso painted this composition on a much-used canvas. Since the layer directly beneath the present composition relates to a drawing dated December 24, 1905, one can confidently assign *La Coiffure* to 1906 despite the fact that Picasso later thought he had painted it in 1905.[10] The picture follows naturally on the backstage circus scenes that Picasso had made in 1904 and 1905, and that alone could be the reason he misremembered the date. Theodore Reff catalogued the appearance of the motif in Picasso's 1905 sketches for an unrealized circus composition.[11] Josep Palau i Fabre noted that Picasso made drawings of women at their toilette after he returned from Holland in the spring of 1905. Two sketches in the collection of the Barnes Foundation (figs. 30.3, 30.4) showing the two female figures in *La Coiffure* are closely

Fig. 30.1. Pierre Puvis de Chavannes, *La Toilette*, 1883. Oil on canvas, 29½ × 24¾ in. (75 × 63 cm). Musée d'Orsay, Paris (RF 3692)

Fig. 30.2. Edgar Degas, *Woman Having Her Hair Combed*, ca. 1886–88. Pastel on light green wove paper, 29⅛ × 23⅞ in. (74 × 60.6 cm). The Metropolitan Museum of Art, New York, H. O. Havemeyer Collection, Bequest of Mrs. H. O. Havemeyer, 1929 (29.100.35)

related to the final composition. That Picasso conceived the figures as clothed rather than nude ties it to his earlier circus scenes, although the lack of any specificity in the setting anticipates the timeless mood of his 1906 neoclassicism. While the dusty palette and pyramidal composition point clearly to Puvis, the pose of the woman with a mirror derives directly from Ingres's *Turkish Bath* (see fig. 65.2), and hence it was probably suggested by the memory of a visit to the Ingres retrospective in the autumn of 1905.[12]

Picasso continued to explore this motif in numerous works executed in and immediately after his stay in Gósol in the summer of 1906, including *La Toilette* (Albright-Knox Art Gallery,

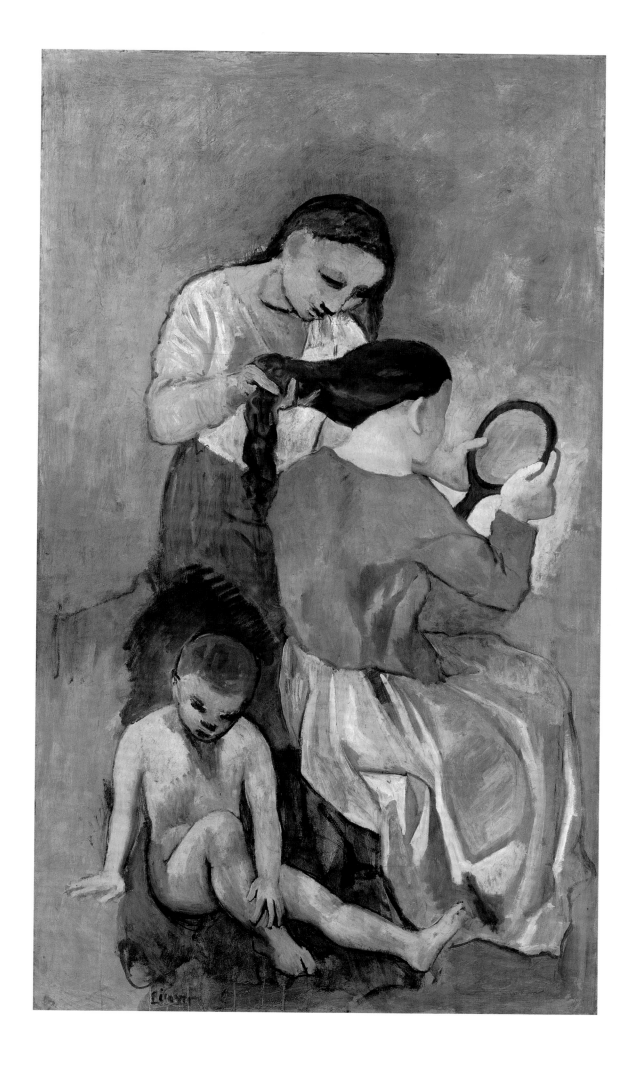

Fig. 30.3. Pablo Picasso, *Woman Dressing the Hair of Another Woman*, 1905–6. Ink on wove paper, 12¼ × 9¼ in. (31.1 × 23.5 cm). The Barnes Foundation, Merion, Pennsylvania (BF686)

Fig. 30.4. Pablo Picasso, *Two Women at Their Toilette*, 1905–6. Ink, colored pencil (?), and graphite on wove paper, 12⅜ × 9¾ in. (31.4 × 24.9 cm). The Barnes Foundation, Merion, Pennsylvania (BF667)

Buffalo) and *The Harem* (The Cleveland Museum of Art). Those works display the delicate classicism and terracotta palette of Gósol, whereas the palette of *La Coiffure* is darker, and the faces tend toward the schematic masks that Picasso began to develop in late spring. As John Richardson has noted, the style of *La Coiffure* most closely resembles that of *Boy Leading a Horse* (fig. 29.2), commonly assigned to the spring of 1906.[13] But there is a harsh and summary aspect to *La Coiffure*, and perhaps that is why many writers think that it was finished in Paris after Picasso returned from Gósol, as was *Gertrude Stein* (cat. 38). He also made a related sculpture, of a woman combing her own hair, in the autumn of 1906 (z 1.329). It is inconceivable, however, as some have written, that Picasso took this large, much-worked, and probably still-wet canvas with him to Gósol. What remains uncertain is whether Picasso began the final composition prior to departing for Gósol and completed it upon his return, or whether the entire painting visible today was made in one campaign in Paris in the spring. The boy was clearly a late addition—he does not appear in the preparatory drawings—but there is no evidence that the two female figures were completely painted before Picasso added the boy. Unlike other paintings made that autumn, such as *Self-Portrait with Palette* (fig. 39.2) or *Two Nudes* (fig. 34.1), this composition looks back rather than forward.

Although Picasso did not exhibit the painting himself, he sold it to Ambroise Vollard, probably in November 1906, and Matisse most likely saw it at the gallery. The emphatic contours of the intertwined figures as well as the unspecified setting must have struck a chord, for Matisse's *Coiffure* of 1907 (Staatsgalerie Stuttgart) is an unmistakable response to Picasso's enigmatic picture.

G T

1. See Richard J. Wattenmaker in Toronto 1975. According to Wattenmaker, Picasso was first introduced to Puvis de Chavannes's work by the Catalan painter Santiago Rusiñol, "an enthusiastic admirer of Puvis who had known his work firsthand prior to his friendship with the teenage Picasso" (ibid., p. 168).
2. Picasso's ca. 1901 sketch *Three Figures* (Museu Picasso, Barcelona) was made after Puvis de Chavannes's *Saint Genevieve Bringing Paris Provisions during the Siege of the Franks* (1897, Panthéon, Paris); ibid., pp. 168–69.
3. The exhibition (April 15–October 15) included three paintings by Puvis de Chavannes (nos. 536–38) and one drawing (no. 1262).
4. Shown as no. 11. The exhibition (October 15–November 15) included forty-three paintings, pastels, drawings, and caricatures, "and ranged from small to monumental and from rough preparatory sketches to finished works" (ibid., pp. 171–72).
5. The catalogue of the exhibition (October 18–November 25) lists sixty-eight entries for the artist.
6. Richard Kendall believes that there was a "steady stream of finished pictures" by Degas to be seen at the art galleries on the rue Laffitte at the turn of the twentieth century. This included *Woman Combing Her Hair* (ca. 1892–96, private collection), which was with Galerie Durand-Ruel in 1899. Kendall in London–Chicago 1996–97, p. 44.
7. Thornley 1889. The same portfolio reproduces *Beach Scene* (The National Gallery, London), which features a maid combing a young girl's hair.

8. Picasso could have seen Renoir's *La Coiffure* (1888, private collection; Daulte 1971, no. 546), which was with Galerie Bernheim-Jeune, Paris, and was sold to Galerie Durand-Ruel on April 16, 1902. It is also worth noting that he would have known Henri Manguin's *La Coiffure* (winter 1904–5, private collection), which the Steins bought in February 1906.

9. Rewald in Tinterow et al. 2007, p. 204. Alfred H. Barr, Jr. (1946, p. 43) also compared the pyramidal composition to "a Raphael *Holy Family*."

10. Christian Zervos, acting on information from the artist, catalogued it as a work of 1905. In completing a questionnaire for The Museum of Modern Art, New York, in October 1945, Picasso reconfirmed that date. Barr 1946, p. 254.

11. Reff 1976.

12. Schapiro 1978, p. 118 n. 4.

13. Richardson 1991–2007, vol. 1 (1991), p. 428.

PROVENANCE

[Galerie Vollard, Paris; bought from the artist, probably November 1906, until at least 1911]; [André Level, Paris]; [Hugo Perls, Berlin, by January 1926, until 1930; sold on May 8, 1930, for $11,000 to Matisse and Dudensing]; [Pierre Matisse, New York, in shares with Valentine Dudensing, New York, from 1930; sold to Clark]; Stephen C. Clark, New York (ca. 1930–37; his anonymous gift to The Museum of Modern Art, 1937); The Museum of Modern Art, New York (1937–51, acc. no. 451.37; deaccessioned in September 1947, for sale to the Metropolitan Museum; sale completed in 1951, transferred in December 1953)

EXHIBITIONS

Berlin 1911, no. 192, ill.; New York (Valentine) 1933, no. 2; New York (MoMA/Summer) 1933, no cat.; New York (MoMA) 1933, no. cat.; New York (MoMA) 1941, no cat., checklist; Utica and other cities 1941–43, no. 51, p. 47; Paris 1966–67, no. 32, ill.; Vienna 1968, no. 7; Tokyo–Kyoto 1972, no. 104, ill.; New York 1973, hors cat.; Richmond 1974, no cat.; New York 1975, ill.; New York 1980, pp. 59, 74 (ill.), and checklist p. 11; Bordeaux 1981, no. 226, p. 174 (ill.); Madrid–Barcelona 1981–82, no. 43, pp. 118–19 (ill.); Canberra–Brisbane 1986, p. 14 (ill.); Barcelona–Bern 1992, no. 192, pp. 94, 364–67 (ill. p. 365), 371; Washington–Boston 1997–98 (shown in Boston only), no. 147, pp. 282 (fig. 10), 283, 285, 286, 315 (pl. 147), 363; Paris 1998–99, pl. 9; New York 2000, pp. 21 (ill.), 125; Paris–Montauban 2004, no. 18, pp. 91, 92 (ill.); Madrid 2006, no. 6, pp. 110–11 (ill.), 112–15 (detail ill.), 412; New York–Chicago–Paris 2006–7, no. 149, pp. 108 (fig. 114), 388 (French ed., no. 96, p. 118 [ill.]); Paris 2008–9, pp. 127, 137 (ill.), 346, 358; London 2009, no. 10, pp. 36–37, 50 (ill.)

REFERENCES

Level 1928, pp. 14, 56 (pl. 14); Zervos 1932–78, vol. 1 (1932), p. 141 (ill.), no. 313; *Fine Arts* 20 (May 1933), frontis. and ill. p. 4; Barr 1942, p. 66, no. 478; Merli 1942, p. 156 (ill.); Barr 1946, pp. 43 (ill.), 254, 282; Anon., September 22, 1947, pp. 1, 24; Barr 1948, pp. 57 (ill.), 318, no. 594; Gómez Sicre 1948, p. 13 (ill.); Merli 1948, pl. 147; Breeskin 1952, p. 108 (ill.); Elgar and Maillard 1955, pp. 32, 267, ill.; Sutton 1955, fig. 54; Elgar and Maillard 1956, p. 36, ill.; Payró 1957, fig. 12; Vallentin 1957, p. 128; Pool 1959, pp. 179 n. 24, 181; Raynal 1959, p. 34 (ill.); Blunt and Pool 1962, pp. 25, 32, pl. 170; Jaffé 1964, pp. 76–77 (ill.); Reff 1966, p. 266; Daix and Boudaille 1967, pp. 90–92, 98, 102, 284, 289 (ill.), no. XIV.20; Jaffé 1967, pp. 74–75 (ill.); Sterling and Salinger 1967, pp. 232–33 (ill.); Lecaldano 1968, p. 107, no. 244, pl. 51 (English ed., pp. 16, 107 [ill.], no. 244, pl. 51); Boudaille 1969, p. 14, pl. XIV; Leymarie 1972, pp. 72 (ill.), 292; Burns 1973, pp. 77, 79, 81; Porzio and Valsecchi 1974, pl. 23; Cabanne 1975a, p. 177; Cabanne 1975b, p. 213; Richard J. Wattenmaker in Toronto 1975, pp. 174 n. 3, 175; Schapiro 1976, p. 250 n. 4; Cabanne 1977, p. 104; Schapiro 1978, p. 118 n. 4; Carol Hynning Smith in New York and other cities 1979–80, p. 78; Christ 1980, p. 22 (ill.); Kodansha 1981, pl. 32; Palau i Fabre 1981b, pp. 441 (ill.), 549, no. 1213; Perry 1982, pp. 129, 132; Bernadac and Du Bouchet 1986, p. 43 (ill.); Larson 1986, p. 47; Staller 1986, p. 89; Topalian 1986, p. 362; Boudaille 1987, p. 31 (fig. 45); Daix 1987a, pp. 58, 64, 100; Daix 1987b, pp. 139 (ill.), 141; Tinterow 1987, pp. 114–15 (fig. 91); Daix and Boudaille 1988, pp. 90, 98, 102, 284, 289 (ill.), no. XIV.20; Jaffé 1988, pp. 58–59 (ill.); Pierre Daix in Paris (Musée Picasso) 1988, vol. 2, pp. 493–94 (fig. 3); Tomkins 1989, p. 307; Chevalier 1991, p. 82 (ill.); Cox 1991, vol. 1, pp. 85, 88, 89, 201, vol. 2, p. 39 (pl. 26); Richardson 1991–2007, vol. 1 (1991), pp. 417, 428 (ill.); Anon., March 1992a, p. 37 (ill.); Anon., March 1992b, ill.; Daix 1992a, pp. 58–59 (fig. 5), 62; Seckel 1992, pl. 22; Warncke 1992, vol. 1, p. 141 (ill.); Daix 1993, pp. 48, 54, 60; Geelhaar 1993, p. 34 (fig. 24), 177; Warncke 1993, vol. 1, p. 141 (ill.); Daix 1995, pp. 50, 84, 199, 248, 348, 406, 462, 694, 698, 765; Varnedoe 1995, pp. 30 (ill.), 31, 34, 53, 55–56, 58–59, 61–62, 69 n. 77; Daix 1996, pp. 268, 294 n. 40; Martí 1998, p. 39; Asher 1999, p. 12 (erroneously listed as 451.47 instead of 451.37); Léal, Piot, and Bernadac 2000, pp. 95, 98 (fig. 200), 505 (English ed., pp. 91, 95, 98 [fig. 200], 505); Belloli 2005, pp. 151–61 (ills.); Cortenova 2005, p. 92 (ill.); Barcelona–Martigny 2006–7, p. 28 (fig. 3); Julia May Boddewyn in New York–San Francisco–Minneapolis 2006–7, pp. 339, 350; Sabine Rewald in Tinterow et al. 2007, pp. 204, 288–89, no. 189

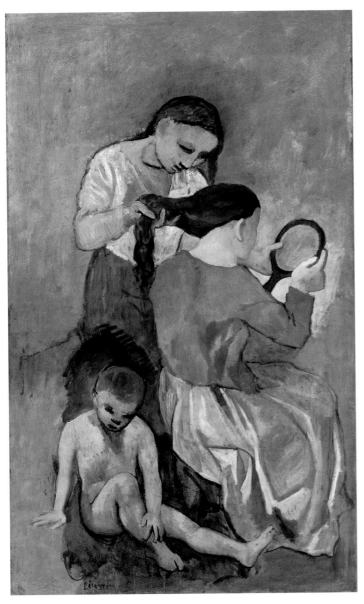

Cat. 30

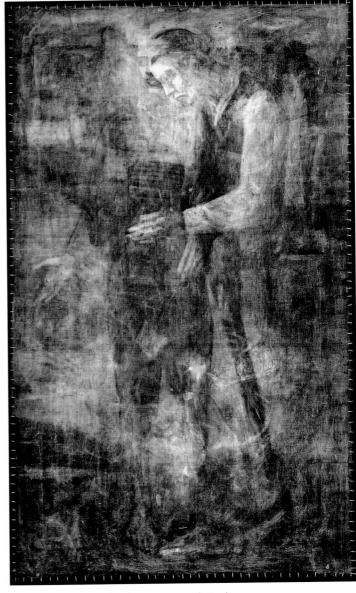

Fig. 30.5. X-radiograph of cat. 30, rotated 180 degrees

TECHNICAL NOTE

This boldly painted work is the culmination of many different efforts by Picasso. X-radiography reveals three complete paintings underneath the present composition as well as two fragmentary works, all based on drawings the artist made between 1902 and 1906. The edges of the canvas, as left by Picasso, show the distinct palettes of the periods encompassed by this time frame.

The first (and thus earliest) painting beneath *La Coiffure* is of a man extending his hands to a young girl, as seen in the 1902 drawing *Interior of the Artist's Studio* (figs. 30.6, 30.7). The man holds a bowl or some similarly round object in his hands, an offering to the girl. The second painting is based on the 1904 drawing *Beggar with a Crutch* (figs. 30.8, 30.9), while the third is of a juggler, as depicted in the drawing *Juggler, Sketches, and Caricatures of Apollinaire*, dated December 24, 1905 (figs. 30.10 30.11). These three paintings were fully finished. Two fragmentary works can also be seen. The first one consists of a forearm and hand, a second hand,

and the curved line of a barrel, elements that originated in the 1905 drawing *Boy with a Barrel* (DB XII.32, Z XXII.310). This figure was eventually incorporated into the painting *Family of Saltimbanques* of 1905 (fig. 26.1), so this fragment would have been executed prior to the juggler painting described above. The second fragment is the partial head of the older brother in *Two Brothers* (Kunstmuseum Basel), a work Picasso probably began in 1906. To paint his final effort—the composition that we see today—Picasso turned the canvas upside down, thus avoiding the distraction of the previous works.

La Coiffure was glue lined and varnished prior to entering the Metropolitan's collection. In 1972 the work was cleaned, and the removal of extensive retouching greatly improved the painting's appearance. Tensions among the numerous layers have created many cracks, which were minimized with retouching prior to revarnishing.

L B

Right: Fig. 30.6. Pablo Picasso, *Interior of the Artist's Studio*, 1902. Ink on paper, 5⅞ × 4¾ in. (15 × 12.2 cm). Museu Picasso, Barcelona (MPB 110.446)

Far right: Fig. 30.7. X-radiograph of cat. 30, with outlines of the composition visible in fig. 30.6

Right: Fig. 30.8. Pablo Picasso, *Beggar with a Crutch*, 1904. Ink and wash on paper, 14⅛ × 9¾ in. (36 × 24.8 cm). Private collection (z 1.223)

Far right: Fig. 30.9. X-radiograph of cat. 30, with outlines of the figure in fig. 30.8

Right: Fig. 30.10. Pablo Picasso, *Juggler, Sketches, and Caricatures of Apollinaire*, 1905. India ink on paper, 6⅞ × 6 in. (17.6 × 15.3 cm). Musée National Picasso, Paris (MP509)

Far right: Fig. 30.11. X-radiograph of cat. 30, with outlines of the juggler in fig. 30.10

31. Youth in an Archway
Gósol, Summer 1906

Conté crayon on laid paper watermarked INGRES
23¼ × 16¾ in. (59.1 × 42.5 cm)
Bequest of Scofield Thayer, 1982
1984.433.273

The works Picasso made at Gósol, in the Spanish Pyrenees, in the summer of 1906 are remarkable for their unself-conscious classicism as well as the uncomplicated ease with which the nude figures, male and female, display their bodies. An extension of the elegiac mood of his studies for *The Watering Place*, the nudes of Gósol were Picasso's response to his interest in the works of Puvis de Chavannes and Ingres he had seen and studied in Paris. He must have also realized that these unclothed figures were the logical vehicle for his art to take as he moved away from the narratives implied by Harlequins and saltim-banques toward a new, timeless figural style.

Most authors trace the figure and pose of this youth to antiquity. Robert Rosenblum identified him as a kouros type: the rather static, monumental Greek sculptures of athletic young men associated with the cult of Apollo. Susan Mayer and Elizabeth Cowling have conjectured that Picasso may have consulted the early volumes of Salomon Reinach's 1897–1931 *Répertoire de la statuaire grecque et romaine*,[1] where similar poses may be found. Another source was Michelangelo, himself deeply inspired by antiquity, whose *Dying Slave* at the Louvre fascinated countless artists, including Cézanne and Matisse, both of whom were of special interest to Picasso at precisely this moment.[2] (In later years, Picasso kept a plaster copy of the *Dying Slave* in his Paris studio for inspiration.) Indeed, it seems likely that the prece-dent provided by Cézanne and Matisse encouraged Picasso to explore the expressivity of the nude figure independent of the trappings of everyday life.

Scholars disagree on whether Picasso made this and similar sketches from life.[3] Whether or not the young man posed, the features clearly belong to an individual, one who reappears in many of Picasso's works dated to Gósol, including the related paintings *Two Brothers* (Kunstmuseum Basel) and *The Adolescents* (fig. 31.1). Scholars also have differing opinions on the level of sexuality expressed by the pose. Rosenblum read it as a sign of provocation, a "strangely voluptuous pose of desire and avail-ability," noting that while Picasso was at Gósol he drew a swineherd who, when stretching his arms above his head, exposed his genitals through his ill-fitting breeches.[4] Yet it can be argued that in this work the gesture is guileless and that Picasso was more concerned with projecting an innocent nudity, before the Fall of Man, than the heightened sexuality he would soon explore.

Picasso made several sketches showing this arch,[5] which Josep Palau i Fabre has interpreted as a strongly Spanish motif.[6] Although he used a variant of the sketch's pose in the paintings noted above, he did not complete a canvas with the arch.

Fig. 31.1. Pablo Picasso, *The Adolescents*, 1906. Oil on canvas, 61¾ × 46 in. (157 × 117 cm). Musée de l'Orangerie, Paris, Jean Walter and Paul Guillaume Collec-tion (1960.35)

1. S. Mayer 1980, fig. 37, n.p.; Cowling 2002, p. 145.
2. Matisse's *Le bonheur de vivre* (1905–6, The Barnes Foundation, Merion, Pennsyl-vania), which Picasso undoubtedly saw at the 1906 Salon des Indépendants, includes a woman with two upraised arms. William Rubin (in Rubin, Seckel, and Cousins 1994, p. 75) noted that Cézanne utilized this pose for several of his female bathers, including *Five Bathers* (ca. 1885–87, Kunstmuseum Basel), and that a reproduction of this work was hanging in André Derain's studio.
3. Cowling (2002, p. 147) contends that Picasso's early Gósol works depicting ado-lescent males were primarily inspired by classical sources, pointing to the artist's use of the well-known spinario pose in, for example, *Two Youths* (1906, National Gallery of Art, Washington, D.C.). John Richardson (1991–2007, vol. 1 [1991], pp. 441, 442), however, believes that Picasso could have drawn works such as *Two Brothers* (1906, Musée Picasso, Paris) and *Two Brothers* (1906, Kunstmuseum Basel) from life. Robert Rosenblum (1997, p. 270) observes that these idealized youths may have been drawn from sculptures or from young men Picasso observed.
4. *Swineherd* (1906, The Museum of Modern Art, New York); Rosenblum 1997, p. 271.
5. Palau i Fabre (1981b, p. 456) notes that it can be seen in *Nude Adolescent under an Arch* (1906; z VI.662) and *Nude Standing under an Arch* (1906, The Barnes Foundation, Merion, Pennsylvania). The closely related basket-handled arch can be seen in *Interior of an Inn* (1906; z VI.758), *Houses in Gósol* (1906, Statens Museum for Kunst, Copenhagen), and *Two Youths* (1906, National Gallery of Art, Washington, D.C.).
6. Palau (ibid.) describes the arch as "an unmistakable stamp of place and time."

PROVENANCE
[Galerie Alfred Flechtheim, Berlin, until 1922; sold in July to Thayer]; Scofield Thayer, Vienna and New York (1922–d. 1982; on extended loan to the Worcester Art Museum, Massachusetts, 1939–82, inv. 39.1701; his bequest to the Metropolitan Museum, 1982)

EXHIBITIONS
Worcester 1941, no. 40; Princeton 1949, no. 3; Worcester 1959, no. 197, p. 99; Worcester 1965, no cat., checklist; Worcester 1971, no cat.; Worcester 1981, no. 115; Barcelona–Bern 1992, no. 138, p. 305 (ill.); New York 1993, no cat.; New York 1995, unnumbered cat.; Paris 1998–99, fig. 12; Madrid 2001–2, no. 16, pp. 64, 65 (ill.), 203

93

REFERENCES

Zervos 1932–78, vol. 6 (1954), p. 80 (ill.), no. 660; Palau i Fabre 1981b, pp. 447 (ill.), 550, no. 1240; Hoog 1984, p. 154; Richardson 1991–2007, vol. 1 (1991), p. 442 (ill.); Marilyn McCully in Málaga 1992–93, pp. 84, 86 (ill. fig. 10); Rosenblum 1997, pp. 272, 275 n. 42

TECHNICAL NOTE

Picasso made the drawing in at least two distinct applications of conté crayon. The first comprises light strokes and smudging, which he used to outline the figure and shade forms; these lines reflect the texture of the paper. The second he did using firmer, darker strokes, which have a spotted pattern created by a textured support—such as a drawing board, table, or fabric—that was beneath the drawing when it was being executed. This effect is also seen in *Young Woman of Gósol* (cat. 33), made at the same time. Green marks on the verso correspond to the trellis vines on the archway, suggesting that some of the color from the support used by the artist offset onto the verso of the drawing.

French Ingres paper was often used by Picasso. This sheet has darkened significantly, and the condition of the drawing and quality of the color suggest that it would originally have been white or off-white, like many of the papers Picasso used for his drawings. Rosin is often added to the pulp during the papermaking process to give the paper moisture resistance and some surface hardness, making it suitable for a variety of media. This paper is known to have been sized sometimes with large quantities of rosin,[1] and over time such high quantities, exacerbated by exposure to light and other environmental factors, can cause dramatic color change and embrittlement of the paper.

"Ingres" refers to a type of white laid paper that was produced beginning in the late nineteenth century by more than one manufacturer, including Canson & Montgolfier, Arches, and Fabriano. This paper is sometimes watermarked INGRES (Canson & Montgolfier used the watermark INGRES 1871), but some types are without a watermark. They all have certain physical characteristics (white, laid, and with a certain quality and finish) for which they are known as artists' papers of the Ingres type. The name "Ingres" is somewhat misleading: this type of textured paper would not have allowed Ingres to produce his precise graphite portraits, which were executed on smooth wove paper. However, the legacy of the great draftsman induced paper companies to produce a paper bearing his name, and Ingres became synonymous with high-quality artists' paper. While Picasso was in Gósol in the summer of 1906, he wrote a letter to his friend Enric Casanovas asking for art supplies and specifically requested *papier Ingres,* indicating a preference for its color and texture (see cat. 34, n. 1). It is well suited to charcoal, chalk, and pastel because its moderate texture allows it to collect and hold pigment from these friable media; Picasso, however, used it for all types of watercolors and drawings. RM

1. Personal communication with Roy Perkinson, former head of paper conservation, Museum of Fine Arts, Boston, May 2008.

32. Old Man and Youth

Gósol, Summer 1906

Charcoal on light blue laid paper watermarked LTM
9½ × 6¼ in. (24.1 × 15.9 cm)
Signed in graphite, lower right: <u>Picasso</u>
Bequest of Scofield Thayer, 1982
1984.433.272

After arriving at Gósol in June 1906, Picasso continued to develop compositions that derive from the figural groups seen in *The Watering Place* (cat. 29), a study for an ambitious though never realized project depicting riders and horses in a desert landscape. Picasso obviously saw Gósol through the lens of his current interests. As a consequence, his Gósol sketches and notebooks sometimes convey the (clearly false) impression that the people of the Pyrenean village walked through the streets in perfect nudity, their finely proportioned limbs covered in rusty pink dust.

This drawing, like many others made at the beginning of his stay, did not result in a canvas, but the idea of male nudity was carried through in paintings such as *The Adolescents* (fig. 31.1) and *Two Brothers* (Kunstmuseum Basel), both dated to Gósol that summer. Moreover, this sheet demonstrates that Picasso was considering a work that would contrast the Ages of Man. The anonymous adolescent reappears frequently in work done at Gósol,[1] while the elder figure bears the features of Josep Fondevila (see cat. 35), Picasso's aged and patient innkeeper.[2] Although several drawings show Fondevila nude, it is not known whether Fondevila posed for them or simply inspired them. GT

1. Núria Rivero and Teresa Llorens (in Barcelona–Bern 1992, pp. 294–95) grouped this drawing with two sketches of a seated male nude (DB XVI.16, 18). Pierre Daix and Anatoli Podoksik disagree on the dating of this group. Daix claims that they are preparatory sketches for the lost canvas *Seated Male Nude*, which dates to the autumn of 1906 (DB, p. 331); Podoksik relates them instead to the classical works. which he dates to the beginning of the Gósol period, such as *The Watering Place* (see cat. 29) and *Boy Leading a Horse* (see fig. 29.2) (Podoksik 1989, p. 158). The adolescent in the Metropolitan's drawing also bears a resemblance—in particular his slightly bowed legs and short-waisted trunk—to the subject of the gouache *Nude* (DB XIV.8), which Podoksik and Daix-Boudaille both date to the spring of 1906 (Podoksik 1989, p. 158; DB, p. 287).
2. For the spelling of "Fondevila," see cat. 35, n. 1.

PROVENANCE

[Probably Wurthle & Sohn, Vienna]; Scofield Thayer, Vienna and New York (ca. 1922–d. 1982; on extended loan to the Worcester Art Museum, Massachusetts, 1939–82, inv. 39.1702; his bequest to the Metropolitan Museum, 1982)

EXHIBITIONS

Worcester 1941, no. 42; Worcester 1959, no. 198, p. 99; Worcester 1981, no. 116; Barcelona–Bern 1992, no. 129, p. 295 (ill.); Paris 1998–99, fig. 3; New York 1995, unnumbered cat.

TECHNICAL NOTE

Picasso first outlined the figures in charcoal and then gently drew over some areas to modify or strengthen lines and forms. The pale blue paper is a fine-quality writing paper; Picasso often used papers from hotels and businesses. While sometimes it appears that he chose this type of paper as an impromptu drawing surface—in contrast to his planned working sessions, such as his time at Gósol, where he ordered fine-art materials from suppliers—Picasso's archives (Musée Picasso, Paris) reveal that he collected a variety of paper types and used both fine-art and commercial materials throughout his career. RM

33. Young Woman of Gósol

Gósol, Summer 1906

Conté crayon on laid paper
24½ × 14¼ in. (62.2 × 36.2 cm)
Bequest of Walter C. Baker, 1971
1972.118.296

During his stay in Gósol, Picasso made numerous drawings of young women in simple dresses and head scarves. Appearing singly with clasped hands or holding hands in pairs, the women in these drawings all display an unselfconscious beauty, a natural elegance, and fine, almost feline features.[1] The young women are not always the same, though there is more than a generic resemblance from one to another; instead, Picasso seems to have sought an underlying truth in their physiognomy. In this instance, John Richardson has proposed that the model may have been the granddaughter of Picasso's beloved innkeeper, Josep Fondevila (see cat. 35), because in another sketch she appears holding a tray of food.[2]

Since Picasso's art developed rapidly in Gósol toward schematic representation and stylistic deformations, scholars have looked for evidence of these changes even in modest drawings such as this. In their catalogue raisonné, Pierre Daix and Georges Boudaille dated works closely related to this sheet—such as *Woman with Loaves* (fig. 33.1) and several other sketches of women in head scarves (DB XV.25–36)—to a transitional, middle period in Gósol that contained the seeds of the archaizing works done at the end of Picasso's stay.[3] In a later essay, Daix placed this series just after the completion of *Nude with Joined Hands (Fernande)* (DB XV.28).[4] He took particular interest in the head scarves that appear on the women at this time, writing that the scarf helped abstract Fernande's face in *Woman with Loaves*, a development that pointed to Picasso's increasing engagement with the "dynamics of deformation."[5] Daix further speculated that the scarf indicated Picasso's interest in "those aspects of Fernande's face and body that could sustain this simplification and reduction to volumes. The psychological emptiness is complete."[6] Robert Rosenblum concurred with this assessment in 1997. He noted that the Spanish mantilla transforms Fernande into an "almost generic image of a peasant woman," mirroring the gradual simplification of her features.[7]

Notwithstanding Picasso's use of the scarf to frame the face and as an aid to abstraction, there can be no doubt that the village women wore them to protect themselves from the harsh sun at the high altitude, to keep the ever-present dust out of their hair, and as an expression of modesty: all good reasons for Fernande to adopt the prevailing custom for herself.[8]

GT

Fig. 33.1. Pablo Picasso, *Woman with Loaves*, 1906. Oil on canvas, 39¼ × 27½ in. (99.5 × 69.8 cm). Philadelphia Museum of Art, Gift of Charles E. Ingersoll, 1931 (1931-7-1)

1. See DB XV.25–30; Z VI.754–56, 758–60, and 780.
2. Richardson 1991–2007, vol. 1 (1991), p. 438. See Z VI.758. Fernande Olivier wrote in her journal (2001a, p. 184), "He's also doing a portrait of the innkeeper's granddaughter, a girl of about twelve." Fondevila's daughter contracted typhoid fever in the middle of August, precipitating Picasso and Fernande's hasty flight from Gósol.
3. DB, p. 292.
4. Daix 1996, p. 264.
5. Daix 1992b, p. 45.
6. Daix 1996, p. 266.
7. Rosenblum 1997, p. 267.
8. Indeed, Daix (1996, p. 266) calls the scarf Fernande wears in *Fernande with a Kerchief* (DB XV.45) and *Reclining Nude (Fernande)* (DB XV.47) a "Gósol scarf."

Picasso began the drawing using a combination of light strokes to make an initial sketch; he then used more definitive strokes of the conté crayon to reinforce the design. Conté crayon—a manufactured artists' crayon—creates dark black marks on paper that normally reflect the texture of the surface to which is applied. Here, however, Picasso placed a more textured material, such as pulp board or fabric, beneath the paper, allowing the crayon to skip across the surface, creating the staccato marks of the lighter sketch; these reflect the texture of the underlayer rather than the paper Picasso chose for the drawing. This effect is also seen in another conté drawing from 1906, *Youth in an Archway* (cat. 31).

In the initial sketch, Picasso erased in some areas and altered the position of the hands, head, shoulder, and skirt. He used a firmer application of the conté crayon to make the definitive outlines for the position of the figure, the finishing details, and the shading of the face. These areas do not have the enhanced texture supplied by the laid-paper support (see cat. 31 technical note for a discussion of Picasso's supports), indicating that Picasso removed the underlayer when he made these final touches.

RM

34. Two Women of Gósol

Gósol, Summer 1906

Ink and fabricated chalk on white laid paper watermarked INGRES
24⅞ × 18¼ in. (62.9 × 46.4 cm)
Signed in graphite, lower left: <u>Picasso</u>
Bequest of Scofield Thayer, 1982
1984.433.280

Fig. 34.1. Pablo Picasso, *Two Nudes*, 1906. Oil on canvas, 59⅝ × 36⅝ in. (151.3 × 93 cm). The Museum of Modern Art, New York, Gift of G. David Thompson in honor of Alfred H. Barr, Jr. (621.1959)

While at Gósol, Picasso conceived a composition with two young women, perhaps sisters, as a female corollary to his paintings *Two Brothers* (Kunstmuseum Basel) and *The Adolescents* (see fig. 31.1) as well as to his unrealized project contrasting the Ages of Man (see entry for cat. 32). There are two handsome drawings in addition to this one, all on expensive Ingres paper,[1] that show the young ladies addressing one another. Given their costumes, fans, and diminutive purses, the scene may be set at a village dance;[2] in the *Carnet Catalan*, Picasso sketched several dancing couples in which the women are similarly clothed.[3]

Maurice Jardot, Picasso's Parisian dealer after World War II, thought that there was a photograph at the root of the composition, but no such photograph has been found.[4] What is remarkable about the three related sheets is Picasso's projection of the naked bodies beneath the clothes. Although the sequence cannot be established with certainty, most scholars agree that he progressed from fully clothed to nude,[5] the opposite of classical drawing technique. In addition, he made several very fine drawings defining the faces of the young women.[6] Rather than honing in on their individual likenesses, however, he generalized and abstracted their physiognomy, which may have been inspired by the twelve-year-old daughter of Picasso's innkeeper, Josep Fondevila.[7] Because of this tendency toward abstraction, these works have long been assigned to the end of Picasso's stay in Gósol.

Picasso never executed the painting of Gósol women that he conceived. Instead, he became obsessed with a composition of two nude women engaged in a strange, ritualistic form of address, one deferring to the other. He made a large number of related drawings and gouaches upon his return to Paris in the autumn of 1906,[8] culminating in the large canvas *Two Nudes* (fig. 34.1).

GT

1. See z VI.780 (The Art Institute of Chicago) and VI.875. Picasso wrote his friend Enric Casanovas (1882–1948), a Catalan sculptor with a studio in Paris, to ask him to send him more paper, which had not arrived by the time Picasso left, about August 12, 1906: "I want you to buy or send me by mail a roll of twenty sheets of *papier Ingres* and as quickly as you can because I have finished the small stock of paper I bought in Barcelona. . . . This you can send by mail inside a cardboard tube (they sell them ready-made). And forgive me for burdening you, but you are the only one I trust for these things and I will recompense you. Tell me if you want me to send you the *cuartos* [cash] or . . . give it to you when you come. Tell me frankly. . . . Could you send me in the same package two or three small *eines* [tools] to work in wood?" Richardson 1991–2007, vol. 1 (1991), p. 444. See also cat. 31 technical note.
2. For Picasso's use of dance scenes in Gósol, see my entry for the related *Peasant Girls from Andorra* in Cambridge–Chicago–Philadelphia 1981, p. 70, no. 20.
3. DB XV.29; D. Cooper 1958, p. 67.
4. Jardot 1959, p. 153.
5. See Palau i Fabre 1981b, p. 470, and Barcelona–Bern 1992, p. 326.
6. z VI.763; z I.354 (not in DB).
7. John Richardson (1991–2007, vol. 1 [1991], p. 438) identifies the "grave-looking girl with a long face" that appears in many of Picasso's drawings of peasant girls as Fondevila's granddaughter because in one sketch she is seen serving a meal at his inn.
8. DB XVI.11–18, 21; P 1388, 1389, 1409, 1410.

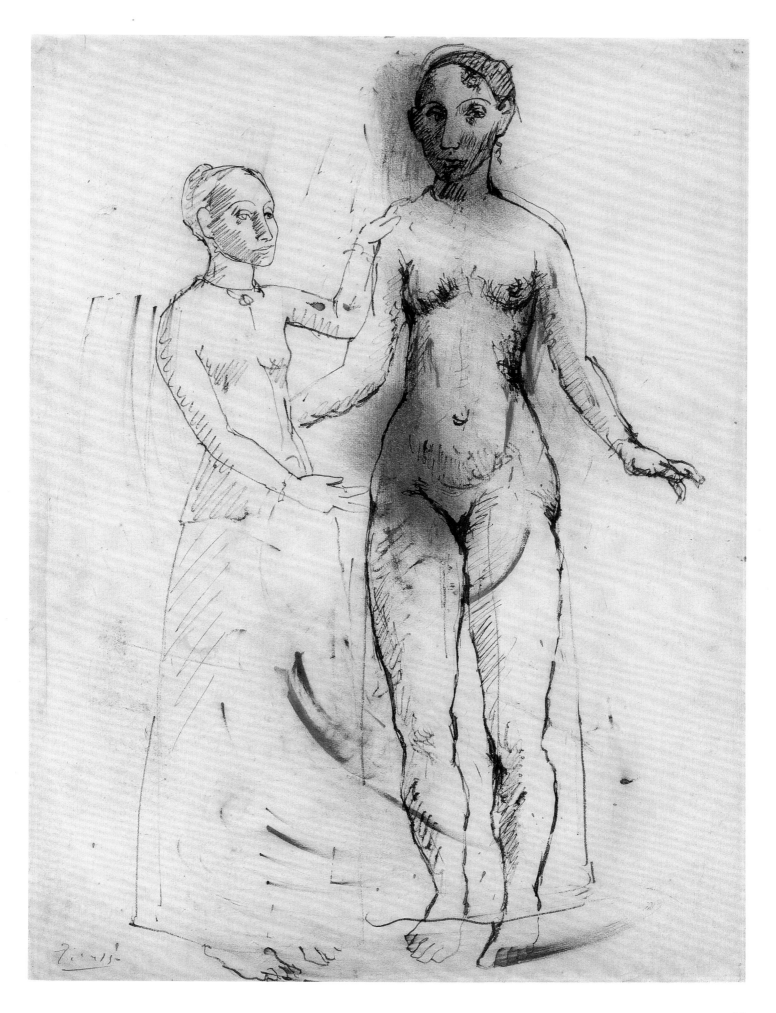

99

PROVENANCE
[Galerie Alfred Flechtheim, Düsseldorf and Berlin, until 1921; sold autumn 1921 to
Thayer]; Scofield Thayer, Vienna and New York (1921–d. 1982; on extended loan
to Worcester Art Museum, Massachusetts, 1934–82, inv. 34.77; his bequest to the
Metropolitan Museum, 1982)

EXHIBITIONS
New York 1924, no. 38; Rochester 1924, no. 81; Hartford 1934, no. 93; Worcester
1941, no. 48; Worcester 1951–52, no cat., checklist (in *Worcester Art Museum Bulletin*),
no. 60, p. 5; Worcester 1959, no. 194, p. 99; Worcester 1965, no cat., checklist;
Worcester 1971, no cat.; Worcester 1981, no. 117; New York (MMA) 1985, no cat.;
Canberra–Brisbane 1986, p. 16 (ill.); New York (Pace Wildenstein) 1995, p. 8, pl. 3;
Paris 1998–99, fig. 11; Balingen 2000, no. 61, ill.; Liège 2000–2001, no. 40, ill.

REFERENCES
Thayer 1923, drawings and engravings, pl. 9; Carey 1924, p. SM10; Craven 1924,
p. 182; Zervos 1932–78, vol. 1 (1932), p. 159 (ill.), no. 339; Lassaigne 1949, pl. 23;
Bouret 1950, pl. 26; Joost 1964, pp. 229, 238; Palau i Fabre 1981b, pp. 471 (ill.), 553,
no. 1352; Núria Rivero and Teresa Llorens in Barcelona–Bern 1992, pp. 326, 328 n. 5;
Julia May Boddewyn in New York–San Francisco–Minneapolis 2006–7, pp. 333, 341

TECHNICAL NOTE

Picasso made this drawing on high-quality artist's paper (see discussion in cat. 31
technical note) using a complex mixture of media applications, from pen and drawn
lines to smears across the sheet and many other, ambiguous types of marks. Seen
under the microscope, almost all of the rich black media contain considerable
amounts of pigment, including charcoal and chalk. Manufactured chalks can have a
variety of components and properties, and the differences among these types is dif-
ficult to characterize, especially when they are mixed into a shellac binder.

On the reverse, the penetration of shellac is uneven and uncharacteristically
excessive for a manufactured India ink. These observations suggest that Picasso
dipped some type of fabricated black chalk into the shellac and drew directly on the
paper, creating the black yet broken lines; to achieve the wide variety of line widths,
he altered the pressure and angle of application. The dipped crayon carried excess
shellac to the paper, which accounts for the larger amounts in the dark areas and
intermittently along the lines, as if Picasso redipped to continue drawing.

Some lines appear to have been drawn with a pen, particularly the loops that
shade the forms, as seen along the leg and the planes of the nude figure's face. How-
ever, the "ink" here appears to be a slurry of the particulate chalk, ink, or shellac;
Picasso may have mixed these and used the restult as an ink, or perhaps the ink
picked up the particles already on the drawing while being applied, because the
continuous looping lines allowed the pen lines to mix with and incorporate the
surrounding material. Both the dipped crayon and the particulate-laden India ink
account for the washlike appearance in some areas and the smearing and stumping
in other. Despite this variety of techniques, the media are consistent across the
entire drawing.

RM

35. Josep Fondevila

Gósol, Summer 1906

Oil on canvas
17¾ × 15⅞ in. (45.1 × 40.3 cm)
Signed, upper left: Picasso
Gift of Florene M. Schoenborn, 1992
1992.37

Josep Fondevila was the nonagenarian innkeeper at Cal Tampa-
nada, the modest lodging where Picasso and Fernande Olivier
stayed in Gósol.[1] Picasso liked him immediately, perhaps seeing
in Fondevila a grandfatherly and approving figure just as his
relationship with Fernande was deepening into something
resembling a marriage. Fernande described Fondevila as "a fierce
old fellow, a former smuggler, with a strange, wild beauty. He's
over ninety but he has kept his hair, and although his teeth are
worn down to the gums, they are very white and not one of
them is missing or has ever been damaged. He's difficult and
cantankerous with everyone else but always good-humored with
Pablo, whose portrait of him is very lifelike."[2] She also noted that
Picasso was as "spell-bound as a child" listening to Fondevila's
smuggling stories.[3] Picasso went so far as to shave his head like
the old man,[4] which, according to John Richardson, the artist
could have viewed as "a metaphor for this austere region, indeed
for the whole austere country."[5] Picasso scholar Hans Christian
von Tavel considers that "the landscape and people of Gósol
most probably had less influence on Picasso than is generally
believed," yet he also feels that "[t]he portrait of old Josep
Fondevila is the exception that proves the rule."[6]

Although Fondevila's features appear in many of Picasso's
drawings, the artist painted but two portraits of him over the
summer of 1906.[7] Returning to Paris in the autumn, Picasso

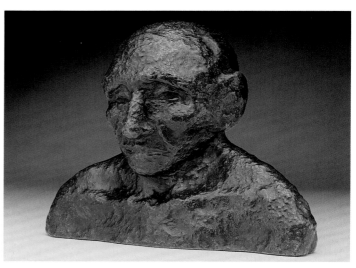

Fig. 35.1. Pablo Picasso, *Bust of a Man (Josep Fondevila)*, 1906. Bronze,
6⅝ × 9 × 4⅝ in. (16.8 × 22.9 × 11.7 cm). Hirshhorn Museum and Sculpture
Garden, Washington, D.C., Gift of Joseph H. Hirshhorn, 1966 (66.4047)

then modeled a sculpture, *Bust of a Man (Josep Fondevila)*
(fig. 35.1). Over the last twenty-five years, scholars have identi-
fied the repercussions of the Fondevila portrait in Picasso's sub-
sequent work, from foreshadowing the masklike portrait
Gertrude Stein (cat. 38) to Picasso's own hieratic self-portrait
from later in 1906 (see fig. 39.2). The simian 1907 portrait of the

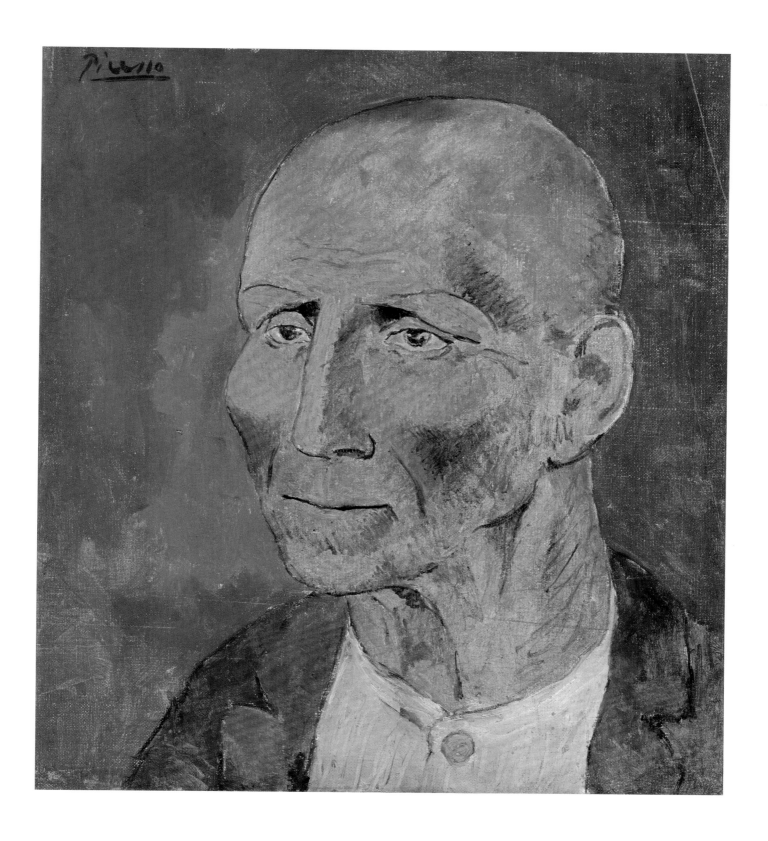

poet André Salmon as well as the *Study for a Wooden Sculpture of André Salmon*, also from that year (both private collection; not in DB) and even Picasso's last self-portraits, done decades later, are likewise indebted.[8] As Richardson wrote, "If there are no drawings for the repainting of Gertrude Stein's portrait, it is because they are all of Fondevila. The old smuggler lives on in her guise."[9] Brigitte Léal called Fondevila's visage "a genuine trampoline for research carried out over two years into the depersonalization of the face."[10] William Rubin observed the temporal element to Picasso's portraits of Fondevila, pointing to the extreme youth of some drawings and the "death-mask" quality of others.[11] He noted that Picasso used this "mask-like" face in conjunction with Iberian sculpture to transform his work when he returned to Paris from Gósol.[12]

What all the subsequent works noted above have in common with the portraits of Fondevila is Picasso's focus on the skull in his attempt to characterize an individual, a reflection of his understanding that the most durable representation is skeletal. But surely not every mask or skull in Picasso's oeuvre has Fondevila at its root; and when Picasso is drawing himself at age ninety, the skull is most likely his own, not Fondevila's. Similarly, there is little resemblance between Fondevila's toothless smile and Gertrude Stein's plump cheeks. Yet for all the prospective importance that scholars give to this portrait, they tend to overlook the simple beauty of the painting. As Fernande Olivier wrote, "it is very life-like," to which one might add, very sympathetic: unlike all the drawings in which Fondevila appears as a stock figure, in this portrait Picasso gave the wizened, nut-brown face a charming smile, gleaming eyes, and a strong sense of canny intelligence.

GT

1. The spelling of "Fondevila" in this catalogue deviates from the accepted spelling of "Fontdevila." As Jordi Falgàs (2006, p. 248 n. 27) points out, Dolorès, Fondevila's granddaughter, corrected the spelling in an interview quoted in *Gósol: Quaderns de divulgació del futur Museu de Gósol*, no. 1 (March 1988), p. 63.

2. Olivier 2001a, p. 184.

3. Olivier 1933, p. 94.

4. According to Palau i Fabre (1981b, p. 442), Picasso shaved his head within days of his arrival at Gósol.

5. Richardson 1991–2007, vol. 1 (1991), p. 438. He also notes that before leaving Gósol, Picasso "even carved the bowl of his meerschaum pipe into the likeness of this *genius loci*" (ibid.).

6. Von Tavel 1992, p. 93.

7. The other is the gouache and watercolor *Head of a Man* (DB XV.52). Drawings that feature Fondevila include *Head of a Man* (DB XV.54), *Head of Josep Fondevila* (Sketchbook 218, Musée Picasso, Paris, 1857.65v.), *Profile of Josep Fondevila*

(Sketchbook 218, Musée Picasso, Paris, 1857.66v.), *Face of Josep Fondevila* (Musée Picasso, Paris, MP517), *Portrait of Josep Fondevila* (Musée Picasso, Paris, MP518), *Josep Fondevila Seated Nude* (OPP 08.096), and *Josep Fondevila Standing Nude* (OPP 08.098).

8. Richardson (1991–2007, vol. 1 [1991], p. 438) was the first to link Picasso's late self-portraits and the head of Fondevila. Robert S. Lubar followed this line in his article "Unmasking Gertrude Stein: Queer Desire and the Subject of Portraiture," specifically linking the visage of Fondevila to Picasso's self-portrait from July 1972 (Penrose Foundation, London; Z XXXIII.436), eight months before his death (Lubar 1997, p. 79).

9. Richardson 1991–2007, vol. 1 (1991), p. 453.

10. Léal 1992, p. 102.

11. See Z XXII.453 and VI.765.

12. Rubin 1996, pp. 28–29 (ill.), and Varnedoe 1996, p. 132.

PROVENANCE

[Richard Dudensing II, New York, until 1952; sold in October to Knoedler]; [M. Knoedler & Co., New York, 1952–53; sold on May 7, 1953, for $8,800 to Marx]; Samuel and Florene Marx, Chicago (1953–his d. 1964); Florene May Marx, later Mrs. Wolfgang Schoenborn, New York (1964–92; on extended loan to The Museum of Modern Art from 1971; on extended loan to the Metropolitan Museum from 1985; her gift to the Metropolitan Museum, 1992)

EXHIBITIONS

New York and other cities 1965–66, p. 19 (ill.); New York 1980, suppl. (brochure) no. 2 (ill.), and checklist p. 11; New York–Paris 1996–97, pp. 28–29 (ill.), 132; New York (MMA/Schoenborn) 1997, brochure no. 13, ill.; Washington–Boston 1997–98, no. 165, pp. 51, 333 (ill.), 365; Paris 1998–99, fig. 16; Cleveland–New York 2006-7, no. 6:5, pp. 240–41 (fig. 4), 501; Naples (Fla.) 2008, brochure fig. 4

REFERENCES

Zervos 1932–78, vol. 6 (1954), p. 93 (ill.), no. 769; Boeck and Sabartés 1955, pp. 460 (fig. 36), 489; Daix and Boudaille 1967, pp. 100, 307 (ill.), no. XV.53; Lecaldano 1968 (both eds.), no. 297, pp. 112 (ill.), 113; Johnson 1976, pp. 52, 211 (fig. 45); Kodansha 1981, pl. 34; Palau i Fabre 1981b, pp. 463 (ill.), 552, no. 1313; Daix and Boudaille 1988, pp. 100, 307 (ill.), no. XV.53; Richardson 1991–2007, vol. 1 (1991), pp. 438, 439 (ill.), 453; Pierre Daix et al. in Barcelona–Bern 1992, pp. 45, 93, 336 (ill.); S. Rewald 1993, p. 63; Daix 1995, pp. 375, 406, 765; Mailer 1995, p. 226 (ill.); Vogel 1996b, pp. A1, C12 (ill.); Lubar 1997, pp. 77, 78 (fig. 22), 79; Cordova 1998, pp. 56–58 (fig. 1.19); Martí 1998, p. 39; Belloli 1999, p. 18; Léal, Piot, and Bernadac 2000, pp. 97 (fig. 198), 505 (Eng. ed.: pp. 95, 97 [fig. 198], 505); Olivier 2001, p. 184

TECHNICAL NOTE

Picasso executed this painting quickly using thin oil paint on a canvas commercially prepared with a white ground. The limited palette of gray, burnt sienna, and white is nevertheless rich and varied. In his final touches to the canvas, Picasso reinforced the initial drawing, done in dilute burnt sienna, using the same color in concentrated form.

The painting is scarred by deep scratches forming irregular lines, perhaps the consequence of the artist's hurried return to Paris from Gósol, when the canvas, most likely removed from its stretcher, would have been stashed away for the journey. The painting was glue lined and varnished prior to entering the Museum's collection, but, interestingly, the restoration did not attempt to mitigate the scratches, perhaps out of respect for the sketchlike quality of the work.

LB

36. Study for "Composition: The Peasants"
Gósol or Paris, late Summer 1906

Ink on off-white wove paper
6⅞ × 4¼ in. (17.5 × 10.8 cm)
Verso: *Standing Female Nude*, ink
Purchase, Mrs. Derald Ruttenberg Gift, 2005
2005.84a, b

This previously unpublished sketch appeared at auction in January 2005, when it was purchased for the Metropolitan Museum by William S. Lieberman, then Jacques and Natasha Gelman Chairman of Modern Art. Although it had not been catalogued by Christian Zervos, Josep Palau i Fabre, Pierre Daix, or Paolo Lecaldano—compilers of some of the standard references on Picasso—Lieberman recognized the drawing as a concise summary of the figural group in the important composition that Picasso was developing just as he left Gósol, precipitously, about August 13–15, 1906. Thanks to his letter to the collector Leo Stein, we know that Picasso was back in Paris by August 17, and that he was "in the process of making" the large

Fig. 36.1. Pablo Picasso, *Composition: The Peasants*, 1906. Oil on canvas, 86 × 51 in. (218.5 × 129.5 cm). The Barnes Foundation, Merion, Pennsylvania (BF140)

Fig. 36.2. El Greco, *Saint Joseph with the Christ Child*, ca. 1600. Oil on canvas, 42⅞ × 22 in. (109 × 56 cm). Museo de Santa Cruz, Toledo

canvas *Composition: The Peasants*, now at the Barnes Foundation, Merion, Pennsylvania (fig. 36.1).[1] The final painting was executed in a new style, characterized by dramatic faceting, lozenge-shaped forms, and irrational lighting, all adapted from El Greco. In the Metropolitan's sketch, we see Picasso beginning to emphasize angles and facets, but the figures still retain the naturalistic simplicity of Picasso's classicizing manner at Gósol.

Picasso originally developed the motif of a child leading an adult porter for the *Family of Saltimbanques* (see fig. 26.1). A woman with a load slung over her shoulder and being led by a young girl is first seen on page 18 of sketchbook number 35 (1905, private collection).[2] Picasso included them in a drypoint (see cat. P5), a gouache,[3] and in an early state of the oil before he painted them out. This may explain why the artist's daughter Maya Widmaier Picasso dated this drawing to 1905 instead of 1906 when it was recently auctioned. Although the origin of the group in *Family of Saltimbanques* has not previously been noted,[4] all scholars agree that the subject of a blind flower seller was conceived in Gósol. Jeffrey Weiss noted that the oxen in the Barnes painting were a late addition to the composition, perhaps added after Picasso was back in Paris,[5] and Patrick O'Brian linked them to a tradition of decorating cattle with wreaths so that they would make a festive entry when brought down into the village from their high summer pasture.[6]

Every scholar who has considered this series of works has noted the audacity of Picasso's new stylistic direction. Alfred H. Barr, Jr., in 1946, was the first to propose a connection to the work of El Greco, particularly *Saint Joseph with the Christ Child* (fig. 36.2), noting that it was reproduced in a book on El Greco published by Picasso's friend Miquel Utrillo.[7] Barr and all

subsequent authorities underscore the significance of the Barnes canvas to the development of Cubism. William Rubin, for example, believed that the painting's "innovative linear Mannerism makes it . . . even more significant for [the development of] *Demoiselles* [see fig. 40.1], stylistically speaking, than such major intervening Iberian works as *Two Nudes* [see fig. 34.1]."[8] John Richardson likewise emphasized the centrality of this work to Picasso's evolving style, although he deemed the Barnes canvas a failure, a combination of "El Greco's mannerism, Blue period compassion, Rose period charm and what looks like Nabis decorativeness."[9]

Blindness is a recurrent theme in Picasso's oeuvre, from his Blue Period obsession with the ravages of syphilis to what he conceived in the 1930s as the mythic blindness of the minotaur.[10] More pertinent to this work, perhaps, is Léon Angély (also known as Père Angély), a blind scout for art dealers who haunted the studios of Montmartre in Picasso's day. Angély was led around the studios by a little girl who described the works to him, and Picasso, according to Richardson, was fascinated by him.[11] Note should also be made of the transformation of the girl in these related compositions, which Palau calls "one of the most curious metamorphoses that I can find in the artist's whole career."[12] She is depicted as a child in the various iterations of the blind flower seller drawings and paintings; she is also shown alone as a young girl holding a bunch of flowers. In later sketches she becomes a naked, plump caricature accompanied by a devil, and her figure becomes larger and more feminine, a predecessor to the women in seminal works such as *Two Nudes* (fig. 34.1).[13] This is particularly significant in light of the voluptuous female figure on the verso of this drawing (ill.). G T

Verso of cat. 36, *Standing Female Nude* (2005.84b)

1. Palau i Fabre 1981b, p. 466. In addition to the Museum's sketch, there are several known studies for *Composition: The Peasants*: DB XV.57, 59–61 and a watercolor (Z XXII.348, DB XV.58), which shows the young girl alone.
2. New York 1986, p. 32, fig. 18.
3. *Circus Family*, 1904–5, The Baltimore Museum of Art, The Cone Collection.
4. I thank Marci Kwon for this important observation.
5. Weiss in Barnes Foundation 1993, p. 200.
6. O'Brian 1976, p. 147.
7. Barr 1946, p. 48. Illustrated as "Sant Joseph, Am Jesus Infant," in Utrillo 1906, p. 28. *Saint Joseph with the Christ Child* was also illustrated in two articles, although they came out in the fall of 1906 after Picasso returned from Gósol: Lafond 1906a, p. 10, and Lafond 1906b, p. 386. See Barr 1946, p. 48.
8. Rubin in Rubin, Seckel, and Cousins 1994, p. 39.
9. Richardson 1991–2007, vol. 1 (1991), p. 448.
10. See also *Blind Man's Meal* (cat. 22).
11. Richardson 1991–2007, vol. 1 (1991), pp. 351–52. I thank Christel Hollevoet-Force for suggesting Angély in this context.
12. Palau i Fabre 1981b, p. 466.
13. See note 1 for related studies for *Composition: The Peasants*. P 1331–1333 show her accompanied by a devil, while P 1334–1338 demonstrate her transformation into a full-figured adult.

PROVENANCE

[Possibly Valentine Dudensing, New York, by 1938]; European art market; sale, "Impressionist and Modern Art," Sotheby's, New York, January 19, 2005, no. 6; to the Metropolitan Museum

EXHIBITION

Possibly Washington 1938, no. 10 (as "Sketch for Flower Vendors," Valentine Gallery, New York)

REFERENCE

Julia May Boddewyn in New York–San Francisco–Minneapolis 2006–7, p. 347 (in chronology, under April 10–May 1, 1938, incorrectly identified as Z 1.311, The Metropolitan Museum of Art; note that Z 1.311 is at the Art Gallery of Ontario, Toronto)

TECHNICAL NOTE

The ink lines of the drawing, which Picasso made using a pen on thin wove paper, were executed freely and quickly. He appears to have worked the composition first in thin light strokes before adding the thicker lines to reinforce outlines and delineate highlights and shadows. In areas of heavy ink application, he used blotting (perhaps with a finger) to blur and lessen the intensity of the ink's blackness and to soften the lines. RM

37. Kneeling Nude
Paris, Autumn 1906

Fabricated chalk on white laid paper watermarked INGRES
24¾ × 18⅞ in. (62.9 × 47.9 cm)
Signed in graphite, lower right: <u>Picasso</u>
Bequest of Scofield Thayer, 1982
1984.433.275

After hastily returning to Paris following a typhoid fever scare in Gósol, Picasso lost none of the extraordinary momentum he had found in the peaceful Pyrenean village. Seemingly without interruption, he continued his exploration of the expressive possibilities of the nude figure—first male, then female. Whereas over the previous five years he relied on costume to provide context and emotional resonance for his compositions, in 1906 he became more confident that he could create equally affecting paintings with the nude figure alone. Accordingly, he looked for inspiration in the work of the masters who had recently interested him: Ingres, Puvis de Chavannes, and Gauguin, all of whom were rooted in classicism and had been given extensive exhibitions at the Paris Salons d'Automne. Gauguin, in particular, was accorded a large posthumous exhibition in 1906.[1]

This drawing of a nude bather reveals the multiple sources that Picasso consulted and combined at this moment. The pretext of the composition—a female bather at a fountain—derives from Ingres and relates to *The Harem* (1906, The Cleveland Museum of Art), Picasso's free reworking of Ingres's *Turkish Bath* (see fig. 65.2) and *La Source* (1856, Musée d'Orsay, Paris).[2] The compact forms and compositional clarity recall Puvis, but the splayed pose and archaizing features point to Gauguin. Ron Johnson suggested that the pose originated in Gauguin's relief *Be in Love and You Will Be Happy* (1889, Museum of Fine Arts, Boston).[3] Susan Stein has identified a Gauguin in the collection of Picasso's friend Paco Durrio that may have intrigued him: *Two Tahitian Women in a Landscape* (fig. 37.1), where the weighty presence and bent posture of the kneeling figure evoke the nude in this drawing. Picasso worked in Durrio's studio in the autumn of 1906.

The masklike faces of the nudes in Picasso's work at this time has provoked much discussion. William Rubin, writing in *Primitivism and Modern Art*, noted that while the influence of the pre-Roman Iberian reliefs put on display at the Louvre in the spring of 1906 is evident in Picasso's Gósol work, it was not until he was back in Paris that their full impact became apparent.[4] Elizabeth Cowling concurs, suggesting that the preparatory drawings for the bronze *Woman Combing Her Hair* (S 7) show a particularly strong Iberian undercurrent.[5] John Richardson, however, disagrees that Iberian reliefs strongly influenced Picasso at this point.[6] Discussing Picasso's completed portrait *Gertrude Stein* (cat. 38), he claims that "it is above all his studies of Fontdevila [*sic*] that enabled Picasso to contrive

Fig. 37.1. Paul Gauguin, *Two Tahitian Women in a Landscape*, ca. 1892. Watercolor, gouache, and green ink, over traces of graphite, on paper, 12⅝ × 9⅜ in. (32.2 × 23.8 cm). The Art Institute of Chicago, Gift of Emily Crane Chadbourne (1922.4795)

the right mask for Gertrude. . . . A drawing of the old smuggler done shortly after the return to Paris reveals the artist in the throes of reconciling the two faces; and a bust executed around this time in Durrio's studio shows Picasso trying out the same trick in three dimensions."[7] Richardson nevertheless assigns at least some of the transformation of Picasso's style in Gósol to the impact of the pre-classical Iberian art he had seen, noting that the women go from "the image of *la Belle Fernande*" to a "flat-footed, bull-necked, banana-fingered earth mother" whose face has been "thickened into a stylized mask taken more or less directly from an Iberian relief."[8] This figural type reached an apogee in Picasso's oeuvre in the late 1906 painting *Two Nudes* (see fig. 34.1). GT

1. According to Richardson, this event "left Picasso even more than ever in this artist's thrall." Richardson 1991–2007, vol. 1 (1991), p. 461. The exhibition (October 6–November 15) included 227 catalogue entries (nos. 1–227), from paintings, works on paper, and sculptures to ceramics and graphic works.
2. Picasso played with this pose and theme in a number of works, including Z XXII.438, 1.336, 341, VI.743, 751.
3. Johnson identified this work as belonging to Paco Durrio but provided no documentary evidence of this fact in either his dissertation (Johnson 1971) or subsequent article on the subject for *Arts Magazine* (Johnson 1975, p. 64). William Rubin objected to this comparison on stylistic grounds and questioned the connection Johnson makes between the two works (Rubin 1984, p. 243, 334 n. 18). Recent scholarship challenges Durrio's ownership of the work. It was with Goupil & Cie (Boussod et Valadon), Paris, from 1889 to 1893 and subsequently was owned by the Schuffenecker brothers. See Paris–Boston 2003–4 (*Gauguin, Tahiti*), pp. 7, 10–11, 342.

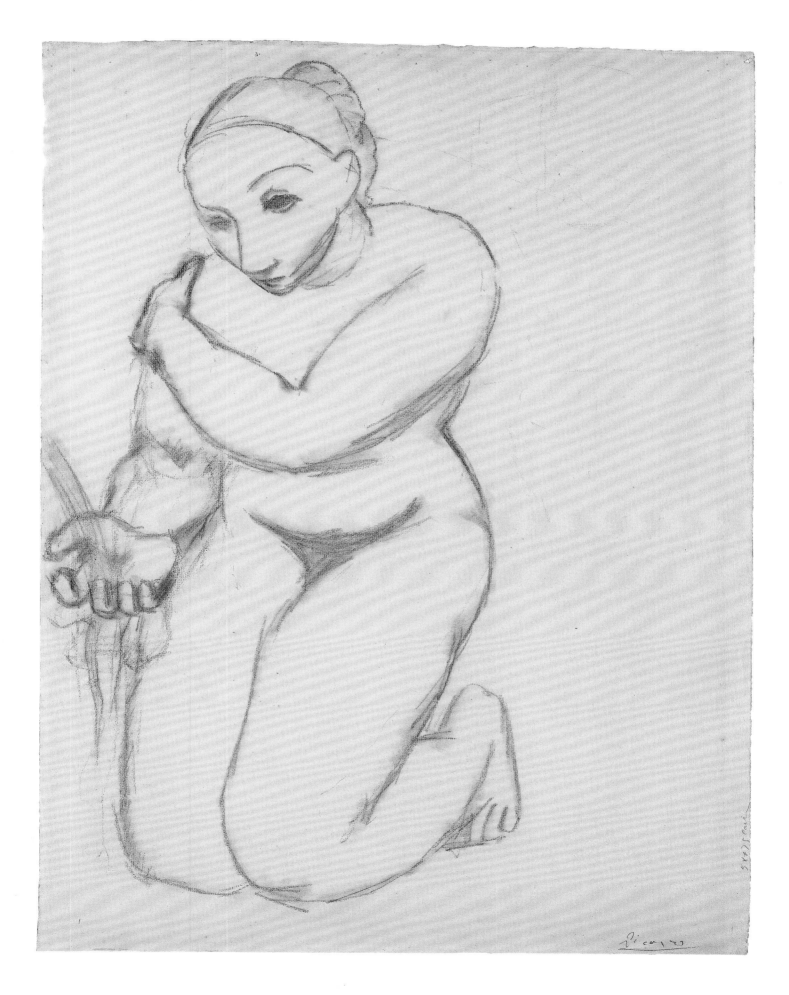

4. Rubin 1984, p. 247.
5. Cowling 2002, p. 151.
6. According to Richardson, "These recently discovered, recently exhibited antiquities had yet to make their full impact." Richardson 1991–2007, vol. 1 (1991), p. 456.
7. Ibid.
8. Ibid., pp. 466, 469.

PROVENANCE

[Galerie Alfred Flechtheim, Düsseldorf and Berlin until 1921; sold on October 2 for $120 to Thayer]; Scofield Thayer, Vienna and New York (1921–d. 1982; on extended loan to the Worcester Art Museum, Massachusetts, 1939–82, inv. 39.1928; his bequest to the Metropolitan Museum, 1982)

EXHIBITIONS

Worcester 1941, no. 52; Worcester 1959, no. 199, p. 99; Worcester 1965, no cat., checklist; New York (MMA) 1985, no cat.; Canberra–Brisbane 1986, pp. 16, 17 (ill.); Barcelona–Bern 1992, no. 205, pp. 380–81 (ill.); Málaga 1992–93, no. 11, ill.; New York (Pace Wildenstein) 1995, pp. 8, 115, pl. 4; Paris 1998–99, fig. 33; Balingen 2000, no. 62, ill.

REFERENCES

Zervos 1932–78, vol. 1 (1932), p. 168 (ill.), no. 355; Joost 1964, ill. between pp. 268–69; *Worcester Art Museum News Bulletin and Calendar*, December 1969, unpaginated, ill. (detail); Joost 1971, p. 488

TECHNICAL NOTE

Picasso drew with a fabricated black chalk with very fine particulates, which can have a variety of working properties. Here he applied the chalk in soft strokes, building up layers to create shadows and emphasize forms. The basket-weave texture of the Ingres paper (see discussion in cat. 31 technical note) is captured in the almost dusty pigment, which sits on the high points of the paper.

RM

38. Gertrude Stein

Paris, Winter 1905/6–Autumn 1906

Oil on canvas
39⅜ × 32 in. (100 × 81.3 cm)
Bequest of Gertrude Stein, 1946
47.106

"For me, it is I, and it is the only reproduction of me which is always I, for me."[1] Thus wrote Gertrude Stein (1874–1946) in 1938. This portrait was proof of her irrevocable link to Picasso, whom she would come to regard as the greatest artist of her time. She saw the painting as a collaboration between two emerging giants, a twenty-four-year-old Spanish painter and a thirty-two-year-old American writer, two expatriates in Paris, each as yet unrecognized but both destined for greatness. As Alice B. Toklas recalled after Stein's death, "there had been a strange exchange in this early creative effort that she and Picasso felt had been expressed in the portrait."[2] "It was a mutual influence," Toklas wrote; "the painter and his model saw things differently after that winter."[3]

Indeed, Picasso and Stein may have always viewed this portrait differently. What was for Stein an exceptional event—sitting for the first of what would be many portraits of her by young artists—was for Picasso unremarkable. From the beginning he had made portraits of people who could help advance his career, whether it was the artists of Els Quatre Gats (see cats. 2–11) or the art dealers who organized his first show in Paris in 1901, Mañach and Vollard (National Gallery of Art, Washington, D.C.; Foundation E. G. Bührle Collection, Zürich). In just a few years, Picasso would make a series of portraits in oil of the dealers whom he was courting: Clovis Sagot (1909, Hamburger Kunsthalle), Wilhelm Uhde (1910, Joseph Pulitzer, Jr., Collection, Saint Louis), Daniel-Henry Kahnweiler (1910, The Art Institute of Chicago), and again, Ambroise Vollard (1911, The Pushkin State Museum of Fine Arts, Moscow). Hence, once Gertrude's brother Leo had bought a picture by Picasso in the spring of 1905, *The Harlequin's Family* (Göteborgs Konstmuseum, Sweden), followed the next autumn by *Girl with a Basket of Flowers* (Rockefeller Collection, New York; z 1.256, DB XIII.8), it was only natural for the young artist to propose portraits of his new enthusiasts: the three Stein siblings (Leo, Gertrude, and Michael), Michael's wife, Sarah, and their son, Allan.[4] Picasso had never met anyone like them, these cosmopolitan, affluent, Harvard-educated, and oddly bohemian American Jews in Paris.

Gertrude may not have met Picasso until the autumn of 1905,[5] but there was an immediate sympathy between them. Picasso had a predisposition to poets—his door was marked "Au rendez-vous des poètes"—yet there was something else at play. Fernande wrote that Picasso "was so attracted to Mlle Stein's physical presence that he suggested he paint her portrait, without even waiting to get to know her better."[6] The attraction was mutual. In *The Autobiography of Alice B. Toklas*, Stein described the artist as "thin, dark, alive with big pools of eyes and a violent but not a rough way. He was sitting next to Gertrude Stein at dinner and she took up a piece of bread. This, said Picasso, snatching it back with violence, this piece of bread is mine. She laughed and he looked sheepish. That was the beginning of their intimacy."[7]

Sometime during the winter of 1905–6, Picasso made portraits of Leo and Allan Stein in gouache on cardboard (both Baltimore Museum of Art). Gertrude's portrait was to be a large canvas. She recalled the first sitting:

There was a couch where everybody sat and slept. There was a little kitchen chair upon which Picasso sat to paint, there was a large easel: and there were many very large canvases . . . of the end of the Harlequin period when the canvases were enormous. . . . There was a little fox terrier there that had something the matter with it and . . . was again about to be taken to the veterinary. . . . Fernande offered to read LaFontaine's stories aloud to amuse Gertrude Stein while Gertrude Stein posed. She took her pose, Picasso sat very tight on his chair and very close to his canvas and on a very small palette which was of a uniform brown grey colour, mixed some more brown grey and the painting began. . . . Toward the end of the afternoon Gertrude Stein's two brothers and her sister-in-law and Andrew Green came to see. They were all excited at the beauty of the sketch and Andrew Green begged and begged that it should be left as it was. But Picasso shook his head and said, non. It is too bad but in those days no one thought of taking a photograph of the picture as it was then and of course no one . . . that saw it then remembers at all what it looked like any more than do Picasso or Gertrude Stein.[8]

Presumably, Picasso's first sketch on the canvas resembled the fluent, graphic, Lautrec-like portraits of Leo and Allan, but this underdrawing cannot be detected today. Although Gertrude later claimed to have posed for some ninety sittings, that is now discounted as hyperbole.[9] Analysis (see the technical note below) has revealed that Picasso did revise the head extensively, so that it evolved from an almost full profile to the three-quarters view in the final picture. Analysis has also confirmed a decisive change before completion. As Stein wrote, "Spring was coming and the sittings were coming to an end. All of a sudden one day Picasso painted out the whole head. I can't see you any longer when I look, he said irritably. And so the picture was left like that."[10]

Toklas recounted that the portrait "was painted while she [Gertrude] was writing *Three Lives* and she walked up to the Place Ravignan in Montmartre two or three times a week for months and months thinking out her work the way she had—so that it would all be clear to her before she commenced to write."[11] "It had been a fruitful winter," wrote Stein. "In the long struggle with the portrait of Gertrude Stein, Picasso passed from the Harlequin . . . period to the intensive struggle which was to end in cubism." For her part, she recorded, "Gertrude Stein had written the story of Melanctha . . . the second story of Three Lives which was the first definite step away from the nineteenth century and into the twentieth century in literature."[12] Thus reads Stein's retrospective notion that she and

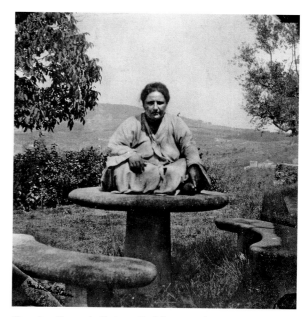

Fig. 38.1. Gertrude Stein as Buddha, Fiesole, 1905. Yale Collection of American Literature, Beinecke Rare Book and Manuscript Library, New Haven, Connecticut

Picasso were both engaged in "struggles" that led to the creation of modern art.

Although Stein may have indeed been struggling with "Melanctha," the story in *Three Lives* written from the perspective of an indigent black woman in Baltimore, the primary difficulty for Picasso was more probably Stein's presence in his studio and the ratcheting expectations for the portrait: Picasso was accustomed to working quickly, alone, and for himself rather than a patron. Conceived in the sweet Saltimbanque period, it naturally evolved over the months as Picasso's vision coalesced into his new neoclassical style. Two spirits hovered over the portrait: that of Ingres's *Louis-François Bertin* (fig. 38.2), which Picasso had studied at the 1905 Salon d'Automne,[13] and that of Cézanne's portrait of his wife (fig. 38.3), which hung in the Steins' studio. Although many scholars believe that Picasso painted this portrait in competition with another painting at the rue de Fleurus, Matisse's *Woman in a Green Hat* (1905, San Francisco Museum of Modern Art), that explosive, painterly picture is so radically different from the sober and solemn portrait of Gertrude that it is difficult to imagine how it could be thought that Picasso was in dialogue with Matisse at this time.[14] On the other hand, Ingres and Cézanne were very much on Picasso's mind—witness *The Watering Place* (cat. 29). John Richardson has suggested that the original position of Gertrude's head may derive from the head of Livia in Ingres's *Virgil Reading the Aeneid* (there are versions in Brussels and Toulouse), and as many have remarked, the final disposition of the body and hands vaguely resembles that of Ingres's Bertin—though, as the technical studies show (see below), Picasso's original conception was quite different from Bertin at inception. The greater affinity is with *Madame Cézanne with a Fan*, as Gertrude herself

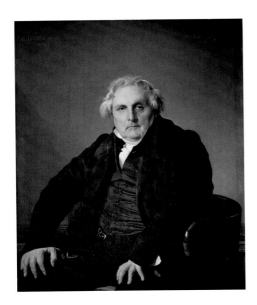

Fig. 38.2. Jean-Auguste-Dominique Ingres, *Louis-François Bertin*, 1832. Oil on canvas, 45⅝ × 37⅜ in. (116 × 95 cm). Musée du Louvre, Paris (RF 1071)

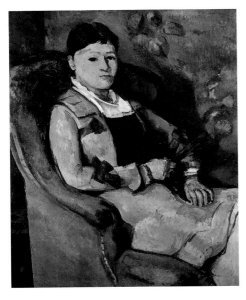

Fig. 38.3. Paul Cézanne, *Madame Cézanne with a Fan*, 1878/88. Oil on canvas, 36⅜ × 28⅞ in. (92.5 × 73.5 cm). Foundation E. G. Bührle Collection, Zürich

acknowledged in her many rehangings of the collection: after her brother Michael and sister-in-law Sarah took their Matisses from rue de Fleurus, Gertrude always balanced her portrait with that of Mme Cézanne (see fig. 3 in the essay by Gary Tinterow in this volume). And Picasso, of course, knew that his picture would have to hold its own in the Steins' densely hung studio, a gathering place for Paris's literary and artistic expatriate community.

Tired perhaps of Gertrude's presence, Picasso dismissed her sometime in the spring of 1906. A postcard from Gertrude to Picasso setting their rendezvous for Friday, March 10, indicates that they no longer had a standing appointment.[15] More revealing, arguably, is the picture on the postcard, a matronly but touchingly beautiful portrait of Holbein's wife and children at the Kunstmuseum Basel (fig. 38.4), which must have had significance for both sitter and painter. After Picasso abandoned the portrait, he and Fernande left for Gósol and the Steins for Fiesole. Picasso returned to Paris in mid-August, and, according

to Gertrude, he repainted the head before he saw her again. Much ink has been spilt over this fact, but as Picasso was accustomed to working alone, and without a model, it is not surprising. John Richardson, William Rubin, and others have suggested that when Picasso repainted the head he had in mind the portrait he had just made of Josep Fondevila, the ancient innkeeper who fascinated the artist in Gósol (cat. 35).[16] But surely they are thinking of late photographs of the elderly Stein, whose skull-like visage and short-cropped hair could be said to resemble Fondevila, because in 1906 the plump, thirty-two-year-old American (fig. 38.1) looked nothing like the wizened, sunken-cheeked old smuggler. Picasso did not need to see Stein again to capture her likeness. Rather than the portraits of Fondevila that he brought back from Gósol, might it not be more likely that he turned to the postcard of the Holbein that Stein had sent him and used that to set the tilt of the head and the compassionate expression?[17]

Stein and all subsequent writers have commented on the masklike visage that Picasso gave her in the finished portrait. Various sources—from a Romanesque Madonna at Gósol to pre-Roman Iberian heads placed on view at the Louvre in the spring of 1906—have been cited, but regardless of the relative weight of the specific sources, Picasso had been developing this hieratic mask in his work over the summer at Gósol. The portrait of Stein was not the first to bear a mask, but it was, as Jane Bowers has noted, one of the first in which Picasso expressed a new sculptural realization in his paintings.[18] He would carry that through to his *Self-Portrait with Palette* (see fig. 39.2), the next significant canvas that Picasso realized after he completed the portrait of Stein, and, in many ways, its proper pendant, one the artist may have hoped the Steins would buy.

Stein's friends were disturbed when they first saw the painting. As she recalled, "Yes, he [Picasso] said, everybody says that she does not look like it but that does not make any difference, she will."[19] "No one will see the picture," she claims Picasso said, "they will see the legend of the picture, the legend that the picture has created . . . a picture lives by its legend, not by anything else."[20] But here one feels that Stein is putting her own words in Picasso's mouth. In her many articles, the two word-portraits of Picasso, and the self-celebrating *Autobiography of Alice B. Toklas*, Gertrude Stein insured that her portrait would live by its legend, and, by extension, guaranteed the immortality of painting, poet, and painter. When she bequeathed the portrait to the Metropolitan Museum, it became the first painting by Picasso to enter the Museum's collection. It remains, sixty years later, the most celebrated.　　　　GT

1. G. Stein 1938b, p. 8.
2. Alice B. Toklas, letter to Charles S. Brown, March 2, 1947, in New York 2000, p. 23.
3. Alice B. Toklas, letter to Louise Taylor, February 20, 1947, in Burns 1973, p. 53. Toklas first met Stein in 1907, after the portrait was made, and thus her recollections of the genesis of the painting are not firsthand; however, she was witness to countless conversations between Picasso and Stein.

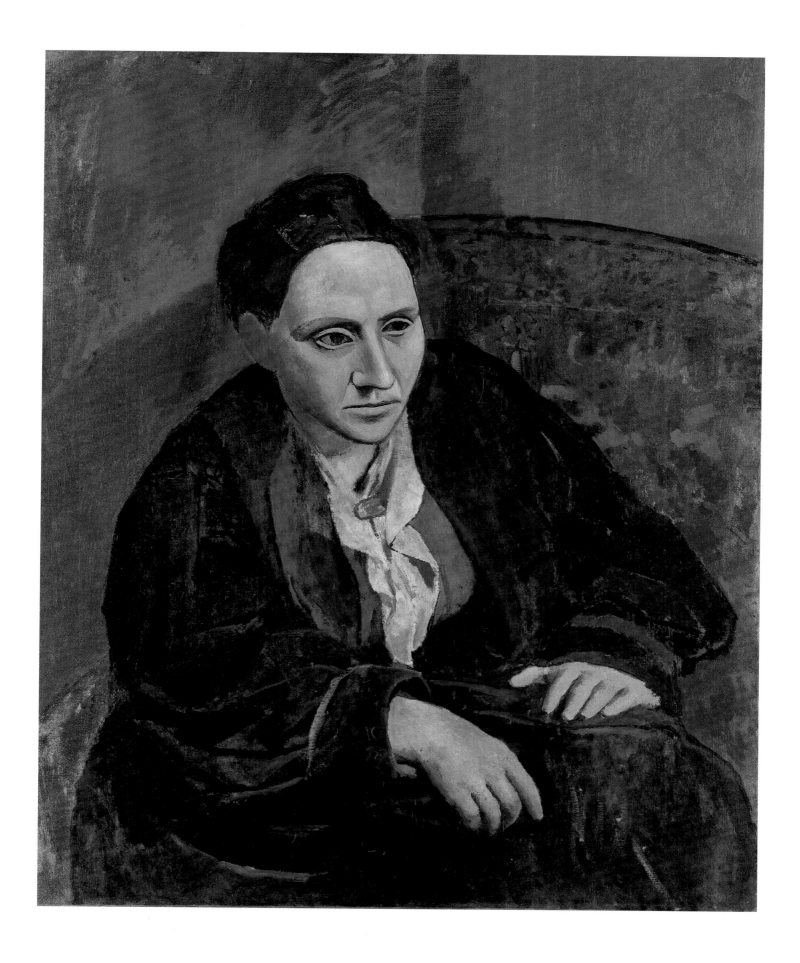

III

Fig. 38.4. Postcard from Gertrude Stein to Pablo Picasso, March 9, 1906. Musée National Picasso, Paris

4. *Portrait of Allan Stein* (1906, The Baltimore Museum of Art); *Portrait of Leo Stein* (1906, The Baltimore Museum of Art).

5. For a discussion of the time line of Picasso's first encounters with the Steins, see Madeline 2008, p. xi.

6. "Picasso les avait rencontrés tous deux [the Steins] chez Sagot, et séduit par la personnalité physique de la femme, il lui avait, avant même de la mieux connaître, proposé de faire son portrait." Olivier 1933, p. 115.

7. G. Stein 1933, pp. 55–56.

8. Ibid., pp. 56–57.

9. John Elderfield suggests (in London–Paris–New York 2002–3, p. 110) that Gertrude exaggerated the number of sittings in order to align her portrait with Cézanne's unfinished one of Vollard (1899, Petit Palais, Paris), which was rumored to have taken 115 sittings, or Ingres's portrait of Bertin, "which was suddenly resolved with an epiphany."

10. G. Stein 1933, pp. 64–65.

11. Letter from Alice B. Toklas to Louise Taylor, February 20, 1947; reprinted in Burns 1973, p. 53.

12. G. Stein 1933, p. 66.

13. Shown as no. 48.

14. The rivalry with Matisse would begin soon: it was the Steins who took Picasso to see Matisse for the first time. See Richardson 1991–2007, vol. 1 (1991), pp. 411–13, and John Golding in London–Paris–New York 2002–3, p. 1. Golding proposes that the Steins took Matisse to see Picasso's portrait of Gertrude.

15. The postcard is dated March 9, 1906, and is in the collection of the Musée Picasso, Paris. See Madeline 2008, pp. 9–10.

16. Richardson 1991–2007, vol. 1 (1991), p. 438; Rubin 1996, p. 29. It is worth noting that Stein recalled the sick fox terrier during her sittings, because the dog died *after* the return from Gósol: in other words, another discrepancy between memoir and fact.

17. Madeline was the first to note this resemblance. Madeline also points out several small holes in the postcard "which show that Picasso must have pinned it up in his studio as visual reference" (2008, p. 9).

18. Bowers 1994, p. 16

19. G. Stein 1933, p. 14.

20. Picasso quoted by Gertrude Stein in Burns 1985, p. 25.

PROVENANCE

Gertrude Stein, Paris (gift of the artist, autumn 1906, until d. 1946; her bequest to the Metropolitan Museum, 1946)

EXHIBITIONS

Paris (Petit Palais) 1937, Picasso section, no. 11, p. 106; on view at MMA, August 22–October 9, 1947; New York (Knoedler) 1947, no. 33, frontis.; New York 1948, no cat.; San Francisco–Portland (Ore.) 1948, no. 3, p. 15, frontis.; New Haven–Baltimore 1951, no. 29, pp. 22 (ill.), 37–38; Paris 1955, no. 12, ill.; New York–Chicago 1957, p. 29 (ill.); Philadelphia 1958, no. 36, p. 16, ill.; Paris 1966–67, no. 38, ill.; Amsterdam 1967, no. 12, ill.; Boston 1970, p. 92 (ill.); New York (MMA) 1970–71, no. 391, pp. 72 (ill.), 324; New York–Baltimore–San Francisco 1970–71 (shown in New York only), pp. 50 (ill.), 59, 60, 63 nn. 7, 8, 9, 91, 93, 94, 167; Paris 1977, p. 194 (ill.); New York 1980, pp. 59, 73 (ill.), and unnumbered checklist p. 12; Madrid–Barcelona

1981–82, no. 44, pp. 120–21 (ill.); Tokyo–Kyoto 1983, no. 32, pp. 55 (ill.), 194 (ill.); Canberra–Brisbane 1986, pp. 7, 12, 13 (ill.); New York–Paris 1996–97, pp. 28, 29, 33, 133, 256–60, 262, 267 (ill.), 268; Washington–Boston 1997–98, no. 168, pp. 283 (fig. 11), 335 (pl. 168), 365, and Boston pamphlet no. 7, ill. (loan approved after the catalogue went to press); New York 2000, pp. 22 (ill.), 23, 24, 25 (ill.); London–Paris–New York 2002–3 (shown in New York only), no. 58, pp. 13, 27, 35, 101, 108 (ill.), 109–13, 114 (ill.), 118, 348 nn. 1, 3, 4, 6, 8, 12, 13, 15, 16, 349 nn. 17, 19, 21, 23, 24, 27, 362–63, 371, frontis.; Madrid (Prado) 2004–5, no. 83, pp. 304, 318 (ill.)

REFERENCES

Camera Work, special number (June 1913), pl. V; Van Vechten 1914, p. 557 (reprinted in Simon 1994); R. Fry 1917, pp. 163 (pl. 1), 168; G. Stein 1924, p. 40; Zervos 1932–78, vol. 1 (1932), p. 167 (ill.), no. 352; Olivier 1933, p. 115 (1945 ed., p. 101); G. Stein 1933, pp. 7, 14, 26, 55–57 (ill.), 60, 64–66, 70, 142, 150; G. Stein 1934, pp. 235 (fig. 2), 238, 239 (fig. 5), 240 (fig. 6), 241 (fig. 7); Lassaigne et al. 1937, pp. 2 (ill.), 8; G. Stein 1937, p. 29 (reprint ed., p. 30); G. Stein 1938a, pp. 26, 31, 32, 50–52, 59 (ill.), 61; G. Stein 1938b, pp. vi, 7, 8, 13–16, 20 (pl. 22), 21, 44, fig. 60 (reprint ed., pp. 7–8, 13–16, 21, 44, pl. 22); McCausland 1939, unpaginated; Alfred H. Barr, Jr. in New York and other cities 1939–41, pp. 56 (ill.), 59, no. 65 (the loan did not occur, as is indicated in the 2nd ed., p. 21); Cassou 1940, p. 165, pl. 41; Wilenski 1940, pp. 200, 215, 219; Sweeney 1941, pp. 190–98 (fig. 1); Merli 1942, p. 53; Monroe Wheeler in New York (MoMA) 1942, pp. 13, 52 (ill.); Dorival 1943–46, vol. 2 (1944), p. 230; McCausland 1944, p. 27; Anon., [August 1946]; Anon., August 11, 1946, p. 46; Barr 1946, pp. 46, 50 (ill.); Anon., August 22, 1947, p. 17; Anon., August 24, 1947, p. X8 (ill.); Anon., September 22, 1947, pp. 1, 24; Leclerc 1947, pp. 2 (ill.), 6, 9; Luce 1947, p. 15 (ill.); L. Stein 1947, p. 174; Schneider 1947–48, p. 81, fig. 1; Anon., January 22, 1948, p. 25; Anon., summer 1948, p. 21; Barr 1948, pp. 58 (ill.), 318, no. 595; Gardner 1948, p. 734; Merli 1948, pp. 70, 599 (fig. 153); Redmond and Easby 1948, pp. 7, 8 (ill.); Sutton 1948 (both eds.), unpaginated; Zennström 1948, pp. 45–46, 48–49 (fig. 12); Lassaigne 1949, p. ix; Fels 1950, p. 225 (ill.); L. Stein 1950, unpaginated, ill.; McBride 1951, pp. 17 (ill.), 63 (reprint ed., p. 431); Rosenthal 1951, p. 1; Wight 1951, p. 12fl9 (ill.); Breeskin 1952, p. 109; Gallup 1953, pp. 34, 339–40, 370; Lieberman 1954, pl. 33; Rousseau 1954, pp. 7, 55 (ill.); G. Stein 1954, p. x (reprinted in Simon 1994); Anon., June 20, 1955, p. 36 (ill.); Anon., June 27, 1955, p. 75; Boeck and Sabartés 1955, pp. 136, 460 (fig. 35), 489, no. 70; Elgar and Maillard 1955, pp. 42, 48, 49, 267 (ill.); Daniel-Henry Kahnweiler in G. Stein 1955, p. xvii (reprinted in Simon 1994); Salmon 1955–61, vol. 1 (1955), pp. 56–57; Sutton 1955, fig. 21; Hess 1955–56, pp. 16 (fig. 7), 17; Camón Aznar 1956, pp. 381 (fig. 272), 382–83, 726; Elgar and Maillard 1956, pp. 46, 49, 51–52, 275 (ill.); Frère 1956, p. 152; Coates 1957, p. 127; Payró 1957, fig. 13; Penrose 1957, p. 32 (fig. 67); Vallentin 1957, pp. 128, 129 (pl. 8), 130, 136–37; Golding 1958, pp. 159, 161 (fig. 14); Penrose 1958, pp. 10, 115–16, 119, 154, 290, pl. IV-1; Saarinen 1958, pp. xiv, 176, 184, 204, ills.; Buchheim 1959, pp. 48 (ill.), 49, 135; Cogniat 1959, pp. 20, 22, 23 (ill.), 54; Golding 1959, pp. 14, 52, 55, 56, 76, pl. 79b; Roché 1959, p. 39 (ill.); Pool 1960, p. 391; Penrose 1961, pl. 15; Blunt and Pool 1962, p. 27; Toklas 1963, p. 28, ill.; Gilot and Lake 1964, pp. 38 (ill.), 68–70; Jaffé 1964, pp. 22, 78–79 (ill.); Olivier 1964, p. 83; Daix and Boudaille 1967, pp. 90, 93–95 (ill.), 98, 284, 318, 321 (ill.), no. XVI.10; Jaffé 1967, pp. 76–77 (ill.); Rosenblum 1967, pp. 136 (fig. 120), 137; Rosenthal 1967, p. 23; Sterling and Salinger 1967, pp. 233–35 (ill.); Arnason 1968, pp. 119, 120 (fig. 194); Golding 1968, pp. 14, 52, 53, 56, 76, pl. 95b; Lecaldano 1968 (both eds.), p. 113 (ill.), no. 306, pl. 64; Mellow 1968, sect. 6, pp. 49 (ill.), 50, 184 (ill.), 185, 187; Boudaille 1969, pp. 10, 14, no. XVI, ill.; Fermigier 1969, pp. 58, 75, 76 (pl. 41), 77 (pl. 42), 393; Peignot 1969, pp. 122 (ill.),124 (ill.), 125; Acton 1970, pp. 168, 171–72 (reprinted in Simon 1994); Burns 1970, pp. 13–14, 23, 25 (ill.), 29–30, 66, 70 (ill.), 71 (ill.), 110, 111 (ill.), 112 (ill.), 113, 114, 117, 130 (ill.); Gardner 1970, pp. 697–98 (fig. 17-5); Leymarie 1971a, pp. 213 (ill.), 292; Ottawa 1971, passim (figs. 1, 4, 5); Penrose 1971a, pl. 15; Penrose 1971b, p. 35 (fig. 63); Barkham 1973; Burns 1973, pp. 5, 8, 42, 49–50, 52–53, 55–57, 58 (ill.), 75–79, 82, 106–7, 125, 186, 223, 238, 281, 327; E. Wilson 1973, pp. 72, 75, 76, 77, 78; Mellow 1974, pp. 84 (ill.), 90–93, 100, 112, 178, 436, 467, 472; Penrose 1974, pp. 124–25, 127 (fig. 3); Porzio and Valsecchi 1974, pp. 61, 260, 262, 267 (pl. 26); Cabanne 1975a, p. 177–78; Hilton 1975, pp. 73, 74–75 (fig. 53); Hobhouse 1975, pp. ix, 51, 74–76, 140, ills.; Johnson 1976, pp. 59–60; O'Brian 1976, pp. 144, 148; Kirk Varnedoe in New York 1976, pp. xii (fig. 1), xiv, 129; Cabanne 1977, pp. 105–6 (ill.); Lenz 1977, pp. 239, 240 (ill.), 241–42; Simon 1977, pp. 194, 196, 197, 247, ill.; Steward 1977, pp. 79–80; Grafe 1978, p. 417 (ill.); Itsuki and Yaegashi 1978, pl. 35; Mayor 1979, pp. 94–95 (ill.); Rubin 1979, p. 144; Christ 1980, p. 22 (ill.); Fischl 1980, p. 17 (ill.); Glueck 1980, sect. 2, pp. 1 (ill.), 25; Gormley 1980, p. 42 (fig. 6); S. Mayer 1980, sect. VII, fig. 16; Cabanne 1981, pp. 9–10; Kodansha 1981, pl. 48; Palau i Fabre 1981b, pp. 435–437, 468 (ill.), 469, 470, 552, no. 1339; Penrose 1981, pp. 117–19, 122, pl. IV-1; Piot 1981, p. 60; Gary Tinterow in Cambridge–Chicago–Philadelphia 1981, pp. 72, 238; Perry 1982, p. 127; Gopnik 1983, pp. 373–74 (ill.); Berlin–Düsseldorf 1983–84, p. 32 (ill.); Dubnick 1984, pp. 15–16, frontis., pl. 1; Rubin 1984, p. 247 (ill.); Palau i Fabre 1985, pl. 80; Tokyo 1985, p. 72 (ill.); Bernadac and Du Brochet 1986, p. 41 (ill.); Burns 1986, vol. 1 (*1913–35*), pp. 90, 94 n. 5, 147 n. 6, 248, vol. 2 (*1935–46*), pp. 658, 673,

674 n. 1, 835, 837 n. 3, 838, 894; Flam 1986, pp. 174, 187; Larson 1986, pp. 42, 47, 48; Warnod 1986, p. 70 (ill.); Magdalena M. Moeller in Hannover 1986–87, p. 17 (ill.); Boudaille 1987, pp. 34 (fig. 48), 35, 48; Daix 1987a, pp. 71, 100; Daix 1987b, pp. 137, 138 (ill.), 139, 141; Greenfeld 1987, pp. 43–44; J. Rewald 1987, pp. 36, 38, 39 (fig. 27), 42–43 (fig. 28), 64; Steiner 1987, pp. 176–77; Tinterow 1987, pp. 116–17 (fig. 92); Bois 1988, p. 140; Daix in Bielefeld 1988, p. 138 (fig. 2); Daix and Boudaille 1988, pp. 90, 93–95 (ill.), 98, 284, 318, 321 (ill.), no. XVI.10; Golding 1988, pp. 41, 45, 73, 226, fig. 105b; Olle Granath in Stockholm 1988–89, p. 29 (ill.); Jaffé 1988, pp. 22, 60–61 (ill.), 64; Kachur 1988, p. 32; Pierre Daix in Paris (Musée Picasso) 1988, vol. 2, pp. 492 (fig. 2), 493; Boone 1989 (both eds.), pp. 58–59 (ill.); Roland Doschka in Balingen 1989, p. 28 (fig. 6); Lyttle 1989, pp. 54, 57, 58, 61; Podoksik 1989, p. 58 (ill.); Stendhal 1989, pp. 59 (ill.), 63 (ill.), 81 (ill.), 88 (ill.), 89 (ill.), 105 (ill.), 135 (ill.), 280 (ill.); Tomkins 1989, p. 307; Yokohama 1989, p. 57 (fig. 4); Judith Cousins in New York 1989–90, pp. 340–42, 439 n. 5; Lombard 1990, p. 4 (ill.); Gail Stavitsky in New York and other cities 1990–91, passim; Kirk Varnedoe and Adam Gopnik in New York–Chicago–Los Angeles 1990–91, pp. 128–29 (fig. 68), 130, 132, 133, 140, 418 nn. 38, 41, 42; Golding 1991, p. 785; Kenner 1991, p. 120 (ill.); Kramer 1991, p. 6; Richardson 1991, pp. 31 (ill.), 36; Richardson 1991–2007, vol. 1 (1991), pp. 402 (ill.), 403–5, 410–11, 419 (ill.), 422, 427, 428, 453, 455, 456 (ill.), 459, 469, 471, 474, 514 n. 36, and vol. 2 (1996), pp. 15, 40, 80, 150, 341, 470 n. 25; Anon., March 1992a, p. 36 (ill.); Cabanne 1992, vol. 1, pl. 14; Daix 1992a, pp. 59–60, 62; Pierre Daix, Núria Rivero, and Teresa Llorens in Barcelona–Bern 1992 (Eng. ed.), pp. 42–43, 46, 342, 350, 364, 367 n. 3, 368 n. 2; Garcia 1992, ill.; Poggi 1992, pp. 32, 72 (fig. 55); Seckel 1992, pl. 39; Warncke 1992, p. 144 (ill.); Francisco Calvo Serraller in Málaga 1992–93, pp. 60 (pl. 16), 62, 305; Boone 1993, pp. 58–59 (ill.); Cope 1993, pp. ix, 36–37, 40, 48, 50, 55, 57–91; Daix 1993, pp. 54, 60–61, 68, 70, 326, 391 n. 10; Geelhaar 1993, pp. 23 (fig. 12), 24–25 (figs. 13–16), 26, 31, 225; Kleinfelder 1993, pp. 16, 17 (fig. 4), 18; Warncke 1993, p. 144 (ill.); Bowers 1994, pp. 6 (fig. 1), 7–9, 11–17, 21–24, 26, 28–30; Kimmelman 1994a, p. C28; Lord 1994, pp. 4–5, 9, 18–21, 32; M. North 1994, pp. 61–62 (ill.), 63, 69, 71–72; Rubin, Seckel, and Cousins 1994, pp. 36–37 (fig. 20), 110, 112; Simon 1994, pp. 27, 33, 43, 112, 172, 173; Stendhal 1994, pp. 34, 46, 47 (ill.), 51 (ill.), 69 (ill.), 71 (ill.), 76 (ill.), 77 (ill.), 93 (ill.), 122 (ill.), 268 (ill.); Barkan and Bush 1995, pp. 271, 273 (fig. 2), 280, 283–84, 289, 427 nn. 46, 53; Daix 1995, pp. 50, 52, 84, 199, 248, 325, 331, 338, 348, 406, 463, 694–95, 698, 738–39, 741, 756, 765, 786, 787, 840, 865, 870; FitzGerald 1995, p. 258; Mailer 1995, pp. 201–5, 208, 212–15 (ill.); Martínez Blasco and Martínez Blasco 1995, p. 31 (fig. 6); Moffitt 1995, pp. xiii, 243, 246 (pl. 61), 256–57; Varnedoe 1995, pp. 30 (ill.), 31, 60, 67–68 n. 64; Weiss 1995, p. 77; sale, Christie's, New York, November 13, 1996, p. 35 (fig. 8);

Kramer 1996, pp. 6, 8; L. Stein 1996, p. 174; Wineapple 1996, pp. 331, 364, 366 (ill.); Anne Baldessari in Paris 1997, pp. 74 (fig. 57), 80–81; Bonduelle-Reliquet 1997, p. 20; Feliciano 1997, p. 64; Henkes 1997, pp. 113–14 (ill.); Kachur 1997, p. 659; Kramer 1997, p. 33; Lubar 1997, pp. 56 (fig. 1), 57–84; Marilyn McCully and Robert Rosenblum in Washington–Boston 1997–98, pp. 48, 49, 51, 264, 274 n. 6, 277, 281, 283 (fig. 11), 284, 285, 286 n. 18, 287 nn. 28, 30, 32, 40, 296, 335 (pl. 168), 365, no. 168; sale, Christie's, New York, May 12, 1997, pp. 63–64 (fig. 4); Arnason 1998, p. 185 (fig. 198); Cordova 1998, pp. 48–58, 339 (fig. 1.13); Pierre Daix in Geneva 1998, p. 18 (fig. 4); William Lieberman in Tokyo–Nagoya 1998, p. 233; Martí 1998; Page 1998, p. 106 (ill.); Pierpont 1998, pp. 83, 88; G. Stein 1998a, pp. 662, 669, 680, 704, 706, 707 (ill.), 710, 713, 717, 723, 779, 784, 920, 927; G. Stein 1998b, pp. 502, 508, 512, 525, 529, 830, 837; S. Watson 1998, pp. 10 (ill.), 39, 320; Belloli 1999, pp. 12–18 (figs. 11, 15–21, 23); Blistène 1999, p. 25 (ill.); Rosenblum 1999, pp. 16, 19 (fig. 26); Léal, Piot, and Bernadac 2000, pp. 106 (fig. 217), 506 (English ed., pp. 106 [fig. 217], 107, 506); Risatti and Colosimo 2000, pp. 445–47, 449–55 (fig. 3); Spies 2000, pp. 34 (ill.), 35; Vienna–Tübingen 2000–2002, p. 14 (fig. 2); Franck 2001, p. 98; C. Green 2001, pp. 64, 65 (fig. 15), 66–67; Griffey 2001, pp. 47–48 (fig. 12); Olivier 2001a, p. 178; Madrid 2001–2, p. 126 (fig. 39); A. Miller 2001, p. 38; H. Cooper 2002, p. 148; Cowling 2002, pp. 153, 154 (fig. 130), 155–59, 179, 279, 652 nn. 74–84; Daix 2002, p. 40; Elizabeth Cowling, John Elderfield, John Golding, and Kirk Varnedoe in London–Paris–New York 2002–3 (French ed.), pp. 17, 31, 39, 110 (ill.), 111–16 (ill.), 120, 369, 378, no. 50, frontis.; Sabin 2002, pp. 94 (ill.), 95, 99 (ill.), 101 (ill.), 397; Dydo 2003, pp. 60–61; Flam 2003, pp. 23–24 (fig. 3.1), 30 (ill.), 31; Gikandi 2003, pp. 460–61 (fig. 2); E. Kahn 2003, p. 60; Malcolm 2003, p. 61; New York (C&M Arts) 2003, p. 11; Blizzard 2004, pp. 8, 63–66, 112–13; H. Foster et al. 2004, p. 80 (ill.); Laurence Madeline in Paris–Montauban 2004, p. 12 (fig. 17); Emily D. Bilski and Emily Braun in New York 2005, pp. 99, 114 (fig. 117), 188 (ill.), 192; Cortenova 2005, p. 99 (ill.); Francisco Calvo Serraller et al. in Madrid 2006, pp. 52 (fig. 17), 53, 117, 118 (fig. 7.1, detail); Madeline 2006, pp. 98, 99 (ill.), 100–101 (detail ills.); Tinterow 2006, pp. 105, 116 n. 22; Michael FitzGerald and Julia May Boddewyn in New York–San Francisco– Minneapolis 2006–7, pp. 19–20 (fig. 5), 240, 350, 359, 363, 364, 375; Giroud 2007, pp. 6–54; Klein 2007, pp. 25–26 (fig. 1), 27; Papanikolas 2007, p. 118; Sabine Rewald in Tinterow et al. 2007, pp. 205 (ill.), 289–90, no. 190; Salber 2007, pp. 144, 145, 146 (ill.), 147; Anne Baldassari in Paris 2007–8, pp. 10, 13, 14, 36 (fig. 3); Macleod 2008, pp. 181, 182 (fig. 70), 183 (fig. 71); Madeline 2008, pp. viii (fig. 1), ix, xii, xiii, xxiv–xxx, 5, 7, 9, 10 (fig. 6), 197 (fig. 26), 261 n. 2, 264 n. 2, 359, 363; Kenneth E. Silver in Greenwich 2008–9, pp. 14–15 (fig. 2); Pierre Daix in London 2009, pp. 55 (fig. 23), 56–57; Woodward 2009, p. B15

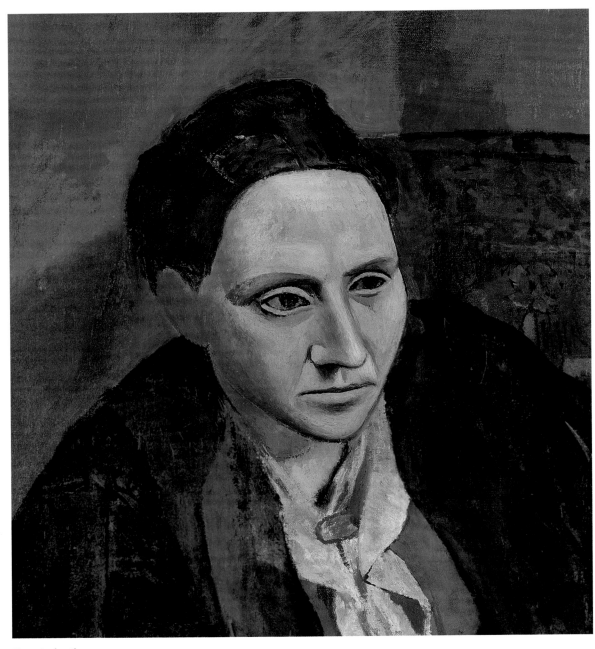

Cat. 38, detail

TECHNICAL NOTE

With the exception of the face and some smaller alterations, Picasso painted the initial portrait quickly and directly using a limited palette. X-radiography (fig. 38.5) and Neutron Activation Autoradiography make it possible to map the changes that Picasso made. (For an in-depth discussion of these techniques and the results, see Belloli 1999.) He executed three different positions (figs. 38.7–38.9) for the head before settling on the one we see now (fig. 38.10); the autoradiograph (fig. 38.6) conveys the style of these earlier versions. The final head and face (see detail above) differ from the others in terms of handling, use of distortion, and overall simplification. The secondary changes, all done late, serve to enhance the power of the final visage.

Picasso painted a vertical line in the center of the background to cover the previous positions of the face; this also had the effect of strengthening the diagonal positioning of the figure. Continuing with the same raw umber, he made a curve around the right side of the figure. He made these changes and added the final masklike face quickly, as indicated by the broad handling and the relatively few strokes.

When the portrait arrived in the Metropolitan Museum, in August 1947, it was in poor condition. Prior to shipment the work had been cut off its stretcher, leaving a very small tacking edge. At the last minute the work was reattached to a stretcher by means of a few nails through the reduced tacking edges. During shipment the stretcher came loose from the frame and the painting tore away from both sides of the stretcher. The right and left edges were wrinkled and crushed, with a loss of paint. After arrival the painting was wax lined, retouched, and varnished.

LB

Fig. 38.5.
X-radiograph
of cat. 38,
showing detail
of Gertrude
Stein's head

Fig. 38.6.
Autoradiograph
of cat. 38,
showing detail
of Gertrude
Stein's head

Fig. 38.7.
First position
of Gertrude
Stein's head

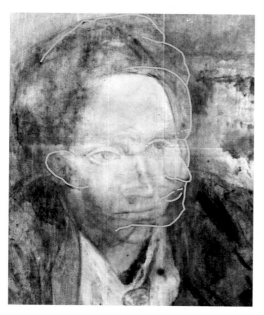

Fig. 38.8.
Second position
of Gertrude
Stein's head

Fig. 38.9.
Third position
of Gertrude
Stein's head

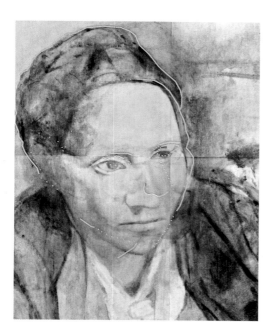

Fig. 38.10.
Fourth and
final position
of Gertrude
Stein's head

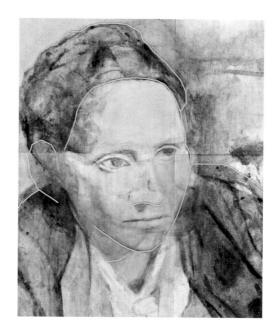

39. Self-Portrait

Paris, Autumn 1906

Oil on canvas mounted on honeycomb panel
10½ × 7¾ in. (26.7 × 19.7 cm)
Jacques and Natasha Gelman Collection, 1998
1999.363.59

Picasso looks much younger than his age in this small self-portrait, which he painted in Paris in the autumn of 1906; that October he turned twenty-five. He had recently returned to the city after spending an invigorating summer with his lover, Fernande Olivier, in Gósol, a small village in northern Catalonia. The trip, Picasso's first to his native country since 1904, was prompted in part when the dealer Ambroise Vollard bought twenty-seven paintings and gouaches from him in May for 2,000 francs. No doubt feeling rich with that amount of money in his pocket, Picasso was eager to travel.

The remote village of Gósol, which sits high up in the Pyrenees, close to the border with Andorra, had been recommended to Picasso by his friend Jacint Reventós, a doctor who sent his patients to convalescence there for the "good air, good water, good milk and good meat."[1] Although Gósol is only about eighty miles north of Barcelona, the final stop on what was then the newly opened Catalan Railways was still some eight miles from town. Covering the final distance—by mule, through mountain gorges and along vertiginous passes—was an arduous, eight-hour-long adventure. Even today Gósol remains relatively unspoiled and unfrequented, if more accessible since the construction of a road in 1942.[2]

As Fernande recalled, Picasso always felt rejuvenated by his visits to Spain: "The Picasso I saw in Spain was completely different from the Paris Picasso; he was gay, less wild, more brilliant and lively."[3] The artist's physical well-being was matched by inspired productivity. Indeed, his stay in Gósol has become synonymous with a decisive new direction in his style. He moved away from pink, the color dominant in his Rose Period, toward ocher and gray, and also to more simplified, stylized forms reflecting the growing influence of archaic Iberian and Catalan sculpture.[4] These changes first appear in works that Picasso created at the end of his stay in Gósol—in the studies for his portrait of Gósol's old innkeeper, Josep Fondevila (see cat. 35)—and then figure prominently in the paintings he completed upon his return to Paris, including the portrait of Gertrude Stein (cat. 38), whose features he endowed with a masklike immobility.

In this small self-portrait—which closely relates to several others, the most famous being the 1906 *Self-Portrait with Palette* (figs. 39.1, 39.2)—the artist's unfurrowed face resembles a painted terracotta sculpture. His cropped hair emphasizes the smooth ovoid of his head, which he had shaved in Gósol probably in a ritual that recalled his childhood summers in Spain, when it was done as protection against lice.[5] As in a child's face,

Fig. 39.1. Pablo Picasso, *Studies for Self-Portraits*, 1906. Graphite on paper, 12⅜ × 18¾ in. (31.5 × 47.5 cm). Musée National Picasso, Paris (MP524 recto)

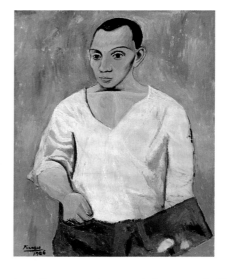

Fig. 39.2. Pablo Picasso, *Self-Portrait with Palette*, 1906. Oil on canvas, 36⅛ × 28⅞ in. (91.9 × 73.3 cm). Philadelphia Museum of Art, A. E. Gallatin Collection, 1950 (1950-1-1)

here Picasso accentuated the upper half of the visage, especially the eyes, and reduced the chin and mouth. The stenciled line of his right eyebrow extends into the outline of the much-enlarged nose. As for the huge "black" eye, we can only guess at its meaning. It might indeed denote the blank eye sockets often found in Iberian sculpture, but it could also be that Picasso merely wanted a large spot of black in the center of the composition.

Picasso made most of his painted self-portraits while young and handsome, and rarely after 1907. Interestingly, he never subjected his own features to the faceting of Analytic or Synthetic Cubism. He returned to draw his likeness—with Ingresque idealization—only in 1917.

S R

1. Richardson 1991–2007, vol. 1 (1991), p. 434.
2. Ibid., p. 436
3. Olivier 1964, pp. 93–95.
4. Picasso was very impressed by a group of ancient stone carvings (600–500 B.C.) excavated in Cerro de los Santos, near Seville, in 1902–4. The statues were acquired by the Louvre and put on display in the spring of 1906. During Picasso's stay in Gósol, he was just as moved by the twelfth-century Madonna and Child (the Santa Maria del Castell de Gósol), now removed to the Museu Nacional d'Art de Catalunya, Barcelona. See Richardson 1991–2007, vol. 1 (1991), pp. 451–52.
5. Varnedoe 1996, p. 132; see also cat. 35, p. 100, and p. 102, note 4.

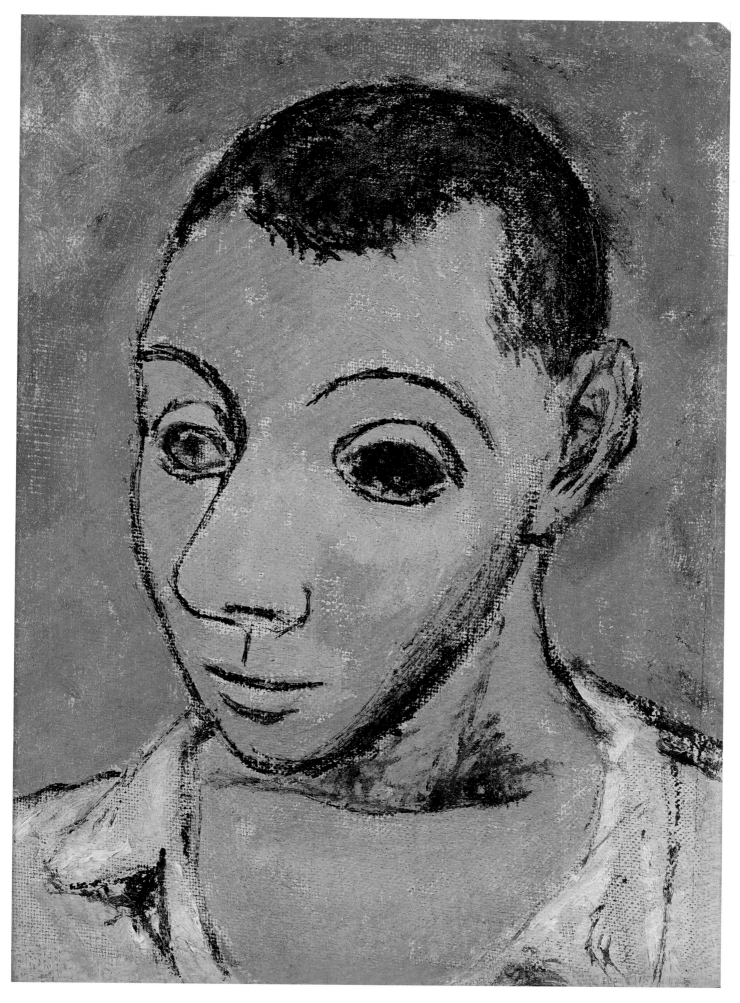

Fig. 39.3. Alice B. Toklas in the apartment at 5, rue Christine, Paris, ca. late 1940s. Behind her at left is Picasso's small *Self-Portrait* (cat. 39). Yale Collection of American Literature, Beinecke Rare Book and Manuscript Library, New Haven, Connecticut

REFERENCES

Zervos 1932–78, vol. 1 (1932), p. 177 (ill.), no. 371; Zennström 1948, ill. facing p. 64 (fig. 13); Elgar and Maillard 1955, pp. 36, 42, 47 (ill.); Sutton 1955, no. 52, ill.; Elgar and Maillard 1956, pp. 25, 51 (ill.); Buchheim 1959, pp. 43 (ill.), 135; Blunt and Pool 1962, p. 27; Daix and Boudaille 1967, p. 327 (ill.), no. XVI.27; Paris (Musée Picasso) 1988, vol. 2, pp. 496–97 (fig. 8); Lombard 1990, p. 4 (ill.); Warncke 1992, p. 145 (ill.); Dobrzynski 1998, pp. A1, B6 (ill.); Anne Baldassari in Paris 2007, p. 15 n. 26; Tinterow 2007, p. 45 (ill.); *Scholastic Art* 39, no. 5 (March 2009), cover ill.

TECHNICAL NOTE

Here Picasso painted *alla prima*—a technique in which paint is applied directly and summarily, in a single application—on a rectangular piece of commercially prepared white canvas. He began by indicating the features in pale gray paint followed by the flesh tones, background, and white shirt. He then quickly reinforced the original lines of the face in black, adding shading to the hair and outlining the shirt. He allowed the ground to show throughout, particularly around the drawn lines, imparting a halo of light to the portrait. X-radiography reveals that he initially painted both eyes in a realistic manner and only later blacked out the proper left one to create the more abstract, impersonal visage we see today.

The canvas is irregularly cut and devoid of tacking edges, suggesting that it was originally part of a larger canvas, perhaps one on which the artist sketched several self-portraits, much like the pencil sketches of self-portraits he made about this time.[1] Insofar as the painting was bought directly from Picasso by Gertrude Stein, it is possible that she may have noticed the canvas and wanted the most complete head. It is also possible that Picasso would not have hesitated to cut out the head and glue it to a ready support; in so doing, the shape became uneven. The work appears somewhat fragmentary in the 1966 catalogue raisonné by Pierre Daix and Georges Boudaille (DB XVI.27)[2] as well as in a photograph of Stein's apartment on rue de Fleurus.[3] It was subsequently mounted on to a honeycomb panel (and thus acquired a regular shape), retouched, and varnished, most likely in 1968, when it was sold from the Stein family collection. LB

1. See, for example, Z XXVI.6, 7; DB A.22; and fig. 39.1.
2. Daix and Boudaille 1967, p. 327.
3. Yale Collection of American Literature, Beinecke Rare Book and Manuscript Library, YCAL MSS 76, Box 156, Folder 3937, image ID 3737224.

PROVENANCE

Leo and Gertrude Stein, Paris (acquired from the artist, ca. 1906–13/14); Gertrude Stein, Paris (ca. 1913/14–d. 1946); her estate (1946–68; sold on December 14, 1968, to Meyer); André Meyer, New York (1968–80; his sale, "Highly Important Paintings, Drawings and Sculpture from The André Meyer Collection," Sotheby Parke-Bernet, New York, October 22, 1980, no. 33, to Sandra Canning Kasper, New York, as agent for Tescher); Lynn Epstein Tescher (Mrs. Martin Tescher), New York (1980–86; sold on May 7, 1986, through same agent, to Gelman); Jacques and Natasha Gelman, Mexico City and New York (1986); Natasha Gelman, Mexico City and New York (1986–d. 1998; her bequest to the Metropolitan Museum, 1998)

EXHIBITIONS

New York–Baltimore–San Francisco 1970–71, p. 168; Ottawa 1971, no. 8, ill.; New York–London 1989–90, pp. 5–7, 35, 98–99 (ill.), 309 (ill.); Martigny 1994, pp. 29, 31, 58, 122–23 (ill.), 331 (ill.); New York (MMA) 1997, hors cat.; New York 2000, pp. 65 (ill.), 125; New York 2001–2, no cat., checklist no. 40; Houston 2007, no. 126, pp. 168–69 (ill.), 245; Berlin 2007, pp. 250–51 (ill.)

40. Standing Nude

Paris, late 1907–early 1908

Watercolor and graphite on white laid paper watermarked INGRES 1871, with countermark of Canson Frères crest
24⅝ × 16⅝ in. (62.5 × 42.2 cm)
Signed in charcoal, lower right: <u>Picasso</u>
Anonymous Gift, in memory of Dr. Avrom Barnett, 1967
67.162

41. Standing Nude

Paris, late 1907–early 1908

Watercolor and charcoal on white laid paper watermarked INGRES 1871, with countermark of Canson Frères crest
24¼ × 18⅝ in. (61.6 × 47.3 cm)
Signed in graphite, lower right: <u>Picasso</u>
Jacques and Natasha Gelman Collection, 1998
1999.363.62

In the summer of 1907, shortly after completing his groundbreaking painting *Les Demoiselles d'Avignon* (fig. 40.1), Picasso showed it to his poet friends Guillaume Apollinaire, Max Jacob, and André Salmon. They met the picture's radically compressed space and distorted figures with embarrassed silence, surprise, even apprehension as they came to terms with the violent and aggressive break from nineteenth-century illusionism that the *Demoiselles* introduced.[1] Although Picasso allowed only a few intimates to see the painting, news of it spread nonetheless by word of mouth. Within two years the new style initiated in the *Demoiselles* evolved into Cubism, which would eventually alter the course of twentieth-century art, design, and architecture. The *Demoiselles*, however, languished in Picasso's studio and was exhibited for the first time only in 1916. In 1924 the French couturier Jacques Doucet acquired it on the advice of the poets Louis Aragon and André Breton.[2] Doucet placed the large canvas in the stairwell of his house in Paris since it was considered too indecent to hang in the salon.[3]

Fig. 40.1. Pablo Picasso, *Les Demoiselles d'Avignon*, 1907. Oil on canvas, 96 × 92 in. (243.9 × 233.7 cm). The Museum of Modern Art, New York, Acquired through the Lillie P. Bliss Bequest (333.1939)

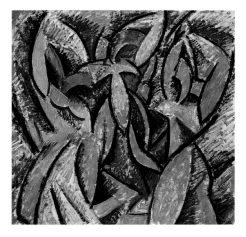

Fig. 40.2. Pablo Picasso, *Three Women (Rhythmic Version)*, 1908. Oil on canvas, 35⅞ × 35⅞ in. (91 × 91 cm). Sprengel Museum Hannover, Germany

These two watercolors belong to a group of seven sketches of single figures[4] that represent ideas Picasso had explored earlier for the *Demoiselles*, did not use, but then took up in late 1907 or early 1908 in his large painting *Three Women* (fig. 43.1), which he made as "a sequel and corrective" to the *Demoiselles*.[5] With striding gaits and oddly peaked left arms, the nudes are composed of elliptical shapes that overlap with the crescent-shaped planes of the surrounding space. In both works, figure and ground merge completely, a phenomenon initiated in the *Demoiselles*. (Oddly, the contrasting blue and burnt sienna, and the linear accents that occur at intervals across the images, harken back, one could argue, to the rhythmic patterns characteristic of the Art Nouveau style, which dates to the 1890s.) A similar, more simplified nude figure appears at the center of the early 1908 canvas *Three Women (Rhythmic Version)* (fig. 40.2). Together, all of these paintings and sketches are part of a larger group of monumental bathers—either single figures, as seen here, or clusters of three or five[6]—that culminated in *Three Women*, which Picasso eventually recast in a more muscular, geometric style using faceted Cubist planes.[7] SR

1. Richardson 1991–2007, vol. 2 (1996), p. 17.
2. Penrose 1973, p. 139.
3. It was probably also too big for the salon. For a photograph of the painting in the stairwell, see Rubin 1994, p. 183.
4. DR 110–116.
5. Pepe Karmel, email to the author, February 13, 2009. Karmel states that "Picasso began making studies for *Three Women* not long after concluding work on the *Demoiselles*, that is, in late 1907 or early 1908," and that "work on the actual canvas was completed in spring 1908." See also Karmel 2003, pp. 34–36; Pierre Daix (DR 131) dates *Three Women* as "spring–autumn (?) 1908." See p. 124, note 1.
6. DR 117–130.
7. See Richardson 1991–2007, vol. 2 (1996), p. 57, and Karmel 2003, p. 60.

STANDING NUDE
67.162

PROVENANCE
[Galerie Percier (André Level), Paris, by 1942]; Dr. Avrom Barnett, New York (by the late 1950s; his family's gift to the Metropolitan Museum, 1967)

EXHIBITIONS
Los Angeles–New York 1970–71, no. 264, pp. 33 (pl. 12), 305; Paris 1973–74, no. 70, pp. 56 (ill.), 159 (pl. 89); London 1983, no. 156, pp. 320–21 (ill.); New York (MMA) 1985, no cat.; Canberra–Brisbane 1986, pp. 16–17 (ill.); on view at MMA, September 4, 1990–January 8, 1991, no cat.; New York 1995, unpaginated; New York (MMA) 1997, hors cat.; Paris 1998–99, fig. 35; Balingen 2000, hors cat.

REFERENCES
Zervos 1932–78, vol. 2a (1942), p. 49 (ill.), no. 101; Bean and McKendry 1968, p. 305 (ill.); Anon., October 1971, pp. 625, 626 (fig. 70); Daix and Rosselet 1979, p. 212 (ill.), no. 114; Ulrich Weisner in Bielefeld 1979, p. 266, pl. 21

TECHNICAL NOTE

This watercolor was built in discrete layers, indicating that Picasso allowed one layer to dry before applying the next. There is almost no blending of colors except in the lower-right corner, where the underlayer was still wet when the artist applied more color. The pencil underdrawing remains visible throughout as part of the final design. RM

STANDING NUDE
1999.363.62

PROVENANCE
[Galerie Kahnweiler, Paris, by 1914; acquired from the artist, stock no. 1106, photo no. 200]; [Galerie Percier (Alfred Richet), Paris, by 1942, until at least 1953]; private collection, Paris (by 1979); [Apollo Arts, Ltd. (Karel Zoller, Kurt Kimmel, and Eugene V. Thaw), Zürich, 1979–80; sold by E. V. Thaw on October 15, 1980, for $500,000 to Gelman]; Jacques and Natasha Gelman, Mexico City and New York (1980–his d. 1986); Natasha Gelman, Mexico City and New York (1986–d. 1998; her bequest to the Metropolitan Museum, 1998)

EXHIBITIONS
Paris 1953, no. 14; Lyons 1953, no. 17; Milan 1953, no. 14, ill.; New York–London 1989–90, pp. 102–3 (ill.), 310 (ill.); Martigny 1994, pp. 31 (ill.), 126–28 (ill. p. 127), 332 (ill.)

REFERENCES
Zervos 1932–78, vol. 2a (1942), p. 49 (ill.), no. 102; Russoli 1953, pl. 14; Russoli and Minervino 1972, pp. 96 (ill.)–97, no. 187; Daix and Rosselet 1979 (both eds.), p. 212 (ill.), no. 115

TECHNICAL NOTE

Picasso applied watercolor over charcoal using a wet-in-wet technique, in which watercolor was laid over still-wet watercolor. This allowed him to work the watercolor on the surface of the paper, altering its thickness and texture. However, in this piece, Picasso did not mix colors but generally confined his paint within each color block. The jagged, definitive brushstrokes are part of the patterning of the design. Typical of many of Picasso's works on paper, he further enhanced the texture of the surface by rubbing and scratching the paper. There are four holes (approximately ¼ in. [0.5 cm] in diameter) near the corners that have been filled and inpainted.
 RM

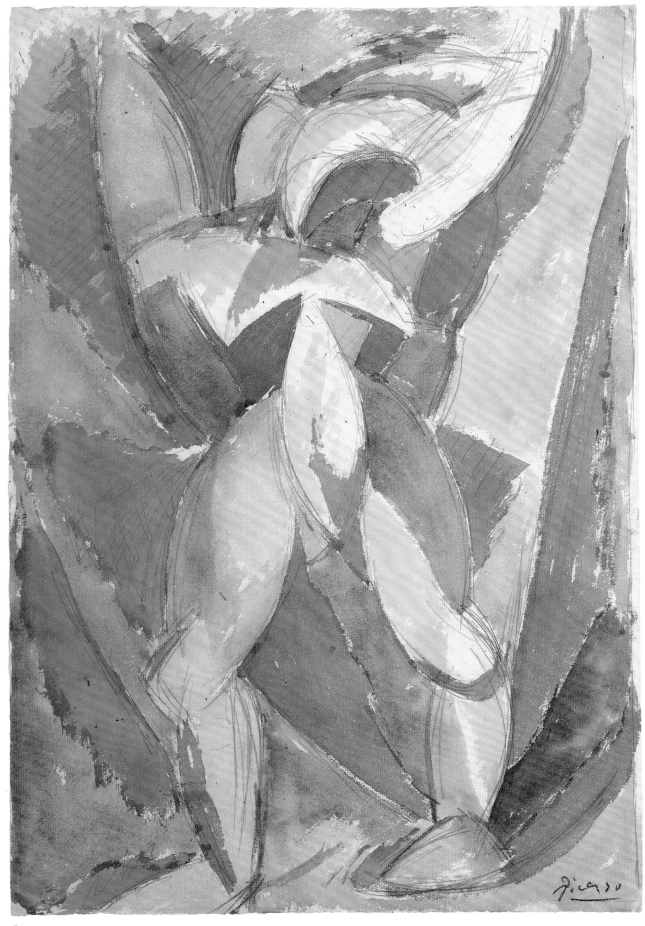

Cat. 40

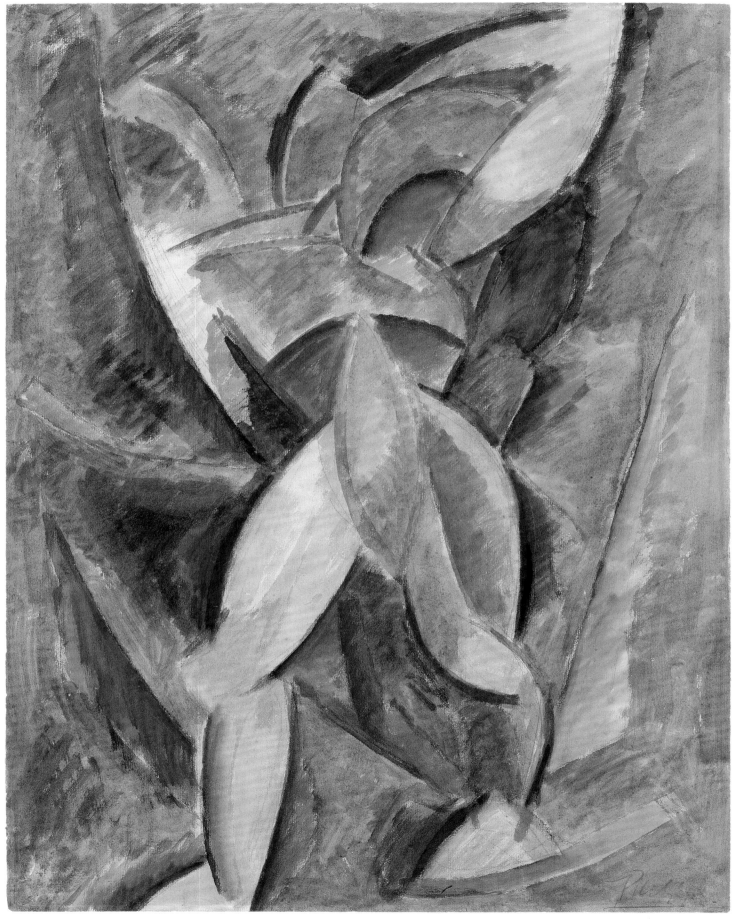

Cat. 41

42. Seated Nude

Paris, Spring 1908

Charcoal and graphite on white laid paper watermarked INGRES 1871, with countermark of Canson Frères crest, mounted to paperboard
24⅞ × 18⅞ in. (63.2 × 47.9 cm)
Signed, lower right: Picasso
Bequest of Scofield Thayer, 1982
1984.433.278

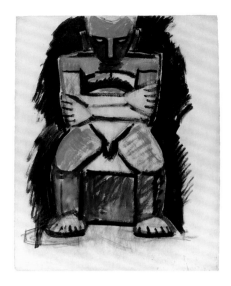

Fig. 42.1. Pablo Picasso, *Seated Man*, 1908. Gouache, charcoal, and India ink on paper, 24¾ × 18⅞ in. (62.8 × 48 cm). Musée National Picasso, Paris (MP572)

Using thick, forceful charcoal and graphite lines, Picasso emphasized the aggressive, self-contained strength of this creature—really more automaton than human—who embodies coiled energy at rest. Although he abstracted and stylized the head, limbs, hands, and chest, Picasso endowed the figure with pubic hair and a penis. The figure's thick spherical head, with its batlike ears and pointed chin, rests on his torso. The convex forehead and the tapered, concave lower face evoke the African Fang masks Picasso had seen during repeated visits to the Musée d'Ethnographie du Trocadéro in Paris in the spring of 1908.[1]

This nearly symmetrical drawing, done in stark close-up, is the most realized of seven related to the gouaches *Seated Man* and *Three Men* (figs. 42.1, 42.2).[2] The latter has been described as a study for a planned painting of a group of three male figures along the lines of *Three Women* (see fig. 43.1).[3] Picasso never followed through on the idea, probably as a result of his near total concentration on *Three Women*; perhaps he also lost interest in a composition in which a rigidly self-contained male figure dominates the center, and where the two others—barely visible at the gouache's bottom and top right edges—are virtually excluded. Although Picasso abandoned this planned pendant to *Three Women*, he did not discard the features of his idea for the center figure: the subject of *Woman with a Fan* (The State Hermitage Museum, Saint Petersburg), done in the summer of 1908, has an inclined, stylized head very similar to the one in this drawing.

<div align="right">SR</div>

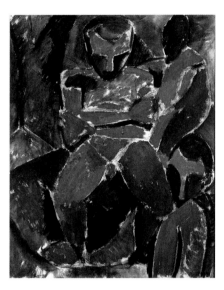

Fig. 42.2. Pablo Picasso, *Three Men*, 1908. Gouache on paper, 25 × 18⅞ in. (63.5 × 48 cm). Philadelphia Museum of Art, Louise and Walter C. Arensberg Collection (50-134-165)

1. Rubin 1984, p. 290.
2. Five of these are illustrated in Léal 1996, vol. 1, "Les Carnets cubistes," 56 R° (z 11b.704); 58 R° (z 11b.703); 59 R°, ill. p. 211; 73 R°, 74 R°, 75 R° (z 11b.705), ill. p. 213; the sixth is z XXVI.302.
3. Daix and Rosselet 1979, p. 218, no. 14.

REFERENCES
Zervos 1932–78, vol. 2b (1942), p. 310 (ill.), no. 706; Boeck and Sabartés 1955, pp. 482 (ill.), 489 (no. 96), no. 250; Daix and Rosselet 1979 (both eds.), p. 218; Julia May Boddewyn in New York–San Francisco–Minneapolis 2006–7, p. 340

PROVENANCE
[Probably Galerie Alfred Flechtheim, Düsseldorf and Berlin, until ca. 1921; sold to Thayer]; Scofield Thayer, Vienna and New York (ca. 1921–d. 1982; on extended loan to the Worcester Art Museum, Massachusetts, 1934–82, inv. 34.73; his bequest to the Metropolitan Museum, 1982)

EXHIBITIONS
Hartford 1934, no. 97; Worcester 1941, no. 47; Princeton 1949, no. 15, ill.; Worcester 1959, no. 192, p. 99; Worcester 1965, no cat., checklist; Worcester 1977, no cat.; Worcester 1981, no. 118; New York 1990–91, no cat.; on view at MMA, May 21–September 30, 1991, no cat.; New York 1993, no cat.; on view at MMA, November 1994, no cat.; Paris 1998–99, fig. 18; New York 2000, pp. 66 (ill.), 125

TECHNICAL NOTE

Using diverse techniques of applying the charcoal and graphite, Picasso expanded the array of textures and colors possible with these drawing materials, often considered monochromatic. He applied a diffuse layer of charcoal and rubbed it into the paper to tone much of the sheet. He then used thinly applied charcoal to shape the figure and to define major elements such as the hands. This slightly harder, browner charcoal has scored the paper in some areas, including the fingers on the sitter's right hand. Picasso used a soft black charcoal stick on its side to apply the wide shading lines across the torso of the figure. To create strong details, and to intensify the shading around the figure, he drew dark black lines with a pointed piece of black charcoal.

In selected areas Picasso worked graphite over the charcoal, simultaneously softening the color of the deep black charcoal with a silvery gray tone and strengthening these areas through the crisp, hard lines that a pencil produces. This use of two tones of a similar color is seen in many of Picasso's drawings.

<div align="right">RM</div>

43. Kneeling Nude

Paris, late 1907–Spring 1908

Charcoal on white laid paper watermarked INGRES 1871, with countermark of Canson Frères crest
25 × 19 in. (63.5 × 48.3 cm)
Signed in brown ink, lower right: <u>Picasso</u>
Jacques and Natasha Gelman Collection, 1998
1999.363.61

Fig. 43.1. Pablo Picasso, *Three Women*, 1907–8. Oil on canvas, 78¾ × 70⅛ in. (200 × 178 cm). The State Hermitage Museum, Saint Petersburg

This drawing of a muscular, kneeling nude woman is a study for a figure in the large painting *Three Women* (fig. 43.1).[1] Picasso initially conceived *Three Women* in 1907 as a flat, decorative composition, but he was displeased with the result.[2] Finding the washlike planes of color inadequate to the painting's scale, he decided to enliven them with brighter colors and hatching, similar to the style he had used in some of the "African" postscripts to *Les Demoiselles d'Avignon* (fig. 40.1).[3] We know about this early version solely through a faded photograph showing the poet André Salmon posed in front of it.[4] Picasso then painted over the composition in a series of advancing and receding planes (or facets) defined by sharp linear edges and powerful shading. The early Cubist style of the final version completed in 1908 evokes a bas-relief carved into rock or wood, with the planes of deep rust, green, and gray imperceptibly linked to one another in what is referred to as a Cubist "passage"; gone are the contrasts of color and striations that an experienced eye can discern in the painting in the photograph.

Because Picasso made these changes to *Three Women* directly on the canvas, there are no studies for the overall composition of the new version. There are, however, studies for the individual figures, including this intermediate one for the revision of the woman on the left. In near textbook fashion, the drawing demonstrates the geometrification of forms leading to early Cubism. The lower part of the body, with its antediluvian limbs, has been only roughly sketched in, but the upper body—where Picasso has "broken up" the torso, the raised arm, and the head into various sections—is more fully developed. The arm, especially, looks as if it were carved out of wood, with the slightly shaded planes evoking volume. The same kneeling figure also appears in the center of *Study for "Bathers in the Forest"* (fig. 43.2).

S R

Fig. 43.2. Pablo Picasso, *Study for "Bathers in the Forest,"* 1908. Graphite on paper, 12⅝ × 17⅛ in. (32 × 43.5 cm). Musée National Picasso, Paris (MP603)

PROVENANCE
[Yvonne Zervos, Paris, by 1942]; [Galerie Berggruen & Cie, Paris]; [Curt Valentin, New York]; Nelson A. Rockefeller, New York (by 1957–78; sold on January 8, 1978, for $90,000 through Harold Diamond, New York, to Gelmans); Jacques and Natasha Gelman, Mexico City and New York (1978–his d. 1986); Natasha Gelman, Mexico City and New York (1986–d. 1998; her bequest to the Metropolitan Museum, 1998)

EXHIBITIONS
New York–Chicago 1957, p. 36 (ill.); Philadelphia 1958, no. 47, p. 16, ill.; New York 1969, p. 134; New York 1980, p. 114 (ill.); New York 1989–90, p. 86 (ill.); New York–London 1989–90, pp. 104–7 (ill. p. 105), 310 (ill.); Martigny 1994, pp. 31 (ill.), 128–31 (ill. p. 129), 332 (ill.)

REFERENCES
Zervos 1932–78, vol. 2b (1942), p. 311 (ill.), no. 707; Leymarie 1967, pp. 32 (ill.), 103 (Eng. ed.: pp. 34 [ill.], 105); Russoli and Minervino 1972, pp. 96 (ill.), 97, no. 189; Daval 1973, p. 202 (ill.); Steinberg 1978, pp. 120, 122 (ill.); Bielefeld 1979, p. 266, pl. 26; S. Mayer 1980, p. 242, fig. 29; Leo Steinberg in Combalía Dexeus 1981, p. 59, fig. 23; Kodansha 1981, p. 107 (ill.); Lieberman 1981, pp. 8, 73 (ill.); Daix 1982b, pp. 44 (ill.), 169; Steinberg 1988, pp. 140 (fig. 18), 221; Podoksik 1989, p. 168 (fig. 289); Karmel 1992, p. 323; Warncke 1992, vol. 1, p. 160 (ill.); Karmel 1993, vol. 1, p. 31, vol. 3, pp. 367–68, vol. 4, fig. 9; Warncke 1993, vol. 1, p. 160 (ill.); Tuma 2003, pp. 148, 150 (fig. 12); Julia May Boddewyn in New York–San Francisco–Minneapolis 2006–7, p. 375; Steinberg 2007, p. 79 (fig. 9)

1. Scholars disagree on the dating of *Three Women*. In 1942 Christian Zervos dated it winter 1908 in his catalogue raisonné (II.108). Pierre Daix dated it spring–autumn (?) 1908 (in Daix and Rosselet 1979, no. 131). William Rubin (in New York 1980, ill. p. 115), gave the summer of 1908 as the date Picasso started it and November 1908–January 1909 as the period when he reworked it; nine years later, however, Rubin changed the date to autumn 1907–late 1908 (in New York 1989–90, ill. p. 11). Josep Palau i Fabre (1990, no. 275, ill. p. 102) dated it as spring–autumn 1908. The date proposed and cogently argued by Pepe Karmel (2003, pp. 34–36, 60, fig. 27), late 1907–spring 1908, seems most persuasive to this author and is therefore the one cited here.
2. Karmel 2003, pp. 34–36, fig. 26.
3. Pepe Karmel, email to the author, March 26, 2009.
4. See an illustration in New York 1980, p. 89.

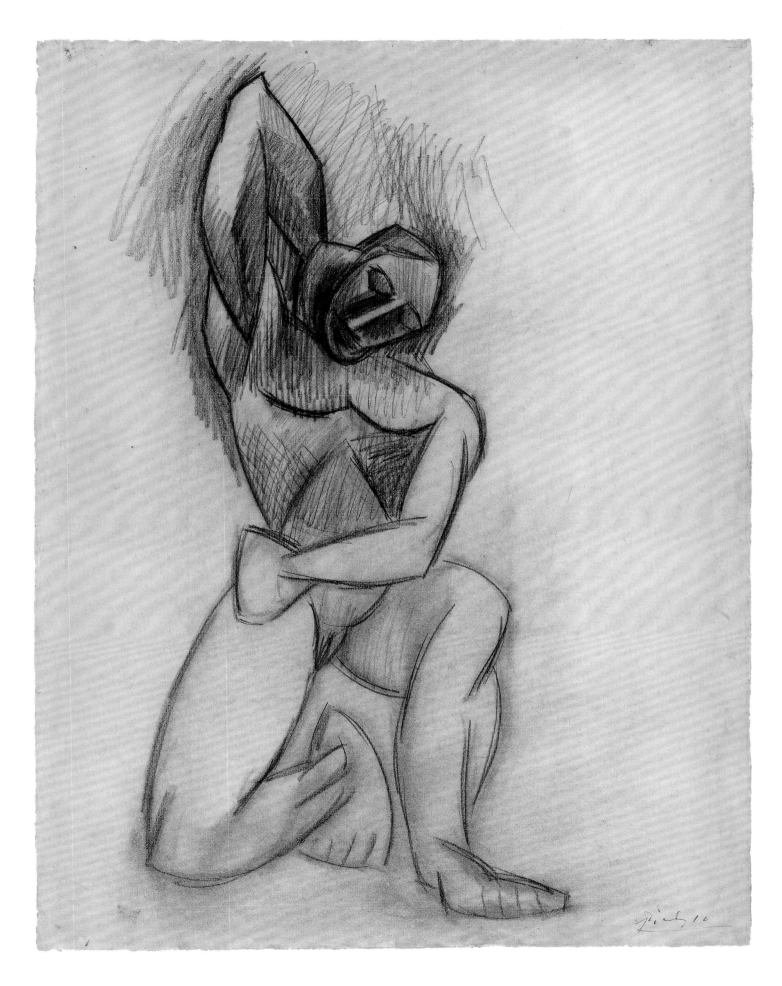

Picasso began by making a light charcoal sketch outlining the forms. He then articulated the figure with strong dark lines of charcoal, combining these with soft lines and stumping, a technique in which the artist uses a tool, such as a stump or *torchon* (a rolled paper or leather stick), or more likely his fingers, to rub the charcoal into the paper, creating diffuse areas of color. In some areas, such as above the figure's head, there is a series of loops where Picasso used a hard or gritty charcoal, which simultaneously deposited and scraped away media, forming a series of white linear scratches haloed by charcoal. RM

44. Head of a Woman
Paris, Spring 1908

Watercolor on white laid Canson and Montgolfier paper watermarked
INGRES 1871
12½ × 9½ in. (31.8 × 24.1 cm)
Signed in graphite on verso, lower left: Picasso
Jacques and Natasha Gelman Collection, 1998
1999.363.60

Fig. 44.1. Pablo Picasso, *The Dryad (Nude in the Forest)*, 1908. Oil on canvas, 72⅞ × 42½ in. (185 × 108 cm). The State Hermitage Museum, Saint Petersburg (GE-7704)

Picasso made innumerable preparatory studies for his groundbreaking painting *Les Demoiselles d'Avignon* of 1907 (see fig. 40.1), but he made just as many related drawings, sketches, and paintings *after* he was done with it. At the time he was working on the *Demoiselles*, Picasso was a frequent visitor to the Musée d'Ethnographie du Trocadéro (later the Musée de l'Homme and now part of the Musée du Quai Branly, Paris), returning either alone or in the company of his poet friends Guillaume Apollinaire, Max Jacob, and André Salmon.[1] Although he had painted the *Demoiselles* under the influence of Iberian art, the tribal art and the generalized memory of the objects he had seen in the Musée d'Ethnographie made such an impression on him that he repainted two of the five "demoiselles" that summer. He changed the faces of the two women on the right and gave them strange, monstrous heads, freely adapting the style of the African and Oceanic art he had seen. These influences are apparent in numerous subsequent head and figure studies, including this small watercolor made the following spring.

Head of a Woman belongs to a group of four studies of inclined heads related to the masklike faces of *Three Women* (see fig. 43.1) and, more directly, to the single figure in *The Dryad (Nude in the Forest)* (fig. 44.1).[2] Each depicts an elongated, oval face with slits for eyes and a long, wedgelike nose with a wide lower rim. The gently inclined head in this study, with its ocher flesh and blue and green shadows, is the most graceful of the four, particularly compared to the somewhat athletic wood nymph lumbering through the forest in *The Dryad*. SR

1. Richardson 1991–2007, vol. 2 (1996), p. 27. The precise date of Picasso's introduction to African and Oceanic art has become a hotly debated topic for art historians. Although most scholars have accepted Picasso's statement that he became interested in tribal art in May or June 1907, John Richardson now believes it was early March of that year (ibid., p. 25).
2. DR 137–140. Pierre Daix (in Daix and Rosselet 1979, no. 133) dates *The Dryad* to summer–autumn (?) 1908, while Pepe Karmel (email to the author, February 13, 2009) believes spring–summer 1908 is the latest plausible date and prefers to date it spring 1908.

PROVENANCE
[André Level, Paris, until 1927; his sale, "Tableaux modernes formant la collection de Mr. L(evel)]," Hôtel Drouot, Paris, March 3, 1927, no. 63, for 3,900 francs to Loeb]; [Albert Loeb, Paris, from 1927]; Helena Rubinstein, Paris and New York (by 1940–66; her sale, "Modern Drawings and Prints: The Helena Rubinstein Collection," Parke-Bernet Galleries, New York, April 28, 1966, no. 810, for $13,500 to Thaw]; [E. V. Thaw & Co., Inc., New York (1966–67; sold on October 31, 1967, for $20,000 to Gelman]; Jacques and Natasha Gelman, Mexico City and New York (1967–his d. 1986); Natasha Gelman, Mexico City and New York (1986–d. 1998; her bequest to the Metropolitan Museum, 1998)

EXHIBITIONS
Washington 1940, no. 6; New York–London 1989–90, pp. 100–101 (ill.), 310 (ill.); Los Angeles–New York–Chicago 1994–95 (shown in New York only), hors cat.; Martigny 1994, pp. 31 (ill.), 124–25 (ill), 332 (ill.)

REFERENCES
Level 1928, pp. 30 (ill.), 54 (no. 14); Zervos 1932–78, vol. 2b (1942), p. 303 (ill.), no. 682; Russoli and Minervino 1972, p. 90 (ill.), no. 52; Daix and Rosselet 1979 (both eds.), pp. 8 (ill.), 216 (ill.), no. 137; Palau i Fabre 1990, pp. 103 (ill.), 498, no. 278; Julia May Boddewyn in New York–San Francisco–Minneapolis 2006–7, p. 354

TECHNICAL NOTE
Picasso relied on a combination of watercolor techniques to shade and define the form. In the neck, he used a technique called "wet-in-wet," in which additional layers of watercolor are applied to still-wet underlayers. This causes the colors to blur and blend, as seen on the proper left side of the face. In "wet-in-dry," the previously applied layer is allowed to dry before subsequent layers are added; evidence of this can be seen in the areas of blue, where Picasso used the technique to allow for strongly defined brushstrokes. He made the green shadow with a much thicker application of media and with highly visible brushstrokes. There is also some puddling of media in this area and a roughening of the paper, characteristic of many of Picasso's drawings in wet media, indicating that he worked the paint in situ on the paper surface. RM

45. The Farmer's Wife
La Rue-des-Bois, August 1908

Charcoal on white laid paper watermarked INGRES 1871, with counter-mark of Canson Frères crest
24¾ × 19 in. (62.9 × 48.3 cm)
Purchase, Gift of Mr. and Mrs. Nate B. Spingold and Joseph Pulitzer Bequest, by exchange, and Van Day Truex Fund, 1984
1984.5.1

Fig. 45.1. Pablo Picasso, *Sketches for "The Farmer's Wife,"* 1908. Black crayon on paper, 19 × 24¾ in. (48.2 × 62.8 cm). Musée National Picasso, Paris (MP606r)

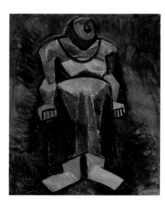

Fig. 45.2. Pablo Picasso, *The Farmer's Wife,* 1908. Oil on canvas, 32⅛ × 25¾ in. (81.5 × 65.5 cm). The State Hermitage Museum, Saint Petersburg (GE-9161)

The model for *The Farmer's Wife* was fifty-eight-year-old Madame Putman (1850–1939), a widow who weighed nearly three hundred pounds and was more than six feet tall. She was Picasso's landlady in La Rue-des-Bois, the backwater village some forty miles north of Paris where he vacationed from early August to early September 1908 with Fernande Olivier.[1] After the death of her husband, Joseph, this powerful woman and mother of seven took over the farm, working the fields, caring for the animals, and also renting rooms. Fernande described the Putman farm in a letter to Guillaume Apollinaire: "We are surrounded by the woods, in a hamlet of 10 houses, so it's real countryside. The [river] Oise runs 10 minutes away from where we are, and as far as we are concerned, Pablo and I, we're very happy here."[2] The village, which is situated along either side of a country road, has no shops or cafés. According to John Richardson, "you can drive through it without realizing you have done so."[3]

Picasso's doctor probably recommended this remote, verdant spot to the artist, who needed to restore his nerves after a particularly intense period of work. He had spent the previous year creating powerful, larger-than-life women in canvases such as *Les Demoiselles d'Avignon* (see fig. 40.1) and *Three Women* (see fig. 43.1). In coming across Madame Putman, a veritable giantess, he must have been delighted to meet such a monumental creature in the flesh, one who seemed "the living embodiment of the primitivism he cherished."[4] The busy Madame Putman had no time to pose, however, and so Picasso observed her while she went about doing her many heavy chores.

This drawing is one of a group of seven (fig. 45.1) that Picasso made in preparation for two paintings of this peasant woman, *The Farmer's Wife (Head and Shoulders)* (August 1908, The State Hermitage Museum, Saint Petersburg) and the full-length *The Farmer's Wife* (fig. 45.2). In terms of the symmetry and stylization of her body, which appears hewn from wood blocks, the drawing is related to the *Seated Nude* from the spring of 1908 (cat. 42). Here, however, instead of Iberian, tribal, or Romanesque art, John Richardson sees the influence of folk art and, more specifically, those "chunky little wood carvings of peasant types" one still finds in tourist shops in Europe.[5] We know that Picasso took only medium-size canvases to La Rue-des-Bois, which explains why the full-length picture of this imposing woman does not match her actual physical height. SR

1. The information on Madame Putman and Picasso's stay in La Rue-des-Bois is from Richardson 1991–2007, vol. 2 (1996), pp. 93–94.
2. Letter from La Rue-des-Bois to Guillaume Apollinaire, August 21, 1908, cited in Olivier 2001a, p. 218.
3. Richardson 1991–2007, vol. 2 (1996), p. 93.
4. Ibid., p. 94.
5. Ibid.

PROVENANCE
The artist, Paris and elsewhere (1908–d. 1973); his estate (1973–78, Succession Picasso inv. 00993); his granddaughter Marina Picasso (1978–84; consigned to Jan Krugier, Geneva, from 1980, and through Krugier to Paul Rosenberg & Co., New York, from 1983–84; sold by the latter in January 1984 for $165,000 to the Metropolitan Museum

EXHIBITIONS
Venice 1981, no. 74, pp. 206–7 (ill.); Munich and other cities 1981–82, no. 61, ill.; Tokyo–Kyoto 1983, no. 45, p. 199 (ill.); New York 1983, no. 9, pp. 24–25 (ill.); Melbourne–Sydney 1984, no. 37, pp. 47 (ill.), 217; New York (MMA) 1997, hors cat.; Paris 1998–99, fig. 20

REFERENCES
Zervos 1932–78, vol. 6 (1954), p. 121 (ill.), no. 1004; Russell 1983, p. C20; Lieberman 1984, p. 106 (ill.); Podoksik 1989, p. 173; Cordova 1998, pp. xiii (fig. 2.3), 145–46, 148, 163–65, 169, 412 (fig. 2.3)

TECHNICAL NOTE
This drawing shows many of the typical attributes of charcoal: a range of tones, from pale gray to dense black; a variety of line widths; and the ability to convey the energy of the application. Here we know that Picasso used considerable force because the pressure and the particulate matter in the charcoal have left numerous scratches and indentations in the good-quality artists' paper. This disruption of the paper support by the act of drawing itself can be seen in many of Picasso's drawings. RM

46. Bust of a Man

Paris, Autumn 1908

Oil on canvas
24½ × 17⅛ in. (62.2 × 43.5 cm)
Signed, upper left: <u>Picasso</u>
Bequest of Florene M. Schoenborn, 1995
1996.403.5

Picasso rarely dated his pictures before 1914, and he did so only intermittently thereafter, providing a challenge to scholars seeking to date his proto-Cubist works. This undated painting offers a perfect example of the methods and reasoning involved in this sometimes esoteric pursuit.[1] Pierre Daix dates *Bust of a Man* to the spring of 1908, seeing "in the geometric treatment of the hair, hollow eyes, drawing of nose and mouth" specific characteristics that, he believes, link it to four other heads from early 1908.[2] Daniel-Henry Kahnweiler and Alfred H. Barr, Jr., both dated it to the summer of 1908,[3] while Christian Zervos and William S. Rubin preferred the autumn of that year.[4] Picasso had spent August and early September 1908 in a tiny village north of Paris called La Rue-des-Bois. According to Rubin, the influences of Iberian and African art—which had been so prevalent in Picasso's recent works—were dormant during his stay in La Rue-des-Bois but reemerged once he returned to Paris in the autumn. That reemergence is clearly evident here, especially in the unusual deep orange and rust colors that predominate and in the figure, whose eyes and mouth the artist rendered as large black lozenges rimmed by bright orange. Unlike the African masks on which it is based, however, the bust has a haunting, almost expressionistic tension.

A recent X-radiograph of *Bust of a Man* (fig. 46.2) offers several interesting and novel clues to its evolution, namely, that it was painted on top of earlier pictures. The first shows a ghostly, alien creature, perhaps an underlying portrait. The sitter sports a collared shirt with a Peter Pan collar, closed with one tiny button, and over it what appears to be a jacket with wide lapels. Picasso paid similar attention to collars of shirts or lapels of jackets in the portrait of his friend the poet Max Jacob, of winter 1907 (fig. 46.1), and in his Cubist self-portrait of summer 1907 (z ii.8). These details might help to date the figure beneath *Bust of a Man* to 1907 because the portraits Picasso painted after that time generally do not feature such sartorial touches.[5]

Picasso abandoned the earlier portrait and seems to have painted a study related to the 1907–8 *Two Women* (DR 100). He then painted a still life over that: the large, ovoid forms of that composition can be made out at upper right, upper left, and, more faintly, at bottom center. This relates to a series of stark, austere still lifes he painted during the summer of 1908. Picasso appears to have grown discontented with it, because sometime after the summer he painted over it with the present composition. The date proposed by Zervos and Rubin, autumn 1908, thus seems most credible. S R

1. The painting was also unsigned until 1921, when Picasso signed it at the request of Henri-Pierre Roché; see provenance.
2. Daix and Rosselet 1979, p. 217, no. 143.
3. See Kahnweiler as cited in Daix and Rosselet 1979, p. 217; Barr in New York and other cities 1939–41, p. 65, ill.; and Barr 1946, ill. p. 43.
4. z iia.76; Rubin 1972, p. 52. ill. p. 53.
5. Glimpses of collars and similar details appear again in the later Cubist portraits of Wilhelm Uhde and Daniel-Henry Kahnweiler.

PROVENANCE
Leo and Gertrude Stein, Paris (ca. 1908–13/14; acquired from the artist); [Galerie Kahnweiler, Paris, by 1914, stock no. 1888; sequestered Kahnweiler stock, Paris, 1914–21; sale, "Vente de biens allemands ayant fait l'objet d'une mesure de Séquestre de Guerre: Collection Henry Kahnweiller [*sic*], Tableaux Modernes, deuxième vente," Hôtel Drouot, Paris, November 17–18, 1921, no. 197, for 1,800 francs, through Léonce Rosenberg, to Roché]; Henri-Pierre Roché, Paris (1921–26; consigned to Galerie Vavin-Raspail, Paris, November 14, 1925; sold January 4, 1926, for 17,500 francs, probably to Loeb); [Galerie Pierre (Pierre Loeb), Paris, probably by 1926, until at least 1932]; Walter P. Chrysler, Jr., New York and Warrenton, Virginia (by 1936, until at least 1942); [Gimpel Fils, London, by 1954, until 1955; sold on January 24 for $22,800 to Marx]; Samuel and Florene Marx, Chicago (1955–his d. 1964); Florene May Marx, later Mrs. Wolfgang Schoenborn, New York (1964–d. 1995; on extended loan to The Museum of Modern Art, New York, from 1971; on extended loan to the Metropolitan Museum from 1985; her bequest to the Metropolitan Museum, 1995)

EXHIBITIONS
Paris 1932, no. 44, p. 22; Zürich 1932, no. 37, p. 3; on view at Palais des Beaux-Arts, Brussels, [1932], no cat.; New York 1932, no cat.; Barcelona–Bilbao–Madrid 1936, no. 2, ill.; New York (Valentine) 1936, no. 29; Chicago (Chrysler) 1937, no. 36; Detroit 1937, no. 2, pp. 2, 4 (ill.); New York (Seligmann) 1937, no. 6, p. 7, ill.; Boston 1938, no. 8; New York (Harriman) 1939, no. 3; Boston 1939, no. 42, p. 52 (ill.); New York (Wildenstein) 1939, no. 31, pp. 46 (ill.), 47; New York and other cities 1939–41 (shown only in New York, Chicago, Saint Louis, and Boston), no. 78, p. 65 (ill.); Richmond–Philadelphia 1941, no. 158, pp. 88–89, ill.; London 1954, no. 26, ill.; New York (MoMA) 1955, no. 112, p. 17 (ill.); New York and other cities 1965–66, p. 17 (ill.); New York 1972, pp. 6, 52–53 (ill.), 201; New York 1980, hors cat., suppl. (brochure) no. 5 (ill.); on view at MMA, November 20, 1991–August 10, 1992, no cat.; New York (MMA/Schoenborn) 1997, brochure no. 14, ill.; Paris 1998–99, pl. 17; New York 2000, pp. 66 (ill.), 125; Madrid 2008–9, hors cat.

REFERENCES
Anon., November 22, 1921, no. 197; Estrada 1936, p. 55, no. 44 (reproduces checklist of Paris 1932); Bulliet 1937, sect. 3, p. 2 (ill.); Anon., February 4, 1939, p. 13; Anon., March 13, 1939, p. 37 (ill.); Anon., April 1, 1939, pp. 8 (ill.), 9; Devree 1939a, p. 7 (ill.); Devree 1939b, p. X9; Frankfurter 1939b, p. 10 (ill.); Genauer 1939, p. 13; Soby 1939, p. 10; Cassou 1940 (both eds.), pp. 59 (ill.), 165; Merli 1942, pl. 172; Zervos 1932–78, vol. 2a (1942), p. 39 (ill.), no. 76; Gómez de la Serna 1945, pl. XI; Barr 1946, pp. 62, 63 (ill.), 65; Gaya Nuño 1950, pl. 18; Barr 1955, pp. 20 (ill.), 34; Penrose 1958, pl. V-3; Roché 1959, p. 40; Penrose 1967, p. 16, pl. 7; Russoli and Minervino 1972, pp. 95 (ill.), 96, no. 177; Daix and Rosselet 1979 (Eng. ed.), p. 217 (ill.), no. 143; Gee 1981, appendix F, sect. 2, p. 42, no. 116; Penrose 1981, pl. V-3; Podoksik 1989, p. 166 (fig. 281); Palau i Fabre 1990, pp. 102 (ill.), 498, no. 276; Geelhaar 1993, p. 190 (ill.); Daix 1995, pp. 69, 148; Bonduelle-Reliquet 1997, pp. 119, 210–11; Cordova 1998, pp. 137, 409 (fig. 1.77); Roché 1998, p. 426; Reliquet and Reliquet 1999, pp. 200, 279; Léal, Piot, and Bernadac 2000 (both eds.), pp. 133 (fig. 290), 508; Julia May Boddewyn in New York–San Francisco–Minneapolis 2006–7, pp. 339, 344, 345, 346, 348, 351, 355, 373

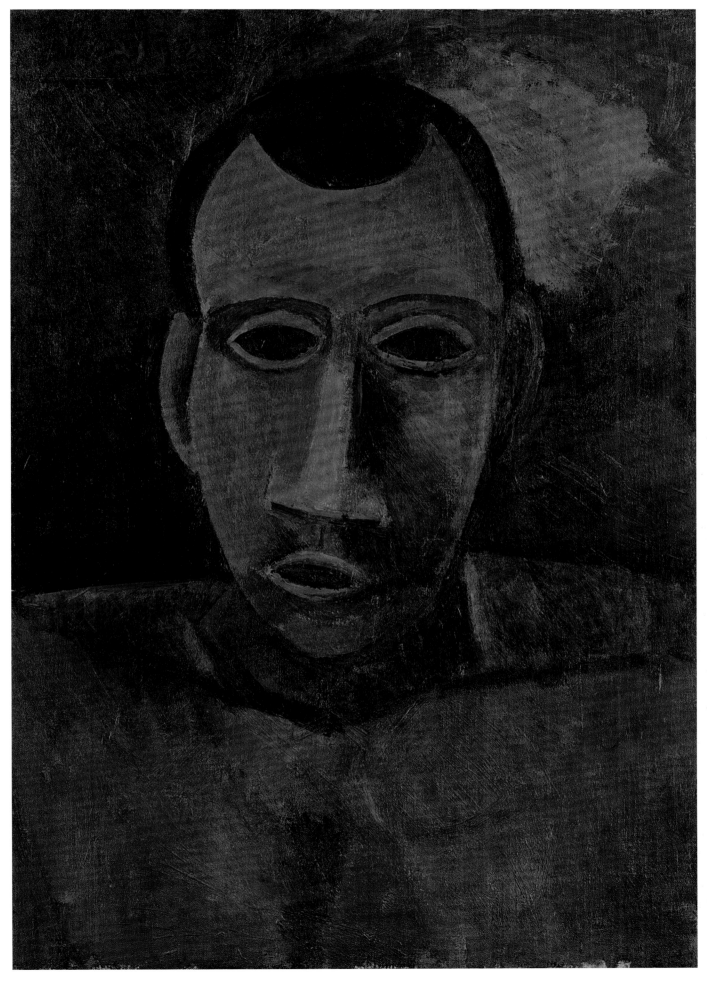

Fig. 46.1. Pablo Picasso, *Portrait of Max Jacob*, 1907. Gouache on paper, 24⅜ × 18¾ in. (62 × 47.5 cm). Museum Ludwig, Cologne (ML/Dep. Slg.L. 1994/5)

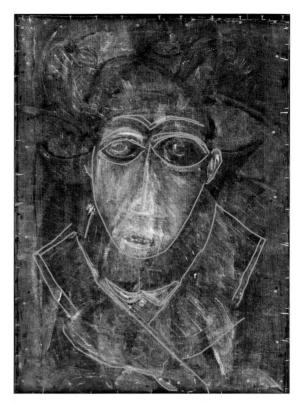

Fig. 46.2. X-radiograph of cat. 46, with lines indicating portrait

Fig. 46.3. Pablo Picasso, *Flowers in a Gray Jug and Wine Glass with Spoon,* 1908. Oil on canvas, 31⅞ × 25⅝ in. (81 × 65 cm). The State Hermitage Museum, Saint Petersburg

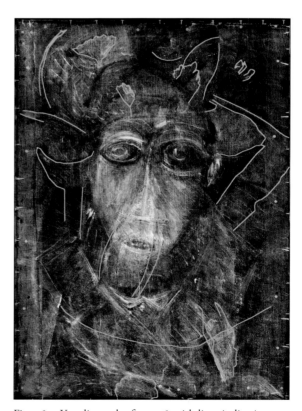

Fig. 46.4. X-radiograph of cat. 46, with lines indicating still life

Because of numerous pentimenti (textural elements that do not correspond to the present painting), this work was X-rayed, and the results point to the existence of paintings beneath the present composition. The earliest, judging from the clarity of the forms, was a fairly realistic portrait of a man (fig. 46.2). It has similarities with *Self-Portrait* (DR 25; Z IIa.8) and is closer still to the *Portrait of Max Jacob* (fig. 46.1), both of 1907. The shapes discernible in another earlier composition (fig. 46.4) are similar to those in the autumn 1908 still life *Flowers in a Gray Jug and Wine Glass with Spoon* (fig. 46.3); the palette of deep greens, white, and grays, seen with the aid of a microscope, is also similar to that still life's.

There exists the possibility of a third underlying painting, a composition related to the drawing *Two Women* (DR 100). This would explain aspects seen in the X-radiograph such as the dramatic diagonal lines along the sides and about the neck of the last head as well as the curve at the top-right corner of the X-radiograph. This composition would have been painted after the initial portrait and before the still life.

Initially *Bust of a Man* had jagged teeth in his open mouth, and his asymmetrical eyes had pupils. Opting for simplification, Picasso painted a nude torso and made the eyes symmetrical and blackened. He kept the mouth open but darkened the teeth, making them less noticeable. The thinness of this final painting accounts for the ease with which the topography of the earlier works can be seen. The canvas has a commercially prepared white ground and is stretched on its original strainer. It was glue lined and varnished prior to entering the Metropolitan's collection. The varnish has since been removed, and the painting now has a pleasingly rich surface.

LB

47. Still Life with Bottle and a Pot of Hyacinths
Paris, Spring 1909

Pastel on white wove paper watermarked CANSON & MONTGOLFIER VIDALON
24⅞ × 19⅛ in. (63.2 × 48.6 cm)
Signed and dated on verso in graphite, upper left: <u>Picasso</u> / 09
Alfred Stieglitz Collection, 1949
49.70.30

Picasso worked on many different types of paper, but his highly finished drawings were executed on fine artists' papers, like the sheet used for the present still life.[1] In this composition a group of objects are assembled on a table—two potted plants, two empty flowerpots, a wine bottle, a carafe with stopper, and a book (or box). Using black pastel, without any pencil underdrawing or visible corrections, the artist positioned each object within receding layers of the composition and deliberately outlined their basic shapes, which are mostly blocky or tubular. His lines vary from light and sketchy to heavily rubbed, while the tonal range of his pastel modulates from pale smoky gray to impenetrable black. Except for the wine bottle and hyacinth plant, which are the focus of the composition, the other objects appear flat and without much internal modeling. Despite this, Picasso manages to create the impression of a shallow relief by emphasizing the blackness of the empty spaces around the objects and by darkening the cast shadows.[2]

The completeness and certainty of Picasso's execution suggest that there must have been preliminary sketches for this still life, although none are recorded; nor are there any related oil paintings. In fact, among the more than sixty-five still lifes (both drawings and paintings) that he made between 1907 and 1909,[3] this drawing is the only one to address the distinctive motif of a flowering hyacinth plant with outspread leaves. More often Picasso's still lifes from the period depict pitchers, glasses, and bowls of fruit, although there are also a few bouquets of cut flowers in vases. In a catalogue of his still lifes, Jean Sutherland Boggs noted that "he was essentially indifferent to botanical structure. . . . [Botanical images] were never to become a serious preoccupation."[4] As for dating this drawing, we may surmise from Picasso's detailed rendering, especially of the hyacinth's florets, that it was drawn from life, most likely in Paris in the spring of 1909, when hyacinths would have been in bloom.

The uniqueness of the subject may be why the drawing was shown in the first large-scale exhibition of Picasso's work in Germany, which opened in Munich in late February 1913 (and why it was illustrated in the catalogue).[5] Organized by Picasso's Paris dealer, Daniel-Henry Kahnweiler, and three German dealers, Heinrich Thannhauser and his son Justin (Munich) and Alfred Flechtheim (Düsseldorf), the exhibition consisted of one hundred fourteen works—seventy-six paintings and thirty-eight drawings, watercolors, and etchings—dating from 1901 to 1912. It was the largest and most comprehensive showing yet made of Picasso's Blue Period to Cubist works, and with slight variations in the selection, the show was also presented in Cologne in March–April.

Several of the pieces in the Munich exhibition were for sale, including *Still Life with Bottle and a Pot of Hyacinths*. It is unknown whether Adolphe Basler, a Parisian art critic, collector, and dealer (Galerie de Sèvres) saw the German shows, but about a year later, on March 31, 1914, he purchased a group of nine Picasso drawings from Thannhauser for 900 marks, including,

probably, the Museum's still life.[6] The Thannhauser invoice lists only inventory numbers, but it seems likely that these are the same nine drawings that Basler brought with him to New York sometime before the outbreak of World War I on August 1, 1914. They were shown in the back room at Alfred Stieglitz's 291 on January 12–26, 1915,[7] immediately following the gallery's Picasso-Braque and Mexican art shows on December 9, 1914–January 11, 1915, and concurrently with an exhibition of Francis Picabia's work. Basler's decision to put them up as collateral for a $300 loan from Stieglitz (along with an Henri Rousseau painting) proved to be a costly mistake, as Stieglitz eventually kept all nine Picassos as repayment of the debt, much to Basler's dismay.[8]

LMM

1. For a discussion of Picasso's artists' papers, see Ténèze, Enshaïan, and Hincelin 2009. Picasso bought some of his papers at Maunoury-Wolff & Cie, a well-known paper supplier in Paris (at 110, rue St.-Martin), whose name and address are written on the back of *Study of a Harlequin* (cat. 24).
2. In the handling of the medium and rendering of shapes and shadows, this hyacinth drawing is very similar to another 1909 drawing, *Bowl of Fruit* (DR 57).
3. See DR 64–70 (1907), 171–78 (1908), 195–215, 220–28, 295, 298–99, 305–21, and p. 57 (1909), and Russoli and Minervino 1972, nos. 59, 60 (1907), 209, 212, 299, 300, 304, 305, 307 (1909).
4. Jean Sutherland Boggs in Cleveland–Philadelphia–Paris 1992, p. 40.
5. A slightly smaller selection of the artist's works, including *Still Life with Bottle and a Pot of Hyacinths*, traveled to Cologne (Der Rheinische Kunstsalon, March–April 1913). Several of his important paintings, now in the Metropolitan Museum's collection—*Seated Harlequin* (cat. 17), *The Blind Man's Meal* (cat. 22), and *At the Lapin Agile* (cat. 25)—were also included in the 1913 German exhibitions.
6. Documentation (from the Thannhauser Archives) about the Thannhauser-Basler sale was provided by Hélène (Seckel) Klein in an email to Christel Hollevoet-Force, Metropolitan Museum Research Associate, May 15, 2009.

7. The hyacinth drawing can be seen installed at 291 in Stieglitz's 1915 photographic portrait of artist Alfred Maurer; see Greenough 2002, vol. 1, p. 245, no. 398.
8. Seven of the nine drawings are part of the Museum's Alfred Stieglitz Collection; see also cats. 24, 48, 49, 53, 56, 57. The correspondence about the loan between Basler and Stieglitz (Alfred Stieglitz/Georgia O'Keeffe Archive, Yale Collection of American Literature, Beinecke Rare Book and Manuscript Library, New Haven, YCAL MSS85, Box 4, Folder 82) is summarized in Karmel 2000, pp. 188, 504–5 nn. 10, 11.

PROVENANCE
[With Moderne Galerie (Heinrich Thannhauser), Munich, 1913–14; probably sold on March 31, 1914, to Basler]; [Adolphe Basler, Paris, 1914–15; left with Stieglitz in December 1914 as collateral for a loan and acquired on August 15, 1915, upon default of loan]; Alfred Stieglitz, New York (1915–d. 1946); his estate (1946–49; gift to the Metropolitan Museum, 1949)

EXHIBITIONS
Munich 1913, no. 100, ill.; Cologne 1913, no. 60, ill.; New York 1915, no cat.; Philadelphia 1920, no. 195; Philadelphia 1944, no. 91; New York 1951, no cat., checklist no. E.L.51.699; Paris 1973–74, no. 73, pp. 57 (ill.), 162 (pl. 92); Yokohama 1989, no. 177, pp. 56, 214 (ill.); Paris 1998–99, fig. 44

REFERENCES
Zervos 1932–78, vol. 2b (1942), p. 303 (ill.), no. 683; Gordon 1974, p. 664; Karmel 2000, pp. 189 (fig. 68), 505 n. 11; Rodriguez 2001, p. 108; Julia May Boddewyn in New York–San Francisco–Minneapolis 2006–7, pp. 329, 359

TECHNICAL NOTE
Picasso executed this drawing in black pastel on an artists' paper that has a prominent basket-weave texture. With the extremely fine and powdery pigment he created soft gradations of tone across the surface. In some areas the pressure of his gritty or sharp crayon has scored the paper.

RM

48. Head of a Woman
Paris, Spring 1909

Ink and charcoal on white laid paper watermarked VIDALON-LES-ANNONAY
B CRAYON ANE<u>NE</u> MANUF<u>RE</u> CANSON & MONTGOLFIER
25⅛ × 19½ in. (63.8 × 49.5 cm)
Signed and dated on verso in graphite, upper left: <u>Picasso</u> / 09
Alfred Stieglitz Collection, 1949
49.70.28

The distinctive coiffure of the model in this drawing—hair rolled thickly across the forehead and gathered into a high, round bun—indicates that she is Fernande Olivier, Picasso's lover and constant companion from 1904 to 1912 (fig. 48.1). From 1905 to 1909 the two lived in his cramped studio in the Bateau Lavoir (13, rue Ravignon) in Montmartre, later in a much larger apartment on the boulevard de Clichy, and they traveled together in the summers to the French countryside and to Spain. Although their relationship was tempestuous at times, as Marilyn McCully has noted, Fernande's presence was also "clearly essential to [Picasso] during these years of artistic and personal struggle. . . . More often than not, Picasso's depictions of women during the years he and Fernande lived together (especially from 1906 to 1909) reflect her physical presence in the studio. In some cases he did paint or draw her embroidering, reading books, or relaxing. But in the vast majority of his figure compositions, Picasso had absorbed her body and features so completely into his visual vocabulary that most of the women became, as it were, generic Fernandes."[1]

In this drawing the facial features are by no means specifically Fernande's. They have been flattened and distorted, broken and twisted into an abstract mask, the shape of which recalls a number of other works from the spring of 1909. In particular, the long triangular face notched in at the temple, crooked nose, and hatlike hairdo find many male (and female) counterparts in Picasso's oils and gouaches of that time, in which dark outlines similarly emphasize irregular contours of the face.[2]

More directly, however, *Head of a Woman* is related to the upper portion of Picasso's 1908–9 full-length study of a standing female nude (fig. 48.2),[3] of which it is a detailed enlargement. In the two drawings the woman's head, raised right arm, and upper torso—including the merged breast and armpit—are identically positioned. The full-length figure is obviously a work in progress, showing the artist's thought processes as he considered altering the figure's pose, including raising the left arm to match the other (it is lightly sketched in at top right). Shortly after, he must have drawn the Museum's large *Head of a Woman*, in which just a few lines (along the far right side of the drawing) indicate the raised left shoulder and arm, bent in at the elbow (to the right of the chignon).

The pose is one that is repeated often in Picasso's work of 1907–9, with various modifications—note, for example, the women in *Les Demoiselles d'Avignon* and *Three Women* (see

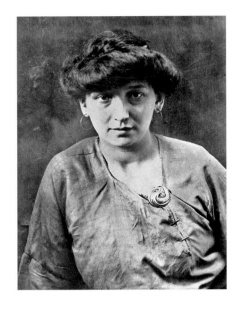

Fig. 48.1. Fernande Olivier, ca. 1908–9. Yale Collection of American Literature, Beinecke Rare Book and Manuscript Library, New Haven, Connecticut

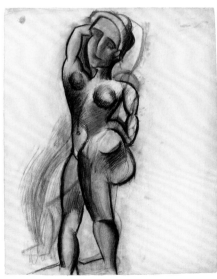

Fig. 48.2. Pablo Picasso, *Standing Nude*, 1908–9. Charcoal and black crayon on paper, 24⅝ × 19 in. (62.5 × 48.2 cm). Musée National Picasso, Paris (MP631)

figs. 40.1, 43.1).[4] And it may derive from a number of sources, including Cézanne's *Bathers*, Michelangelo's *Dying Slave* (Musée du Louvre, Paris), classical Greek marbles such as the *Dying Niobid* (Museo Nazionale Romano, Rome), and the postcards Picasso collected of African women carrying bowls on their heads, which were based on photographs by Edmond Fortier.[5] This was a period of rapid development in Picasso's work, and it is often in his drawings that change is reflected most clearly.

Head of a Woman shows particularly unusual new distortions of scale and shape. They represent, as Gary Tinterow argued, a masterful display of Picasso's "willful manner which can only be understood as an assertion of the artist's right to re-create reality. Such an assertion was, naturally, an essential pre-condition for the creation of the new pictorial language of Cubism, and six months later Picasso created in Horta de Ebro his first series of works in a wholly Cubist idiom."[6] When the present drawing was shown at Alfred Stieglitz's gallery 291 in 1915,[7] it was part of a group of heads that, as Pepe Karmel has observed, "documented Picasso's transition from an 'African' style of uneven bulges and hollows to a 'crystalline' style of regular facets."[8]

LMM

1. Marilyn McCully in Olivier 2001, pp. 10, 16.
2. See DR 245, 250–55, 259, 260, 264, 270.
3. In addition to that full-length study, *Head of a Woman* also relates to *Bather* (winter 1908–9, The Museum of Modern Art, New York; DR 239) and other paintings and drawings from the first half of 1909 (see DR 236–41, 245, 246).
4. In addition, the figures in *Three Women* are depicted with eyes closed in somnolent reverie, like the woman in this drawing.
5. For further discussion of the meanings and sources of this pose, see Leo Steinberg's essay "Resisting Cézanne: Picasso's *Three Women*" (2007). Regarding Picasso's postcard collection, see Anne Baldassari in Houston–Munich 1997–98, pp. 45–61; one of which (fig. 57 on p. 54) seems particularly relevant to *Head of a Woman*.
6. Gary Tinterow in London 1983, p. 326, no. 160.
7. For the 1915 Picasso exhibition at Alfred Stieglitz's gallery and Adolphe Basler, the former owner of this drawing, see the entry for cat. 47. It is likely that *Head of a Woman* was the drawing Basler referred to in a July 7, 1915, letter in which he asked Stieglitz to return "the big Head of a Woman" (Alfred Stieglitz/Georgia O'Keeffe Archive, Yale Collection of American Literature, Beinecke Rare Book and Manuscript Library, YCAL MSS85, box 4, folder 82).
8. Karmel 2000, p. 189.

PROVENANCE
[Probably with Moderne Galerie (Heinrich Thannhauser), Munich, by 1913 and sold on March 31, 1914, to Basler]; [Adolphe Basler, Paris, 1914–15; left with Stieglitz in December 1914 as collateral for a loan and acquired on August 15, 1915, upon default of loan]; Alfred Stieglitz, New York (1915–d. 1946); his estate (1946–49; gift to the Metropolitan Museum, 1949)

EXHIBITIONS
Probably Munich 1913, no. 97 or 99; probably Cologne 1913, no. 58 or 59; New York 1915, no cat., no checklist; Philadelphia 1944, no. 94; New York (MoMA) 1947, no cat., checklist no. 91; Chicago 1948, no cat., checklist no. 20; New York 1951, no cat., checklist no. E.L.51.697; New York 1967, no cat., unnumbered checklist; Los Angeles–New York 1970–71, no. 266, pp. 42 (pl. 22), 305; Paris 1973–74, no. 72, pp. 57 (ill.), 161 (pl. 91); London 1983, no. 160, pp. 326–27 (ill.); Canberra–Brisbane 1986, pp. 17, 18 (ill.), 19; Paris 1998–99, fig. 36; Washington 2000, pp. xxviii, xxix (figs. 23, 24), 189–90 (pl. 53), 505 n. 11, 536; Paris–Madrid 2004–5, no. 43, pp. 93 (ill.), 325

REFERENCES
Russoli and Minervino 1972, p. 97 (ill.), no. 198; Elderfield 1978, pp. 68, 192 (fig. 50); Ulrich Weisner in Bielefeld 1979, p. 267, pl. 46; Rodriguez 2001, p. 108; Julia May Boddewyn in New York–San Francisco–Minneapolis 2006–7, pp. 329, 359, 362

TECHNICAL NOTE

Picasso began this drawing with a very faint charcoal sketch of the general outline of the final figure, which can be seen here beneath the ink. He applied the black ink with a brush and modulated shades of black by varying the amount of ink on the paper. Along the woman's nose, left eye, and hair, he applied an additional thicker stroke, emphasizing the features in what appears to be a brown ink. Under magnification, flecks of charcoal are visible in it, possibly accounting for the warmer color of this ink. The watermark in the paper, "Canson & Montgolfier," refers to a French company that was one of the most prominent manufacturers of artists' papers. Picasso selected their stocks for many drawings made in this period. The specific type used here, B crayon, which is also named in the watermark, was manufactured for use with pencil; however, Picasso used it with a variety of media.

RM

49. Head
Paris, Spring 1909–Horta de Ebro, Summer 1909

Ink on white laid paper watermarked INGRES 1871, with countermark of Canson Frères crest
24¾ × 18⅞ in. (62.9 × 47.9 cm)
Signed and dated on verso in graphite, upper left: Picasso / 09
Alfred Stieglitz Collection, 1949
49.70.35

During the spring, summer, and autumn of 1909, when Picasso was focused on his large series of heads of Fernande Olivier—see, for example, the Museum's bronze sculpture (cat. 50) and drawing (cat. 48) from that year—he also made a number of male heads. The latter share certain physical characteristics—in particular, an elongated face, a distinctive hairline (receding in the front), and pronounced cheekbones.[1] They often incorporate generalized aspects of Fernande as well, such as almond-shaped eyes, arched eyebrows, full lips, heavy jawline, and creased forehead, all of which are in evidence in this drawing. It is not surprising, then, that in the course of its exhibition and publication history this head has been identified as male, female, and of indeterminate sex.

The drawing bears a striking resemblance to one of Picasso's paintings made during the summer of 1909 at Horta de Ebro, Spain, titled *Head and Shoulders of a Man* (fig. 49.1).[2] In these works, the facial features are remarkably similar (compare the eyes, eyebrows, nose, mouth, and jaw), even reiterating, at right, the shapes and placement of the cheekbone and ear; moreover, the head is oriented in the same upright, three-quarters position (looking to the viewer's left).[3] What differentiates the drawing

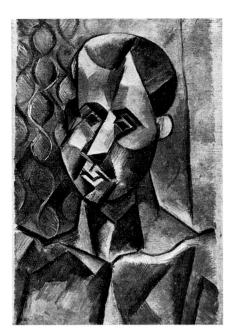

Fig. 49.1. Pablo Picasso, *Head and Shoulders of a Man*, 1909. Oil on canvas, 25⅝ × 16⅜ in. (65 × 41.5 cm). Private collection

1. Some or all of these characteristics can be found in a number of earlier male heads painted by Picasso, including the Metropolitan Museum's *Josep Fondevila* (cat. 35) and *Self-Portrait* (cat. 39), both of 1906, and *Bust of a Man* (cat. 46), of 1908.
2. Another version of this man (Museu de Arte de São Paulo; DR 297) is less Cubistic but more clearly shows the muscled shoulder that is suggested in the Metropolitan Museum's drawing by the rounded arc at lower left.
3. The pose of the man in *Head and Shoulders of a Man* (fig. 49.1) is an example of Picasso's habit of transposing visual imagery from one work to another; it is almost a mirror image of his summer 1909 painting *Portrait of Fernande* (DR 288). As noted by Jeffrey Weiss (in Washington–Dallas 2003–4), the upright head position is unusual in the Fernande series of 1909; there, the heads are almost always depicted at a downward angle.
4. See DR 264, 266; see also Weiss in Washington–Dallas 2003–4, pp. 56–58, cat. nos. 6–9. The dating of these drawings to the spring of 1909 (Paris) and their obvious stylistic connections to the present work suggest a similar dating for the Metropolitan's *Head*. However, our drawing's equally strong connection to the painting *Head and Shoulders of a Man* (fig. 49.1) has led us to date it slightly later, to spring–summer 1909.

from the painting, however, is the radically Cubist treatment of the planes of the face, which in the painting is more softly rounded. Creating sharply faceted angular forms, Picasso emphasized the hard geometry of the countenance by means of dramatic contrasts of light and dark planes. Certain other drawings of heads from the spring of 1909 show the same Cubist geometry and clusters of long diagonal brushstrokes.[4] As with the majority of Picasso's drawings, these studies (including the present one) are not necessarily preparatory drawings for a particular painting or sculpture, but rather repetitions and permutations on a theme. In this case, however, there is a natural temptation to relate the sculptural blockiness of the drawing, which gives the impression of having been executed with a blade, to Picasso's first real sculptural masterpiece, *Head of a Woman* (cat. 50), which he made a few months later, in the autumn of 1909, after he returned to Paris from Horta de Ebro.

<div align="right">LMM</div>

PROVENANCE
[Probably with Moderne Galerie (Heinrich Thannhauser), Munich, by 1913 and sold on March 31, 1914, to Basler]; [Adolphe Basler, Paris, 1914–15; left with Stieglitz in December 1914 as collateral for a loan and acquired on August 15, 1915, upon default of loan]; Alfred Stieglitz, New York (1915–d. 1946); his estate (1946–49; gift to the Metropolitan Museum, 1949)

EXHIBITIONS
Probably Munich 1913, no. 101; New York 1915, no cat.; Philadelphia 1944, no. 93; New York (MoMA) 1947, no cat., checklist no. 90; Chicago 1948, no cat., checklist no. 21; Toronto 1949, no. 38; New York 1951, no cat., checklist no. E.L.51.696; New York 1967, no cat., unnumbered checklist; Los Angeles–New York 1970–71, no. 265, pp. 42 (pl. 21), 305; Paris 1973–74, no. 71, pp. 56 (ill.), 160 (pl. 90); Canberra–Brisbane 1986, pp. 18 (ill.), 19; London 1994, no. 52, p. 263, ill.; Paris 1998–99, fig. 24; Washington 2000, pp. 189, 199 (pl. 56), 505 n. 11, 536; New York 2000, hors cat.

REFERENCES
Hamilton 1970, p. 380 (fig. 6); Russoli and Minervino 1972, pp. 98–99 (ill.), no. 236; Ulrich Weisner in Bielefeld 1979, p. 267, pl. 51; Rodriguez 2001, p. 108; Julia May Boddewyn in New York–San Francisco–Minneapolis 2006–7, pp. 329, 359, 362

TECHNICAL NOTE
Picasso used two colors to create this drawing, brown and black. The brown color—ink (or possibly watercolor) diluted to make an array of tones—has a degree of body and has formed cloudy pools in areas where it has been thickly applied. Above that layer Picasso used a dense black ink, applied in quick, repeating strokes. The use of two media that are very close in color is seen in many of Picasso's drawings, watercolors, and pastels.

Ingres artists' paper, a type often selected by Picasso, can be used with a variety of media; its slight texture makes it appropriate for use with chalk, charcoal, or pastel. Here the brush-applied ink was affected by the paper texture only when Picasso applied it more dryly or with less pressure, thus causing a lighter, broken line.

<div align="right">RM</div>

50. Head of a Woman

Paris, Autumn 1909 (Vollard edition, cast date unknown)

Bronze
16 × 10¼ × 10 in. (40.6 × 26 × 25.4 cm)
Incised on reverse: Picasso
Bequest of Florene M. Schoenborn, 1995
1996.403.6

Picasso's productive summer in Horta de Ebro, Spain (June–ca. September 11, 1909), yielded an impressive number of paintings and drawings of Fernande Olivier, his companion of five years. In them, and in his pictures of Horta architecture, he further developed the visual language of early Cubism. While all of his works that summer were two-dimensional (paintings and drawings), his depictions of Fernande's face and body were actually quite sculptural in appearance, emphasizing the planes, ridges, protrusions, and valleys of her physiognomy. Within weeks of his return to Paris in mid-September, he modeled a lifesize Cubist sculpture of Fernande's head in clay, which was later cast in plaster and bronze.

Until then Picasso's sculptural output had been of minor importance. Of the twenty-three other sculptures he made between 1902 and 1909, only three from 1906 were significant: two portrait busts and a kneeling woman; the other twenty were small wood carvings, plasters, and clay models.[1] What makes *Head of a Woman* particularly notable is that it was Picasso's first large Cubist sculpture.[2] As it was to be a solid object in the round, he had to find ways of achieving the shifting space and fractured forms that characterized his Cubist paintings and drawings of the same year. This he did by creating a highly articulated surface of crescent-shaped knobs of hair, a faceted face, and a striated neck that reflected the light in irregular patterns and suggested the dissolution of form, without actually breaching the structure.[3] Still recognizable as a head despite its transformative move toward abstraction, it also conveys the body's movements as the head tilts diagonally downward and the neck twists as if the woman is ready to look over her shoulder.

In mid- to late September or early October 1909, Picasso modeled the original clay version of this sculpture in the Paris studio of his friend the Spanish sculptor Manolo (Manuel Martínez Hugué). The following year, probably about September 1910, when the artist was in need of money, Ambroise Vollard, the art dealer who had given Picasso his first show in Paris in 1901, acquired it (as well as four other sculptures) and the right to make an unlimited number of bronze editions from it.[4] His intention may have been to include all five sculptures in his next Picasso show, scheduled for December 20, 1910, through late February 1911.[5] Vollard had a plaster cast made from the clay original, which was destroyed in the process;[6] at some time before casting the first bronze, Picasso recut some of the planes of the plaster, particularly in the neck area, to "make it look more carved than modeled."[7]

Head of a Woman was an immediate commercial success and found admirers in both Europe and America, inspiring what Werner Spies called "a whole [new] sculptural genre."[8] European modernists such as Alexander Archipenko, Raymond Duchamp-Villon, Juan Gris, Henri Laurens, Jacques Lipchitz, and especially the Italian Futurist Umberto Boccioni were influenced to make their own Cubistic sculptures after seeing Picasso's *Head of a Woman* either at Vollard's gallery or reproduced in publications in the early 1910s.[9] One of the first to purchase a cast-bronze *Head of a Woman* from Vollard (in January 1912) was the American photographer and gallerist Alfred Stieglitz, whose photographs of the sculpture were reproduced in the same issue of *Camera Work* (August 1912) as Gertrude Stein's word-portrait "Pablo Picasso."[10] In 1913 Stieglitz lent his cast to the New York venue of the large International Exhibition of Modern Art (known as the Armory Show), where Picasso's work inspired many American artists to take up the Cubist banner.[11]

The number of casts made of *Head of a Woman* is undocumented but is probably fewer than thirty. While Vollard did not keep detailed records of his cast orders or sales, some eighteen casts have been identified as having been made during the dealer's lifetime (1866–1939). These bronzes are unnumbered and were produced on an order-by-order basis between 1910 and 1939 and cast by a number of different foundries in France. Much later, in 1960, a numbered edition of nine casts was made for the art dealer Heinz Berggruen, with the permission of the artist. The Museum's (unnumbered) head was purchased by Samuel and Florene Marx from the Buchholz Gallery in New York in May 1951. LMM

1. See Spies 2000, pp. 346–47, nos. 1–23. In 1910 the dealer Ambroise Vollard acquired the three important 1906 sculptures—*The Jester* (s 4), *Head of a Woman (Fernande)* (s 6), and *Woman Combing Her Hair* (s 7), and he made casts of them throughout the 1930s.
2. About the same time he made *Head of a Woman*, Picasso carved two much smaller Cubist sculptures—an abstract head and an apple—neither of which was ever cast in bronze (see s 25, 26). For an in-depth study of the Fernande series, including *Head of a Woman*, see Washington–Dallas 2003–4.
3. Initially Picasso had another plan for this sculpture: "I thought that the curves you see on the surface should continue into the interior. I had the idea of doing them in wire" (quoted by Roland Penrose in New York 1967–68, p. 19).
4. The date Vollard purchased Picasso's clay sculptures was suggested by Valerie Fletcher (2003, p. 172): "Quite probably the sale took place in or soon after September 1910, when [Daniel-Henry] Kahnweiler decided not to buy Picasso's most recent paintings. Vollard took them instead and announced plans for an exhibition of Picasso's works from 1900 to 1910." In addition to works cited in note 1 above, Vollard purchased a *Bust of a Man* (fig. 35.1). On Vollard's acquisition of the right to make editions of the present work, see Gary Tinterow (2006, p. 112) and Diana Widmaier Picasso (2006, pp. 182–88), who also cites

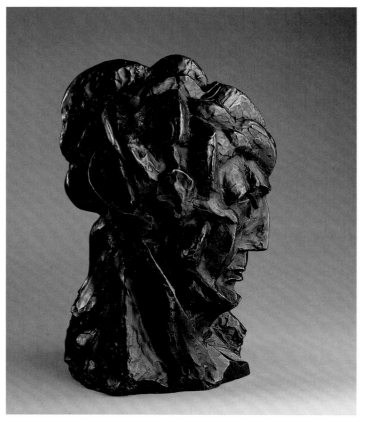

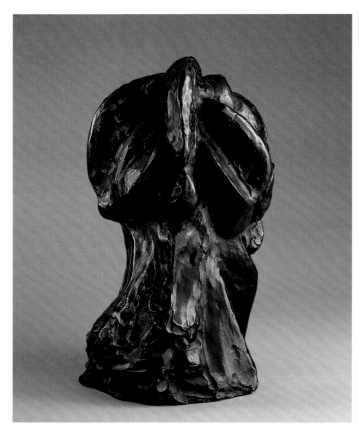

Cat. 50, side view

Cat. 50, back view

information from Vollard's letters and ledgers about the manufacture and sale of early casts of *Head of a Woman*.

5. There is no catalogue or checklist of Vollard's December 1910–February 1911 show of Picasso paintings from 1900 to 1910 to confirm the inclusion of sculpture, but both Valerie Fletcher and Metropolitan Museum curator Rebecca Rabinow agree that as a savvy businessman Vollard would most likely have shown Picasso sculptures if they were in his possession at the time (correspondence with the author). Fletcher noted that "Vollard intended to reveal Picasso's sculptural talents to the world. Although the Spaniard's paintings were gaining fame, none of the artist's previous exhibitions—including the most recent one at Wilhelm Uhde's gallery in May 1910—had featured sculpture" (see Fletcher 2003, p. 172).

6. See Fletcher 2003, pp. 172, 175–76, on the casting process. A 1910 photograph of the artist's studio (see Paris 1994, p. 207, fig. 152) shows three bronze sculptures on the floor, including *Head of a Woman*, presumably a cast given to Picasso by Vollard as an artist's proof (now in the Musée Picasso, Paris, *dation* 1979, inv. 243).

7. Picasso mentioned this to Douglas Cooper and John Richardson about 1955 (see London 1994, p. 256). In addition, "a few small ridges, such as that over the proper right eye, may have been discreetly accentuated at the same time with the tip of a knife" (Fletcher 2003, p. 175).

8. Spies 1971, p. 27.

9. Boccioni's sculpture *Antigraceful* (1913, The Metropolitan Museum of Art, New York) is closely related to it in subject and execution.

10. G. Stein 1912, pp. 29–30, Stieglitz's photographs of this sculpture (*Head of a Woman*), n.p. Stieglitz's cast is in the collection of The Art Institute of Chicago.

11. Max Weber was one of the first American artists influenced by Picasso's work, which he saw in Paris in 1905–8, and continued to emulate after he returned to New York. Weber's sculpture *Figure in Rotation* (ca. 1915–17, The Metropolitan Museum of Art, New York) pays homage to Picasso's *Head of a Woman*. See also Michael FitzGerald's catalogue to New York–San Francisco–Minneapolis 2006–7.

PROVENANCE
[Buchholz Gallery (Curt Valentin), New York, by 1949–51; possibly purchased on July 12, 1949, from Henri Kaeser, Lausanne; sold on May 7, 1951, for $2,200 to Marx]; Samuel and Florene Marx, Chicago (1951–his d. 1964); Florene May Marx, later Mrs. Wolfgang Schoenborn, New York (1964–d. 1995; on extended loan to the Metropolitan Museum from 1985; her bequest to the Metropolitan Museum, 1995)

EXHIBITIONS [specific to Metropolitan Museum's cast]
Possibly in Paris 1910–11; possibly New York (Buchholz) 1949, no. 36, ill.; possibly New York (Buchholz/Sculpture) 1949, no. 40; Philadelphia–New York 1952–53 (shown in New York only), pp. 25–26, 130 (ill.), 131 (ill.) (erroneously identified as the MoMA cast but Marx cast was lost); New York (MMA/Schoenborn) 1997, brochure no. 15; New York–Chicago–Paris 2006–7 (shown in New York only), no. 163, pp. 101, 112, 117 n. 37, 182, 185 (fig. 198), 186, 187 nn. 3, 22, 25, 28, 29, 32, 188 nn. 37, 41, 208 (fig. 221), 285, 301 n. 213, 392 (ill.), 393

REFERENCES [not specific to Metropolitan Museum's cast]
Camera Work, special number (August 1912), pp. 41, 43 (ills.); Apollinaire 1913 (1960 reprint, pp. 409–10; 1988 reprint, pp. 320, 501 n. 48; 1991 reprint, p. 599); V. Benes in Prague 1913, no. 25; Laurvik 1913, p. 2, ill.; Mather 1913, p. 504 (ill.); New York–Chicago–Boston 1913 (New York ed.), p. 45, no. 598; Prague 1923, p. 389; Einstein 1926, p. 270 (ill.); Basler 1928, p. 42 (ill.); Einstein 1928, pp. 268 (ill.), 559; Level 1928, p. 56 (ill.); Zervos 1928b, p. 286 (ill.); Einstein 1931, pp. 311 (ill.), 637; Paris 1932, no. 22; Olivier 1933, p. 143; G. Stein 1933, p. 23; Alfred H. Barr Jr. in New York (MoMA) 1936, pp. 31, 103, 220, no. 212, fig. 90; González 1936, p. 189; Giedion-Welcker 1937, pp. 36–37 (ill.); G. Stein 1938a, p. 9; Zervos 1938a, p. 298 (ill.); Alfred H. Barr Jr. in New York and other cities 1939–41, p. 68 (ill.), no. 83; Cassou 1940, pp. 159 (ill.), 167; Mackenzie 1940, pl. VI; Douglas C. Fox in Richmond–Philadelphia 1941, p. 92 (ill.), no. 163; Frankfurter 1941, p. 18 (ill.); Monroe Wheeler in New York (MoMA) 1942, pp. 48 (ill.), 141; Zervos 1932–78, vol. 2b (1942), p. 266 (ill.), no. 573; Barr 1946, p. 69 (ill.); E. L. T. Mesens and Robert Melville in London 1947, p. 17, no. 5; Gaffé 1947–48, pp. 36–37; Gómez Sicre 1948, p. 17 (ill.); Kahnweiler 1948, pl. 8; Kahnweiler 1949b, pl. 8; Toronto 1949, no. 30, cover ill.; Gieure 1951, figs. 131, 132; Argan 1953, pp. 10, 26, pl. VI; Perry T. Rathbone in New York (Valentin) 1954, no. 25, ill.; Boeck and Sabartés 1955, pp. 462 (fig. 54), 490 (no. 112); Elgar and Maillard 1955, p. 61 (ill.); Giedion-Welcker 1955, pp. 40–41 (ill.), 251; Camón Aznar 1956, pp. 660 (fig. 540), 731; Elgar and Maillard 1956, p. 83 (ill.); H. Read 1956,

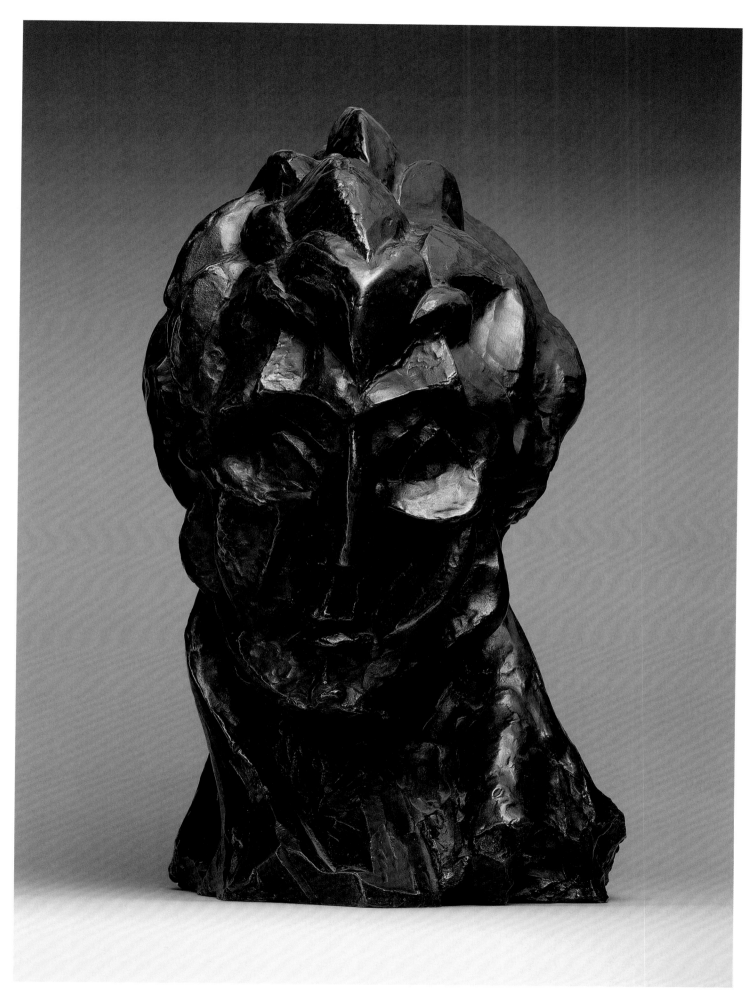

pl. 191; Alfred H. Barr Jr. in New York–Chicago 1957, p. 37 (ill.); Hunter 1957, ill.; Daniel-Henry Kahnweiler in New York (Fine Arts Associates) 1957, no. 8, ill.; Penrose 1958, p. 240, pl. VI-4; Carl Zigrosser in Philadelphia 1958, p. 121, no. 9, ill.; Golding 1959, pp. 81–83, 169, pl. 6; Giedion-Welcker 1960, pp. xi, 46–47; Padrta 1960, no. 11, ill.; Rosenblum 1960, pp. 262, 265, 269 (fig. 188), 323; Jiří Šetlík in Prague 1960, no. 16; Zürich and other cities 1960–61, no. 202, ill.; New York 1962 (exhibited at Gerson), no. 12; Jean Sutherland Boggs in Toronto–Montreal 1964, p. 66 (ill.), no. 53; Jaffé 1964, p. 17 (fig. 15); Prague 1964, p. 33, no. 6; H. Read 1964, pp. 60 (pl. 54), 62; Olga Macková in Prague 1966, pp. 46 (ill.), 60, no. 121; Národní Galerie 1966, no. 93, ill.; Jean Leymarie in Paris 1966–67, sculpture sect., no. 215, ill.; Jaffé 1967, p. 15 (fig. 15); Licht 1967, p. 332 (ill.), no. 219; Roland Penrose in London 1967, pp. 10, 30 (ill.), no. 13; Roland Penrose in New York 1967–68, pp. 19, 20, 23, 41, 56 (ill.), 57, 221, no. 13; B. Farrell 1968, p. 64 (ill.); Golding 1968, pp. 81–83, 169, pl. 6; Ulf Linde et al. in Humlebaek 1968, pp. 19 (ill.), 68, no. 21; Gertrude Sandner and Heribert Hutten in Vienna 1968, p. 59, no. 78; Elsen 1969, pp. 25–26 (ill.); Goldwater 1969, pp. 42 (ill.), 45, 145; Hammacher 1969, pp. 98, 102 (pl. 108), 138; Douglas Cooper in Los Angeles–New York 1970–71, pp. 232–33 (pl. 281), no. 288; Spies 1971, pp. 26–28, 42 (ill.), 43 (ill.), 302, no. 24; Karpel 1972, vol. 1, p. 45, vol. 3, doc. 5; Rubin 1972, pp. 61 (ill.), 203; Russoli and Minervino 1972, pp. 101 (ill.), 102, no. 296; Bouillon 1973, pp. 190–91; Bowness 1973, pp. 129 (fig. 212), 130, 277; Daval 1973, p. 268 (ill.); Albert E. Elsen in London 1973, pp. 35 (ills.), 138–39, no. 166; Justice 1973, p. A7 (ill.); Kirstein 1973, pp. 38 (pl. 11), 147, 183; Kozloff 1973, pp. 61–62 (fig. 19); Elsen 1974, p. 46 (fig. 62); Penrose 1974, p. 130 (reprint ed., p. 143); Porzio and Valsecchi 1974, p. 62 (ill.); Daix 1975, pp. 126 (ill.), 127; Warnod 1975, p. 135 (ill.); Baumann 1976, pp. 57 (pl. 98), 58, 206; Johnson 1976, pp. 101–5, 112–13, 167 (no. 23), 231 (fig. 84); Rosenblum 1976, pp. 294, 344, pl. 188; Mario Amaya and Eric Zafran in Norfolk–Nashville 1977, no. 55, pl. 55; Una E. Johnson in New York and other cities 1977–78, pp. 11, 41, 46, 89 (ill.), 170, no. 230 (and brochure, ill.); Robin Gibson in London 1978, pp. 34 (fig. 27), 35; Daix and Rosselet 1979, p. 66 (ill.) (English ed., p. 67 [ill.]); S. Foster 1979, pp. 267, 271 (fig. 7), 272; William Rubin in New York 1980, pp. 132 (ill.), 153; Jiří Kotalík in Turin 1980–81, p. 52 (ill.), no. 5; Giorgio de Marchis in Rome 1980–81, p. 57 (pl. 2); Achille Bonito Oliva and Jiří Kotalík in Florence 1981, pp. 121 (ill.), 160, no. 73; Corredor-Matheos 1981, p. 385; Jaffé 1981, pp. 15, 22; Kodansha 1981, p. 105 (fig. 19); Penrose 1981, p. 154, pl. VI.4; Jean-Louis Prat in Saint-Paul 1981, p. 184 (ill.), no. 157; Pierre Daix in Hamburg 1981–82, pp. 28, 57 (ill.); Werner Spies in Munich and other cities 1981–82, pp. 248 (ill.), 249, no. 66; Alan G. Wilkinson in Toronto 1981–82, p. 116 (ill.), no. 52; Marianne L. Teuber in Cologne 1982, pp. 33 (fig. 18), 240 (pl. 127), no. 127; William S. Lieberman in Mexico City 1982–83, pp. 32 (ill.), 33 (ill.), no. 16; Gary Tinterow in London 1983, pp. 360–61 (ill.), no. 190; Werner Spies and Christine Piot in Berlin–Düsseldorf 1983–84, pp. 47, 48 (ill.), 49 (ill.), 52–54, 327 (ill.), 373, no. 24; Gossa 1984, p. 46 (fig. III); Gilberte Martin-Méry in Bordeaux 1984, pp. 245 (ill.), 246, no. 155; Petrová 1984, pp. 72 (fig. 32), 176 (ill.), 233, no. 93; Rubin 1984, pp. 304 (ill.), 311, 312, 314, 320 nn. 182, 183; H. Read 1985, pp. 60 (pl. 54), 301; Arnason 1986, p. 152 (fig. 217); Bernadac and Du Bouchet 1986, p. 2 (fig. 1); Bernadac, Richet, and Seckel 1986, pp. 153 (ill.), 154 (ill.), no. 286; Rowell in Paris 1986, pp. 16, 20 (ill.), 431, no. 5; Alan G. Wilkinson in Toronto and other cities 1986, pp. 2–11, cover ill.; Magdalena M. Moeller in Hannover 1986–87, p. 23 (ill.); Aurelio Torrente Larrosa in Madrid 1986–87, pp. 62–63 (pl. 6); Boudaille 1987, p. 46 (fig. 66); Michèle Richet in Bernadac, Richet, and Seckel 1985–87, vol. 1 (1987), p. 106 (fig. 5), nos. 244, 245; Nicole Barbier in Lugano 1988, pp. 9, 13, 24 (ill.), 63; "Femme à la mandoline by Pablo Picasso, Property of Hester Diamond," sale, Christie's, New York, November 15, 1988, suppl. pp. 12, 15 (fig. 7); Golding 1988, pp. 81–83, 169, pl. 6; Hammacher 1988, pp. 98, 102 (pl. 108), 138; Olivier 1988, ill. between pp. 128 and 129; Platt 1988, p. 285 (ill.); Olle Granath in Stockholm 1988–89, pp. 68 (ill.), 238, no. 106; Roland Doschka in Balingen 1989, p. 133 (ill.); Podoksik 1989, pp. 104, 108, 109, 184 (ill.); Judith Cousins in New York 1989–90, pp. 141 (ill.), 363, 413; Jiří Kotalík, Ivan Neumann, and Jiří Šetlík in Barcelona–Madrid 1990, pp. 13, 25, 81 (ill.), 114 (fig. 21); Palau i Fabre 1990, pp. 152 (ill.), 502, no. 433; Persin 1990, p. 57 (ill.); Bernier 1991, pp. 168–69 (ill.); Kendall in London 1991, pp. 110–11 (ill.), no. 34; Jean Sutherland Boggs et al. in Cleveland–Philadelphia–Paris 1992 (Eng. ed.), pp. 74–75 (fig. 16d), 346 (ill., plaster); Warncke 1992, vol. 1, pp. 184 (ill.), 188; Geelhaar 1993, p. 237 (fig. 267); Warncke 1993, vol. 1, pp. 184 (ill.), 188; Andreotti 1994, p. 138 (fig. 1); Anne Baldassari in Paris 1994, p. 207 (fig. 152); Cork 1994; Elizabeth Cowling and John Golding in London 1994, pp. 16–17, 20–21, 39 nn. 17–19, 50 (ill.), 53 (ill.), 256, nos. 5, 6, and brochure, no. 1 (ill.); Golding 1994, pp. 44 (ill.), 45, 47; Graham-Dixon 1994, pp. 110–11 (ill.); Januszczak 1994; Léal 1994, p. 243; Russell 1994, p. 42; David F. Setford in West Palm Beach 1994, pp. 30 (ill.), 55, no. 7; Tait 1994; Tuchman 1994; Daix 1995, pp. 606 (ill. in plate section, p. 3), 821, 865, 867; Martínez Blasco and Martínez Blasco 1995, pp. 136–37 (fig. 54); P. Read 1995, p. 98; Steven A. Nash in San Francisco 1995–96, p. 8 (ill.); Daix 1996 (both eds.), pp. 276 (ill.), 278; Einstein 1996, pp. 444 (ill.), 774; Huth 1996, p. 49; Podoksik 1996, pp. 134, 136 (ill.); Richardson 1991–2007, vol. 2 (1996), pp. 138 (ill.), 139–41 (ill.), 308, 454 nn. 4–6, 467 n. 44; Angela Schneider in Berlin 1996, pp. 72–73 (ill.), 306, no. 18; Vogel 1996b, p. A1; Michael Brenson in San Francisco–New York 1996–97, pp. 50, 53, 111 (ill., plaster); Berggruen 1997, pp. 99–102; Kirk Varnedoe and Pepe Karmel in Atlanta–Ottawa–Los Angeles 1997–99, pp. 54–55 (ill.), 146; Arnason 1998, p. 191 (fig. 207); Cordova 1998, pp. xx, 289–91, 508 (fig. 4.12); Gerhard Graulich in Schwerin 1999, pp. 113–14; Mady Menier in Vallauris 1999, pp. 12–13; Daix 2000, pp. 111–13 (ill.); Léal, Piot and Bernadac 2000, pp. 142 (fig. 314), 508 (Eng. ed., pp. 140, 142 [fig. 314], 143, 508); Spies and Piot in Paris 2000, pp. 10 (ill.), 24, 26, 28, 31–32, 38, 55, 57, 59 (ill.), 60–65, 84, 89, 332, 347 (ill.), 395, no. 24 (Eng. ed., pp. 24, 38, 55, 57, 58 [ill.], 60, 62–65, 67, 84, 89, 332, 336 nn. 177, 178, 347 [ill.], 395, 427, no. 24); Charles Brock in Washington 2000, pp. 124, 125 (pl. 22), 499 n. 53; Liège 2000–2001, no. 54, ill.; C. Plieger in Vienna–Tübingen 2000–2002, pp. 18 (fig. 9), 29; sale, Christie's, New York, November 6, 2001, pp. 34–37, no. 7, ills.; Olivier 2001b, p. 182; Pophanken and Billeter 2001, pp. 373 (ill.), 401, no. 36; Bernice B. Rose in Milan 2001–2 (both eds.), pp. 48, 161 (ill.), 356, no. 19; Ana Vázquez de Parga in Madrid–Las Palmas de Gran Canaria 2001–2, p. 69 (ill.); Cowling 2002, pp. 212–13 (fig. 182), 256; W. Jeffett and Sanda Miller in Madrid 2002, pp. 204, 207 (ill.), 214, 253, 267, 273, 301, 302; Dorthe Aagesen in Copenhagen 2002–3, pp. 124–25 (ill.), 127, no. 54; Anne Baldassari in London–Paris–New York 2002–3 (Eng. ed.), pp. 264 (ill.), 265–67, 269–70, 272 (ill.), no. 139; Norman Mailer in Chemnitz 2002–3, p. 88 (ill.); Barbara Haskell in New York (Whitney) 2003, pp. 37 (fig. 28), 38; Karmel 2003, pp. 64, 66, 67 (figs. 78, 79), 68–69, 73, 123, 168, 207 nn. 34, 40; Robert Rosenblum in New York (Gagosian) 2003, pp. 34–35 (ill.); Jeffrey Weiss, Valerie J. Fletcher, and Kathryn A. Tuma in Washington–Dallas 2003–4, pp. 10–12, 15–17 (figs. 3, 4), 18 (fig. 5), 19–24 (ill.), 25, 28, 43, 106 (fig. 64), 107 (fig. 65), 108 (ill.), 109 (ills.), 110 (ills.), 111 (ills.), 112 (ills.), 158, 166, 167 (figs. 1, 2), 168, 169 (ills.), 171–72, 174 (ill.), 175–82 (ills.), 183–88 (ills.), 189–91, 196, no. 66; Marilyn McCully and Michael Raeburn in Ferrara 2004–5, pp. 106 (ill.), 107 (ill.); Anne Baldassari in Paris 2005, p. 78 (fig. 56); Diana Widmaier Picasso in Kahnweiler 2005, pp. vii–viii, ill.; Arayashiki Toru et al. in Kanagawa 2006, pp. 22 (fig. 25), 48 (fig. 4), 168, 173; Cowling 2006, pp. 303, 387 n. 98; Holtmann, Herzog, and Jacobs van Renswou 2006, p. 43 (doc. 2.1); Michael FitzGerald and Julia May Boddewyn in New York–San Francisco–Minneapolis 2006–7, pp. 36, 42 (pl. 12), 386; Frankfurt 2006–7, p. 19 (ill.); Robert S. Lubar in Málaga 2006–7, pp. 68, 89 (ill.), 177–79, no. 8; Cahn 2007, p. 71; Anne Baldassari in Paris 2007–8 (both eds.), pp. 95, 147, 226 (ill.), 338; Elderfield 2009, p. 550 n. 5

51. Woman in an Armchair
Paris, Autumn 1909–Winter 1909/10

Oil on canvas
32 × 25¾ in. (81.3 × 65.4 cm)
Signed, lower left: Picasso
The Mr. and Mrs. Klaus G. Perls Collection, 1997
1997.149.7

In this painting and other related works from the series (see below), Picasso addressed the subject of a woman seated in an armchair, a motif that recurs sporadically in his work through the decades and which in 1909–10 certainly reflected the influence of Paul Cézanne's many paintings of his wife in an armchair (fig. 51.1).[1] Unlike in other works that Picasso painted before and after 1909–10 in which figures are shown sitting on the ground, on boxes, and on unseen supports, the chair in this painting is an important element of the composition. It is treated as an extension of the woman's body, echoing its forms and colors. Although the woman is likely based on Fernande Olivier, judging by her swept-up hairstyle and rounded C-shaped eyebrow (evident in photographs of Fernande from the period), she is all but anonymous, with few identifying features.

In September 1909 Picasso and Fernande moved from their shabby and almost empty Bateau Lavoir apartment (on the rue Ravignan) into a larger and more fully furnished place on the boulevard de Clichy, near the place Pigalle. As Fernande described it: "He had rented a large north-facing studio and an apartment on the south side with two windows overlooking the beautiful trees and gardens of Avenue Frochot. . . . It was the beginning of a completely different life, at least in its externals. . . . Behind the bedroom, at the back, there was a small sitting room with a couch, a piano and a pretty piece of Italian furniture inlaid with ivory, mother-of-pearl and tortoise-shell, which Picasso's father had sent him together with some other fine antique furniture. . . . We would also go to the flea market, where. . . . we found some beautiful pieces of tapestry . . . verdures, Aubusson and Beauvais."[2] Photographs taken by Picasso in 1909–12 show the wide chair-rail moldings that ran around the walls and the elaborate floral wall covering that decorated at least one room.[3] The new residence was a tangible sign of the artist's professional success, yet such trappings of respectability often left him conflicted, "torn between bourgeois pride . . . and bohemian shame."[4]

The Metropolitan's *Woman in an Armchair* is one of at least five related pictures that date from Picasso's first months in the new apartment (autumn 1909 to spring 1910).[5] Its style reflects his ongoing experimentation with integrating the human figure into its surroundings. Although the process eventually resulted in the dissolution of all form into lines and planes (Analytic Cubism), at this transitional stage the architecture still retains its solidity; even so, the curves of the woman's body have begun to merge into the patterned drapery (at right). Picasso emphasizes

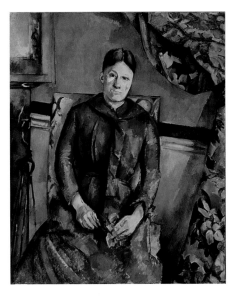

Fig. 51.1. Paul Cézanne, *Madame Cézanne in a Red Dress*. Oil on canvas, 45⅞ × 35¼ in. (116.5 × 89.5 cm). The Metropolitan Museum of Art, New York, The Mr. and Mrs. Henry Ittleson Jr. Purchase Fund, 1962 (62.45)

the setting, not the figure, depicting the heavy cornices and pilasters, the light-filled window with curtain tieback knob, the elegant scroll of the chair back, and the floral fabric with brighter and lighter colors (pale yellow beiges and rosy pinks), even as the undefined woman all but dissolves into shadow.

The figure's role in the finished painting was not always diminished, however, as is evidenced by earlier states of the composition (see technical note below). Originally, the woman's head was significantly larger (about three inches longer and two inches wider) and shaped more like the pointed, masklike heads in *Les Demoiselles d'Avignon* of 1907 (see fig. 40.1).[6] Also, the diagonal beams at the top center of the composition once intersected with the head. Other changes to the face, torso, and arms are now concealed with rough overpainting that was thickly applied in those areas. It is astonishing that, despite Picasso's obvious difficulties in resolving the figure, he painted all of the architectural background in one sure campaign, in a thin layer of paint, without making any changes at all.

LMM

1. Picasso once said that Cézanne (1839–1906) was his "one and only master. It was the same with all of us—he was like our father" (quoted in Richardson 1991–2007, vol. 2 [1996], p. 52). In Paris, Picasso could have seen Cézanne's portraits of his wife in Ambroise Vollard's gallery as well as at the 1907 Salon d'Automne, where Cézanne's works occupied two entire rooms. Influenced by Cézanne's compositional arrangements of a woman seated in an interior, which often depict wall coverings and fabrics in floral and other patterns, Picasso sometimes adopted Cézanne's manner of paint application as well as his color palette.

Fig. 51.2. Pablo Picasso, *Bust of a Woman (Fernande)*, Horta de Ebro, Summer 1909. Oil on canvas, 36⅝ × 29⅛ in. (93 × 74 cm). The Hiroshima Museum of Art

Fig. 51.3. X-radiograph of cat. 51, with lines indicating previous compositions

2. Olivier 2001a, pp. 251, 253, 254.
3. See Picasso's photographs of the boulevard de Clichy apartment (Houston and other cities 1997–98, figs. 98, 103, 105, 106, 108–15, 118).
4. Richardson 1991–2007, vol. 2 (1996), p. 143.
5. For related works, see DR 327, 329, 331, 332, 342, 343. The Metropolitan Museum's *Woman in an Armchair* (DR 333) would seem to predate the two last works cited above (DR 342, 343), which are painted in the style of Analytic Cubism.
6. In the winter of 1909–10, Picasso painted a similar mask-shaped head in a smaller watercolor and gouache study on paper, *Head and Shoulders of a Woman* (DR 327).

PROVENANCE
[Paul Guillaume, Paris, by 1929–d. 1934]; his widow, Domenica Guillaume, née Juliette Lacaze, later Mme Jean Walter, Paris (from 1934); Jacques Sarlie, New York (by 1954; his sale, Sotheby's, London, October 12, 1960, no. 10, for £30,000, through Kirnberger, to Perls); [Perls Galleries (Klaus G. Perls), New York, from 1960, stock no. 6410]; Mr. and Mrs. Klaus G. Perls (until 1997; their gift to the Metropolitan Museum, 1997)

EXHIBITIONS
Paris 1929, pp. 123 (ill.), 189; New York (Perls) 1954, no. 3, ill.; New York (Perls) 1961, no. 14, ill.; New York (Knoedler) 1962, no. 43, ill.; New York (Perls) 1965, no. 1, ill.; New York 2000, pp. 67 (ill.), 125, brochure no. 2, ill.; Kyoto–Tokyo 2002–3, pp. 59 (pl. 15), 168

REFERENCES
Zervos 1932–78, vol. 2a (1942), p. 98 (ill.), no. 198; Sabartés 1946a, pl. 6; Daix and Rosselet 1979 (both eds.), p. 252 (ill.), no. 333; Palau i Fabre 1990, pp. 166, 167, 502 (ill.), no. 470; Giraudon 1993, p. 103 (ill.); Anon., May 21, 1996, p. F2; Kaufman 1996a, p. 14; Richardson 1991–2007, vol. 2 (1996), p. 145 (ill.); Vogel 1996, p. C11; Pierre Georgel in Montreal–Fort Worth 2000–2001, pp. 36 (installation view of Bernheim-Jeune [Paris 1929]), 68; Karmel 2003, pp. 69–70 (fig. 83), 124 (fig. 142), 125; Julia May Boddewyn in New York–San Francisco–Minneapolis 2006–7, p. 371; Grimes 2008, p. B6

TECHNICAL NOTE
Picasso's application of paint varied across the canvas, from extremely thin and direct, as in the background, to other areas that he heavily built up, primarily the head and torso. X-radiography revealed numerous changes that he made to the composition, including three different positions of the head (fig. 51.3). The first two heads were oval with a sharp chin; both were significantly larger than the final version. The first head—largest of all—merged with the architectural molding, which cascaded into the head and zigzagged down to the top of the armchair. The woman's proper right eye was clearly visible, as were her right ear, long sharp nose, and mouth. The second head was much like the first, but smaller, contained within the outline of the former. The present head is smaller still, with no proper right eye, ear, or mouth. The features on the right side are now seen in profile, a device that the artist would use frequently in later works. This final head tilts toward the woman's right, unlike the more frontal previous heads, and this tilt counterbalances the slight turn to the left of the torso.

Changes in the arms and the armchair are also apparent. Initially the woman's arms were in a position reminiscent of an earlier work, *Bust of a Woman (Fernande)* (fig. 51.2), that is, folded across her abdomen. The proper left arm was placed higher and nestled in the elbow of the right arm; the proper right arm of the chair emerged in a generous curve that began at the molding and the right scroll of the back of the chair. The left arm of the chair was also fuller and flared out toward the edge of the canvas, though not as dramatically as the right arm. Picasso eventually reduced the woman's upper right arm and added a hand that now grasps the greatly reduced right arm of the chair. He changed the direction of the left upper arm so that it faces downward and painted a forearm and hand (palm up) on top of the erstwhile green armrest.

The result of these changes is a more abstract figure. The blending of colors indicates that these changes closely followed one another. The final state has beautifully painted areas, particularly the proper right hand. Passages that the artist decided to eliminate, using primarily brown paint, lack the crispness and immediacy of the more directly painted sections.

Picasso painted *Woman in an Armchair* on a commercially prepared white ground applied to medium-weight canvas. The painting was glue-lined before entering the Metropolitan Museum's collection. A series of horizontal cracks in the paint suggests that the work was rolled at one time, and the lining may have been done to stabilize the cracks. The original canvas shrank during that process and as a result the paint has slight overlaps throughout. It was varnished, most likely at the time it was lined.

LB

52. Standing Female Nude
Paris, Autumn–Winter 1910

Charcoal on white wove paper watermarked A LAVIS ANE^{NE} MANUF^{RE}
CANSON & MONTGOLFIER
19 × 12⅜ in. (48.3 × 31.4 cm)
Signed and inscribed on verso in graphite, lower left: 49 bis <u>Picasso</u>
Inscribed on verso in graphite, upper left (in Stieglitz's hand): Property - / AS
Alfred Stieglitz Collection, 1949
49.70.34

Standing Female Nude is one of Picasso's best-known Cubist
drawings. It has commanded interest from the time of its
debut, as is reflected in its publication and exhibition history for
the past century.[1] Of particular note is its inclusion in Picasso's
first two exhibitions in America, his 1911 solo show of drawings
and watercolors at Alfred Stieglitz's New York gallery, 291,[2] and
the large International Exhibition of Modern Art (Armory
Show), of 1913, where Picasso was represented by eight works.[3]
The press coverage of these events occasionally singled out this
particular drawing for illustration or comment, where it was
mainly disparaged or misunderstood. Mockingly referred to in one
review as a "fire escape, and not a good fire escape at that," it
became an example of what many perceived as Picasso's "aston-
ishing travesties on humanity."[4] Even the painter-photographer
Edward Steichen, who had helped select the drawings for the
1911 show, wrote skeptically to Stieglitz about Picasso's recent
Cubist work, saying that it was "certainly '*abstract*' nothing but
angles and lines that has got the wildest thing you ever saw laid
out for fair," adding: "I admire him but he is worse than greek
to me. I am afraid I am too human and too sensitive to flesh to
follow a man's abstractions into such fields. There is one late
picture that represents a nude woman. If you can make it out
you are as good as I am."[5] Steichen included a sketch that makes
it clear he was referring to *Standing Female Nude*.

Marius de Zayas's essay in the pamphlet written for the 291
show was a preemptive attempt to explain the artist's Cubist
work, but it did little to deflect the negative responses.[6] For
Stieglitz, who introduced Picasso's work to America precisely
because it was the "red rag" that would grab people's attention,
and who purchased *Standing Female Nude* for his own collec-
tion from the 1911 show for the same reason, this drawing repre-
sented the pinnacle of modern innovation.[7] In three separate
issues of *Camera Work* (October 1911, August 1912, and June
1913) he featured the drawing together with examples of avant-
garde writing, photography, and art. And in a 1913 letter to
Arthur Jerome Eddy (in whose pioneering book *Cubists and
Post-Impressionism* it was reproduced the next year), Stieglitz
summed up his feelings by saying that it was "probably the fin-
est Picasso drawing in existence . . . as perfect as a Bach Fugue."[8]

When the Museum accessioned *Standing Female Nude* in
1949, the following inscription in Stieglitz's hand was on the
back of the frame: "This drawing was the finest of the series

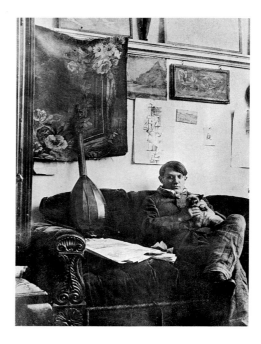

Fig. 52.1. Picasso
in his studio on
boulevard de Clichy,
1910, with cat. 52
on wall behind him.
Gelatin silver print.
Musée National
Picasso, Paris (DP18)

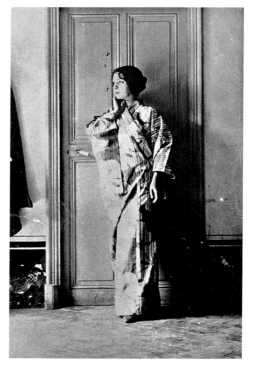

Fig. 52.2. Eva Gouel
wearing a kimono,
ca. 1910 (?). Docu-
menation, Musée
National Picasso,
Paris, Gift of Sir
Roland Penrose
(DP24)

shown [at 291] & according to P[icasso] himself is one of the most beautiful things he ever did."[9] A number of small black-and-white photographs taken by the artist and his friends in late 1910–early 1911 (fig. 52.1) attest to the fact that *Standing Female Nude* occupied a place of honor in Picasso's Paris studio on the boulevard de Clichy, where it was prominently displayed for visitors to see.[10] In these snapshots of himself and his associates (Daniel-Henry Kahnweiler, Max Jacob, and Ramon Pichot, *Standing Female Nude* is tacked to the wall (unframed)[11] over one of Picasso's newest possessions, an "immense Louis-Philippe couch, upholstered in violet velvet with gold buttons."[12] The drawing's placement over the center cushion and the charcoal's strong graphic lines against the white paper make it a focal point of the wall and of the photographs as well, where it seems to be almost deliberately coupled with the seated men. While these pairings may be purely accidental, one cannot help but wonder if the woman in the drawing held some particular significance for Picasso, as he often depicted the women he was emotionally involved with in his art, sometimes even before the affair was made public. In this case, the similarity between the pose of this figure—all angles and zigzags—and a photograph of Eva Gouel (Marcelle Humbert), who entered Picasso's social circle in 1910, eventually replacing Fernande in his affections, encourages speculation (fig. 52.2).[13]

The figure's pose in *Standing Female Nude* also relates to a series of slightly earlier pen-and-ink drawings of standing nudes that Picasso made in the spring of 1910, in Paris, and later that summer, at Cadaqués.[14] Those drawings eventually evolved into two etchings made to illustrate Max Jacob's novel *Saint Matorel*.[15] As Brigitte Baer noted in the catalogue *Picasso the Printmaker*, "The summer in Cadaqués was of paramount importance in Picasso's development. He was struggling with new ideas which were already nascent in the work of spring 1910, and, to quote Kahnweiler, began 'to blow up the coherent form.' It seems likely that the etchings for *Saint Matorel* were the catalysts for the birth of what is now called Analytical Cubism."[16] During this new phase, Picasso's imagery grew increasingly more difficult to decipher as it became less closely tied to a literal transcription of reality. Solid form was now depicted as an open and somewhat untethered lattice of arcs and vertical and horizontal lines, as it is in *Standing Female Nude*, where the artist has accentuated the figure's verticality, imparting to it a "graceful contrapposto," as Gary Tinterow observed of this drawing, which "reveals the artist's supreme control over his stylistic syntax. No single line or plane literally describes a particular aspect of this woman; instead they converge and coalesce to provide an image which is, in effect, the equivalent of a standing figure."[17]

LMM

1. Scholars have put forward dates for this drawing that range from spring 1910 to early 1911. Christian Zervos (z iia.208) favored spring 1910 [Paris]; Gary Tinterow (in Cambridge–Chicago–Philadelphia 1981, p. 106) proposed Paris, autumn 1910; William Rubin (in New York 1989–90, p. 167) preferred Cadaqués or Paris, summer–autumn 1910; Josep Palau i Fabre (1990, p. 190) suggested Cadaqués,

summer 1910; and Pepe Karmel (2003, p. 83) opted for Paris, winter 1910–11. The exact date may be impossible to determine, but it is certain that the drawing was finished by the time it was shipped from Paris to New York for Picasso's 1911 show organized by Alfred Stieglitz at 291, and indeed, in light of the inscription on its verso—"49 bis"—it appears to have been a late addition to the shipment.

In a letter probably written in January or February 1911, Edward Steichen notified Stieglitz, "I am sending the Picassos on the next boat," and reported: "Numbers 1 to 49 bis are the pictures we intended for the walls—some as you will see belong in groups and can go under one glass." (Alfred Stieglitz/Georgia O'Keeffe Archive, Yale Collection of American Literature, Beinecke Rare Book and Manuscript Library, YCAL MSS 85, box 46, folder 1095). On the basis of this letter, we may establish that fifty drawings and watercolors were sent for the exhibition (i.e., one more ["bis"] than the forty-nine works, generally thought to have been featured in the display), which possibly also included some etchings (see Norman 1973, p. 107); thirty-four additional drawings were made available for viewing in portfolios. In the absence of an exhibition checklist or installation photographs, the precise contents of the show have proven elusive, but there can be no doubt as to the presence of *Standing Female Nude* or of the one other drawing that was purchased from the show, *Study of a Nude Woman* (ca. 1905–6, now in the Museum of Fine Arts, Boston).

2. For the 291 exhibition, see note 1, above.

3. The works by Picasso in the Armory Show represented a broader array of media (painting, sculpture, and drawing) than had been shown at 291 but did not reveal much about his artistic development since 1911 (for example, no collages or constructed cardboard sculptures were included).

4. Quoted from [Hoeber] 1911, p. 12.

5. Steichen to Stieglitz, January or February 1911 (see note 1 above).

6. Based on his 1910 interview with Picasso, de Zayas's essay for the 1911 show was reprinted in *Camera Work* 34–35 (April–July 1911), pp. 65–67. It was the first in-depth analysis of Picasso's art published in America.

7. Steichen used the phrase "red rag" in a letter to Stieglitz, written about June 1908 (Stieglitz/O'Keeffe Archive, YCAL MSS 85, box 46, folder 1094), when they were first contemplating a Picasso exhibition at 291: "As for the red rag I am sure Picasso would fill the bill if I can get them—but he is a crazy galoot hates exhibiting etc.—however we will try him."

Stieglitz purchased *Standing Female Nude* for $65. The price is cited in a letter of December 19, 1939, from Stieglitz to E. A. Jewell of the *New York Times* (Stieglitz/O'Keeffe Archive, YCAL MSS 85, box 36, folder 866). The letter was published in "To The Art Editor," *New York Times*, December 24, 1939, p. 91.

8. Alfred Stieglitz to Arthur Jerome Eddy, November 10, 1913 (Stieglitz/O'Keeffe Archive, YCAL MSS 85, box 15, folder 367).

9. Recorded in the NCMC archives.

10. The photographs are undated but were probably taken in late (fall/winter) 1910 or early 1911. Some of these photographs and original glass negatives of others survive in the Picasso Archives, Musée Picasso, Paris; for reproductions, see Houston and other cities 1997–98, figs. 105, 108, 110, 111. According to Palau i Fabre (1990, p. 198, fig. 551a), the photograph of Picasso on the couch (fig. 52.1 here) was taken by Ramon Pichot.

11. A single tack hole can still be found in the drawing, located slightly left of center at the top of the page.

12. Olivier 1964, p. 136.

13. For information about Eva Gouel, whom Picasso secretly referenced in several paintings (adding her initials, for example, or physical attributes), see Richardson 1991–2007, vol. 2 (1996), pp. 179–80, 221–23. Picasso owned the undated photograph of Eva in a kimono (fig. 52.2) and may have taken it himself (see Tucker 1982, p. 298). Yet, despite the strong visual similarities between *Standing Female Nude* and the photograph, the uncertain dating of both works renders any connection between them purely speculative.

14. For the related pen-and-ink drawings, see Karmel 2003, pp. 72–80, and Karmel 1993, figs. 19–25, 35–52. Without these small ink drawings and the related paintings from the summer of 1910, it would be difficult to identify the Metropolitan's drawing as a nude. The drawing is the only one of the series executed in charcoal on a large sheet of paper (without noticeable revisions), and it represents the summation of the series.

15. The novel was published in Paris in 1911 by Daniel-Henry Kahnweiler with four etchings by Picasso. Two of them depict the novel's female character Mlle Léonie standing and reclining in a chaise longue. *Standing Female Nude* combines elements found in both of these etchings, including the overall configuration of the body and the T-shaped marks that form its structural framework and a number of small linear signs representing different body parts (the "melon-slice" shoulders, angled knees, curved breasts, and tubular neck).

16. Baer in Dallas and other cities 1983–84, p. 36.

17. Tinterow in Cambridge–Chicago–Philadelphia 1981, p. 106.

PROVENANCE

Alfred Stieglitz, New York (1911–d. 1946; purchased from the artist in March 1911 for $65); his estate (1946–49; gift to the Metropolitan Museum, 1949)

EXHIBITIONS

New York 1911, no cat.; New York–Chicago–Boston 1913, no. 351 (New York), no. 287 (Chicago), no. 144 (Boston); Philadelphia 1920, no. 196; New York (MoMA) 1936, no. 213, pp. 42, 43 (fig. 27), 220; New York (American Place) 1937, no. 38; New York and other cities 1939–41 (shown in New York only), no. 92, p. 72 (ill.); New York (American Place) 1941, no. 16; New York 1944, pp. 43 (ill.), 95; New York (MoMA) 1947, no cat., checklist no. 92; Chicago 1948, no cat., checklist no. 99; Toronto 1949, no. 39; Philadelphia 1950–51, no. 115, p. 39 (ill.); New York 1951, no cat., checklist no. E.L.51.695; New York–Chicago 1957, p. 39 (ill.); Philadelphia 1958, no. 51, p. 17, ill.; Rotterdam 1958, no. 216, pp. 139–40, 201 (ill.); Paris 1958, no. 216, pl. 216; New York 1959, no. 216, pp. 139, 201 (ill.); Utica–New York 1963, no. 351, pp. 87 (ill.), 200; New York 1967, no cat., unnumbered checklist; Los Angeles–New York 1970–71, no. 267, p. 305, ill.; New York (MMA) 1970–71, no. 399, p. 329 (ill.); Paris 1973–74, no. 74, pp. 57 (ill.), 163 (fig. 93); Paris 1977, pp. 256, 257 (ill.); New York 1980, pp. 122 (ill.), 141 (ill.); Cambridge–Chicago–Philadelphia 1981, no. 37, pp. 106–7 (ill.); New York 1989–90, p. 167 (ill.); New York–San Francisco–Minneapolis 2006–7 (shown in New York only), pp. 25, 29 (pl. 5), 30, 32, 36, 51, 53, 68, 329, 330, 343, 346, 351, 359, 362, 375, 386

REFERENCES

Camera Work, no. 36 (October 1911), pl. 1; *Camera Work*, special number (August 1912), p. 39 (ill.); *Camera Work*, special number (June 1913), p. 53 (pl. VII); Laurvik 1913, p. 2 (ill.); Eddy 1914, ill. facing p. 100; Frank et al. 1934, pl. VIIIa; Stieglitz 1939, p. 91; Zervos 1932–78, vol. 2a (1942), p. 103 (ill.), no. 208; Barr 1946, pp. 72 (ill.), 73; Boeck and Sabartés 1955, p. 44 (ill.); Penrose 1957, p. 37 (ill.); Jardot 1959, p. 154, pl. 29; Rosenberg 1959, pp. xxiv, 127, pl. 232b; Rosenblum 1960, pp. 56 (fig. 34), 60, 62, 226; M. Brown 1963, pp. 75, 216–17 (ill.), 276, no. 351; Bean 1964, no. 96, ill.; Jaffé 1964, p. 18 (fig. 17); Jaffé 1967, p. 16 (fig. 17); Leymarie 1967, pp. 30, 33 (ill.) (English ed., pp. 35 [ill.], 105); Hamilton 1970, p. 379; Kahnweiler 1971, ills. between pp. 16–17; Russoli and Minervino 1972, pp. 103–4 (ill.), no. 331; Norman 1973, p. 108 (fig. 47); Gordon 1974, pp. 673, 699, 715 (Armory Show cats.); Porzio and Valsecchi 1974, p. 38 (ill.); Rosenberg 1974, p. 165, fig, 296b; Hilton 1975, pp. 104–5 (fig. 71), 279; Baumann 1976, pp. 65 (fig. 112), 206; Johnson 1976, p. 219 (fig. 219); Daix 1977, p. 17 (ill.); Homer 1977, pp. 62, 65 (fig. 32); Marrinan 1977, pp. 760–61 (fig. 38); Schapiro 1978, fig. 1 facing p. 138; Frank et al. 1979, pl. 50; Monnier and Rose 1979, pp. 202 (ill.), 273; Steinberg 1979, pp. 120 (fig. 6), 121; Ulrich Weisner in Bielefeld 1979, p. 267 (ill.), 343 (fig. 8), 344–45, pl. 58; Edgerton 1980, pp. 498–501 (fig. 52), 502; Kodansha 1981, p. 107 (pl. 22); Daix 1982b, pp. 55 (ills.), 164; Tucker 1982, pp. 291, 294 (fig. 11); Rubin 1984, pp. 282 (ill.), 300 (ill.); Isabelle Monod-Fontaine in Paris 1984–85, p. 105 (ill.); Alley 1986, p. 15 (fig. 18); Bernadac, Richet, and Seckel 1986, pp. 142 (ill.), 231 (ill.); Michèle Richet in Bernadac, Richet, and Seckel 1985–87, vol. 2 (1987), p. 107 (fig. 6); M. Brown 1988, p. 302, no. 351; Jouvet 1989, p. 8 (ill.); Podoksik 1989, p. 104 (ill.); Palau i Fabre 1990, no. 533, p. 190 (ill.); Percy North in Atlanta and other cities 1991–93, pp. 23, 24 (fig. 3, upside down); Bois 1992, discussion, p. 212 (fig. 3); Warncke 1992, vol. 1, p. 193 (ill.); Karmel 1993, vol. 1, p. 65, vol. 3, "Appendix I: Dating of the Figures," pp. 382–83, 439 n. 24, vol. 4, figs. 53, 54; Rose 1993, pp. 52–53 (fig. 7); Warncke 1993, vol. 1, p. 193 (ill.); Anne Baldassari in Paris 1994, pp. 119–21 (figs. 90–92); Hélène Seckel in Quimper–Paris 1994, p. 74 (fig. 1); sale, Christie's, New York, November 7, 1995, p. 34 (fig. 2, upside down); Daix 1995, pp. 672–73; P. Read 1995, p. 115 (ill.); Richardson 1991–2007, vol. 2 (1996), pp. 144 (ills.), 300 (ill.), 312 (ill.); de Zayas 1996, pp. 24 (fig. 28), 26; Anne Baldassari in New York–Paris 1996–97 (both eds.), pp. 183 (ill.), 210–11 (ills.); Céret 1997, ill.; Anne Baldassari in Houston–Munich 1997–98, pp. 90 (fig. 105), 93 (fig. 108), 94 (fig. 110), 95 (fig. 111); Villeneuve d'Ascq 1999, p. 13 (ill.); Sarah Greenough, Charles Brock, and Helen M. Shannon in Washington 2000, pp. 36, 37 (fig. 14), 116 (fig. 41), 120, 124, 176, 382, 537, 559; Léal, Piot, and Bernadac 2000 (Eng. ed.), pp. 18 (ill.), 151 (fig. 332), 509; P. North 2000, p. 77 n. 25; Schapiro 2000, pp. 21, 22 (fig. 30), 188; New York (Hollis Taggart) 2001–2, p. 25 (ill.); Greenough 2002, vol. 1, pp. xxv–xxvi (fig. 18); Karmel 2003, pp. 82–83 (fig. 100), 123 (fig. 140); Paris–Madrid 2004–5, pp. 72 (fig. 22), 168 (fig. 83); C. Green 2005, p. 8 (fig. 4); Kanagawa 2006, p. 61 (fig. 4); New York 2007, p. 36 (ill.); Anne Baldassari in Paris 2008–9, p. 30 (ills.); Debra Bricker Balken in Williamstown 2009, p. 5 (fig. 3); K. Wilson 2009, p. 26 (fig. 6, installation view of New York [An American Place] 1937); New Haven–Durham 2009–10, p. 16 (fig. 1)

TECHNICAL NOTE

Picasso executed *Standing Female Nude* in two types of charcoal on a white wove artists' paper. Charcoal can either be natural—created from a charred piece of plant material such as wood or a piece of a vine, known as vine charcoal—or a fabricated stick composed of charcoal powder compressed into a crayon. The variety found in natural materials and the variances in manufacturing mean that charcoal can have a range of shades, textures, and working properties for the artist.

The predominate medium Picasso used in this drawing is a deep rich black charcoal whose glittery quality is produced by minute shards of the material that have detached from the crayon. The shards have collected on the paper around the drawn lines, giving a softness to the otherwise deliberate strokes. The artist used this type of charcoal to create subtle modulations of tone. In some areas Picasso stumped, or deliberately smudged, the charcoal lines with a cloth, tool, or more likely his finger to create a variety of grays. In other areas he used a light stroke so that the color would deposit only on the high points of the textured paper. He also used this rich black charcoal to reinforce the major lines with strong deliberate strokes of black.

Picasso frequently used two shades of similar color in his charcoals, pastels, and ink drawings. Here a second type of charcoal, laid down in thin lines, has a distinctly brown hue. This less prominent shade is most visible in the head of the figure but can be found throughout the drawing. The layering of the colors and strokes indicates that Picasso applied the brown lines to the paper first and then followed using the black. The brown charcoal, which is harder than the black and possibly grittier, scraped and scored the paper, leaving white streaks that follow the lines of the drawing.

Picasso often chose a high-quality artists' paper as the support for his drawings. This sheet, manufactured by one of the preeminent artist paper manufacturers, Canson & Montgolfier, is a paper that Picasso used frequently for his drawings in this period. Its pebbley texture facilitated the transfer of particles of charcoal to the paper and provided sufficient tooth to hold them on the surface. The paper is watermarked "A LAVIS," to indicate it was created for artists to use with watercolors; however, this was also an indication of a paper created for general artists' use, and Picasso often chose papers and combinations of media that suited his working methods rather than follow a prescribed usage.

RM

53. Still Life with Cruet Set
Paris, early 1911

Ink on white wove paper
12⅜ × 9½ in. (31.4 × 24.1 cm)
Signed on verso in ink, upper left: <u>Picasso</u>
Alfred Stieglitz Collection, 1949
49.70.31

The early history of this little drawing is somewhat uncertain. It seems likely that it was one of nine purchased by the Parisian art dealer Adolphe Basler on March 31, 1914, from the Moderne Galerie in Munich, run by Heinrich Thannhauser, and deposited with Alfred Stieglitz in New York in December 1914 as collateral for a loan.[1] When Basler defaulted on the loan (on August 15, 1915, after two extensions), the nine drawings became Stieglitz's property in spite of his protestations that he never really wanted them in the first place.[2] Although made only four years before it entered Stieglitz's collection, this drawing already represented an earlier phase of Cubism (Analytic Cubism), which had been superseded by Synthetic Cubism and Picasso's experiments with the audacious new genre of papier collé (see also cats. 58, 59).

The subject of the drawing is an ordinary cruet set, which has been transformed into an elaborate architectural scaffolding, much like the figure in *Standing Female Nude* (cat. 52) of about the same time. The two-tiered metal stand, or caster, is constructed of two horizontal ellipses on four skinny legs, and on either side of the center post topped by a ring are two stoppered glass bottles for holding oil and vinegar. These objects retain a semblance of reality and some recognizability despite Picasso's recent interest in deconstructing form and space. Not only does the diagonal placement of the ellipses introduce a sense of shallow recession into space, the addition of cast shadows, where the metal feet meet the table surface, inserts a surprising note of realism.

When Picasso chose the same subject for one of his oil paintings of January 1911 (fig. 53.1), he depicted it in a considerably looser, more linear, and more reductive manner, with almost no three-dimensional allusions and with its identity as a cruet set all but lost, save for the title.[3] Using the drawing as a guide, we can read in the painting the caster legs, glass flasks, and structural ovoid shapes. These are the artist's only known images of this object, but the fully thought out, well-executed nature of the drawing, which was done in ink without any pencil under-drawing or corrections, suggests that he may have made some preliminary studies. Based on the drawing's close relationship to the painting, we date it to early 1911, although it might have been done late in 1910.[4]

The subject is unusual in Picasso's oeuvre; the work is one of a number of simple still lifes that he did in Paris in the winter of 1910–11, which often focused on a single object. Among them are the paintings *Bottle and Books*, *The Inkwell*, *The Writing*

Fig. 53.1. Pablo Picasso, *The Cruet*, 1911. Oil on canvas, 9½ × 7½ in. (24 × 19 cm). Private collection

Desk, *The Dressing Table*, and *Field Glasses*[5] and a small pen-and-ink study of a rolling ink blotter that is very similar in technique to *Still Life with Cruet Set*.[6] In their very ordinariness, as Douglas Cooper reminds us, these pictures can be "replete with intimate and often topical references." He continues: "Cubism has often been accused of being formalist and divorced from life. . . . [but] we must not overlook the personal relevance and time-bound significance which this seemingly banal subject matter also had for Braque and Picasso. . . . [D]aily life . . . is enshrined in their still lifes: things to eat, drink, smoke, read and discuss. . . . Thus even though the artists seem to have neglected the human element, we find on examination that cubist painting was in fact a very real record of their private lives and experiences."[7]

LMM

1. See the entry for cat. 47. We suspect that Thannhauser's 1913 Picasso exhibition in Munich was the source for this group of drawings (see also cats. 24, 48, 49, 53, 56, 57); however, not all of the works may be definitely identified in the catalogue to the show (only one was illustrated in Munich 1913; see cat. 47). The present drawing appears to have been listed as number 108, ("L'huilier," 1911, marked for sale). In March 1915, before Stieglitz acquired it, this drawing was reproduced in the first issue of the journal *291* (where it was titled "Oil and Vinegar Caster").

2. Stieglitz to Basler, May 7, 1915, p. 2 (Alfred Stieglitz/Georgia O'Keeffe Archive, Yale Collection of American Literature, Beinecke Rare Book and Manuscript Library, YCAL MSS 85, box 4, folder 82): "Now I made you clearly understand that I did not want the pictures, having no right to spend any money for pictures, and even if I did have the right I would prefer to spend the money for more modern work by Picasso."

3. The canvas is signed and dated on the verso. It was included in the Thannhauser Picasso exhibition (Munich 1913, no. 59, *L'huilier*, 1911).

4. A winter 1910–11 date for the drawing was suggested by art historian Lewis Kachur in a letter to the Museum of January 22, 1985 (NCMC archives), and by Josep Palau i Fabre (1990, p. 505, no. 562).

5. DR 371–75.

6. See Palau i Fabre 1990, p. 504, no. 558, ill. p. 202.

7. Cooper in Los Angeles–New York 1970–71, pp. 62, 64.

PROVENANCE

[Probably with Moderne Galerie (Heinrich Thannhauser), Munich, by 1913 and sold on March 31, 1914, to Basler]; [Adolphe Basler, Paris, 1914–15; left with Stieglitz in December 1914 as collateral for a loan and acquired on August 15, 1915, upon default of loan]; Alfred Stieglitz, New York (1915–d. 1946); his estate (1946–49; gift to the Metropolitan Museum, 1949)

EXHIBITIONS

Probably Munich 1913, no. 108; probably Cologne 1913, no. 108; New York 1915, no cat.; Philadelphia 1920, no. 188; Philadephia 1944, no. 97; Chicago 1948, no cat., checklist no. 16; New York 1951, no cat., checklist no. E. L.51.700; New York 1967, no cat., unnumbered checklist; Tübingen–Düsseldorf 1986, no. 76, p. 277, ill.; Stockholm 1988–89, no. 166, p. 241; London 1994, no. 53, pp. 76 (ill.), 263–64; New York 1995, unnumbered cat.

REFERENCES

291, no. 1 (March 1915), p. 3 (ill.); Ester Coen in New York 1988–89, p. 148 (ill.); Palau i Fabre 1990, p. 203 (fig. 562); Karmel 2000, p. 189; Rodriguez 2001, p. 108; Julia May Boddewyn in New York–San Francisco–Minneapolis 2006–7, pp. 329, 359

TECHNICAL NOTE

Picasso drew with a metal nib pen on thick, white wove artists' paper, which has a nubby texture and was probably intended for use with watercolors. He first outlined the design in a thin diluted ink that appears gray and then formed the design, with full-strength black ink, using loops, lines, and short strokes to define forms and indicate shadows. RM

54. Still Life with a Bottle of Rum

Céret, Summer 1911

Oil on canvas
24⅛ × 19⅞ in. (61.3 × 50.5 cm)
Signed and inscribed on verso in dark gray paint, upper center:
Picasso / ceret
Jacques and Natasha Gelman Collection, 1998
1999.363.63

Picasso painted *Still Life with a Bottle of Rum* in the summer of 1911, which he spent in Céret, a small town in the foot-hills of the French Pyrenees. Ideally situated between the Mediterranean coast and the mountains, Céret also had the advantage of being unspoiled and relatively inexpensive.[1] He learned about it from two friends, the painter Frank Burty Haviland and the sculptor Manolo (Manuel Martínez Hugué), who had settled there in 1910. Picasso lived first at the Hôtel du Canigou and for a studio used a room in Haviland's large house, the Maison Alcouffe. After Georges Braque joined him in Céret in mid-August, they moved together to much larger quarters: the second floor of the Maison Delcros, which Picasso rented from a local family. The house later became known as "La maison des cubistes."[2]

One is hard-pressed to discern the bottle of rum indicated in the title of the painting, made during the most abstract phase of Cubism, known as "high" or Analytic Cubism (1910–12). Until that time, one could usually recognize the subject in a Cubist picture, even though Picasso and Braque had dissected (or "ana-lyzed") the figures or objects into a multitude of small facets and then reassembled them, after a fashion, to evoke those same figures or objects. This changed in late 1910 as Picasso and Braque began to break down forms even further into large abstracted and faceted planes, various types of arcs, narrow and wide angles, and series of straight and diagonal lines. They used a sober palette of grays, browns, and blacks (some opaque, some not) and, often, short brushstrokes to create a dappled effect, allowing planes to overlap and merge in shallow, relieflike space. While such works—be they still life, figure study, or, less fre-quently, a landscape—are rooted in reality, any links to the nat-ural world save the barest clues appear to have been severed. At top center of this picture, the neck and opening of a bottle can be made out. Spidery black lines to the left of the bottle might denote sheet music; the round shape farther down could be the base of a glass; and in the center at far right is what appears to be the pointed spout of a *porrón*, a traditional type of Spanish wine bottle.[3] The degree of abstractness of this and other Cubist paintings prompted Daniel-Henry Kahnweiler, Picasso's and Braque's dealer and friend, to plead with the artists to give these works descriptive titles. Yet the titles given to them (we do not always know by whom) occasionally prove misleading. One collector lived happily with his "landscape" when, in fact, he owned a figure of a musician.[4]

In the spring of 1911 Braque introduced stenciled letters, words, and numbers into his work because they constitute "forms. . . outside space and [are] therefore immune to deformation."[5] The inherent two-dimensionality of a letter emphasizes the flat-ness of the picture surface on which it floats; it also makes the shallow space beneath it look more three-dimensional. In addi-tion, the letters in a Cubist painting often refer obliquely to the subject of the picture. Braque thus added not only a touch of realism to the Cubist repertoire of images, which in some ways

had perhaps become too abstracted and cerebral, he devised a welcome source for further ambiguity and visual puns.

Still Life with a Bottle of Rum, made less than a month after Braque's innovation, is one of the first works in which Picasso included letters.[6] On the picture's left edge are the letters "LETR" arranged in a half circle, so that the much smaller "R" sits below the "T." Picasso left the vertical bar of the "L" outside the picture's edge. It has been suggested that these letters refer to *Le Torero*, a magazine for bullfighting enthusiasts—Picasso being one of them—but they might just as easily be a pun on the French word "*lettre*."[7] S R

1. See the lengthy description of Céret by John Richardson in the chapter "Summer at Céret 1911," in Richardson 1991–2007, vol. 2 (1996), pp. 183–97. Although Céret is less than twenty miles inland, it can be reached only by mountain road.
2. Daix 1995, p. 172.
3. Lewis C. Kachur (1988, p. 131) detected the *porrón*.
4. Penrose 1958, p. 178.
5. Vallier 1954, p. 16, cited by Richardson 1991–2007, vol. 2 (1996), p. 190.
6. In this regard it is preceded only by *Still Life "Le Torero,"* also of 1911 (z 11b.266; DR 413).
7. Gary Tinterow in London 1983, p. 260.

PROVENANCE

[Galerie Kahnweiler, Paris, 1911–14; acquired from the artist, stock no. 1791]; sequestered Kahnweiler stock, Paris (1914–21; sale, "Vente de biens allemands ayant fait l'objet d'une mesure de Séquestre de Guerre: Collection Henry Kahnweiller [*sic*], Tableaux Modernes, deuxième vente," Hôtel Drouot, Paris, November 17–18, 1921, no. 189; for 370 francs, to Ozenfant); Amédée Ozenfant, Paris (1921); Le Corbusier (Charles-Édouard Jeanneret), Paris (ca. 1921–63); Fondation Le Courbusier, Paris (1963–69; sale, "Ancienne Collection Le Corbusier," Palais Galliera, Paris, December 9, 1969, no. A, for 1,130,000 francs, to Hahn and Thaw); [Stephen Hahn and E. V. Thaw & Co., Inc., New York, 1969–70; sold by Thaw on September 23, 1970, in exchange for a painting by Picasso (z 11a.249) and $250,000, to Gelman]; Jacques and Natasha Gelman, Mexico City and New York (1970–his d. 1986); Natasha Gelman, Mexico City and New York (1986–d. 1998; her bequest to the Metropolitan Museum, 1998)

EXHIBITIONS

Munich 1913, no. 61; Cologne 1913, no. 37; likely in Berlin–Dresden 1913–14, no cat.; Vienna 1914, no. 21; Zürich 1914, no. 27; likely in Basel 1914, no cat.; London (Zwemmer) 1937, no. 24; New York 1971, no. 13, p. 27 (ill.); New York 1980, pp. 123, 143 (ill.); London 1983, no. 125, pp. 260–61 (ill.); New York–London 1989–90, pp. 113, 114 (ill.), 115, 310–11 (ill.); Mexico City 1992, p. 12 (fig. 1); Martigny 1994, pp. 31 (ill.), 137–39 (ill.), 332 (ill.); New York 2000, pp. 71 (ill.), 125; New York 2001–2, no cat., checklist no. 41; New York 2007, pp. 84 (ill.), 100–101, 186

REFERENCES

Raynal 1921, pl. 40; Zervos 1932–78, vol. 2a (1942), p. 132 (ill.), no. 267; Lassaigne 1949, pl. 44; Crastre 1950, p. 56, fig. 5; Kahnweiler 1950, no. 28, ill.; Payró 1957, fig. 21; *Artnews* 68, no. 8 (December 1969), advertisement p. 13 (ill.); Anon., August 1970, p. 79 (fig. 2); "International Salesroom," *Connoisseur* 173, no. 697 (March 1970), p. 193 (fig. 27); Seghers 1970, pp. 257–58 (ill.); Will-Levaillant 1971, p. 46; Russoli and Minervino 1972, pp. 107–8 (ill.), no. 415; Gordon 1974, p. 664 (Munich 1913, no. 61), 794 (Vienna 1914, no. 21); Cabanne 1975a, vol. 1, p. 16; Daix 1977, pp. 113, 116 n. 33; Daix and Rosselet 1979, pp. 89, 268 (ill.), no. 414 (English ed., p. 268 [ill.], no. 414); Gee 1981, appendix F, section 2, p. 42 (no. 113); Kodansha 1981, pl. 45; Daix 1982a, pp. 28, 43 n. 10; Daix 1982b, pp. 63, 169; Farr 1983, pp. 508, 509 (ill.); Wood 1983, p. 276 (ill.); Kachur 1988, pp. 131–32; Judith Cousins in New York 1989–90, p. 377; Palau i Fabre 1990, pp. 221 (ill.), 505, no. 603; Warncke 1992, vol. 1, p. 193 (ill.); Geelhaar 1993, p. 62; Warncke 1993, vol. 1, p. 193 (ill.); Daix 1995, pp. 172, 851; Richardson 1991–2007, vol. 2 (1996), p. 319 (ill.); Dobrzynski 1998, p. A1; Tobias G. Natter in Vienna 2003–4, pp. 140 n. 190, 141 (ill., reprint of Vienna 1914); Bernice Rose in New York 2007, pp. 84 (ill.), 100–102

TECHNICAL NOTE

As with most of his Analytic Cubist compositions, Picasso painted *Still Life with a Bottle of Rum* on finely woven canvas commercially prepared with a white ground. He brushed on a transparent, washlike layer of ocher paint on the ground layer before painting his composition with oil, alternating from very thin to thick applications of paint; this allows the ocher layer to show through in various places. Examination using infrared reflectography did not show any underdrawing—and X-radiography confirms that Picasso painted his composition directly onto the canvas—but it did reveal geometric lines in the upper half of the painting that the artist later painted over. Such lines are also present in the contemporary (and very similar) work *Still Life "Le Torero"* (z 11a.266, DR 413).

The painting has remained unlined. Prior to this exhibition, a discolored and inappropriate layer of varnish was removed. This allows for a clearer reading of the subtly intersecting planes of the composition, revealing the variations in the texture and degree of sheen intended by the artist. I D

55. Pipe Rack and Still Life on a Table
Céret, late Summer 1911–Autumn 1911

Oil and charcoal on canvas
19½ × 50 in. (49.5 × 127 cm) [irregular]; mounted, 20 × 50¼ in. (50.8 × 127.6 cm)
Signed, lower right: Picasso
The Mr. and Mrs. Klaus G. Perls Collection, 1997
1997.149.6

This painting's long, narrow format is unusual for a work created during the high phase of Cubism, also called Analytic Cubism (1910–12), when Picasso generally preferred canvases measuring no more than a meter in height or width.[1] The picture's atypical size has convinced scholars that it was originally part of a planned large wall decoration commissioned by Hamilton Easter Field, an American painter, critic, aesthete, and arts patron.[2] Field met with Picasso during a brief visit to Paris in 1909 and the two discussed plans to have the artist paint wall panels for the library of Field's family mansion in Brooklyn. One year later, on July 12, 1910, Field sent Picasso sketches of the library's layout, an elevation, and, most important, the dimensions of the wood panels on which the artist's pictures would be hung.[3] The commission called for a total of eleven panels, nine at least 54 inches (185 cm) in height, and two horizontal overdoors.[4] The dimensions of the Metropolitan's painting match almost exactly those Field gave Picasso for the overdoors: 50 × 130 centimeters (19⅝ × 51⅛ in.).[5] Field assured the artist that the library would have no furniture except for bookshelves and a few low chairs, and that it would be lit at night by electricity. As envisioned, this monument to high Cubism would no doubt have been a striking space, if not actually one conducive for concentrating and reading.

The meeting between Field and Picasso was likely arranged by Field's cousin Frank Burty Haviland, a patron of the artist's. Born and educated in France, Haviland (who called himself "Frank Burty," adopting the surname of his maternal grandfather, Philippe Burty, a writer and critic) was a descendant of David Haviland, the American founder of a porcelain factory in Limoges that still bears his name. Artistically inclined, Haviland fell under the spell of Picasso's work in 1910 and out of admiration set aside his interest in music and began to paint in a naïvely "cubified" realism.[6] He befriended and helped many other artists as well, among them the Spanish sculptor Manolo (Manuel Martínez Hugué), a close friend of Picasso's who had been the first to settle in Céret, in 1910, and who persuaded his artist friends, as well as Haviland, to join him there. As a man of means, Haviland lived initially in a large house in Céret, the Maison Alcouffe, but in 1913 he bought (and later restored) an old monastery, the Couvent des Capucins.

Various reasons have been proposed for why the project for Field's library was never completed, foremost among them the fact that the abstracted and faceted planes and the stark palette of Analytic Cubism would have been inappropriate for such large-scale "decoration."[7] Moreover, Cubism as practiced in 1911 was suitable for an easel painting but would have been difficult to apply to such large compositions.[8] More curious perhaps is Field's apparent lack of interest in the project after he returned to Brooklyn: he never asked for photographs of the work in progress or visited the artist in Paris. Picasso is said to have painted the two compositions for the proposed overdoors in the late summer or fall of 1911 at Céret.[9] The presence of his patron Frank Burty there—Picasso at first used several rooms of the Maison Alcouffe as his studio—no doubt helped focus the artist's attention on Field's commission. By 1915, however, Picasso regarded the project, for which he had yet to receive any money, a failure, and he abandoned it. After Field's death, in 1922, Picasso sold three of the completed panels, repainted three others at a later date, and kept back those that were unfinished.[10]

Picasso did not extend the Cubist composition into the far left and right of this canvas, convincing some scholars that this painting, too, is unfinished.[11] He must have signed the work when he sold it at a later date.[12] Among the planes and facets, which are in various hues of ocher and earth tones, can be identified, from left to right: three pipes hanging on a piece of string nailed to the wall; the white handle of a cup; the spout of a coffeepot; and the outlines of a water carafe. A folded paper on the right edge of the round table bears two overlapping images of the black stenciled letters "& OCEAN." Three smaller letters, "hef"—Hamilton Easter Field's initials—are just below them. Higher up on the right float the letters "LA/AUX/DUMAS," as in the title of the 1848 novel *La Dame aux camélias* by Alexandre Dumas *fils*.[13] Picasso likely inserted the literary reference mindful that the canvas would hang in a library; it might also be a playful hint that any respectable library should own a copy of this French classic, even one in so faraway a place as Brooklyn, across the "OCEAN" with "hef."[14]

SR

1. Richardson 1991–2007, vol. 2 (1996), p. 170.
2. See William Rubin, "Appendix: The Library of Hamilton Easter Field," in New York 1989, pp. 63–69, ill. p. 67, and Richardson 1991–2007, vol. 2 (1996), pp. 167–72, ill. p. 169; DR 417 does not refer to the library commission.
3. Rubin in New York 1989–90, p. 63. Field's letter is in the archive of the Musée Picasso, Paris.
4. The nine panels were all to be 185 centimeters (54 inches) in height and would range in width, from an extremely narrow 30 centimeters to horizontal formats up to 300 centimeters wide. See Rubin in New York 1989–90, p. 63.
5. Regarding the irregular measurements, see the technical note below.
6. See Loize 1966, pp. 27–32.
7. Richardson 1991–2007, vol. 2 (1996), p. 167.
8. Rubin in New York 1989–90, p. 64.
9. Ibid., pp. 66–67. The other overdoor is *Piano with Still Life* (Museum Berggruen, Berlin; Z 11b.728; DR 462), which Picasso began in Céret in 1911 but finished only in the spring of 1912.
10. Richardson 1991–2007, vol. 2 (1996), pp. 171–72.
11. Rubin in New York 1989–90, p. 68.
12. Daix says that it was "subsequently" signed.
13. The novel was adopted for the stage in 1852; one year later, Verdi turned it into the opera *La Traviata*.
14. These initials, more so than the painting's unusual dimensions, should have been proof enough that this work was once part of the Field library commission, and yet until now no one has referenced or identified them as such.

PROVENANCE

[Galerie Georges Moos, Geneva, until 1951, stock no. 7440, sold on October 8 for $8,000 to Perls]; [Perls Galleries (Klaus G. Perls), New York, from 1951; stock no. 5021]; Mr. and Mrs. Klaus G. Perls, New York (until 1997; their gift to the Metropolitan Museum, 1997)

EXHIBITIONS

New York (Perls) 1952, no. 123, ill.; New York (Perls) 1953, no. 133; New York (Perls/Cubism) 1954, no. 5, cover ill.; New York (Perls) 1954, no. 172; New York (Perls) 1955, no. 162; Chicago 1955, no. 23; New York (Perls) 1956, no. 187; New York 1962 (shown at Saidenberg Gallery), no. 4, ill.; Tokyo–Kyoto–Nagoya 1964, no. 16, p. 137, ill.; New York (Perls) 1965, no. 3, ill.; Fort Worth–Dallas 1967 (shown in Dallas only), no. 16, p. 93, ill.; New York 1980, pp. 122, 144 (ill.), 459 (rev. ed., pp. 144 [ill.], 459), and checklist p. 24; on view at Nichido Museum, Tokyo, March 1–May 30, 1981; New York 1989–90, pp. 64, 66, 67 (ill.), 68; New York 2000, pp. 68–69 (ill.), 125; Kyoto–Tokyo 2002–3, pp. 56, 60–61 (pl. 16), 168; Madrid 2005–6, no. 17, p. 62 (English ed.), ill.

REFERENCES

Zervos 1932–78, vol. 2b (1942), p. 317 (ill.), no. 726; Zervos 1946, p. 428; Russoli and Minervino 1972, pp. 105 (ill.), 106, no. 372; Daix and Rosselet 1979 (both eds.), p. 268 (ill.), no. 417; Daix 1982b, pp. 63, 169; Leighten 1983, p. 234; Bolger 1988, p. 87; Kachur 1988, p. 66; Safran 1989; Palau i Fabre 1990, pp. 228 (ill.), 229, 506, no. 629; Cabanne 1992, vol. 1, p. 370; Kaufman 1996, p. 14; Richardson 1991–2007, vol. 2 (1996), pp. 169 (ill.), 170–72; Vogel 1996a, p. C11; Léal, Piot, and Bernadac 2000, pp. 154 (fig. 341), 509 (English ed., pp. 154 [fig. 341], 156, 509); José Álvarez Lopera in Madrid 2006, p. 142; Julia May Boddewyn in New York–San Francisco–Minneapolis 2006–7, pp. 369, 370, 371, 373; Grimes 2008, p. B6

TECHNICAL NOTE

Working on a commercially prepared white ground, Picasso built the painting on top of a charcoal drawing, alternating thin and thick oil paint to create an interplay of depth. Having reinforced the initial charcoal scaffolding with black paint, before completing the work Picasso returned with charcoal to emphasize these same lines. The initial application of greatly thinned oil has reticulated in some areas, tenuously adhering to a greasy ground. Clusters of oil paint from other wet paintings once stacked against it sit on the surface of the work, while scrapes and smears caused by contact with objects while the paint was still fresh can be found throughout. These conditions suggest the work languished for years in Picasso's various studios.

The canvas is of a fine weave, typical of Picasso's Analytic Cubist works. The edges are irregular and marked by depressions caused by large-head tacks, with which the artist attached the canvas to a wall for painting. The work has no tacking edges on top and bottom, but the sides have a ¼-inch tacking edge. It is possible that Picasso expected the canvas to be glued directly to the overdoor panel for Hamilton Easter Field's library, and thus edges would not have been needed.

In 1951 the New York dealer Klaus Perls wrote to Georges Moos, the dealer in Geneva from whom he bought this painting, noting that the stretcher was too small for it and that this condition could be attended to in New York.[1] Moos probably had the top and bottom edges folded back to tack them to a stretcher; no doubt Perls had the painting glue-lined in order to have tacking edges, so that once stretched one could see the entire painting. The depressions were filled and retouched along the top edge at this time. After stretching, the edges were covered by paper tape; subsequently the paper tape was partially removed so that more of the work could be seen, jagged edges and all. After the painting entered the Metropolitan Museum's collection the surface was cleaned, the discolored fills were retextured, and the color corrected. The painting was never varnished and retains a soft, pastel-like quality. — LB

1. Letter from Klaus Perls to Georges Moos, October 6, 1951, Perls Galleries records, 1937–1997, Archives of American Art, Smithsonian Institution, file 33, box 15, 33.15.

56. Seated Man Reading a Newspaper

Sorgues, Summer 1912

Ink on off-white wove paper
12⅛ × 7¾ in. (30.8 × 19.7 cm)
Signed on verso in graphite, upper right: Picasso
Alfred Stieglitz Collection, 1949
49.70.27

After an exceptionally productive period of work from the winter of 1911 to the spring of 1912, which resulted in some twenty-six paintings (mostly still lifes) and his first Synthetic Cubist collage (*Still Life with Chair Caning*, Musée Picasso, Paris),[1] Picasso abruptly left Paris in May 1912 for southern France, admonishing his dealer not to tell "ANYONE, ANYONE AT ALL where I shall be."[2] Accompanied by his new love, Eva Gouel (Marcelle Humbert), and wishing to elude his companion, Fernande Olivier, the couple moved first to Céret and then to Sorgues, where they settled for the summer (June 23–September 23, 1912).[3]

In letters of that summer, the artist often mentions the paintings he is working on, including one called *The Aficionado* (fig. 56.1; see also 57.1) that is closely related to the Metropolitan Museum's drawing *Seated Man Reading a Newspaper*.[4] As that painting progressed, Picasso transformed a generic male subject into a fan, or "aficionado," of the bullfights by adding references such as the name of the bullfighting newspaper *Le Torero*, a banderilla, or spear used to poke the bull, and "Nîmes," the nearby city where bullfights were held that summer.[5] Yet despite such specific details, the man seems fictitious, an invention of the artist's imagination or perhaps a composite of several aficionados, rather than an actual portrait of a real person.

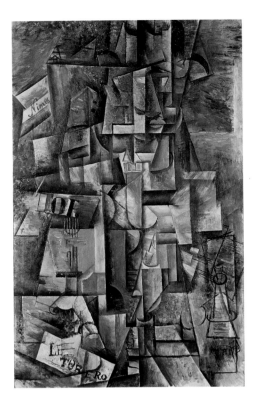

Fig. 56.1. Pablo Picasso, *The Aficionado*, 1912. Oil on canvas, 53⅛ × 32¼ in. (135 × 82 cm). Kunstmuseum Basel, Gift of Raoul La Roche (2304)

1. For the paintings see DR 444–65, 467–70; for the collage, see DR 466.

2. Picasso to Daniel-Henry Kahnweiler, June 20, 1912 (from Céret), excerpted in Cousins 1989, p. 396.

3. Since Picasso and Fernande had spent the previous summer in Céret, he decided to relocate about 160 miles northeast to the small town of Sorgues-sur-l'Ouvèze.

4. Picasso's letters from Céret and Sorgues are excerpted in Cousins 1989, pp. 391–404, and Paris 2007–8 (English ed.), pp. 345–47, with slightly different translations.

5. In his July 10, 1912, letter to Georges Braque (Paris 2007–8, p. 346), Picasso wrote: "I'm constantly thinking of those aficionados from Nîmes, and I've already transformed a canvas I'd begun as a man into an aficionado. I think he might be good with a banderilla in his hand and I'm trying to give him a truly southern face." The Roman arena in Nîmes was modified to host bullfights in 1863.

6. See DR 499, 500; Z 11b.325, 327; Z XXVIII.91, 96, 110, 111, 156. For illustrations in a small sketchbook (3½ × 5¾ in. [8.9 × 14.6 cm]; Musée Picasso, Paris) that Picasso filled with pen-and-ink and pencil drawings in Sorgues that summer, many of which are related to *The Aficionado*, see New York 1986, p. 316, no. 53, and Karmel 2003, nos. 157, 196–201.

7. Picasso's photographs of Apollinaire and Haviland, taken in his boulevard de Clichy apartment in Paris about 1910–11 (illustrated in Houston–Munich 1997–98, figs. 106, 109), show a round-jawed Apollinaire with pipe and crossed legs and Haviland with a walking stick—objects that are also seen in the Metropolitan Museum's *Seated Man Reading a Newspaper*. Photographs of Max Jacob from about 1915–16, hatted and carrying a walking stick, are illustrated in Quimper–Paris 1994, pp. XVII (second row from top, center) and 122 (fig. 5). Although none of the men in these photographs has a mustache, a sculpture of Haviland by Manolo (Manuel Martínez Hugué) of 1909 (Musée d'Art Moderne de Céret) shows him with a small handlebar mustache (illustrated in Crastre 2006, p. 67); my thanks to Jessica Murphy for pointing this out to me.

The summer of 1912 marked Picasso's return to the human figure in a number of painted and drawn Cubist heads and three-quarter-length figures.[6] Most depict men, often with small handlebar mustaches, hats, stiff white shirt collars, walking sticks, long-stemmed smoking pipes, and newspapers. In all the pictures, he used the same shorthand notations to represent these various elements—for example, the shirt collar is represented by a quarter-circle line ending in one or two triangles, the walking stick by a long narrow rectangle with a ball top, and the mustache by two crescents.

The group of three-quarter-length figures to which *Seated Man Reading a Newspaper* belongs are drawn in pen and ink on moderately small pieces of paper; most of the large heads were done in charcoal on larger sheets. In the present drawing Picasso's pen scratched the paper in the more heavily worked areas along the left and top center of the composition (by the man's head, shoulder, arm, and chair, and at the tip of his mustache). These darkened areas give the forms a slightly solid appearance, but the rest of the composition is minimally outlined in general shapes that represent (from top center to lower right) the rounded crown of the man's hat, the starched collar, open newspaper, bent arm, walking stick, kneecap, and crossed leg. The abstractness of this image, with its multiple small components, makes it difficult to read, but luckily we are aided by the existence of a second, almost identical drawing, *Seated Man in a Hat* (Z XXVIII.91), that provides a simpler and more coherent view of the man. Like the painted aficionado, the subjects of *Seated Man Reading a Newspaper* and the related drawing may be composite images, taken from several sources, including Picasso's photographs of his friends Guillaume Apollinaire and Frank Burty Haviland and, quite possibly, Max Jacob, who was a dapper dresser and often wore a hat and carried a walking stick.[7]

LMM

PROVENANCE

[Probably with Moderne Galerie (Heinrich Thannhauser), Munich, by 1913 and sold on March 31, 1914, to Basler]; [Adolphe Basler, Paris, 1914–15; left with Stieglitz in December 1914 as collateral for a loan and acquired on August 15, 1915, upon default of loan]; Alfred Stieglitz, New York (1915–d. 1946); his estate (1946–49; gift to the Metropolitan Museum, 1949)

EXHIBITIONS

Probably Munich 1913, no. 110; New York, 1915, no cat.; possibly Philadelphia 1920, no. 196; Philadelphia 1944, no. 98; New York (MoMA) 1947, no cat., checklist no. 94; Chicago 1948, no cat., checklist no. 131; New York 1951, no cat., checklist no. E.L.51.694; New York 1967, no cat., unnumbered checklist; Los Angeles–New York 1970–71, no. 270, pp. 64 (pl. 57), 306; New York 1989–90, p. 238 (ill.); New York (MMA) 1997, hors cat.; Tokyo–Nagoya 1998, no. 38, pp. 84 (ill.), 239

REFERENCES

Hamilton 1970, p. 379 (fig. 5, mislabeled *Nude*, 1910; text refers to *Standing Female Nude*, 49.70.34); Ulrich Weisner in Bielefeld 1979, p. 268, pl. 74; Daix 1996 (both eds.), pp. 280, 287 (ill.); Karmel 2000, pp. 189, 191 (fig. 69), 505 n. 11; Rodriguez 2001, p. 108; Karmel 2003, pp. 153–54 (fig. 202); Julia May Boddewyn in New York–San Francisco–Minneapolis 2006–7, pp. 329, 359, 362–63

TECHNICAL NOTE

This drawing was executed not on a traditional artists' paper but on a sheet that was calendered, meaning that during the papermaking process it was made to have a smooth finish. Picasso created the initial drawing, defining the forms and the areas of shading, and then reinforced the deep shadows with another layer of strokes heavily laden with ink. Ink on a smooth surface does not absorb easily, and the ink stays on the surface. As a result, here the marks from the metal nib pen are easily visible beneath the ink that bled out of the pen and was pushed around on the surface, where it pooled and blended into amorphous areas, thus emphasizing the shadows of the composition. The pen also scratched the surface of the paper during the artist's vigorous execution. The ink, now brown, may have faded, and the wove paper has darkened slightly over time.

RM

57. Head of a Man

Sorgues or Paris, late Summer–Autumn 1912

Charcoal on white laid paper watermarked Ingres FRANCE, with countermark of monogram in oval
24½ × 19 in. (62.2 × 48.2 cm)
Signed on verso in graphite, upper right: <u>Picasso</u>
Alfred Stieglitz Collection, 1949
49.70.29

This Analytic Cubist drawing is full of visual ambiguities and contradictions. Iconic and monumental in its frontality and overall shape, it is also internally fractured and disjointed. Volume and flatness, representational and abstract imagery are evoked with the same marks and signs but differentiated by shading or detail. As Gary Tinterow noted: "In 1912, as the fabric of Picasso's Cubist compositions became more tightly woven and the planar units grew larger to serve a more important structural role, line emerged once again as the dominant vehicle of expression in Picasso's drawings. It carried two functions: Picasso used line both for delineating the edges of the planes and as an independent element."[1] Here, he lightly sketched in the composition with charcoal before going back over the lines with more emphatic strokes. Although the charcoal is inherently very black, Picasso's handling of it produced many subtle gradations of tone that softened the mechanical effect of the figure.

Depending upon where we look, the lines and shapes either coalesce into something almost recognizable or dissolve into randomness. Even as we attempt to take in the whole picture, our eyes can't help but jump back and forth over the long black vertical line that divides the composition into two distinct parts. On the left side of the line, the image reads as a head in relief, or perhaps two heads. On the right side, we see a completely nonobjective design of "independent" lines. The effect of the nearly two-foot-long dividing line is dramatic, deliberate, and unusual: what was the artist's intent and inspiration? He may have been attempting to simulate the effects of early cinematography, where double exposures, flickering lights, changing frames, and space-time jumps in the story lines were all part of the experience.[2] Rather than replicating actual film-still images, however, Picasso adapted the concept of film as a conveyer of movement and change to the media of painting and drawing.[3]

This work relates to a series of male heads drawn by Picasso in 1911–12, most of them in charcoal on sheets of paper similar in size to the Museum's example.[4] As in many of his figurative works, he recycled the same repertoire of abstract lines and shapes to represent specific body parts—for example, the closed half circles are eyes, and the wide dome at the top of this drawing is the crown of a head.[5] Just below the dome, Picasso drew the edge of the man's hairline with a short diagonal curve ending in a sharp, straight, horizontal line and filled the intervening space with short striations of black charcoal representing hair.[6] While we can identify the eyes, nose, mouth, and ear in this

Fig. 57.1. Picasso in front of *The Aficionado* (fig. 56.1), Sorgues, 1912. Yale Collection of American Literature, Beinecke Rare Book and Manuscript Library, New Haven, Connecticut

drawing, Picasso disregarded what would have been their normal spatial relationships, turning the composition into an assemblage of disconnected parts that shift within a circumscribed space, much like a mobile.[7] And yet somehow he managed to maintain the essential identity of the head, a feat that brings to mind Leo Stein's remark that for Picasso, the parts of a head "could be distributed any way you like" because "the head remained a head."[8]

Although Picasso never made any mobiles, he did sketch a number of heads, figures, and guitars during the summer of 1912 in Sorgues that suggest he was planning some sculptural projects several months before he undertook them.[9] Drawings, such as *Head of a Man*, made in late summer–autumn 1912 in Sorgues and Paris record the link between these percolating ideas and their inventive outcome—the constructed cardboard, and later sheet-metal guitars[10] and the papiers collés of October–December 1912 (see cats. 58, 59). As Pepe Karmel expressed it, "The drawings of summer and fall 1912 [such as this *Head of a Man*] marked the convergence of Picasso's two chief concerns of the preceding years: the definition of projective space and the reinvention of the body as sculptural form. Construction with superimposed planes solved both of these problems."[11]

LMM

161

1. Tinterow in Cambridge–Chicago–Philadelphia 1981, p. 16.
2. My thanks to Bernice Rose for sharing her thoughts about the influence of cinema on Picasso's work. See Rose's *Picasso, Braque and Early Film in Cubism* (New York 2007); Staller 1989; and Henderson 1983.
3. According to Natasha Staller (1989, p. 202): "The relation between the cinema of [Georges] Méliès and the Cubism of Picasso and Braque is not one of visual resemblance. Cubist works do not look like stills from Méliès' films. . . . Yet many of Cubism's most radical features—such as the comic fragmentation of body parts, the use of conflicting perspectives, and the insertion of letters, numbers, advertising copy and real prosaic objects into artistic contexts—all had previously occurred in their most literal form . . . in the popular culture which was pervasive at the time. Picasso and Braque took the tricks and effects also found in three-minute films shown in street fairs or the basements of billiard parlours and transformed them into the instruments of high art."
4. For related male heads, see DR 499, 532, 579; Z II.328, IIa.325, 327. The Museum's drawing also relates to a series of standing female figures drawn by Picasso ca. 1912–13, whose heads are similarly structured (See Z IIb.762, Z XXVIII.228, 233, 236; DR 642, 643; and Karmel 2003, p. 95, no. 122; some of these figures also have the vertical wavy line along the left side that appears in *Head of a Man*, Picasso's frequent symbol for women's hair. In Karmel 2003, pp. 57–58, 136–37, he compares Picasso's drawings of heads to illustrations in Camille Bellanger's book, *L'Art du peintre: traité pratique du dessin et de la peinture* (Paris, 1909), analyzing the proportions and angles of the human face.
5. The round dome might also be construed as the crown of a hat, which is more easily done in the case of a related drawing, *Head of a Man with a Mustache* (1912; Z IIa.325).
6. The distinctive hairstyle suggested by these simple lines is similar to the one worn by Picasso at this time, as seen in a 1912 photograph of the artist (fig. 57.1). See also the caricature of Picasso by Marius de Zayas (of a slightly later date) that shows him with the same haircut (illustrated in de Zayas 1996, p. 225, fig. 143).
7. The mobile analogy can be made about some other drawings of male heads that Picasso did in 1912 (see Z XXVIII.82–84).
8. L. Stein 1947, p. 177.
9. See Z IIb.740–44; Z XXVIII.126, 130–32, 135, 151.
10. See DR 471, 556, 633.
11. Karmel 2003, p. 91.

PROVENANCE
[Probably with Moderne Galerie (Heinrich Thannhauser), Munich, by 1913 and sold on March 31, 1914, to Basler]; [Adolphe Basler, Paris, 1914–15; left with Stieglitz in December 1914 as collateral for a loan and acquired on August 15, 1915, upon default of loan]; Alfred Stieglitz, New York (1915–d. 1946); his estate (1946–49; gift to the Metropolitan Museum, 1949)

EXHIBITIONS
Probably Munich 1913, no. 113; New York 1915, no cat.; Philadelphia 1944, no. 99; New York (MoMA) 1947, no cat., checklist no. 93; Chicago 1948, no cat., checklist no. 23; New York 1951, no cat., checklist no. E.L.51.698; New York 1967, no cat., unnumbered checklist; Los Angeles–New York 1970–71, no. 269, pp. 53 (pl. 39), 305; London 1980, no. 3, p. 28; New York 1989–90, p. 246 (ill.); Washington 2000, no. 54, pp. 191, 195 (pl. 54), 196, 197, 505 n. 11, 537

REFERENCES
Ulrich Weisner in Bielefeld 1979, p. 268, pl. 73; Rodriguez 2001, p. 108; Greenough 2002, vol. 1, pp. xxviii–xxix (figs. 25, 26); Danielle Tilkin et al. in Paris–Madrid 2004–5, p. 77 (ill.), no. 29; Julia May Boddewyn in New York–San Francisco–Minneapolis 2006–7, pp. 329, 359, 362

TECHNICAL NOTE

Picasso varied the widths of the lines of rich black charcoal by adjusting the pressure on the crayon and the angle of application. He drew over the main lines of the design many times, and he reinforced with stronger strokes with some soft pale lines, which may have been part of the original sketch. Although charcoal is easily smudged to make smooth variations of tone, Picasso created most of the effects of light and shadow in this drawing with hatch marks or groups of parallel lines; however, in the long trapezoid at the upper left of the face, he smudged the hatched lines to shade the background. RM

163

58. Bottle and Wine Glass on a Table

Paris, December 1912

Charcoal, ink, cut and pasted newspaper, and graphite on white laid paper watermarked INGRES 1862, with countermark of Canson Frères crest
24⅝ × 18¾ in. (62.5 × 47.6 cm)
Signed on verso in graphite, upper left: <u>Picasso</u>
Alfred Stieglitz Collection, 1949
49.70.33

The Cubists did not originate the concept of collage, but their application of it to the fine arts is considered a major development in the evolution of modern art.[1] Early in September 1912, Georges Braque made the first papiers collés—a subcategory of collage created entirely of glued paper—by adding strips of wood-grained wallpaper into his drawings. He was aware at the time that he had accomplished something revolutionary,[2] and when Picasso saw Braque's papiers collés a week or two later, in mid-September, he was inspired to experiment with the new genre, as he wrote to Braque in early October: "I am using your latest papery and powdery procedures."[3] Picasso's first few papiers collés were also made of wallpaper,[4] but almost immediately the artist turned to a new material—cut newspaper—and it became the foundation of the majority of his subsequent papiers collés.[5] In total, Picasso produced some eighty collages between September or October 1912 and spring 1914, of which at least fifty-two included pasted newspaper. The Metropolitan Museum's *Bottle and Wine Glass on a Table* features a clipping from *Le Journal* dated December 3, 1912, while *Man with a Hat and a Violin* (cat. 59) combines clippings from several issues (including the one for December 3).[6]

The newspaper clipping in *Bottle and Wine Glass on a Table* has been turned sideways, and the artist cut through two different articles in such a way as to make neither very coherent, although it is clear that both concern politics and the impending war in Europe.[7] To what extent the printed words offer subtexts for the images or are overt expressions of the artist's political views has sparked much debate,[8] but no matter how compelling the answers to these questions turn out to be, they should not obscure the fact that the clippings offered an obvious way to add pattern, texture, and perhaps some color to otherwise primarily black-and-white line drawings (see technical note). More important still, as the artist explained to Françoise Gilot years later, the purpose of the papiers collés was to challenge "the reality in nature." "We tried to get rid of *trompe-l'oeil* to find a *trompe-l'esprit*. We didn't any longer want to fool the eye; we wanted to fool the mind. . . . [N]ewspaper was never used in order to make a newspaper. It was used to become a bottle or something like that. . . . If a piece of newspaper can become a bottle, that gives us something to think about. . . . This displaced object has entered a universe for which it was not made and where it retains, in a measure, its strangeness. And this strangeness was what we wanted to make people think

Fig. 58.1. Pablo Picasso, installation of papiers collés (no. 3) in the studio at 3, boulevard Raspail, Paris, ca. mid-December 1912. Cat. 58 is on bottom row, second from right. Gelatin silver print, 3⅜ × 4½ in. (8.6 × 11.9 cm). Private collection

about because we were quite aware that our world was becoming very strange and not exactly reassuring."[9]

Bottle and Wine Glass on a Table and *Man with a Hat and a Violin* provide examples of the three subjects Picasso addressed in his papiers collés: still-life arrangements with a bottle and glass on a table,[10] the heads of men (who often are wearing hats), and musical instruments (violin or guitar). As Picasso worked on all three subjects concurrently, occasionally combining two in a single composition, he emphasized the visual corollaries in their shapes and lines. Thus, a guitar sound hole resembles the rim of a glass, the round edge of a café table suggests the curve of a guitar, and the shoulders of a bottle echo the dome of a man's head and hat. Such visual similes are evident in three installation photographs Picasso took about mid-December 1912 of three different groups of papiers collés arranged on the wall of his boulevard Raspail studio in Paris, including one that shows the present work (fig. 58.1).[11]

Bottle and Wine Glass on a Table is one of three closely related papiers collés that depict the same arrangement of objects on a round (café?) table: a tall wine, liquor, or absinthe bottle or siphon in the center; a stemmed goblet next to it, at right; and possibly the open pages of a newspaper, suggested by winglike

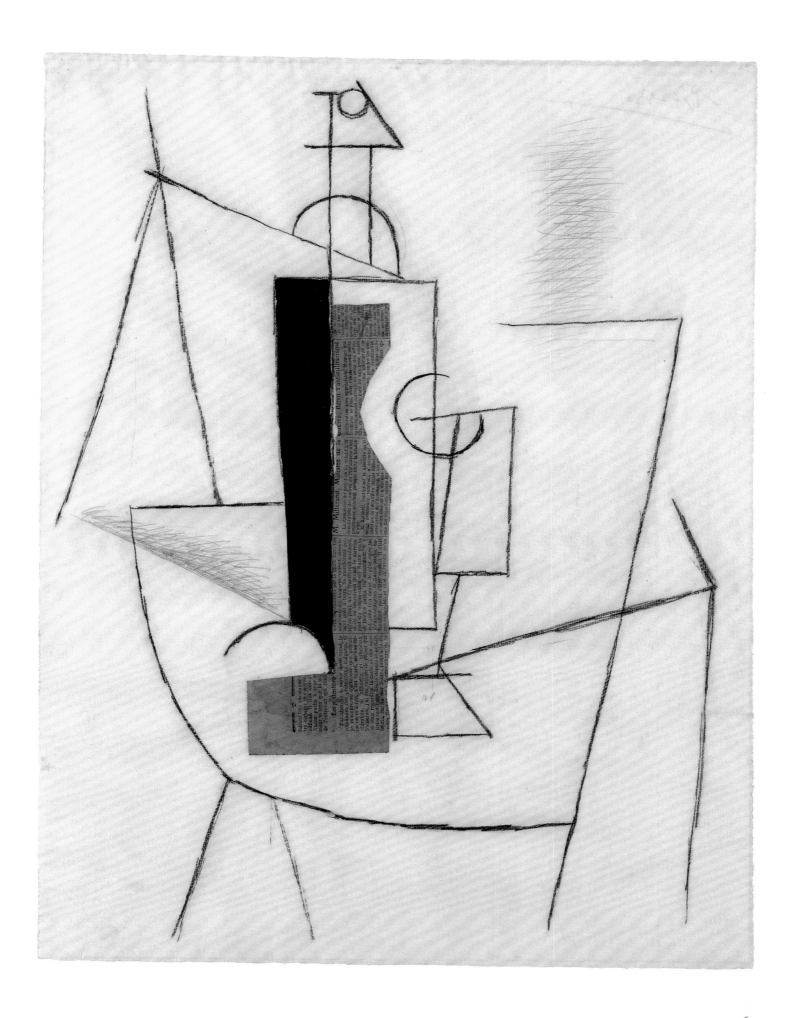

lines on both sides of the bottle.[12] While the overall effect of these works is two-dimensional, they flirt with three-dimensional allusion because some objects overlap within the shallow pictorial space and perspective shifts within the composition (from head-on to aerial). In this case, the artist also added a cast shadow at the base of the bottle with feathery pencil strokes that cleverly suggest mass and volume.

One of the first to write favorably about Picasso's papiers collés was the poet and art critic Guillaume Apollinaire, who prophetically observed in 1913 that it was "impossible to foresee all the possibilities, all the tendencies of an art so profound and painstaking."[13] Indeed, although Picasso's immersion in the medium lasted less than two years, this new genre influenced generations of modern artists to this day. When Alfred Stieglitz owned *Bottle and Wine Glass on a Table*, he added his own acclaimation to the back of the frame, writing: "I consider it the most important Picasso drawing I have ever seen. One of the most important things he ever did. . . . The most complete 'abstraction' of the modern movement."[14]

LMM

1. Collage is the art of adhering paper, fabric, or any natural or manufactured material to paper, canvas, or other flat supports. See R. Mayer 1969, s.v. "collage"; Lucie-Smith 1984, s.v. "collage"; Hoffman 1989; and B. Taylor 2004. By the time the Cubists "discovered" it, there were already many vernacular forms of collage in existence in different cultures, including "twelfth-century Japanese text-collages embellished with foil papers; African tribal emblems; eighteenth- and nineteenth-century butterfly-wing collages, German folk-art weather charms, lace valentines, and other conceits" (Waldman 1992, p. 8).

2. In a later interview Braque recalled, "I have to admit that after having made the [first] papier collé I felt a great shock, and it was an even greater shock for Picasso when I showed it to him" (Verdet 2000, p. 21).

3. Picasso to Braque, October 9, 1912 (quoted in Cousins 1989, p. 407). The word "papery" refers to Braque's method of pasting wallpaper onto his drawings and "powdery" to his addition of sand and sawdust to paint to give it texture.

4. See DR 526, 527.

5. Picasso's first three papiers collés were probably *Guitar, Sheet Music, Glass*; *Violin*; and *Bottle of Suze* (DR 513, 517, 542). He used clippings from *Le Journal*, November 18, 1912, for all three; however, it is not entirely safe to date the works on the basis of the clipping dates since the artist is known to have kept stacks of old newspapers in his studio for later use. See E. Fry 1988, p. 310 (appendix II) for a list of Picasso's 1912 papier collés arranged by clipping date.

6. Almost all of Picasso's papiers collés include cuttings from *Le Journal*, a popular Parisian newspaper with a large readership, whose political reporting at the time was conservative and nationalistic, focusing on the growing militarism throughout Europe.

7. The first two columns are devoted to a discussion of Bulgaria and Nazim Pacha, chief of staff of the army for the Ottoman Empire during the First Balkan War. The headline that runs across the third, fourth, and possibly fifth columns reads, "M. Millerand, Ministre de la guerre, flétrit l'antimilitarisme" (Mr. Millerand, Minister of War, denounces antimilitarism).

8. The differing opinions are discussed in Rubin and Zelevansky 1992, Baldassari 2000, and Staller 2001, pp. 380–81 n. 36.

9. Quoted in Gilot and Lake 1964, p. 77.

10. For still lifes with bottles dating from the spring of 1912 (just a few months before the papiers collés), see DR 460, 476 and Z 11a.296. Jean Sutherland Boggs's description of the objects in *Bar Table (Bottle of Pernod and Glass)* (spring 1912, The State Hermitage Museum, Saint Petersburg; DR 460) matches the array in *Bottle and Wine Glass on a Table*; see Boggs in Cleveland–Philadelphia–Paris 1992, p. 106.

11. *Bottle and Wine Glass on a Table* is visible in the third installation photograph (fig. 58.1, bottom row, second from right), which was taken on or after December 14, 1912 (see Baldassari 2000, pp. 68–69, 71). In all three photographs, Picasso's constructed cardboard guitar sculpture (DR 633) is seen at top center. Patricia Leighten has noted that this guitar incorporated pieces cut from a copy

of *Le Journal* for December 3, 1912, as part of its internal structure (the same issue used for *Bottle and Wine Glass on a Table* and cat. 59); see Leighten 1989, p. 129.

12. For the other two papiers collés, see DR 547, 549. A very similar composition is found in a painting in oil on canvas with pasted newspapers (DR 567). Other related papiers collés include DR 544, 545, 550–552.

13. Apollinaire made one of the first public references to papier collé in a January 1913 lecture in Berlin, which was subsequently published as "Die moderne Malerei" in the magazine *Der Sturm*. On March 14, 1913, his article "Picasso et les papiers collés" was published in the Parisian journal *Montjoie!* (for an English translation, see Schiff 1976, pp. 50, 52).

14. This inscription was written on the original frame's cardboard backing by Stieglitz on May 20, 1917 (NCMC archives).

PROVENANCE
[Galerie Kahnweiler, Paris, by 1914]; Francis Picabia, Paris (until 1915; sold for $150 to Stieglitz, 1915); Alfred Stieglitz, New York (1915–d. 1946); his estate (1946–49; gift to the Metropolitan Museum, 1949)

EXHIBITIONS
New York 1914–15, no cat.; Philadelphia 1920, no. 188; New York (MoMA) 1936, no. 219, pp. 80 (fig. 65), 82, 96, 221; New York (An American Place) 1937, no. 39; New York and other cities 1939–41 (shown in New York only), no. 107, p. 79 (ill.); New York (An American Place) 1941, no. 14; Philadelphia 1944, no. 100; New York (MoMA) 1947, no cat., checklist no. 95; Chicago 1948, no cat., checklist no. 19; Toronto 1949, no. 42; New York 1951, no cat., checklist no. E.L.51.693; New York–Chicago 1957, no. 67, p. 43 (ill.); Philadelphia 1958, no. 67, p. 17, ill.; New York 1967, no cat., unnumbered checklist; Los Angeles–New York 1970–71, no. 258, pp. 186 (pl. 205), 304; Paris 1977, pp. 256–57 (ill.); Cologne 1982, no. 106, pp. 233 (ill.), 256; Cleveland–Philadelphia–Paris 1992 (shown in Philadelphia only), no. 37, pp. 117, 118 (ill.), 119; New York (MMA) 1997, hors cat.; New York–San Francisco–Minneapolis 2006–7 (shown in New York only), pp. 51, 53, 54 (pl. 19), 280, 329, 330, 343, 346, 351, 359, 362–63, 375, 378, 386

REFERENCES
Camera Work 48 (October 1916), p. 64 (pl. IV, installation view of New York 1914–15); Zervos 1932–78, vol. 2b (1942), p. 200 (ill.), no. 428; Barr 1946, p. 80 (ill.); Hamilton 1970, p. 380 (fig. 7); Russoli and Minervino 1972, p. 115 (ill.), no. 575; Daix and Rosselet 1979 (both eds.), pp. 126 (ill.), 294 (ill.), no. 548; Ulrich Weisner in Bielefeld 1979, p. 268, pl. 82; Daix 1982a (both eds.), p. 41 (fig. 29); Daix 1982b, p. 104 (fig. 3); Paudrat 1984, p. 152 (installation view of New York 1914–15); Leighten 1985, pp. 665, 667, 668 (figs. 12, 13) (reprint ed., figs. 7.11, 7.11a); Tinterow 1987, p. 118 (fig. 94); E. Fry 1988, p. 310; Leighten 1989, pp. xiii, 127, figs. 85, 86; New York 1989–90, p. 34 (ill.); Poggi 1992, p. 56 (fig. 46); Rubin and Zelevansky 1992, p. 192 (fig. 26); Anne Baldassari in Paris 1994, pp. 215, 220–21 (fig. 160); Daix 1995, p. 119; Stieglitz 1997, p. 766 (ill.); Anne Baldassari in Houston–Munich 1997–98, pp. 106, 109, 114–15 (fig. 132); Karmel 2000, pp. xxviii, 184 (pl. 51), 192 (fig. 71), 197; Antliff and Leighten 2001, pp. 184 (fig. 154), 185 (fig. 155); C. Green 2001, p. 7 (fig. 3); Staller 2001, pp. 226, 227 (fig. 234); Greenough 2002, vol. 1, pp. xxxi (fig. 29), 242 (ill.), no. 393; Baldassari 2003, pp. 75, 78–79 (fig. 65), 80, 226 n. 294; K. Wilson 2009, pp. 16 (ill.), 27 (fig. 7, installation view of New York [An American Place] 1937)

TECHNICAL NOTE

Picasso often chose white laid paper as a support for his drawings and collages. The cut newspaper collage elements of *Bottle and Wine Glass on a Table* were originally a warm, creamy color and were always darker than the support, as a photograph of it hanging in Picasso's studio in 1912 shows (fig. 58.1). Since then, the newspaper has darkened significantly, increasing the contrast between the two papers. Picasso created the black rectangle at center with a shiny shellac-based ink called India ink (a common artists' material) laid on very heavily with a brush. Charcoal and graphite provide two other textures and shades of gray and black in the restricted palette of the collage. Picasso applied the charcoal first, and some of those lines extend under the newspaper. The graphite pencil shading lies on top of the charcoal, while the charcoal strokes capture the texture of the paper. In certain areas a halo of gray surrounds the strokes, which may have formed during the original application, but in other areas the smudging occurred over time as the thick, unfixed charcoal was disturbed. Around the edges of the newspaper, the support sheet, a high-quality artists' paper, has puckered significantly. This occurred because the artist used a wet adhesive to adhere the newspaper, and it would have been visible when the collage was made.

RM

59. Man with a Hat and a Violin

Paris, December 1912

Cut and pasted newspaper and charcoal on two joined sheets of white laid paper watermarked INGRES L'ESCALIER 6
Signed on verso in graphite, upper left: Picasso [in frame]
49 × 18⅞ in. (124.5 × 47.9 cm)
Jacques and Natasha Gelman Collection, 1998
1999.363.64

Picasso and his new love, Eva Gouel (Marcelle Humbert 1885–1915), spent the summer of 1912 in Sorgues, a small town about six miles north of Avignon, in Provence. When they returned to Paris in the autumn, they moved into a new studio at 242, boulevard Raspail, in Montparnasse,[1] and Picasso began to experiment with the papiers collés Braque had invented in Sorgues late that summer. Using this technique of pasting colored or printed pieces of paper onto their compositions, Picasso and Braque entered a new phase in their development of Cubism. In the previous phase, known as Analytic Cubism, they reassembled the small facets of a dissected (or "analyzed") object to evoke that object in shallow space; in Synthetic Cubism, the phase initiated with the papiers collés in September 1912,[2] the component pieces of paper themselves allude to a particular object often because they are either cut out in the relevant shape or bear some graphic element that clarifies the association.

The present work belongs to a group of eighteen papiers collés Picasso made that autumn and winter 1912 using only newspaper texts.[3] Here, he arranged cuttings from three issues of Le Journal (November 25, December 3, and December 9, 1912) on a sort of scaffolding of straight and slightly curved charcoal lines.[4] A man's head—one eye is visible—is seen from both the front and back, below his top hat. The left side of his face, echoed in the shaped piece of newspaper at lower left, resembles the contours of a stringed instrument. The man dwarfs the tiny violin he holds in his lap.

One wonders why Picasso, who neither cared for classical music nor played any stringed instruments, depicted them so often in his works: from the autumn of 1912 to early 1913, the violin appears in at least fourteen of some forty papiers collés, and the guitar in six. One reason could be that stringed instruments such as violins, guitars, or mandolins can be visually referenced by the use of small but unmistakable details—scroll, pegs, and sound holes, or by a simple curved silhouette—some of which can also allude to the human form. As for the newspaper clippings themselves, many scholars, beginning with Robert Rosenblum, have debated Picasso's intentions. The clippings in this work refer to various topics—from the Balkan Wars and unrest in French mines (in the "Nord" and "Pas-de-Calais" *départements*) to critical issues being considered in government as well as to local announcements, serial novels, and advertisements.[5] It has been suggested that Picasso purposely selected texts that refer to the Balkan Wars as a reflection of his antimilitarism and

antinationalism.[6] However, it would have been difficult for Picasso not to have included such references, as those events dominated the pages of most newspapers at the time.

What is virtually certain is that the cutting that makes up the body of the violin was not chosen at random. It is from an article that appeared on page six of the December 9 issue of *Le Journal*, and its heading—"Tragique roman d'amour" (Tragic Tale of Love; see detail)—must have piqued Picasso's curiosity.[7] It tells the story of one Henri Aubert, a twenty-six-year-old salesman, and his lover Léonie Vignon, a twenty-three-year-old singer whom he met in a café concert at the avenue du Maine, in Paris. Léonie's fickleness apparently aroused Henri's jealousy, and one evening during a quarrel he stabbed her three times in the arm. She fled, taking refuge with friends, but Henri tracked her down and wrote to her pleading for her to come back to him. He even tried to gain entry to her flat using a skeleton key, but with no success. Finally, Henri asked the owner of the café where Léonie had recently been singing to intervene on his behalf, but she still refused him. The news of Léonie's rejection was brought to Henri at a small café at the corner of rue Didot and rue d'Alésia, where, mad with despair, he pulled out his revolver and shot himself in the temple. He died shortly thereafter in hospital.

Told in this blunt, matter-of-fact way, the melodramatic events of Henri Aubert's obsession and death—at least in the context of Picasso's collage—come across like a popular ballad that could have been part of this musician's repertoire. No doubt the circumstances of the suicide would have reminded Picasso of his friend Carles Casagemas (see cat. 2), who in 1901, disappointed in love, shot himself dead in a Paris café.

SR

1. Montparnasse had replaced Montmartre as the place for up-and-coming modern artists. Picasso and Eva disliked the new studio, however, because it was on the ground floor, rather dark and gloomy, and you "could reach out of the back window and touch the tombs in the Montparnasse cemetery." See Richardson 1991–2007, vol. 2 (1996), p. 249.
2. William Rubin (in New York 1989–90, pp. 20, 55 n. 23) credits the critic Carl Einstein (in 1934, p. 101 and passim) as the first to "identif[y] . . . Cubism before and after *papier collé* as 'Analytic' and 'Synthetic.'"
3. For the others, see DR 524, 535–39, 542–47, 549, 550, and 552–54.
4. Lewis Kachur kindly suggested that I check issues of *Le Journal* from December 1912 for six of the seven clippings; see Daix (DR 535) for the clipping of November 25, 1912.
5. Leighten 1985, p. 665.
6. Leighten 1989, pp. 121–42.
7. Picasso cut off the headline and the first three lines of the article.

Detail of cat. 59, highlighting the "Tragic Tale of Love," in *Le Journal*, December 9, 1912

PROVENANCE
[Galerie Kahnweiler, Paris, acquired from the artist, ca. 1913, stock no. 1288];
[René Gaffé, Brussels, by 1932–37; sold in June or July 1937 for £135 to Penrose];
Roland Penrose, London (1937–ca. 1952; stored at The Museum of Modern Art,
New York, during World War II); [Curt Valentin Gallery, New York, by 1953–55;
sold in May 1955 for $5,500 to Thompson]; G. David Thompson, Pittsburgh (1955–
ca. 1962; sold to Diamond); Harold and Hester Diamond, New York (ca. 1962–82;
sold February 26, 1982, for $450,000 to Gelman); Jacques and Natasha Gelman,
Mexico City and New York (1982–his d. 1986); Natasha Gelman, Mexico City and
New York (1986–d. 1998; her bequest to the Metropolitan Museum, 1998)

EXHIBITIONS
Paris 1932, no. 74, p. 30; Zürich 1932, no. 71; London (Zwemmer) 1937, no. 26;
London 1939, no. 22, ill.; New York and other cities 1939–41 (shown in New York,
Chicago, Saint Louis, Boston, and San Francisco), no. 106, p. 79 (ill.); New York
(MoMA) 1941, no cat., unnumbered checklist; London 1947, no. 22, ill.; Venice
1950, no. 36, p. 55; London 1951, no. 20, ill.; São Paulo 1953–54, no. 5, p. 29, ill.;
New York–Chicago 1957, p. 42 (ill.); Philadelphia 1958, no. 66, p. 17, ill.; Norfolk
1973, no cat., checklist; New York 1980, p. 166 (ill.); Tübingen–Düsseldorf 1986,
no. 81, p. 277, ill.; New York–London 1989–90, pp. 116 (ill.), 117–18, 311 (ill.); Mar-
tigny 1994, pp. 140–42 (ill.), 333 (ill.); New York (MMA) 1997, hors cat.

REFERENCES
Estrada 1936, p. 56, no. 74 (reproduces checklist of Paris 1932); *London Bulletin* 2,
nos. 15–16 (May 15, 1939), no. 22, ill.; Zervos 1932–78, vol. 2b (1942), p. 190 (ill.),
no. 399; Kahnweiler 1949a, pp. viii, 30 (ill.); Hunter 1957, unpaginated ill.; Gaffé

1963, p. 74 (ill.); Rosenblum 1971, p. 606 n. 23; Russoli and Minervino 1972, p. 114
(ill.), no. 562; Anon., July 1973, p. 2; Justice 1973, p. A7; Daix and Rosselet 1979
(both eds.), pp. 116 (ill.), 289 (under no. 524), 291 (ill.), 292, no. 535; Perry 1982,
p. 188; Leighten 1983, pp. 229, 247–48, fig. 106; Leighten 1985, pp. 665, 667 (fig. 11);
Hohl 1986, p. 26 (ill.); E. Fry 1988, p. 310; Leighten 1989, pp. xiii, 127, 140, fig. 84;
Palau i Fabre 1990, pp. 307 (ill.), 511, no. 871; Daix 1995, p. 449; Cowling 2006,
pp. 30–32, 350 nn. 45, 46; Julia May Boddewyn in New York–San Francisco–
Minneapolis 2006–7, pp. 351, 356, 375

TECHNICAL NOTE

Picasso combined two sheets of white laid paper to create a tall, narrow support for
the collage. He used this paper type—referred to as Ingres paper, made by several
French and Italian papermakers—for many of his drawings and collages (see tech-
nical note for cat. 31). He cut the newspaper clippings jaggedly from a typical news-
print sheet. Thus, between the two sheets there is a contrast not only in color (even
though the newsprint has darkened, it would always have been a creamy yellow),
but also in the look of the high-quality artists' paper compared to that of the every-
day newspaper. The acidity of newsprint has also caused some discolored haloing
around the forms made with newspaper.

Picasso drew the charcoal lines in more than one stage, as they appear both
under and over the newspaper collage elements. (The detail above shows how the
pressure of the charcoal pierced and roughened the newspaper in an area not fully
adhered to the support paper.) He then went over the drawn forms several times to
strengthen the outlines and change the appearance of the solidity of the line.

RM

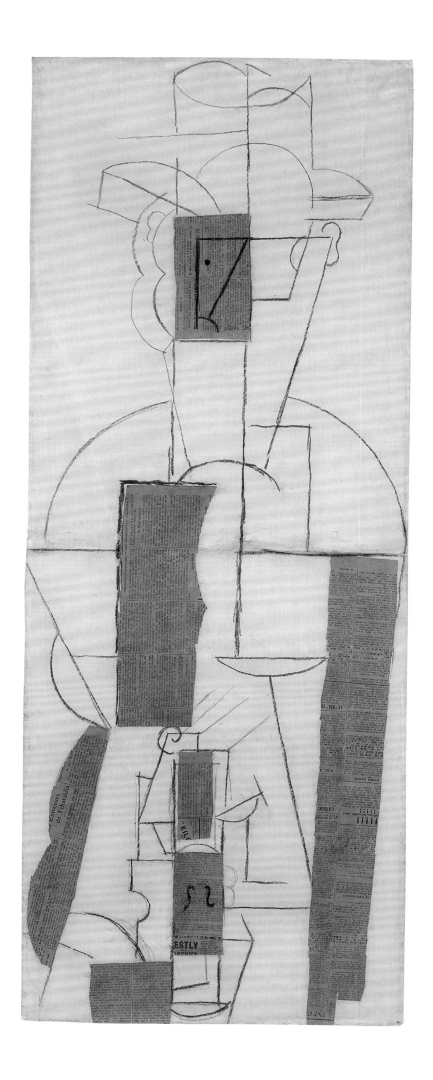

169

60. Card Players at a Table
Avignon, Summer 1914

Graphite on off-white wove paper
11¾ × 7¾ in. (29.8 × 19.7 cm)
Purchase, The Morse G. Dial Foundation Gift, in memory of
Ethelwyn G. Dial and Morse G. Dial, 1984
1984.5.2

Fig. 60.1. Paul Cézanne, *The Card Players*, 1890–92. Oil
on canvas, 53¼ × 71⅝ in. (135.3 × 181.9 cm). The Barnes
Foundation, Merion, Pennsylvania (BF141)

Fig. 60.2. Cat. 60, with
red lines showing pencil
lines that Picasso erased

The summer of 1914 was especially productive for Picasso. Delighted by Provence, looking first in Tarascon and settling in Avignon by June 23, the artist and his companion, Eva Gouel, exchanged visits with Braque and Derain, who were staying nearby, and made new friends among "the cream of Avignon society."[1] He realized a startling development in his Cubism, but by the end of July, as the run-up to World War I imposed itself, his achievements were overshadowed by great anxiety. On August 2 Braque and Derain were mobilized, and Picasso accompanied them to the Avignon train station, none knowing whether they would see each other again. Meanwhile, their friend and art dealer, Daniel-Henry Kahnweiler, a German national, fled Paris for Rome, and his gallery stock—considered "enemy property," including hundreds of works by Picasso, Braque, Gris, and Léger—would soon be seized by the French state. As a Spaniard in France without proper papers, Picasso, too, felt vulnerable as he faced an uncertain future.

Picasso nevertheless explored a dramatically new path in his studio, contrasting in the same work a Cubist treatment of objects and figures with a simple, sometimes naïve, naturalism. Although he had been thinking about Cézanne episodically since he first saw his works at Vollard's gallery in 1901, being in Provence—Cézanne country—triggered a new set of associations. In the cafés of Avignon, he saw men dressed identically to those in Cézanne's late paintings, and he made a number of works inspired by the card players of the Master of Aix (fig. 60.1). The card player subject conveniently provided a pretext for Picasso to juxtapose two figures in differing styles, as he does here in such an amusing manner.

This drawing was made in a notebook with many similar sketches.[2] The notebook remained intact until at least 1926, when several sheets—including this one—were published by Waldemar George, no doubt because their proto-Surrealist wit struck a resonant chord.[3] The Synthetic Cubist card player, at left, confronts a smiling, mustachioed peasant, at right. John Richardson identifies the similar figure in *Man in a Hat, Playing a Guitar* (summer 1914, private collection) as the Basque painter Francesco Iturrino (1864–1924), with whom Picasso had shared his first show in Paris, at Galerie Vollard, in 1901.[4] Derain also portrayed Iturrino in 1914 (Musée National d'Art Moderne, Centre Pompidou, Paris). Described by Gustave Coquiot, who helped organize the 1901 show, as a "monk by Zurbaran,"[5] Iturrino's furrowed brow, prominent cheekbones, and facial hair may well have contributed to Picasso's caricature. Although

some writers have mistakenly interpreted the scene as a meal, seeing a chicken leg at the right end of the table,[6] careful examination of the sheet shows that Picasso originally drew cards on the table and even placed bowlers, à la Cézanne, on the players. The dog, however, is unmistakable: Derain's German shepherd, named Sentinelle, was photographed by Picasso sitting at Eva's feet,[7] and included in several drawings, proof of Picasso's affection.

GT

1. Letter from Braque to Kahnweiler, July 15, 1914, as quoted in translation by William Rubin in New York 1989–90, pp. 51, 62 n. 158.
2. Other works in the sketchbook likely included: *Sailor and Woman* (Musée Picasso, Paris; Richet 355), *Reclining Woman and Guitar Player* (Musée Picasso, Paris; z VI.1151), *Untitled Drawing* (reproduced in Waldemar George 1926, pl. 7, under *Album inédit de l'artiste*), *Half Pear and Glass* (Picasso Estate; z VI.1193), *Pipe and Glass with a Sprig of Lily of the Valley* (Picasso Estate; z XXIX.49), *Pensive Man* (Picasso Estate; PF 1194), *The Drinker* (PF 1201), *Old Woman Sitting in an Armchair* (Marina Picasso Collection, z VI.1202), *Masked Man with a Guitar* (Marina Picasso Collection; z XXIX.126), *Head and Trunk of a Naked Man* (Picasso Estate; z VI.1262), *Man Standing, Leaning on a Balustrade* (PF 1271), *Seated Man with a Moustache* (Picasso Estate; Milan 2001–2, no. 46), and *Girl with a Guitar* (z XXIX.124; Vienna–Tübingen 2000–2002, no. 29).

3. Waldemar George 1926, p. 7, pl. 5.
4. Richardson 1991–2007, vol. 2 (1996), pp. 340–41.
5. Coquiot 1916, p. 116; quoted in Isabelle Monod-Fontaine in Copenhagen 2007, p. 142.
6. See Reinhold Hohl in Munich and other cities 1981–82, p. 276.
7. The photograph is reproduced in Richardson 1991–2007, vol. 2 (1996), p. 334.

PROVENANCE

The artist, Paris and elsewhere (1914–d. 1973); his estate (1973–78; Succession Picasso inv. 01787); his granddaughter Marina Picasso (1978–84; consigned to Jan Krugier, Geneva, from 1980, and through Krugier to Paul Rosenberg & Co., New York, from 1983–84; sold by the latter in January 1984 for $55,000 to the Metropolitan Museum)

EXHIBITIONS

Venice 1981, no. 112, pp. 240–41 (ill.); Munich and other cities 1981–82, no. 98, pp. 276–77 (ill.); Tokyo–Kyoto 1983, no. 82, p. 220 (ill.); New York 1983, no. 24, pp. 54–55 (ill.); New York (MMA) 1984, no cat.; Canberra–Brisbane 1986, p. 19 (ill.); New York 1989–90, p. 330 (ill.); New York (Pace Wildenstein) 1995, p. 116, pl. 20; Tokyo–Nagoya 1998, no. 44, pp. 90 (ill.), 239

REFERENCES

Waldemar George 1926, p. 7, pl. 5; Lieberman 1984, p. 106 (ill.); Palau i Fabre 1990, pp. 410, 519 (ill.), no. 1221

TECHNICAL NOTE

Picasso created this drawing using a graphite pencil on smooth wove paper. By altering the pressure and deliberateness of his stroke and by incorporating erasure, he varied the quality of the line. Picasso reinforced some of the graphite lines with multiple strokes in order to intensify them, such as the S-shaped arm of the figure at right. Other lines are pale and thin, drawn with a light touch, and may indicate areas of the original sketch that the artist decided not to emphasize as the drawing evolved; this is seen in the arching arms of the figure at left. Many of the graphite lines were erased but remain visible: this includes the playing cards on the table, the head and hair (or hats) of the figures, and other, less well-defined forms that disrupt the negative space (fig. 60.2).

RM

61. Ambroise Vollard

Paris, August 1915

Graphite on white wove paper watermarked PM FABRIANO
18⅜ × 12⅝ in. (46.7 × 32.1 cm)
Signed and dated in graphite, lower right: <u>Picasso</u> / Paris Aout 1915
The Elisha Whittelsey Collection, The Elisha Whittelsey Fund, 1947
47.140

In the summer of 1915, a year after the outbreak of World War I and the mobilization of friends such as Braque, Derain, and Apollinaire, Picasso found himself reconstructing his own life in Paris. His dealer, Daniel-Henry Kahnweiler, a German citizen, left Paris as the hostilities began, and his gallery stock, with about eighteen months of Picasso's work, was seized by the French state as enemy property.[1] Picasso had signed an exclusive contract with Kahnweiler in December 1912; the war did not void the contract but instead rendered it moot. Although the art market ground to a halt, Picasso was casting about for a representative. He had always made portraits of the dealers he was wooing, whether it was Vollard and Mañach in 1901, Clovis Sagot in 1909, or Wilhelm Uhde, Kahnweiler, or Vollard again in 1910. In August 1915, he made this pencil portrait of Vollard, quite self-conciously in the style of Ingres's pencil portraits. A few weeks later he made a similar portrait of the dealer Léonce Rosenberg (Rosenberg Collection, New York). Vollard did not give Picasso a contract, and Rosenberg eventually began to sell his paintings. Picasso showed Vollard sitting on a chair in his new studio on the rue Schoelcher; a year later Picasso drew Apollinaire in the same chair, wearing his recently acquired war wound and *croix de guerre* (1916, private collection; z 11b.923). Although Vollard famously enjoyed sitting to artists for his portrait—"He had the vanity of a woman," Picasso told Françoise Gilot[2]—it is unlikely that Vollard posed for this drawing. Picasso used a photograph as his model; the surviving copy was printed in reverse, but one can see that Picasso followed the photograph quite closely (fig. 61.1).

Picasso had been seriously flirting with naturalism since the summer of 1914, adopting some of the motifs and mannerisms of Cézanne. But for the pencil portaits of his close friends, he returned to Ingres, who had been a touchstone for the artist since 1904 (see the entry for *The Actor*, cat. 23). His first essay in this new venture was a portrait of the poet Max Jacob (Musée Picasso, Paris), made in January 1915 at the time of Jacob's conversion from Judaism to Catholicism.[3] Without question, Picasso had hoped to rival if not exceed Ingres. A recently rediscovered article by a Swedish journalist, Arvid Fougstedt, provides rare insight into the artist's interests at this moment. Fougstedt wrote about his visit to Picasso's studio in the January 9, 1916, *Svenska Dagbladet*:

—'My, an Ingres,' I say while grabbing a drawing on the nearest table.

Fig. 61.1. Thérèse Bonney, photograph of Ambroise Vollard, ca. 1915. Bibliothèque et Archives des Musées Nationaux, Paris, Fonds Vollard, MS 421 (3, 9), fol. 10

—'I just made it; I finished it yesterday; it gave me a lot of trouble,' [Picasso] adds; 'I will make a series and exhibit it after the war.'
—'Astonished, I look at the canvas, of the wildest cubist style, then at the drawing. It is a portrait of the art dealer Vollard; with a lead pencil as fine as a needle he modeled the most delicate shades of the face and underlined every eyelash. It is as if he wanted to say: I can do it; aren't I so clever!'[4]

Because Picasso was one of the few young artists in Paris who continued to work despite the war—his compatriot Juan Gris was another—these audaciously antimodern portraits provoked inordinate attention. Amédée Ozenfant published the portrait of Jacob on the first page of his journal *L'Élan* (no. 10, December 1, 1916).[5] Francis Picabia published a parody of the same work, *Portrait of Max Goth* (a drawn body with a pasted photograph for the head), to illustrate a mocking article titled "Picasso Repentant" in the Dada review *391* (January 25, 1917), ridiculing what he called Picasso's new Beaux-Arts, or Kodak, style.[6] Roger Fry wrote to Vanessa Bell in the summer of 1916 to say "Picasso [is] a little dérouté [derailed] for the moment but doing some splendid things all the same—among others an Ingres-like realistic drawing of Vollard."[7] Others, such as the stylish Jean

Cocteau, sensed that new times demanded new expression; he dropped in to have his portrait drawn in May 1916[8] and soon thereafter introduced Picasso to the world of Diaghilev and the Ballets Russes, inaugurating a new chapter in Picasso's life and the "rappel à l'ordre" in modernist painting and sculpture.

Ambroise Vollard (1866–1939) was one of the most extraordinary art dealers of the twentieth century. Although the sums he paid were notoriously small and the prices he demanded from collectors famously high, his support of artists such as Cézanne, Gauguin, and even Picasso, from 1906 to 1911, was crucial. More important, through his activities as a publisher of illustrated books, prints, ceramics, and sculptures, he spread the work and fame of his artists throughout Europe and America. From his first show at Vollard's Paris gallery on the rue Laffitte, in 1901, through his creation, in the 1930s, of the extraordinary set of one hundred etchings known as the *Vollard Suite* (see cats. P46–P52), Picasso had great but wary respect for the canny dealer and even, as one sees in this portrait, some grudging affection. Vollard bought the portrait from Picasso for 500 francs in August 1915 and immediately provided the artist with a photograph of it.[9] Unlike the marvelous Cubist portrait in oil from 1910 (The Pushkin State Museum of Fine Arts, Moscow), which Vollard sold within a few years, Vollard kept this drawing until his death. G T

1. John Richardson writes, "Since he had sold most of the items, Picasso had no legal claim on Kahnweiler's stock. However, the last lot of paintings, drawings and sculptures had not been paid for, and Picasso was adamant that this was his property and should be returned to him. He also felt that he had a stronger moral claim to the works that Kahnweiler had acquired from him than the custodian of enemy property." Richardson 1991–2007, vol. 2 (1996), p. 357. The value of the unpaid works amounted to 20,000 francs.
2. Gilot and Lake 1964, p. 49. Picasso said: "The most beautiful woman who ever lived never had her portrait painted, drawn, or engraved any oftener than Vollard—by Cézanne, Renoir, Rouault, Bonnard, Forain, almost everybody, in fact. I think they all did him through a sense of competition, each one wanting to do him better than the others."
3. This portrait, too, was based on a photograph. See Anne Baldassari in Houston–Munich 1997–98, pp. 142–43.
4. The article is reproduced in Paris–Montauban 2004, p. 168. Fougstedt also writes: "Mais à la porte je saisis à nouveau le dessin de Vollard et je le regarde tant bien que mal dans l'obscurité grandissante. —je crois bien que cela vous intéresse, dit-il en riant. Ces choses-là, je les vends toujours, les musées allemands ont acheté beaucoup de mes toiles naturalists, mais les cubists, je me les garde. Oui—ce dessin serait une trouvaille pour n'importe quell musée, croyez-moi." Fougstedt visited with Max Jacob and the dealer Adolphe Basler. Scholars say that Fougstedt visited in December, but one wonders whether Picasso could have managed such an encounter so close to the death of his companion Eva Gouel, on December 14, 1915. Picasso's statement that he had just completed the portrait of Vollard, dated August 1915, suggests the visit occurred in late summer.
5. According to Yve-Alain Bois, "The reactions, except for that of a few faithful friends, were at best of utter confusion. Not a month had passed before an anonymous critique, comparing a Cubist work and Max Jacob's portrait, wondered, 'which one is the true Picasso?'" Bois in Rome 2008–9, p. 26, quoting "Les deux Picassos" (Anon., January 13, 1917), reproduced in Quimper–Paris 1994, p. 134.
6. See Richardson 1991–2007, vol. 3 (2007), pp. 54, 55; see also Bois in Rome 2008–9, pp. 25–26.
7. Roger Fry to Vanessa Bell, July 3, 1916 (Sutton 1972, vol. 2, pp. 399–400).

8. "Posé ce matin chez Picasso. Il commence une tête très 'Ingres.'" Letter from Cocteau to Valentine Gross, May 1, 1916, cited in Steegmuller 1973, p. 112.
9. August (?) 1915:
 Dear Monsieur Picasso,
 Please find enclosed the 500 francs agreed upon as the price of my portrait. Because I am unable to get away myself, I told [the photographer Étienne] Deletang to pick it up on Saturday, in the morning, at about 10 o'clock; he will give you a [photographic] reproduction of it immediately, and the photos of whatever else I possess will follow very quickly.
 Vollard
 (Bibliothèque et Archives des Musées Nationaux, Paris, Fonds Vollard, MS 421 [4, 1], p. 278; published in translation in New York–Chicago–Paris 2006–7, p. 390.)

PROVENANCE
Ambroise Vollard, Paris (1915–d. 1939; purchased from the artist in August 1915 for 500 francs); his estate; [Martin Fabiani, Paris]; [André Weil, New York, until 1947; sold in December for $2,925, through John Rewald, to the Metropolitan Museum]

EXHIBITIONS
New York–Chicago 1957, p. 48 (ill.); Philadelphia 1958, no. 76, p. 18, ill.; Rotterdam 1958, no. 217, pp. 140–41, 202 (ill.); Paris 1958, no. 217, pl. 217; New York 1959, no. 217, pp. 139–40, 202 (ill.); Fort Worth–Dallas 1967 (Fort Worth), no. 171, pp. 36 (ill.), 102; New York (MMA) 1970–71, p. 329 (fig. 398); Paris 1973–74, no. 75, pp. 15, 58 (ill.), 164 (pl. 94); New York 1976, no. 96, pp. 130 (ill.), 131, 195; New York and other cities 1977–78, hors cat., only unnumbered checklist; New York 1980, pp. 179, 192 (ill.), and unnumbered checklist p. 33; Cambridge–Chicago–Philadelphia 1981 (shown only in Cambridge and unnumbered), no. 52, pp. 136–37 (ill.); London 1990, no. 131, pp. 205–6 (ill.); Quimper–Paris 1994, no. 155, pp. 120 (ill.), 327; New York–Paris 1996–97, pp. 192, 299 (ill.), 300; New York–Chicago–Paris 2006–7, no. 154, pp. 113 (fig. 118), 390 (ill.) (French ed., no. 100, p. 125 [ill.])

REFERENCES
Fougstedt 1916, p. 10; Skira 1921, p. 9; Zervos 1932–78, vol. 2b (1942), p. 384 (ill.), no. 922; Barr 1946, pp. 94–95 (ill.), 96, 110; Schneider 1947–48, pp. 82, fig. 2; Anon., summer 1948, p. 21; Barr 1951, pp. 204, 586; Russoli in Milan (Palazzo Reale) 1953, p. 103; Maurice Jardot in São Paulo 1953–54, p. 18; Boeck and Sabartés 1955, pp. 177–78; Elgar and Maillard 1955, pp. 86, 93 (ill.); Elgar and Maillard 1956, pp. 88, 90, 97 (ill.); Oslo 1956, p. 97; Vallentin 1957, p. 221; Penrose 1958, p. 192; Jardot 1959, pp. 42 (ill.), 155; Rosenberg 1959, pp. 205–6 (pl. 131); Rosenblum 1960, pp. 86 (fig. 56), 98, 319; Millier 1961, ill.; John Richardson in New York 1962, unpaginated; Bean 1964, no. 97, ill.; Jaffé 1964, p. 20 (fig. 19); Sanouillet 1966, p. 251; Jaffé 1967, p. 18 (fig. 19); Leymarie 1967, pp. 11, 42–43 (ill.), 104 (English ed., pp. 44 [ill.], 45, 106); Arnason 1968, p. 323 (fig. 512); Blunt 1968, p. 187; Prideaux 1968, p. 58 (ill.); Fermigier 1969, pp. 126 (fig. 70), 127; Leymarie 1971b, pp. 206 (ill.), 291; Cirlot 1972, p. 159; Leymarie 1972, pp. 206 (ill.), 293; Mahar 1972, pp. 446, 449–51 (figs. 5), 452–55, 463; Bacou 1973, p. 311 (fig. 4); Penrose 1973, pp. 212, 225; Hilton 1975, pp. 131–33 (fig. 94), 280; Hobhouse 1975, p. ix, ill.; Baumann 1976, pp. 81 (fig. 138), 206; Rosenblum 1976, pp. 93, 114 (fig. 56), 341; Arnason 1977, p. 331 (fig. 521); Daix 1977, p. 147; Robin Gibson in London 1978, p. 9 (fig. 5); Daix and Rosselet 1979, pp. 170–71 (ill.), 376 (English ed., pp. 164, 170–71 [ill.]); Gedo 1980, pp. 106 (ill.), 107; Kodansha 1981, p. 103 (ill.); Palau i Fabre 1981b, chronology; Penrose 1981, pp. 205–6; Jouvet 1982, p. 123, pl. 48; Gary Tinterow in Madrid 1985, p. 49 (ill.); Arnold Glimcher and Marc Glimcher in New York 1986, p. 82; Daix 1987a, p. 170; Pierre Daix, Kenneth Silver, and Ulrich Weisner in Bielefeld 1988, pp. 78 (fig. 4), 141, 167 (fig. 6); Jaffé 1988, p. 20 (fig. 19); Leighten 1989, p. xiv, fig. 106 facing p. 143; Silver 1989, pp. xii, 69, 70 (fig. 40); Palau i Fabre 1990, no. 1336, pp. 444 (ill.), 521; Batchelor 1993, pp. 67 (pl. 59), 68; Daix 1993, p. 170; Geelhaar 1993, p. 19 (fig. 7); FitzGerald 1995, pp. 54, 55 (fig. 17), 281 n. 18; Richardson 1991–2007, vol. 2 (1996), p. 359 (ill.); Arnauld Pierre in Grenoble 1997–98, pp. 14–15 (fig. 27), 132, 141, 132 (pl. 30), 134, 139; Seckel-Klein 1999, p. 20; Léal, Piot, and Bernadac 2000, pp. 180 (fig. 415), 510 (English ed., pp. 180 [fig. 415], 511); Schapiro 2000, pp. 27, 28 (fig. 35), 188–89; Antliff and Leighten 2001, p. 17 (fig. 10); Llorens Serra 2001, p. 75; Cowling 2002, pp. 281 (fig. 242), 282; Laurence Madeline in Paris–Montauban 2004, pp. 22 n. 104 (fig. 22), 28, 167–69; Julia May Boddewyn in New York–San Francisco–Minneapolis 2006–7, p. 376; Isabelle Monod-Fontaine in Copenhagen 2007, p. 121; Anne Baldassari and Paule Mazouet in Paris 2007–8, p. 351; Rome 2008–9, p. 24 (fig. 8)

Picasso composed the portrait in short lines made with a hard graphite pencil;[1] pale thin strokes facilitated the drawing's fine details, refined forms, and soft, gradual shadows. He intensified and darkened the shadows by applying multiple strokes, and he used stumping in some places to smooth the pencil lines and soften tonal transitions. The overall gray haze is graphite that was smeared across the surface and which has become imbedded over time. This shading of the paper may have been intentional, much like the atmospheric toning of some of the artist's chalk or charcoal drawings (see, for example, cat. 69).

Picasso chose a smooth-wove white Italian paper, manufactured by Fabriano. The paper's lack of texture allowed him to apply deliberate, fine strokes without

interference from the regular linear texture found in laid paper. Ingres chose this type of paper for his precise graphite portraits for the same reason. Indeed, Picasso appears to have made a conscious choice to mimic Ingres's materials in order to create his "Ingresque" portraits. The tack holes and the light band around the perimeter of the sheet may indicate that, like Ingres, Picasso secured a stretched sheet of paper to a drawing board in order to have a firm, flat, immobile surface on which to work. RM

1. Graphite pencils are manufactured to have varying degrees of hardness, which in turn affects the quality of the line.

62. Guitar and Clarinet on a Mantelpiece
Paris, Autumn–Winter 1915

Oil, sand, and paper on canvas
51¼ × 38¼ in. (130.2 × 97.2 cm)
Signed and dated in black and orange paint, upper left: <u>Picasso</u> / 1915
Bequest of Florene M. Schoenborn, 1995
1996.403.3

My life is hell," wrote Picasso to Gertrude Stein just before the death of his companion Eva Gouel in December 1915. "Eva is still ill and gets worse every day and now she has been in a nursing home for a month . . . my life is pretty miserable and I hardly do any work, I run backwards and forwards to the nursing home and I spend half my time in the Métro. . . . However I have done a picture of a Harlequin [fig. 62.1] that I think in my opinion and several people's opinion is the best I have ever done."[1] Eva, who entered a nursing home for the first time in January 1915,[2] remained bed-ridden with cancer until her death on December 14. Picasso's preoccupation with her health, the war, his friends in the army, and his status as a Spanish citizen in France accounts for his small output that year. And while he was truly distraught over Eva's decline and death, he managed nonetheless to sneak to Saint Tropez for a few days with a new lover, Gabrielle Lespinasse (née Depeyre).[3]

Although Picasso's few friends remaining in Paris were fascinated and confused by his foray into representational portraiture (see cat. 61), they all noted the presence of large Cubist compositions in his studio on the rue Schoelcher, overlooking the Montparnasse cemetery. This is confirmed by a series of photographs that Picasso took of himself posing in front of his pictures (figs. 62.2, 62.3). The photographs were taken over a period of time, and they show canvases at different stages of completion while Picasso wears different costumes: a banker's suit, a porter's smock, a flamenco costume, even bare chest and shorts. Perhaps because his dealer, Daniel-Henry Kahnweiler, had suspended operations and did not expect regular delivery of pictures, Picasso kept the canvases in his studio longer and reworked them more. As Metropolitan conservator Isabelle Duvernois explains in the technical note below, Picasso repainted

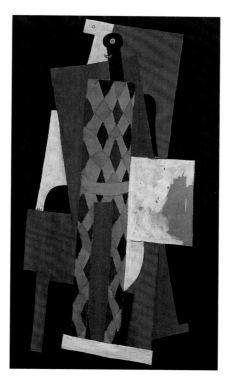

Fig. 62.1. Pablo Picasso, *Harlequin*, late 1915. Oil on canvas, 72¼ × 41⅜ in. (183.5 × 105.1 cm). The Museum of Modern Art, New York, Acquired through the Lillie P. Bliss Bequest (70.1950)

this composition innumerable times, and in the course of his reworking the composition passed from a drab palette of browns, gray, and blue to the vivid hues characteristic of the works he made in Avignon in the summer of 1914, back to drab browns, and then, finally, to the dark colors associated with his despair over Eva's decline. Throughout, he simplified the forms and reduced their number, as he did with the *Harlequin*, which was in his studio at the same time. While most scholars assign the completion of this work to late 1915, it is impossible to say when it was begun. The flat planes of the guitar and clarinet resemble

Figs. 62.2, 62.3. Photographs Picasso took of himself in his rue Schoelcher studio, Paris, ca. 1915–16, with cat. 62 visible on floor at right. Gelatin silver print, 7⅜ × 4⅝ in. (18.8 × 11.8 cm). Private collection

the papiers collés of 1912, but the pointillistic passages and organic shapes recall the playful spirit of Avignon in 1914. Picasso made a small number of wood still-life reliefs, some with "naturalistic" elements such as pieces of bowls and turned moldings.[4] Although the dating of the still lifes is disputed, many scholars believe they were made in 1915, and similar scalloped forms appear in this work. Picasso—and Braque, after the war—painted many still lifes on a mantel, and this one may be the first. It shows Picasso reveling in texture by adding sand to his paint; at the same time he stresses the anthropomorphic aspects of the still-life elements, encouraging the cheeks of the mantel to be read as legs and the musical instruments to be associated with male and female anatomy. Indeed, the composition may have begun as a man seated at a table, which Picasso eventually transformed into the still life on a mantel, leaving suggestions of the earlier forms. Picasso clearly considered this richly painted canvas an important work—not only did he photograph it in progress, he later gave it a prominent position in his country house in Fontainebleau (fig. 62.7) and kept it until 1930.

GT

1. Pablo Picasso, letter to Gertrude Stein, December 9, 1915, reprinted in Madeline 2008, p. 179.
2. Letter from Picasso to Apollinaire, February 7, 1915, reprinted in Caizergues and Seckel 1992, pp. 128–29.
3. John Richardson notes that although there is no documentary evidence for Picasso's trip, "three summery Provençal interiors" (*Provençal Kitchen*, *Provençal Dining Room*, and *Provençal Bedroom*; all Musée Picasso, Paris) that he did for Gaby prove that he must have left Paris at some point during 1915. See Richardson 1991–2007, vol. 2 (1996), p. 364. The On-line Picasso Project states they made a trip to Saint-Tropez in the summer to autumn of 1915.
4. See MP 289–295.

PROVENANCE
The artist, Paris and elsewhere (1915–30; sold on July 31, 1930, to Rosenberg and Wildenstein); [Paul Rosenberg, Paris, in joint ownership with Georges Wildenstein, Paris, 1930, until at least spring 1934]; [Galerie Pierre (Pierre Loeb), Paris, after spring 1934–1940; consigned, through Käte Perls, Paris, to Perls Galleries (Klaus G. Perls), New York, stock no. 1074; consigned by Perls on November 14, 1940, to Matisse; sold on December 21, 1940 (in full on June 30, 1941) for $3,500 to Matisse]; [Pierre Matisse Gallery, New York, 1940–44; stock no. 1027; sold on January 17, 1944, for $8,500 to Marx]; Samuel and Florene Marx, Chicago (1944–his d. 1964); Florene May Marx, later Mrs. Wolfgang Schoenborn, New York (1964–d. 1995; on extended loan at The Museum of Modern Art, New York, from 1971; her bequest to the Metropolitan Museum, 1995)

EXHIBITIONS
Zürich 1932, no. 92, pl. 11; Hartford 1934, no. 29; New York 1940–41, unnumbered cat.; New York 1943, no. 7; Chicago 1946, no. 21; New York (MoMA) 1955, no. 114, p. 17 (ill.); New York and other cities 1965–66, p. 22 (ill.); New York 1972, pp. 6, 96–97 (ill.), 214; New York (MMA/Schoenborn) 1997, brochure no. 16, ill.; New York 2000, pp. 75 (ill.), 125; Kyoto–Tokyo 2002–3, pp. 57, 67 (pl. 21), 91, 168; Paris 2007–8, p. 309 (ill.)

REFERENCES
New York and other cities 1939–41, p. 88, no. 125 (listed as lent by Pierre Loeb but the loan did not occur); Cassou 1940, pp. 91 (ill.), 166; Zervos 1932–78, vol. 2b (1942), p. 251 (ill.), no. 540; Sabartés 1946a (both eds.), pl. 7; Cassou and Sabartés 1950, pl. 7; Barr 1955, pp. 21 (ill.), 34; Prideaux 1968, p. 63 (ill.); Russoli and Minervino 1972, pp. 124–25 (ill.), no. 821; Daix and Rosselet 1979 (both eds.), p. 342 (ill.), no. 812; Palau i Fabre 1990, pp. 450 (ill.), 522, no. 1361; Geelhaar 1993, pp. 191 (fig. 209), 200, 201 (fig. 223); Anne Baldassari in Paris 1994, pp. 73–74 (figs. 47, 48): Daix 1995, p. 433; Vogel 1996b, p. A1; New York–Paris 1996–97 (both eds.), p. 141 (ills.); Andre 1997; Anne Baldassari in Paris 1997, pp. 202 (ill.), 208 (fig. 204); Anne Baldassari in Houston–Munich 1997–98, pp. 136, 137 (ills.), 166 (ill.); Maison de la Chimie sale 1998, pp. 10, 32 (ill.), under no. 164; Staller 2001, frontis.; Anne Baldassari in Paris 2005 (both eds.), p. 74 (fig. 49); Julia May Boddewyn in New York–San Francisco–Minneapolis 2006–7, pp. 355, 358, 361, 373; O'Brien 2007, p. 121 (ill.); Richardson 1991–2007, vol. 3 (2007), p. 107 (ill.)

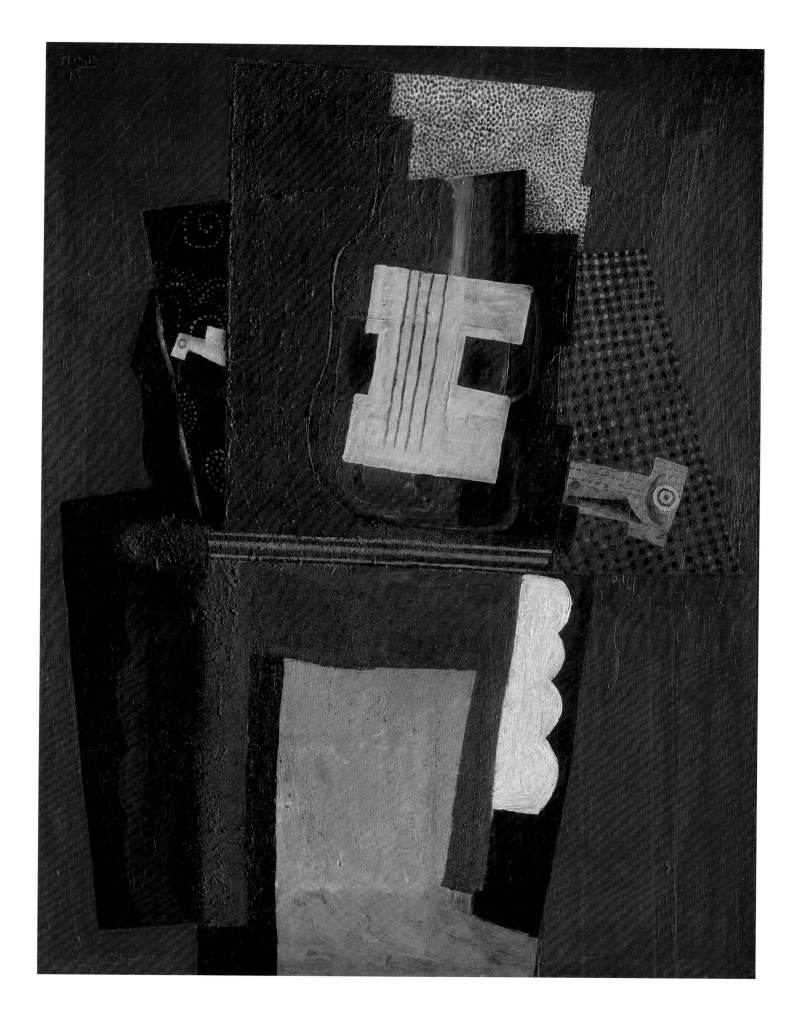

Fig. 62.4. X-radiograph of cat. 62

Fig. 62.5. Photograph of cat. 62, with outlines indicating compositional changes

Fig. 62.6. Cross section photograph (original magnification x 200) of cat. 62, showing the dark ground layer and five successive paint layers

TECHNICAL NOTE

The composition was painted on very fine canvas that was prepared—presumably by the artist—not with a traditional white ground but a layer of dark brown oil paint. This underlayer is discernible within the composition and is visible along most of the tacking edges.[1] The composition consists of oil paint (often thickly applied), paper collage elements, and sand. The buildup and textures of these materials give the painting's surface tangible three-dimensionality. Picasso must have worked on the canvas while it was lying flat, as opposed to upright, which would have facilitated manipulation and control of the sand as he added it to the paint; doing so would also have allowed him to build up the high paint ridges and glue on the paper elements. That paint was applied from multiple directions supports this assumption.

The overall thickness of the paint layer as well as the numerous ridges visible under the paint surface indicate that Picasso repeatedly reworked the composition. While X-radiography clarifies the various changes that he made (fig. 62.4), it does not inform us about their chronological sequence, as we can observe only the various shapes and outlines and their alternate dispositions on the picture plane (fig. 62.5).[2] For example, a sinuous curvilinear line in the lower right quadrant was once juxtaposed to the vertical white scalloping pattern painted on top of the black rectangle. This shape—echoing a similar sinuous profile in red and blue along the left side of the mantelpiece—was a recurrent motif of Picasso's visual vocabulary at the time, signifying perhaps either a table or chair leg or a human limb. Numerous contemporary drawings show how the artist played with the anthropomorphic nature of this motif.[3]

Similar ambiguous outlines can be seen in the X-ray to the right of the guitar—now covered by the black and ocher dotted plane—or in the scalloping pattern originally present in the top center under the white area with pointillistic colored strokes (fig. 62.4). These various shifts and changes suggest that Picasso worked to balance the linear and curvilinear elements; they also reflect the permutations of shape the artist investigated in many drawings, where the guitar on a table becomes the guitarist in a chair and vice versa.[4]

Picasso also substantially altered the color scheme. Most of the color fields reveal a different paint layer underneath, visible either as a result of the transparency of the oil paint or in the drying cracks. The colors directly beneath the colorful surface are generally more neutral—light and dark grays, dark green, ocher, black, and white—and closer to the artist's earlier, Cubist palette. Only the black and ocher polka-dot field at right and the pointillistic pattern at top center were retained.

A cross section of an area next to an old loss in the burnt sienna paint layer, along the left edge of the composition, reveals six distinct layers of color (fig. 62.6). It clearly shows how Picasso went back and forth with the color scheme of his composition, from neutral to light colors. It is not known whether such layering is present beneath the entire composition, but given the thickness of the paint that is a reasonable assumption. It is, therefore, no surprise that the paint surface has developed such prevalent drying cracks, resulting from the artist's successive reworking on paint layers that were not yet dry.

Although the painting is in good and stable condition, the various varnish applications and the wax lining have altered the surface, which now looks unnaturally flat and uniform, and somewhat dull. Early photographs of the painting in Picasso's studio (see figs. 62.2 and 62.3) reveal that the pointillistic area at top center has significantly darkened; as a result, a subtle shadow effect originally in this field has been practically eliminated.[5] Overall, the visual distinction among the various paints, their original gloss and texture, and the paper elements has been irrevocably reduced. The removal of the varnish in 1986 significantly improved the general appearance of the painting, but it could not entirely restore the original surface.

<div align="right">ID</div>

1. This layer comprises bone or ivory black, barium sulfate, and trace amounts of zinc white pigments bound in oil. Raman Spectroscopy, SEM-EDS, and ATR analyses were performed by Silvia A. Centeno, Julie Arslanoglu, and Mark Wypyski, Department of Scientific Research.
2. A photograph from 1912 showing earlier papiers collés on a wall of Picasso's studio in the boulevard Raspail shows that some of these studies share compositional features with the early variations of this work (see fig. 58.1; see also Paris 2007–8, p. 244).
3. See the various drawings from 1914–15 that show a man with a pipe seated at a table; see also Zervos 1932–78, vol. 6, pp. 143–47.
4. See Léal 1996, vol. 1, no. 17 (summer 1913–14), pp. 229–45.

Fig. 62.7. Pablo Picasso, photograph of Olga Picasso reading, Fontainebleau, summer 1921, with cat. 62 hanging on wall at top left. Gelatin silver print, 4⅛ × 2½ in. (10.6 × 6.2 cm). Musée National Picasso, Paris (APPH 6653)

63. Illustrated Letter to Jean Cocteau
Paris, November 16–19, 1916

Watercolor and ink on folded graph paper
Half sheet: 6⅞ × 4⅜ in. (17.5 × 11.1 cm)
Full sheet: 6⅞ × 8¾ in. (17.5 × 22.2 cm)
Signed in ink, lower right: <u>Picasso</u>
Bequest of William S. Lieberman, 2005
2007.49.78

Sometime in June 1915 the French poet, writer, artist, film-maker, social butterfly, and Parisian literary dandy Jean Cocteau (1889–1963) made "the greatest encounter of his life"—he met Picasso.[1] But, as John Richardson observed, "They might never have met if Cocteau, in a bid to reinvent himself as a modernist, had not made a determined effort to involve Picasso in his machinations."[2] Cocteau was aspiring to produce a new piece for Sergei Diaghilev's Ballets Russes, which was performing throughout Europe at that time, and he wanted to interest Picasso in designing the costumes and sets. (Cocteau's dream project eventually became the ballet *Parade*, which had its gala opening in Paris on May 18, 1917, at the Théâtre du Châtelet, billed as a collaboration between Cocteau, Picasso, and musician Erik Satie, who composed the score.)[3] After many failed attempts to meet Picasso, Cocteau finally secured an introduction through the good offices of an avant-garde composer, Edgard Varèse. Initially Picasso did not really enjoy Cocteau's company, despite—or because of—the latter's charm, elegance, and great aptitude for conversation. But finally the poet's flattery, fascinating social persona, and inventive mind as well as certain idiosyncrasies such as his use of makeup—pow-der, rouge, and lipstick[4]—captured Picassso's interest, and their contacts became friendly and frequent. As was the custom at the time, they corresponded frequently about current events and social occasions.

The present letter from Picasso to Cocteau is written on the front of a single sheet of vertically folded graph paper, most likely torn out of a notebook. Scribbled in pen and brown ink, the missive itself is surrounded by a decorative border of geo-metric patterns and dots in different hues of green, red, and black watercolor.[5] Although it is not dated, its resemblance to a dated letter to Guillaume Apollinaire (fig. 63.1) and several ear-lier letters with similar decorative motifs addressed to his par-amour Gabrielle Lespinasse (née Depeyre) suggest that Picasso wrote it between the sixteenth and the nineteenth of November, 1916.

Beneath the address inscribed at the top, "Montrouge (Seine)/22 Rue Victor Hugo," Picasso says that he hopes to see Cocteau at Montparnasse on the following Wednesday at the "festivities in honor <u>of the musician</u>." The date on Picasso's let-ter to Apollinaire, also inscribed "Montrouge," is Thursday, November 16, 1916, and in it the artist refers to an event that will take place on the following Sunday, November 19. Cocteau

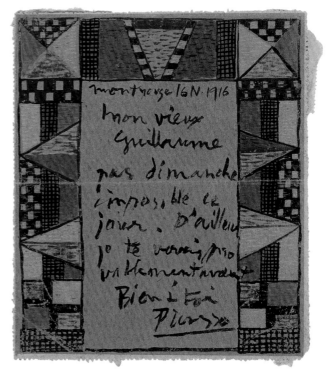

Fig. 63.1. Pablo Picasso, illustrated letter to Guillaume Apollinaire, dated November 16, 1916. Musée National Picasso, Paris

was a member of a music society known as Lyre et Palette, whose purpose was to organize charitable events in support of the bohemian community. From Sunday, November 19, through Tuesday, December 5, 1916, Lyre et Palette presented a pan-arts festival. On the first day, the program featured poems by Blaise Cendrars and Cocteau (the latter were dedicated to Erik Satie). Three days later—the "next Wednesday" that Picasso mentions to Cocteau—a Satie festival, *Instant Musical*, took place, and Cocteau attended, in the company of Sergei Diaghilev and Ernest Ansermet.[6]

The decorative border of the present letter, like the one with which Picasso embellished his note to Apollinaire, has a vocabu-lary of form that Picasso had explored in some of his paintings of autumn 1915, such as *Bottle of Anis del Mono* (Detroit Institute of Arts), and that he would later apply freely to the costumes for *Parade*. The border does, in fact, suggest a textile pattern.

MD

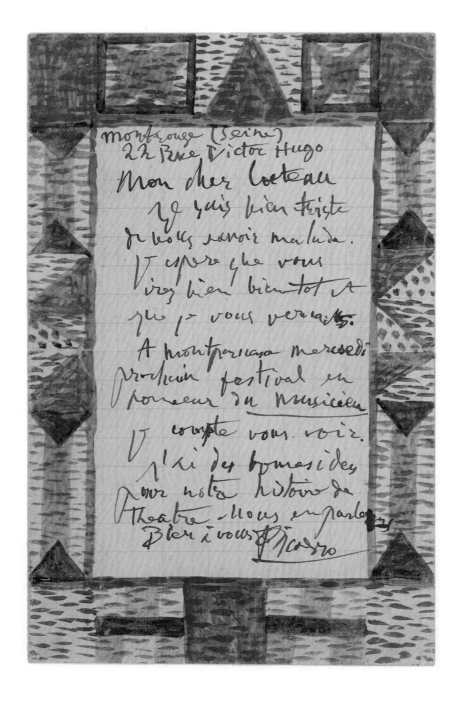

1. Cocteau and Fraigneau 1988, p. 21, as quoted in Richardson 1991–2007, vol. 2 (1996), p. 380.
2. Ibid., p. 379.
3. The details of *Parade*'s development have been discussed at length in books on Picasso and his involvement in the theater. See, most recently, Richardson 1991–2007, vol. 2 (1996), pp. 384–93; Cowling 2002, pp. 293–307; and Frankfurt 2006–7, pp. 67–70.
4. Richardson 1991–2007, vol. 2 (1996), p. 381.
5. As Picasso's handwriting is difficult to read and his French idiosyncratic, the letter is worth quoting here, in full and in translation (mine): "Mon cher Cocteau / je suis bien triste / de vous savoir malade. /j espere que vous / irez bien bientot et / que je vous verrais. / A Montparnasse Mercredi / prochain festival en/ honneur <u>du musicien</u> / je compte vous voir. / j'ai des bonnes idees / sur notre histoire du / theatre. Nous en parlerons / Bien à vous / <u>Picasso</u>" (My dear Cocteau / I am quite sad / that you are ill. / I hope that you / will be well soon and / that I will see you. / At Montparnasse next Wednesday's / festivities in honor <u>of the musician</u> / I hope to see you. / I have good ideas / for our theater story / we shall talk about it/ Best / <u>Picasso</u>).
6. For an in-depth discussion of the events, see F. Brown 1968, pp. 157–58.

PROVENANCE
Sent by the artist on November 16–19, 1916, to Cocteau; Jean Cocteau, Paris; William S. Lieberman, New York (until d. 2005; his bequest to the Metropolitan Museum, 2005)

64. Three Bathers by the Shore

Juan-les-Pins, August 22, 1920

Graphite on white wove paper watermarked [VIDALON]-LES-ANNONAY
B CRAYON ANE^{NE} MANUF^{RE} CANSON & MONTGOLFIER
19⅜ × 25¼ in. (49.2 × 64.1 cm)
Signed and dated in graphite, lower right: <u>Picasso</u> / 20
Dated and inscribed on verso in graphite, lower left: 22-8-20-/(I)
Bequest of Scofield Thayer, 1982
1984.433.277

In 1918 a new subject, bathers by the shore, entered Picasso's lexicon of depicted themes. A particularly prolific period for the motif was the summer of 1920, which Picasso and his wife, Olga Kokhlova (1891–1955), spent on the French Riviera. Beginning in mid-June, they sojourned at Saint-Raphaël and in July moved to a villa above the little village of Juan-les-Pins on Cap d'Antibes, where they remained through September. At Juan-les-Pins Picasso created a series of drawings of bathers in groups, lying, sitting, walking, reclining, or running on the beach. The works were executed in a more naturalistic style than his earlier Synthetic Cubist pictures, as he gravitated toward the conventions of classical art. In this respect, Picasso was following the general tendency among artists after the end of World War I toward greater conservatism of stylistic expression, which his friend Jean Cocteau defined as the "rappel à l'ordre" (call to order).[1]

Picasso's inclination toward classicism had also been stimulated by his exposure to the art of classical antiquity, which he saw not only in Paris at the Musée du Louvre but also during his prolonged stay in Italy in 1917 while working on the ballet *Parade* for Sergei Diaghilev's Ballets Russes.[2] At that time he visited museums and ancient sites in Rome and Naples. His interest in the art of ancient Greece was enhanced in 1919 and 1920 during trips to London, again to work for Diaghilev, this time on two ballets, *Le Tricorne* and *Pulcinella*.[3] He took the opportunity then to see the fragmentary marbles from the high-relief frieze of the Parthenon at the British Museum, the so-called Elgin Marbles.

Furthermore, three consecutive summers by the sea in unspoiled, ideal settings—in 1918, on a honeymoon with Olga, at the villa of a wealthy Chilean art collector and friend in Biarritz, and in 1919 and 1920 at fashionable beach resorts on the French Riviera—revived in the artist's mind images of a Mediterranean Arcadia of times past. The bathers of 1920 are shown at leisure, mostly nude and with classical profiles and ample bodies rendered palpable by means of a thin, energetic, and unshaded contour line. In their style, poses, and groupings, they also reflect the nineteenth-century artists Picasso most admired, Ingres and Cézanne.

The present sheet depicts three nude women at the seashore, arranged in a diagonal grouping that implies spatial depth and suggests that a wider stretch of beach extends off to the right. Sea and sky are defined by two superimposed horizontal lines. Two of the nudes are shown in languorous poses. The third,

closest to the viewer and holding a towel or a drapery, seems to be walking. The figures at left and at right have the generalized classical features of Greek goddesses, while those of the reclining nude in the center appear more individual. That figure may represent Picasso's wife, Olga. The standing or walking nude seems most closely related to an image of a Greek goddess, perhaps a draped figure from the Parthenon frieze or on a Greek vase. The women's heads are all lifted toward the sky, as if attracted by the sight or the noise of a passing object, such as an airplane; thus, the artist introduces into a classical composition an incongruous aspect of modern life.

Another reference seems implied by the boneless flesh and the poses of the three bathers, namely, the nude figures in such early compositions by Picasso's friend and rival Henri Matisse as *Le bonheur de vivre* (1905–6, The Barnes Foundation, Merion, Pennsylvania), *Le Luxe I* (1907, Musée National d'Art Moderne, Centre Pompidou, Paris), *Le Luxe II* (1907–8, Statens Museum for Kunst, Copenhagen), and *Bathers with a Turtle* (1909, Saint Louis Art Museum). Not only the figures but also the tripartite horizontal spatial organization of the composition suggest Matisse's early works. Ever since April 1906, when the two artists were introduced by Gertrude Stein, an avid collector of their works, Matisse and Picasso had felt a certain rivalry as to their professional progress and inventiveness. Frequently their "responses" to each other's work were not made immediately but after some time had passed. Here, Picasso looks back to the first experimental decade of Matisse's work, arriving at his own conflation of antique and modern elements. The distortion of forms and the elegant and delicate contour drawing, which both flattens the figures yet describes volume and anchors them in space, foretell the statuesque nudes and full-bodied figures of Picasso's forthcoming classical period.

This drawing was acquired by the Museum through the Scofield Thayer bequest. Thayer, the co-owner and editor of *The Dial*, one of America's renowned "little magazines,"[4] purchased it in July 1923 from Picasso's Parisian dealer, Paul Rosenberg. An enthusiastic but somewhat eccentric collector, Thayer had a great preference for drawings of nudes, and between 1921 and 1924 he bought numerous examples by Picasso from various dealers in Europe. They nourished his passion for collecting, but Thayer generally also acquired them for reproduction in *The Dial*, intending to acquaint his readers with the most recent examples of modern art.

On the verso of the drawing, the date "22-8-20" is inscribed, and the roman numeral "I" appears underneath. Clearly it makes a pair with *Three Bathers Reclining by the Shore* (cat. 65), executed in the same manner, on the same paper, on the same day, and incribed with the roman numeral "II."

<div align="right">MD</div>

1. Cocteau 1926.
2. For details, see Richardson 1991–2007, vol. 3 (2007), chap. 1, pp. 3–20 (Rome); chap. 2, pp. 21–30 (Naples), chap. 3, pp. 31–46 (*Parade*).
3. Ibid., chap. 10, pp. 113–33 (London and *Tricorne*), and chap. 12, pp. 144–55 (*Pulcinella*).
4. Founded in Chicago in 1880 by Francis F. Browne, the magazine moved to New York in 1918, where it was published under the editorship of Scofield Thayer. Its history and Thayer's tenure as editor are discussed in Joost 1964, pp. 3–20 and 74–113.

PROVENANCE
[Paul Rosenberg, Paris, by 1922–23; sold on July 7, 1923, to Thayer]; Scofield Thayer, Vienna and New York (1923–d. 1982; on extended loan to the Worcester Art Museum, Massachussetts, 1934–82, inv. 34.76; his bequest to the Metropolitan Museum, 1982)

EXHIBITIONS
Munich 1922, no. 43 (ill.); New York 1924, no. 34; Worcester 1924, no. 30; Northampton 1924, no cat.; Hartford 1934, no. 113; Worcester 1941, no. 46; Worcester 1959, no. 193, pp. 96 (ill.), 99; Worcester 1965, no cat., unnumbered checklist; Worcester 1971, no cat.; New York (MMA) 1985, no cat.; Canberra–Brisbane 1986, p. 20 (ill.); Bielefeld 1988, no. 29, pp. 228 (ill.), 317; on view at MMA, May 21–September 30, 1991, no cat.; New York 1993, no cat.; West Palm Beach 1994, no. 14, pp. 17, 37 (ill.), 55;

New York (MMA) 1997, hors cat.; Tokyo–Nagoya 1998, no. 55, pp. 104 (ill.), 239; Stuttgart 2005, no. 18, pp. 43, 46 (ill.); Frankfurt 2006–7, pp. 198 (ill), 274

REFERENCES
The Dial 76 (June 1924), ill. after p. 492; Éluard 1945, p. 62 (ill.); Éluard 1947, p. 62 (ill.); Zervos 1932–78, vol. 4 (1951), p. 102 (ill.), no. 288; Wasserstrom 1963, ill. between pp. 204–5; Warncke 1992, vol. 1, p. 276 (ill.); Anon., July 23, 1993, ill.; Warncke 1993, vol. 1, p. 276 (ill.); Chipp and Wofsy 1995–2009, vol. [2] (1995), pp. 84 (ill.), 285, no. 20-269; Julia May Boddewyn in New York–San Francisco–Minneapolis 2006–7, pp. 333, 341

TECHNICAL NOTE
Like many of Picasso's drawings of 1920, this one was done with a soft graphite pencil that produced thick, dark, metallic marks on the sheet. The artist created long, smooth lines by maintaining unbroken contact between the pencil and the paper. When Picasso applied less pressure on the pencil, some of the texture of the underlying board he was using as a support was transferred to the sheet; it is visible, for example, in the hair of the figure at upper left.

In many of his drawings made at the same time and place, Picasso selected different materials. Here, however, he used the same paper and techniques seen in the related *Three Bathers Reclining by the Shore* (cat. 65).

RM

65. Three Bathers Reclining by the Shore

Juan-les-Pins, August 22, 1920

Graphite on white wove paper watermarked VIDALON-LES-ANNONAY B
CRAYON ANE<u>NE</u> MANUF<u>RE</u> CANSON & MONTGOLFIER
19½ × 25¼ in. (49.5 × 64.1 cm)
Signed and dated in graphite, lower right: <u>Picasso</u> / 20
Dated and inscribed on verso in graphite, lower right: 22-8-20-/(II)
Bequest of Scofield Thayer, 1982
1984.433.279

This drawing belongs to a group of works depicting nude bathers on the beach that Picasso made in Juan-les-Pins during the summer of 1920. Two years later, Picasso's dealer Paul Rosenberg sent the drawing and a similar one (cat. 64) to an exhibition of Picasso's work at Heinrich Thannhauser's Moderne Galerie, in Munich.[1] The American collector Scofield Thayer purchased both drawings from Rosenberg for reproduction in Thayer's magazine *The Dial*.[2] Thayer, who had a taste for pictures of nudes, including erotica (see cat. 20), and a preference for line drawings, acquired several of Picasso's bathers of the early 1920s (see cats. 64, 66, 67, 71).

The three reclining nudes in this pencil drawing were inspired by the art of antiquity; more directly, they reflect Picasso's fascination with the paintings and drawings of Ingres. Spread out within a shallow space, the figures assume Ingresque poses. The nude in the foreground is clearly a descendant of Ingres's *Grand Odalisque* (fig. 65.1), while the other two bring to mind his *Turkish Bath* (fig. 65.2). The composition emphasizes the tension between two- and three-dimensionality, and despite its simplicity, the linear style of drawing—the figures are devoid of internal modeling and shading—suggests volume. The space is organized vertically by a horizontal line that defines the shore and another above it that represents a high horizon. The whiteness of the support conjures up the sea and sky. Although grouped, the women appear to be psychologically isolated from one another, each existing in her own space and time continuum.

Like *Three Bathers by the Shore* (cat. 64), the present sheet is dated "22-8-20" on the verso at upper left, and a Roman numeral—in this case, "II"—appears below the date. The technique and the paper support are also the same for these two drawings conceived as pendants.

MD

1. See the catalogue of the exhibition, "Pablo Ruiz Picasso" (Munich 1922, no. 45, ill.), for which Rosenberg himself wrote a preface. Rosenberg sent the work either on loan or on consignment.
2. See Joost 1964, p. 137, where the present drawing is mistakenly dated June 1924.

Fig. 65.1. Jean-Auguste-Dominique Ingres, *The Grand Odalisque*, 1814. Oil on canvas, 35⅞ × 63⅝ in. (91 × 162 cm). Musée du Louvre, Paris (RF 1158)

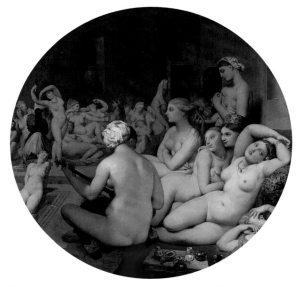

Fig. 65.2. Jean-Auguste-Dominique Ingres, *The Turkish Bath*, 1862. Oil on canvas on wood panel, diameter 42½ in. (108 cm). Musée du Louvre, Paris (RF 1934)

PROVENANCE
[Paul Rosenberg, Paris, by 1922–24; sold on July 7, 1923, to Thayer]; Scofield Thayer, Vienna and New York (1924–d. 1982; on extended loan to the Worcester Art Museum, Massachussetts, 1934–82, inv. 34.78; his bequest to the Metropolitan Museum, 1982)

EXHIBITIONS
Munich 1922, no. 45, ill.; New York 1924, no. 35; Worcester 1924, no. 31; Northampton 1924, no cat.; Hartford 1934, no. 111; Worcester 1941, no. 44; Worcester 1959, no. 195, pp. 8 (ill.), 99; Worcester 1965, no cat., unnumbered checklist; Worcester 1971, no cat.; New York (MMA) 1985, no cat.; Canberra–Brisbane 1986, pp. 19, 20 (ill.); Bielefeld 1988, no. 28, pp. 227 (ill.), 317; Málaga 1992–93, no. 17, ill.; New

York 1993, no cat.; West Palm Beach 1994, no. 15, pp. 17, 37 (ill.), 55; Tokyo–Nagoya 1998, no. 54, pp. 104 (ill.), 239; Balingen 2000, no. 88, ill.; Liège 2000–2001, no. 73, ill.; Stuttgart 2005, no. 17, p. 223, ill.; Frankfurt 2006–7, pp. 199 (ill.), 274

REFERENCES
De Zayas 1923, p. 326 (ill.); Cheney 1924, p. 25 (ill.); *The Dial* 76 (June 1924), ill. after p. 492; d'Ors 1930, p. 41 (ill.); Nikodem 1936, pl. 21; d'Ors [1946], fig. 16; Zervos 1932–78, vol. 4 (1951), p. 34 (ill.), no. 105; Joost 1964, pp. xv, 137 (ill.); Warncke 1992, vol. 1, p. 276 (ill.); Warncke 1993, vol. 1, p. 276 (ill.); Chipp and Wofsy 1995–2009, vol. [2] (1995), pp. 84 (ill.), 284, no. 20-271; Julia May Boddewyn in New York–San Francisco–Minneapolis 2006–7, pp. 333, 341

TECHNICAL NOTE

Picasso executed this drawing with a graphite pencil applied with nearly consistent pressure across the sheet of white artists' paper. The softness of the graphite and the heavy deposition of media on the paper account for the slight smearing visible in many areas. The texture of the board the artist used to support the paper while he was working is visible in numerous places, including along the back of the foreground figure and on the left side of the nude nearest the sea. The same paper and techniques used here may be found in *Three Bathers by the Shore* (cat. 64).

RM

185

66. Two Bathers Seated by the Shore

Juan-les-Pins, September 4, 1920

Graphite on gray laid paper watermarked FRANCE, with countermark
of monogram in oval
29⅝ × 41¼ in. (75.2 × 104.8 cm)
Signed and dated in graphite, lower left: Picasso; upper right: 4-9-20-
Bequest of Scofield Thayer, 1982
1984.433.281

This unusually large drawing, almost twice the size of other
classicizing depictions of nudes by the seashore that Picasso
produced during a prolific summer at Juan-les-Pins, was exe-
cuted, according to the inscribed date, on September 4, 1920.
Like the two other sheets from that group included in this cata-
logue (cats. 64, 65), it formed part of the collection of *The Dial*,
the art and literary review co-owned and edited by Scofield
Thayer, who, according to one of his editors-in-chief, Alyse
Gregory, was a character of the measure of Lord Byron, "the
embodiment of the aesthete with over-refined tastes and
sensibilities."[1]

Thayer acquired the work from Picasso's Parisian dealer, Paul
Rosenberg, and sent it shortly afterward to the 1924 exhibition
of The Dial Collection at the Montross Gallery in New York.
The figures in the composition are beautifully defined with a
seemingly uninterrupted pencil line—sure, soft, and flawless,
with only one obvious inflection, on the right forearm of the
larger seated figure. Striking here are the relative proportions of
the figures (the seated one seems distinctly larger than the
reclining nude), their relationship to one another (is the larger
figure male or female?), and the placement of the group within
the field of composition. Although the poses of the individuals
are different, their attitude brings to mind Ingres's famous
painting *Jupiter and Thetis* (Musée Granet, Aix-en-Provence).

The composition differs from two similar drawings of bathers
in the Museum's collection in the special rapport of figures to
landscape. Here, the bathers are situated closer to the edge of
the sea, so that the foreground implies a wider stretch of sandy
beach, and the large figure is placed so high on the sheet that it
dominates the sky as well as the sea and land. The serenity of
the composition creates an exquisite atmosphere of spacious-
ness, and the vitality of line suggests the joy of life experienced
in an ancient Mediterranean Arcadia. MD

1. Gregory 1948, p. 178.

PROVENANCE
[Paul Rosenberg, Paris, by 1922–23; sold ca. 1923, to Thayer]; Scofield Thayer,
Vienna and New York (ca. 1923–d. 1982; on extended loan to the Worcester Art
Museum, Massachusetts, 1934–82, inv. 34.82; his bequest to the Metropolitan
Museum, 1982)

EXHIBITIONS
Munich 1922, no. 44, ill.; New York 1924, no. 36; Rochester 1924, no. 82; Worcester
1924, no. 32; Northampton 1924, no cat.; Hartford 1934, no. 112; New York and
other cities 1939–41, no. 152; Worcester 1941, no. 45; Worcester 1959, no. 196, pp. 98
(ill.), 99; Worcester 1971, no cat.; Worcester 1981, no. 119; Canberra–Brisbane 1986,
pp. 19–20 (ill.); Bielefeld 1988, no. 27, pp. 226 (ill.), 317; New York 1995, unpagi-
nated cat.; Tokyo–Nagoya 1998, no. 56, pp. 105 (ill.), 239; Stuttgart 2005, no. 20,
pp. 46 (ill.), 224

REFERENCES
Thayer 1923, pl. 10; Carey 1924, p. SM10; Craven 1924, p. 182, ill. after p. 202; R. Fry
1926, p. 207, pl. 34A; Zervos 1932–78, vol. 4 (1951), p. 60 (ill.), no. 181; Joost 1964,
pp. xv, 137 (ill.), 229, 236; Chipp and Wofsy 1995–2009, vol. [2] (1995), pp. 124
(ill.), 285, no. 20-397; Marilyn McCully in Balingen 2000 (both eds.), p. 19 (fig. 5);
Julia May Boddewyn in New York–San Francisco–Minneapolis 2006–7, pp. 333,
341, 352

TECHNICAL NOTE
Picasso made this drawing on a large sheet of highly textured, gray, laid artists'
paper, which has gradually darkened and become warmer in tone. He drew the
forms with thick strokes of a soft graphite pencil, creating rich metallic deposits on
the paper surface. In many of Picasso's drawings, the lines are formed by long curvi-
linear strokes, but here, except for the horizon, all the lines are formed by short,
choppy strokes. An example is the curve that defines one breast of the figure lying
on the sand. Picasso created this small form—approximately two centimeters in
diameter—with as many as eight small, deliberate lines.
 RM

67. Reclining Bather with a Book
Fontainebleau, Summer 1921

Graphite on wove paper
8⅞ × 11 in. (22.5 × 27.9 cm)
Signed in graphite, lower right: <u>Picasso</u>
Bequest of Scofield Thayer, 1982
1984.433.271

Picasso spent the summer of 1921 in the idyllic forest land-scape of Fontainebleau, far from the Mediterranean shore where he had vacationed the previous year. Nevertheless, the subject of nude bathers on the beach remained with him even there, and in many ways the drawings from that summer represent a continuation of the series of reclining bathers he had made at Juan-les-Pins (see cats. 64–66).

In this fluidly drawn sketch, Picasso varied the thickness of his line by slight adjustments in the pressure and angle of the graphite pencil. The lines range in texture from smooth to choppy, and, as conservator Rachel Mustalish discusses in the technical note below, a discernible pattern in the lines suggests that while he was drawing Picasso placed the paper on a textured surface, as he did at Gósol (see cat. 31). Where the bathers Picasso drew in Juan-les-Pins were relatively slender, the nude in this drawing is closer to his more sculptural figures of 1921, especially the monumental body and the more classical rendering of the frizzy hair and the nose, which is flattened on the ridge in a manner that recalls the pastel *Head of a Woman* (cat. 68). The bather reclines on a sheet spread on the beach, and the composition, tightly confined within the pictorial space between the high horizon line and the folds of the sheet, emphasizes the robustness of her limbs and the general massiveness of her body. Seemingly lost in thought, she is perhaps contemplating a passage from her book; she could also be observing something outside the boundaries of the depicted space, much like the figures in *Three Bathers by the Shore* (cat. 64). Picasso further defined her dreamy face with sharply delineated and curved eyebrows, which, together with the classically modeled nose, add to the figure's highly sculptural, expressive power.

MD

PROVENANCE
[Galerie Alfred Flechtheim, Berlin, until 1922; sold in July to Thayer]; Scofield Thayer, Vienna and New York (1922–d. 1982; on extended loan to the Worcester Art Museum, Massachusetts, 1939–82, inv. 39.1950; his bequest to the Metropolitan Museum, 1982)

EXHIBITIONS
Worcester 1941, no. 41; Worcester 1959, no. 200, p. 99; Worcester 1971, no cat.; Málaga 1992–93, no. 29, ill.; Tokyo–Nagoya 1998, no. 57, pp. 105 (ill.), 239

REFERENCE
The Dial 82, no. 3 (March 1927), ill. between pp. 232–33

TECHNICAL NOTE
Picasso drew in long strokes with a graphite pencil to create the sinuous lines of this work. The support, a thin wove paper, possibly writing paper or from a sketchbook, has discolored from a white or off-white to a yellow tone. A stripe pattern seen in most of the drawn lines indicates that while the drawing was being executed Picasso supported the sheet of paper on a textured surface, perhaps a slab of wood. Picasso often used the texture imparted by a drawing support to realize a variety of patterns in his drawn strokes (see cats. 31, 64, 65).

RM

68. Head of a Woman
Fontainebleau, September 1921

Pastel on wove paper
25⅝ × 19¾ in. (65.1 × 50.2 cm)
Signed in black pastel, lower right: Picasso; dated below, in graphite:
Septembre 1921
Dated and inscribed on verso in pastel, upper left: Septembre 1921 /
Fontainebleau
Bequest of Scofield Thayer, 1982
1984.433.270

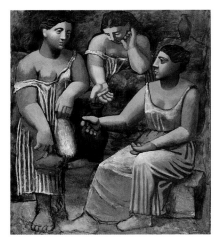

Fig. 68.1. Pablo Picasso, *Three Women at the Spring*, 1921. Oil on canvas, 80¼ × 68½ in. (203.9 × 174 cm). The Museum of Modern Art, New York, Gift of Mr. and Mrs. Allan D. Emil (332.1952)

Fig. 68.2. Pablo Picasso, Olga Picasso in the Fontainebleau studio, 1921, with cat. 68 at upper right. Gelatin silver print, 2¾ × 4¾ in. (7 × 12 cm). Archives, The Pushkin Sate Museum of Fine Arts, Moscow

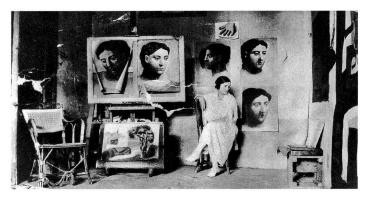

After three summers spent at the seashore, first on the Atlantic coast in Biarritz (1918) and then on the French Riviera (1919 and 1920), Picasso and his family chose to vacation in 1921 at Fontainebleau, a little town about forty miles southeast of Paris. With its beautiful forest and splendid sixteenth-century château, Fontainebleau had been a retreat for French kings and Parisian bourgeoisie for centuries and a favored site for earlier generations of landscape painters, from Corot to Monet. It also has a temperate climate and is within easy reach of Paris, which would have appealed to Picasso's young wife, Olga, who was caring for their new son, Paulo, born on February 4. From the end of June until mid-September the family lived in a rented villa, and Picasso set up his studio in an adjacent coach house.

It was a prolific time for Picasso, who was exploring a number of different stylistic possibilities. Among his major works from this period are two Synthetic Cubist versions of *Three Musicians*,[1] but he also continued to pursue the neoclassical idiom that had occupied him in previous summers, as seen in the masterpiece *Three Women at the Spring* (fig. 68.1). In this monumental painting, Picasso manipulated the scale and expressive qualities he had developed under the influence of classical art to arrive at the friezelike arrangement of three giant women. In preparation, he executed numerous works presenting different views of the women, and of the composition as a whole, in a variety of media, including pastel, charcoal, sanguine, oil, and combinations thereof. This striking pastel is one of the studies he made for the head of the woman standing at left and holding a water pitcher in her right hand.

The present drawing and several other pastels related to *Three Women at the Spring* are documented in a photograph that shows Olga seated in Picasso's garage studio. The studies can be seen pinned to the wall behind her, with the Museum's pastel at upper right (fig. 68.2; unfortunately the photographic reproduction does not show the blue top of the garment).[2] Given that Picasso drew numerous portraits of Olga that summer at Fontainebleau, one might deduce a certain kinship between her profile in the photograph and those of the figures in the pastels. The pastels also have a sculptural quality that reflects the influence of Late Hellenistic art, such as the head of Hera at the Vatican (Galleria delle Statue, Museo Pio-Clementino, Rome) or the bust of Juno at the Museo Archeologico Nazionale, Naples (fig. 68.3),

which Picasso likely saw during his travels in Italy in 1917.[3] The style of the figure relates to the frescoes of Pompeii and Herculaneum as well as to works by Masaccio, Raphael, and Ingres. Yet, as he had so often done in other works, here Picasso combined and transformed his various sources to unique effect, in this case an evocation of sculptural monumentality.[4]

Head of a Woman is an excellent demonstration of Picasso's masterful use of pastel, whereby he alternated thin and thick applications—sometimes blending layers but elsewhere leaving them discrete—to convey a great immediacy as well as the sculptural presence noted above. The woman's neck, for example, similar in color to red chalk, has less medium applied over the darker underlayers. The modulation of different strokes is particularly evident in the hair, where hints of pink and white pastel create a soft, braidlike effect; in some areas the strokes remain distinct, giving the appearance of volume and texture. The blue background likewise comprises numerous visible layers of pastel, which the artist built up and shaded in several directions.

MD

1. The first version of *Three Musicians* is in the Philadelphia Museum of Art, A. E. Gallatin Collection; the second is in The Museum of Modern Art, New York. For a discussion of these two paintings, see Palau i Fabre 1999, pp. 290–91.
2. That the Museum's pastel was pinned to the wall in this manner is confirmed by the presence of pinholes in the corners (see technical note). Many other studies for *Three Women at the Spring* are reproduced in Palau i Fabre 1999, pp. 281–87.

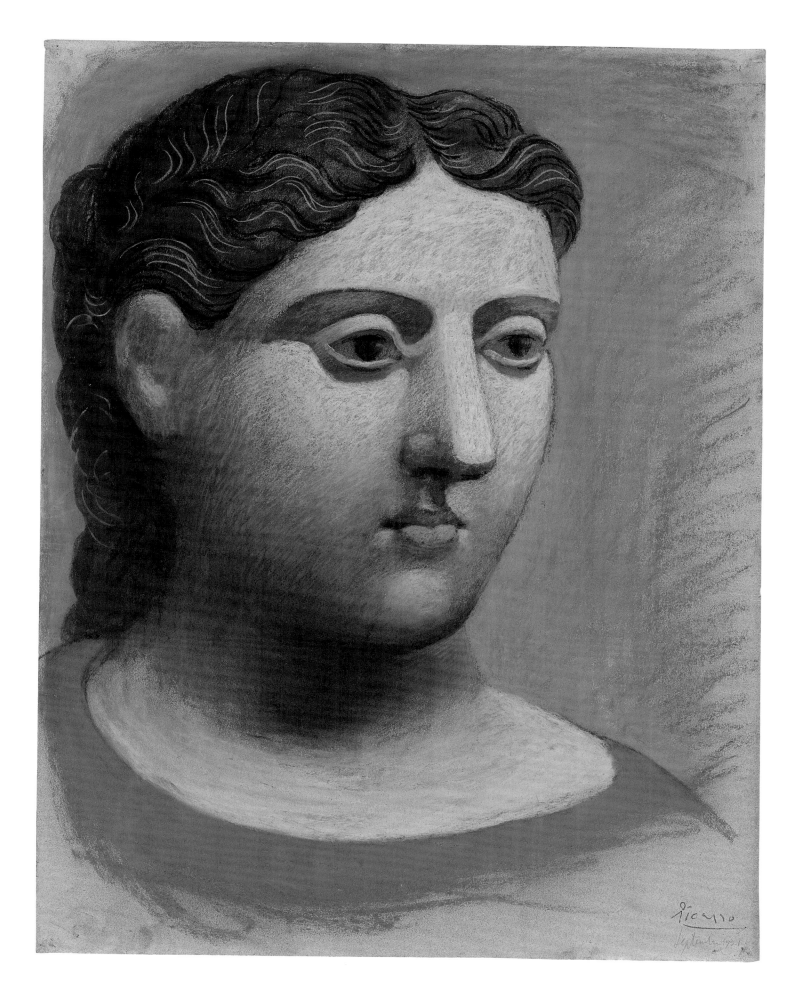

Fig. 68.3. Bust of Juno, Roman copy of original by Alkamenes, 5th century B.C. Marble, H. 23⅝ in. (60 cm). Museo Archeologico Nazionale, Naples

and other cities 1939–41 (shown only in New York), no. 158, p. 106 (ill.); Cambridge 1941, no cat.; Worcester 1959, no. 79, pp. 86–87, ill.; Worcester 1965, no cat., unnumbered checklist; Worcester 1971, no cat.; Worcester 1981, no. 109, pp. 125 (ill.), 158; New York (MMA) 1985, no cat.; New York 2000, hors cat.; Cleveland–New York 2006–7 (shown only in New York), no. 6:21, pp. 261 (fig. 2), 501

REFERENCES
Bell 1922, p. 82 (ill.); *The Dial* 81, no. 3 (September 1926), frontis.; F. Taylor 1932, p. 70; Frankfurter 1939b, pp. 5, 14, 20 (ill.), cover ill.; Mackenzie 1940, in "Classic Period, 1918 to 1925" section, pl. XI; Barr 1946, p. 118 (ill.); Merli 1948, p. 601, fig. 245; Zervos 1932–78, vol. 4 (1951), p. 136 (ill.), no. 346; Jean Sutherland Boggs in Toronto–Montreal 1964, p. 91; Joost 1964, ill. between pp. 268–69; Blunt 1968, pp. 188, 189 (fig. 22); Blunt 1981, pp. 148, 149 (fig. 34); Kodansha 1981, pl. 60; Messinger 1985, pp. 48 (ill.), 49; Richardson 1987, p. 158 (ill.); Tinterow 1987, p. 128 (fig. 106); FitzGerald 1996 (both eds.), pp. 314 (ill.), 319; Anne Baldassari in Paris 1997, p. 221 (fig. 221); Anne Baldassari in Houston–Munich 1997–98, pp. 124 (ill.), 175 (ill.); Palau i Fabre 1999, pp. 300 (fig. 1114), 512; John Richardson in New York (C&M Arts) 2003, p. 12 (ill.); Kanagawa 2006, p. 87 (ill.); Julia May Boddewyn in New York–San Francisco–Minneapolis 2006–7, pp. 333, 334, 348, 352; Richardson 1991–2007, vol. 3 (2007), pp. 184 (ill.), 196 (ill.)

3. For Picasso's travels in Italy, see Richardson 1991–2007, vol. 3 (2007), pp. 21–30; for the head of Hera, see New York (C&M Arts) 2003, p. 12.

4. See Anthony Blunt's (1968, p. 188, fig. 22) still-apt description ("the flattened ridge of the nose leading straight into the plane of the forehead, the sharp edge of the brows, the simplified modelling of the cheeks") and his assessment of the heads.

PROVENANCE
[Paul Rosenberg, Paris, ca. 1922–no later than 1924; sold to Thayer]; Scofield Thayer, Vienna and New York (ca. 1922/by January 1924–d. 1982; on extended loan to the Worcester Art Museum, Massachusetts, 1931–82, inv. 31.769; his bequest to the Metropolitan Museum, 1982)

EXHIBITIONS
New York 1924, no. 31; Worcester 1924, no. 28; Northampton 1924, no cat.; Boston 1939, no. 60, p. 68 (ill.); New York (Wildenstein) 1939, no. 41, p. 58 (ill.); New York

TECHNICAL NOTE

Picasso used broad, rough strokes of pastel to block in areas of color and sharp, smooth lines to define details, such as in the eyes and hair. In the shadows, he blended the pastel during applications of subsequent layers; in other areas, such as the hair, the top strokes remain distinct. This technique—creating an overall shape for the hair with a field of color and then adding crisper, defining strokes on top—is also seen in the large chalk drawing *Head of a Woman* from 1922 (cat. 69).

The support is a moderately textured wove paper; this texture is reflected in the broken strokes of the pastel. The dark blue fibers in the mottled paper are still readily visible, but overall the original gray-blue hue has faded to tan. There are pinholes in the corners, an indication that the drawing was tacked to a board during execution or pinned to the wall for informal display (see fig. 68.2). RM

69. Head of a Woman
Dinard, Summer 1922

Chalk on wove paper watermarked Montgolfier à St. Marcel-Les Annonay
42⅜ × 28⅜ in. (107.6 × 72.1 cm)
Signed and dated in black chalk, upper left: <u>Picasso</u> / 22
Bequest of Scofield Thayer, 1982
1984.433.276

In a letter mailed from London and dated July 19, 1923, the American arts patron Scofield Thayer wrote to Picasso's Parisian dealer, Paul Rosenberg, about a recent visit with the artist: "After leaving you on Thursday evening of last week, Mr. Mortimer and I went to see Picasso who was good enough to show us some things. I bought a large female head with hair streaming out behind for which I have today sent my check to Monsieur Picasso."[1] The drawing described in the letter, *Head of a Woman*, was first shown in 1924 at the now famous "Living Art" exhibition of Thayer's Dial Collection at the Montross Gallery, New York, and published in *The Dial* in 1929 (where it was titled

simply *Sanguine Drawing*). For the next half century it became known as *Heroic Head of a Woman*.[2] The inscription in the upper-left corner suggests that it was made in the summer of 1922, which Picasso spent with his family at Dinard, in Brittany. In his catalogue raisonné of Picasso's oeuvre, Christian Zervos lists this work as a pastel titled *Nu à mi-corps de dos* (Torso of a Nude Seen from the Back) and dates it to 1921.[3] This date seems unconvincing, however, especially when the style of the figure is compared to that of the heads from the Fontainebleau period (see cat. 68; fig. 68.2) and those from Dinard (see cat. 70), particularly the definition of the body and more delicate treatment of the face.

Unlike the previous year at Fontainebleau, Picasso did not have a studio in Dinard. Thus, except for one gouache on plywood,[4] he spent most of his time drawing. Here, the artist is more clearly inspired by the art of classical antiquity he had encountered in 1917 during his travels to Rome, Naples, and

193

Pompeii. While in Italy, according to Enrico Prampolini, a young Futurist painter whom Picasso saw in Rome, the artist "found himself face to face with the great Classical and Renaissance works of art: with Raphael and Michelangelo. It was a seminal moment for the artist, as it revealed to him an essential trajectory of his own pictorial evolution. I remember the artist's rapture before the frescoes at the Sistine [Chapel] and in the Raphael Stanze. It was the meeting between the Humanistic enchantment of the Renaissance objective figuration and the subjective world of the intrinsic geometric speculation of the formal relationships of Cubist painting, to which he adhered at the time."[5] Indeed, this heroic head shows more similarities to works such as Michelangelo's Sibyls and Raphael's Jurisprudence—note, for instance, the sculptural facial features and the large form isolated in infinite space—than it does to the remarkable draftsmanship of Ingres, whom Picasso had studied intensely while working out his own figurative idiom. Many of the stylistic and compositional strategies seen here anticipate some of the large monumental bathers Picasso made in subsequent years.

Head of a Woman is essentially a study in chiaroscuro. Picasso executed the drawing in red and brown chalk, adding touches of black chalk to define strands of hair and to outline the neck and facial features. The features themselves are stylized, almost masklike; particularly refined passages include the almond-shaped eyes, the carefully delineated eyebrows, and the clear highlights on the eyelids, nose, and lips. The erasures on the forehead, similar to those that move from the top of the back toward the shoulder, give the skin a smooth appearance and create the blush on the woman's right cheek. The treatment of the hair, with its rhythmic modulation of closely related hues and black strokes of differing intensities, is similar to the hair in the pastel *Head of a Woman* from the preceding year (cat. 68). The shadowlike softness of the erased and shaded area around the head allows the figure to stand out against the mottled background and emphasizes her sculptural qualities. Two other passages call attention to Picasso's skill in rendering the fullness and strength of the body: the arm and underarm section, and the solid area of the neck just below the chin. For the latter, Picasso used a combination of soft strokes of red, black, brown, and white chalk. To convey the roundness of the shoulder and the top of her right arm he turned to delicate cross-hatching in

red chalk; he used the same subtle strokes on the back to define the outline and impart an impression of smooth skin. On the one hand, there is a decided softness to the figure and to her finely modeled face; on the other hand, her body appears massive, a perception only magnified by the upward tilt of her classically sculptured head. MD

1. This letter and another one Thayer sent to Picasso the same day, which confirm the mailing of the check for the drawing in the amount of 5,000 francs, are preserved in the Metropolitan Museum Archives as part of the Scofield Thayer correspondence. Thayer refers to Charles Raymond Mortimer Bell (1895–1980), a prominent British writer, art and literary critic, and one of his closest friends. Mortimer lived in Paris during the 1920s and beginning in 1921 was a regular contributor to *The Dial*. For details, see Joost 1964, pp. 58, 79, 166, 176; see also Raymond Mortimer Collection, 1905–1979, Department of Rare Books and Special Collections, Princeton University Library, Manuscripts Division.
2. The work was listed as *Heroic Head of a Woman* in Wadsworth 1934, Worcester 1959, 1965, 1971, 1981.
3. Z IV.306.
4. *Two Women Running on the Beach (The Race)* (Musée Picasso, Paris).
5. See Prampolini 1953, quoted in translation in Venice 1998, pp. 316–17.

PROVENANCE
The artist, Paris (1922–23; sold in July 1923, through Paul Rosenberg, Paris, for 5,000 francs to Thayer); Scofield Thayer, Vienna and New York (1923–d. 1982; on extended loan to the Worcester Art Museum, Massachusetts, 1934–82, inv. 34.83; his bequest to the Metropolitan Museum, 1982)

EXHIBITIONS
New York 1924, no. 37; Hartford 1934, no. 118; Worcester 1959, no. 80, p. 87, ill.; Worcester 1965, no cat., unnumbered checklist; Worcester 1971, no cat.; Worcester 1981, no. 112, p. 158; New York 1993, no cat.; New York (MMA) 1997, hors cat.; Venice 1998, no. 213, p. 285 (ill.)

REFERENCES
Waldemar George 1924, pl. III; *The Dial* 86 (March 1929), p. 181 (ill.); d'Ors 1930, p. 20 (detail ill.); Zervos 1932–78, vol. 4 (1951), p. 113 (ill.), no. 306; Joost 1964, ill. between pp. 268–69; *Worcester Art Museum News Bulletin and Calendar*, May 1971, cover ill.; Palau i Fabre 1999, pp. 335 (fig. 1239), 515; Julia May Boddewyn in New York–San Francisco–Minneapolis 2006–7, pp. 333, 341

TECHNICAL NOTE
Working on a large sheet of fine artists' paper, Picasso applied red, black, and brown chalks in two methods. First, he created the rounded forms and the subtle modulation of tone through a thin application of chalk, which he then deliberately rubbed (stumped) into the paper. He further refined the forms by erasure, creating the highlights of the rounded shapes, as seen at the top of the shoulders and on the eyelids, nose, and lips. Over these broad areas of color and erasures are distinct lines of chalk, which Picasso used to define certain elements of the design; these vary from emphatic lines, such as those around the hair and nose, to very subtle yet clear lines, as seen on the eyes and lips. He also used erasure to define the space around the head, which he then shaded with thick, soft strokes of black chalk.

RM

70. Standing Nude
Dinard, Summer 1922

Graphite on wove paper
16½ × 11½ in. (41.9 × 29.2 cm)
Signed, lower left: Picasso
Bequest of Gregoire Tarnopol, 1979, and Gift of Alexander Tarnopol, 1980
1980.21.22

Picasso probably executed this drawing in the summer of 1922 at Dinard, when he was working on a number of heads inspired by classical art (see cat. 69), but it also points forward to his major painting of the following year, *Woman in White* (cat. 72). Picasso drew avidly during that summer; most of the drawings depict the surroundings of his villa and views of the

garden, however, and none are so strictly academic as the present example. The artist had no proper studio at Dinard, and, as John Richardson suggested, this was likely the reason Picasso focused his energies instead on drawings and small paintings, primarily formulaic landscapes produced at the request of his Parisian dealer, Paul Rosenberg.[1] Another favorite subject—the mother and child—was inspired by the presence of the artist's wife, Olga, and their infant son, Paulo. One has to agree with Richardson that these *maternité* images are in many ways pastiches of Renoir's late paintings, which Picasso had beeen studying for some time. In 1921 he had acquired from Rosenberg Renoir's *Seated Bather in a Landscape* (also known as *Eurydice*; 1895–1900, Musée Picasso, Paris), which served as a model for the classicizing nudes that his dealer hoped would ensure Picasso's rightful place within the French classical tradition.

The present drawing, a masterful study of a standing nude posed in an attitude of a classical sculpture, is one of the very few works the artist executed in this traditional manner. Because Picasso worked with a hard pencil, the lines are rather pale and the silhouette appears seamless. Around the head, hair, and neck one can clearly see pentimenti, which allow us to follow the development of the composition. The delicate shading in the area around the left leg and the fingers of the left hand, for example, seem to have been drawn twice or extended. The face and especially the solid, chunky legs resemble nothing more than Picasso himself.[2]

MD

1. For a detailed description of this summer, see Richardson 1991–2007, vol. 3 (2007), pp. 213–17.
2. I thank Gary Tinterow for bringing this idea to my attention, and indeed, I feel that these aspects are strongly visible.

PROVENANCE
The artist, Paris (until June 1925/June 1927; sold to Rosenberg); [Paul Rosenberg, Paris, by June 1927, stock no. 1780]; Frank Crowninshield, New York (by 1939, until 1943; his sale, Parke-Bernet Galleries, New York, October 20, 1943, no. 5); Gregoire Tarnopol, New York (by 1965–d. 1979; his bequest to the Metropolitan Museum, 1979) and his brother, Alexander Tarnopol, New York (until 1980; his gift to the Metropolitan Museum, 1980)

EXHIBITIONS
Paris 1927, no. 50; New York and other cities 1939–41 (shown only in New York), no. 168; Canberra–Brisbane 1986, p. 21 (ill.); Bielefeld 1988, no. 50, pp. 249 (ill.), 325; Málaga 1992–93, no. 34, ill.; New York 1995, unnumbered cat.; Venice 1998, no. 212, p. 284 (ill.); Balingen 2000, no. 91, ill.

REFERENCES
Zervos 1932–78, vol. 4 (1951), p. 154 (ill.), no. 377; Chipp and Wofsy 1995–2009, [vol. 3] (1996), pp. 33 (ill.), 265, no. 22-101; Palau i Fabre 1999, pp. 327 (fig. 1207), 510

TECHNICAL NOTE

The drawing is on a piece of wove paper from a sketchbook; the left edge retains the remnants of perforations. The hard pencil that Picasso used created pale lines on the sheet, and the buildup of darker tone in the shadows, via repeated strokes of the pencil, disturbed the paper fibers and the underlying layers of graphite. At some point a fixative was applied to the drawing; this smoothed out the disturbances in the graphite, which now appear as small dark spots, and also caused the overall yellowing of the sheet. There are traces of erased graphite around the head of the figure, indicating that Picasso made changes to this area of the composition.

RM

71. Seated Nude
Cap d'Antibes, Summer 1923

Ink on white wove paper
11½ × 8⅞ in. (29.2 × 22.5 cm)
Signed in ink, lower right: Picasso
Bequest of Scofield Thayer, 1982
1984.433.282

The theme of a bather sitting on a rock or reclining on a beach, either alone or with other figures, remained one of Picasso's preferred subjects from about 1918 until almost the end of the 1930s. The present nude, drawn on a small sheet of paper with a minimal number of strokes—six lines for the hair, two for an ear—demonstrates the artist's renowned skill in rendering a motif in quick, gestural marks. The figure is seated in the foreground, in proximity to the viewer, and stands out from the mountainous landscape cursorily indicated on the horizon in delicate summary strokes.

Picasso probably made the drawing in the summer of 1923, when he and his family vacationed at Cap d'Antibes, on the French Riviera, in the company of the famous American expatriates Gerald and Sara Murphy and their playful entourage. There, among the lively society and the pleasures of boating and beachgoing, Picasso executed numerous drawings, including many sketches of his wife, the Russian ballerina Olga Kokhlova, and Sara Murphy in particular, whose charm and vivaciousness proved enormously attractive to the artist—and a welcome antidote to Olga's much more formal demeanor.

Seated Nude can be considered in the context of Picasso's many other drawings of bathers, which he frequently rendered in pencil with an emphasis on the linear quality of the figure. He made most of them in sketchbooks, primarily large albums of white sheets bound "à l'Italienne," in which a thread-stitched binding allows the sketchbook to be opened flat. Like all of the

nudes from that summer, *Seated Nude* conveys an atmosphere of relaxation and playfulness (if not exuberance), especially when compared to the earlier, more sober neoclassical drawings of Juan-les-Pins, Fontainebleau, Dinard, and Biarritz (see cats. 64–70).

MD

PROVENANCE
[Paul Rosenberg, Paris, until 1924; sold on September 4, 1924, to Thayer]; Scofield Thayer, Vienna and New York (1924–d. 1982; in storage, ca. 1931–82; his bequest to the Metropolitan Museum, 1982)

EXHIBITION
New York 1998, no cat.

REFERENCES
The Dial 82, no. 3 (March 1927), ill. between pp. 232–33; Zervos 1932–78, vol. 5 (1952), p. 21 (ill.), no. 32

72. Woman in White
Paris, Autumn 1923

Oil, water-based paint, and crayon on canvas
39 × 31½ in. (99.1 × 80 cm)
Signed, lower right: Picasso
Rogers Fund, 1951; acquired from The Museum of Modern Art,
Lillie P. Bliss Collection
53.140.4

After the rigidity and formality of Picasso's neoclassical works from about 1921–22, which were inspired in part by Greco-Roman sculpture, his output in 1923 became freer and more lyrical, with greater fluidity in the posture of the subjects and looser modeling.[1] *Woman in White*, one of the high points of the artist's classical phase (1917–25), was likely painted in Paris in 1923, probably in September, after the artist had returned from his family holiday at Cap d'Antibes, on the French Riviera. Picasso depicted the model as a dreamlike vision of fragile perfection and refinement. Seated in a chair, with her arms crossed on her chest in a casual fashion, she looks thoughtfully into the distance. There is a feeling of introspection and isolation about her, as if she exists in her own time and space, emotionally distant from the viewer. Picasso achieved this effect by applying several layers of white washes and delicate, superimposed contours in soft shades of brown and gray. Like many of his other portraits from this time, *Woman in White* reflects Picasso's absorption of classical art, including a certain idealization in the treatment of facial features. However, the informal pose, along with the loose-fitting, almost diaphanous dress, give the figure a gentle and relaxed air, while the soft, muted palette adds a romantic and pensive tone.

The model for *Woman in White* has usually been identified as the artist's Russian wife, Olga Kokhlova, who became one of his principal subjects after their marriage in 1918. However, in the catalogue to the seminal 1996 exhibition "Picasso and Portraiture,"[2] William Rubin suggested that Picasso's muse in this portrait and numerous others made between 1922 and 1923 (some two hundred paintings and drawings) was in fact the American beauty Sara Murphy (1883–1975), wife of the American Precisionist painter Gerald Murphy (1888–1964). This wealthy expatriate couple lived in Paris and vacationed on the French Riviera, where they were the focus of a dazzling social and artistic milieu in the 1920s.[3] Their charm and unconventional lifestyle, associated with Jazz Age frivolity and free spiritedness, attracted a circle of notable friends, especially artists, musicians, and writers from Europe and America, such as Jean Cocteau, Cole Porter, F. Scott Fitzgerald,[4] and Ernest Hemingway. Picasso and Olga met the Murphys in the autumn of 1921, and the couples remained close over the next two summers, vacationing nearby in Brittany and Normandy as well as on the Côte d'Azur. During the summer of 1923, Picasso, Olga, and their young son, Paulo, stayed with the Murphys and their children at the Hôtel du Cap d'Antibes and frolicked together on the beach of La Garoupe.

The delicate, chiseled features of the *Woman in White* and her luxuriant hair—worn in a fashion favored by Sara Murphy (pulled up and cascading down her neck and back)—as well as the sitter's evident warmth and relaxed persona are indeed compatible with other portraits of her. Olga, who purportedly was always tense, formal, and fastidious, usually kept her hair pinned tightly in a bun at the nape of her neck, a style possibly retained from her years as a ballet dancer.[5] Nonetheless Olga's facial features, as seen in a portrait of her seated on a chair that dates from about the same time (z v.53), also bear a likeness to the face of the *Woman in White*. As we know that in his portraits Picasso frequently conflated the features of different people, it is entirely possible that in this case he integrated the features of Olga and Sara (with whom, according to his biographers, Picasso was infatuated from 1921 until 1924[6]) into a masterful and striking composition full of tenderness as well as a generalized—and idealized—classical beauty. MD

1. For an in-depth discussion of the stylistic changes in Picasso's neoclassical portraiture, see Rubin 1996, pp. 38–59.
2. See ibid, pp. 46–59.
3. For a biography of the Murphys, see Vaill 1998 and Williamstown–New Haven–Dallas 2007–8.
4. It is generally known that Gerald Murphy (and his way of life) served as a model for the character of Dick Diver and the events narrated in Fitzgerald's novel *Tender Is the Night* (1934).
5. Olga wears her hair in this fashion in most existing photographs of her.
6. Rubin 1996, pp. 46–59.

PROVENANCE
[Paul Guillaume, Paris (from 1926; bought at Salon du Franc, Paris, on October 29, 1926, for 79,000 francs)]; [Étienne Bignou, Paris]; [Alex Reid and Lefevre, London, by 1927]; [Kraushaar Galleries, New York, 1927; sold to Bliss]; Lillie P. Bliss, New York (1927–d. 1931); her estate (1931–34; bequest to The Museum of Modern Art, New York, 1934–51, acc. no. 96.34; deaccessioned in September 1947 for sale to the Metropolitan Museum; sale completed in 1951; transferred in December 1953)

EXHIBITIONS
Paris 1926, hors cat., added as no. 100 bis; Glasgow 1927, no. 55, pp. 34, 39; New York 1927, no. 17, ill.; New York (MoMA) 1930, no. 73, ill.; New York (MoMA) 1931, no. 101; Andover 1931, no. 78; Indianapolis 1932, no. 74, p. 11; New York 1932, no cat.; Chicago 1933, no. 407; New York 1934, no. 48; New York 1934–35, no. 129; Saint Louis–Pittsburgh–Northampton 1935, no cat.; New York 1935, no cat., unnumbered checklist; Washington–Detroit 1936, no cat.; Dallas 1936, no. 5, pp. 33, 37; Boston 1938, hors cat.; Toronto 1938, no. 57, pp. 14 (ill.), 15; New York (MoMA) 1939, no. 160, ill.; New York and other cities 1939–41, no. 179, pp. 115 (ill.), 195; New York (MoMA) 1941, no cat., checklist no. 179; Mexico City 1944, p. 42; Denver 1945, unnumbered cat.; Cleveland 1966, no. 29, p. 205; Humlebaek 1968, hors cat.; Leningrad–Moscow 1975, no. 78; Athens 1979, no. 114, p. 285 (ill.); New York 1980, p. 242 (ill.), and checklist p. 41; Canberra–Brisbane 1986, p. 15 (ill.); Málaga 1992–93, no. 43, ill.; Los Angeles–New York–Chicago 1994–95 (shown only in New

York), hors cat., brochure no. 5; New York–Paris 1996–97, pp. 55–57 (ill.); Seattle 1997, no cat.; Venice 1998, no. 217, p. 291 (ill.); New York 2000, pp. 45 (ill.), 125; Kyoto–Tokyo 2002–3, no. 41, pp. 91, 99 (ill.), 168; New York (C&M Arts) 2003, no. 21, ill.; New York–San Francisco–Minneapolis 2006–7 (shown in New York only), pp. 100, 102 (pl. 47), 114, 115, 169, 334, 336, 338, 339, 342, 343, 349, 352, 387

REFERENCES

Benoist 1926, p. 288; "Feuilles volantes," *Cahiers d'art* 2, no. 4–5 (1927), suppl. p. 7 (installation photo of Glasgow 1927); Anon., January 25, 1930, pp. 4, 12 (ill.); Flint 1930, pp. 196, 198 (ill.); Pène du Bois 1931, p. 611; Barr 1933, pp. 11 (ill.), 34; Rich 1933, p. 383; Gardner 1936, pp. 727–28; Rogers et al. 1936, pp. 12, 23 (ill.), 30; *The Gift and Art Buyer* (New York), February 1938, p. 33; Anon., May 1938, p. 109; Pijoán 1938, p. 360 (ill.); Brenner 1939, p. 13 (ill.); McCausland 1939, ill.; Skidelsky 1939, p. 55 (ill.); Mackenzie 1940, pl. XI; Wilenski 1940, p. 300; Barr 1942, pp. 67 (ill.), 69, no. 487; Merli 1942, p. 185 (ill.); Shoolman and Slatkin 1942, p. 556, pl. 570; Monroe Wheeler in New York (MoMA) 1942, p. 14; Goodyear 1943, p. 30; Anon., August 5, 1944, pp. 62 (ill.), 63 (installation photo of Mexico City 1944); Crespo de la Serna 1944, p. 25; McCausland 1944, pp. 11, 22 (ill.), 27; Anon., March 26, 1945, p. 8 (ill.); Barr 1946, pp. 129 (ill.), 282; Anon., September 22, 1947, pp. 1, 24; L. Stein 1947, p. 181; Barr 1948, pp. 59 (ill.), 318, no. 607; Gardner 1948, p. 734; Gómez Sicre 1948, p. 13 (ill.); Merli 1948, ill. facing p. 184; Gaya Nuño 1950, pl. 29; Munsterberg 1951, p. 16; Rousseau 1952, p. 33; Zervos 1932–78, vol. 5 (1952), p. 1 (ill.), no. 1; *Herald Tribune* (New York), January 9, 1954, ill.; Elgar and Maillard 1955, pp. 103, 130 (ill.); Elgar and Maillard 1956, pp. 107, 134 (ill.); Payró 1957, no. 28, ill.; Vallentin 1957, p. 262; Sterling and Salinger 1967, pp. 235–37, ill.; Canaday 1972, p. D21 (ill.); Burns 1973, p. 81; D. Cooper 1976, p. 12 (ill.); S. Mayer 1980, pp. 430–31, fig. 97; Gee 1981, pp. 34, 182; Kodansha 1981, pl. 43; Venice 1981, p. 54 (ill.); Eduard Beaucamp in Munich and other cities 1981–82, p. 84 (ill.); Larson 1986, p. 47; Topalian 1986, p. 362; Tinterow 1987, pp. 128–29 (fig. 107); Silver 1988, pp. 86–87 (fig. 25); Silver 1989, pp. 284–91, pl. VI; Tomkins 1989, pp. 307, 365; Geelhaar 1993, pp. 178, 179 (fig. 186), 239, 296 n. 243; Giraudon 1993, p. 99 (ill.), 133; Kimmelman 1994b, pp. C19 (ill.), C22; Kimmelman 1994c, p. 127; MacIntyre 1994, p. 122; Rubin 1994, pp. 138–47, cover ill., fig. 12; Martínez Blasco and Martínez Blasco 1995, pp. 61–62, fig. 28; Varnedoe 1995, pp. 16 (ill.), 18 (ill.), 30 (ill.), 31, 53, 54, 55, 56, 58, 59, 61, 62, 68 n. 74, 69 n. 77, 70 n. 83; Chipp and Wofsy 1995–2009, [vol. 3] (1996), p. 105 (ill.), no. 23-003; Anne Baldassari in Houston–Munich 1997–98, pp. 154, 253 n. 433; Asher 1999, p. 13; Palau i Fabre 1999, p. 353 (ill.), 516, no. 1298; Muñoz Molina 2005, p. 188; Shubinski 2007, pp. 18, 23 (fig. II.7); Deborah Rothschild in Williamstown–New Haven–Dallas 2007–8, pp. 52 (ill.), 53; K. Wilson 2009, p. 136 (fig. 166, installation view of New York 1932)

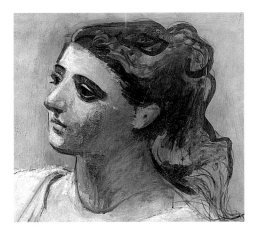

Fig. 72.1. Infrared reflectogram (detail) of cat. 72

TECHNICAL NOTE

Picasso achieved the "antique" look of the painting by building up his composition in layers of thick and thin matte paint, in a complex and unconventional sequence using the respective opacity and transparency of the layers to render form and volume subtly and with seemingly minimal effort. First, he freely applied a thin layer of dusty mauve paint on fine canvas commercially prepared with a white ground. He then loosely sketched the figure with a black crayon and proceeded to paint the flesh tones, starting with terracotta middle tones. Using a small brush dipped in black paint, he modeled the woman's main features, a process clearly seen with the aid of infrared reflectography (fig. 72.1). He scumbled a dusty pink tone over these dark features and then, finally, added the light flesh tones in a thick application of paint. These rich white highlights, broadly applied along the median of the face in a kind of white mask, evoke the appearance of a marble sculpture.

The dress, in contrast, was broadly painted, with the loose folds sketched in thick strokes of white paint over which the artist applied a thin buff-colored layer to accent shadows. This layer has a particularly dry appearance and has tended to reticulate over the underlying white. Some proteinaceous and gum components identified in the buff-colored paint layer suggest the presence of gouache or casein, both water-based paints,[1] which if applied over an oil-based medium would indeed explain the reticulation.

Picasso loosely brushed a final, semitransparent white layer partly composed of zinc white over and around the figure's body in a washlike manner,[2] adding freely applied strokes of brown paint as finishing touches on top to accentuate the woman's features and her wavy hair. The composition has remained unlined and unvarnished and is remarkably well preserved.

ID

1. Media analyses were conducted by Julie Arslanoglu and Adrianna Rizzo in the Department of Scientific Research.
2. The use of this pigment was inferred from the presence of zinc, as identified by X-ray Fluorescence analysis conducted by Arslanoglu and Silvia A. Centeno.

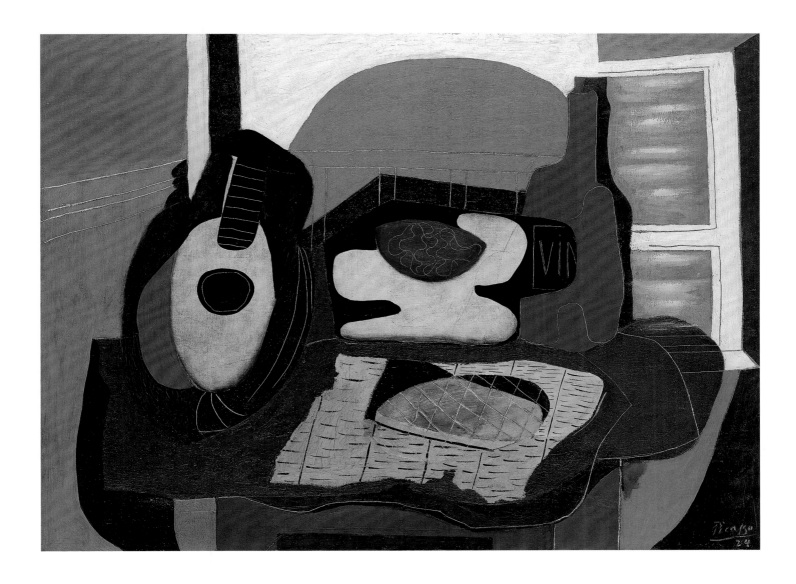

73. Still Life with Mandolin and Galette
Paris, May 16, 1924

Oil and sand on canvas
38½ × 51½ in. (97.8 × 130.8 cm)
Signed and dated in vermilion and pink paint, lower right: <u>Picasso</u> / 24
Jacques and Natasha Gelman Collection, 1998
1999.363.65

By 1924 Picasso was rich and famous. He had been married to the Russian Olga Kokhlova, a former dancer with Sergei Diaghilev's Ballets Russes, for six years, and they lived with their three-year-old son Paulo at a fine address—23, rue La Boétie—next door to the artist's dealer, Paul Rosenberg. Françoise Gilot described Picasso's "fashionable" lifestyle among Parisian society of the day as follows:

> Olga's social ambitions made increasingly greater demands on his time. In 1921 their son Paulo was born and then began his period of what the French call *le high-life*, with nurse, chambermaid, cook, chauffeur, and all the rest, expensive and at the same time distracting. In spring and summer they went to Juans-les-Pins, Cap d'Antibes, and Monte Carlo, where—as in Paris—Pablo found himself more and more involved with fancy dress balls, masquerades, and all the other high jinks of the 1920s, often in company with Scott and Zelda Fitzgerald, the Gerald Murphys, the Count and Countess Etienne de Beaumont, and other international birds of paradise.[1]

World War I had put an end to Picasso's and Braque's Cubist symbiosis. Braque had been drafted and sent into battle, and Picasso, with the rigorous single-mindedness of Cubism behind him, turned to work in various styles simultaneously. Although in subsequent years he continued to experiment with Cubism, he did so in a more simplified, decorative, and curvilinear form. At the same time, he created Ingresque drawings (1915–20) and worked in his neoclassical idiom (1920–23), in which he often endowed female figures with colossal proportions.

A similar monumentality can be seen in the still-life elements of a number of pictures that Picasso painted in 1924. Some of these are viewed against an open window or balcony, as is the case with *Still Life with Mandolin and Galette*.[2] Actually, for Picasso this theme dated back to 1914, when he placed a still life against a landscape (z 11.541). He then perfected it in 1919 in a group of exquisite gouaches in which a table—as always, piled high with a poetic clutter of objects—was set against the open window of his hotel room overlooking a view of Saint-Raphaël, on the French Riviera (z 111.396–399, 401–403).

In *Still Life with Mandolin and Galette*, the most somber and uncluttered of the 1924 group, the objects are truly fit for giants. They are limited to a mandolin and a bottle of wine that flank a bowl of fruit with what might be grapes and a galette (a thin almond-paste tart with a crisscross crust), the latter sitting on what might have been its newspaper wrapping. Picasso incised the lines of the room's molding, the outside railing, and additional outlines of some of the objects probably with the wood end of his paintbrush (see fig. 73.1), variously exposing the light or dark underpainting. S R

1. Gilot and Lake 1964, p. 149, quoted in Richardson 1991–2007, vol. 3 (2007), pp. 173–74.
2. Interestingly, the railing of the balcony seen through the window in this painting, which Picasso painted in Paris, relates to the railing in the large still life *Mandolin and Guitar* (Solomon R. Guggenheim Museum, New York), which Picasso painted later that summer in Juan-les-Pins, where he stayed beginning about July 20.

PROVENANCE
[Paul Rosenberg, Paris, acquired from the artist before June 1925]; Alphonse Kann, Saint-Germain-en-Laye and London (by 1930–42; on loan to The Museum of Modern Art, New York, November 1939–April 1941; consigned to Paul Rosenberg & Co, New York; sold on March 8, 1942, through its London branch, Rosenberg & Helft, to MoMA); The Museum of Modern Art, New York (1942–77, acc. no. 190.42; deaccessioned by sale on February 15, 1977, through E. V. Thaw, New York, for Artemis S.A. Luxembourg, for $600,000 to Gelman); Jacques and Natasha Gelman, Mexico City and New York (1977–his d. 1986); Natasha Gelman, Mexico City and New York (1986–d. 1998; her bequest to the Metropolitan Museum, 1998)

EXHIBITIONS
Probably Paris (Rosenberg) 1926, no. 29; Paris 1932, no. 146, p. 50; New York and other cities 1939–41, no. 185, p. 120 (ill.); New York (MoMA) 1941, no cat., checklist no. 193; New York (MoMA Collection) 1941, no cat.; New York (Rosenberg) 1942, no. 3; New York (MoMA/New Acquisitions) 1942, no cat., hors checklist (late addition); New York 1942–43, no cat. (listed in press release dated July 29, 1942); New York (MoMA) 1944, no cat.; New York (Art in Progress) 1944, p. 223; New York 1944–45, no cat.; New York 1945–46, no cat.; New York 1946, no cat.; New York (MoMA) 1946, no cat.; Newark 1948, no cat.; New York (MoMA) 1948, no cat.; New York 1949, no cat.; New York (MoMA) 1949, no cat.; New York and other cities 1949–52, no cat., checklist no. 48; New York (MoMA) 1952, no cat.; exhibited in conference rooms, United Nations Headquarters, New York, February 3–September 15, 1954, no cat.; New York 1952–54, no cat.; New York 1954–55, no cat., unnumbered checklist; exhibited in conference rooms, United Nations Headquarters, New York, June 2, 1955–February 26, 1962, no cat.; New York (MoMA) 1962, no cat., unnumbered checklist; New York 1962–63, no cat.; Pittsburgh 1963–64, no cat.; exhibited in the Secretary General's Office, United Nations Headquarters, New York, February 1964–May 1976, no cat.; New York 1964–69, no cat.; New York 1970, no cat.; Portland (Ore.) 1970, no. 26, pp. 38 (ill.), 54 (ill.); New York 1972, pp. 119 (ill.), 221; Basel 1976, no. 48, pp. 96, 100, 98 (ill.); Tokyo–Kyoto 1976, no. 83, pp. 19 (ill.), 107; New York–London 1989–90, pp. 168 (ill.), 169, 311 (ill.); Cleveland–Philadelphia–Paris 1992, p. 353 (ill.); Martigny 1994, pp. 23 (ill.), 192–93 (ill.), 333 (ill.); New York 2001–2, no cat., checklist no. 42; Barcelona 2008–9, pp. 156, 157, 161 (ill.)

Fig. 73.1. Photomicrograph (detail) of cat. 73, showing scored lines and paint layers on ground

Fig. 73.2. X-radiograph (detail) of cat. 73

REFERENCES
Bulletin de l'effort moderne (Paris), no. 13 (March 1925), ill. facing p. 8; Schaeffner 1930, p. 164 (ill.); Zervos 1930, p. 291 (ill.); Waldemar George 1932, ill. between pp. 268–69; Zervos et al. 1932, p. 158 (ill.); Estrada 1936, p. 58, no. 146 (Spanish ed. of checklist of Paris 1932); Soby 1939, pp. 9, 12; Cheney 1941, p. 458 (ill.); Barr 1942, no. 489, pp. 68 (ill.), 69; Bonfante and Ravenna 1945, p. 224, pl. 25; Barr 1946, pp. 134 (ill.), 135, 282; Gómez Sicre 1947, p. 9 (ill.); Barr 1948, pp. 102 (ill.), 318, no. 608; Gómez Sicre 1948, p. 17 (ill.); Munsterberg 1951, pp. ix, 9 (pl. 6); Zervos 1932–78, vol. 5 (1952), p. 90 (ill.), no. 185; Camón Aznar 1956, pp. 200 (ill.), 733; Leepa 1957, pp. 132 (fig. 46), 253; Barr 1958, p. 49; Raynal 1959, p. 83 (ill.); Rosenblum 1960, pp. 92 (pl. 66), 108, 320; Harmon 1962, pp. 62–63 (ill.); Daulte 1966, pp. 38, 39 (ill.); Hart and Rojas 1966, p. 62 (ill.); Leymarie 1972, p. 51 (ill.); Daix 1977, pp. 190–91, 194 n. 38; Daix 1983, pp. 126 (ill.), 127; Warncke 1992, vol. 1, p. 314 (ill.); Warncke 1993, vol. 1, p. 314 (ill.); Daix 1995, pp. 206, 549–50; Chipp and Wofsy 1995–2009, [vol. 3] (1996), pp. 216 (ill.), 266, no. 24-073; Dobrzynski 1998, pp. A1, B6; Asher 1999, p. 13; Julia May Boddewyn in New York–San Francisco–Minneapolis 2006–7, pp. 352, 359, 367, 372

TECHNICAL NOTE

Picasso made *Still Life with Mandolin and Galette* using oil paints to which he added varying amounts of sand. He worked on fine-weave canvas commercially prepared with a white ground.[1] He added a layer of greenish raw umber paint to cover the white ground: a grayish, earthy layer that suppressed the luminosity of the white and that gives the composition its warm, somewhat dim tonality. Picasso proceeded by painting the various elements, juxtaposing flat fields of colors and often changing colors within each field. The numerous superimpositions of paint layers, distinguishable under high magnification, reveal that the artist kept revisiting the color scheme of his composition, a common practice for Picasso. He then scored some of the outlines of the composition—down to the ground layer—probably using the wood tip of a paintbrush (fig. 73.1). For the mandolin's soundboard and the fruit bowl, he neatly scraped away the paint layer within the contours of those forms, leaving the ground layer thoroughly exposed. The color of this ground layer, now a dusty ocher, is an artifact of the greenish raw-umber layer that Picasso had first applied. These two areas of exposed, tinted ground also show various finely scored, doodle-like intersecting lines that do not describe any recognizable shapes. Such

lines probably belong to some initial sketch for this or some other work that he scraped off prior to starting over.

X-radiography reveals that Picasso made a few compositional changes, the most notable being in and around the galette (fig. 73.2). The galette, originally depicted with three-dimensional volume, was later reduced to a single plane in which the golden yellow cake and its black shadow are depicted as two adjacent flat fields of color. The gray field, presumably a depiction of some paper wrapping, was simplified and rendered more abstract in the process. Originally it was scored with fine, short undulating lines resembling calligraphy, possibly a representation of writing on the paper, suggestive of a newspaper. Picasso subsequently painted over these lines in gray and replaced them with short, flat linear strokes of black paint. Finally, at bottom center, he eliminated some curvilinear lines that intersected with a horizontal line, possibly indicating an early outline of the table and a tablecloth. A few other scored lines, visible in the X-ray, were painted over as well.

Although the painting is in good condition overall, some colors developed drying cracks early on: a result of layering paints of different thicknesses and drying times. Areas of viridian green and burnt umber to the left of the mandolin and in the center foreground were especially affected. The extensive network of wide cracks in those areas reveals the underlying colors and accidentally lends an added texture to the paint layer. The painting was glue lined, varnished, cleaned, and revarnished before it entered the Metropolitan's collection.[2] The last coating, a synthetic varnish that yielded a uniform, dull shiny surface, was inappropriate for the composition and was removed in 2009. Doing so allowed for a fuller appreciation of the subtle relationships between the different sheens and textures of the paint layers, affording an increased sense of depth owing to the admixture of sand and scored lines, especially in contrast to wide areas of exposed ground. As a result of restoring spatial depth to the composition, objects loom large in the foreground while the sea and sky, seen through the open window, recede in the background.

ID

1. Many Picasso still lifes painted between 1923 and 1927 have the same or similar dimensions (97 × 130 cm): this was the size of a standard #60 prepared pre-stretched canvas, available at color merchants who supplied the artist with materials at that time.
2. The date assigned in Zervos, May 16, 1924 ("16 Mai 1924"), was written on the reverse of the canvas and would have been legible before the canvas was lined in 1941 (z v. 185).

74. Mandolin, Fruit Bowl, and Plaster Arm
Juan-les-Pins, Summer 1925

Oil on canvas
38½ × 51½ in. (97.8 × 130.8 cm)
Signed and dated in black paint, lower left: Picasso / 25
Bequest of Florene M. Schoenborn, 1995
1996.403.2

Picasso imbued his still lifes with the same palpable sense of drama one normally associates with the artist's great figurative compositions. Of the 236 works he selected for his seminal 1932 retrospective at the Galerie Georges Petit in Paris, nearly one-quarter were still-life compositions.[1] In 1992, on the occasion of the first exhibition devoted solely to his still lifes—"Picasso & Things" at The Cleveland Museum of Art—curator Jean Sutherland Boggs observed that Picasso had chosen still life "for many of his greatest works during Cubism, the twenties and thirties, the Second World War, and the 1940s and 1950s."[2] John Richardson is likewise convinced that Picasso explored the genre of still life "more exhaustively and develop[ed it] more imaginatively than any other artist in history."[3] According to Richardson, Picasso embedded within his still lifes hidden meanings, codes, or secrets, using them "as a metaphor not just for sex but for all manner of conflicts and confrontations."[4]

Picasso insisted that he used only the most "common objects" when assembling his paintings: "a pitcher, a mug of beer, a pipe, a package of tobacco, a bowl, a kitchen chair with a cane seat, a plain common table—the object at its most ordinary."[5] Sometimes, however, the objects he painted are neither ordinary nor common, such as the pristine yet oddly incongruous white plaster arm nestled among the sedate mandolin and fruit bowl in this still life.[6] The brick-red cloth draped on the table only heightens the unusual effect of the white plaster. The hollow, bent arm is foreshortened, making the upper arm appear much shorter than the forearm. The clenched fist is notably huge, its fleshy fingers clutching what might be a thin white rod or a classical scroll. Picasso positioned the hollow arm carefully so that its disc-like white-and-black aperture floats slightly off center, visually echoing the four round fruits above it and the mandolin's sound hole to its left.

This work shares a number of elements with *Still Life with Mandolin and Galette* from 1924 (cat. 73). Both pictures have the same dimensions and style (a decorative, curvilinear Cubism), and both include monumental representations of a mandolin and fruit bowl. However, they differ markedly in mood. In the earlier still life, which is set against an opened balcony door with a view of blue sky beyond, the bottle of wine and the cake evoke a relaxed Mediterranean ambience and sensuousness, despite the overall somber palette. *Mandolin, Fruit Bowl, and Plaster Arm* does not appeal to the senses in the same way; it impresses, instead, by dint of a masculine strength and a faintly surreal air.[7]

S R

1. Jean Sutherland Boggs in Cleveland–Philadelphia–Paris 1992, p. 13. From Paris, the retrospective traveled to the Kunsthaus, Zürich.
2. Ibid. It should be noted that the few Picasso still lifes among the Metropolitan Museum's holdings, for the most part gifts and bequests, are more a reflection of the tastes of donors than they are a true representation of the genre's singular place within Picasso's oeuvre.
3. Richardson 1991–2007, vol. 1 (1991), p. 441.
4. Ibid.
5. Gilot and Lake 1964, p. 74, cited by Boggs in Cleveland–Philadelphia–Paris 1992, p. 14.
6. Two similar casts of arms, one clutching a rod and the other clenching its fist, appear in the allegorical still life *Studio with Plaster Head*, made in Juan-les-Pins in the summer of 1925 (The Museum of Modern Art, New York).
7. Discussing *Studio with Plaster Head* (see note 6 above), Richardson traces the arm motif to an Empire clock at the Villa Belle Rose in Juan-les-Pins, which Picasso rented during his stay. He made a drawing of the figure of Jupiter on top of the clock, who was "poised to hurl a thunderbolt at anyone checking the time. This figure's tiny arm brandishing his celestial weapon inspired the huge plaster arm clutching a thunderbolt that dominates [that] summer's most celebrated painting, MoMA's allegorical still life." Richardson 1991–2007, vol. 3 (2007), p. 292.

PROVENANCE
[Paul Rosenberg, Paris, acquired from the artist by June 1925, until at least 1934, stock no. 1289; sold to Bélanger]; M. Bélanger, Paris (until 1952; sold back to Rosenberg on July 21); [Paul Rosenberg & Co., New York, 1952–53, stock no. 5453; sold on September 10, 1953, for $45,000 to Marx]; Samuel and Florene Marx, Chicago (1953–his d. 1964); Florene May Marx, later Mrs. Wolfgang Schoenborn, New York (1964–d. 1995; on extended loan to The Museum of Modern Art, New York, from 1971; on extended loan to the Metropolitan Museum from 1985; her bequest to the Metropolitan Museum, 1995)

EXHIBITIONS
Paris (Rosenberg) 1926, no. 48; Paris 1932, no. 164, p. 55; Zürich 1932, no. 159, p. 11; Hartford 1934, no. 58; New York (Rosenberg) 1955, no. 8, pp. 3, 7 (ill.); New York and other cities 1965–66, pp. 22–23 (ill.); Buenos Aires–Santiago–Caracas 1968, p. 41 (ill.); on view at MMA, March 14, 1989–July 26, 1990, April 13–August 10, 1992, January 5, 1993–May 17, 1994, and February 1996, no cats.; New York (MMA/Schoenborn) 1997, brochure no. 17; New York 2000, pp. 100 (ill.), 125; Kyoto–Tokyo 2002–3, no. 42, pp. 91, 100–101 (ill.), 168

REFERENCES
Zervos 1926a, pl. 33; Zervos 1926b, p. 91 (ill.); Zervos 1930, p. 292 (ill.); Zervos et al. 1932, p. 159 (ill.); Estrada 1936, p. 58, no. 164 (Spanish ed. of checklist of Paris 1932); Zervos 1932–78, vol. 5 (1952), p. 178 (ill.), no. 444; Camón Aznar 1956, pp. 478 (fig. 350), 727; D. Cooper 1963, pp. 282 (ill.), 291; Paris–Nantes 1991–92, p. 18 (fig. 8); Geelhaar 1993, p. 150 (fig. 150); FitzGerald 1995, p. 159 (fig. 53); Chipp and Wofsy 1995–2009, [vol. 4] (1996), p. 26 (ill.), no. 25-085; Julia May Boddewyn in New York–San Francisco–Minneapolis 2006–7, pp. 340, 372

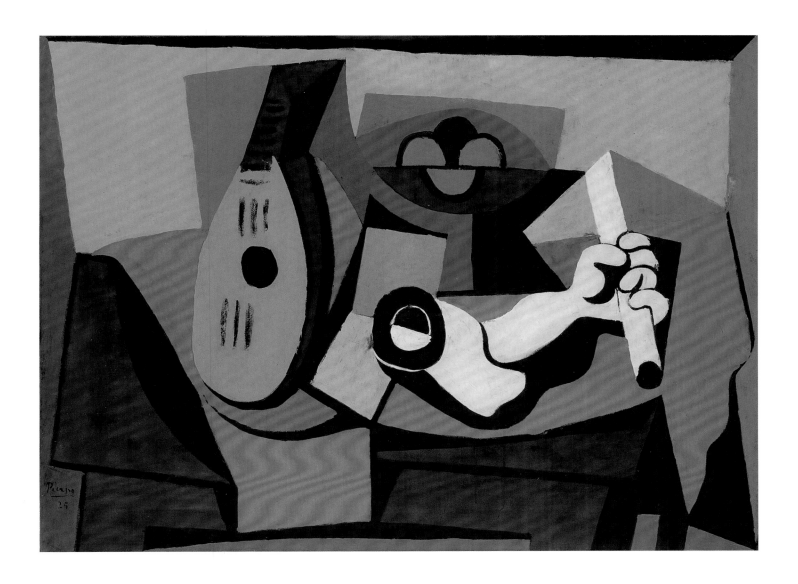

TECHNICAL NOTE

The composition was painted with oil paint on fine-weave canvas commercially prepared with a white ground.[1] Picasso applied a layer of dark brown paint, thinly diluted and somewhat gritty, on the ground layer. It can be seen in areas such as the table and the mandolin and remains visible along the edges of the canvas. This dark preparatory layer intensifies the strong color contrasts of the composition.

The artist began the composition by blocking in the main elements with fluid, matte black paint applied with a brush. He then defined them by spreading fields of color with a palette knife, using the knife to add to and subtract from the paint layer. For example, to define the strings and the sound hole of the mandolin, he scraped off the yellow ocher layer to reveal the underlying black paint. The paint ridges and numerous scraping marks left by the knife give the painting a rich, modulated surface. The black paint is generally leaner and more matte than the other colors, which overall have a creamy texture and varying degrees of sheen. When

fluid paint dripped down, as seen at bottom center, Picasso left it there: the one uncontrolled element in an otherwise precisely executed composition. There are no signs of compositional changes visible under the paint surface.

The painting was wax lined and varnished before it entered the Metropolitan's collection. Although the removal of the varnish in 1986 could not fully retrieve the painting's original surface, it did restore some of the subtle differences in surface texture and gloss. I D

1. The dimensions of the canvas are the same as those of many other still lifes Picasso painted between 1923 and 1927. This size, a standard #60 prepared, prestretched canvas, was sold by the color merchants who supplied the artist at the time.

75. Harlequin
Paris, Spring 1927

Oil on canvas
32 × 25⅝ in. (81.3 × 65.1 cm)
Signed and dated in black and two shades of gray paint, upper right:
Picasso / 27
The Mr. and Mrs. Klaus G. Perls Collection, 1997
1997.149.5

The commedia dell'arte stock character Harlequin was one of Picasso's favorite subjects in the early decades of his creative life. Harlequin entered the artist's repertoire in the autumn of 1901 (see cat. 17) along with representations of circus performers and other figures from the commedia, and he became Picasso's alter ego in paintings such as *At the Lapin Agile* (cat. 25). Harlequin continued to figure in Picasso's oeuvre throughout his subsequent stylistic phases—from the Cubist years (particularly Synthetic Cubism) to his theater works for Diaghilev's Ballets Russes, such as *Pulcinella* (1920), to his later classical phase—until about 1937.

In the early works, Picasso usually represented Harlequin dressed in the character's traditional multicolored, checkered costume, as seen, for example, in *At the Lapin Agile* or the 1917 portrait of the Diaghilev dancer and choreographer Léonide Massine (Museu Picasso, Barcelona); this is true even in the famous Synthetic Cubist *Harlequin* of 1915 (fig. 62.1). Yet despite their gay attire, these figures emanate a mood of solitude, melancholy, alienation, and introspection. They reflect the often stark realities of the times as well as the artist's state of mind, not to mention his ever-evolving stylistic and formal vocabulary. From 1920 to 1925, when Synthetic Cubism coexisted in Picasso's work with his neoclassical idiom, he frequently reserved the former mode for still lifes and the latter for portraiture or other images of the human figure. About 1925 he began to distort the elegant, flat planes of Synthetic Cubism into forms that could be described as almost expressionistic, even tortured. This shift paralleled disturbing events in Picasso's personal life, namely, his boredom with the pretentious lifestyle to which his wife, Olga, aspired, and the continuing discord stemming from her increasing possessiveness, jealousy, and depressive moods: in effect, the disintegration of his marriage. In turn, his line became dry and tough, and forms that had previously been merely "dislocated" began to verge on the grotesque.

That darker tenor prevails in this 1927 version of *Harlequin*, where Picasso reinterpreted his long-favored subject in a new idiom that combines Synthetic Cubist elements with those of Surrealism, at that time the dominant intellectual and artistic movement in France.[1] It is almost as if Picasso attempted to adapt the Cubist vocabulary to serve Surrealist ambitions, turning the sad, lyrical figures of the early 1900s (and the more formal Cubist ones that followed) into a horrible, threatening apparition. Harlequin's nose—the large oblong form with two

Fig. 75.1. Pablo Picasso, photograph of his profile, 1927. Musée National Picasso, Paris

round nostrils at top—twists upward into a black, geometric L shape, at either end of which are vertical lozenges of different sizes (the eyes), both expressing anguish. That black L form symbolizes Harlequin's mask, while the shape looming above it, outlined partially by a black line, evokes his traditional bicorne hat. At center is an oval orifice with a row of rectangular white teeth: a large screaming mouth, threatening and cruel. Many authors[2] have seen in this shape an implicit analogy to a vaginal opening or the so-called *vagina dentata*; perhaps it is also an allusion to Picasso's double life as the distinguished and socially prominent (but unsatisfied) husband of Olga, whom he increasingly viewed as a harpy, and as the secret lover of a much younger woman, Marie-Thérèse Walter (see cat. 76), who would become the primary focus of his art for the next decade.

An important element of the compositional structure of *Harlequin* is the inclusion of a classic double profile. At right is a dark profile that bisects the face; on the left, at the edge of the canvas, is a much lighter one. Recent research has revealed that this looming, shadowesque silhouette, long considered to be that of Marie-Thérèse, in fact belongs to the artist himself and is connected to Picasso's use of photography,[3] specifically a photograph he took of himself in Paris in 1927 (fig. 75.1). Its use within the painting can be read as the artist's multiple presence in the composition as both the masqued Harlequin and as his more recognizable self. The L-shaped mask thus plays a complex role: it conceals the identity of the fictional Harlequin, the

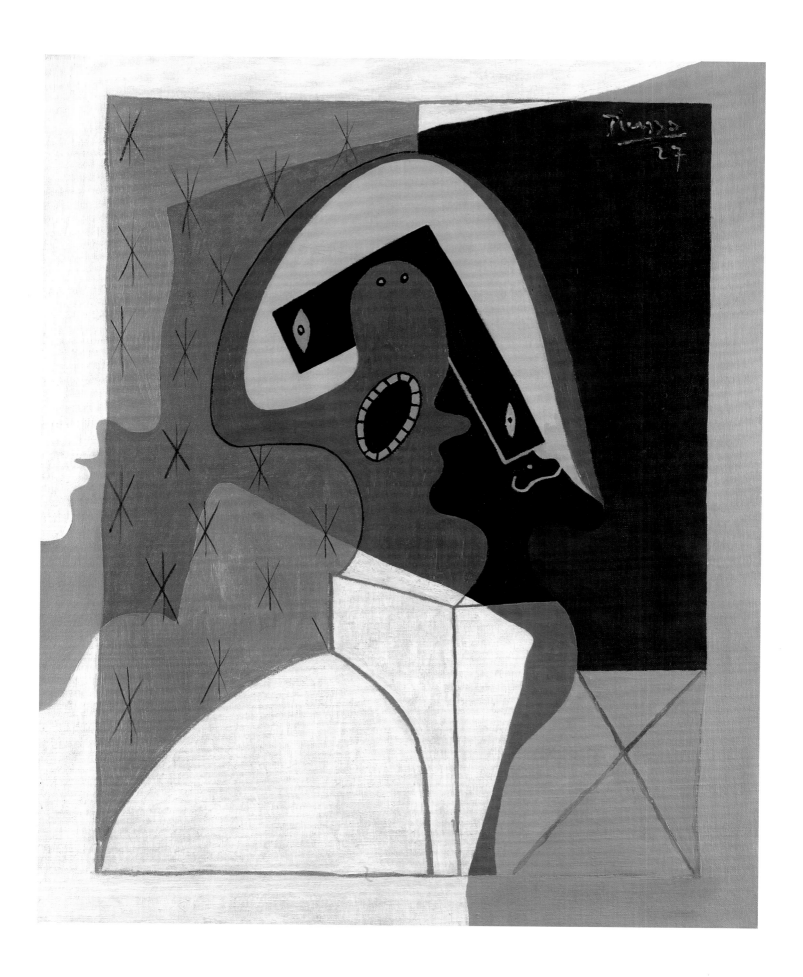

nominal subject of the painting, but it also becomes an important prop given the facts of Picasso's "secret" life at the time. On a pictorial level, all of the forms interact with one another to create push-and-pull sensations suggestive of visual transformation and the continuous movement of contour, line, and plane into different ectoplasmic shapes.

Far from a conventional image of a human figure, this *Harlequin* is a somber expression of a tormented being, one whose aggressive contortions, it has been suggested, might have been inspired by Picasso's familiarity with the theories of hysteria propounded by Jean-Martin Charcot (1825–1893), a neurologist at La Salpêtrière, the Parisian hospital and asylum for women. Charcot's theories, originally published in 1873, were broadly discussed by the Surrealists, particularly André Breton.[4] In collaboration with Louis Aragon, Breton published "Le Cinquantenaire de l'hystérie" in the March 1928 issue of *La Révolution surréaliste*, where, among numerous photographs of hysterics, they illustrated a similar Harlequin painting (z VII.73).[5] Although the painting's use in this context could be seen as an attempt by Breton and Aragon to depict the Surrealist spirit rather than evidence of Picasso's interest in Charcot's studies, the latter possibility should not be entirely excluded.

<div align="right">MD</div>

1. The conceptual and formal aspects of the *Harlequin* relate closely to a group of paintings made between 1927 and 1929, among them *Figure and Profile* (1928; z VII.129), *Studio* (1928–29, Musée Picasso, Paris), or *Bust of a Woman with Self-Portrait* (1929; z VII.248).
2. See, for example, Richardson 1991–2007, vol. 3 (2007), pp. 282, 327–34, and Cowling 2002, chap. 7, pp. 486–87.
3. See Anne Baldassari in Paris 1994, pp. 82–85; also Varnedoe 1996, pp. 149–52, and Baldassari in Houston–Munich 1997–98, pp. 189–91.
4. This is discussed by Elizabeth Cowling (2002, pp. 486–87, 669 nn. 97, 98). See Gautier et al. 2009.
5. Ibid., p. 669 n. 97.

PROVENANCE
[Paul Rosenberg, Paris, and Georges Wildenstein, Paris and New York, bought from the artist in joint ownership, July 31, 1930; with Rosenberg, until at least 1938, stock no. 2531]; [Perls Galleries (Klaus G. Perls), New York, by 1961, stock no. 6144]; Mr. and Mrs. Klaus G. Perls, New York (until 1997; their gift to the Metropolitan Museum, 1997)

EXHIBITIONS
New York (Valentine) 1931, no. 11; Paris 1932, no. 173, p. 57; Zürich 1932, no. 171, p. 12; Boston 1938, no. 21; possibly New York (Valentine) 1942, no. 6; New York (Perls/Twenties) 1961, no. 23, ill.; New York 1962 (shown at Rosenberg Galleries), no. 47, ill.; Toronto–Montreal 1964, no. 92, p. 100 (ill.); Toulouse 1965, no. 102, p. 64, ill.; New York (Perls) 1965, no. 9, ill.; Fort Worth–Dallas 1967 (shown in Dallas), no. 46, p. 55 (ill.); Tokyo and other cities 1977–78, no. 40, ill.; Cleveland 1979, no. 66, pp. 114, 115 (ill.), 117; Los Angeles–New York–Chicago 1994–95 (not shown in Chicago), hors cat., checklist no. 6, ill.; New York (MMA) 1997, hors cat.; New York 2000, pp. 102 (ill.), 125; Barcelona–Martigny 2006–7, no. 192, pp. 222 (ill.), 339; Rome 2008–9, no. 19, pp. 18 (fig. 1), 19, 22, 150–51 (ill.)

REFERENCES
Dale 1930, pl. 42; Bataille 1930, p. 132 (ill.); Zervos et al. 1932, unpaginated ill.; Estrada 1936, p. 59, no. 173 (Spanish ed. of the checklist of Paris 1932); Zervos 1932–78, vol. 7 (1955), p. 34 (ill.), no. 80; Sieberling 1968, p. 123 (ill.); Fermigier 1969, p. 141 (fig. 87); Leymarie 1971b, pp. 25 (ill.), 292; Gasman 1981, pp. 689, 1720 (pl. 189); Piot 1981, p. 247 n. 183; Warncke 1992, vol. 1, p. 79 (ill.); Warncke 1993, vol. 1, p. 79 (ill.); Chipp and Wofsy 1995–2009, [vol. 4] (1996), p. 84 (ill.), no. 27-014; Kaufman 1996, p. 14; Varnedoe 1996, p. 150 (ill.); Andre 1997, p. 63; S. Rewald 1997, p. 76 (ill.); Volta 1998, p. 91 (ill.); Cowling 2002, p. 486 (fig. 449); Anne Baldassari in Paris 2005 (both eds.), pp. 74 (fig. 48), 79, 111 (fig. 104), 112; Julia May Boddewyn in New York–San Francisco–Minneapolis 2006–7, p. 337

Fig. 75.2. Photomicrograph (detail) of cat. 75, showing pencil line and paint application

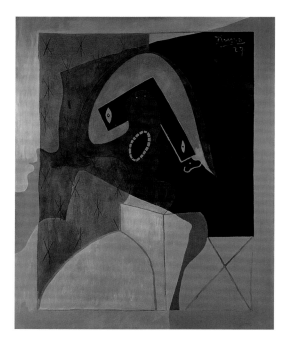

Fig. 75.3. Photograph of cat. 75 under ultraviolet light

TECHNICAL NOTE

Harlequin is remarkable for its controlled execution, which is appreciable today thanks to the excellent preservation of its original state. Picasso delicately drew the composition with thin graphite pencil lines on fine canvas commercially prepared with a white ground. He outlined the large rectangle, simulating a framed picture within the picture, as well as the various figures and silhouettes.[1] These pencil lines, clearly visible with infrared reflectography, can also be seen under high magnification (fig. 75.2). The artist then painted each outlined field precisely, following the pencil lines but occasionally covering them, as in the gray lines that separate the four white fields at bottom center. The fields of color show subtle variations in texture, from smooth and lean to creamy and gritty. The oil paint layer, generally thinly applied, often reveals the fine weave of the canvas. The exceptions to this are the light brown shape at center and the white fields directly below it, which are thickly painted. The black starlike motifs, which suggest the diamond patterns of Harlequin's traditional costume, as well as the thin black curved line on the left representing his bicorne hat, are the elements Picasso painted last; he added them on top of the green areas using a thin pointed brush.

Picasso made no changes to the composition; it is direct and precise. The canvas was glue lined in the past, no doubt to protect the fine-weave canvas, and was restretched on what appears to be its original stretcher. Evidence shows that an aging varnish layer was partially removed at some point and that subsequently the paint layer was left mostly unvarnished.

A strong green fluorescence was revealed under ultraviolet examination in certain areas: the light pink-brown along the right edge, also partially visible along the left; the light gray paint at bottom right and filling in the eyes, mouth, and ear of the central figure; and the middle brown area adjacent to the light gray area (fig. 75.3). Analysis determined that these particular colors contain relatively large amounts of zinc oxide pigment, whereas much smaller amounts of zinc were found in all other areas, including the ground layer.[2] Zinc oxide is known to frequently fluoresce under ultraviolet illumination, and the analyses confirmed the presence of high levels of zinc in the fluorescent passages.[3] This concentration of zinc, coupled with the presence of a semi-drying oil (such as safflower oil), suggests that Picasso could have used household commercial paint in the fluorescent passages while using artists' paints for the rest of the composition.[4] This would not be unusual for Picasso, given numerous other instances that testify to his use of commercial paints—indeed, he used them as early as 1912, as Gertrude Stein recorded.[5]

ID

1. A 1927 ink drawing that is a clear study for this composition includes several changes in the background. See Léal 1996, vol. 2, no. 34 (December 1926–May 8, 1927), p. 73.
2. Silvia A. Centeno performed Raman Spectroscopy; nondestructive XRF analyses were conducted with Julie Arslanoglu and Tony Franz, Department of Scientific Research.
3. Feller 1986, p. 172.
4. FTIR and GC-MS analyses of the binding media were conducted by Julie Arslanoglu. See Gautier et al. 2009, pp. 597–603.
5. See G. Stein 1933, p. 141 (in 1961 ed.). According to Penrose, Picasso said he liked to mix Ripolin Mat (a commercial enamel-based paint) with ordinary oil colors because it dried fast and became very hard. See Cowling 2006, p. 111 (I am grateful to Marilyn McCully for pointing out this information to me).

76. Head of a Woman

Paris, Autumn 1927

Oil and charcoal on canvas
21¾ × 13¼ in. (55.2 × 33.7 cm)
Signed, upper right: Picasso
Jacques and Natasha Gelman Collection, 1998
1999.363.66

On a cold day in January 1927, the forty-five-year-old Picasso approached the seventeen-year-old Marie-Thérèse Léontine Walter (1909–1977), a voluptuous blonde, outside the Galeries Lafayette, a department store in Paris. Marie-Thérèse had just bought a new *col Claudine* (sometimes called a Peter Pan collar) and matching cuffs.[1] "Mademoiselle," Picasso told her, "you have an interesting face. I would like to make your portrait. I am Picasso."[2] She had never heard his name before, but for the next nine years Marie-Thérèse would be the object of Picasso's greatest love and physical passion.

By the summer of 1927 the artist's nine-year-old marriage to Olga Kokhlova had badly deteriorated. Nevertheless, as always during the summer months, Picasso left Paris with his wife and son and moved to the country, that year to Cannes. Bereft of his mistress Marie-Thérèse, Picasso conjured her up in an extended series of drawings (z VII.84–119).[3] They depict her curvaceous body in a pneumatic fashion, or, in the words of John Richardson, "in terms of his own tumescent penis."[4] By the time the lovers were reunited at the end of the summer, Marie-Thérèse permeated Picasso's work, albeit in a covert way, as the artist did not want his liaison to become known.[5] At her most recognizable, Marie-Thérèse appears as a generalized classic white profile.

A very different set of figures from this time have odd-looking heads, with apertures ringed by teeth or pierced by vagina-like eyes and hair that flies about in strands. This *Head of a Woman* belongs to a series of sixteen paintings of heads or figures that resemble misshapen boomerangs (z VII.117–33). Picasso drew the head in one continuous line against a stark background of three color bars, one white and two brown. He then added the two oddly sized eyes, a set of tiny nostrils, three long hairs, and the four nail-like teeth. Although all of the ostensibly female heads in the series sprout these scrawny hairs and sport similar pairs of eyes and nostrils, this is the only one with such ferocious teeth: an image that the Surrealists would have construed as the *vagina dentata*, a symbol of masculine anxiety in the face of a "monstrous" female sexuality.

Various sources (besides the artist's own fertile imagination) have been proposed for the shape of the head. Picasso's younger compatriot Joan Miró (1893–1983) had moved to Paris in the early 1920s, and about 1923–24 he adopted symbols from neolithic cave art in his work. According to scholar John Golding, some of these amorphous, abstract forms, often with sexual associations, might have intrigued Picasso.[6] Richardson sees the source of these boomerang-shaped heads in the *col Claudine* that Marie-Thérèse habitually wore, and which had initially brought the lovers

together at their fateful encounter. The pointed ovoid shape below the hovering head might also refer to the collar or to one of the matching cuffs. The nails, however, are unthinkable within the context of the placid and tender Marie-Thérèse. They evoke, rather, the ever-growing rages of Olga, whom Picasso saw as a castrating monster. SR

1. The *col Claudine* is named in honor of Colette's heroine in her trio of novels, the first being *Claudine à Paris* (1901).
2. Walter quoted by Jane Fluegel in New York 1980, p. 253.
3. See the two Cannes sketchbooks in Léal 1996, vol. 2, pp. 81–92, no. 35 (July 17–September 1927), and pp. 92–95, no. 36 (September 11–24, 1927).
4. John Richardson, "Picasso and Marie-Thérèse Walter," in New York (Beadleston) 1985, p. [3].
5. Ibid.
6. Golding 1973, p. 92.

PROVENANCE
[Galerie Pierre (Pierre Loeb), Paris, by 1938; probably sold to Paalen, possibly by exchange]; Wolfgang Paalen, Mexico City; Jacques and Natasha Gelman, Mexico City and New York (by the 1940s, until his d. 1986); Natasha Gelman, Mexico City and New York (1986–d. 1998; her bequest to the Metropolitan Museum, 1998)

EXHIBITIONS
Tokyo–Kyoto–Nagoya 1964, no. 39, p. 58 (ill.); New York–London 1989–90, pp. 178–79 (ill.), 312 (ill.); Los Angeles–New York–Chicago 1994–95 (not shown in Chicago), pp. 139 (fig. 96), 170 nn. 20, 21, and MMA brochure with checklist, no. 8; New York 2001–2, no cat., checklist no. 43; London–New York 2001–2 (shown only in New York), pp. 274 (fig. 266), 334

REFERENCES
Éluard 1927, p. 20 (ill.); Zervos 1938b, p. 108 (ill.); Merli 1942, pp. 200 (ill.), 299; Guiette 1947–48, p. 42 (ill.); Zervos 1932–78, vol. 7 (1955), p. 52 (ill.), no. 119; Daix 1977, pp. 218, 221 n. 20; Cowling 1985, pp. 98, 104 n. 82; Calado 1994, p. 64 (ill.); Sabine Rewald in Martigny 1994, pp. 31 (ill.), 202–3 (ill.), 333 (ill.); Vallan 1994, p. 39 (ill.); Chipp and Wofsy 1995–2009 [vol. 4] (1996), pp. xvi, 104 (ill.), 224, no. 27-070; S. Rewald 2000, p. 59 (ill.); Anne Baldassari in Paris 2005 (both eds.), pp. 110 (fig. 103), 111–12 n. 237; Basel 2005, pp. 218 (under October 1, 1927, erroneously titled *Harlequin* [sic], z VII.119), 219 (fig. 88, reproduction of our work as ill. in *La Révolution Surréaliste*, October 1927 [erroneously as March 1928; see Éluard 1927])

TECHNICAL NOTE
Picasso painted this composition on coarse open-weave canvas prepared with a fairly grainy white ground layer, perhaps while it was stretched on to a solid surface. The striated horizontal pattern and uneven buildup of this preparation layer also suggest that he might have used a spatula or palette knife. The artist then painted a rather fluid imprimatura layer of burnt sienna whose relative transparency suggests that the oil paint was thinned with excess diluent. Picasso drew the composition, using charcoal (or a charcoal-like material),[1] on this toned background while it was still wet: first the two vertical center lines, which veer almost imperceptibly to the left, and then the figure. He drew these thick outlines with single, continuous strokes; as a result, it cannot be determined where, exactly, he started and stopped the drawing of the center figure.[2] Finally, he carefully painted between the two vertical lines using a creamy lead-white paint, precisely circumventing all of the black outlines.

Evidence suggests that the painting was stretched long after completion; the turnover edges of the canvas are systematically broken along all sides, and the preparation and imprimatura layers cover most of the tacking edges. The canvas was glue lined and attached to a new stretcher prior to entering the Museum. X-radiography reveals that the white paint did not originally extend to the bottom of the canvas but, as at the top, stopped less than 1 centimeter from the edge. Ultraviolet examination confirms this later addition at bottom, probably made at the time the painting was lined. In 2009 the surface of the paint layer was cleaned, inappropriate retouching was removed, and discolored retouches were corrected. The paint layer is currently not varnished, which enables full appreciation of the subtle juxtapositions of its various transparent, matte, gritty, and creamy layers and their respective textures. ID

1. Raman analysis conducted by Silvia A. Centeno (Department of Scientific Research) identified the material as a carbon-based black.
2. Drawing with charcoal on a wet canvas would have dictated the use of a solid surface to support the pressure exerted by his hand.

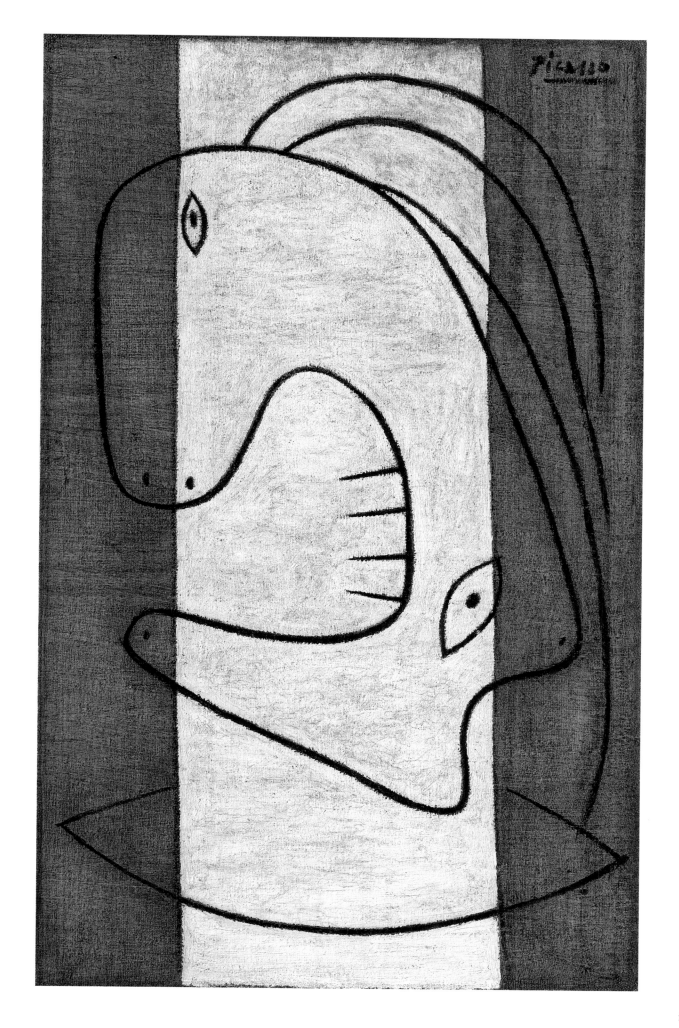

211

77. Nude Standing by the Sea

Paris, April 1929

Oil on canvas
51⅛ × 38⅛ in. (129.9 × 96.8 cm)
Signed and dated in black and gray paint, lower left: P<u>icasso</u> / 29
Bequest of Florene M. Schoenborn, 1995
1996.403.4

Although Picasso never officially joined the Surrealist movement, he did participate in various Surrealist exhibitions, and his work between 1926 and 1939 has often been characterized as Surrealist owing to its often bizarrely contorted and sexually charged imagery. The violent anatomical dislocations of the female figure in *Nude Standing by the Sea* would certainly have appealed to the Surrealists. Executed in Paris in April 1929, the painting ranks among Picasso's most disquieting images. It relates to his unusually distorted "bone" paintings of the same year, his sculptural efforts from the autumn of 1928, and his drawings for a never-realized series of huge bathers to be cast in concrete and placed along La Croisette in Cannes, the town's main seaside promenade. The motif was also inspired by his sketches from the summer of 1927, which he spent in Cannes, and by those from the summer of 1928 at Dinard, in Brittany, where he surreptitiously arranged for his mistress, Marie-Thérèse Walter, to live in a nearby beach community. There, unbeknownst to his wife, Olga, Picasso could observe Marie-Thérèse running or playing ball on the beach with other young people, enjoying the pleasures of sand and sea.

Picasso subjected the monumental female bather in this canvas to drastic formal transformations. She is at once tumescent and stony, as if she were indeed cast in concrete, and her figure is strangely mutated: part geometry and part large inflated balloon. This eccentrically metamorphosed creature stands with her arms over her head at the edge of the beach, perched against a deep blue sea and sky. The rounded buttocks also suggest breasts, while the pair of pointed cones/breasts might equally represent sharp teeth; similarly, the horizontal slit might double as both a navel and female genitalia. The hands form an arch above the figure's pin-size head,[1] which is mounted onto an obelisk neck, and taken as a whole the posture might mockingly refer to Olga's former career as a ballet dancer. Olga sometimes posed for photographs and pictures in dancing attitudes, and occasionally she even dressed as a dancer for various social outings or for the costume balls of Parisian high society.

John Richardson proposed that the figure's statuesque legs, firmly planted on the sand, are reminiscent of the rock formations in Étretat, on the coast of Normandy, where Picasso spent some time at the end of the 1920s and early 1930s.[2] In particular, Richardson compared them to the arch known as the Porte d'Aral as described by the nineteenth-century writer Guy de Maupassant, who likened the rock formation to "the leg of a colossus [with] the separate 'Needle'. . . pointing its sharp head

at the sky,"[3] a fitting description of the compositional parts of the figure. Because of the unusual anthropomorphic permutations in works such as this, where Picasso included both female and male sexual attributes, the figural type is sometimes referred to as the *femme-phallus*.

The bather looms exceptionally large over the small, discrete patch of beach, and the combination of warm ocher tones and grisaille-like shadows only emphasizes her sculptural and monumental qualities. In terms of structure and meaning, the figure is ambiguous: a contradiction between vulnerability and sensuality, cold detachment and dominance. This duality may reflect Picasso's inner turmoil over the failure of his marriage to Olga and his ongoing sexual liaison with Marie-Thérèse. In this context, it is worth noting that when the painting was first exhibited—in Paris, in 1930—it was titled "L'Allégorie." Perhaps the painting does indeed depict an allegory of sacred and profane love.

MD

1. John Richardson believes that the hands represent those of Marie-Thérèse. See Richardson 1991–2007, vol. 3 (2007), pp. 366–67.
2. Ibid.
3. Ibid., pp. 366, 545 n. 17.

PROVENANCE
[Alex Reid and Lefevre, London, 1929, until at least 1936, stock no. 491/29; probably purchased directly from the artist; co-owned for this period in shares with Étienne Bignou, Paris and New York, M. Knoedler & Co., New York, London, Paris, and probably Valentine Dudensing, New York, from 1930]; Aline Barnsdall, Santa Barbara; her estate (1946–52; sold to Knoedler in March); [M. Knoedler & Co., New York, March–September 1952; sold, probably through Pierre Matisse, New York, for $12,500 to Marx]; Samuel and Florene Marx, Chicago (1952–his d. 1964); Florene May Marx, later Mrs. Wolfgang Schoenborn, New York (1964–d. 1995; on extended loan to The Museum of Modern Art from 1971; on extended loan to the Metropolitan Museum from 1980; her bequest to the Metropolitan Museum, 1995)

EXHIBITIONS
Paris 1930, no. 56; New York (Valentine) 1931, no. 15, ill.; London 1931, no. 31, ill.; Paris 1932, no. 187, p. 62, ill. facing p. 70; Zürich 1932, no. 187, p. 14; New York (MoMA) 1936, no. 231, p. 221, pl. 211; Santa Barbara 1951, no cat.; New York (MoMA) 1955, no. 119, p. 17 (ill.); New York–Chicago 1957, p. 66 (ill.); Philadelphia 1958, no. 120, p. 19, ill.; New York and other cities 1965–66, p. 27 (ill.); New York 1972, pp. 134 (ill.), 225; Canberra–Brisbane–Sydney 1993, no. 237, pp. 42–43 (ill.), 325; Los Angeles–New York–Chicago 1994–95 (shown in New York only), hors cat., MMA brochure no. 13; New York (MMA/Schoenborn) 1997, brochure no. 18, ill.; Tokyo–Nagoya 1998, no. 73, pp. 131 (ill.), 233–34, 240; New York 2000, pp. 103 (ill.), 125; London–New York 2001–2, pp. 274, 275 (fig. 267), 334

REFERENCES
Dale 1930, pl. 43; Robert Desnos in Bataille 1930, p. 114 (ill.); Anon., June 3, 1931, p. 381 (ill.); Goodrich 1931, p. 414 (ill.); Estrada 1936, p. 59, no. 187 (Spanish ed. of the checklist of Paris 1932); Merli 1942, pp. 204 (ill.), 299; Barr 1955, pp. 22 (ill.), 34, no. 119; Elgar and Maillard 1955, p. 282 (ill.); Zervos 1932–78, vol. 7 (1955), p. 101

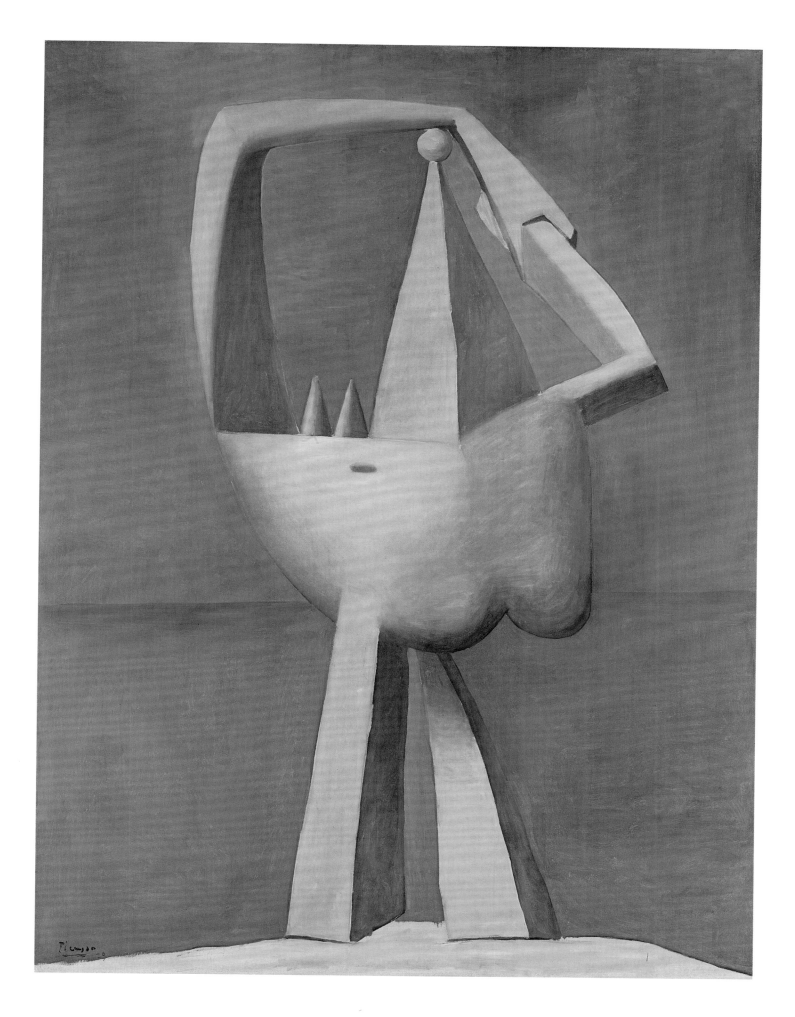

(ill.), no. 252; Baumann 1976, p. 120 (fig. 210); Gasman 1981, pp. 350, 1673 (pl. 114); Kodansha 1981, pl. 161; Geelhaar 1993, pp. 186 (fig. 200), 194 (fig. 218); Chipp and Wofsy 1995–2009, [vol. 4] (1996), p. 196 (ill.), no. 29-026; Vogel 1996b, p. A1; Andre 1997, p. 63; Anne Baldassari in Paris 2005 (both eds.), p. 81 (fig. 60); Michael FitzGerald and Julia May Boddewyn in New York–San Francisco–Minneapolis 2006–7, pp. 127 (fig. 60), 337, 344, 373, 376; Richardson 1991–2007, vol. 3 (2007), pp. 366–67 (ill.)

TECHNICAL NOTE

The painting is on medium-weight linen canvas commercially prepared with a white ground. Picasso began with an underdrawing apparently executed in a dry, charcoal-like material, particles of which became embedded in the oil paint as the artist's brush passed over it. The drawing can be seen under magnification at discrete areas within the boundaries between colors. Picasso applied paint methodically, area by area, leaving reserves for adjacent colors, in a palette of blue, black, white, and ocher. He worked quickly and energetically in all directions, as indicated by X-radiography, which shows his brushwork clearly. The X-ray also reveals the directness and economy of his paint application.

The painting was wax lined before entering the Metropolitan's collection, and the original auxiliary support was replaced with an expansion-bolt stretcher. The tacking margins indicate that the canvas has been restretched at least twice. A synthetic varnish that imparted an unnatural gloss to the work was removed in 1986.

SD-P

78. The Dreamer

Boisgeloup, July 1932

Oil on canvas
39⅞ × 36¾ in. (101.3 × 93.3 cm)
Signed in black paint, lower left: Picasso
Inscribed and dated on verso in black paint on horizontal stretcher bar, left: Boisgeloup/juillet XXXII
The Mr. and Mrs. Klaus G. Perls Collection, 1997
1997.149.4

In 1932 there was a marked change in Picasso's art, not so much stylistic as in mood, palette, and imagery, which became more overtly sexual. *The Dreamer* belongs to a group of some thirty paintings made between 1932 and 1934 that exude an air of erotic fulfillment and relaxation. According to the inscription on the stretcher, it was executed in July 1932 (the month of Picasso's one-man show at Galerie Georges Petit, Paris)[1] at the Château de Boisgeloup, the artist's hideaway near Gisors, some forty miles north of Paris, where he escaped from social obligations, family pressures, and, especially, from his wife, Olga. Indeed, Picasso was comfortably installed at Boisgeloup with his mistress, Marie-Thérèse Walter, who was the model for *The Dreamer* as well as the other paintings in the series.[2]

Picasso bought the château in June 1930, by which time the sensuous Marie-Thérèse had become a ubiquitous presence in the artist's work. He depicted her most often in languid, passive poses, frequently asleep—as if she were taking a catnap or were in a profound slumber—and yet still radiating sexual and physical satisfaction. Here her plump and limp figure is spread lazily on a white sheet laid out on green grass dappled with a multitude of white flowers. Her pink-lavender flesh is swollen into bulbous forms. Limbs and fingers, bones and joints: each part is subsumed within roundness and twisted curves, expressive not only of physical pleasure but also the pleasure of rendering it in paint.[3] Picasso echoed this roundness in other shapes, such as the flowers, the black form in the background, and the definition of the blue sky. Metamorphosed into a vessel of fertility and stripped of material substance, the dreamer seems to

Fig. 78.1. Jean-Auguste-Dominique Ingres, *Odalisque and Slave*, 1858. Pencil, pen, sepia ink, brown wash, and white highlighting on marouflaged tracing paper, 13⅝ × 18¾ in. (34.5 × 47.5 cm). Musée du Louvre, Paris, Roger Gallichon Bequest, 1918 (RF 4622)

descend into an unconscious and erotic lightness of being. She is Persephone and Venus combined, inviting comparison to depictions of both (including works by such artists as Giorgione, Titian, Veronese, and Velázquez) and more specifically to the draped nude in Ingres's *Odalisque and Slave* (fig. 78.1), whose full, sensuous body strikes a similar pose (see cat. P39).

Although Picasso had no real affinity for the orthodox theories of Surrealism, Robert Rosenblum perceptively suggests that "it might nevertheless be argued that his masterpieces of the

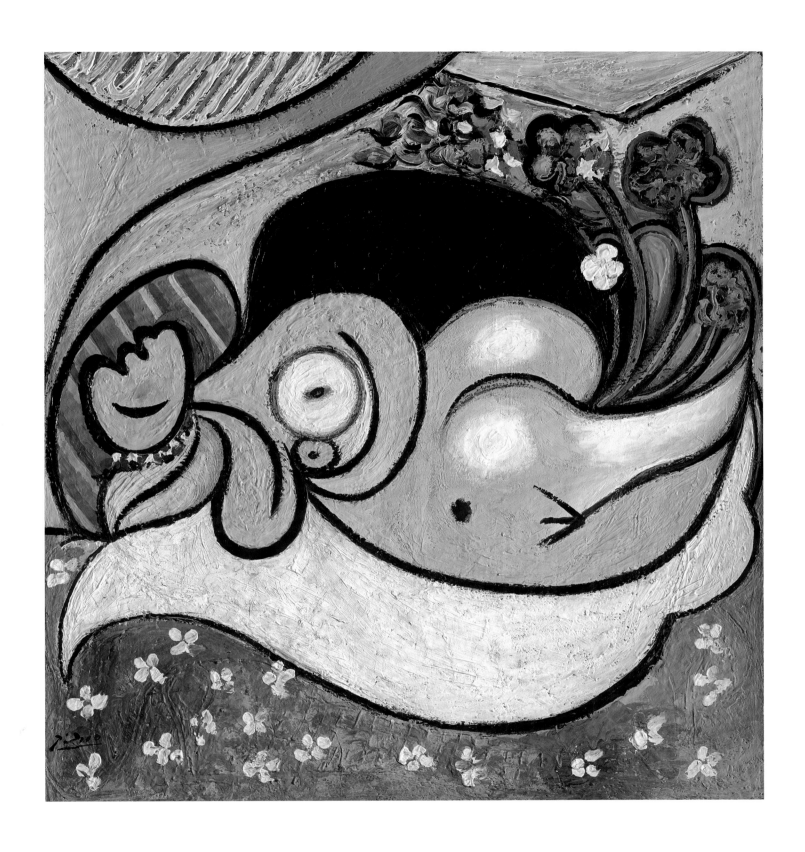

early thirties (and I definitely would include *The Dreamer*) are, in fact, the greatest triumph of the Surrealists' efforts to create a pictorial style and imagery appropriate to the exploration of dreams, and to the uncovering of those profound biological roots that link man more firmly to irrational nature than to technological civilization."[4] One could add, however, that here Picasso's exploration of dreams seems much more voraciously personal and forceful in terms of its all-pervading eroticism.

MD

1. The exhibition took place exactly a year after the gallery's one-man show of Matisse's work, which Picasso saw, of 145 paintings, mostly of seated, standing, and reclining nudes, primarily from the Nice period (1917–29).
2. Between 1927 and 1935 Marie-Thérèse was Picasso's primary source of inspiration for works in various media, including painting, sculpture, drawing, and etching. They had a daughter together, Maya. Marie-Thérèse remained devoted to the artist for the rest of her life. An illuminating exhibition on the subject of Picasso's depictions of Marie-Thérèse was held at Acquavella Galleries, New York, in 2008, accompanied by a catalogue with essays by Michael FitzGerald and Elisabeth Cowling; see New York 2008.
3. For an interesting discussion of this series of paintings, see Christine Piot in Léal, Piot, and Bernadac 2000, pp. 265–75.
4. Rosenblum in Toronto–Montreal 1964, pp. 16, 111.

PROVENANCE

The artist, Paris (1932–55; sold in summer 1955 in Paris, through Sam Kootz, to Rübel); Peter and Elizabeth Rübel, Cos Cob, Connecticut, and New York (1955, until after 1973; sold to Perls); [Perls Galleries (Klaus G. Perls) New York (after 1973, stock no. 7143)]; Mr. and Mrs. Klaus G. Perls, New York (until 1997; their gift to the Metropolitan Museum, 1997)

EXHIBITIONS

Milan (Palazzo Reale) 1953, no. 65, ill.; Rome 1953, no. 23, p. 36, pl. 23; New York (Kootz) 1956, unnumbered cat., ill.; New York (Perls) 1957, no. 34, pp. 80–81 (ill.); New York 1962 (shown at Perls Galleries), no. 4, ill.; Toronto–Montreal 1964, no. 110, pp. 16, 111 (ill.); Los Angeles–New York–Chicago 1994–95 (shown only in New York), no. 23; New York (MMA) 1997, hors cat.; Tokyo–Nagoya 1998, no. 75, pp. 133 (ill.), 233–34; New York 2000, pp. 104 (ill.), 125; London–New York 2001–2 (shown only in New York), hors cat.; Chemnitz 2002–3, p. 182 (ill.); New York 2008, no. 7, pp. 26, 28 n. 30, 58–59 (ill.), 77

REFERENCES

Zervos 1935a, p. 77 (ill.); Zervos et al. 1935, p. 213 (ill.); Merli 1948, pl. 401; Zervos 1932–78, vol. 7 (1955), p. 180 (ill.), no. 407; Penrose and Golding 1973, pp. 112, 114 (pl. 187), 277; Warncke 1992, vol. 1, p. 352 (ill.); Warncke 1993, vol. 1, p. 352 (ill.); Drath 1996, p. G04; Kaufman 1996, p. 14; Vogel 1996a, pp. C11–12 (ill.); Chipp and Wofsy 1995–2009, [vol. 5] (1997), p. 113 (ill.), no. 32-058; Widmaier Picasso 2004, p. 32 (fig. 7); Grimes 2008, p. B6

TECHNICAL NOTE

The painting is on lightweight, open-weave linen canvas commercially prepared with a white ground. Picasso developed the composition using bold, direct strokes of paint, which he applied thickly within curvilinear black outlines. Determining the sequence in which he laid in the colors is not possible because the image developed organically from earlier stages. He arrived at the present composition after several significant reworkings, which accounts for the thick and heavy paint film. Various changes are suggested by textures within the paint film that bear no relation to the present composition, including the hatch patterns in the blue sky at top left and in the black passage at top center, and the curvilinear and linear elements in the green passage at bottom.

The first application of paint absorbed into the ground and is visible through the openly woven canvas from the back. Infrared reflectography of the verso shows the initial stage of the painting, including a complete composition outlined in black paint applied in bold and direct strokes (fig. 78.2). The most noticeable changes made to this composition involve repositioning the sitter's left leg, at least twice, and the head and neck, three times. The pose became increasingly dynamic as Picasso reworked the head at steeper and steeper angles and moved the legs apart. This composition

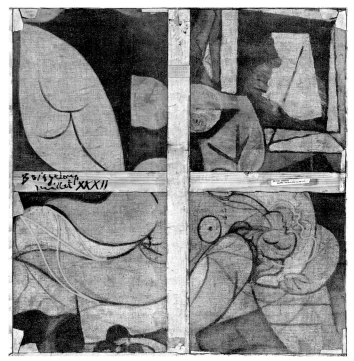

Fig. 78.2. Infrared reflectogram of cat. 78 from reverse, showing initial stage of the composition, with outlines indicating previous positions of the leg and head

Fig. 78.3. X-radiograph of cat. 78, with outlines indicating the position of the black contour lines in the final composition

differs from the finished painting in several ways. First, in the earliest version the setting appears to be an artist's studio rather than the outdoors, and the sitter is surrounded by various objects. In the infrared image there is a bowl of fruit in the foreground, possibly a mirror, at left, with a reflection of the sitter's backside; a sculpture at center; and a painting or a window, at right, through which Picasso's profile seems to loom in the background, overlooking the scene. Also, in this earlier composition the sitter is lower in the picture plane than in the final version, and instead of dozing peacefully she reclines in an apparent state of passionate exhaustion. Picasso developed the initial composition by filling in broad areas with color; passages of black, red, and green paint that have seeped through from the

Fig. 78.4. Cross section (original magnification × 100) of cat. 78

In the final work Picasso changed the setting from the interior described above to an open-air scene. He thus replaced the mirror and window (or picture) with grass, flowers, sky, and certain other details—such as the pattern at the top left corner and the black shape at top center—that are presently unidentifiable. The sheet became more cloudlike in appearance; the position of the breasts was shifted again; and the proper left arm was lowered. A cross section from an area of green paint along the bottom of the left side comprises no fewer than fourteen layers of paint (fig. 78.4). Evidence of the numerous changes made to the color scheme can be seen at skips in the paint throughout the work, suggesting the possibility of even more changes than those indicated by examination in infrared and X-ray. Indeed, *The Dreamer* offers a perfect example of Picasso's tendency to develop his paintings in a spontaneous and organic manner, transforming them fearlessly in pursuit of an end result with little or no attachment to any intermediate steps, however complete or accomplished.

The painting is supported on its original stretcher, which is in good condition. Moreover, it is secured with the original folded brads and has never been removed from the stretcher. Oxidation of the brads has caused the canvas to deteriorate, however, and in some areas the canvas underneath the brads no longer exists; this is most pervasive at the top left and right corners, where the tension on the canvas from the heavy paint film is greatest. In 2002 the canvas in these areas was reinforced. Examination of the paint film revealed losses—particularly in white passages— that had been covered with original paint, indicating that the work began to flake before Picasso completed it. The painting has never been varnished. The surface was cleaned in 2002 to remove superficial dirt that dulled the contrast and gloss of the paint film. SD-P

front of the canvas are visible at the back under magnification and even with the unaided eye.

Examination with X-radiography reveals an intermediate stage in which the artist further abstracted the figure (fig. 78.3). He moved her up and shifted the position of her breasts. He gave the sheet more prominence and transformed the arms from naturalistic limbs into tentacle-like appendages. The artist also added a realistically painted portrait at top left in place of the profile.

79. Reading at a Table

Boisgeloup, March 1934

Oil on canvas
63⅞ × 51⅜ in. (162.2 × 130.5 cm)
Signed and dated, upper right: <u>Picasso</u>/XXXIV
Bequest of Florene M. Schoenborn, in honor of William S. Lieberman, 1995
1996.403.1

According to the conventional story, Picasso met Marie-Thérèse Walter on January 8, 1927, in front of the Parisian department store Galeries Lafayette and was immediately struck by her beauty, purity, and naïveté (see entry for cat. 76). Her statuesque body exuded sexuality even as her appearance emanated teenage innocence (she was only seventeen at the time).[1] Most of Picasso's innumerable depictions of Marie-Thérèse show her sleeping or dreaming, always displaying her voluptuous body in sexually suggestive poses, conveying to the viewer a vision of an erotic Eve in the garden of Eden. These works are suffused with the intensity of the artist's passion for her, which he expressed not only through pose but also through vibrant, sensuous color.

Marie-Thérèse, who for Picasso was the embodiment of sexuality, was a physical, outdoorsy type, and depictions of her in intellectual pursuits such as reading are rare.[2] In the present painting she resembles a young schoolgirl immersed in a book. Her classic profile, with a pronounced straight nose and rounded cheeks, here seen from a double viewpoint, recalls many other portraits of her done by Picasso at the time, both in painting and sculpture. The hot reds juxtaposed with vibrant

greens and touches of white in the garland crowning her head reinforce the intensity of her concentration on the task at hand. Unlike the portraits that underscore Marie-Thérèse's carnality and sexual abandon through sweeping curves and luscious colors, here Picasso made his goddess-like muse almost ethereal. Except for her rounded breasts, her body merges with the back of the bright red chair, and her delicate lavender-and-white face glows in the bright golden light of the table lamp. This is surely the most tender portrait Picasso ever made of Marie-Thérèse, whom he typically presented as an obvious object of desire. Indeed, while the painting certainly emits an atmosphere of hedonism, it also evokes a moment of peace and comfort and, at the same time, shows the subject as intensely alive. MD

1. See Widmaier Picasso 2004, pp. 28–29, 34–35 nn. 15–18. Numerous archival sources document the decisive meeting as that encounter in 1927. However, recent research suggests that Picasso might have seen Marie-Thérèse at the Gare Saint-Lazare in Paris some two years earlier, in January or February 1925, and executed some drawings of her in 1925–26.
2. At the end of March (27–29) 1934, Picasso painted a couple of oil versions of *Deux personnages*, depicting Marie-Thérèse and her sister Jeanne reading.

[Paul Rosenberg, Paris, and Rosenberg & Helft, London, acquired from the artist by March 1936, until at least 1937, stock no. 3414]; Victor William (Peter) Watson, London (probably by 1937, and certainly by 1939, until 1945; stored at The Museum of Modern Art, New York, during World War II; sold in New York on November 28, 1945, through L. Denham (Denny) Fouts of London, for $12,500 to Marx); Samuel and Florene Marx, Chicago (1945–his d. 1964); Florene May Marx, later Mrs. Wolfgang Schoenborn, New York (1964–d. 1995; on extended loan to The Museum of Modern Art from 1971; on extended loan to the Metropolitan Museum from 1985; her bequest to the Metropolitan Museum, 1995)

EXHIBITIONS
Paris 1936, no. 17; London (Rosenberg & Helft) 1937, no. 23; New York and other cities 1939–41 (shown at New York, Chicago, Saint Louis, Boston, and San Francisco), no. 264, p. 164 (ill.); Utica and other cities 1941–43 (shown at Utica, Durham, Kansas City, Milwaukee, Grand Rapids, Hanover, and Poughkeepsie), no. 264, p. 164 (ill.); Toronto 1949, no. 22; New York (MoMA) 1955, no. 121, p. 17 (ill.); New York–Chicago 1957, frontis.; Philadelphia 1958, no. 137, p. 20, ill.; London 1960, no. 136; New York and other cities 1965–66, pp. 28 (ill.), 29; Fort Worth–Dallas 1967 (shown in Dallas), no. 57, p. 96; Chicago 1968, no. 37, pp. 37 (ill.), 114; New York 1972, pp. 6, 144 (ill.), 145; New York 1980, hors cat., checklist and brochure (accounting for loans added after printing of the catalogue), no. 14, ill.; Los Angeles–New York–Chicago 1994–95 (not shown in Chicago), no. 34, ill.; New York (MMA/Schoenborn) 1997, no. 19, ill.; New York (MMA) 1997, hors cat.; Tokyo–Nagoya 1998, no. 78, pp. 134–35 (ill.), 233–34; New York 2000, pp. 104–5 (ill.), 125; Kyoto–Tokyo 2002–3, no. 60, pp. 124 (ill.), 168

REFERENCES
Zervos 1935a, p. 101 (ill.); Zervos et al. 1935, p. 237 (ill.); Melville 1939, p. 23; Bonfante and Ravenna 1945, p. 60, pl. 33; Barr 1946, p. 189 (ill.); Merli 1948, p. 603, fig. 415; H. Read 1948, p. 25, pl. 117; Cassou 1949, fig. 41; Barr 1955, pp. 22 (ill.), 34, no. 121; Camón Aznar 1956, pp. 509 (fig. 380), 728; Zervos 1932–78, vol. 8 (1957), no. 246, p. 114 (ill.); D. Cooper 1963, pp. 284 (ill.), 291; Fermigier 1969, p. 219 (fig. 139); Gasman 1981, pp. 1182, 1183, 1831 (pl. 355a); Kodansha 1981, vol. 5, p. 86 (fig. 39); Geelhaar 1993, p. 156 (fig. 162); Vogel 1996b, p. A1; Chipp and Wofsy 1995–2009, [vol. 5] (1997), p. 241 (ill.), no. 34-113; Lieberman 1997, pp. 76, 77 (ill.); Crase 2004, pp. 126, 150, 159, 163; Korn 2004, p. 126 (as P. Watson purchase, *Femme lisant*); Julia May Boddewyn in New York–San Francisco–Minneapolis 2006–7, pp. 353, 356, 373

Fig. 79.1. X-radiograph of cat. 79, with outlines indicating compositional changes

TECHNICAL NOTE

The painting is on medium-weight linen canvas commercially prepared with a white ground. Picasso applied paint quickly in thick, opaque, bold strokes, often with a loaded brush, as in the pale blue and pale purple passages in the face and hands, where the paint skipped across the surface as a result. Although he generally applied paint crisply, the pale green details in the flowers in the top left quadrant and the pale purple at top were applied in a softer manner, suggesting that these details may have been added later.

The orientation of the textured brushstrokes is not always consistent with visible passages within the paint film, indicating that the artist made changes to the composition during the painting process. In certain areas, as seen through skips in the paint, there are underlayers apparently related to such a reworking. One can glimpse varying shades of blue at discrete areas beneath the black and green along the flower stem in the lower left quadrant. Blue paint is also visible under the green, white, black, and red paint throughout the lower right quadrant. Gray paint can be seen beneath the figure's wreath.

X-radiography reveals that the irises of the sitter's eyes were initially visible and that her nose was more naturalistic; the top of the chair was larger; the present table was wider and extended farther to the left; and there was originally either another surface or an extension of the chair located beneath and behind the present table (fig. 79.1). The X-ray also indicates that Picasso made changes to the plant at bottom left and the figure of the woman and chair at bottom right; however, these details cannot be clearly identified.

Before entering the Metropolitan's collection, the painting was wax lined. Also, its original auxiliary support was replaced with a stretcher ½ inch larger than the initial size of the picture plane in order to relieve pressure on the original turnover edges. As a result, part of the original tacking margins moved onto the front face of the painting, visible as a narrow band of exposed ground around the perimeter of the work. Multiple sets of tacking holes indicate that the work was restretched several times. A degraded synthetic varnish that gave the painting a somewhat greasy, glossy, and hazy surface was removed in 2009, revealing a variable gloss more in keeping with the artist's intentions.

SD-P

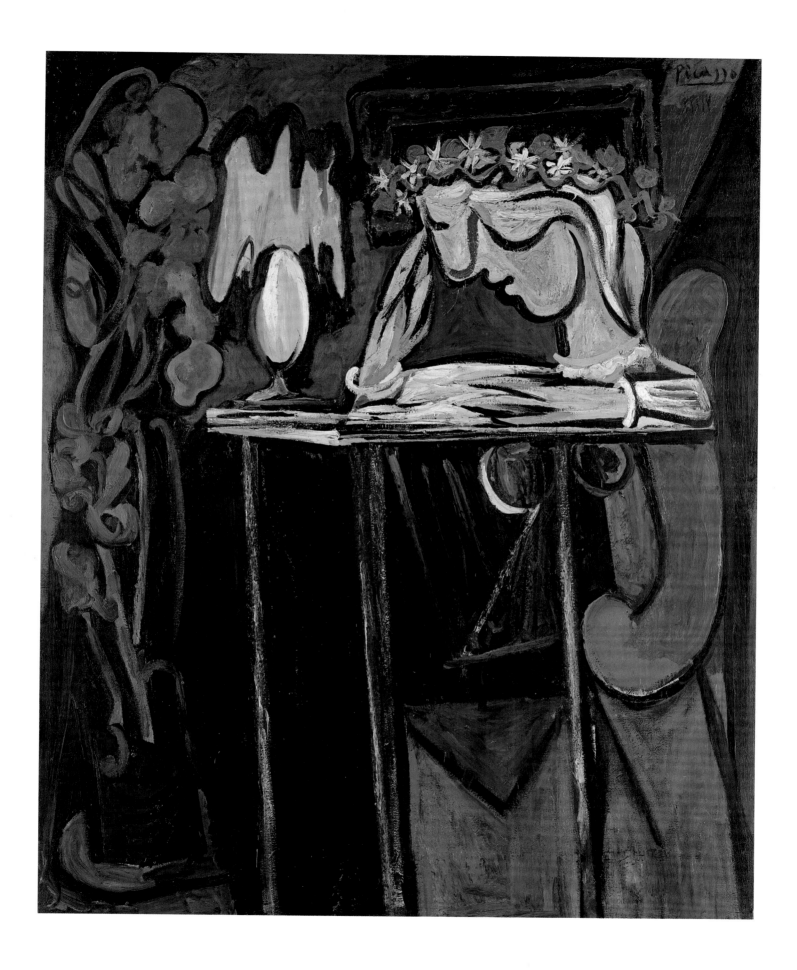

80. Dying Bull
Boisgeloup, July 16, 1934

Oil on canvas
13¼ × 21¾ in. (33.7 × 55.2 cm)
Signed, dated, and inscribed in gray paint, upper left: Boisgeloup/16 juillet/
XXXIV-/Picasso
Jacques and Natasha Gelman Collection, 1998
1999.363.67

Dying Bull belongs to a group of some seventeen works—paintings, drawings, and etchings—depicting bullfighting scenes that Picasso made between June and September 1934 while working at the Château de Boisgeloup, his country house some forty miles northwest of Paris.[1] As the château is situated far from any bullfighting arenas, the artist must have worked from memory. But then Picasso was an old hand at representing bullfights; his father took him to one in his native Málaga when he was only eight or nine years old, and the spectacle so impressed him that it became the subject of his earliest painting (1889–90, private collection; P 4; Z VI.3). Here he focused solely on the dying bull and excluded all of the paraphernalia—and the fury—usually connected with a bullfight, from the horses and spectators to the matador, who has just plunged his sword into the bull's left shoulder blade.

Picasso sometimes gave bestial qualities to the human figures in his works, especially their heads. The paintings he made of Olga Kokhlova in the years when their marriage was deteriorating (ca. 1925–32) come readily to mind. It is not surprising, therefore, that his representations of animals should, in turn, seem oddly human. However exaggerated the brutishness of this bull may appear, particularly its wrinkled and gray hide and dinosaurian proportions, such animal attributes are offset by the beast's hauntingly anguished expression. That Picasso took liberties with bovine anatomy—he added a row of upper front teeth—can hardly be the result of ignorance. It seems more likely that Picasso's early experience and fascination with bullfights led him to identify with toreros and bulls. Perhaps he believed that by anthropomorphizing the bull he could make the spectator better understand the animal's agony.

Between 1933 and 1934 Picasso made the Minotaur, the half-man, half-bull monster of Greek mythology, the subject of numerous drawings and etchings. As Picasso's alter ego, the beast is seen locked in a passionate embrace with the painter's mistress, Marie-Thérèse Walter, in numerous ink drawings from 1933. He sits nonchalantly holding a sword on the cover Picasso designed for the inaugural issue of *Minotaure*, the arts magazine founded by the Surrealists in 1934. The Minotaur also figures in the series of one hundred etchings known as the *Vollard Suite* (1930–37; see cats. P46–P52): in eleven etchings of 1933 the Minotaur is shown enjoying life and women, while in five others of 1933–34 he is pictured as blind and helpless.

Fig. 80.1. Poster for the Plaza de Toros in Vallauris, August 1952

This painting was reproduced, probably in 1952, as a poster announcing a bullfight that took place the weekend of August 2–3 at the Plaza de Toros in Vallauris, the small town in the hills above Antibes, on the Côte d'Azur, where Picasso designed and produced ceramics.[2] In the summer of 1947 Picasso had initiated the revival of Vallauris's languishing ceramics industry through his works in that medium (see cats. C1–C10). In gratitude, the town made him its "civil patron." After 1951 Picasso also became patron of Vallauris's annual bullfights, which he vigorously encouraged. SR

1. For the bullfighting series, see Z VIII.211, 212, 214, 215, 217–219, 221, 224–230, 232, and 233.
2. The photograph of the poster first appeared in Hélène Parmelin, *Picasso sur la place*, in 1959; this means that she either managed to publish it only a year after the event took place, in 1958, or, more plausibly, in 1952, when the second of August—the date listed on the poster ("Samedi 2 Aout")—also fell on a Saturday.

PROVENANCE
[Paul Rosenberg, Paris, and Rosenberg & Helft, London, acquired from the artist February/March 1936, stock no. 341; sold by April 1937 to Falk]; Oswald T. Falk, Esq., London (by April 1937); [Bignou Gallery, New York, by 1941]; Keith Warner, New York (by 1946); G. David Thompson, Pittsburgh (until 1961; sold, through

Beyeler, to Feigen); [Richard L. Feigen Gallery, Chicago, 1961; sold to Douglas]; Kirk Douglas, Beverly Hills (1961, until at least 1967); [Heinz Berggruen, Paris, by 1977 until at least 1980]; [Interart, Ltd., Zug, Switzerland, until 1982; sold on December 7, for $420,000, to Gelman]; Jacques and Natasha Gelman, Mexico City and New York (1982–his d. 1986); Natasha Gelman, Mexico City and New York (1986–d. 1998; her bequest to the Metropolitan Museum, 1998)

Exhibitions

Paris 1936, no. 20; London (Rosenberg & Helft) 1937, no. 25; New York (Bignou) 1941, no. 13; Los Angeles 1961, no. 27, ill.; Fort Worth–Dallas 1967 (shown in Dallas), no. 56, p. 96; Tokyo and other cities 1977–78, no. 43, ill.; New York 1980, p. 315 (ill.) and checklist p. 54; New York–London 1989–90, pp. 192 (ill.), 193–94, 312 (ill.); Martigny 1994, pp. 216–18 (ill.), 333 (ill.), 334; New York (MMA) 1997, hors cat.; New York 2001–2, no cat., checklist no. 44

References

Zervos 1935a, p. 21 (ill.); Zervos 1935b, p. 154 (ill.); Haesaerts 1938, p. 8, cover ill.; Mackenzie 1940, pl. 18; Bonfante and Ravenna 1945, pp. 60, 224, pl. 30; Barr 1946, pp. 186–87 (ill.); Merli 1948, p. 603, ill., no. 417; Cassou 1949, fig. 38; Vinchon 1951, p. 15 (ill.); Camón Aznar 1956, pp. 503 (fig. 378), 504, 728; Zervos 1932–78, vol. 8 (1957), p. 105 (ill.), no. 228; Gasser 1958, p. 18 (ill.); Champris 1960, pp. 127 (fig. 130), 290; Parmelin 1963, ill. facing p. 126; Kodansha 1981, vol. 5, p. 108 (fig. 17); Warncke 1992, vol. 1, p. 362 (ill.); Warncke 1993, vol. 1, p. 362 (ill.); Daix 1995, pp. 145, 605; Chipp and Wofsy 1995–2009, [vol. 5] (1997), pp. 234 (ill.), 310, no. 34-097; Léal, Piot, and Bernadac 2000, pp. 290 (fig. 703), 518 (English ed., pp. 286, 290 [fig. 703], 518); Cowling 2002, pp. 559–60 (fig. 534); Korn 2004, p. 125 (as Sir O. Falk purchase, *La Mort du taureau*)

TECHNICAL NOTE

Picasso applied paint directly, and somewhat thinly, on medium-weight canvas commercially prepared with a white ground. Skips in the paint layer reveal the white ground, such as to the right of the sword hilt. He appears to have left reserves for each passage of color, with the possible exception of some areas of blue in the foreground. Any overlapping of colors occurs predominantly at the boundaries between colors.

Picasso began by roughing in the form of the bull with gray paint; applications of green followed, then yellow, blue, and pink. He refined the modeling of the gray paint throughout the process. Some of the last details the artist added to the composition include the black lines that outline the bull and the terrain on which the animal stands. These lines contribute significantly to the bull's power and intensity, as is evident when the outlined areas are compared to a passage without the lines (such as the proper right hind leg). X-radiography suggests the artist made at least one revision to the composition: originally the hilt of the sword was oriented with the hand guard facing down rather than up.

Three sets of tacking holes indicate the canvas has been stretched at least three times. The work is now on a stretcher, but records show that its original auxiliary support was a strainer, which was replaced because of structural concerns in 1989. The canvas had a series of stiff distortions and required a stronger, tensionable auxiliary support to maintain it in a stable and planar state. The painting has never been varnished and retains a relatively even surface gloss. The work was surface cleaned in 1989 and again in 2008 to fully reveal the contrasts and crispness of the brushstrokes.

SD-P

81. Woman Asleep at a Table
Le Tremblay-sur-Mauldre, December 18, 1936

Oil and charcoal on canvas
38¼ × 51¼ in. (97.2 × 130.2 cm)
Signed and dated, lower left: 18 D. XXXVI. <u>Picasso</u>
The Mr. and Mrs. Klaus G. Perls Collection, 1997
1997.149.3

Between 1934 and 1936 Picasso made a series of paintings and drawings on the subject of women sleeping, dreaming, or reading. This canvas, executed in grisaille with touches of reddish brown, is one of several that depict a young woman at a table. Picasso's companion, Marie-Thérèse Walter, is shown sleeping rather than reading, as she is in the 1934 canvas in the Metropolitan's collection (cat. 79).

The interior setting of the picture gives the impression of a garret, a novelty in Picasso's art. In 1936 Picasso, following his separation from Olga Kokhlova, moved Marie-Thérèse and their daughter, Maya, to a small country house at Le Tremblay-sur-Mauldre, near Versailles, which he rented from the art dealer Ambroise Vollard. The angular walls, probably suggested by a room at Tremblay, close in on the sleeping figure. Anticipating Picasso's masterpiece of the next year, *Guernica* (see fig. 82.2), this work shares with it complex spatial relationships and a muted grisaille palette to convey an atmosphere of stark desolation. Both this work and *Guernica* are illuminated by a single spare bare bulb. The austere mood is in clear contrast to the artist's other sexually charged, colorful depictions of Marie-Thérèse. The "collapsed" walls also recall the spatial structure of many of Picasso's Synthetic Cubist paintings. MD

PROVENANCE
Carlo Frua de Angeli, Milan (acquired from the artist, probably through his wife, Mary (Meric) Callery, in the late 1930s); [Perls Galleries (Klaus G. Perls), New York, from 1964; stock no. 6593]; Mr. and Mrs. Klaus G. Perls, New York (until 1997; their gift to the Metropolitan Museum, 1997)

EXHIBITIONS
São Paulo 1953–54, no. 32, p. 31, ill.; Toronto–Montreal 1964, no. 164, p. 121 (ill.) (also traveled to Tokyo, Kyoto, and Nagoya); New York (Perls) 1965, no. 15, ill.; Paris 1966–67, no. 168, ill.; Vienna 1968, no. 42, p. 51, pl. 11; Humlebaek 1968, no. 46, pp. 55 (ill.), 68; Tokyo and other cities 1977–78, no. 45, ill.; New York (MMA) 1997, hors cat.; San Francisco–New York 1998–99, no. 1, pp. 98 (detail ill.), 123 (ill.); New York 2000, pp. 107 (ill.), 126; Kyoto–Tokyo 2002–3, no. 61, pp. 125 (ill.), 168

REFERENCES
Zervos 1932–78, vol. 8 (1957), p. 146 (ill.), no. 309; Daix 1995, p. 555; Drath 1996, p. G04; Kaufman 1996, p. 14; Vogel 1996a, p. C11; Vogel 1996b, p. A1; Chipp and Wofsy 1995–2009, [vol. 5] (1997), p. 303 (ill.), no. 36-104; Grimes 2008, p. B6

TECHNICAL NOTE

The painting, executed on fairly coarse canvas commercially prepared with a white ground, is attached to what appears to be its original stretcher. The dimensions of the canvas correspond to a standard French size (#60),[1] and a colorman's stencil, "Huiles et Couleurs Fines A. Barillon, 60 Rue de La Rochefoucauld, Paris," is on the reverse of the canvas at top left.[2] While the canvas has remained unlined, a second set of tack holes visible along the tacking edges indicates that it was restretched in the past.

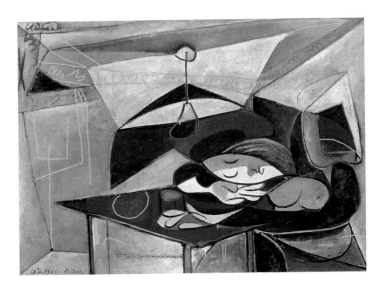

Fig. 81.1. Photograph of cat. 81, with compositional changes outlined

An additional white priming layer was applied on top of the commercial ground layer, probably by the artist, followed by an overall reddish-brown imprimatura layer.[3] The imprimatura, visible in numerous places within the composition, varies in color from pale mauve to deep brown. It complements the painting's nocturnal setting and intensifies the artist's minimal palette of blacks, whites, and shades of gray.

Picasso did not execute the painting in a systematic way. Rather, he alternated between outlining the elements under and over the paint layer and working wet-in-wet, utilizing the paint's transparency but also making numerous changes in the process. These changes, clearly visible under the paint layer as pentimenti, are concentrated in elements of the background. Picasso seems to have shifted the side window from the left to the right and adjusted the angles and molding of the walls so that they slope like those of a mansard roof; he also adjusted the left profile of the overhead light (fig. 81.1). He defined all of the outlines either with a medium-rich black paint or by using the leaner and drier red-brown underlayer in reserve. Although the paint layer shows all the characteristics of a commercial enamel-type paint, which was available at the time—it is highly glossy, medium rich, and fluid, and it levels flat and evenly on the imprimatura surface—analysis reveals that all of the paints are artists' oils.[4] Picasso used a more matte and gritty looking black paint to trace or fill in some elements. He also used charcoal (or a charcoal-like material) to trace black

lines on top of the wet paint layer: final accents left grainy graphite particles embedded in the fluid white paint.[5] These accents made with dry media provide contrasting textures to the rich and glossy paint layer. As the painting was never varnished, they are intact, as is the drier red-brown imprimatura that was left exposed.

ID

1. See London 1990–91, p. 46. Picasso seems to have favored this size of prepared canvas, which he used repeatedly for his still lifes from the 1920s and 1930s, including cats. 73, 74.
2. This street is adjacent to the rue Pigalle, in the 9th Arrondissement. At the time, Picasso still had his studio at 23, rue la Boétie, which was within walking distance of Barillon's store (Marilyn McCully, personal correspondence).
3. The dark staining present on the reverse of the canvas has the appearance of a large oil stain, probably the result of one of these layers being overly diluted and unevenly applied.
4. FTIR and Py-GC-MS analyses by Julie Arslanoglu, Department of Scientific Research.
5. Raman Spectroscopy analysis by Silvia A. Centeno (Department of Scientific Research) identified this material as an amorphous carbon-based pigment.

82. Dora Maar in a Wicker Chair
Paris, April 29, 1938

Ink, charcoal, and pastel on white laid paper watermarked with
Montval mark
30½ × 22½ in. (77.5 × 57.2 cm)
Signed and dated in black ink, lower right: 29.4.38· / Picasso
On verso, in graphite, upper center: large arc, approximately 18 in. wide
Jacques and Natasha Gelman Collection, 1998
1999.363.70

The fateful encounter between Picasso and the Surrealist photographer Dora Maar (Henriette Theodora Markovitch, 1907–1997) in early 1936—when he was fifty-four and she was twenty-eight—has become the stuff of legend. Picasso and his poet friend Paul Éluard, the story goes, were sitting in the café Les Deux Magots, on the boulevard Saint-Germain, in Paris; at a nearby table was Dora Maar, a friend of Éluard's. Dora has been described as a "dark, tall, powerfully mysterious woman given to strange acts,"[1] and one of these acts unfolded as Dora nonchalantly pulled a small pointed penknife from her purse and drove it "between her fingers into the wood of the table. Sometimes she missed and a drop of blood seeped through the roses that were embroidered on her black gloves."[2] Picasso was riveted by the spectacle, just as Dora intended, and asked Éluard to introduce him. Picasso addressed her in French, and she replied in Spanish: he was even more impressed.

Dora's life had been unusual. She was born in Paris, the daughter of a Croatian architect and a French mother. In 1910, when she was three, her family moved to Buenos Aires, where her father worked on important building commissions. In 1916 she returned to Paris and enrolled at the Union Centrale des Arts Décoratifs, then the École de Photographie, and later at the Académie Julian. Subsequently, she studied painting in André Lhote's studio, where she met the photographer Henri Cartier-Bresson. Initially dividing her energies between painting and photography, she decided to pursue the latter, for which she showed both talent and had received encouragement; during this time she also changed her name to Dora Maar. By the mid-1930s she was closely associated with the Surrealist writers, among them René Char and Georges Bataille, who became her lover for several months between late 1933 and 1934. In the early 1930s she also shared a studio with Brassaï. In 1934 she opened her own photography studio and darkroom at 39, rue d'Astorg, in Paris, receiving commissions from conventional fashion magazines and also from erotic reviews.[3] The street photographs she took in Barcelona, London, and Paris in 1934 combine the uncanny with the emphatic.[4] Her most famous photograph, *Portrait of Ubu*, a human-animal/foetus-cadaver hybrid, was shown at the "International Surrealist Exhibition" in London in 1936.

After their initial encounter, Picasso and Dora spent the summer of 1936 at Mougins, on the French Riviera. Dora

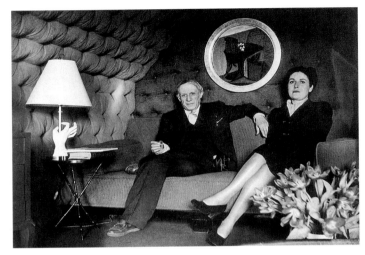

Fig. 82.1. Picasso and Dora Maar, 1940s

became Picasso's principal, or "public," mistress,[5] while Marie-Thérèse Walter, who in 1934 had given birth to Picasso's daughter, Maya, remained a private liaison. Picasso continued to see Marie-Thérèse and Maya as well as his estranged wife, Olga, and their son, Paulo. In early 1937, on Dora's suggestion, Picasso rented and moved into a large second-floor studio at 7, rue des Grands-Augustins, on the Left Bank. It was a historic seventeenth-century mansion on the same street where Balzac set his 1837 short story "Le Chef-d'oeuvre inconnu" (The Unknown Masterpiece), about a mad painter whose supposed masterwork is revealed to be nothing but a maze of lines. On May 1, 1937, working in his new studio, Picasso began the many sketches for his 26-foot-long mural painting *Guernica* (fig. 82.2), named after the ancient Basque town the Germans had bombed into oblivion on April 26. Starting on May 11 and continuing over the next three weeks, Dora captured on film the seven stages of the composition, filled with animals and figures, as Picasso conjured up the terrifying destruction. The photographs furnish an extraordinary and invaluable record of the evolution of this great mural. By mid-June 1937 *Guernica* was installed at the Spanish pavilion of the Exposition Universelle, in Paris.[6]

This portrait of Dora Maar is part of a large group of related works Picasso created, largely in pen and ink, in an overall weblike design.[7] He defined the cumbersome wood armchair

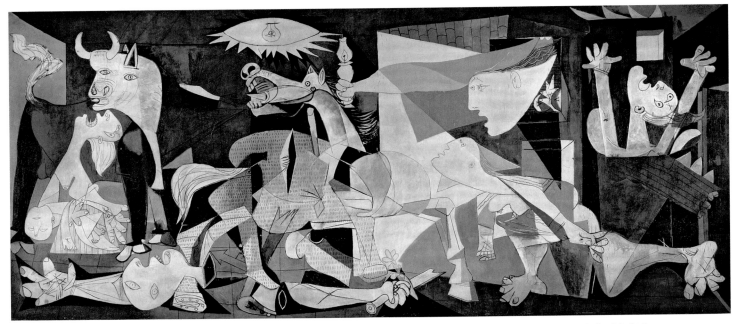

Fig. 82.2. Pablo Picasso, *Guernica*, 1937. Oil on canvas, 137 × 305 in. (349 × 776 cm). Museo Nacional Centro de Arte Reina Sofía, Madrid

and its wicker caning with a multitude of straight lines; curved marks were reserved for the sitter and her hands, torso, head, shoes, and skirt (see cats. P87, P88). Most areas of the sheet are lightly tinted with local color. Dora appears as a sort of giddy spider-queen who sits on a throne with crossed arms and legs. Her features and profile are clearly recognizable, as they are in many other drawings and paintings in which Picasso showed her seated, inside and outdoors, in the same or a similar chair. Dora was fond of hats, which obviously delighted Picasso as well.

Picasso was also fascinated by Dora's hands, and in some of the drawings and paintings of her, he depicted one of them as a cluster of feathery digits. In other works both are shown, sometimes as clenched fists and sometimes resembling claws; here, emphasis is placed on her pointed fingernails. The hands are curiously splayed and pierced, and they seem useless as they flop on either side of her body. Her breasts are indicated by conical shells, her ears by two little bells. The entire figure recalls a doll: a large, limp toy that one might toss or shake.

<div align="right">S R</div>

1. Most of the information on Dora Maar is taken from Mary Ann Caws's biography of her, *Picasso's Weeping Woman*. For the quotation, see Caws 2000, p. 83.
2. Ibid, p. 81.
3. Illustrated in ibid., pp. 18–55; see the chapter "The Young Photographer 1930–1933."
4. Ibid., pp. 40–43.
5. Ibid., p. 54.
6. After the exhibition, and following a lengthy tour of Europe and the United States, *Guernica* and its studies remained at The Museum of Modern Art, New York, on extended loan until 1981, when it was returned to Spain. It is now in the Museo Nacional Centro de Arte Reina Sofía, Madrid, whose archives preserve Dora Maar's photographs.
7. See z ix.131, 133, 134, 142, 146–149, 157, 179, 211–213, 219–221, 226, and 232.

PROVENANCE
[Mary (Meric) Callery, Boulogne-sur-Seine (by 1939, until ca. 1972/73; acquired from the artist; sold to Diamond)]; [Harold and Hester Diamond, New York, ca. 1972/73, until 1981; sold on May 21, 1981, for $300,000 to Gelman]; Jacques and Natasha Gelman, Mexico City and New York (1981–his d. 1986); Natasha Gelman, Mexico City and New York (1986–d. 1998; her bequest to the Metropolitan Museum, 1998)

EXHIBITIONS
New York and other cities 1939–41 (shown in all venues), no. 352, p. 188 (ill.); Philadelphia 1945, p. 39; New York (Buchholz) 1945, no. 22; New York (MoMA/Private Collections) 1948, no cat.; New York 1980, p. 355 (ill.); Tübingen–Düsseldorf 1986, no. 173, p. 281, ill.; New York–London 1989–90, pp. 204–6 (ill.), 312 (ill.); Martigny 1994, pp. 228–30 (ill.), 334 (ill.); New York–Paris 1996–97, pp. 396 (ill.), 495

REFERENCES
Zervos 1938b, p. 145 (ill.); Barr 1946, p. 220 (ill.); Merli 1948, p. 604, no. 508, ill.; Zervos 1932–78, vol. 9 (1958), p. 64 (ill.), no. 132; Daix 1977, p. 286; Piot 1981, pp. 161–62 (fig. 140); Judi Freeman in Los Angeles–New York–Chicago 1994–95, pp. 181, 183 (fig. 134); Chipp and Wofsy 1995–2009, [vol. 6] (1997), pp. xv, 158 (ill.), 266, no. 38-068; Dobrzynski 1998, pp. A1, B6; Léal, Piot, and Bernadac 2000, pp. 332 (fig. 816), 521 (English ed., pp. 332 [fig. 816], 520); Julia May Boddewyn in New York–San Francisco–Minneapolis 2006–7, pp. 360, 364

TECHNICAL NOTE

This drawing is composed of layers of media. Picasso first sketched the forms loosely in charcoal; although he minimized its appearance by brushing away the excess material, numerous strokes remain visible. The next layer is a nib-pen drawing in a glossy India (shellac-based) ink, followed by bright, high chroma pastel, manufactured to have fine particles and a slightly creamy appearance. After the pastel, Picasso refined the design with additional ink, and in many areas he painstakingly followed the underlayer of pen nearly exactly. He also applied the ink in thicker streams, concealing the underlayer and emphasizing the line. In other areas, such as in the skirt, the first layer of pen can be seen beneath the purple pastel and is offset from the position of the subsequent final ink layer, leaving the original pen lines visible.

Throughout the drawing, the high-gloss India ink contrasts with the matte, powdery pastel. Rather than employ the paper reserve to highlight the face, hands, and legs, Picasso used a white pastel that has a cooler tone than the white paper. For the shoes, he added a small amount of water to liquefy the pastel and create a paint-like material; he applied it with a brush and his fingers, which left prints on the drawing.

<div align="right">R M</div>

83. Man with a Lollipop
Mougins, July 23, 1938

Graphite on cream colored wove paper with indecipherable watermark
12⅛ × 9⅛ in. (30.8 × 23.2 cm)
Signed and dated lower right, in graphite: 23.7.38·; in black ink: <u>Picasso</u>
Jacques and Natasha Gelman Collection, 1998
1999.363.68

84. Man with a Lollipop
Mougins, August 20, 1938

Oil on paper, mounted on canvas
26⅞ × 17⅞ in. (68.3 × 45.4 cm)
Signed and dated, upper left: 20A38/<u>Picasso</u>
Jacques and Natasha Gelman Collection, 1998
1999.363.69

Picasso spent the summer of 1938 at Mougins, a small hilltop village a few miles inland from Cannes on the Côte d'Azur.[1] It was his third summer there; he stayed at the Hôtel Vaste Horizon accompanied by his mistress Dora Maar (see cat. 82), the poet Paul Éluard (1895–1952), and Éluard's wife, Nusch (Maria Benz, 1906–1946). Between July 23 and August 20, Picasso painted and drew a number of works showing men sucking lollipops or licking ice cream cones.[2] These licking and sucking creatures were not inventions: they were based on real people the artist observed during his holidays. Opinions among scholars differ as to their identities. Roland Penrose believes they are "village youths,"[3] but not all of them are young. Pierre Cabanne describes them as "tourists," but some look more menacing than mere vacationers.[4] When James Thrall Soby discussed the Museum's painting *Man with a Lollipop* in 1939— when it was titled "Man with an All-day Sucker"—he thought it was inspired by the sixteenth-century Italian mannerist Giuseppe Arcimboldo, who painted bizarre figures composed of fruits and vegetables.[5] Whoever they may be, Picasso endowed his sugar-craving subjects with monstrous heads; they are always in profile or three-quarter view, and they are outfitted with two full eyes, two ears, huge inflated nostrils on double-sided noses, large voracious mouths, and deformed hands.

The Museum's drawing of the lollipop-sucking man predates the painting by a month. On July 23 Picasso sketched the hirsute youth, who wears a striped undershirt and a torn straw hat, in quick, hatchet-like pencil strokes. It must have been with a certain relish that he recorded the sitter's thick forehead locks, his stubby and unruly beard, and the profuse growths of hair on his neck, shoulders, and chest. As was his custom when presenting figures in profile or three-quarter view (it is often difficult to tell them apart), Picasso added a second eye and ear and doubled the size of the nose. The cone-shaped lollipop, clutched in the man's gnarled right hand, is not recognizable at first glance: it is partly hidden behind the man's mouth, not in it, with the

upper edge flush with the brim of the hat. In August, when he turned to the painting, Picasso transformed the swarthy youth into a weatherbeaten old man, his face riddled with grotesque wrinkles and furrows. Earlier that year, Picasso had applied a basket-weave pattern to the surfaces of his forms (see cat. 82). Here he did so again, and the pattern perfectly matches the weave of the man's tattered straw hat and striped jersey. It also serves to break down the face and hands into angular, crystalline shapes. Only the diamond-shaped lollipop was not subjected to this fantastic patterning, and amid a palette of mainly blacks, reds, and whites, it shines a bright emerald green.

Given Picasso's predilection for the sexual and macabre, one cannot help but see the young man in the drawing as having suggestive overtones. As for the old man sucking a lollipop, the artist might have been poking fun, rather crudely, at those who, late in life, revert to childlike pleasures or seek substitutes for erotic ones.

S R

1. In 1961 Picasso bought the villa Notre-Dame-de-Vie in Mougins; he lived there until his death in 1973.
2. z IX.186–190; 2203–2206.
3. Penrose 1973, p. 327.
4. Cabanne 1977, p. 315.
5. Soby 1939, p. 8.

MAN WITH A LOLLIPOP
1999.363.68

PROVENANCE
[Galerie Käte Perls, Paris, and Perls Galleries (Klaus and Frank Perls), New York, 1938, until no later than 1944; acquired from the artist, sold to Ault]; Lee Ault, New York (by April 1944–1962; sold to Thaw); [E. V. Thaw & Co., New York, 1962–ca. 1963; sold to Bareiss]; Walter Bareiss, Greenwich, Conn. (ca. 1963–73; returned to Thaw in exchange for another work of art); [E. V. Thaw & Co., New York, ca. 1973–77; sold on February 16, 1977 to Gelman]; Jacques and Natasha Gelman, Mexico City and New York (1977–his d. 1986); Natasha Gelman, Mexico City and New York (1986–d. 1998; her bequest to the Metropolitan Museum, 1998)

EXHIBITIONS
New York (Valentine) 1944, no. 44; New York 1962 (shown at the New Gallery), no. 37, ill.; New Haven 1971–72, no. 15, cover ill.; Tübingen–Düsseldorf 1986, no. 177, p. 281, ill.; New York–London 1989–90, pp. 206–7 (ill.), 312 (ill.); Martigny 1994, pp. 230–31 (ill.)

REFERENCES
Zervos 1938b, p. 164 (ill.); Merli 1942, pp. 290 (ill.), 301; Zervos 1932–78, vol. 9 (1958), p. 90 (ill.), no. 188; Daix 1977, pp. 287, 290 n. 19; Chipp and Wofsy 1995–2009, [vol. 6] (1997), pp. xv, 175 (ill.), no. 38-131; Julia May Boddewyn in New York–San Francisco–Minneapolis 2006–7, p. 359

TECHNICAL NOTE
Picasso made this drawing with very firm strokes, using a soft graphite pencil. The vigor of the artist's application strongly indented the smooth, soft, cream colored wove paper and had the effect of enhancing the metallic sheen of the graphite. In some areas it also disturbed the top layer of paper, causing the fibers to pill on the surface. Several campaigns of lighter graphite lines and erasures can be discerned, revealing how the artist repositioned the hat, hand, and other features during the execution of the drawing.

RM

Cat. 83

Cat. 84

Man with a Lollipop
1999.363.69

PROVENANCE

[Galerie Käte Perls, Paris, and Perls Galleries (Klaus and Frank Perls), New York, 1938; acquired from the artist]; Walter P. Chrysler, New York and Warrenton, Virginia (by 1939–50; sale, Sotheby Parke-Bernet, New York, February 16, 1950, no. 61, for $5,100, to Bragaline); Edward A. Bragaline, New York (from 1950, until at least November 1963); [E. V. Thaw & Co, New York, ca. 1983]; Wendell Cherry, Louisville, Kentucky (ca. 1984); [Acquavella Galleries, New York, until 1985; sold on February 14 to Gelman]; Jacques and Natasha Gelman, Mexico City and New York (1985–his d. 1986); Natasha Gelman, Mexico City and New York (1986–d. 1998; her bequest to the Metropolitan Museum, 1998)

EXHIBITIONS

New York and other cities 1939–42 (shown only in New York, Chicago, Saint Louis, and Boston), no. 355, p. 189 (ill.); Richmond–Philadelphia 1941, no. 187, pp. 15, 108, ill.; New York (Perls/Picasso) 1953, no. 14; New York–Chicago 1957, p. 80 (ill.); Philadelphia 1958, no. 198, p. 22, ill.; New York 1962 (shown at Perls Galleries), no. 17, ill.; New York (Knoedler) 1963, no. 26, ill.; New York 1971, no. 55, p. 65 (ill.); New York–London 1989–90, pp. 206–8 (ill.), 313 (ill.); Martigny 1994, pp. 31 (ill.), 232–33 (ill.), 334 (ill.)

REFERENCES

Zervos 1938b, p. 179 (ill.); Frankfurter 1939a, p. 20 (ill.); Soby 1939, pp. 8, 12 (ill.); Cassou 1940, p. 140 (ill.); Mackenzie 1940, pl. 19; Anon., February 1, 1941, p. 1; Frankfurter 1941, p. 17 (ill.); Junkin 1941, p. 105; Barr 1946, pp. 218 (ill.), 219; Leclerc 1947, p. 41 (ill.); Merli 1948, p. 604, pl. 520; Elgar and Maillard 1955, pp. 178–79, 288 (ill.); Elgar and Maillard 1956, pp. 178–79, 288 (ill.); Hunter 1957, ill. facing pl. 10; Vallentin 1957, p. 335; Zervos 1932–78, vol. 9 (1958), p. 98 (ill.), no. 203; Champris 1960, pp. 160 (ill.), 291, no. 171; Jaffé 1964, p. 28 (fig. 35); Jaffé 1967, p. 26; Penrose 1967, pl. 24; Glueck 1971, pp. 118 (ill.), 119; Lipton 1976, pp. 266, 380 (pl. 29); Daix 1977, pp. 287, 290 n. 19; Jaffé 1988, pp. 28 (fig. 35), 110; Chipp and Wofsy 1995–2009, [vol. 6] (1997), pp. xv, 182 (ill.), no. 38-149; Julia May Boddewyn in New York–San Francisco–Minneapolis 2006–7, pp. 353, 355, 370, 377

TECHNICAL NOTE

Man with a Lollipop, which was painted directly on paper and shows no sign of underdrawing, demonstrates Picasso's remarkable dexterity working *alla prima*.[1] The left edge of the paper support shows evidence of having been roughly cut from a larger sheet. No traditional ground layer was applied, but the artist loosely brushed on a thin orange-colored wash, presumably to tone down the brightness of the paper (cat. 84). This light wash underlines and complements the rich red-orange color scheme of the figure. In some areas, Picasso applied a wash on top of the paint layer as well—for example, on certain black outlines of the lollipop—which reminds us that he never followed any one pre-established technique, but instead constantly changed and reinvented his approach.

The paint layer, which is identified as gouache in a label on the stretcher, does not have the porosity and dryness of gouache; rather, it has the homogeneous and sometimes creamy texture normally associated with oil. The gray background seems to have been a later addition, as three different colors show through the gray paint: a thin, uneven layer of blue, visible along the top of the hat on the left side; a white paint layer, discernible along the right side of the composition; and a yellow layer, similar to the paint used for the straw hat, along the left side of the figure, especially between the man's mouth and nostril.

Except for a slight adjustment to the contour of the man's neckline above his left shoulder, Picasso made no substantial changes to the composition. He originally painted on medium-weight wove paper; the paper was later glued onto two layers of canvas tacked on to a stretcher, giving the work the appearance of a painting on canvas. Today the overall tonality of the composition is darker, a result of natural aging (originally the paper was probably a cream color but is now a light brown) and a varnish applied to the surface, which in addition to altering the color saturation and various textures of the paint layer also contributed to the darkening of the paper support. ID

1. He relied instead on a preparatory study, *Man with a Lollipop* (cat. 83), which shows the various changes he made to the composition.

85. Sheep Skull with Grapes
Royan, October 1, 1939

Ink and gouache on off-white laid paper watermarked MONTGOLFIER/ ANNONAY
18¼ × 25½ in. (46.4 × 64.8 cm)
Signed and dated in ink, lower left: 1ᵉʳ octobre 39· Picasso
Gift of Mr. and Mrs. Alexander Liberman, 1991
1991.354

Picasso arrived in Royan, a small town on France's southern Atlantic coast, on September 1, 1939, just two days before the outbreak of World War II. With the exception of a few trips to Paris, he remained there for the following year. We know quite a bit about the artist's life at Royan from his secretary, Jaime Sabartés, who accompanied him and devoted the last thirty pages of his book *Picasso: Portraits & Souvenirs* to this period.[1] Yet the ever-discreet Sabartés gives the impression that he and Picasso were alone in Royan when in fact Picasso's extended "family"—his mistress Marie-Thérèse Walter and their daughter, Maya, as well as his current consort, Dora Maar—were there, too, as were his chauffeur, Marcel, and Sabartés's wife. Picasso arranged for his two mistresses to live in different parts of the city. He and Dora Maar stayed at the Hôtel du Tigre, and he had a studio at the villa Gerbier de

Joncs; in January 1940 he moved his studio to the villa Les Voiliers.

Here, Sabartés describes the day following their arrival: "[S]till badly installed, or as badly installed as he always was when in a new place, he starts to draw, having with him a pad of paper, a pen, ink, crayons, or brushes; all that he needed to continue working while trying to get accustomed to the new surroundings."[2] Since canvas was getting more and more scarce, Picasso stocked up on notebooks at the Librairie Hachette on his trips to Paris.[3] Back in Royan, moored in unfamiliar surroundings, he drew incessantly, and by the time he returned to Paris for good at the end of August 1940 he had filled eight sketchbooks. The first, which Picasso began in Royan on September 30 and completed there on October 29, contains numerous studies of sheep's skulls, jawbones, and similar remains that reveal the artist's fascination with these peculiarly long, grisly structures,[4] whose empty eye sockets, long gashlike mouths, and spiky front teeth make them look particularly ominous.

Picasso based this large drawing on one of the studies of a sheep's skull in his first Royan sketchbook. He placed the skull in a setting reminiscent of a landscape and added a bunch of grapes.[5] During his stay in Royan, Picasso also painted the first

of three more stylized, flayed sheep's heads that convey a sense of foreboding and death.[6] Scholars have suggested that when Picasso made these works he was thinking of the Spanish master Francisco de Goya, who lived in Bordeaux, not far from Royan, during the last four years of his life (1824–28). Goya painted one particularly stark still life depicting a sheep's head and joints of meat (ca. 1808–12) that Picasso would have known from his frequent visits to the Louvre.

But where did Picasso get the skulls? As recounted by Sabartés, while in Royan he and Picasso developed a daily routine of visiting the city's market and *brocante* shops (sellers of second-hand goods). We must assume that they also made stops at a butcher shop or slaughterhouse. According to Dora Maar, Picasso kept the skulls in the studio to feed to his Afghan hound, Kasbek.[7] The gruesome irony that both animals' heads share a similarly elongated bone structure would not have been lost on Picasso. S R

1. Sabartés 1946b, pp. 199–229.
2. Ibid., p. 199.
3. Ibid., pp. 204–5.
4. Léal 1996, vol. 2, pp. 146–65. See also z x.7–20, 26, 28, 47, 50, 65–68, 71, 72, 74.
5. *7 V Study of a Skull* (Léal 1996, vol. 2, ill. p. 148; see also z x.16). That study also served as the basis for a more detailed and precise rendering of a skull in which the bone glistens with the moisture of the recently removed skin.
6. See z IX.351 and 349; z X.122.
7. John Richardson's interview with Dora Maar, July 1992, cited in McCully 1993, p. 166 n. 1.

PROVENANCE
[Galerie Pierre (Pierre Loeb), Paris]; Mr. and Mrs. Alexander Liberman, New York (until 1991; their gift to the Metropolitan Museum, 1991)

EXHIBITION
New York 1995, unnumbered cat., ill.

REFERENCES
Zervos 1932–78, vol. 9 (1958), p. 64 (ill.), no. 350; Chipp and Wofsy 1995–2009, [vol. 7] (1998), no. 39-180

TECHNICAL NOTE
Picasso made the drawing using loose brushstrokes of black ink; the transparency of the ink, when diluted, allowed him to create a range of gray tones. He added a small amount of white gouache in some areas, most heavily at the left edge, to lighten and opacify the transparent, fluid media. R M

86. Dora Maar in an Armchair
Royan, October 26, 1939

Oil on canvas
28⅞ × 23¾ in. (73.3 × 60.3 cm)
Signed and dated, lower center: 26.10.39/Picasso
Inscribed and dated on verso in black paint, upper right: Royan/26.10.39
The Mr. and Mrs. Klaus G. Perls Collection, 1998
1998.23

Dora Maar, arguably the most intellectual of Picasso's consorts, became the artist's principal mistress in 1936, replacing in position, but not affection, his lover at that time, Marie-Thérèse Walter.[1] Picasso created vastly different images of the two women. His depictions of the blond, placid, and plump Marie-Thérèse convey sensuousness and comfort, and she is often shown asleep and nude. The dark-haired, elegant, and rarely undressed Dora, meanwhile, typically confronts the viewer with her wide-eyed and high-strung intelligence. In this work, Dora's sparkling eyes compete with the stars of the ugly wallpaper behind her. Picasso painted the picture in Royan less than two months after leaving Paris, along with his extended entourage, in the grand Hispano-Suiza driven by his chauffeur, Marcel. Marie-Thérèse and Picasso's four-year-old daughter, Maya, had been in Royan since July, staying at the villa Gerbier de Joncs, where Picasso set up his studio. He and Dora took rooms at the Hôtel du Tigre, and we can assume that the garish patterned wallpaper surrounding Dora in this portrait decorated one of the rooms there.

In 1937 Dora had recorded with her camera the evolution of Picasso's masterpiece *Guernica* during three intense weeks in May (see fig. 82.2). She does not appear in the painting, but the features of the women in the series of etchings, drawings, and paintings known as the Weeping Women—which might be regarded as postscripts to and commentaries on *Guernica*—are no doubt based on her. She is easily recognized despite Picasso's transformation of her face and figure into grotesquerie. As he did in the Weeping Women, here Picasso first disjointed Dora's face before rejoining it in both frontal and profile views.

Dora was the only one of Picasso's lovers who was his match in mind and temperament.[2] But unlike the artist's previous mistresses, Dora's fierce intelligence, pride, and creativity would not let her accept the submissiveness expected of her by the artist. When Picasso met the twenty-one-year-old painter Françoise Gilot (b. 1921) in 1943, his relationship with Dora, always volatile, began to deteriorate. He painted the last portrait of Dora in 1943, and the last one of Marie-Thérèse in 1944. However, Dora and Picasso continued to see each other until 1946. After suffering a nervous breakdown, she underwent two years of analysis with Jacques Lacan, founder of the Freudian School of Paris. Upon her recovery, Dora devoted herself again to painting, as had been advised by Picasso when they were lovers. In hindsight, it seems perverse advice considering that she was a much finer photographer than painter. Dora became a devout Roman Catholic, and in her later years she was increasingly isolated. During the winter in Paris, she continued to live at 3, rue de Savoie in an apartment she had occupied since 1937, which was just around the corner from Picasso's studio. During the summer in Ménerbes, an old fortified village in the Vaucluse, she camped in a dilapidated house that stood along the town's ramparts.[3] It was Picasso's parting gift to her in 1945.

SR

1. Even after Dora Maar replaced Marie-Thérèse, Picasso's principal lover since 1927, the artist continued to see Marie-Thérèse and their daughter, Maya, about once or twice a week.
2. Caws 2000, p. 189.
3. The rear of the house was built directly on the wall of a rock, and thus the rooms at the back had no windows. The author spent many summers in Ménerbes, often passing the house and, sometimes, Dora Maar on the street or at the local cemetery.

PROVENANCE
[Louis Carré, Paris and New York]; [Pierre Colle, Paris]; [probably Sidney Janis, New York, possibly by 1946]; [Perls Galleries (Klaus G. Perls), New York, by 1965, stock no. 6581]; Mr. and Mrs. Klaus G. Perls, New York (until 1998; their gift to the Metropolitan Museum, 1998)

EXHIBITIONS
New York (Perls) 1965, no. 16, ill.; Bordeaux 1966, no. 144, pp. 99, LXXI (pl. 69); Tokyo and other cities 1977–78, no. 49, ill.; New York 1980, p. 363 (ill.), checklist p. 64; Düsseldorf 1987–88, hors cat.; Cologne 1988, no. 3, pp. 33 (ill.), 291; Los Angeles–New York–Chicago 1994–95 (shown in New York only), hors cat., MMA brochure no. 79, ill.; New York 2000, pp. 113 (ill.), 126

REFERENCES
Janis and Janis 1946, p. xi, pl. 75; Cabanne 1975a, ill. between pp. 344–45; Story 1994, p. 33; Anon., May 21, 1996, p. F2; Drath 1996, p. G04; Kaufman 1996, p. 14; Chipp and Wofsy 1995–2009, [vol. 7] (1998), p. 65 (ill.), no. 39-347

TECHNICAL NOTE
The painting is on medium-weight canvas commercially prepared with a white ground. Picasso initially blocked out the color of the composition with thinly applied oil paint, as may be seen beneath the hatchwork of the sitter's clothing in the pale purple, pale blue, and black passages. Picasso then added strokes of paint with a loaded brush. These lines, present throughout the work, are heavily textured with sharp, crisp, impasto. Picasso used them to create designs within the garment, head, and background. The straight and crosshatched lines, as may be seen in the garment, were apparently done first, followed by the curvilinear lines that reinforce the outlines and contours. The background was developed after the figure was established; he used a palette knife to create a rich and smooth surface, which he articulated with impastoed design work. It is likely that he alternated between these techniques in developing the design.

Changes Picasso made to the color scheme account for the thickness of paint in some areas. For example, the green half-moon shape at the lower right side of the sitter sits on top of successive layers of pale blue and black. Similarly, Picasso painted the background white before repainting it in blue. X-radiography (fig. 86.1) reveals

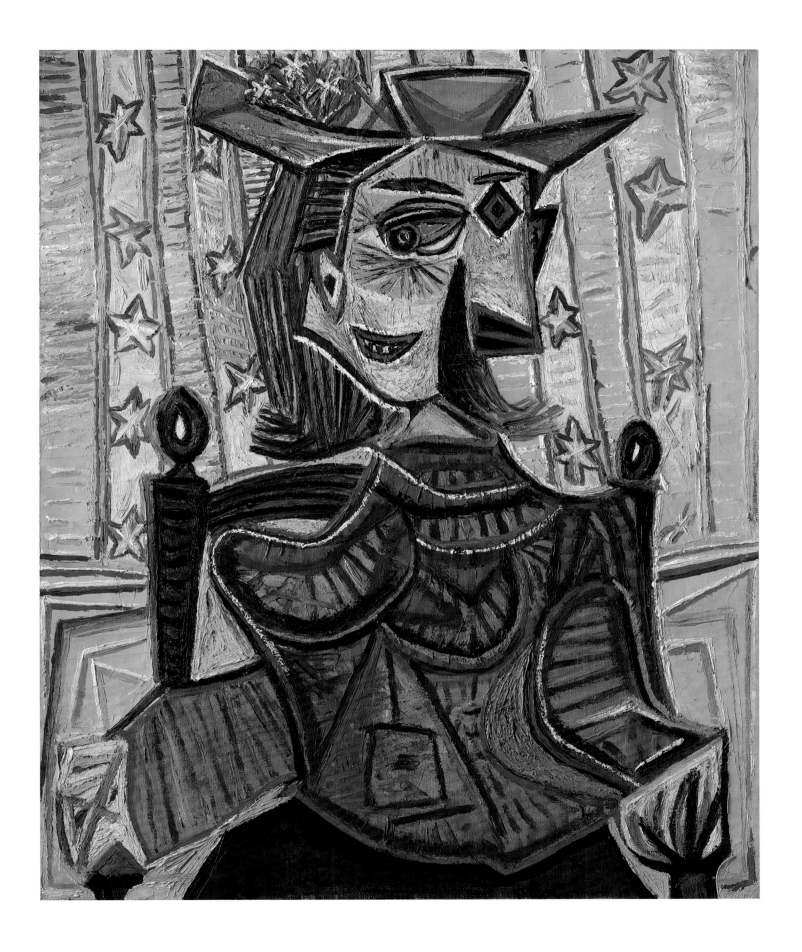

233

that diagonal lines once ran over the present mouth and that the contour of the clothing, along the proper right side of the sitter's torso, was revised, making it less dramatic. Picasso refashioned the sitter's coiffure, adding hair at both sides of the head. Later in the painting process, he returned to those passages in the background affected by these additions, to fine-tune his design. These changes contributed to a less abstract, more personal, and realistic portrait that more closely resembles Dora Maar and the way she wore her hair.

The tacking margins indicate that the canvas was restretched twice. Previously used tacking holes do not correspond to holes in the stretcher, suggesting that the stretcher is not original. The paint film was executed in leanly bound oil paint, which created a dry, beautiful surface with clean, intense colors but left the paint brittle and vulnerable to cracking. Numerous horizontal cracks in the paint film suggest that the painting was rolled at some point. The tacking edges are also worn, requiring reinforcement in 2009. The work was never varnished and thus retains its exquisite dry surface, which has a slightly variable gloss related to paint selection and technique. S D - P

Fig. 86.1. X-radiograph of cat. 86, with lines showing three changes in composition

87. Seated Nude

Paris, January 1943

Graphite on off-white wove paper watermarked Arches, with countermark
25¾ × 20 in. (65.4 × 50.8 cm)
Signed in graphite, lower right: Picasso
Bequest of Ann Eden Woodward (Mrs. William Woodward Jr.), 1975
1978.264.7

In late 1942 to early 1943 there occurred the kind of brief classical interlude that periodically entered Picasso's work, this time in the form of simplified figure drawings that have little in common with his paintings of the same moment. Picasso remained in Paris throughout the Nazi Occupation, ensconced in his studio at 7, rue des Grands-Augustins. During this period he made relatively few major oils but produced a large number of works on paper and several sculptures. He devoted a great deal of his energy to the seven-foot-tall bronze *Man with Sheep* (s 280) completed in February or March 1943, around which he had made hundreds of drawings, beginning in the summer of 1942.

This seated nude belongs to a group of drawings made in January 1943 of quiet, classicized female figures composed in a pure linear style, a manner that descends directly from Picasso's neoclassical bathers from the 1920s (see cats. 67, 71). From December 13, 1942, to January 20, 1943, Picasso composed at least eighteen variations of a seated nude woman on a bed

quietly watching a sleeping man with his arms raised above his head, framing his face.[1] In an unusual reversal of one of the artist's most familiar themes, the woman regards rather than is regarded. The tender and tranquil mood of these drawings recalls the beautiful watercolor *Meditation (Contemplation)* (late 1904, The Museum of Modern Art, New York), in which the observer is Picasso. As the woman watches her lover, Picasso experimented with her pose, shifting her hands from her lap to her face, her elbows to her knees, and extending her legs in front of her or crossing them as the model does in the present drawing.

For the second sequence of drawings, which includes the Metropolitan's work, Picasso concentrated exclusively on the woman from this couple. Like the works from 1942–43 discussed above, these nudes were all composed on large sheets of off-white Arches paper, though most were executed in India ink rather than in graphite, as was the Metropolitan's drawing.

234

Fig. 87.1. Pablo Picasso, *Seated Nude*, 1943. Graphite on paper, 25½ × 18⅝ in. (65.5 × 50 cm). Museum Würth, Künzelsau, Germany

Fig. 87.2. Pablo Picasso, *Head of a Woman, Leaning on Her Hand*, 1920. Charcoal on paper, 5½ × 4½ in. (14 × 11.4 cm). Private collection

of the sheet, as does the sitter in our work. The women in all of these drawings share the same ample figure and generically classical physiognomy but do not specifically call to mind any of the women in Picasso's life at the time. Dora Maar did not inspire such calm, and the artist did not meet Françoise Gilot until May 1943.

In the Metropolitan's drawing, Picasso delineated the figure in long, sure strokes, lifting his pencil only to sketch in the details of head, hands, and feet. He conveys the solidity of the woman's body with no shading or interior articulation, persuasively achieving plastic expression only by way of a slightly undulating contour.[2] The setting is summarily indicated with a few wavy lines, perhaps a shorthand recollection of the bedsheets beneath the loving couple. This nude belongs to a long line of pensive women in Picasso's work. She gently rests her right arm on her leg and cups her face in her hands. Her left hand, with one finger extended, assumes a familiar pose, borrowed from Ingres's *Madame Moitessier* (1856, The National Gallery, London), and appearing in previous works such as the 1920 *Seated Woman Reading* (z IV.180) and drawings of the same year (fig. 87.2). An even earlier echo of the gesture occurs in the Metropolitan's *Seated Harlequin* of 1901 (cat. 17), though the Museum's 1943 nude is less suffused with melancholy than lost in reverie. The tranquility that resides in these works is all the more remarkable given that it surfaced in the midst of the upheavals and deprivations of a cold wartime winter.[3]

MP

1. z XII.184–185, 187–197, 206, 211, 212, 218, and 219. These eighteen drawings followed in the wake of a painting (December 1942) of two male nudes—one standing, one sleeping—and Pan playing a horn (z XII.155). In the spring of 1947 Picasso revisited the subject in a number of lithographs. See Bloch 1971, vol. 1, nos. 434, 435, 452, 453, and 455.
2. The work was catalogued by Zervos as *Nu* (XII.214), but the author provides no dimensions and identifies the medium as "encre de chine," so he clearly had not seen the drawing. Chipp and Wofsy place the work among other drawings made on January 12, 1943, although they also mistakenly describe the medium as "India ink" (1995–2009, vol. 8 [1999], p. 186, no. 43-017). A date in this vicinity seems likely.
3. On June 14–15, 1944, Picasso made another similar group of drawings of female nudes in continuous line drawings (z XIII.306–310).

In one example from January 12 (z XII.215), Picasso seated the nude cross-legged before a mirror as she clasps a necklace at the back of her neck. A second work, very close in spirit to the Metropolitan's drawing and also in graphite, is an undated sheet in the Museum Würth, Künzelsau (fig. 87.1). This example exudes the same contemplative mood, and the model has similarly curly hair. Her graceful frame occupies the entire height

PROVENANCE
Ann Eden Woodward (Mrs. William Woodward, Jr.), New York (until d. 1975; her bequest to the Metropolitan Museum, 1975)

REFERENCES
Zervos 1932–78, vol. 12 (1943), p. 110 (ill.), no. 214; Chipp and Wofsy 1995–2009, [vol. 8] (1999), p. 186 (ill.), no. 43-017

88. Paul Verlaine
Paris, June 5, 1945

Ink on white wove paper
11⅝ × 8¼ in. (29.5 × 21 cm)
Dated, upper left and upper right: 5.6.45
Signed, dated, and inscribed on verso, in ink: Pour/Paul Eluard/<u>Picasso</u>/
Paris le mardi 6 juin 1945[1]
Bequest of William S. Lieberman, 2005
2007.49.81

Picasso's small but powerfully concentrated portrait of Paul Verlaine (1844–1896) commemorates his admiration for the Symbolist poet and, more generally, embodies the artist's life-long connection to men of letters. The drawing was a gift from the painter to the Surrealist poet Paul Éluard, whom Picasso met in the 1920s. But years before that encounter, another writer, Max Jacob, fostered Picasso's literary education, beginning with Verlaine, during the artist's early years in Paris.[2]

Picasso would not have known Verlaine, who died in Paris on January 8, 1896, but members of his circle had had direct contact with the poet or knowledge of his work. Carles Casagemas (see cat. 2), the short-lived friend Picasso met in Barcelona in 1899, was conversant with Symbolist literature and Verlaine. Henri Cornuty, a young French poet who had known Verlaine in Paris, associated with the circle in Madrid around the magazine Picasso helped found in 1901, *Arte joven.* "He spoke awful Spanish," Picasso told Robert Otero in 1966, "But he was the one who taught all those people in Madrid what they needed to know about French poetry and a lot of other things."[3] Picasso depicted the emaciated, bedraggled Cornuty at least three times, once with a companion and a glass of absinthe in a Paris café in 1902 or 1903.[4] Picasso met another Verlaine acquaintance in Paris, André Salis, nicknamed Bibi-la-Purée, and in 1901 made four portraits of the bald eccentric, a frequenter of the Latin Quarter and, perhaps, Verlaine's occasional lover.[5] The popularization of Verlaine was widespread in Paris. The renowned French actor, theater director, and teacher Charles Dullin arrived in Paris in 1904 and "first survived by reciting Verlaine and other poets in courtyards, cabarets, and bars, including Le Lapin Agile"[6] (see cat. 25). According to Fernande Olivier, Dullin was an amusing visitor to Picasso's studio.[7]

But it was Max Jacob who was largely responsible for Picasso's early education in French literature and his introduction to Verlaine's poetry. Erudite and utterly devoted to Picasso, Jacob established the prototype for Picasso's close relationships with writers. They met in Paris in the summer of 1901, after Jacob had admired Picasso's show at Galerie Vollard. Picasso knew little more French than Jacob knew Spanish, but the two men established an immediate rapport.[8] Jacob claimed Verlaine as the favorite poet of their circle, and, as a struggling, penniless writer, he clearly envisioned himself as a latter-day "poète maudit." In addition to his prodigious knowledge and amusing

wit, Jacob had superlative skills as an improvisational performer. This facility comes across in Jaime Sabartés's lively description of Jacob's extemporaneous recitation of a Verlaine poem in Picasso's Bateau Lavoir studio:

> In utter darkness, as if he were extracting the verses from the shadows of a very remote remembrance, he began to read the poem "Un grand Sommeil Noir." He must have known it by heart. Now he recited slowly, in a hollow voice, he stretched out the cadence between alternating vocal spasms and silences which at times gave the impression of leaving the verse in mid-air; ending the last stanza, he smothered the words, "silence. . . silence. . ." in a sigh, after which he stretched out supine on the floor.[9]

According to the artist's dealer, Daniel-Henry Kahnweiler, "Picasso had a very keen sense of French poetry. Apollinaire once told me, 'Even several years ago, when he could hardly speak French, he was completely able to judge, to appreciate immediately the beauty of a poem.'"[10] According to his poet friend Maurice Raynal, Picasso had very diverse literary tastes: "He had a lot of books. . . . Detective and adventure novels next to works by our best poets: Sherlock Holmes and racy publications like Nick Carter or Buffalo Bill alongside Verlaine, Rimbaud and Mallarmé."[11] Françoise Gilot surmised that by surrounding himself with writers and poets Picasso learned to speak more articulately about his own work: "At each period the poets created around him the language of painting. Afterwards Pablo, who—for things like that—was an extremely adaptable, supple person, always talked very perceptively about *his* painting because of his intimacy with those who had been able to discover the right words."[12] One should add that Picasso wrote poetry (in Spanish and French) throughout much of his life.

The first literal evidence of Picasso's interest in Verlaine dates to the summer of 1905, during a six-week trip to the village of Schoorl, north of Amsterdam. In a sketchbook filled with studies for paintings from 1905, including *Family of Saltimbanques* (see fig. 26.1) and *The Wedding of Pierrette* (private collection), Picasso carefully copied Verlaine's poem "Cortège," part of the collection "Fêtes galantes," first published on January 1, 1868, in the widely read review *L'Artiste* ("Cortège" appeared in the second installment, March 1, 1869).[13] Verlaine's "Fêtes galantes" poems were inspired by commedia dell'arte characters and

eighteenth-century painters such as Watteau. It is not difficult to understand Picasso's attraction to the mischievous eroticism of "Cortège," where Verlaine evokes a lady's retinue that includes a monkey bedecked in a brocade jacket. Unbeknownst to the lady (perhaps), "The ape surveys with eager eye/Her bosom, pale and splendor-fraught," while the black page carrying her train slyly raises it "Higher, from time to time, than he/Ought do, his sumptuous load, to see/The pleasure that he dreams of nightly."[14] Parallels have been drawn between the poem and Picasso's paintings from the period, but the ribald nature of the imagery uncannily anticipates work from much later, suggesting that the poet's imagery persisted in his memory. In the artist's watercolor from January 26, 1954, for example, *Seated Man, Woman with a Monkey and Apple*, a comely young woman toys with a monkey as it straddles her bare legs, and a fat old man, naked and grinning, gawks lasciviously.[15]

Picasso's drawing of the middle-aged Verlaine has not been linked to any previous portrait of him, but the poet's distinctive visage was frequently reproduced in contemporary venues (fig. 88.1). The art critic Louis Vauxcelles maintained, "Few poets' faces from the last century were—with the exception of Hugo and Musset—more popularized than the image of Verlaine."[16] He then listed more than twenty-five artists who depicted the poet, including the best known, Eugène Carrière (1849–1906). Picasso admired Carrière and was surely familiar with his 1890 portrait of Verlaine. The painting, a gift to the poet from Carrière and today in the Musée d'Orsay, was widely exhibited and illustrated and, in 1896, was made into an engraving after the artist's lithograph for further dissemination.

Picasso's Verlaine has none of the dreamy, penumbral atmosphere of the Carrière. He chose instead to convey the poet's profound intellect, his "esprit," and psychological intensity not only through the record of his familiar features but through the vigorous execution of the drawing. He worked the image freely and furiously, covering the page with a dense welter of ink strokes, alternating between pen and brush. He scored the surface with his nib, at times even piercing the soft, thin paper. Verlaine's head floats, engulfed in darkness, and his distinctive, high-domed forehead, reinforced by Picasso with circular strokes of ink wash, emerges as a luminous, mysterious mass. The beard, mouth, and tufts of hair over his ears nearly disappear into the blackness. His narrow, deeply shadowed eyes just barely penetrate the darkness, recalling the description by the novelist Rachilde of Verlaine's "terrible gaze—intense, brooding, a sovereign's gaze."[17]

Gilot, who saw Paul Éluard and his wife, Nusch (Maria Benz), frequently after meeting Picasso in May 1943, described the poet as a "fine bibliophile." "From time to time," she continued, "Pablo would give him a drawing or a painting or decorate his copy of an illustrated book so that when times were too difficult, Paul could sell something and resolve the crisis."[18] It appears that Picasso's drawing of Verlaine was originally drawn alongside a sketch of Stéphane Mallarmé on the endpapers of a

Fig. 88.1. Photograph of Paul Verlaine, ca. 1880. Hulton Archive / Getty Images

Fig. 88.2. Pablo Picasso, drawing of Mallarmé (left) opposite drawing of Verlaine. Documentation, Musée National Picasso, Paris

book belonging to Éluard, an edition of Mallarmé's *Autobiographie. Lettre à Verlaine*, written in 1885 (fig. 88.2). At some point before 1966, when the Museum's portrait was first exhibited as an independent drawing, the work was separated from the book and its companion drawing.[19] Although Mallarmé's poetry is usually discussed in connection with Picasso's Cubist painting, the poet and his Symbolist contemporaries were obviously much on his mind in 1945. On a visit to Picasso's studio on May 12, 1945, Brassaï reported that Picasso proudly showed him a first edition of Mallarmé's poetry. "He had just acquired it. Hardly had he paid for it when he enriched it with a very good likeness of the poet. He tells me, smiling: 'I paid a high price for this book and I wanted to recover my money.'"[20] A few weeks after Brassaï's visit, Picasso composed the portrait of Verlaine (and presumably the sketch of Mallarmé) and dedicated it to Éluard the following day.

Among the Surrealist poets in Picasso's orbit, Éluard (born Eugène Grindel, 1895–1952) was the most sympathetic to painting. He collected art, including many works from several periods by Picasso, and visual artists were as critical to his development as writers were to Picasso's. According to Roland Penrose, a friend

5.6.45.

239

to both, "Of all the poets that Picasso had known it was Éluard who had the most complete appreciation of his work," and Pierre Daix claimed that the two friends had the same taste in poetry from the most spontaneous to the "plus savante."[21]

Picasso met Éluard in the mid-1920s through his associations with the Surrealists, particularly André Breton.[22] In 1926 Éluard penned a poem inspired by the artist, "Pablo Picasso," the first of many tributes, and included it in his collection *Capitale de la douleur* (The Capital of Pain). In 1932 another poem titled "Pablo Picasso" was published in a special issue of *Cahiers d'art* dedicated to the artist, and the following year both men contributed to the first issue of the Surrealist journal *Le Minotaure*, and subsequent issues thereafter.[23] But they did not become especially close until 1935, when Éluard elected to act as Picasso's proxy and lecture at his exhibition in Spain on January 17, 1936, in Barcelona (followed by Madrid and Bilbao).[24] On the eve of Éluard's departure for Barcelona on January 8, 1936, Picasso drew a straightforward portrait of him in pencil, the first of several depictions of his friend (z VIII.273). In addition, Picasso contributed original illustrations to Éluard's poetry collections and portrayed his wife, Nusch, at least fourteen times between 1936 and 1941, mostly during summers vacationing in Mougins with the Éluards and Dora Maar (who was introduced to Picasso by Éluard).[25]

Picasso joined the French Communist Party on October 4, 1944, with the strong encouragement of Éluard, and remained a member until his death.[26] The day after his party affiliation was made public, almost eighty of his works went on view in Paris at the Salon d'Automne, the so-called Salon de la Libération. When reactionaries demonstrated against Picasso, Éluard joined other intellectuals in support of him in a letter published in the Communist-affiliated *Les Lettres françaises*. Picasso dedicated his drawing to Éluard just a month after VE Day (May 7, 1945); Éluard's book *À Pablo Picasso* went on sale that September.

Meanwhile, Max Jacob, a convert to Catholicism in 1915, had been cloistered at a monastery, Saint-Benoît-sur-Loire, since 1921. He was arrested at the abbey on February 24, 1944, and died March 5 at the Drancy concentration camp. In 1942 Jacob had been commissioned to make portraits of several artists and writers, including Apollinaire, Jarry, Mallarmé, Picasso, Rimbaud, and Verlaine, and was furnished with photographs of the writers by the commissioner. After his death, gouaches of Apollinaire, Jarry, and Verlaine as well as an incomplete portrait of Picasso from 1944 were found on his worktable at Saint-Benoît.[27]

<div align="right">M P</div>

1. June 6, 1945, was actually a Wednesday.
2. John Richardson concludes, "If Verlaine was the first French poet for whom Picasso developed a taste, it was largely Jacob's doing. Even when Apollinaire converted him to the rival cult of Rimbaud, Picasso never abandoned his first enthusiasm." Richardson 1991–2007, vol. 1 (1991), p. 339.
3. Picasso in Otero 1974, p. 123.
4. z I.182. Jacob wrote a long description of the sitter attached to the back of this watercolor (see Quimper–Paris 1994, pp. 202–3, 204 n. 5, no. 14). Richardson (1991–2007, vol. I [1991], pp. 259, 502 n. 23) places the drawing in 1903 and concludes that Jacob probably owned this work.

5. For Picasso's portraits of Salis, see z VI.355, 360, and 1460 and OPP 01.084. On Salis's relationship with Verlaine, see Adam 1963, p. 53.
6. P. Read 1997, p. 217.
7. Olivier 1988, p. 200.
8. On this initial encounter, see Jacob's lecture from 1937, quoted in Quimper–Paris 1994, pp. 1–2, and Jacob 1927, pp. 199–200.
9. Sabartés 1948, p. 72. In 1967 Picasso recalled, "Alfonso Allais's novels were always read to me by Éluard. Only he knew how." (Picasso in Otero 1974, p. 166.)
10. Kahnweiler 1971, p. 49. Jaime Sabartés, speaking about 1902, said he never saw Picasso with a book in his hand but marveled at his knowledge of literature (Sabartés 1946b, p. 97). Sabartés observed that Picasso read everything the members of his circle were reading, "First Verlaine, then Verhaeren, Mallarmé, Baudelaire etc. The most popular then was Verlaine."(Sabartés 1954, pp. 61–62; author's translation.)
11. Raynal 1922, pp. 52–53; author's translation.
12. Gilot and Lake 1964, p. 136.
13. Sketchbook 2, Musée Picasso, Paris; see Léal 1996, vol. 1, pp. 75–90.
14. For this translation of "Cortège," see Shapiro 1999, p. 41. Picasso probably knew the poem through Jacob (see Hélène Seckel in Quimper–Paris 1994, p. 41).
15. z XVI.229. On the relationship of "Cortège" and Picasso's painting *The Marriage of Pierrette*, see Léal 1996, vol. 1, p. 77.
16. Vauxcelles 1937, p. 58; author's translation. François Ruchon (1947, passim) illustrates more than 150 images of Verlaine in all media, from age four to his deathbed.
17. Rachilde is the pseudonym of Marguerite Eymery. Her description is paraphrased in Adam 1963, p. 53. Picasso made a second, very different drawing of Verlaine in 1965 (z XXV.52), today in the Musée National d'Art Moderne, Centre Pompidou, Paris, which he gave to another poet friend, Michel Leiris.
18. Gilot and Lake 1964, p. 137.
19. The information on the back of the photograph in the documentation department of the Musée Picasso, Paris (fig. 88.2), indicates that the drawings were photographed in the book by Mallarmé belonging to Éluard: "Mallarmé et Verlaine dessins faits sur édition lettre autographe de Mallarmé à Verlaine. Coll. Paul Eluard." I do not know the whereabouts of the 1945 companion drawing of Mallarmé. Éluard's edition of Mallarmé was most likely the 1924 facsimile published by Albert Messein, Paris. In the 1940s Picasso made at least three other drawings of Mallarmé, all derived from Paul Gauguin's depiction of the poet, a well-known etching from 1891. For Picasso's other Mallarmé portraits, see z XIII.97 (Centre Pompidou, Paris); OPP 45.118 (private collection); and a drawing from June 29, 1948, in the collection of the Fondation Flandresy-Espérandieu, Avignon. On Picasso's relationship to the Symbolist poet, see Olds 1998. I am very grateful to Professor Marshall C. Olds for discussing his findings with me regarding the initial placement of Picasso's portraits inside Éluard's copy of Mallarmé's autobiographical letter, which he first pointed out in the above article (p. 171). We were both ably assisted in this endeavor by Jeanne Sudour, chief archivist, Musée Picasso, Paris, and Christel Hollevoet-Force, research associate at the Metropolitan Museum.
20. Brassaï 1999, p. 206. On the drawings Brassaï saw on this occasion and the artist's profoundly personal connection to Mallarmé, see Olds 1998, pp. 171–73.
21. Penrose 1981, p. 283. See also Daix 1982c, p. 27.
22. On their relationship, see Daix 1982c pp. 25–35.
23. Éluard 1932, p. 154.
24. Portions of the lecture were published as "Je parle de ce qui est bien" (I Speak of What Is Good) in an issue of *Cahiers d'art* dedicated to Picasso (10 [1935], pp. 165–68).
25. z VIII.273. For a discussion of Picasso's portraits of Nusch and Paul Éluard, including a bizarre depiction of Éluard as a woman in a painting from 1937 (z VIII.373), see Rubin 1996, pp. 77–86. The author also provides a synopsis of a purported affair between Picasso and Nusch.
26. Much has been written about the degree and nature of the political engagement of both men. For recent discussions on Picasso, see San Francisco–New York 1998–99; Utley 2000; and the forthcoming Liverpool 2010.
27. On these portraits, see Seckel in Quimper–Paris 1994, pp. 264, 265–66 nn. 9, 10, 266 n. 13. The portrait of Picasso from 1944 is in ibid., p. 273, no. 298. For an illustration of Jacob's depiction of Verlaine (unrelated to Picasso's), see Billy 1945, unpaginated.

PROVENANCE

Paul Éluard (Eugène Grindel), Paris (gift of the artist, June 6, 1945, until d. 1952); possibly Éluard's daughter, Cécile Éluard; [M. Knoedler & Cie, Paris and New York, by 1966, until 1967; sold in October for $8,000 to Avnet]; Lester Francis and Joan Avnet, New York (1967–ca. 1978); William S. Lieberman, New York (ca. 1978– d. 2005; his bequest to the Metropolitan Museum, 2005)

EXHIBITIONS
Paris 1966, no. 74, ill.; New York 1969–70, no. 106, ill.; Tokyo–Kurume 1971, no. 91, ill.; Auckland–Melbourne–Sydney 1971–72, no. 91, ill.; Honolulu–San Francisco 1972, no cat.; Otterlo 1973, no. 88, ill.; Sheffield 1973, no. 91; Milan 1973–74, no. 91, pp. 150, 161 (ill.); Lisbon 1974, no. 90, ill.; Tokyo and other cities 1977–78, no. 132, ill.; New York 1980, p. 387 (ill.), and checklist p. 67

REFERENCES
Elaine L. Johnson in New York 1972, pp. 7, 165 (ill.), 236; Olds 1998, pp. 171, 173; Chipp and Wofsy 1995–2009, [vol. 9] (2000), p. 38 (ill.), no. 45-068

TECHNICAL NOTE

Picasso vigorously applied ink with a brush and a metal nib pen, using repeated pen strokes to form most of the design. The forceful application of the thin lines roughened the paper and pierced it in several places, allowing ink to seep through to the verso. Dilutions of this black ink produced the varying gray shades seen in the head. Repeated brush applications of dark black ink cover most of the periphery of the sheet, obscuring many of the pen lines around the lower face. It also hides the inscribed date at upper left, which the artist reinscribed at upper right.

The soft-wove paper originally constituted half of a larger sheet; Picasso used the other half for a portrait of Stéphane Mallarmé (see catalogue entry). A photograph (fig. 88.2) of the intact bifolio shows the blotting of the ink along the fold, indicating that the drawing was still wet when it was folded. While the damp drawing was folded, Picasso inscribed the verso of the Verlaine portrait causing the name "Paul" to "print" onto the opposing sheet under the portrait of Mallarmé, in the manner of a carbon copy. The pattern of dots on the opposing drawing are likewise offset from the Verlaine portrait. The surface texture of the heavily inked lower area of the drawing also confirms that it was folded when still wet. RM

89. Arm
Vallauris, late Summer or Autumn 1951

Patinated brass
22 × 4¼ × 3¼ in. (55.9 × 10.8 × 8.3 cm)
Stamped on far end of arm: EGodard / Cire perdue / 2/2
Gift of Arthur Luce Klein and Luce Arthur Klein, 1992
1992.178

During the postwar years, when he was finally able to travel again to the south of France, Picasso was especially productive in the areas of sculpture and ceramics, the latter a newly discovered medium for him. *Arm* was made in Vallauris, the ancient pottery village situated in the hills above Golfe-Juan between Cannes and Antibes, probably in the late summer or autumn of 1951. Although Picasso had first visited Vallauris in 1936 with Dora Maar, he only began to make ceramics in earnest there in 1947 at the Madoura pottery workshop run by Suzanne and Georges Ramié, whom he had met the previous summer. In 1948 Picasso and Françoise Gilot moved to a modest house atop a hill in Vallauris, called La Galloise, with their young son, Claude (their daughter, Paloma, was born the following year). In the spring of 1949 the artist set up a studio in a nearby abandoned perfume factory on the rue du Fournas.

The sculptures of 1950–51 consist mostly of small-scale bronzes—tiny seated fauns, goats, and female figurines in relief—but also include memorable sculptures such as *Girl Jumping Rope* (1950; s 408) and *Baboon with Young* (1951; s 463), both made with parts cast from found objects in the Fournas studio. Among the small bronzes from 1951 are four curious sculptures—two hands and two forearms—that were clearly

modeled from clay, not cast from life.[1] Three of the works depict flattened, unnaturalistic hands with short, chubby fingers that were cast in part from broken pieces of ceramic plates, while the Metropolitan's *Arm* consists of a stiff, bonelike limb ending in a fist. Throughout his career Picasso depicted many hands and arms—his own and those of others—conspicuously detached from the body. In Paris in 1913, for example, he famously constructed two disembodied arms—stand-ins for his own—made of newspaper pinned to a drawn Cubist figure on the wall and playing an actual guitar. And in the 1940s he made a number of small sculptures of hands in shirt cuffs (fig. 89.1).[2]

Arm is made of brass rather than bronze and is covered in a somewhat mottled, dark brown patina. To form the arm Picasso folded a soft slab of clay into a roughly tubular shape and smoothed out the adjoining seam on the right underside of the arm. Unlike Picasso's earlier hand sculptures, the fingers of this work are highly abstracted. Picasso shaped the curves of the fingers and employed a stylus or other sharp instrument to slice openings between them. The hands of the artist, who was working directly in clay, are apparent in many areas, as in the underside of the wrist, which was formed by pinching the clay between two fingers. Around the wrist is a type of manacle or

Fig. 89.1. Pablo Picasso, *Hand*, 1948. Bronze, 2¾ × 9⅞ × 4⅜ in. (7 × 25 × 11 cm). Musée National d'Art Moderne, Centre Pompidou, Paris (AM 958S)

cuff, probably added to reinforce and conceal the seam between the arm and hand, where the work is most narrow.[3] The thick underside of the hand is smoothed down, so the object securely rests, knuckles up, on a flat surface. The sculpture has been exhibited both in a recumbent position and vertically, fist in the air, although the elbow edge of *Arm* is curved and requires an armature to hold it upright.[4]

In each of the four arm/hand sculptures from 1951, a hole has been included at the wrist or elbow end, and it is likely that the works were intended as door knockers, "heurtoirs de porte," in which case *Arm* could be suspended, fist down, against a vertical surface. Installed upright on a pedestal, the object assumes a more aggressive and perhaps political expression, as a defiantly clenched Communist fist, for example. (Picasso became a Party member in 1944, and Vallauris was a Communist town.) If employed as a door knocker, one grasps the hand—Picasso's hand, as it were—in one's own. For these informal, modestly scaled works, a downward orientation seems most appropriate. Door knockers, in use since antiquity, would have been a common sight in the south of France, and one traditional type was (and still is) a closed hand, facing down, holding an object such as a ball for extra heft. Given the utilitarian nature of much of the local ceramic production in Vallauris, such as vases, cookware, and so forth, perhaps Picasso was encouraged to try his own hand at fabricating functional objects for daily use.[5]

M P

1. In 1937 Picasso had made hand sculptures cast from life. These include a plaster cast of Dora Maar's hand (s 168a) and at least six casts of his own—left and right, open flat or in a fist—some of which were cast in bronze (s 220, 220a, 220b, 220c, 221, and 224). The four sculptures from 1951 are s 415 (the present work) and 416–418. See also from this period two related works made in Vallauris, *Hand* (1949; s 340) and *Hand* (1950; s 348), both with the palm facing down and cut at the wrist, placed atop a round plaque.

2. See, for example, *Raised Hand* (1943; s 223), *Hand with Sleeve* (1947; s 338), and *Hand* (1947; Tacoma 1998–99, p. 121, no. 3). In 1943 Picasso also incorporated an Easter Island object from his collection—a carved, life-size hand in toromiro wood at the end of a round, baton-like arm—into his sculpture *Woman in a Long Dress* (s 238).

3. The "cuff" as a reinforcing device was suggested by Metropolitan objects conservator Kendra Roth. Alloy composition determined by X-ray fluorescence spectrometry by Tony Frantz, Department of Scientific Research.

4. *Arm* was installed vertically, with the hand at the top, at the Metropolitan at the entrance of the exhibition "Picasso and the Weeping Women" (Los Angeles–New York–Chicago 1994–95). Another cast of the work was shown in a recumbent position in "The Sculpture of Picasso" (New York 1982, no. 22, as seen in installation photographs in Pace Gallery's archives). Like most of the works from this period, *Arm* was made in an edition of two, with one numbered and one unnumbered cast. The unnumbered example is in a private collection.

5. There is no evidence of wear or scratching around the hole to indicate its having been hung. I am grateful to Diana Widmaier Picasso, author of the forthcoming catalogue raisonné of Picasso's sculpture, for suggesting that these works may have been intended as door knockers and for examining *Arm* with me alongside two other hand sculptures from 1951. When Picasso intended a hand sculpture to be vertical, such as *Raised Hand* (1943; s 223), the work easily sits upright. *Arm* (1959; s 555), featuring an arm and hand with spread fingers dramatically reaching upward, is Picasso's best-known example of the subject; it has a self base that orients the work vertically, with the hand in an upright position. In addition, the underside of the 1951 *Arm* seems unfinished and perhaps not intended to be seen in the round.

PROVENANCE
[Galerie Louise Leiris (Daniel-Henry Kahnweiler), Paris; acquired from the artist, stock no. 15924; sold to Bernard]; [Galerie Claude Bernard, Paris, until 1972/73; sold to O'Hana]; [O'Hana Gallery, London, by 1972/73, stock no. 1570]; sale, "Impressionist and Modern Sculpture, Contemporary Art," Sotheby's, London, July 2, 1975, no. 80; private collection, New Rochelle, New York; sale, "Impressionist and Modern Paintings, Drawings, Watercolours and Sculpture," Phillips, Son & Neale, London, April 3, 1989, no. 7; Dr. and Mrs. Arthur Luce Klein, New Rochelle, New York (until 1992; their gift to the Metropolitan Museum, 1992)

EXHIBITIONS
London 1972, no. 59; London 1973, no. 120, ill.; Los Angeles–New York–Chicago 1994–95 (shown at entrance, in New York only), hors brochure; Tokyo–Nagoya 1998, no. 99, pp. 161 (ill.), 241

REFERENCES [not specific to Metropolitan Museum's cast]
Spies 1971, p. 309, no. 415; Robert Rosenblum in New York 1982, pp. 30 (ill.), 70, no. 22; Werner Spies and Christine Piot in Berlin–Düsseldorf 1983–84, pp. 353 (ill.), 391, no. 415; Chipp and Wofsy 1995–2009, [vol. 11] (2000), p. 62 (ill.), no. 51-073

90. Faun with Stars

Nice or Cannes, July 9, 1955

Oil on canvas
36 × 28½ in. (91.4 × 72.4 cm)
Signed, lower left: <u>Picasso</u>
Dated on verso in black paint, upper right: 9 · 7 · / 55.
Gift of Joseph H. Hazen, 1970
1970.305

Roughly twenty-five years after he made a closely observed study of an antique faun's head in 1894 as a student in Coruña, Picasso adopted the horned deity as one of his favorite subjects.[1] Beginning in 1919 he cast the mythical creature, a Roman adaptation of a Greek satyr, in many roles: dancing, playing music, engaged in bacchic revelry, or in friendly combat with a centaur. Perhaps the best-known incarnation of the subject and, arguably, the most moving appeared in the *Vollard Suite* etching and aquatint *Faun Revealing a Sleeping Woman (Jupiter and Antiope, after Rembrandt)* (1936).[2] But Picasso, who felt free to adapt mythological subjects to his own purposes, usually reserved the faun for more lighthearted fare. For example, he favored the subject for a group of small bronze sculptures of seated fauns in 1951 and the ceramic plates, tiles, and linoleum cuts he produced by the dozens in the 1940s and the 1950s. Horned and bearded, and sometimes with goat hooves and tail, the frolicsome creature is a relatively harmless member of Picasso's dramatis personae, unlike the more threatening and lustful centaur. A rare sinister incarnation appeared in *Nymph and Faun* (January 7, 1954), a drawing Picasso made for the review *Verve* in which a predatory faun is about to assault a sleeping woman.[3] In later years he usually depicted only the head or bust of a faun, with its distinctive, outward-turning horns, rather than cast him in a narrative context. The happy faun is mostly a phenomenon of the later work, and Picasso associated such Arcadian themes with the Mediterranean south. If the Minotaur is the artist's alter ego, the pleasure-seeking faun can surely be understood as one of the many surrogates Picasso co-opted for himself.

The artist had passed through a difficult period in the eighteen months preceding the execution of *Faun and Stars*. In addition to the traumas of his final breakup with Françoise Gilot in 1954, he lost several friends: the writer Maurice Raynal, his first biographer and one of his oldest friends; the painter André Derain; the sculptor Henri Laurens; and, most important, Henri Matisse, who died in Nice on November 3, 1954. Finally, Picasso's first wife, Olga, died in Cannes on February 11, 1955. By the summer of 1955 Picasso had taken up with Jacqueline Roque (1927–1986), forty-five years his junior, and moved with her into La Californie, a grand Edwardian villa above Cannes. Although there would be occasional trips to Paris, the south of France became their permanent home.

Fig. 90.1. Edward Quinn, photograph of Picasso during the filming of *Le mystère Picasso*, Nice, 1955. Original print, 7½ × 10⅜ in. (19.2 × 26.3 cm). Edward Quinn Archive, Uerikon, Switzerland

Over several weeks in the summer of 1955, Picasso allowed the filmmaker Henri-Georges Clouzot (1907–1977) to record him in the process of painting. The small crew worked on a vast set in the Studios de la Victorine in Nice (fig. 90.1). For his documentary, Clouzot—best known for the feature films *Le Salaire de la peur* (The Wages of Fear, 1953) and *Diabolique* (1954)— experimented with a new CinemaScope system for shooting widescreen. The film, *Le mystère Picasso*, offers a rare if contrived glimpse of Picasso at work and documents the evolution of a large number of drawings and paintings. Enduring long hours in stifling heat, Picasso obligingly performed for the camera. He drew with felt-tip pens and other instruments on taut, translucent paper secured upright on a specially constructed easel. The highly solvent ink soaked through the sheet, and the process could be filmed from the opposite side.[4] The drawings appear as if by magic, unobstructed by the artist's hands. Picasso worked with remarkable speed and concentration, flaunting his technical facility and endless capacity to invent forms in an unpremeditated manner. Throughout this impressive display of artistic

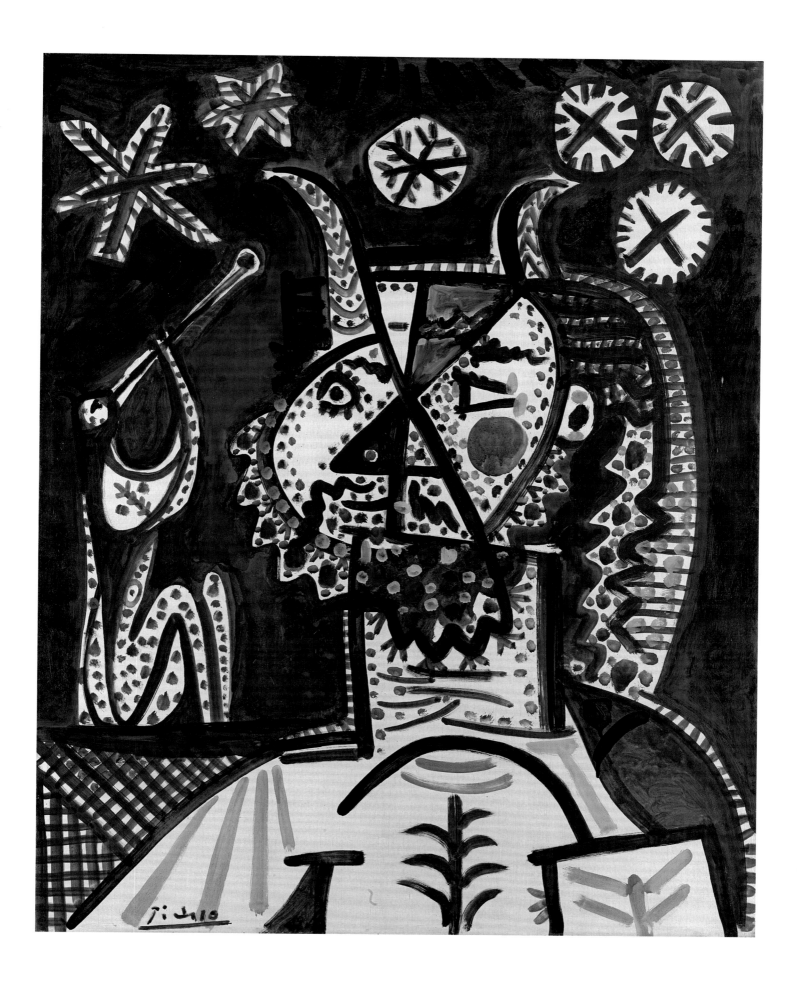

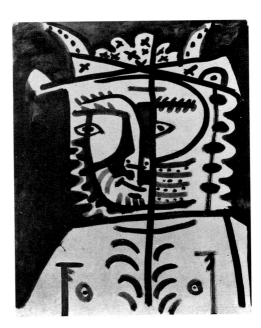

Fig. 90.2. Pablo Picasso, *Head of a Faun*, 1955. Wash drawing, 25⅝ × 19⅝ in. (65 × 50 cm). Private collection

creature. At first glance the painting appears to be monochrome, but Picasso added subtle touches of thinned blue paint in some areas, as in the triangle on the forehead or the dots on the beard. The simple, decorative style is informed by the imagery Picasso had developed in his ceramics, but the surface patterning also calls to mind work from the 1930s, such as the Metropolitan's *Man with a Lollipop* (cats. 83, 84), albeit with a looser, more painterly approach. M P

1. *Tête de faune* (1894, Museu Picasso, Barcelona; OPP 94.023).
2. Bloch 1971, vol. 1, no. 230. See also cats. P61, P287.
3. *Nymphe et faune* (January 7, 1954; Z XVI.161).
4. According to Pierre Cabanne (1977, p. 467), Picasso called Clouzot before filming began to say that "he had just received some bottles of a new kind of ink from the United States, and had immediately done a brush profile of a goat with it. Holding it up to the light, he had seen that the drawing came out as well on the back as on the front of the paper." This "new process," writes Cabanne, was used in the film.
5. On the drawings made during production of the film, see Dupuis-Labbé and Enshaian 2005.
6. The faun drawing from June 8, 1955, is Z XVI.394.
7. *The Sun and the Faun* is PP 55.109. Not all of the drawings made during the shooting appear in the film.

PROVENANCE
[Knoedler & Co., New York, until 1957; sold on May 23 to Hazen]; Joseph H. Hazen, New York (1957–70; his gift to the Metropolitan Museum, 1970)

EXHIBITIONS
New York (MMA) 1958, no. 99, p. 9; New York 1962 (shown at Cordier-Warren Gallery), no. 19, ill.; Jerusalem and other cities 1966–67, no. 96; West Palm Beach 1994, no. 24, pp. 46 (ill.), 56; New York 2001–2, no cat., unnumbered checklist; Milan 2001–2, no. 159, pp. 289 (ill.), 362; Naples (Fla.) 2008, brochure fig. 11

REFERENCES
Zervos 1932–78, vol. 16 (1965), p. 143 (ill.), no. 396; Chipp and Wofsy 1995–2009, [vol. 10] (2000), p. 295 (ill.), no. 55-086; Madacsi 2007, p. 92; Costello 2008, p. E1; Paine 2008

legerdemain, a whole repertoire of subjects emerges: the artist and model, bullfights, beach scenes, still lifes, sleeping women, and fauns. At least thirty-nine drawings, today in the Musée Picasso, Paris, emerged from the film shoot.[5] Picasso's performance in the film is indicative of the extraordinary energy and prodigious output that would characterize the next two decades of his life.

Clouzot's film opens with a shot of Picasso examining two ink wash drawings—one the head of a faun—that are tacked to a freestanding wood wall. The faun drawing (fig. 90.2) is very similar to the Metropolitan's *Faun*, which was made a month later. In the course of shooting the film, Picasso drew other, rather clownish fauns with the same distinctive X shape on the face. One drawing made on the set, titled *The Sun and the Faun*, is a simplified variant of the Metropolitan's painting, though it features a bright sun in lieu of stars above the faun's head.[7]

Faun with Stars, painted thinly and quickly, is clearly a product of the themes and impromptu inventions undertaken in the filming process. Picasso composed the faun with strong outlines and, reserving large areas of bare canvas, filled them in with playful patterns: hatch marks, plaid patterns, zigzags, X shapes, and polka dots. The face, a combined frontal and profile view, is compartmentalized into distinctive shapes, dominated by the strong diagonal running from the tip of the faun's horn to his beard. He appears to be sitting in a cane chair beneath a night sky and, with a slight smile, watches a small Pan figure playing the pipe in the distance. On his torso is a tree-like shape that appears on each of the fauns in this group, a glyph standing for the hairy chest of this hybrid man/goat

TECHNICAL NOTE

In this late work, which is in an excellent state of preservation, Picasso simplified his process of building the composition as well as his use of color. He painted directly on fine-weave canvas commercially prepared with a white ground using a lean and matte black oil paint; in some places the paint is diluted, which recalls the black ink drawings on transparent paper he produced during the summer of 1955, when this work was executed.

He first outlined the figures and stars with broad black brushstrokes, using the white ground layer as a color by leaving a fair amount of it exposed. He later filled in the detailed patterns and background.[1] The various values of blue color used to highlight some of the faun's features have a much thicker, glossier texture than the black oil paint, but medium analysis shows that it, too, is an oil paint.[2] The painting has remained unvarnished, allowing full appreciation of the subtle, soft sheen of the black paint, reminiscent of ink, the luminous blue hues, and the dry white ground layer. The unlined canvas was restretched on a new stretcher before it entered the Metropolitan's collection. I D

1. Ronald Penrose recalled how Picasso painted this composition in less than an hour in the afternoon of July 9, 1955, after a two-hour-long rehearsal for the film shoot and before taking a nap. See Cowling 2006, pp. 128–29.
2. FTIR analysis conducted by Julie Arslanoglu, Department of Scientific Research.

91. Tie

Cannes, May 16, 1957

Wax crayon on wove paper
12⅞ × 3⅜ in. (32.7 × 8.6 cm) (irregular)
Dated and inscribed on verso, in gray crayon: Cravate à porter pour le vernisage / 16.5.57.
Bequest of William S. Lieberman, 2005
2007.49.79

Picasso sent five ties, four made of paper and one of silk, to Alfred H. Barr, Jr. (1902–1981) for the opening of "Picasso: 75th Anniversary Exhibition" at The Museum of Modern Art (May 22–September 8, 1957). Three of the paper ties are in the archives of The Museum of Modern Art, and each is dated, like the present work, May 16, 1957, and inscribed by the artist, "tie to wear to the opening."[1] They were mailed from Cannes in a large envelope addressed in multicolored crayons by Picasso to "Monsieur Alfred Barr/Musée of Modern Art/New York/U.S.A." Two of the ties are decorated with wide-open eyes, as in the current work, and one features colorful flowers playfully linked by a green line. The silk tie, with three eyes applied by silkscreen, and signed by the artist, also arrived in its own cheerfully decorated envelope. At the opening Barr posed for a photograph wearing one of the paper ties over his own bowtie (fig. 91.1).

In 1957 Barr, founding director of The Museum of Modern Art in 1929, was director of collections and also director of the anniversary exhibition, which included more than three hundred works by Picasso from 1898 to 1956.[2] One of the ties was given to William S. Lieberman (1923–2005), then curator of prints at the Modern, who had selected the seventy drawings in the show. From 1945 to 1949 Lieberman had been Barr's assistant

Fig. 91.1. Alfred H. Barr, Jr., wearing paper tie designed for him by Picasso, at the opening of "Picasso: 75th Anniversary Exhibition," The Museum of Modern Art, New York, May 1957

and was his "right hand" for the exhibition.[3] In 1979 Lieberman left the Modern, where he was then director of the department of drawings, to become chairman of twentieth-century art at the Metropolitan. He gave a large number of works to the Metropolitan, both during his tenure and as a bequest, including this tie, three other drawings, and six prints by Picasso. In addition, he donated works to The Museum of Modern Art and gave his collection of Japanese prints, among other works, to the Fogg Art Museum / Harvard Art Museum, Cambridge, Massachusetts.

The *Tie* illustrates the lighter side of Picasso, who made countless ephemeral objects from paper or humble materials throughout his career, many of which no doubt do not survive. He performed little acts of wizardry to amuse his family and friends, such as making toys and paper dolls for his children. In 1943 Brassaï photographed an astonishing group of ingenious paper structures that Picasso had torn, burned, or wrinkled to create animal heads and skulls. One of these was a dog's head for Dora Maar, whose dog had died. Picasso roughly tore out the shape for the head and formed the eyes with a lit cigarette.[4] He had used colored crayons occasionally since at least 1899 but employed them more frequently beginning in the 1940s. He favored the medium especially for simple, childlike drawings, informal gifts to friends, and quick sketches inside a book or on a gallery announcement. By 1954 he was also making metal cut-out sculpture for which he produced small maquettes in paper or cardboard that were then cut from large metal sheets by craftsmen. In 1956 Picasso met the photographer David Douglas Duncan (b. 1916) and allowed him to record intimate moments from life at the artist's home, La Californie. Photographs from 1957 depict Picasso mugging for the camera wearing paper masks he had made and, in other shots, pinning a paper scarf covered with X's on Jacqueline's sweater (fig. 91.2).

The 1957 retrospective was Barr's third major exhibition of Picasso's work; the first two were held in 1939 and 1946 (though he attempted a show as early as 1931). The 1957 exhibition was actually smaller than the comprehensive survey from 1939 (which included more than 340 works), but it provided American audiences with the first serious exposure to Picasso's production since the end of World War II and set an attendance record, with more than 100,000 visitors the first month. The groundbreaking exhibitions, not to mention Barr's scholarship and staggering acquisitions of Picasso's works, qualified him by mid-century as the leading promoter of and authority on the artist in the world.

Picasso celebrated his seventy-fifth birthday on October 25, 1956, in Vallauris with his wife, Jacqueline. He did not attend the opening at the Modern the following spring. In fact, he never visited the United States, and at any rate would have had difficulty, as a member of the Communist Party, even entering the country at the height of the Cold War.[5] Barr, who had championed the artist's "anarchic individualism" in his catalogue for the show in 1946, had his own serious reservations about the artist's allegiance to the party, which had driven Picasso as far

Fig. 91.2. David Douglas Duncan, Photograph of Picasso trying out a paper scarf on Jacqueline Roque at La Californie, 1957. David Douglas Duncan Collection, Harry Ransom Center, The University of Texas, Austin

as providing a scandalous depiction of Stalin after the dictator's death for *Les Lettres françaises*.[6]

Relations between the artist and Barr, soft-spoken but tenacious, were not always smooth. According to John Richardson, "Picasso thought very highly of Barr but never really warmed to him. He found Barr dry and academic, but the problem may have been Barr's clever, caustic, outspoken, Irish-Italian wife, Marga."[7] Marga was multilingual; her husband was not. Communication between the two men was limited, and apparently Barr, on occasion, "was so embarrassed to venture an opinion in broken French that he turned to the wall pictures he didn't like."[8] While preparing the 1957 exhibition, Barr recalled the difficulties he had experienced with Picasso around the first exhibition and expressed reservations about the artist in a letter to René d'Harnoncourt, the director of the museum. "He is not a reasonable man and the immense diet of flattery he has fed on, his age and his sense of power have certainly increased since 1939."[9] The gift of the ties was a friendly gesture, but perhaps it was also Picasso's sly comment on the reserved nature and sartorial habits of the curator. An old friend of Barr's described him thus: "His appearance was important—he dressed carefully, to the hilt. [He was] conscious of appearance, of deportment. That he was not without mannerism there can be no doubt."[10] In the end, the tie's wide staring eyes constitute a clever ruse: Picasso delivered his own eyes (his most famous feature) to the opening, and, in his stead, they looked out upon his own work.

M P

1. See Alfred H. Barr, Jr. Papers, 12.V, The Museum of Modern Art Archives, New York.
2. The exhibition opened in two stages. On May 4, the work from 1898–1925 was mounted; the rest of the show went on view May 22. It was also presented at The Art Institute of Chicago (October 29–December 8, 1957) and the Philadelphia Museum of Art (January 6–February 23, 1958).
3. Barr in New York–Chicago 1957, p. 6.
4. See, for example, Spies 2000, nos. 247–57. Our *Tie*, cut from a simple, construction-paper-like material, has folded and creased areas that reflect its history and use.
5. The Internal Securities Act of 1950 excluded "aliens" who were Communist Party members from admission into the United States.

6. On Picasso's politics during and after the war, see FitzGerald 1998, Utley 2000, and the forthcoming Liverpool 2010
7. Richardson 1991–2007, vol. 3 (2007), p. 387.
8. Kimmelman 2003, p. 12. In this book review Michael Kimmelman recounts the story as told to him by a curator from The Museum of Modern Art.
9. Letter dated June 15, 1954, quoted in FitzGerald 1996, p. 443 n. 6.
10. Edward King in an interview from 1981 with Sybil Gordon Kantor (Kantor 2002, p. 9). Picasso had given Barr a gift before; although Barr was scrupulous about not accepting personal gifts from artists while at the Modern, Picasso said he would not sell the print *Minotauromachy* (1935) to the museum unless Barr accepted one as a gift. See ibid., pp. 71–72.

PROVENANCE
Sent by the artist to Alfred H. Barr, Jr., New York, 1957; his gift to Lieberman; William S. Lieberman, New York (1957–d. 2005; his bequest to the Metropolitan Museum, 2005)

REFERENCE
Bee and Elligott 2004, p. 113 (ill.)

92. Head of a Woman
Cannes or Vauvenargues, November 28 and 30, 1960

Oil on canvas
25⅝ × 21¼ in. (65.1 × 54 cm)
Signed, upper left: <u>Picasso</u>
Dated on verso in red paint, upper center: 28.11.60. / 30.
Gift of Mr. and Mrs. Leonard S. Field, 1990
1990.192

She hangs on every wall. And dozens of her heads cut off at the neck look at you from all sides with their eyes of paint above a cheek of iron."[1] Such was the impression recorded by Hélène Parmelin, a novelist, critic, and close friend of Picasso's, during a visit in 1966 to Notre-Dame-de-Vie, the artist's home near Mougins. She was referring to the ubiquitous face of Jacqueline, Picasso's last wife (they married in 1961) and the subject of hundreds of works of art made between 1954 and 1972.

Picasso first met Jacqueline Roque, then twenty-five, in the summer of 1952, while she was working for Suzanne and Georges Ramié at the Galerie Madoura, the salesroom for their ceramic studio in Vallauris. At the time he painted the Metropolitan's portrait, the couple lived in Cannes, at La Californie, but Picasso also occasionally worked during this period at Vauvenargues, a fourteenth-century château he had purchased in 1958 near Aix-en-Provence.

Although Picasso had on occasion painted Jacqueline from life, for his portrayals of her he relied ultimately on his prodigious visual memory and her continual presence in his life. As he aged, Picasso's life with Jacqueline became more circumscribed; the couple seldom traveled or received friends in their various homes in southern France. Temperamentally calm and patient, and utterly devoted to the work-obsessed artist, Jacqueline adjusted easily to her role as mistress of the house and rarely left her husband's side. Parmelin summed it up thus: "A model poses. / Jacqueline does not pose. / But she is there all the time. / She does not pose. / She lives."[2] Her classical features—high cheekbones, long straight nose, enormous eyes, and dark hair—were so thoroughly internalized by Picasso that her likeness seems to permeate his female subjects whether they specifically portray her or not. He assigned her no particular style.

Indeed, through the hundreds of pictorial formulas he devised for her portrayals, Jacqueline's visage became emblematic of the stylistic multiplicity that marks Picasso's late work.

While many signature images of Jacqueline capture her erect bearing from the side—what William Rubin described as the "heraldic absoluteness of her profile"—she is presented here full face, in an emphatically flat and hieratic manner.[3] *Head of a Woman* appears to be the culmination of a series of ten heads on paper Picasso completed in a single day, November 12, 1960 (see fig. 92.1). In these wash drawings—stark black-and-white studies of a woman's face with Jacqueline's distinctive features[4]—the artist experimented with the geometricized shape of the head and positive/negative variations on his familiar double face. They derive from several of his own paintings from 1949: colorful portraits of his former mistress, Françoise Gilot, in an armchair. In lieu of heads consistent with the fluid, colorful forms of the figures, Picasso composed them as if they were rectangular black-and-white drawings that had been "collaged" on to the painting.[5] In recapitulating these earlier works, he essentially retrieved images of Françoise to transmute them into his 1960 portraits of Jacqueline.

In a gouache made two days before *Head of a Woman*, Picasso drastically exaggerated the distortions of the sitter's face and

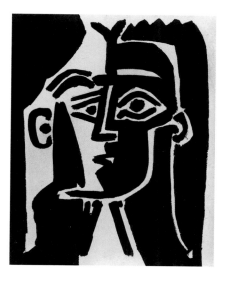

Fig. 92.1. Pablo Picasso, *Head*, 1960. Wash drawing, 25⅝ × 19⅝ in. (65 × 50 cm). Private collection

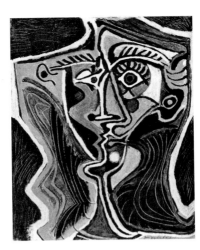

Fig. 92.2. Pablo Picasso, *Head*, 1960. Gouache, 25⅝ × 19⅝ in. (65 × 50 cm). Private collection

1. Parmelin 1969, p. 93. Parmelin was married to the painter Édouard Pignon (1905–1993) and provided invaluable eyewitness accounts of the postwar years.
2. Parmelin [1967?], p. 66.
3. Rubin 1996a, p. 476.
4. z XIX.386–389 and 391–396 and PP 60.309–318. John Richardson (1988, p. 37) identified the heads as Jacqueline's, and Picasso showed him the group of drawings soon after they were finished. In 1985 Andy Warhol based a large group of paintings on these drawings as they were reproduced in Christian Zervos's catalogue raisonné. See Paris (Warhol) 1997.
5. z XV.128, 131–133. On one of these works from 1949, *Woman in an Armchair (Françoise)* (no. 128), see FitzGerald 1996, pp. 428–29.
6. z XIX.398; it was made November 25–26. This work is the same size as the black-and-white drawings (25⅝ × 19¾ in. [65 × 50 cm]) and only slightly smaller than the Metropolitan's painting.

PROVENANCE
[Kootz Gallery, New York, until 1962; sold to Field]; Mr. and Mrs. Leonard S. Field, New York (1962–90; their gift to the Metropolitan Museum, 1990)

EXHIBITIONS
Toronto–Montreal 1964, no. 271, pp. 20, 153 (ill.); Washington 1966, no. 69, ill.; Berkeley 1970, no. 540; Naples (Fla.) 2008, fig. 21

REFERENCES
Zervos 1932–78, vol. 19 (1968), p. 126 (ill.), no. 408; Chipp and Wofsy 1995–2009, [vol. 12] (2002), p. 106 (ill.), no. 60-326; Costello 2008, p. E1 (ill.)

heightened the disturbing sense of asymmetry (fig. 92.2).[6] He softened the sharp angles of the wash drawings until the features seem elasticized, stretching the head this way and that. These distortions are somewhat subdued in the Metropolitan's oil painting, but the head remains a pliant, malleable form. Picasso created a tension between the conflicting views of the face that refuse to resolve into a single reading. The shadowed profile view, looking inward to the self, appears to be superimposed on a frontal view, directed at the viewer, but Picasso paradoxically flipped the nose and placed a frontal eyebrow above the profile eye. He scrambled the already conflated orientation, thus thwarting any integrated reading of the totality. In Jacqueline's proper right profile, to the left in the painting, her hair is pulled behind her ear, logically for a profile reading, but in a frontal reading it pulls the head to one side. Picasso composed Jacqueline's face with discrete shapes in white, shades of gray, and light blue that suggest shadows moving across her features. Some of these forms are remnants of the earlier black wash drawings, such as the black triangular shape under her eye, which here adds a somber note. Perhaps this dualistic presentation is a veiled reference to the recurrent illness that overshadowed Jacqueline's first years with Picasso.

The strong silhouette of Jacqueline's hair, rendered as thick strands of gray and black paint, is set against a green background in the upper half of the canvas, over which Picasso scumbled white paint, leaving a brilliant emerald outline around her hair. The terracotta area beneath this zone perhaps indicates the back of a chair. The work was painted on two separate days, which probably accounts for the compositional changes visible beneath the top paint layer and the drying cracks on Jacqueline's cheeks. Picasso adjusted her left shoulder and reduced the size of her profile eye. The simple contoured shapes and planar nature of the work is likely informed by the linoleum cuts the artist was making at the same time. In turn, this type of composition would lend itself well to the many linocut portraits Picasso would make of Jacqueline in 1962 (for example, cats. P187, P188).

MP

TECHNICAL NOTE

For this painting, which is on fine-weave canvas commercially prepared with a white ground, Picasso used paints containing varying amounts of oil medium. The full variety of rich textures, subtle sheens, and matte finishes of these oil paints can still be fully appreciated as the paint surface has remained unvarnished. The painting is in perfect condition except for some drying cracks, mostly in the light gray paint along the woman's cheeks, which results from layering paints with different oil contents and drying ratios.

Picasso painted directly on the canvas, with no underdrawing. He made several small shifts and changes, however, which are visible under the paint layer. X-radiography confirms and clarifies some of these changes. For example, Picasso shifted the contour of the woman's proper left shoulder. He originally outlined it with a sloping curve going from her neck to her shoulder but later changed its shape to a more triangular form, which he filled with white paint (fig. 92.3). Five small horizontal strokes, painted one above the other, are visible in the X-ray at the center of the neck area under the thick patch of white paint. The opacity of this overlying white paint prevents a clear reading of the feature Picasso originally painted, but the top rounded stroke seems to have been connected to the original curving outline along the shoulder, described above. More underlying strokes are visible along the proper right side of the woman's face. The outline of her right eye was originally much wider and larger than the other eye, as seen in other portraits of Jacqueline from that time. A few small strokes visible beneath the blue paint layer on the proper right side of the sitter's chest indicate that Picasso shifted the outline of her décolletage.

ID

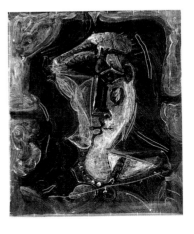

Fig. 92.3. X-radiograph of cat. 92, with outlines to show compositional changes

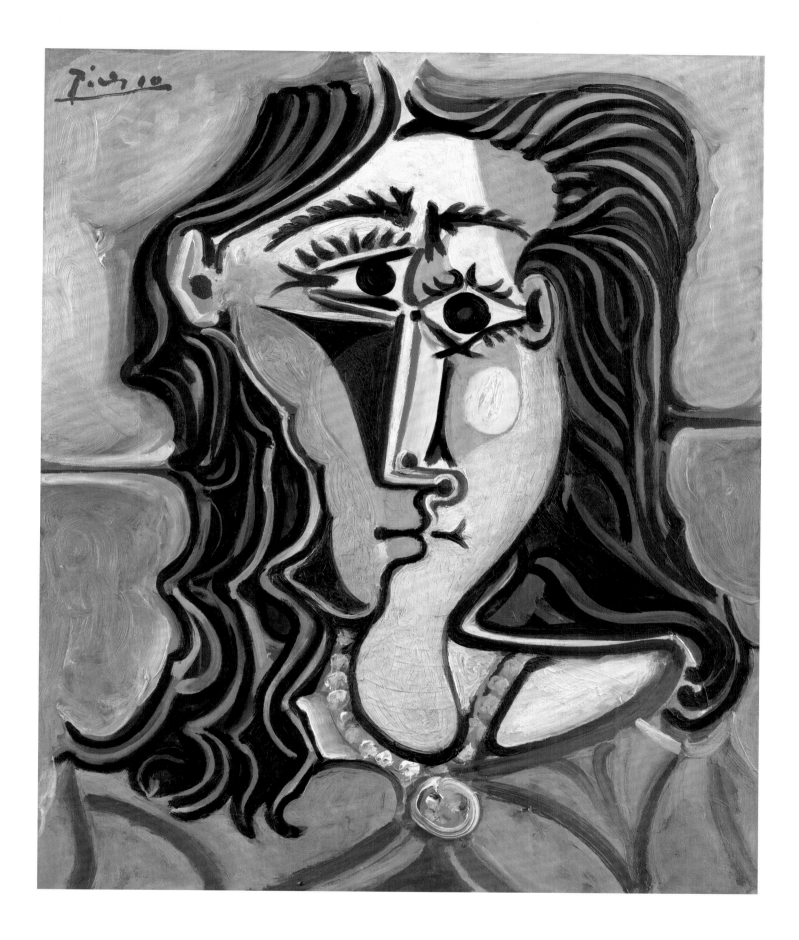

93. Woman and Musketeer

Mougins (Notre-Dame-de-Vie), February 22–March 1, 1967

Oil on canvas
39⅜ × 31⅞ in. (100 × 81 cm)
Signed (in pink) and dated (scored in pencil), upper left: 22.2.67. / Picasso
Dated on verso in black paint, upper right: 1.3/28/27/26/25/24/23/22.2.67;
and on horizontal crossbar of stretcher, at center right: 22.2.67.
Jacques and Natasha Gelman Collection, 1998
1999.363.71

The swashbuckling, seventeenth-century musketeer, a subject Picasso had sketched in his youth as early as 1892–93, was one of the most prevalent characters in his art from the last six years of his life.[1] In the mature work, the mustachioed, sword-toting musketeer in full regalia—ruff collar, breeches, and plumed hat—first appeared in a drawing for *Verve* (January 21, 1954), but he gained a steady presence in early 1967. Picasso underwent a serious ulcer operation on November 16, 1965, in Paris (his last trip to the city), and during his long recovery he painted very little and reread, among other classics, Alexandre Dumas's *The Three Musketeers*, a book that John Richardson claims the artist knew by heart.[2] He also seems to have studied reproductions of Rembrandt's work in depth at the same time. After Picasso's death, when André Malraux asked Jacqueline if the musketeer subject was related to Velázquez and Picasso's variations of *Las Meninas*, she countered, "They came to Pablo when he'd gone back to studying Rembrandt."[3] With the introduction of the musketeer, Picasso added one last lively chapter to his many paraphrases of the old masters. He is an amalgam of Dumas's adventurers, the noblemen (or *hidalgos*) of Spain's golden age, and the militiamen of Rembrandt (Picasso projected *Nightwatch* onto the walls of his studio).[4] As if making up for lost time, Picasso returned to work after his illness with a sense of urgency that fueled the prolific production of the last years. When he took up painting again in early 1967, *Woman and Musketeer* was his first full-scale oil.

Picasso's direct source for the Metropolitan's painting was his own 1963 work *Rembrandt and Saskia* (fig. 93.1), made in tribute to the Dutchman's *Self-Portrait with Saskia (In the Scene of the Prodigal Son)* (ca. 1635, Staatliche Kunstsammlung en Dresden), in which the artist, foppishly attired in a plumed hat, holds his young wife on his lap as he gallantly turns to raise a toast to the unseen visitor.[5] The moralizing undertone of the biblical theme no doubt attracted Picasso less than the bawdiness of the tavern scene. In Picasso's version, a nude sits in the lap of a painter at his easel. She addresses the viewer, as does Rembrandt's (fully clothed) Saskia, but she holds a glass in her right hand and points to the canvas with her left. She is rendered in striking green and lavender and, typically, is portrayed from both the front and the rear. Picasso repeated the lavender hue in the prominent thigh of his 1967 nude as well as the distinctive double curve of the buttocks shape.[6] The boundaries between the musketeer subject

Fig. 93.1. Pablo Picasso, *Rembrandt and Saskia*, 1963. Oil on canvas, 51⅛ × 63¾ in. (130 × 162 cm). Private collection

Fig. 93.2. Reverse of cat. 93 (detail), showing dates inscribed by the artist on canvas and crossbar of stretcher

and the artist and model theme were obviously fluid, just as the musketeer could effectively embody the alter egos of Picasso and Rembrandt simultaneously.

At a time when he was usually producing one or more large paintings in a single day, Picasso, then eighty-five, worked on this painting for eight consecutive days, meticulously documenting each day on the verso before assigning it a final date of March 1, 1967 (fig. 93.2). Yet he initially seems to have regarded it as finished on February 22, the date on the front of the canvas near his signature. From related works made at the same time, it

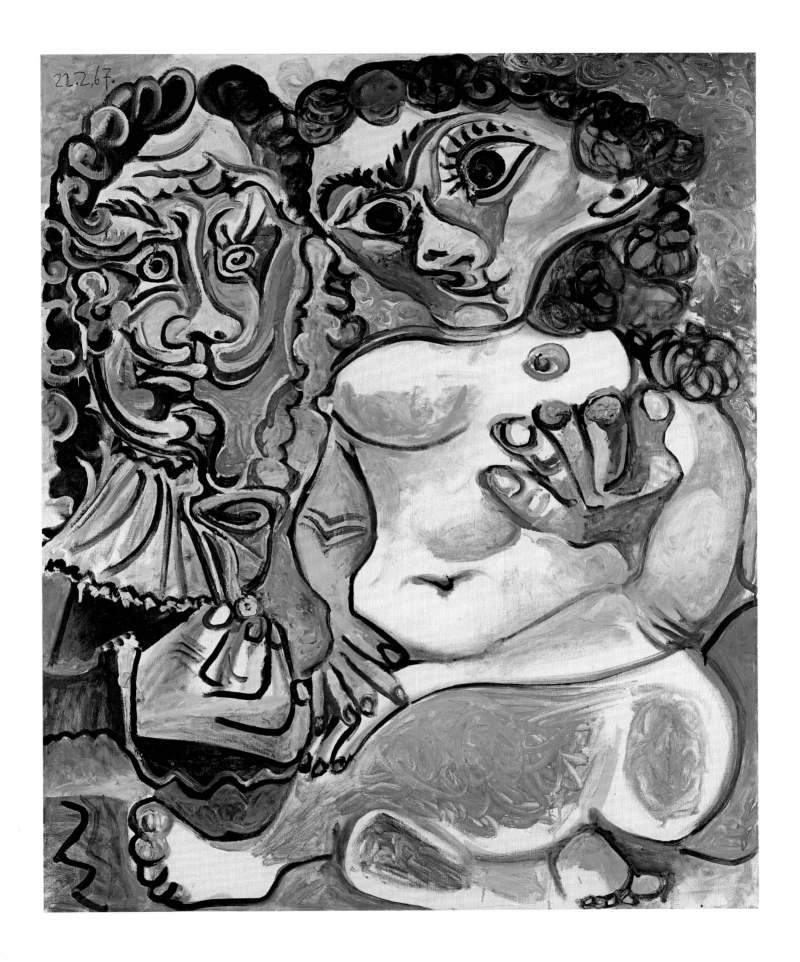

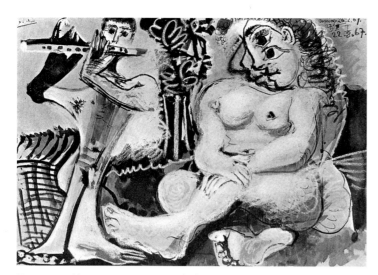

Fig. 93.3. Pablo Picasso, *Woman and Flautist*, 1967. Wash and crayon, 18¼ × 24¾ in. (46.5 × 63 cm). Private collection

Fig. 93.4. Rembrandt van Rijn, *Bathsheba at Her Bath*, 1654. Oil on canvas, 55⅞ × 55⅞ in. (142 × 142 cm). Musée du Louvre, Paris, Dr. Louis La Caze Bequest, 1869 (MI 957)

is clear that Picasso was exploring alternatives in form and subject. The day before undertaking this work, he painted another, very similar composition on the same size canvas, *Homme et Femme nue* (z XXV.284), but the work is cursory and unresolved, with none of the rich palette of the Metropolitan's work. He made another, even larger variation on February 22 (z XXV.285), the day he began *Woman and Musketeer*, in which the head of the musketeer is very faintly realized and the seated nude awkwardly raises her right elbow.[7] Apparently, in subsequent days, Picasso chose to bring the Museum's work to a fuller state of completion, and perhaps the painterly textures, such as the swirls of blue in the background, the hastily brushed lavender of the nude's thigh, or the thick areas of dripping white paint on her nose and the musketeer's eyebrow, emerged in the later sessions.

At one point Picasso altered the theme altogether. In *Woman and Flautist* (fig. 93.3), a wash and crayon drawing made while he was working on the Museum's painting, the same nude fills the sheet top to bottom. She rests her hands demurely on her leg and is endowed with the same curly hair, rounded anatomy, and squat proportions as her counterpart in *Woman and Musketeer*.[8] She looks not toward her musketeer lover but toward a young man playing the flute. Both of her enormous eyes are stacked in a profile view of her face, and her proper right foot is logically tucked under her extended left leg. Opting for greater distortion in his painting, Picasso flipped the foot, rendering its position anatomically impossible, and squeezed the sitter's head into a rubbery triangular shape, giving her a comic, doll-like countenance. The nude's expression in the drawing, however, is gentle and thoughtful, and Picasso redrew her profile three times. He clearly had in mind not only Saskia but Rembrandt's later painting *Bathsheba at Her Bath* (fig. 93.4), in which the old master portrayed his nude mistress, Hendrickje Stoffels, her face in profile and deep in thought, her hand resting on her leg. Such a source would account for the large portion of space allotted Picasso's nude in the Metropolitan's painting as well as her

plumpness, especially the fleshy softness of her belly. This area, largely the light shade of unpainted ground, corresponds to Hendrickje's illuminated torso.

The musketeer is little more than a large, elongated head in a ruff collar, with a preposterous mustache, heavily lined face, and color accents in citrus yellow. He cups his fingers around the bowl of a pipe while grasping the woman with his huge, paw-like left hand, a coarse translation of Rembrandt's embrace of Saskia. The disregard for the smoker's body could reflect the many boisterous depictions of musketeers' heads, all with similar features, that preoccupied Picasso throughout the last years. He animated the painting surface with repeated circular strokes in wriggling, spiraling patterns. The ringlets of the musketeer's peruke mingle with the woman's curls and the trails of smoke that billow up between them. While Picasso may not have intended a likeness of his own wife in this golden-haired, portly figure, she has Jacqueline's unmistakable black eyebrows. If he could merge Rembrandt's loves in his mind's eye, given the intensely private nature of his vision in these late works, he was certainly at liberty to do the same with his own.

MP

1. Gert Schiff noted this early manifestation in the margin of a Latin textbook. See Schiff in New York (Guggenheim) 1984, p. 68. For two drawings of the subject from 1894, see z VI.40 and XXI.18.
2. Richardson 2009, p. 20.
3. Malraux 1995, p. 4. For a discussion of the relationship of Picasso's late work to Rembrandt, see Schiff in New York (Guggenheim) 1984, pp. 30–40, and Cohen 1983.
4. Richardson 2009, p. 19
5. *Rembrandt and Saskia* is z XXIII.171.
6. In a close examination of these works, Janie L. Cohen demonstrated the significance to Picasso of this double curve contour, originally derived from the line that defines the buttocks of Rembrandt's Saskia. He included it in the painting *The Couple* (June 10, 1967, Kunstmuseum Basel; not in Zervos, PP 67.238) as a white line in the area where it corresponds to Rembrandt's painting, "independent of the body it ostensibly belongs to, almost as a residual compositional element." The author also identifies the sitter's golden hair in the Metropolitan's painting with Saskia's. See Cohen 1983, pp. 120–21.

7. Dakin Hart (2009, pp. 255–56) posits that the male figures in these two works, along with the Metropolitan's painting, represent, respectively, Dumas's three musketeers, Aramis, Porthos, and Athos.

8. z xxvii.460. The work is dated February 26 and 27 and August 22, 1967. The flute player was borrowed from contemporaneous drawings of a flautist and a man with a sheep around his shoulders. See, for example, z xxv.267–270, 272, and 273. Schiff (in New York [Guggenheim] 1984, p. 28) sees the large female figure as Gaea Tellus (Earth Mother).

PROVENANCE
[Galerie Louise Leiris (Daniel-Henry Kahnweiler), Paris, 1968–87; purchased from the artist, May 1968, stock no. 12566; sold in February 1987 to Saidenberg]; [Saidenberg Gallery, New York, 1987]; private collection, United States; [Thomas Ammann Fine Art, Zürich, until 1988; sold to Gelman]; Natasha Gelman, Mexico City and New York (1988–d. 1998; her bequest to the Metropolitan Museum, 1998)

EXHIBITIONS
Kaiserslautern 1970, no. 36, p. 80; New York 1971 (shown at Marlborough Gallery), no. 99, p. 108 (ill.); Menton 1974, no. 8, ill.; Montauban 1975, no. 15, ill.; Tokyo and other cities 1977–78, no. 77, ill.; Basel 1981, no. 19, pp. 31 (fig. 23), 159; Madrid–Barcelona 1981–82, no. 134, pp. 300–301 (ill.); New York (Guggenheim) 1984, no. 28, pp. 32, 33 (fig. 41), 128; Mexico City 1984, no. 13, p. 94; New York–London 1989–90, pp. 278–80 (ill.), 313 (ill.); Martigny 1994, pp. 302–3 (ill.), 335 (ill.); London–New York 1998–99, hors cat.; New York 2001–2, no cat., checklist no. 45

REFERENCES
Zervos 1932–78, vol. 25 (1972), p. 129 (ill.), no. 292; Basel 1976, p. 172; Cohen 1983, pp. 120 (fig. 8), 121; Warncke 1992, vol. 2, p. 638 (ill.); Warncke 1993, vol. 2, p. 638 (ill.); Daix 1995, pp. 450, 682; Chipp and Wofsy 1995–2009, [vol. 13] (2002), pp. xiii, 291 (ill.), no. 67-084; John Richardson in New York 2009, pp. 255 (fig. 51), 256

TECHNICAL NOTE

The painting is on medium-weight linen canvas commercially prepared with a white ground and is supported by its original six-member stretcher. Picasso painted directly and quickly, often in wet-in-wet technique. He began by sketching in the image with a thin pale wash of gray paint, as seen around the perimeter of the proper left foot of the nude. This was followed by local applications of color; the warm brown hair of the female figure, many of the yellow highlights in the face of the musketeer, and several touches of blue at the top were among the earliest additions. The artist then alternated between applying black linear outlines (such as in the toes of the proper left foot), viscous gray and white paint, and further elements of color. Some of the last details he added were the lavender flesh of the nude figure and the blue paint at lower right. Picasso also used the ground color as part of his palette, as seen, for instance, in many of the unclothed areas of the nude figure.

Although the technique and apparent ease of paint handling give the impression that Picasso executed the work quickly, the dates on the verso indicate that it was developed over a period of eight days, from February 22 to March 1 (fig. 93.2). The work is inscribed on the front at top left and on the back of the stretcher with the date the artist began the painting. Since few areas show any evidence of reworking, one wonders what Picasso did in the days that followed. One of the passages that he did rework is the area of contact between the two figures. Here the texture of the paint and examination with X-radiography indicate the presence of underlying brushstrokes that do not appear in the visible paint film, the most curious of which is a diagonal line going from the chin of the musketeer up to the breast of the seated nude. This line could reflect an earlier position of the collar on the musketeer's jacket or an earlier position of the nude's proper right arm. Given the high concentration of lead white in the area of the nude's arm relative to the rest of her figure, where there is very little, the reworking of the arm is perhaps the most plausible explanation.

The date at top left was incised (apparently with a pencil) into wet paint, something uncommon in Picasso's oeuvre. The signature is very faint; it contains an organic colorant, which is susceptible to fading. Under magnification, local areas of red paint may be seen pooled in air pockets in the ground layer. Shielded from light, these areas have retained a brighter, more intense color. Judging from the tacking margins and a drip of paint that rounds the turnover edge and passes over one of the tacks, it appears that the canvas has never been removed from the stretcher. Tacks were removed only at the corners, most likely for local and subtle tension adjustments. The painting has never been varnished and has a beautiful surface with a slightly variable gloss related to paint selection and technique. A layer of surface dirt that dulled the contrasts of the painting was removed in 2009, revealing a fresher, more vibrant surface.

SD-P

94. Standing Nude and Seated Musketeer

Mougins (Notre-Dame-de-Vie), November 30, 1968

Oil on canvas
63¾ × 51 in. (161.9 × 129.5 cm)
Signed upper right: <u>Picasso</u>
Dated on verso in orange paint, upper left: 30.11.68
Gift of A. L. and Blanche Levine, 1981
1981.508

Even by the measure of Picasso's extraordinary productivity during the last decade of his life, the outpouring of work in 1968 is astounding. Between March 16 and October 5 (or 203 days), the artist, well into his ninth decade, completed 347 intaglio prints, known as the *347 Suite*, in collaboration with the master printers Piero and Aldo Crommelynck in Mougins (see cats. P260–P389). This is in addition to the more than 250 drawings, paintings, and ceramics he made during the same year. The proliferation of refined, intricately scribed images in the *347 Suite* clearly demonstrates that Picasso's genius as a draftsman had never waned and that the panoply of characters he had rehearsed over a lifetime were still resilient, personally meaningful subjects. His painting style, meanwhile, had grown looser and more impetuous every year, as if the accelerated tempo of his brush was mandated by the furious pace of his production and his compulsive drive to create. Picasso had long inveighed against his own technical facility, but the willful distortions and the stylistic crudity of handling in the late paintings takes these antivirtuosic tendencies to a new extreme.

The bearded, bewigged musketeer (apparently bearing a certain resemblance to Piero Crommelynck) makes frequent appearances in the prints of the *347 Suite*, but he is by far the dominant male presence in the paintings throughout the roughly twenty-one months that separate this work from the Metropolitan's *Woman and Musketeer* of 1967 (cat. 93). The elaborately garbed "*mosquetero*" evoked Picasso's Spanish heritage and reiterated his long-standing esteem for the painters of the Baroque era, chiefly Velázquez and Rembrandt. In this imposing composition, executed on one of the largest scales Picasso favored at the time, the expansive figure of the musketeer takes center stage, while the schematically rendered nude at his side seems somewhat incidental. The work exudes little of the earthy eroticism of the earlier picture, and it is executed in a different, highly expressionistic idiom. The static, nearly monochromatic figure of a woman may have been an afterthought. Nearly all of the musketeer subjects Picasso painted in the two months leading up to this work are single, centralized male figures, similarly attired, usually with legs crossed, and smoking long clay pipes, as in *Musketeer with Pipe* (fig. 94.1).

It is no small task to assemble this hilariously disjointed musketeer. He is seated on, or mostly off, a red cane chair topped by round knobs, a chair that in various forms appears in most of Picasso's portraits of seated musketeers. Other circular

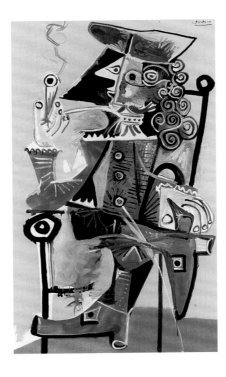

Fig. 94.1. Pablo Picasso, *Musketeer with Pipe*, 1968. Oil on canvas, 57⅝ × 35⅛ in. (146.5 × 89.3 cm). Private collection

forms—eyes, breasts, pipe bowl, buttons, toes—populate the canvas and contribute to its jaunty, syncopated rhythms. Quick, comma-shaped strokes of yellow and creamy white fill in the area beneath the chair. The musketeer's dislocated left arm, trimmed in an orange cuff, flops over the back of the chair, and his crossed legs, in blue striped stockings and buckled shoes, also float independent of the body. Composed in an equally cursory manner, his torso dissolves into loosely brushed areas of azure with deep blue accents and horizontal white strokes. Such abbreviated passages and shapes are standard elements in the pictorial shorthand Picasso had developed in the late work: blue and black squiggles for hair, or a large V shape for a nose. The artist's friend Hélène Parmelin described this visual language after looking at works from the 1960s with Picasso: "Every time he shows a canvas in which a dot is enough for the breast, a dash for the painter, five spots of colour for a foot, a few pink or green st[r]okes . . . [Picasso] says, 'That's enough, don't you think? What more do I need to do? What can I add to that? I've said it all. . . .'"[1]

The lavender nude is more fully integrated than her male companion, but she is painted with far less exuberance. Her silhouette is deprived of any sense of corporeality, and her face holds no expression. More of an apparition than flesh and

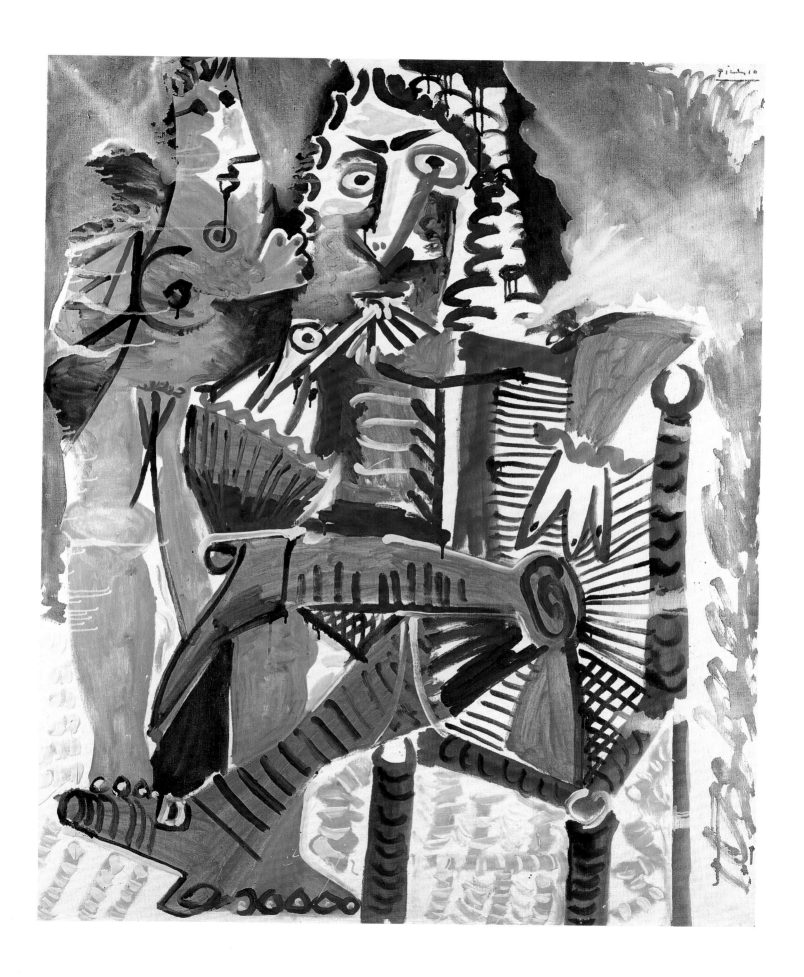

blood, she is perhaps a projection of the musketeer's ripe imagination. This flattened, simplified shape recurs in paintings of the 1960s and calls to mind the metal cutout sculptures Picasso had been making since 1954. The woman seems to reach toward the musketeer or proffer something with a stubby little hand that emerges from her breast, and she coyly places her elephantine foot on his boot. Like most of the late works, *Standing Nude and Seated Musketeer* was painted *alla prima* in a rapid and spontaneous manner. Transitional areas, such as the space between and around the figures, are brushed over with thin milky washes of white paint. The horizontal drips of watery white paint on the nude's figure at the left or on the chair at the right indicate that Picasso probably rotated the picture while painting it and may have turned it on its right side (see technical note). He tended to work on large canvases on a table rather than an easel.[2]

The musketeer holds a pipe in his green, outsize hand. Such long-stemmed clay pipes are a familiar feature of Dutch genre painting and generally accompany lowlife characters partaking of dissolute pastimes. Picasso had smoked pipes when he was young (and drew himself smoking them), and pipes and smoking accoutrements were mainstays of the Cubist pictures. Just as the pervasive concupiscence of the late work can be understood in part as nostalgia for lost virility, the pipe, for an artist forced late in life to give up tobacco for his health, is a sign of longing for his smoking days. He told Brassaï in 1971, "Age has forced us to give it [smoking] up, but the desire remains. It's the same thing with making love. We don't do it anymore, but the desire for it is still with us!"[3]

In Picasso's universe the musketeer could act out the role of painter, musician, smoker, and voyeur, but never a fighter. They might wield a brush but rarely a sword. These dashing soldiers of adventure are ultimately cartoonish, absurd figures, and their amorous exploits are more comically libidinous than the sexually predatory behaviors of some of Picasso's previous male incarnations. In a persuasive recent reading of the subject, Dakin Hart maintains that the musketeer paintings are not merely motivated by Picasso's retreat into the world of the Dutch and Spanish old masters but should be seen as a response to the incendiary political events and sexual revolution of the 1960s. These emblems of pacifism, according to the author, are one last manifestation of the artist's "humanist social agenda."[4]

MP

1. Parmelin 1969, p. 21.
2. Richardson 2009, p. 33.
3. Brassaï 1971, p. 96. Gert Schiff cites the Dutch emblem tradition in which smoke is a symbol of the futility and fleetingness of love. See Schiff in New York (Guggenheim) 1984, p. 40. On the multiple meaning of pipes and smoking in Dutch art, see Schama 1988, pp. 195–217.
4. D. Hart 2009, p. 267. Along these lines, the exhibition "Picasso: Peace and Freedom" will be on view at Tate Liverpool May 21–August 30, 2010.

PROVENANCE
[Galerie Louise Leiris (Daniel-Henry Kahnweiler), Paris, until 1969; sold in August to Loria]; [Jeffrey Loria & Co., New York, 1969–70; sold in January 1970 to Levine]; A. L. and Blanche Levine, Verona, New Jersey, and Palm Beach, Florida (1970–81; their gift to the Metropolitan Museum, 1981)

EXHIBITIONS
New York (Guggenheim) 1984, no. 52, p. 129; Mexico City 1984, no. 17, p. 94; Paris (Pompidou) 1988, no. 54, pp. 245 (ill.), 342; London 1988, no. 38, pp. 198 (ill.), 273; Humlebaek 1988–89, no. 31, pp. 63 (ill.), 64; Bielefeld 1993–94, no. 12, pp. 32 (ill.), 294–95; Lisbon 1997–98, no. 10, pp. 48–49 (ill.); Tokyo–Nagoya 1998, no. 134, pp. 31 (ill.), 200 (ill.), 233–34, 243; New York 1999, hors cat.; Sydney 2002–3, no. 35, pp. 15, 16, 114 (ill.), 196; Vienna–Düsseldorf 2006–7, no. 72, pp. 120 (ill.), 234

REFERENCES
Zervos 1932–78, vol. 27 (1973), p. 165 (ill.), no. 384; Messinger 1982, p. 60 (ill.); Pace 1994, p. B6; Chipp and Wofsy 1995–2009, [vol. 14] (2003), p. 76 (ill.), no. 68-226; *Impressionist and Modern Art Evening Sale*, Sotheby's, London, June 25, 2008, p. 130 (ill.).

TECHNICAL NOTE
The painting is on medium-weight linen canvas commercially prepared with a white ground. Picasso worked freely and quickly, often painting wet-in-wet. No visible underdrawing or underpainting is present, indicating that the work was developed spontaneously. The artist continuously added touches of color and reinforced contours as he progressed. For the most part, however, he appears to have first worked up the pink, blue, and red passages, subsequently adding the green and orange details, followed by the black outlines. He then populated the foreground with yellow accents, added white highlights, filled in the sides with black, and, finally, put on a thin wash of white at the sides, discussed below. He also made use of the color of the white ground, intentionally leaving it exposed in certain areas.

Picasso clearly enjoyed playing with the transparency and viscosity of his materials. The wash of white paint he added toward the end of the process, which covers areas of black at the sides of the painting, some blue and lavender flesh paint at left, and some red paint at right, was done with paint diluted to a semi-transparent film in order to soften the tone of these passages, thereby accentuating the figure of the seated musketeer and drawing the attention of the viewer to the center of the work. The veil of white paint was also diluted to a thin, watery consistency, such that, when the canvas was turned onto its right side in order to apply this layer, it dripped down as it dried. Picasso allowed—or more likely enabled—such drips throughout the work, but he occasionally covered them up, too, as on the proper left knee of the standing figure. He also added touches of creamy, viscous white paint throughout to create softly impastoed accents.

The tacking margins indicate that the work was restretched once; this most likely occurred when it was removed from its original auxiliary support and stretched on to its present expansion-bolt stretcher. The painting has never been varnished and has a fresh, vibrant surface with a variable gloss related to paint selection and technique.

SD-P

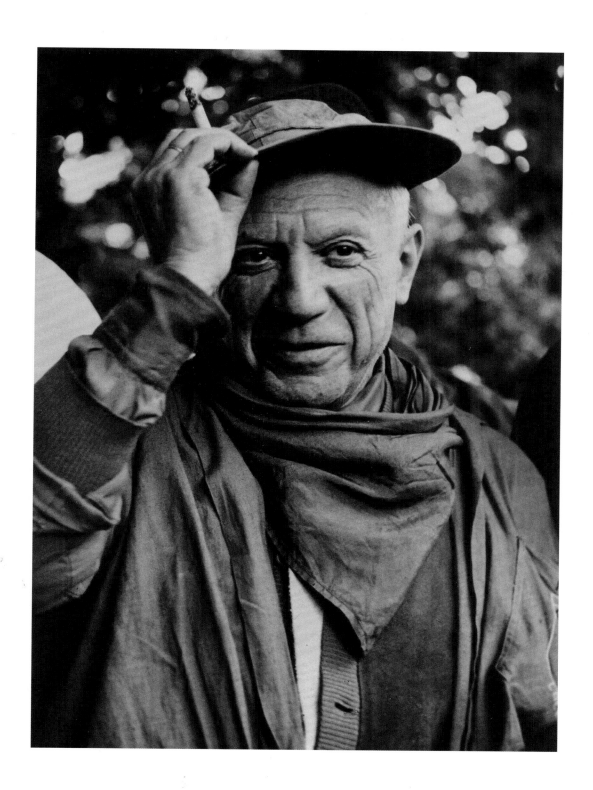

Picasso's Graphic Work

Samantha Rippner

It was a real pleasure to work with Picasso. It was known to the people around him that when he dedicated himself to printmaking . . . he was in a good mood.[1]

—Aldo Crommelynck

The Metropolitan Museum's collection of graphic work by Picasso reflects the artist's long and distinguished engagement with printmaking. Numbering close to four hundred prints in various techniques, the Museum's holdings represent only a fraction of his total output, for, as with most everything he pursued, Picasso was voracious about printmaking. Over the course of his career he made more than two thousand prints, the majority of which he worked in multiple states.[2] Picasso was also non-hierarchical about his work; his prints existed on an equal footing with his painting and sculpture, and their making often provided him with relief from a particularly intense period of painting. Picasso's natural facility for drawing on an etching plate, recalled Aldo Crommelynck, one of his most valued and trusted intaglio printers, precipitated a rather casual way of working. Frequently after lunch, or preferably a late dinner, Picasso would sit at the dining room table, prop up a small copperplate on his knee, and begin drawing his image.[3] He would often execute several prints in a few hours' time.

Picasso's prints in the Metropolitan's collection span almost the length of his career, from the early *Saltimbanques* suite of 1904–6 to the masterful *347 Suite*, which Picasso executed in his late eighties. Within this vast framework there are strengths and weaknesses. William M. Ivins, Jr., the first curator of prints at the Museum, purchased a small but important group of etchings and drypoints in 1922–23 that contained *The Frugal Repast*; William S. Lieberman, the late Natasha and Jacques Gelman Chairman of Modern Art, acquired another group in 1997 that included several innovative aquatints for the *Histoire naturelle* by Georges Louis Leclerc, comte de Buffon. Yet the overwhelming majority of Picasso's printed work entered the collection through generous donations.[4] Together with the tastes and priorities of the department's curators, these seminal gifts have shaped the Museum's holdings.[5] Although the print department's charge as an encyclopedic repository of Western printmaking from the fifteenth century to the present may have precluded a full representation of Picasso's graphic mastery, it is precisely within this context—alongside Rembrandt and Goya—that his extraordinary achievements can be weighed.

The Frugal Repast (cats. P1, P2; fig. 2), the result of Picasso's second attempt at printmaking, is among his most iconic images in any medium. Executed in Paris in 1904 and closely related to his 1903 painting *The Blind Man's Meal* (cat. 22), this remarkable etching of a lonely couple conveys a sense of despondency and isolation typical of his Blue Period. Picasso's adept handling of the etching needle produced a range of

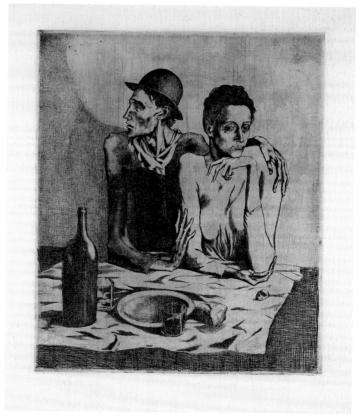

Fig. 2 (cat. P1). Pablo Picasso, *The Frugal Repast*, 1904, printed 1913. Etching, plate: 18¼ × 14⅞ in. (46.4 × 37.8 cm), sheet: 25¹¹⁄₁₆ × 19¹¹⁄₁₆ in. (65.2 × 50 cm). The Metropolitan Museum of Art, New York, Harris Brisbane Dick Fund, 1923 (23.31.1)

Opposite: Fig. 1 (cat. P51). Pablo Picasso, *Blind Minotaur Led by a Girl through the Night* (detail), from the *Vollard Suite*, 1934, printed 1939. Aquatint, plate: 9½ × 13⅝ in. (24.1 × 34.6 cm), sheet: 13⅜ × 17⅝ in. (34 × 44.8 cm). The Metropolitan Museum of Art, New York, Purchase, Reba and Dave Williams Gift, 1997 (1997.408)

dark and light tones that emphasize the hollow faces and attenuated bodies of his protagonists. The print is all the more impressive considering Picasso's lack of formal training in printmaking; he had received only rudimentary instruction from his friend and fellow Spaniard Ricard Canals.[6] Picasso eventually mastered several print techniques and, moreover, transformed them through intimate collaborations with a handful of master printers, all of whom opened up new creative possibilities for the artist.

Published in 1913 by the dealer Ambroise Vollard, the suite of fourteen prints from 1904–6 known as the *Saltimbanques* contained eleven drypoints and three etchings. While there are several works from this suite in the collection, a 1906 drypoint, *The Watering Place* (cats. P10, P11), deserves special mention. It is closely related to a series of drawings of the subject Picasso executed that year, including a gouache in the Metropolitan's collection (cat. 29). These studies were for a highly ambitious, but ultimately unrealized, painting that the young artist hoped would garner him much-needed public attention.[7] The Museum is fortunate to have two impressions of the print: a rare proof (cat. P10; fig. 3) pulled by Auguste Delâtre, Picasso's first master printer, and another impression—after the plate had been steel-faced—from Vollard's edition of 250 (cat. P11).[8] Picasso's confident and economical line in the drypoint stands in contrast to the drawing's more searching and worked-up composition.

In early 1907 Picasso acquired a small hand-operated printing press, a sure sign of his dedication to the medium. While he still worked closely with the aging Delâtre, Picasso was often impatient to see the results of his work. The press enabled

him to pull proofs immediately in his studio and to study the progress of his image. The ability to see and chronicle a print's evolution, to watch its transformations—a quality unique to printmaking—is what most appealed to Picasso. He began to pull many of his own proofs shortly after purchasing the press, a period that coincides with the formative days of Cubism. This period is marked in the Museum's collection by a small 1908–9 drypoint, *Still Life with a Fruit Bowl* (cat. P12), whose composition was clearly inspired by Cézanne.[9]

Picasso's classicizing style of the early 1920s is represented in the collection by a number of editioned impressions but only one rare proof, *Nude Woman Crowned with Flowers* (cat. P30; fig. 4). Using just a few strokes of an etching needle, he delivered a graceful and balanced image. This etching is one of only three impressions pulled at the time the plate was created in 1929 and inscribed by Picasso for his dealer, Paul Rosenberg. The artist, largely uninterested in pulling editions of his prints, was often content with just one or two proofs.[10] His interest in printmaking lay chiefly in exploring its specific attributes: in creating work that could not be achieved any other way. As a result, many of his prints, including *Nude Woman Crowned with Flowers*, were published several years after they were made; others are unique or were printed in a handful of impressions. In 1960, sixty-six images executed between 1919 and 1955 that were never editioned at the time of their making were selected for publication by Picasso. These works have come to be known as the *caisse à remords*, or "guilt box." Picasso's dealer Daniel-Henry Kahnweiler brought him a case filled with the prints to sign, but Picasso, overwhelmed by the sheer number, put them aside and never signed them. Eight

years after the artist's death these impressions were stamped with an official signature and placed on the market for sale. Reiss-Cohen Inc. generously donated forty-five of the prints to the Museum in 1983. Among the many significant images are five etchings of women bathing at the beach (cats. P33, P34, P36, P37, P43), influenced, in part, by Surrealism and Picasso's relationship with Marie-Thérèse Walter; they date to 1932–33, precisely the time he was working on large-scale paintings of the same theme (see cats. 77–79).

Picasso's rather straightforward, linear etching style gave way to greater experimentation and an expanded use of intaglio processes when he began working with master printer Roger Lacourière in 1933.[11] Lacourière, whose father and uncle had been engravers, introduced Picasso to novel ways of creating tonal variations on the plate using sugar-lift aquatint, spit-bite, and open-bite techniques, often in concert with etching, drypoint, or scraper.[12] Picasso's embrace of these methods is evident in his epic series of one hundred prints known as the *Vollard Suite*. Works such as *Blind Minotaur Led by a Girl through the Night* (cat. P51; fig. 1) exemplify his new mastery

Fig. 5 (cat. P49). Pablo Picasso, *Rembrandt with a Palette*, from the *Vollard Suite*, 1934, printed 1939. Etching, plate: 10¹⁵⁄₁₆ × 7¹³⁄₁₆ in. (27.8 × 19.8 cm), sheet: 17⁹⁄₁₆ × 13⁷⁄₁₆ in. (44.6 × 34.1 cm). The Metropolitan Museum of Art, New York, Gift of Mr. and Mrs. David Tunick, 1984 (1984.1199.1)

of aquatint, a painterly medium that enabled Picasso to create dramatic chiaroscuro and to infuse the scene with a dreamlike haze. Several etchings for the *Vollard Suite*, such as *Rembrandt with a Palette* (cat. P49; fig. 5), possess a renewed forcefulness and greater sense of freedom in their use of line. Picasso initiated a dialogue with Rembrandt in the *Vollard Suite* that he would continue to explore more intensely in his late series, *347*. The intaglio techniques he learned from Lacourière would be pushed even further in the same group of prints.

In the mid-1940s Picasso took up lithography in the workshop of Fernand Mourlot. Working with the same focus and intensity he had brought to the etchings with Lacourière, Picasso produced more than 350 lithographs, half of which he made during a concentrated period between 1946 and 1949. As with his intaglio work, the artist regularly manipulated his images in successive states from a single stone, relishing the unique properties of lithography and using them to control the conceptual and formal development of his work. Rather than simply draw on the stone, he experimented with different forms of tusche to exploit the possibilities of black.[13] Mourlot's studio assistants were in awe: "As lithographers we were astonished by him. . . . He would scrape and add ink and

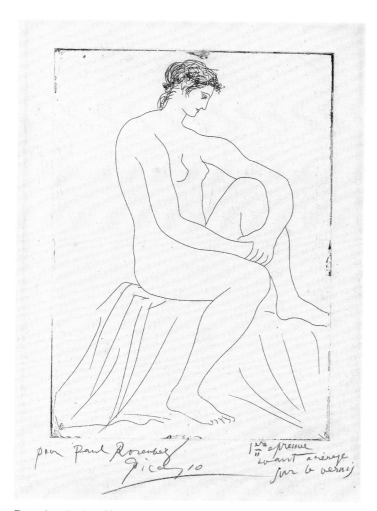

Fig. 4 (cat. P30). Pablo Picasso, *Nude Woman Crowned with Flowers*, 1929. Etching, plate: 11 × 7⅝ in. (27.9 × 19.4 cm), sheet: 15 × 11 in. (38.1 × 27.9 cm). The Metropolitan Museum of Art, New York, Gift of Mr. and Mrs. Alexandre Rosenberg, 1981 (1981.1234)

Fig. 6 (cat. P90). Pablo Picasso, *David and Bathsheba, after Lucas Cranach*, 1947. Lithograph, fourth state of ten, image: 25⅜ × 18⅞ in. (64.5 × 47.9 cm), sheet: 25¾ × 19¾ in. (65.4 × 50.2 cm). The Metropolitan Museum of Art, New York, Bequest of William S. Lieberman, 2005 (2007.49.603)

Fig. 7 (cat. P184). Pablo Picasso, *Le déjeuner sur l'herbe, after Manet I*, 1962. Linoleum cut, block: 20¹³⁄₁₆ × 25¼ in. (52.8 × 64.1 cm), sheet: 24⅜ × 29⅝ in. (61.9 × 75.2 cm). The Metropolitan Museum of Art, New York, The Mr. and Mrs. Charles Kramer Collection, Gift of Mr. and Mrs. Charles Kramer, 1979 (1979.620.50)

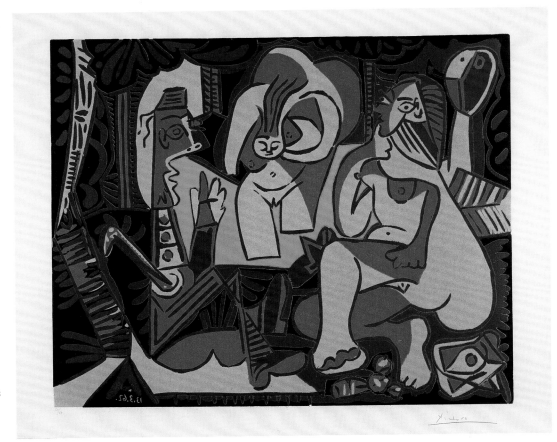

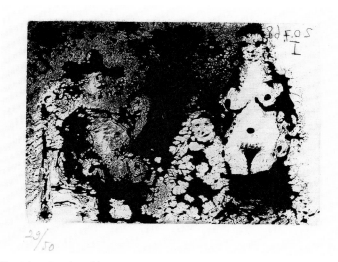

Fig. 8 (cat. P337). Pablo Picasso, *Seated Man with Pipe, Maja, and Célestine*, from *347 Suite*, 1968. Sugar-lift aquatint, plate: 2⅜ × 3⁵⁄₁₆ in. (6 × 8.4 cm), sheet: 9⅞ × 12⅞ in. (25.1 × 32.7 cm). The Metropolitan Museum of Art, New York, Gift of Reiss-Cohen Inc., 1985 (1985.1165.38)

crayon and change everything! After this sort of treatment the design generally becomes indecipherable and is destroyed. But, with him! Each time it would turn out very well."[14] One of the prints made with Mourlot, *David and Bathsheba, after Lucas Cranach* (cat. P90; fig. 6), executed in ten states, captures the cinematic quality of much of Picasso's printmaking.

While Picasso experimented with color in his lithographs, he did not explore its full potential until his work in linoleum cut, which began in earnest in 1958. That year he purchased the Château de Vauvenargues, near Aix-en-Provence, and relocated permanently to the south of France, with little desire to return to Paris. His move to the south stifled his print production; shuttling lithographic stones and etching plates back and

forth between home and Paris became too troublesome, and he had little patience for the resulting delays that would slow down his creative process. Eager to continue printmaking and always open to new techniques, Picasso turned to the linoleum cut (or linocut). He had first discovered the relief process in 1951, using it to produce an annual poster for the town of Vallauris that advertised its famed ceramic exhibitions and bullfights (see, for example, cats. P100, P101). Thanks to a generous gift by Mr. and Mrs. Charles Kramer in 1979, the Museum has a nearly comprehensive collection of the more than 150 linoleum cuts Picasso executed between 1958 and 1964 with the assistance of the Vallauris printer Hidalgo Arnéra. Picasso, who focused almost obsessively on this medium, was particularly attracted to its malleable surface, which yielded fluid lines and broad areas of flat, opaque color. One of his most complex linocuts, and the first of 1958, *Portrait of a Woman, after Lucas Cranach II* (cat. P121; see fig. 8 in the essay by Gary Tinterow in this volume), required that he cut six separate blocks, one for each distinct color: black, red, green, yellow, brown, and blue. Dissatisfied with the print's imperfect registration and even more with its laborious process, Picasso invented a revolutionary way of printing a multi-colored image from a single matrix, now known as the reductive linocut.[15] Arnéra commented insightfully on Picasso's ability to solve problems: "He had a sort of aggressive delight in encountering an obstacle and surmounting and conquering it. Difficulty, moreover, by providing experience, gave him a jumping off point from which to conquer fresh fields."[16]

The themes of Picasso's linoleum cuts are diverse but not unfamiliar from his other works. From portraits of his last wife, Jacqueline, and pastoral scenes of bacchanalia to clowns

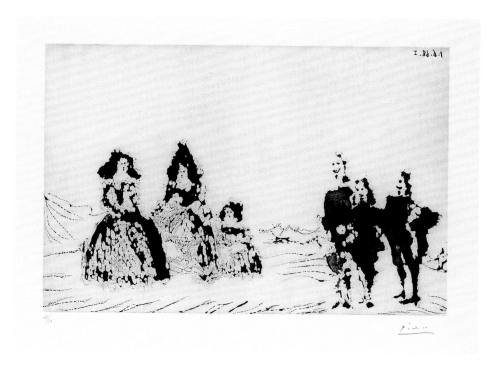

Fig. 9 (cat. P307). Pablo Picasso, *Las Meninas and Gentlemen in the Sierra*, from *347 Suite*, 1968. Sugar-lift aquatint, plate: 13¼ × 19⁷⁄₁₆ in. (33.7 × 49.4 cm), sheet: 19¾ × 25¹¹⁄₁₆ in. (50.2 × 65.3 cm). The Metropolitan Museum of Art, New York, Gift of Reiss-Cohen Inc., 1985 (1985.1165.28)

and still lifes, he rethought each image in vivid color. Picasso also made several, mostly earthen-colored linocuts of the bull-fight, a culturally rich and significant subject for him, that evoke Goya's *La Tauromachia*, and he appropriated subjects from other artists, including Rembrandt, El Greco, and Manet. In particular, he pursued Manet's *Le déjeuner sur l'herbe*, executing several variations (cats. P179, P184, P221, P222, P336, P384; fig. 7) in addition to a ceramic plaque of one of the linocut blocks (cat. C1). The process used to make this editioned ceramic plaque, one of ten in the Museum's collection (see cats. C1–C10), derived from printmaking rather than from traditional ceramic techniques (see the note by Metropolitan conservator Kendra Roth on p. 317). A plaster mold was taken of the artist's carved linoleum, and the mold served as a block for the ceramic edition. Picasso, who considered the plaques essentially graphic works printed on clay—an extension of his linocut practice—was excited by the challenge of adding a support other than paper to the mix. "If I engrave your thigh," he declared, "that's engraving too!"[17]

The cyclical or serial nature of Picasso's graphic work in terms of subject matter and technique was central to his practice. According to John Richardson, Picasso's oeuvre "has to be seen not as a succession of finished works but as a series of series, an open-ended process."[18] The artist confirmed this idea in his often-quoted remark that "in finishing a work you kill it."[19] This culminated in his 1968 suite of intaglio prints, *347*, where Picasso revisited, often with great wit, early subject matter (most notably, the blind old procuress Célestine) and influences, challenging the most revered old masters in an attempt to establish his rightful place alongside them.[20]

Picasso returned to his favored intaglio techniques for the creation of this suite thanks to the arrival in Mougins of the master printers Aldo and Piero Crommelynck, with whom he had worked in Lacourière's Paris workshop. In order to be at Picasso's disposal, the brothers established their own small shop a mile and a half away from the artist's home, Notre-Dame-de-Vie. The Crommelyncks were more than just Picasso's printers; they became intimate members of his coterie; he even depicted them in several prints from the period. In the *347 Suite* Picasso employed etching, drypoint, and aquatint with virtuosity, but his greatest achievements were made in sugar-lift aquatint, a technique he turned on its head by wildly subjecting it to unconventional treatment.[21] The artist attained astounding results, most notably a sublime sense of surface texture and a wide range of tonality. Many of these images, often devoid of line, seem to emerge miraculously from pools of murky ink and possess an otherworldly air (figs. 8, 9). Close to half of the suite is represented in the Museum's collection (cats. P260–P389).

According to Aldo Crommelynck, Picasso never dismissed or abandoned a plate as a technical failure.[22] Instead, he would work arduously to save it, frequently scraping away parts of the old image to create a new one. Moreover, Picasso, ever hopeful of seeing what could materialize from such a destructive act, did not pass this painstaking task on to an assistant. As early as 1935 the artist recognized this idea as central to his working method: "In the old days pictures went forward toward completion by stages. . . . A picture used to be a sum of additions. In my case a picture is a sum of destructions. I do a picture—then destroy it. It would be very interesting to preserve photographically, not the stages, but the metamorphoses of a picture."[23] Picasso's uncanny ability to push past failure, and not only to embrace the medium but also to challenge it, is what unites him with such great printmakers as Dürer, Rembrandt, and Goya. Indeed, it is arguably alongside these masters that the full bloom of Picasso's graphic oeuvre—its breadth as well as its grand ambitions—can best be appreciated.

1. Crommelynck 1995, p. 16.
2. For a complete accounting of Picasso's prints, see Geiser and Baer 1933–96 and Mourlot 1950–64.
3. Crommelynck 1995, p. 16.
4. A gift of ten color pochoirs that reproduce gouache drawings made by Picasso between 1919 and 1922 was given to the Museum by Paul J. Sachs in 1922. This early gift of reproductive prints is not included on the checklist of Picasso's original prints in the Museum's collection in this volume.
5. During A. Hyatt Mayor's twenty-year tenure as curator of the Print Room (1946–66), he preferred not to purchase prints for the Museum's collection that could be found in neighboring collections; see Janet S. Byrne, Colta Ives, and Mary L. Myers in Mayor 1983, p. 10.
6. Richardson 1991–2007, vol. 1 (1991), p. 137.
7. Brigitte Baer in Dallas and other cities 1983–84, p. 34; Richardson 1991–2007, vol. 1 (1991), pp. 424–25.
8. Steel-facing is a process in which a thin layer of iron is deposited by electroplating on the surface of a copperplate—after engraving but before printing—to prevent deterioration of the plate. Vollard steel-faced Picasso's etched plates so that they would stand up to the large editions (generally 250) of his publications. Picasso disliked the effects of steel-facing, however, believing that it deadened the image.
9. The Museum's impression of *Still Life with a Fruit Bowl* is from the edition of one hundred published by Daniel-Henry Kahnweiler, who published many of Picasso's Cubist prints after they were printed.
10. Crommelynck 1995, p. 16.
11. Baer in Dallas and other cities 1983–84, pp. 72–74.
12. For detailed explanations of these and other print processes, see Gascoigne 1986.
13. Lieberman 1952, p. 7.
14. Mourlot 1970, unpaginated.
15. For a detailed explanation of the linocut process, see Karshan 1968, pp. x–xii.
16. Arnéra quoted by Patrick Elliot in Edinburgh 2007, p. 22.
17. Picasso quoted in Bloch 1972, p. 7.
18. Richardson 1988, p. 37.
19. Picasso quoted in ibid.
20. For a discussion of the iconography of the *347 Suite*, see Holloway 2006; Janie Cohen in Burlington 1995; and Baer 1988.
21. For a discussion of Picasso's experimental techniques, see Crommelynck 1995, pp. 14–15, and Baer in Dallas and other cities 1983–84, pp. 174–85.
22. Crommelynck 1995, p. 15.
23. Picasso quoted in Zervos 1935c, translated by Myfanwy Evans in Barr 1946, p. 272.

Prints

The checklist of prints is organized chronologically according to the order established by the catalogues raisonnés of Picasso's graphic oeuvre by Georges Bloch (1971) and by Bernhard Geiser and Brigitte Baer (1933–96). Within each date or range of dates (for example, 1926 or 1926–27), works follow Bloch order except when a new date has been established by Baer. Works not published in either catalogue, including posters, appear at the end of each respective date range.

Printing dates are noted in parentheses for works that were editioned after Picasso executed the plate. In some cases, such as the prints known as the *caisse à remords* (see the essay by Samantha Rippner in this volume), the printing date does not correspond to the publication date. For a full accounting of publication dates, consult the catalogues raisonnés cited in the checklist.

Catalogues Raisonnés

Bloch
Georges Bloch. *Pablo Picasso: Catalogue de l'oeuvre gravé et lithographié, 1904–1967*. 2nd ed. 2 vols. Bern, 1971.

Czwiklitzer
Christophe Czwiklitzer. *Pablo Picasso, Plakate, 1923–1973: Werkverzeichnis*. Munich, 1981.

Geiser/Baer
Bernhard Geiser and Brigitte Baer. *Picasso: Peintre-graveur*. 7 vols., and suppl. Bern, 1933–96.

MMA
Picasso Linoleum Cuts: The Mr. and Mrs. Charles Kramer Collection in The Metropolitan Museum of Art. Exhibition, The Metropolitan Museum of Art, New York, March 7–May 12, 1985. Catalogue by William S. Lieberman; catalogue entries by L. Donald McVinney. New York, 1985.

Mourlot
Fernand Mourlot. *Picasso: Lithographie*. 4 vols. Monte Carlo, 1950–64.

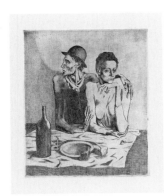

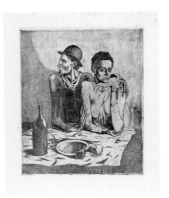

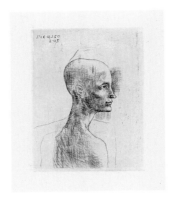

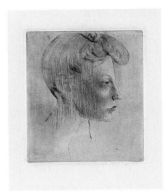

P1.

The Frugal Repast

1904 (printed 1913)

Printed by Louis Fort
Published by Ambroise Vollard, Paris
Etching
Plate, 18¼ × 14⅞ in. (46.4 ×
37.8 cm); sheet, 25¹¹⁄₁₆ × 19¹¹⁄₁₆ in.
(65.2 × 50 cm)
Bloch 1; Geiser/Baer 2.II.b.2
Harris Brisbane Dick Fund, 1923
23.31.1

P2.

The Frugal Repast

1904 (printed 1913)

Printed by Louis Fort
Published by Ambroise Vollard, Paris
Etching
Plate, 18¼ × 14⅞ in. (46.4 ×
37.8 cm); sheet, 25¹¹⁄₁₆ × 19¹¹⁄₁₆ in.
(65.2 × 50 cm)
Bloch 1; Geiser/Baer 2.II.b.2
Bequest of Scofield Thayer, 1982
1984.1203.109

P3.

Bust of a Man

1905 (printed 1913)

Printed by Louis Fort
Published by Ambroise Vollard, Paris
Drypoint
Plate, 4¾ × 3⁹⁄₁₆ in. (12 × 9.1 cm);
sheet, 14⅝ × 11⅝ in. (37.1 × 29.5 cm)
Bloch 4; Geiser/Baer 5.b.2
Gift of Mrs. Maurice E. Blin, 1977
1977.582.10

P4.

Head of a Woman, in Profile

1905 (printed 1913)

Printed by Louis Fort
Published by Ambroise Vollard, Paris
Drypoint
Plate, 11½ × 9⅞ in. (29.2 × 25.1 cm);
sheet, 19¾ × 18⅛ in. (50.2 × 46.1 cm)
Bloch 6; Geiser/Baer 7.b.2
Gift of Mrs. Maurice E. Blin, 1977
1977.582.11

P5.

Saltimbanques

1905 (printed 1913)

Printed by Louis Fort
Published by Ambroise Vollard, Paris
Drypoint
Plate, 11⁵⁄₁₆ × 12¹⁵⁄₁₆ in. (28.7 ×
32.9 cm); sheet, 14¹⁵⁄₁₆ × 21³⁄₁₆ in.
(37.9 × 53.8 cm)
Bloch 7; Geiser/Baer 9.II.b.2
Rogers Fund, 1922
22.112.7

P6.

Seated Saltimbanque

1905 (printed 1913)

Printed by Louis Fort
Published by Ambroise Vollard, Paris
Drypoint
Plate, 4¾ × 3½ in. (12.1 × 8.9 cm);
sheet, 20 × 12¾ in. (50.8 × 32.4 cm)
Bloch 10; Geiser/Baer 12.b
Bequest of Scofield Thayer, 1982
1984.1203.111

P7.

The Bath

1905 (printed 1913)

Printed by Louis Fort
Published by Ambroise Vollard, Paris
Drypoint
Plate, 13½ × 11¼ in. (34.3 × 28.6 cm);
sheet, 21 × 14⅞ in. (53.3 × 37.8 cm)
Bloch 12; Geiser/Baer 14.b.2
Harris Brisbane Dick Fund, 1923
23.31.2

P8.

The Dance

1905 (printed 1913)

Printed by Louis Fort
Published by Ambroise Vollard, Paris
Drypoint
Plate, 7⁵⁄₁₆ × 9⅛ in. (18.6 × 23.2 cm);
sheet, 10⅞ × 14 in. (27.6 × 35.6 cm)
Bloch 15; Geiser/Baer 18.b.2
Gift of Helen Frankenthaler, 1973
1973.653.2

P9.

At the Circus

1905–6 (printed 1913)

Printed by Louis Fort
Published by Ambroise Vollard, Paris
Drypoint
Plate, 8¹¹⁄₁₆ × 5⁹⁄₁₆ in. (22.1 ×
14.1 cm); sheet, 18½ × 13 in. (47 ×
33 cm)
Bloch 9; Geiser/Baer 11.b.2
Rogers Fund, 1922
22.112.6

P10.

The Watering Place

1906

Printed by Auguste Delâtre
Drypoint
Plate, 4¾ × 7⅜ in. (12.1 × 18.7 cm);
sheet, 8¾ × 12³⁄₁₆ in. (22.2 × 31 cm)
Bloch 8; Geiser/Baer 10.a
Bequest of Scofield Thayer, 1982
1984.1203.110

P11.

The Watering Place

1906 (printed 1913)

Printed by Louis Fort
Published by Ambroise Vollard, Paris
Drypoint
Plate, 4¾ × 7⅜ in. (12.1 × 18.7 cm);
sheet, 13 × 19¼ in. (33 × 48.9 cm)
Bloch 8; Geiser/Baer 10.b.2
Harris Brisbane Dick Fund, 1923
23.50

P12.

Still Life with a Fruit Bowl

1908–9 (printed 1911)

Printed by Auguste Delâtre
Published by Daniel-Henry
Kahnweiler, Paris
Drypoint
Plate, 5⅛ × 4⅜ in. (13 × 11.1 cm);
sheet, 17⅛ × 12¾ in. (43.5 × 32.4 cm)
Bloch 18; Geiser/Baer 22.III.b
Alfred Stieglitz Collection, 1949
49.55.315

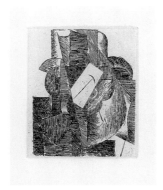
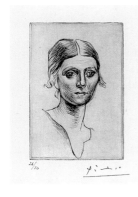
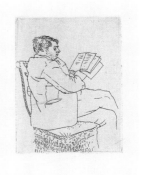

P13.

Man with a Hat

1914 (printed 1947)

From *Du cubisme*, by Albert Gleizes
and Jean Metzinger
Printed by Thirot
Published by Compagnie des Arts
Graphiques, Paris
Etching
Plate, 2¾ × 2¼ in. (7 × 5.7 cm);
overall, 10¼ × 8¼ × ¹³⁄₁₆ in. (26 ×
21 × 2 cm)
Bloch 29; Geiser/Baer 42.B.f
The Elisha Whittelsey Collection,
The Elisha Whittelsey Fund, 1968
68.665.4

P14.

Olga Picasso

1920 (printed 1961)

Printed by Jacques Frélaut
Published by Galerie Louise Leiris,
Paris
Drypoint
Plate, 5⅞ × 3⅞ in. (14.9 × 9.8 cm);
sheet, 12⅞ × 9¾ in. (32.7 × 24.8 cm)
In graphite at lower left: *26/50*
Bloch 37; Geiser/Baer 57.b.1
Gift of Reiss-Cohen Inc., 1983
1983.1212.2

P15.

Cravates de chanvre,
by Pierre Reverdy

1922

Printed by Eugène Delâtre
Published by Éditions NordSud,
Paris
Illustrated book with three etchings,
including *Pierre Reverdy Reading* (ill.)
Plate, 4⅝ × 3½ in. (11.8 × 8.9 cm)
Book (overall), 9⁵⁄₁₆ × 6¹¹⁄₁₆ × ⁹⁄₁₆ in.
(23.6 × 17 × 1.5 cm)
Bloch 46–48; Geiser/Baer 63–65
Harris Brisbane Dick Fund, 1923
23.19.4

P16.

Maternal Joy

1922 (printed 1961)

Printed by Jacques Frélaut
Published by Galerie Louise Leiris,
Paris
Etching
Plate, 3¹⁵⁄₁₆ × 5⅞ in. (10 × 14.9 cm);
sheet, 8⅜ × 10¾ in. (21.3 × 27.3 cm)
In graphite at lower left: *26/50*
Bloch 49; Geiser/Baer 66.B.b.1
Gift of Reiss-Cohen Inc., 1983
1983.1212.3

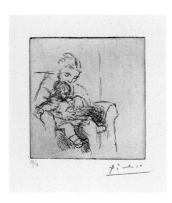

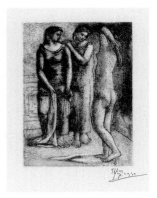

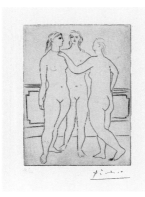

P17.

Mother and Son

1922 (printed 1961)

Printed by Jacques Frélaut
Published by Galerie Louise Leiris,
Paris
Etching
Plate, 5½ × 5 in. (14 × 12.7 cm);
sheet, 12⅞ × 9¹³⁄₁₆ in. (32.7 ×
24.9 cm)
In graphite at lower left: 26/50
Bloch 50; Geiser/Baer 67.B.b.1
Gift of Reiss-Cohen Inc., 1983
1983.1212.4

P18.

Profile I

1922 (printed 1961)

Printed by Jacques Frélaut
Published by Galerie Louise Leiris,
Paris
Drypoint
Plate, 6¹⁄₁₆ × 4½ in. (15.4 × 11.4 cm);
sheet, 12¾ × 9⅝ in. (32.4 × 24.4 cm)
In graphite at lower left: 26/50
Bloch 53; Geiser/Baer 71.III.B.b.1
Gift of Reiss-Cohen Inc., 1983
1983.1212.5

P19.

*Two Women Looking at a
Nude Model*

1923 (printed 1929)

Printed by Leblanc et Trautmann
Published by Marcel Guiot, Paris
Drypoint and etching
Plate, 7 × 5¹⁄₁₆ in. (17.8 × 12.9 cm);
sheet, 15¾ × 11¾ in. (40 × 29.8 cm)
In graphite at lower left: 56/100
Bloch 57; Geiser/Baer 102.VI.a
Harris Brisbane Dick Fund, 1938
38.9

P20.

The Necklace

1923 (printed 1961)

Printed by Jacques Frélaut
Published by Galerie Louise Leiris,
Paris
Drypoint
Plate, 7 × 5⅛ in. (17.8 × 13 cm);
sheet, 12¼ × 9⅝ in. (31.1 × 24.4 cm)
In graphite at lower left: 26/50
Bloch 58; Geiser/Baer 103.B.b.1
Gift of Reiss-Cohen Inc., 1983
1983.1212.8

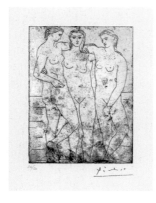

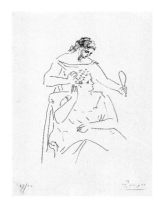

P21.

The Three Bathers II

1923

Printed by Jacques Frélaut
Published by Galerie Louise Leiris,
Paris
Etching
Plate, 7 × 5¹⁄₁₆ in. (17.8 × 12.9 cm);
sheet, 12¼ × 9⁷⁄₁₆ in. (31.1 × 24 cm)
In graphite at lower left: 26/50
Bloch 61; Geiser/Baer 107.B.b.1
Gift of Reiss-Cohen Inc., 1983
1983.1212.9

P22.

La Coiffure

1923

Printed by Charlot Frères
Published by Édition Galerie Simon,
Paris
Lithograph
Image, 10¼ × 6⅝ in. (26 × 16.8 cm);
sheet, 15 × 11⅛ in. (38.1 × 28.3 cm)
In graphite at lower left: 29/50
Bloch 64; Geiser/Baer 234.b
Bequest of Scofield Thayer, 1982
1984.1203.113

P23.

La Toilette

1923

Printed by Charlot Frères
Published by Édition Galerie Simon,
Paris
Lithograph
Image, 10⅛ × 8 in. (25.7 × 20.3 cm);
sheet, 15 × 11 in. (38.1 × 27.9 cm)
In graphite at lower left: 31/50
Bloch 65; Geiser/Baer 235.b
Bequest of Scofield Thayer, 1982
1984.1203.114

P24.

Woman and Child

1923

Printed by Charlot Frères
Published by Édition Galerie Simon,
Paris
Lithograph
Image, 7⅝ × 11½ in. (19.4 ×
29.2 cm); sheet, 11 × 15 in. (27.9 ×
38.1 cm)
In graphite at lower left: 32/50
Bloch 66; Geiser/Baer 236.b
Bequest of Scofield Thayer, 1982
1984.1203.115

P25.

Couple at the Shore

1925 (printed 1961)

Printed by Jacques Frélaut
Published by Galerie Louise Leiris,
Paris
Drypoint
Plate, 3 1/16 × 4 5/8 in. (7.8 × 11.7 cm);
sheet, 9 5/8 × 12 1/4 in. (24.4 × 31.1 cm)
In graphite at lower left: 26/50
Bloch 71; Geiser/Baer 115.B.b.1
Gift of Reiss-Cohen Inc., 1983
1983.1212.10

P26.

*At the River's Shore, Couple
on the Grass*

1925 (printed 1961)

Printed by Jacques Frélaut
Published by Galerie Louise Leiris,
Paris
Drypoint
Plate, 3 × 4 3/4 in. (7.6 × 12.1 cm);
sheet, 9 1/2 × 12 1/8 in. (24.1 × 30.8 cm)
In graphite at lower left: 26/50
Bloch 72; Geiser/Baer 116.B.b.1
Gift of Reiss-Cohen Inc., 1983
1983.1212.11

P27.

Guitar on a Table

1925–26 (printed 1961)

Printed by Jacques Frélaut
Published by Galerie Louise Leiris,
Paris
Etching and drypoint
Plate, 3 1/8 × 4 3/4 in. (7.9 × 12.1 cm);
sheet, 8 1/4 × 11 3/4 in. (21 × 29.8 cm)
In graphite at lower left: 26/50
Bloch 54; Geiser/Baer 72.II.B.b.1
Gift of Reiss-Cohen Inc., 1983
1983.1212.6

P28.

Head of a Man

1925–26 (printed 1961)

Printed by Jacques Frélaut
Published by Galerie Louise Leiris,
Paris
Etching
Plate, 4 5/8 × 3 1/8 in. (11.7 × 7.9 cm);
sheet, 12 1/8 × 9 1/2 in. (30.8 × 24.1 cm)
In graphite at lower left: 26/50
Bloch 55; Geiser/Baer 88.B.b.1
Gift of Reiss-Cohen Inc., 1983
1983.1212.7

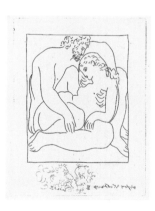
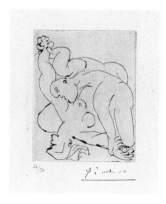

P29.

The Nude Model

1927 (printed after 1932)

Printed by Leblanc et Trautmann
Published by Édition Société
des Amateurs d'Art et des
Collectionneurs
Etching
Plate, 10 15/16 × 7 9/16 in. (27.8 ×
19.2 cm); sheet, 14 3/4 × 11 1/4 in.
(37.5 × 28.6 cm)
In graphite at lower left: 29/40
Bloch 78; Geiser/Baer 119.II.c
Harris Brisbane Dick Fund, 1930
30.96.11

P30.

*Nude Woman Crowned
with Flowers*

1929

Printed by Louis Fort
Etching
Plate, 11 × 7 5/8 in. (27.9 × 19.4 cm);
sheet, 15 × 11 in. (38.1 × 27.9 cm)
In graphite at lower left: pour Paul
Rosenberg/Picasso
In graphite at lower right: 1ere
épreuve/avant acierage/sur le vernis
Bloch 97; Geiser/Baer 142.A
Gift of Mr. and Mrs. Alexandre
Rosenberg, 1981
1981.1234

P31.

Metamorphoses, by Ovid

1931

Printed by Louis Fort
Published by Albert Skira, Lausanne
Illustrated book with an additional
suite of 30 etchings with remarques,
including *Love of Jupiter and Semele*
(ill.)
Plate sizes vary, each approximately
12 1/4 × 8 3/4 in. (31.1 × 22.2 cm)
Sheet sizes vary, each approximately
13 × 10 1/4 in. (33 × 26 cm)
Book (overall), 13 × 10 1/4 × 2 1/2 in.
(33 × 26 × 6.4 cm)
Bloch 99–128; Geiser/Baer 143–172
Purchase, Anne Cox Chambers Gift,
2003
2003.422a-uuuuuu

P32.

The Rape I

1932 (printed 1961)

Printed by Jacques Frélaut
Published by Galerie Louise Leiris,
Paris
Drypoint
Plate, 4 13/16 × 3 5/8 in. (12.2 × 9.2 cm);
sheet, 11 5/8 × 8 1/4 in. (29.5 × 21 cm)
In graphite at lower left: 26/50
Bloch 239; Geiser/Baer 264.B.b
Gift of Reiss-Cohen Inc., 1983
1983.1212.12

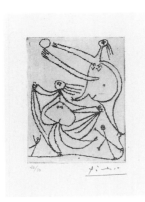

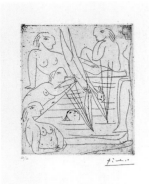

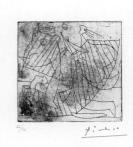

P33.

The Beach III

1932 (printed 1961)

Printed by Jacques Frélaut
Published by Galerie Louise Leiris,
Paris
Etching
Plate, 6¹⁄₁₆ × 4⁹⁄₁₆ in. (15.4 ×
11.6 cm); sheet, 12⅛ × 9½ in.
(30.8 × 24.1 cm)
In graphite at lower left: 26/50
Bloch 240; Geiser/Baer 267.C
Gift of Reiss-Cohen Inc., 1983
1983.1212.13

P34.

Bathing

1932 (printed 1961)

Printed by Jacques Frélaut
Published by Galerie Louise Leiris,
Paris
Etching
Plate, 9 × 7⅜ in. (22.8 × 18.8 cm);
sheet, 17⅝ × 12⅞ in. (44.7 ×
32.7 cm)
In graphite at lower left: 26/50
Bloch 242; Geiser/Baer 270.B.b
Gift of Reiss-Cohen Inc., 1983
1983.1212.14

P35.

The Ball Players

1932 (printed 1961)

Printed by Jacques Frélaut
Published by Galerie Louise Leiris,
Paris
Etching
Plate, 4⅜ × 4⅜ in. (11.1 × 11.1 cm);
sheet, 12⅛ × 9⁹⁄₁₆ in. (30.8 × 24.3 cm)
In graphite at lower left: 26/50
Bloch 243; Geiser/Baer 271.B.b
Gift of Reiss-Cohen Inc., 1983
1983.1212.15

P36.

The Rescue I

1932 (printed 1961)

Printed by Jacques Frélaut
Published by Galerie Louise Leiris,
Paris
Etching
Plate, 6¼ × 7⅝ in. (15.9 × 19.4 cm);
sheet, 9⅞ × 12¹³⁄₁₆ in. (25.1 × 32.5 cm)
In graphite at lower left: 26/50
Bloch 244; Geiser/Baer 272.C
Gift of Reiss-Cohen Inc., 1983
1983.1212.16

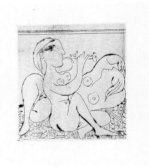

P37.

The Rescue III

1932 (printed 1961)

Printed by Jacques Frélaut
Published by Galerie Louise Leiris,
Paris
Etching
Plate, 8¹⁄₁₆ × 8¹⁵⁄₁₆ in. (20.5 ×
22.7 cm); sheet, 13 × 17¹¹⁄₁₆ in.
(33 × 44.9 cm)
In graphite at lower left: 26/50
Bloch 246; Geiser/Baer 274.B.b
Gift of Reiss-Cohen Inc., 1983
1983.1212.17

P38.

*Surrealist Figures on the
Beach*

1932 (printed 1961)

Printed by Jacques Frélaut
Published by Galerie Louise Leiris,
Paris
Soft-ground etching
Plate, 6¹¹⁄₁₆ × 6¹³⁄₁₆ in. (17 ×
17.3 cm); sheet, 12⅞ × 9⅝ in.
(32.7 × 24.4 cm)
In graphite at lower left: 26/50
Bloch 247; Geiser/Baer 276.B.b
Gift of Reiss-Cohen Inc., 1983
1983.1212.18

P39.

*Flutist and Sleeping
Woman II*

1933 (printed 1970)

Printed by Jacques Frélaut
Published by Galería Colibrí,
San Juan
Drypoint
Plate, 3½ × 3⅛ in. (8.9 × 7.9 cm);
sheet, 12¾ × 9¾ in. (32.4 × 24.8 cm)
Geiser/Baer 292 III
Bequest of William S. Lieberman,
2005
2007.49.470

P40.

Head of a Woman

1933 (printed 1961)

Printed by Jacques Frélaut
Published by Galerie Louise Leiris,
Paris
Drypoint
Plate, 12⁹⁄₁₆ × 9 in. (31.9 × 22.9 cm);
sheet, 18⁹⁄₁₆ × 14¾ in. (47.1 ×
37.5 cm)
In graphite at lower left: 26/50
Bloch 250; Geiser/Baer 288.XX.C.b
Gift of Reiss-Cohen Inc., 1983
1983.1212.19

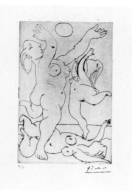
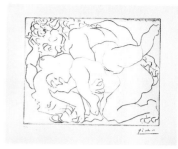

P41.

Head of a Woman Turned to the Right
1933 (printed 1961)

Printed by Jacques Frélaut
Published by Galerie Louise Leiris, Paris
Soft-ground etching
Plate, 2¹³⁄₁₆ × 2³⁄₈ in. (7.1 × 6 cm); sheet, 11¹¹⁄₁₆ × 8³⁄₈ in. (29.7 × 21.3 cm)
In graphite at lower left: 26/50
Bloch 252; Geiser/Baer 290.II.B.b
Gift of Reiss-Cohen Inc., 1983
1983.1212.20

P42.

Sculptured Bust on a Pedestal
1933 (printed 1961)

Printed by Jacques Frélaut
Published by Galerie Louise Leiris, Paris
Etching, aquatint, and drypoint
Plate, 4¹⁵⁄₁₆ × 1³⁄₁₆ in. (12.5 × 3 cm); sheet, 10¾ × 8⁵⁄₁₆ in. (27.3 × 21.1 cm)
In graphite at lower left: 26/50
Bloch 253; Geiser/Baer 291.XIII.C.b
Gift of Reiss-Cohen Inc., 1983
1983.1212.21

P43.

Game on the Beach
1933 (printed 1961)

Printed by Jacques Frélaut
Published by Galerie Louise Leiris, Paris
Drypoint
Plate, 11 × 7 in. (27.9 × 17.8 cm); sheet, 17⅝ × 12¹⁵⁄₁₆ in. (44.8 × 32.9 cm)
In graphite at lower left: 26/50
Bloch 254; Geiser/Baer 293.B.b
Gift of Reiss-Cohen Inc., 1983
1983.1212.22

P44.

Minotaur Raping a Woman
1933 (printed 1961)

Printed by Jacques Frélaut
Published by Galerie Louise Leiris, Paris
Drypoint
Plate, 11¾ × 14⅜ in. (29.8 × 36.5 cm); sheet, 16³⁄₁₆ × 20⅝ in. (41.1 × 52.4 cm)
In graphite at lower left: 26/50
Bloch 262; Geiser/Baer 372.B.b
Gift of Reiss-Cohen Inc., 1983
1983.1212.23

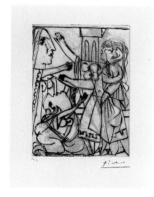
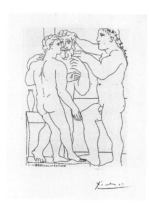
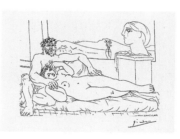
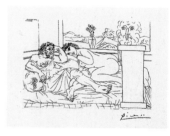

P45.

The Women's Lament, from *Lysistrata* by Aristophanes
1933 (printed 1961)

Printed by Jacques Frélaut
Published by Galerie Louise Leiris, Paris (unpublished in 1934 book or suite; see cats. P53–58)
Aquatint, burin, and drypoint
Plate, 11 × 7⅞ in. (27.9 × 20 cm); sheet, 17⅞ × 12¹³⁄₁₆ in. (45.4 × 32.5 cm)
In graphite at lower left: 26/50
Bloch 1328; Geiser/Baer 393.IV.C.b
Gift of Reiss-Cohen Inc., 1983
1983.1212.24

P46.

Two Sculptured Men, from the *Vollard Suite*
1933 (printed 1939)

Printed by Roger Lacourière
Published by Ambroise Vollard, Paris
Etching
Plate, 10⅝ × 7⅝ in. (27 × 19.4 cm); sheet, 17½ × 13⁵⁄₁₆ in. (44.5 × 33.8 cm)
Bloch 161; Geiser/Baer 314.II.c
Gift of Ann E. Kripke, 1960
60.722

P47.

The Sculptor at Rest II, from the *Vollard Suite*
1933 (printed 1939)

Printed by Roger Lacourière
Published by Ambroise Vollard, Paris
Etching
Plate, 7⅝ × 10½ in. (19.3 × 26.7 cm); sheet, 13⅜ × 17⁹⁄₁₆ in. (33.9 × 44.6 cm)
Bloch 172; Geiser/Baer 325.II.c
Bequest of Jane Costello Goldberg, 1986
1987.1173.2

P48.

The Sculptor at Rest IV, from the *Vollard Suite*
1933 (printed 1939)

Printed by Roger Lacourière
Published by Ambroise Vollard, Paris
Etching
Plate, 7⁹⁄₁₆ × 10½ in. (19.2 × 26.6 cm); sheet, 13¼ × 17⁷⁄₁₆ in. (33.7 × 44.3 cm)
Bloch 174; Geiser/Baer 327.II.c
Gift of Mrs. Maurice E. Blin, 1977
1977.582.12

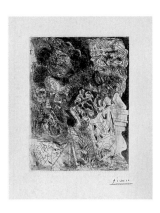

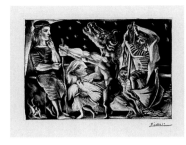

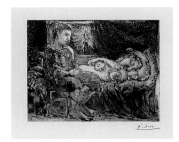

P49.

Rembrandt with a Palette, from the *Vollard Suite*
1934 (printed 1939)

Printed by Roger Lacourière
Published by Ambroise Vollard, Paris
Etching
Plate, 10¹⁵⁄₁₆ × 7¹³⁄₁₆ in. (27.8 × 19.8 cm); sheet, 17⁹⁄₁₆ × 13⁷⁄₁₆ in. (44.6 × 34.1 cm)
Bloch 208; Geiser/Baer 406.III.c
Gift of Mr. and Mrs. David Tunick, 1984
1984.1199.1

P50.

Heads and Entangled Figures, from the *Vollard Suite*
1934 (printed 1939)

Printed by Roger Lacourière
Published by Ambroise Vollard, Paris
Etching
Plate, 11 × 7¾ in. (27.9 × 19.7 cm); sheet, 17⅝ × 13¼ in. (44.8 × 33.7 cm)
Bloch 211; Geiser/Baer 410.II.c
Florence and Joseph Singer Collection, 1970
1970.734.3

P51.

Blind Minotaur Led by a Girl through the Night, from the *Vollard Suite*
1934 (printed 1939)

Printed by Roger Lacourière
Published by Ambroise Vollard, Paris
Aquatint
Plate, 9½ × 13⅝ in. (24.1 × 34.6 cm); sheet, 13⅜ × 17⅝ in. (34 × 44.8 cm)
Bloch 225; Geiser/Baer 437.IV.c
Purchase, Reba and Dave Williams Gift, 1997
1997.408

P52.

Boy and Sleeping Girl by Candlelight, from the *Vollard Suite*
1934 (printed 1939)

Printed by Roger Lacourière
Published by Ambroise Vollard, Paris
Etching and aquatint
Plate, 9⅜ × 11⅝ in. (23.8 × 29.5 cm); sheet, 13½ × 17⅝ in. (34.3 × 44.8 cm)
Bloch 226; Geiser/Baer 440.IV.c
Purchase, Reba and Dave Williams Gift, 1997
1997.407

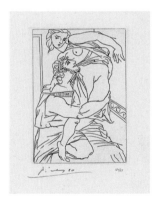

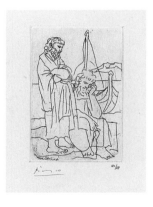

P53.

Oath of Women, from *Lysistrata* by Aristophanes
1934

Printed by Roger Lacourière
Published by The Limited Editions Club, New York
Etching and aquatint
Plate, 8¹¹⁄₁₆ × 5¾ in. (22.1 × 14.6 cm); sheet, 15⅛ × 11⅛ in. (38.4 × 28.3 cm)
In graphite at lower right: 150/67
Bloch 267; Geiser/Baer 387.II.b
Gift of David A. Prager, in memory of Henry G. Schiff, 1984
1984.1038.1(1)

P54.

Couple and Child, from *Lysistrata* by Aristophanes
1934

Printed by Roger Lacourière
Published by The Limited Editions Club, New York
Etching
Plate, 8⅛ × 5⅜ in. (20.6 × 13.7 cm); sheet, 15⅛ × 11¹⁄₁₆ in. (38.4 × 28.1 cm)
In graphite at lower right: 150/67
Bloch 268; Geiser/Baer 388.B
Gift of David A. Prager, in memory of Henry G. Schiff, 1984
1984.1038.1(2)

P55.

Cinésias and Myrrhine, from *Lysistrata* by Aristophanes
1934

Printed by Roger Lacourière
Published by The Limited Editions Club, New York
Etching
Plate, 8⅜ × 5¾ in. (21.3 × 14.6 cm); sheet, 15⅛ × 11⅛ in. (38.4 × 28.3 cm)
In graphite at lower right: 150/67
Bloch 269; Geiser/Baer 389.II.B
Gift of David A. Prager, in memory of Henry G. Schiff, 1984
1984.1038.1(3)

P56.

Two Old Men and a Sailboat, from *Lysistrata* by Aristophanes
1934

Printed by Roger Lacourière
Published by The Limited Editions Club, New York
Etching
Plate, 8¼ × 5½ in. (21 × 14 cm); sheet, 15⅛ × 11¹⁄₁₆ in. (38.4 × 28.1 cm)
In graphite at lower right: 150/67
Bloch 270; Geiser/Baer 390.B
Gift of David A. Prager, in memory of Henry G. Schiff, 1984
1984.1038.1(4)

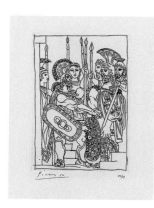

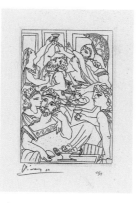

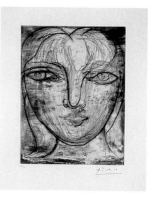

P57.

Accord between the Warriors of Sparta and Athens, from *Lysistrata* by Aristophanes
1934

Printed by Roger Lacourière
Published by The Limited Editions Club, New York
Etching
Plate, 8½ × 5⅞ in. (21.6 × 14.9 cm); sheet, 15⅛ × 11⅛ in. (38.4 × 28.3 cm)
In graphite at lower right: 150/67
Bloch 271; Geiser/Baer 391.II.B
Gift of David A. Prager, in memory of Henry G. Schiff, 1984
1984.1038.1(5)

P58.

The Feast, from *Lysistrata* by Aristophanes
1934

Printed by Roger Lacourière
Published by The Limited Editions Club, New York
Etching
Plate, 8½ × 5⅝ in. (21.6 × 14.3 cm); sheet, 15⅛ × 11¹⁄₁₆ in. (38.4 × 28.1 cm)
In graphite at lower right: 150/67
Bloch 272; Geiser/Baer 392.II.b
Gift of David A. Prager, in memory of Henry G. Schiff, 1984
1984.1038.1(6)

P59.

Reclining Nude Woman
1934 (printed 1961)

Printed by Jacques Frélaut
Published by Galerie Louise Leiris, Paris
Etching and drypoint
Plate, 5⁷⁄₁₆ × 8³⁄₁₆ in. (13.8 × 20.8 cm); sheet, 8⁵⁄₁₆ × 11¾ in. (21.1 × 29.8 cm)
In graphite at lower left: 26/50
Bloch 273; Geiser/Baer 403.C
Gift of Reiss-Cohen Inc., 1983
1983.1212.25

P60.

Head, Full Face
1934 (printed 1961)

Printed by Jacques Frélaut
Published by Galerie Louise Leiris, Paris
Drypoint
Plate, 12⅜ × 9 in. (31.4 × 22.9 cm); sheet, 19¾ × 15¾ in. (50.2 × 40 cm)
In graphite at lower left: 26/50
Bloch 276; Geiser/Baer 417.II.C.b
Gift of Reiss-Cohen Inc., 1983
1983.1212.26

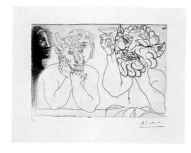

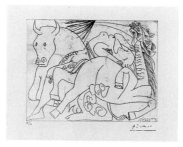

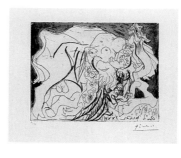

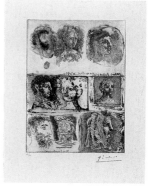

P61.

Young Man with a Bull's Mask, Faun, and Profile of a Woman
1934 (printed 1961)

Printed by Jacques Frélaut
Published by Galerie Louise Leiris, Paris
Etching
Plate, 8¾ × 12³⁄₁₆ in. (22.2 × 31 cm); sheet, 15¾ × 20 in. (40 × 50.8 cm)
In graphite at lower left: 26/50
Bloch 279; Geiser/Baer 422.C.b
Gift of Reiss-Cohen Inc., 1983
1983.1212.27

P62.

Female Torero IV
1934 (printed 1961)

Printed by Jacques Frélaut
Published by Galerie Louise Leiris, Paris
Etching
Plate, 9⅜ × 11¾ in. (23.8 × 29.8 cm); sheet, 14 × 20 in. (35.6 × 50.8 cm)
In graphite at lower left: 26/50
Bloch 280; Geiser/Baer 428.b
Gift of Reiss-Cohen Inc., 1983
1983.1212.28

P63.

Female Torero V
1934 (printed 1961)

Printed by Jacques Frélaut
Published by Galerie Louise Leiris, Paris
Etching
Plate, 9⅜ × 11¾ in. (23.8 × 29.8 cm); sheet, 14 × 20⁹⁄₁₆ in. (35.6 × 52.2 cm)
In graphite at lower left: 26/50
Bloch 281; Geiser/Baer 429.B.b
Gift of Reiss-Cohen Inc., 1983
1983.1212.29

P64.

Nine Heads
1934 (printed 1961)

Printed by Jacques Frélaut
Published by Galerie Louise Leiris, Paris
Etching, drypoint, and sugar-lift aquatint
Plate, 12½ × 8⅞ in. (31.8 × 22.5 cm); sheet, 19½ × 12⅞ in. (49.5 × 32.7 cm)
In graphite at lower left: 26/50
Bloch 285; Geiser/Baer 438.B.b
Gift of Reiss-Cohen Inc., 1983
1983.1212.30

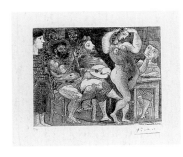
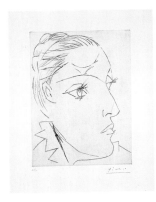
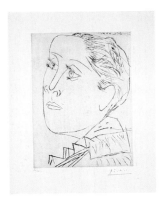

P65.

At the Cabaret
1934 (printed 1961)

Printed by Jacques Frélaut
Published by Galerie Louise Leiris,
Paris
Etching
Plate, 9⅜ × 11¾ in. (23.8 × 29.8 cm);
sheet, 16 × 19¾ in. (40.6 × 50.2 cm)
In graphite at lower left: 26/50
Bloch 286; Geiser/Baer 439.C.b
Gift of Reiss-Cohen Inc., 1983
1983.1212.31

P66.

Dora Maar with a Chignon I
1936 (printed 1961)

Printed by Jacques Frélaut
Published by Galerie Louise Leiris,
Paris
Drypoint
Plate, 13⅝ × 9¹¹⁄₁₆ in. (34.6 ×
24.6 cm); sheet, 20⅛ × 15⅞ in.
(51.1 × 40.3 cm)
In graphite at lower left: 26/50
Bloch 291; Geiser/Baer 611.C.b.1
Gift of Reiss-Cohen Inc., 1983
1983.1212.32

P67.

Dora Maar with a Chignon II
1936 (printed 1961)

Printed by Jacques Frélaut
Published by Galerie Louise Leiris,
Paris
Drypoint
Plate, 13⁹⁄₁₆ × 9¾ in. (34.4 × 24.8 cm);
sheet, 20 × 15¾ in. (50.8 × 40 cm)
In graphite at lower left: 26/50
Bloch 292; Geiser/Baer 612.C.b.1
Gift of Reiss-Cohen Inc., 1983
1983.1212.33

P68.

Ass, from *Picasso:
Original Etchings for
the Texts of Buffon*
1936 (printed 1942)

Printed by Roger Lacourière
Published by Martin Fabiani, Paris
Sugar-lift aquatint and etching
Image (plate mark trimmed), 10½ ×
8 in. (26.7 × 20.3 cm); sheet, 14⅜ ×
10¾ in. (36.5 × 27.3 cm)
Bloch 329; Geiser/Baer 576.IV.B.b
Purchase, Reba and Dave Williams
Gift, 1997
1997.385.1

P69.

Ram, from *Picasso:
Original Etchings for
the Texts of Buffon*
1936 (printed 1942)

Printed by Roger Lacourière
Published by Martin Fabiani, Paris
Sugar-lift aquatint and drypoint
Image (plate mark trimmed), 10⅝ ×
8 in. (27 × 20.3 cm); sheet, 14⅜ ×
10¾ in. (36.5 × 27.3 cm)
Bloch 332; Geiser/Baer 579.II.B.b
Purchase, Reba and Dave Williams
Gift, 1997
1997.385.2

P70.

Cat, from *Picasso:
Original Etchings for
the Texts of Buffon*
1936 (printed 1942)

Printed by Roger Lacourière
Published by Martin Fabiani, Paris
Sugar-lift aquatint and drypoint
Image (plate mark trimmed), 10½ ×
8¹⁄₁₆ in. (26.6 × 20.5 cm); sheet,
14⅜ × 10¾ in. (36.5 × 27.3 cm)
Bloch 333; Geiser/Baer 580.II.B.b
Purchase, Reba and Dave Williams
Gift, 1997
1997.385.3

P71.

Wolf, from *Picasso:
Original Etchings for
the Texts of Buffon*
1936 (printed 1942)

Printed by Roger Lacourière
Published by Martin Fabiani, Paris
Sugar-lift aquatint
Plate, 13⅝ × 9¾ in. (34.6 × 24.8 cm);
sheet, 14⅜ × 10¾ in. (36.5 × 27.3 cm)
Bloch 337; Geiser/Baer 584.B
Purchase, Reba and Dave Williams
Gift, 1997
1997.385.8

P72.

Baboon, from *Picasso:
Original Etchings for
the Texts of Buffon*
1936 (printed 1942)

Printed by Roger Lacourière
Published by Martin Fabiani, Paris
Sugar-lift aquatint and drypoint
Image (plate mark trimmed),
10¹⁵⁄₁₆ × 8⅛ in. (27.8 × 20.6 cm);
sheet, 14⅜ × 10¾ in. (36.5 × 27.3 cm)
Bloch 339; Geiser/Baer 586.II.B.b
Purchase, Reba and Dave Williams
Gift, 1997
1997.385.9

P73.

Vulture, from *Picasso: Original Etchings for the Texts of Buffon*
1936 (printed 1942)

Printed by Roger Lacourière
Published by Martin Fabiani, Paris
Sugar-lift aquatint and drypoint
Image (plate mark trimmed), 10⅝ × 8⅛ in. (27 × 20.7 cm); sheet, 14½ × 11⅛ in. (36.8 × 28.3 cm)
Bloch 341; Geiser/Baer 588.B
Purchase, The Gerta Charitable Trust Gift, 1997
1997.89

P74.

Vulture, from *Picasso: Original Etchings for the Texts of Buffon*
1936 (printed 1942)

Printed by Roger Lacourière
Published by Martin Fabiani, Paris
Sugar-lift aquatint and drypoint
Image (plate mark trimmed), 10⅝ × 8⅛ in. (27 × 20.7 cm); sheet, 14¼ × 10¾ in. (36.2 × 27.3 cm)
Bloch 341; Geiser/Baer 588.B
Purchase, Reba and Dave Williams Gift, 1997
1997.385.10

P75.

Ostrich, from *Picasso: Original Etchings for the Texts of Buffon*
1936 (printed 1942)

Printed by Roger Lacourière
Published by Martin Fabiani, Paris
Sugar-lift aquatint and drypoint
Image (plate mark trimmed), 10⅝ × 8⅜ in. (27 × 21.2 cm); sheet, 14⅜ × 10¾ in. (36.5 × 27.3 cm)
Bloch 343; Geiser/Baer 590.II.B.b
Purchase, Reba and Dave Williams Gift, 1997
1997.385.4

P76.

Mother Hen, from *Picasso: Original Etchings for the Texts of Buffon*
1936 (printed 1942)

Printed by Roger Lacourière
Published by Martin Fabiani, Paris
Etching and aquatint
Image (plate mark trimmed), 10⁹⁄₁₆ × 8¹⁄₁₆ in. (26.9 × 20.5 cm); sheet, 14½ × 11 in. (36.8 × 27.9 cm)
Bloch 345; Geiser/Baer 592.III.B
Purchase, The Gerta Charitable Trust Gift, 1997
1997.87

P77.

Turkey, from *Picasso: Original Etchings for the Texts of Buffon*
1936 (printed 1942)

Printed by Roger Lacourière
Published by Martin Fabiani, Paris
Sugar-lift aquatint and drypoint
Image (plate mark trimmed), 10¹³⁄₁₆ × 7⅞ in. (27.5 × 20 cm); sheet, 14¼ × 10¾ in. (36.2 × 27.3 cm)
Bloch 346; Geiser/Baer 593.IV.B
Purchase, Reba and Dave Williams Gift, 1997
1997.385.5

P78.

Lizard, from *Picasso: Original Etchings for the Texts of Buffon*
1936

Printed by Roger Lacourière
Sugar-lift aquatint and drypoint; first state of two
Image (plate mark trimmed), 10⁹⁄₁₆ × 8⅛ in. (26.8 × 20.7 cm); sheet, 14½ × 11 in. (36.8 × 27.9 cm)
Bloch 355; Geiser/Baer 602.II.B
Purchase, Reba and Dave Williams Gift, 1997
1997.385.6

P79.

Toad, from *Picasso: Original Etchings for the Texts of Buffon*
1936 (printed 1942)

Printed by Roger Lacourière
Published by Martin Fabiani, Paris
Sugar-lift aquatint and drypoint
Image (plate mark trimmed), 10⁹⁄₁₆ × 8¼ in. (26.8 × 21 cm); sheet, 14⅝ × 11 in. (37.1 × 27.9 cm)
Bloch 356; Geiser/Baer 603.II.B.b
Purchase, The Gerta Charitable Trust Gift, 1997
1997.88

P80.

Frogs, from *Picasso: Original Etchings for the Texts of Buffon*
1936 (printed 1942)

Printed by Roger Lacourière
Published by Martin Fabiani, Paris
Sugar-lift aquatint and drypoint
Image (plate mark trimmed), 10⅝ × 8⅛ in. (27 × 20.7 cm); sheet, 14½ × 11 in. (36.8 × 27.9 cm)
Bloch 357; Geiser/Baer 604.II.B
Purchase, Reba and Dave Williams Gift, 1997
1997.385.7

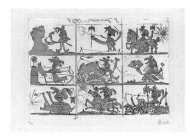 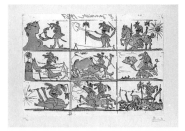

P81.

Dream and Lie of Franco I

1937

Printed by Roger Lacourière
Published by the artist
Etching and sugar-lift aquatint
Plate, 12⁷⁄₁₆ × 16⁹⁄₁₆ in. (31.6 ×
42.1 cm); sheet, 15³⁄₁₆ × 22½ in.
(38.6 × 57.2 cm)
In graphite at lower left: 321/850
Bloch 297; Geiser/Baer 615.II.B.e
Anonymous Gift, 1985
1985.1070.1

P82.

Dream and Lie of Franco I

1937

Printed by Roger Lacourière
Published by the artist
Etching and sugar-lift aquatint
Plate, 12⁷⁄₁₆ × 16⁹⁄₁₆ in. (31.6 × 42 cm);
sheet, 15³⁄₁₆ × 22½ in. (38.6 × 57.2 cm)
In graphite at lower left: 283/850
Bloch 297; Geiser/Baer 615.II.B.e
Gift of Mr. and Mrs. E. Powis Jones,
1986
1986.1224.1(1)

P83.

Dream and Lie of Franco II

1937

Printed by Roger Lacourière
Published by the artist
Etching and sugar-lift aquatint
Plate, 12⁷⁄₁₆ × 16⁹⁄₁₆ in. (31.6 ×
42.1 cm); sheet, 15⅛ × 22⁵⁄₁₆ in.
(38.4 × 56.7 cm)
In graphite at lower left: 321/850
Bloch 298; Geiser/Baer 616.V.B.e
Anonymous Gift, 1985
1985.1070.2

P84.

Dream and Lie of Franco II

1937

Printed by Roger Lacourière
Published by the artist
Etching and sugar-lift aquatint
Plate, 12⁷⁄₁₆ × 16½ in. (31.6 × 41.9 cm);
sheet, 15⅛ × 22⅜ in. (38.4 × 56.8 cm)
In graphite at lower left: 283/850
Bloch 298; Geiser/Baer 616.V.B.e
Gift of Mr. and Mrs. E. Powis Jones,
1986
1986.1224.1(2)

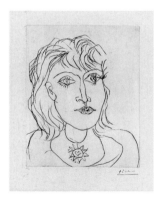 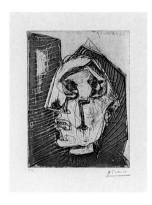 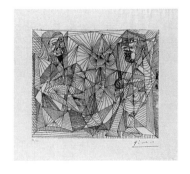 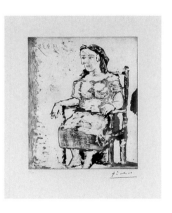

P85.

Dora Maar with a Necklace

1937 (printed 1961)

Printed by Jacques Frélaut
Published by Galerie Louise Leiris,
Paris
Drypoint
Plate, 16⅜ × 12⁹⁄₁₆ in. (41.6 ×
31.9 cm); sheet, 20¹³⁄₁₆ × 16⁵⁄₁₆ in.
(52.9 × 41.4 cm)
In graphite at lower left: 26/50
Bloch 300; Geiser/Baer 628.B.b.1
Gift of Reiss-Cohen Inc., 1983
1983.1212.34

P86.

*Weeping Woman in Front of
a Wall*

1937 (printed 1961)

Printed by Jacques Frélaut
Published by Galerie Louise Leiris,
Paris
Aquatint and drypoint
Plate, 13⅝ × 9¾ in. (34.6 × 24.8 cm);
sheet, 20 × 15¾ in. (50.8 × 40 cm)
In graphite at lower left: 26/50
Bloch 302; Geiser/Baer 630.II.B.b.i
Gift of Reiss-Cohen Inc., 1983
1983.1212.35

P87.

Two Seated Women

1938 (printed 1961)

Printed by Jacques Frélaut
Published by Galerie Louise Leiris,
Paris
Etching
Plate, 9¾ × 10⅞ in. (24.8 × 27.6 cm);
sheet, 14 × 20⅞ in. (35.6 × 53 cm)
In graphite at lower left: 26/50
Bloch 309; Geiser/Baer 645.B.b.i
Gift of Reiss-Cohen Inc., 1983
1983.1212.36

P88.

*Woman in an Armchair:
Dora Maar*

1939 (printed 1961)

Printed by Jacques Frélaut
Published by Galerie Louise Leiris,
Paris
Aquatint and burin
Plate, 11¹³⁄₁₆ × 9⁷⁄₁₆ in. (30 × 24 cm);
sheet, 19⅜ × 16 in. (49.2 × 40.6 cm)
In graphite at lower left: 26/50
Bloch 318; Geiser/Baer 649.II.C.b.1
Gift of Reiss-Cohen Inc., 1983
1983.1212.37

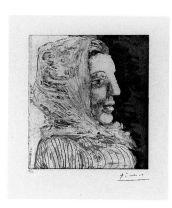

P89.

Bust of a Woman with a Kerchief

1939 (printed 1961)

Printed by Jacques Frélaut
Published by Galerie Louise Leiris, Paris
Aquatint and drypoint
Plate, 10³⁄₁₆ × 8¹³⁄₁₆ in. (25.9 × 22.4 cm); sheet, 19½ × 15⅞ in. (49.5 × 40.4 cm)
In graphite at lower left: 26/50
Bloch 324; Geiser/Baer 672.II.C.b.1
Gift of Reiss-Cohen Inc., 1983
1983.1212.38

P90.

David and Bathsheba, after Lucas Cranach

1947

Printed by Fernand Mourlot
Published by Galerie Louise Leiris, Paris
Lithograph; fourth state of ten
Image, 25⅜ × 18⅞ in. (64.5 × 47.9 cm); sheet, 25¾ × 19¾ in. (65.4 × 50.2 cm)
In graphite at lower left: 36/50
Bloch 441; Mourlot 109
Bequest of William S. Lieberman, 2005
2007.49.603

P91.

World Congress of the Peace Partisans

1949

Printed by Fernand Mourlot
Photolithography
Sheet, 31⁵⁄₁₆ × 23⅜ in. (79.6 × 59.4 cm)
Bloch 583; Mourlot 141; Czwiklitzer 61
Gift of Mr. and Mrs. Albert Mitchell, 1977
1977.512

P92.

The Young Artist

1949

Printed by Fernand Mourlot
Published by Galerie Louise Leiris, Paris
Lithograph; second state of two
Image, 15⁹⁄₁₆ × 11¾ in. (39.5 × 29.8 cm); sheet, 19⁹⁄₁₆ × 15 in. (49.7 × 38.1 cm)
In graphite at lower left: 25/50
Bloch 609; Mourlot 150
Bequest of William S. Lieberman, 2005
2007.49.576

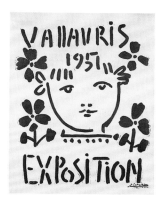

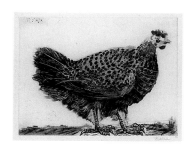

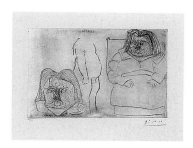

P93.

Venus and Cupid, after Lucas Cranach

1949

Printed by Fernand Mourlot
Published by Galerie Louise Leiris, Paris
Lithograph; second variation of three, second state of two
Image, 26¼ × 19½ in. (66.7 × 49.5 cm); sheet, 30 × 22¼ in. (76.2 × 56.5 cm)
In graphite at lower left: 27/50
Bloch 615; Mourlot 183, second variation
Bequest of William S. Lieberman, 2005
2007.49.629

P94.

Vallauris Exhibition 1951

1951

Printed by Hidalgo Arnéra
Published by Arnéra, Vallauris
Linoleum cut
Block, 23⅜ × 18¾ in. (59.4 × 47.6 cm); sheet, 25⅝ × 19¾ in. (65.1 × 50.2 cm)
Czwiklitzer 8; MMA 120
The Mr. and Mrs. Charles Kramer Collection, Gift of Mr. and Mrs. Charles Kramer, 1979
1979.620.139

P95.

The Hen

1952

Printed by Roger Lacourière
Published by Galerie Louise Leiris, Paris
Aquatint and drypoint
Plate, 20¼ × 26⅛ in. (51.4 × 66.4 cm); sheet, 22⅛ × 29⅞ in. (56.2 × 75.9 cm)
Bloch 694; Geiser/Baer 896.VI.B.b.1
Purchase, Reba and Dave Williams Gift, 1997
1997.84

P96.

Honoré de Balzac

1952 (printed 1961)

Printed by Jacques Frélaut
Published by Galerie Louise Leiris, Paris
Etching
Plate, 9¹⁄₁₆ × 13⅝ in. (23 × 34.6 cm); sheet, 14⅛ × 20⅞ in. (35.9 × 53 cm)
Inscribed at lower left: 26/50
Bloch 713; Geiser/Baer 899.B.b.1
Gift of Reiss-Cohen Inc., 1983
1983.1212.39

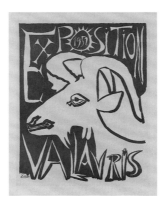

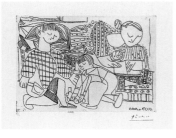

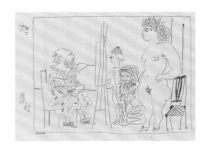

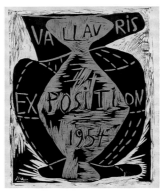

P97.

Vallauris Exhibition 1952

1952

Printed by Hidalgo Arnéra
Published by Galerie Louise Leiris,
Paris
Linoleum cut
Block, 25⅛ × 21 in. (63.8 × 53.3 cm);
sheet, 31½ × 23⅝ in. (80 × 60 cm)
Bloch 1257; Czwiklitzer 11; MMA 121
The Mr. and Mrs. Charles Kramer
Collection, Gift of Mr. and Mrs.
Charles Kramer, 1979
1979.620.111

P98.

Françoise, Claude, Paloma:
Reading and Playing I

1953 (printed 1961)

Printed by Jacques Frélaut
Published by Galerie Louise Leiris,
Paris
Etching
Plate, 9¾ × 12⅝ in. (24.8 × 32.1 cm);
sheet, 14⅝ × 20¹¹⁄₁₆ in. (37.1 ×
52.5 cm)
In graphite at lower left: 26/50
Bloch 735; Geiser/Baer 900.B.b.1
Gift of Reiss-Cohen Inc., 1983
1983.1212.40

P99.

Model and Two Characters

1954

Printed by Fernand Mourlot
Published by Galerie Louise Leiris,
Paris
Lithograph
Image, 19¾ × 25½ in. (50.2 ×
64.8 cm); sheet, 22¼ × 30 in.
(56.5 × 76.2 cm)
In graphite at lower left: 35/80
Bloch 759; Mourlot 258
Bequest of Jane Costello Goldberg,
1986
1987.1173.3

P100.

Vallauris Exhibition 1954

1954

Printed by Hidalgo Arnéra
Published by Arnéra, Vallauris
Linoleum cut
Block, 26⅞ × 21⅛ in. (68.3 ×
53.7 cm); sheet, 27½ × 22¾ in.
(69.9 × 57.8 cm)
Bloch 1263; Czwiklitzer 12; MMA
122; Geiser/Baer 1026.B
The Mr. and Mrs. Charles Kramer
Collection, Gift of Mr. and Mrs.
Charles Kramer, 1979
1979.620.112

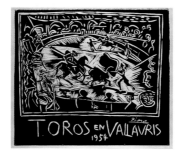

P101.

Bulls in Vallauris 1954

1954

Printed by Hidalgo Arnéra
Published by Arnéra, Vallauris
Linoleum cut
Block, 28⅞ × 31⅜ in. (73.3 ×
79.7 cm); sheet, 29⅞ × 37⅞ in.
(75.9 × 96.2 cm)
Bloch 1264; Czwiklitzer 13; MMA
123; Geiser/Baer 1027.B
The Mr. and Mrs. Charles Kramer
Collection, Gift of Mr. and Mrs.
Charles Kramer, 1979
1979.620.113

P102.

U.A.P. 54

1954

From *U.A.P. 54*, by Dominique
Baudart and Sylvette David
Published by Union des Artes
Plastiques de Vallauris
Linoleum cut
Block, 7½ × 5⅞ in. (19.1 × 14.9 cm);
sheet, 7¾ × 6½ in. (19.7 × 16.5 cm)
Bloch 1839
The Mr. and Mrs. Charles Kramer
Collection, Gift of Mr. and Mrs.
Charles Kramer, 1982
1982.1147

P103.

Squab

ca. 1954–57 (printed 1957)

Printed by Robert Blanchet
Published by Berggruen, Paris
Linoleum cut
Block, 6¼ × 7⅝ in. (15.9 × 19.4 cm);
sheet, 14⅝ × 11 in. (37.1 × 27.9 cm)
In graphite at lower left: 42/226
Bloch 326; MMA 49; Geiser/Baer
1028.B.a
The Mr. and Mrs. Charles Kramer
Collection, Gift of Mr. and Mrs.
Charles Kramer, 1979
1979.620.1

P104.

Bacchanal with Child Playing
Cymbals

1955 (printed 1961)

Printed by Jacques Frélaut
Published by Galerie Louise Leiris,
Paris
Etching
Plate, 10⅛ × 12⅛ in. (25.7 ×
30.8 cm); sheet, 14⅛ × 18⅛ in.
(35.9 × 46 cm)
In graphite at lower left: 26/50
Bloch 772; Geiser/Baer 947.B.b.1
Gift of Reiss-Cohen Inc., 1983
1983.1212.41

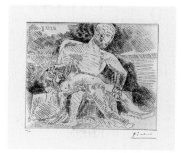
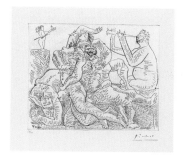

P105.

Bacchanal with a Flute Player
1955 (printed 1961)

Printed by Jacques Frélaut
Published by Galerie Louise Leiris,
Paris
Etching
Plate, 10³⁄₁₆ × 12⅛ in. (25.9 ×
30.8 cm); sheet, 14⅝ × 18⅝ in.
(37.1 × 47.3 cm)
In graphite at lower left: 26/50
Bloch 773; Geiser/Baer 949.B.b.1
Gift of Reiss-Cohen Inc., 1983
1983.1212.42

P106.

*Bacchanal with Young Man
in a Mask*
1955 (printed 1961)

Printed by Jacques Frélaut
Published by Galerie Louise Leiris,
Paris
Etching
Plate, 10⅛ × 12¹⁄₁₆ in. (25.7 ×
30.6 cm); sheet, 15⅞ × 20 in.
(40.3 × 50.8 cm)
In graphite at lower left: 26/50
Bloch 774; Geiser/Baer 948.B.b.1
Gift of Reiss-Cohen Inc., 1983
1983.1212.1

P107.

The Abduction
1955 (printed 1961)

Printed by Aldo and Piero
Crommelynck
Published by Galerie Louise Leiris,
Paris
Etching
Plate, 10⅛ × 12⅛ in. (25.7 × 30.8 cm);
sheet, 15¾ × 20 in. (40 × 50.8 cm)
In graphite at lower left: 26/50
Bloch 775; Geiser/Baer 950.B.b.1
Gift of Reiss-Cohen Inc., 1983
1983.1212.43

P108.

Bacchanal with Cupid
1955 (printed 1961)

Printed by Jacques Frélaut
Published by Galerie Louise Leiris,
Paris
Etching
Plate, 10¹⁄₁₆ × 12¹⁄₁₆ in. (25.6 ×
30.6 cm); sheet, 15¾ × 19⅞ in.
(40 × 50.5 cm)
In graphite at lower left: 26/50
Bloch 776; Geiser/Baer 951.B.b.1
Gift of Reiss-Cohen Inc., 1983
1983.1212.44

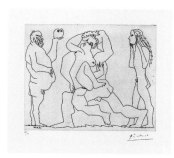
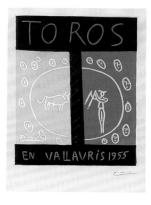
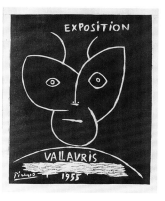
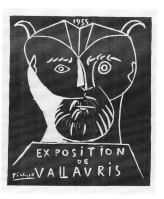

P109.

*Bacchanal with Owl and
Young Man in a Mask*
1955 (printed 1961)

Printed by Jacques Frélaut
Published by Galerie Louise Leiris,
Paris
Etching
Plate, 10⅛ × 12¹⁄₁₆ in. (25.7 ×
30.6 cm); sheet, 15⅞ × 20 in.
(40.3 × 50.8 cm)
In graphite at lower left: 26/50
Bloch 777; Geiser/Baer 952.B.b.1
Gift of Reiss-Cohen Inc., 1983
1983.1212.45

P110.

Bulls in Vallauris 1955
1955

Printed by Hidalgo Arnéra
Published by Arnéra, Vallauris
Linoleum cut
Block, 25⅞ × 20½ in. (65.7 ×
52.1 cm); sheet, 35 × 23⅜ in. (88.9 ×
59.4 cm)
Bloch 1265; Czwiklitzer 14; MMA
124; Geiser/Baer 1029.B
The Mr. and Mrs. Charles Kramer
Collection, Gift of Mr. and Mrs.
Charles Kramer, 1979
1979.620.114

P111.

Vallauris Exhibition 1955
1955

Printed by Hidalgo Arnéra
Published by Arnéra, Vallauris
Linoleum cut
Block, 26 × 21 in. (66 × 53.3 cm);
sheet, 31⅜ × 23½ in. (79.7 × 59.7 cm)
Bloch 1266; Czwiklitzer 15; MMA
125; Geiser/Baer 1030.B
The Mr. and Mrs. Charles Kramer
Collection, Gift of Mr. and Mrs.
Charles Kramer, 1979
1979.620.115

P112.

Vallauris Exhibition 1955
1955

Printed by Hidalgo Arnéra
Published by Arnéra, Vallauris
Linoleum cut
Block, 26 × 21⅛ in. (66 × 53.7 cm);
sheet, 35¼ × 23⅜ in. (89.5 × 59.4 cm)
Bloch 1267; Czwiklitzer 16; MMA
126; Geiser/Baer 1031.B
The Mr. and Mrs. Charles Kramer
Collection, Gift of Mr. and Mrs.
Charles Kramer, 1979
1979.620.116

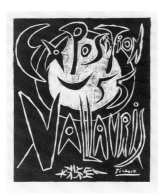

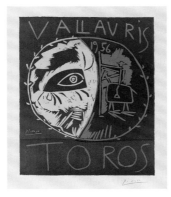

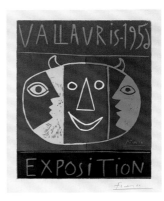

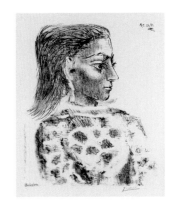

P113.

Vallauris Exhibition 1955

1955

Printed by Hidalgo Arnéra
Published by Arnéra, Vallauris
Linoleum cut
Block, 26 × 20⅞ in. (66 × 53 cm);
sheet, 33¼ × 23⅛ in. (84.5 × 58.7 cm)
Bloch 1268; Czwiklitzer 17; MMA
127; Geiser/Baer 1032.B
The Mr. and Mrs. Charles Kramer
Collection, Gift of Mr. and Mrs.
Charles Kramer, 1979
1979.620.117

P114.

Bulls in Vallauris 1956

1956

Printed by Hidalgo Arnéra
Published by Arnéra, Vallauris
Linoleum cut
Block, 25¾ × 21⅛ in. (65.4 ×
53.7 cm); sheet, 39¼ × 25⅞ in.
(99.7 × 65.7 cm)
Bloch 1270; Czwiklitzer 18; MMA
129; Geiser/Baer 1043.B
The Mr. and Mrs. Charles Kramer
Collection, Gift of Mr. and Mrs.
Charles Kramer,
1979.664.2

P115.

Vallauris Exhibition 1956

1956

Printed by Hidalgo Arnéra
Published by Arnéra, Vallauris
Linoleum cut
Block, 25⅞ × 21¼ in. (65.7 × 54 cm);
sheet, 39⅜ × 25⅞ in. (100 × 65.7 cm)
Bloch 1271; Czwiklitzer 19; MMA
128; Geiser/Baer 1042.B
The Mr. and Mrs. Charles Kramer
Collection, Gift of Mr. and Mrs.
Charles Kramer, 1979
1979.620.118

P116.

Bust with Check Cloth Blouse

1957

Printed by Fernand Mourlot
Published by Galerie Louise Leiris,
Paris
Lithograph; first state of two
Image, 21⅞ × 17¼ in. (55.6 ×
43.8 cm); sheet, 25⅝ × 20 in.
(65.1 × 50.8 cm)
In graphite at lower left: 19/50
Bloch 849; Mourlot 308
Bequest of William S. Lieberman,
2005
2007.49.630

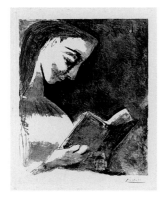

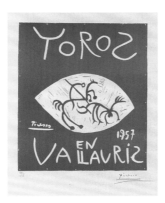

P117.

Jacqueline Reading

1957

Printed by Fernand Mourlot
Published by Galerie Louise Leiris,
Paris
Lithograph
Image, 21⅞ × 17⅜ in. (55.6 ×
44.1 cm); sheet, 25¹³⁄₁₆ × 19¹⁵⁄₁₆ in.
(65.6 × 50.6 cm)
In graphite at lower left: 19/50
Bloch 851; Mourlot 309 I
Gift of William S. Lieberman, in
memory of Jacques Gelman, 1986
1986.1170

P118.

Bulls in Vallauris 1957

1957

Printed by Hidalgo Arnéra
Published by Arnéra, Vallauris
Linoleum cut
Block, 25¼ × 21 in. (64.1 × 53.3 cm);
sheet, 31⅞ × 25½ in. (81 × 64.8 cm)
Bloch 1276; Czwiklitzer 23; MMA
130; Geiser/Baer 1045.B
The Mr. and Mrs. Charles Kramer
Collection, Gift of Mr. and Mrs.
Charles Kramer, 1979
1979.620.119

P119.

Vallauris Exhibition 1957

1957

Printed by Hidalgo Arnéra
Published by Arnéra, Vallauris
Linoleum cut
Block, 24⅞ × 20⅞ in. (63.2 × 53 cm);
sheet, 39⅜ × 26½ in. (100 × 67.3 cm)
Bloch 1277; Czwiklitzer 24; MMA
131; Geiser/Baer 1044.B
The Mr. and Mrs. Charles Kramer
Collection, Gift of Mr. and Mrs.
Charles Kramer, 1979
1979.620.120

P120.

*Picasso Paintings 1955–1956,
Galerie Louise Leiris*

1957

Printed by Fernand Mourlot
Published by Galerie Louise Leiris,
Paris
Lithograph
Image, 20⅞ × 14¾ in. (53 × 37.5 cm);
sheet, 28¾ × 21⅜ in. (73 × 54.3 cm)
Mourlot 299 A; Czwiklitzer 25
Gift of Galerie Louise Leiris, 1957
57.676

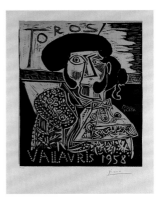

P121.

Portrait of a Woman, after Lucas Cranach II

1958

Printed by Hidalgo Arnéra
Published by Galerie Louise Leiris, Paris
Linoleum cut
Block, 25½ × 21 in. (64.8 × 53.3 cm); sheet, 30½ × 22½ in. (77.5 × 57.2 cm)
In graphite at lower left: 18/50
Bloch 859; MMA 1; Geiser/Baer 1053.C.a
The Mr. and Mrs. Charles Kramer Collection, Gift of Mr. and Mrs. Charles Kramer, 1985
1985.1079.1

P122.

Ceramics Exhibition, Vallauris, Easter 1958

1958

Printed by Hidalgo Arnéra
Published by Arnéra, Vallauris
Linoleum cut
Block, 17¾ × 12 in. (45.1 × 30.5 cm); sheet, 26¼ × 17⅜ in. (66.7 × 44.1 cm)
In graphite at lower left: 53/100
Bloch 1279; Czwiklitzer 29; MMA 132; Geiser/Baer 1047.B.2
The Mr. and Mrs. Charles Kramer Collection, Gift of Mr. and Mrs. Charles Kramer, 1979
1979.620.121

P123.

Bulls in Vallauris 1958

1958

Printed by Hidalgo Arnéra
Published by Arnéra, Vallauris
Linoleum cut
Block, 25½ × 20⅞ in. (64.8 × 53 cm); sheet, 36¾ × 29½ in. (93.3 × 74.9 cm)
In graphite at lower left: 30/195
Bloch 1282; Czwiklitzer 28; MMA 133; Geiser/Baer 1049.B.a
The Mr. and Mrs. Charles Kramer Collection, Gift of Mr. and Mrs. Charles Kramer, 1979
1979.620.122

P124.

Picasso Ceramics and White Pottery Exhibition, Céret 1958

1958

Printed by Hidalgo Arnéra
Published by Musée Municipal d'Art Moderne, Céret
Linoleum cut
Block, 23⅝ × 17¾ in. (60 × 45.1 cm); sheet, 26 × 19⅜ in. (66 × 49.2 cm)
Bloch 1283; Czwiklitzer 32; MMA 134; Geiser/Baer 1048.B.2
The Mr. and Mrs. Charles Kramer Collection, Gift of Mr. and Mrs. Charles Kramer, 1979
1979.620.123

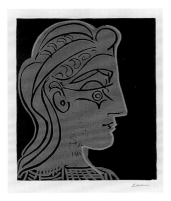

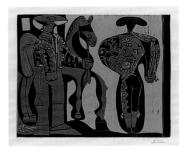

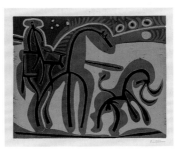

P125.

Vallauris Exhibition 1958

1958

Printed by Hidalgo Arnéra
Published by Arnéra, Vallauris
Linoleum cut
Block, 25 × 20⅞ in. (63.5 × 53 cm); sheet, 39⅜ × 25½ in. (100 × 64.8 cm)
In graphite at lower left: 140/175
Bloch 1284; Czwiklitzer 27; MMA 135; Geiser/Baer 1050.B.a
The Mr. and Mrs. Charles Kramer Collection, Gift of Mr. and Mrs. Charles Kramer, 1979
1979.620.124

P126.

Head of a Woman in Profile

1959

Printed by Hidalgo Arnéra
Published by Galerie Louise Leiris, Paris
Linoleum cut
Block, 25¼ × 21 in. (64.1 × 53.3 cm); sheet, 29⅝ × 24 in. (75.2 × 61 cm)
In graphite at lower left: 48/50
Bloch 905; MMA 13; Geiser/Baer 1246.IV.B.a
The Mr. and Mrs. Charles Kramer Collection, Gift of Mr. and Mrs. Charles Kramer, 1979
1979.620.2

P127.

Picador and Torero Awaiting the Parade of the Quadrille

1959

Printed by Hidalgo Arnéra
Published by Galerie Louise Leiris, Paris
Linoleum cut
Block, 20⅞ × 25¼ in. (53 × 64.1 cm); sheet, 24½ × 29⅝ in. (62.2 × 75.2 cm)
In graphite at lower left: 29/50
Bloch 906; MMA 12; Geiser/Baer 1231.II.B.a
The Mr. and Mrs. Charles Kramer Collection, Gift of Mr. and Mrs. Charles Kramer, 1979
1979.620.3

P128.

Picador and Bull

1959

Printed by Hidalgo Arnéra
Published by Galerie Louise Leiris, Paris
Linoleum cut
Block, 20⅞ × 25¼ in. (53 × 64.1 cm); sheet, 24½ × 29⅝ in. (62.2 × 75.2 cm)
In graphite at lower left: 8/50
Bloch 907; MMA 13; Geiser/Baer 1229.IV.B.a
The Mr. and Mrs. Charles Kramer Collection, Gift of Mr. and Mrs. Charles Kramer, 1979
1979.620.4

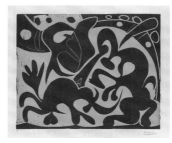
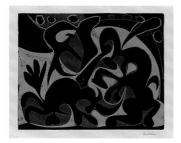

P129.

The Lance

1959

Printed by Hidalgo Arnéra
Published by Galerie Louise Leiris,
Paris
Linoleum cut
Block, 20⅞ × 25⅛ in. (53 × 63.8 cm);
sheet, 24½ × 29½ in. (62.2 × 74.9 cm)
In graphite at lower left: 8/50
Bloch 908; MMA 15; Geiser/Baer
1227.B.a
The Mr. and Mrs. Charles Kramer
Collection, Gift of Mr. and Mrs.
Charles Kramer, 1979
1979.620.5

P130.

The Picador

1959

Printed by Hidalgo Arnéra
Published by Galerie Louise Leiris,
Paris
Linoleum cut
Block, 20⅞ × 25¼ in. (53 × 64.1 cm);
sheet, 24⅜ × 29½ in. (61.9 × 74.9 cm)
In graphite at lower left: 47/50
Bloch 909; MMA 14; Geiser/Baer
1226.II.B.a
The Mr. and Mrs. Charles Kramer
Collection, Gift of Mr. and Mrs.
Charles Kramer, 1979
1979.620.6

P131.

Bull and Picador

1959

Printed by Hidalgo Arnéra
Published by Galerie Louise Leiris,
Paris
Linoleum cut
Block, 21 × 25⅛ in. (53.3 × 63.8 cm);
sheet, 24⅝ × 29⅝ in. (62.5 × 75.2 cm)
In graphite at lower left: 5/50
Bloch 910; MMA 17; Geiser/Baer
1230.II.B.a
The Mr. and Mrs. Charles Kramer
Collection, Gift of Mr. and Mrs.
Charles Kramer, 1979
1979.620.7

P132.

The Lance II

1959

Printed by Hidalgo Arnéra
Published by Galerie Louise Leiris,
Paris
Linoleum cut
Block, 20⅞ × 25⅛ in. (53 × 63.8 cm);
sheet, 24½ × 29½ in. (62.2 × 74.9 cm)
In graphite at lower left: 16/50
Bloch 911; MMA 16; Geiser/Baer
1228.B.b.2.a
The Mr. and Mrs. Charles Kramer
Collection, Gift of Mr. and Mrs.
Charles Kramer, 1979
1979.620.8

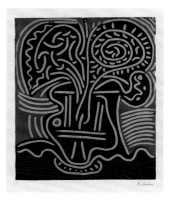
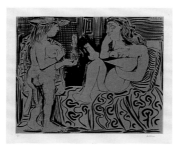

P133.

*Standing Picador with His
Horse*

1959

Printed by Hidalgo Arnéra
Published by Galerie Louise Leiris,
Paris
Linoleum cut
Block, 25¼ × 21 in. (64.1 × 53.3 cm);
sheet, 29⅝ × 24 in. (75.2 × 61 cm)
In graphite at lower left: 42/50
Bloch 912; MMA 27; Geiser/Baer
1237.B.a
The Mr. and Mrs. Charles Kramer
Collection, Gift of Mr. and Mrs.
Charles Kramer, 1979
1979.620.9

P134.

*Standing Picador with His
Horse and a Woman*

1959

Printed by Hidalgo Arnéra
Published by Galerie Louise Leiris,
Paris
Linoleum cut
Block, 25¼ × 21 in. (64.1 × 53.3 cm);
sheet, 29¾ × 24¼ in. (75.6 × 61.6 cm)
In graphite at lower left: 43/50
Bloch 913; MMA 28; Geiser/Baer
1238.B.a
The Mr. and Mrs. Charles Kramer
Collection, Gift of Mr. and Mrs.
Charles Kramer, 1979
1979.620.10

P135.

Bouquet in a Vase

1959

Printed by Hidalgo Arnéra
Published by Galerie Louise Leiris,
Paris
Linoleum cut
Block, 25¼ × 20⅞ in. (64.1 × 53 cm);
sheet, 29⅝ × 24½ in. (75.2 × 62.2 cm)
In graphite at lower left: 42/50
Bloch 914; MMA 47; Geiser/Baer
1242.III.B.a
The Mr. and Mrs. Charles Kramer
Collection, Gift of Mr. and Mrs.
Charles Kramer, 1979
1979.620.11

P136.

*Two Women with a Vase of
Flowers*

1959

Printed by Hidalgo Arnéra
Published by Galerie Louise Leiris,
Paris
Linoleum cut
Block, 20⅞ × 25¼ in. (53 × 64.1 cm);
sheet, 24½ × 29⅝ in. (62.2 × 75.2 cm)
In graphite at lower left: 49/50
Bloch 915; MMA 8; Geiser/Baer
1239.IV.B.a
The Mr. and Mrs. Charles Kramer
Collection, Gift of Mr. and Mrs.
Charles Kramer, 1979
1979.620.12

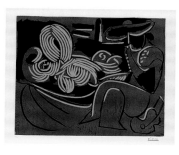 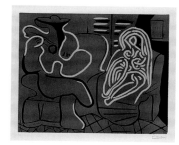 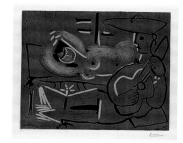 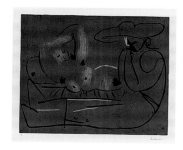

P137.

The Aubade with Sleeping Woman

1959

Printed by Hidalgo Arnéra
Published by Galerie Louise Leiris, Paris
Linoleum cut
Block, 20⅞ × 25⅛ in. (53 × 63.8 cm); sheet, 24½ × 29⅝ in. (62.2 × 75.2 cm)
In graphite at lower left: 23/50
Bloch 916; MMA 29; Geiser/Baer 1234.II.B.a.2
The Mr. and Mrs. Charles Kramer Collection, Gift of Mr. and Mrs. Charles Kramer, 1979
1979.620.13

P138.

The Aubade with a Woman in an Armchair

1959

Printed by Hidalgo Arnéra
Published by Galerie Louise Leiris, Paris
Linoleum cut
Block, 20¾ × 25¼ in. (52.7 × 64.1 cm); sheet, 24½ × 29⅝ in. (62.2 × 75.2 cm)
In graphite at lower left: 36/50
Bloch 917; MMA 30; Geiser/Baer 1232.II.B.a
The Mr. and Mrs. Charles Kramer Collection, Gift of Mr. and Mrs. Charles Kramer, 1979
1979.620.14

P139.

The Aubade with Guitarist

1959

Printed by Hidalgo Arnéra
Published by Galerie Louise Leiris, Paris
Linoleum cut
Block, 20⅞ × 25¼ in. (53 × 64.1 cm); sheet, 24½ × 29⅝ in. (62.2 × 75.2 cm)
In graphite at lower left: 42/50
Bloch 918; MMA 31; Geiser/Baer 1235.III.B.a
The Mr. and Mrs. Charles Kramer Collection, Gift of Mr. and Mrs. Charles Kramer, 1979
1979.620.15

P140.

The Aubade with Harmonica Player

1959

Printed by Hidalgo Arnéra
Published by Galerie Louise Leiris, Paris
Linoleum cut
Block, 20⅞ × 25⅜ in. (53 × 64.5 cm); sheet, 24½ × 29⅝ in. (62.2 × 75.2 cm)
In graphite at lower left: 47/50
Bloch 919; MMA 32; Geiser/Baer 1236.III.B.a
The Mr. and Mrs. Charles Kramer Collection, Gift of Mr. and Mrs. Charles Kramer, 1979
1979.620.16

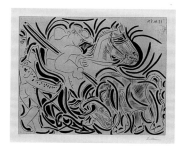 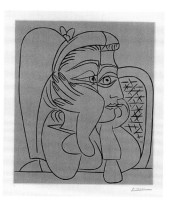 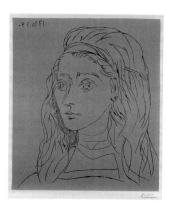

P141.

The Lance III

1959

Printed by Hidalgo Arnéra
Published by Galerie Louise Leiris, Paris
Linoleum cut
Block, 20⅞ × 25⅛ in. (53 × 63.8 cm); sheet, 24½ × 29⅝ in. (62.2 × 75.2 cm)
In graphite at lower left: 8/50
Bloch 920; MMA 18; Geiser/Baer 1243.III.B.a
The Mr. and Mrs. Charles Kramer Collection, Gift of Mr. and Mrs. Charles Kramer, 1979
1979.620.17

P142.

Broken Lance

1959

Printed by Hidalgo Arnéra
Published by Galerie Louise Leiris, Paris
Linoleum cut
Block, 21 × 25¼ in. (53.3 × 64.1 cm); sheet, 24½ × 29⅝ in. (62.2 × 75.2 cm)
In graphite at lower left: 13/50
Bloch 921; MMA 19; Geiser/Baer 1244.B.a
The Mr. and Mrs. Charles Kramer Collection, Gift of Mr. and Mrs. Charles Kramer, 1979
1979.620.18

P143.

Jacqueline Leaning on Her Elbows

1959

Printed by Hidalgo Arnéra
Published by Galerie Louise Leiris, Paris
Linoleum cut
Block, 25¼ × 20⅞ in. (64.1 × 53 cm); sheet, 29⅝ × 24½ in. (75.2 × 62.2 cm)
In graphite at lower left: 38/50
Bloch 922; MMA 3; Geiser/Baer 1240.B.a
The Mr. and Mrs. Charles Kramer Collection, Gift of Mr. and Mrs. Charles Kramer, 1979
1979.620.19

P144.

Jacqueline

1959

Printed by Hidalgo Arnéra
Published by Galerie Louise Leiris, Paris
Linoleum cut
Block, 25⅛ × 20⅞ in. (63.8 × 53 cm); sheet, 29⅝ × 24⅜ in. (75.2 × 61.9 cm)
In graphite at lower left: 6/50
Bloch 923; MMA 4; Geiser/Baer 1245.B.a
The Mr. and Mrs. Charles Kramer Collection, Gift of Mr. and Mrs. Charles Kramer, 1985
1985.1079.2

P145.

Morning: Two Waking Women

1959

Printed by Hidalgo Arnéra
Published by Galerie Louise Leiris, Paris
Linoleum cut
Block, 20⅞ × 25⅜ in. (53 × 64.5 cm); sheet, 24½ × 29¾ in. (62.2 × 75.6 cm)
In graphite at lower left: 42/50
Bloch 924; MMA 10; Geiser/Baer 1252.B.a
The Mr. and Mrs. Charles Kramer Collection, Gift of Mr. and Mrs. Charles Kramer, 1979
1979.620.20

P146.

Two Waking Women

1959

Printed by Hidalgo Arnéra
Published by Galerie Louise Leiris, Paris
Linoleum cut
Block, 21 × 25⅜ in. (53.3 × 64.5 cm); sheet, 24½ × 29¾ in. (62.2 × 75.6 cm)
In graphite at lower left: 48/50
Bloch 925; MMA 9; Geiser/Baer 1249.II.B.a
The Mr. and Mrs. Charles Kramer Collection, Gift of Mr. and Mrs. Charles Kramer, 1979
1979.620.21

P147.

Three Waking Women

1959

Printed by Hidalgo Arnéra
Published by Galerie Louise Leiris, Paris
Linoleum cut
Block, 20⅞ × 25⅜ in. (53 × 64.5 cm); sheet, 24¼ × 29¾ in. (61.6 × 75.6 cm)
In graphite at lower left: 42/50
Bloch 926; MMA 11; Geiser/Baer 1248.III.B.a
The Mr. and Mrs. Charles Kramer Collection, Gift of Mr. and Mrs. Charles Kramer, 1979
1979.620.22

P148.

Bacchanal

1959

Printed by Hidalgo Arnéra
Published by Galerie Louise Leiris, Paris
Linoleum cut
Block, 21 × 25¼ in. (53.3 × 64.1 cm); sheet, 24½ × 29⅝ in. (62.2 × 75.2 cm)
In graphite at lower left: 42/50
Bloch 927; MMA 34; Geiser/Baer 1255.B.a
The Mr. and Mrs. Charles Kramer Collection, Gift of Mr. and Mrs. Charles Kramer, 1979
1979.620.23

 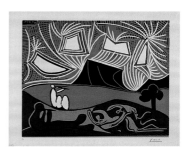 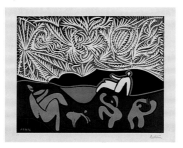

P149.

Jacqueline with a Necklace Leaning on Her Elbow

1959

Printed by Hidalgo Arnéra
Published by Galerie Louise Leiris, Paris
Linoleum cut
Block, 25 × 30¾ in. (63.5 × 78.1 cm); sheet, 29⅝ × 24½ in. (75.2 × 62.2 cm)
In graphite at lower left: 48/50
Bloch 928; MMA 5; Geiser/Baer 1258.II.B.a
The Mr. and Mrs. Charles Kramer Collection, Gift of Mr. and Mrs. Charles Kramer, 1979
1979.620.24

P150.

Bacchanal with Seated Woman Holding a Baby

1959

Printed by Hidalgo Arnéra
Published by Galerie Louise Leiris, Paris
Linoleum cut
Block, 25⅛ × 20⅞ in. (63.8 × 53 cm); sheet, 29⅝ × 24½ in. (75 × 62.2 cm)
In graphite at lower left: 2/50
Bloch 929; MMA 38; Geiser/Baer 1254.III.B.a
The Mr. and Mrs. Charles Kramer Collection, Gift of Mr. and Mrs. Charles Kramer, 1979
1979.620.25

P151.

Couple and Flutists at the Edge of a Lake

1959

Printed by Hidalgo Arnéra
Published by Galerie Louise Leiris, Paris
Linoleum cut
Block, 20¾ × 25 in. (52.7 × 63.5 cm); sheet, 24½ × 29⅝ in. (62.2 × 75.2 cm)
In graphite at lower left: 5/50
Bloch 930; MMA 35; Geiser/Baer 1259.B.2.a
The Mr. and Mrs. Charles Kramer Collection, Gift of Mr. and Mrs. Charles Kramer, 1979
1979.620.26

P152.

Bacchanal with Kid and Spectator

1959

Printed by Hidalgo Arnéra
Published by Galerie Louise Leiris, Paris
Linoleum cut
Block, 20¾ × 25 in. (52.7 × 63.5 cm); sheet, 24½ × 29⅝ in. (62.2 × 75.2 cm)
In graphite at lower left: 8/50
Bloch 931; MMA 36; Geiser/Baer 1260.B.2.a
The Mr. and Mrs. Charles Kramer Collection, Gift of Mr. and Mrs. Charles Kramer, 1979
1979.620.27

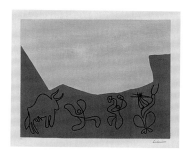
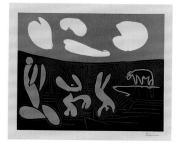

P153.

Bacchanal with Bull

1959

Printed by Hidalgo Arnéra
Published by Galerie Louise Leiris,
Paris
Linoleum cut
Block, 20¾ × 25¼ in. (52.7 ×
64.1 cm); sheet, 24¼ × 29½ in.
(61.6 × 74.9 cm)
In graphite at lower left: 6/50
Bloch 932; MMA 41; Geiser/Baer
1262.B.2.a
The Mr. and Mrs. Charles Kramer
Collection, Gift of Mr. and Mrs.
Charles Kramer, 1979
1979.620.28

P154.

Bacchanal with an Acrobat

1959

Printed by Hidalgo Arnéra
Published by Galerie Louise Leiris,
Paris
Linoleum cut
Block, 20¾ × 25⅛ in. (52.7 ×
63.8 cm); sheet, 24½ × 29⅝ in.
(62.2 × 75.2 cm)
In graphite at lower left: 8/50
Bloch 933; MMA 37; Geiser/Baer
1264.B.2.a
The Mr. and Mrs. Charles Kramer
Collection, Gift of Mr. and Mrs.
Charles Kramer, 1979
1979.620.29

P155.

Fauns and Goat

1959

Printed by Hidalgo Arnéra
Published by Galerie Louise Leiris,
Paris
Linoleum cut
Block, 20⅞ × 25⅛ in. (53 × 63.8 cm);
sheet, 24½ × 29⅝ in. (62.2 × 75.2 cm)
In graphite at lower left: 48/50
Bloch 934; MMA 39; Geiser/Baer
1263.B.2.a
The Mr. and Mrs. Charles Kramer
Collection, Gift of Mr. and Mrs.
Charles Kramer, 1979
1979.620.30

P156.

Bacchanal with a Black Bull

1959

Printed by Hidalgo Arnéra
Published by Galerie Louise Leiris,
Paris
Linoleum cut
Block, 20¾ × 25¼ in. (52.7 ×
64.1 cm); sheet, 24½ × 49½ in.
(62.2 × 125.7 cm)
In graphite at lower left: 5/50
Bloch 935; MMA 40; Geiser/Baer
1253.B.g.2.a
The Mr. and Mrs. Charles Kramer
Collection, Gift of Mr. and Mrs.
Charles Kramer, 1985
1985.1079.3

P157.

Nocturnal Dance with an Owl

1959

Printed by Hidalgo Arnéra
Published by Galerie Louise Leiris,
Paris
Linoleum cut
Block, 20⅞ × 25¼ in. (53 × 64.1 cm);
sheet, 24½ × 29⅝ in. (62.2 × 75.2 cm)
In graphite at lower left: 43/50
Bloch 936; MMA 42; Geiser/Baer
1256.II.B.a
The Mr. and Mrs. Charles Kramer
Collection, Gift of Mr. and Mrs.
Charles Kramer, 1979
1979.620.31

P158.

Grape Gatherers

1959

Printed by Hidalgo Arnéra
Published by Galerie Louise Leiris,
Paris
Linoleum cut
Block, 21 × 25¼ in. (53.3 × 64.1 cm);
sheet, 24½ × 29⅝ in. (62.2 × 75.2 cm)
In graphite at lower left: 47/50
Bloch 937; MMA 33; Geiser/Baer
1241.V.B.a
The Mr. and Mrs. Charles Kramer
Collection, Gift of Mr. and Mrs.
Charles Kramer, 1979
1979.620.32

P159.

Bacchanal with an Owl

1959

Printed by Hidalgo Arnéra
Published by Galerie Louise Leiris,
Paris
Linoleum cut
Block, 20⅞ × 25½ in. (53 × 64.8 cm);
sheet, 24½ × 29⅝ in. (62.2 ×
75.2 cm)
In graphite at lower left: 47/50
Bloch 938; MMA 43; Geiser/Baer
1265.B.a
The Mr. and Mrs. Charles Kramer
Collection, Gift of Mr. and Mrs.
Charles Kramer, 1979
1979.620.33

P160.

Bacchanal: Flutist and Dancers with Cymbals

1959

Printed by Hidalgo Arnéra
Published by Galerie Louise Leiris,
Paris
Linoleum cut
Block, 20⅞ × 25¼ in. (53 × 64.1 cm),
sheet, 24½ × 29⅝ in. (62.2 × 75.2 cm)
In graphite at lower left: 39/50
Bloch 939; MMA 44; Geiser/Baer
1251.II.B.a
The Mr. and Mrs. Charles Kramer
Collection, Gift of Mr. and Mrs.
Charles Kramer, 1979
1979.620.34

 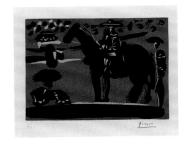 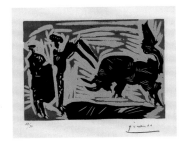

P161.

The Banderillero

1959

Printed by Hidalgo Arnéra
Published by Galerie Louise Leiris,
Paris
Linoleum cut
Block, 21 × 26 in. (53.3 × 66 cm);
sheet, 24⅜ × 29⅜ in. (61.9 × 74.6 cm)
In graphite at lower left: 31/50
Bloch 940; MMA 20; Geiser/Baer
1225.IV.B.a
The Mr. and Mrs. Charles Kramer
Collection, Gift of Mr. and Mrs.
Charles Kramer, 1979
1979.620.35

P162.

Before the Lance II

1959

Printed by Hidalgo Arnéra
Published by Galerie Louise Leiris,
Paris
Linoleum cut
Block, 21⅛ × 24½ in. (53.7 ×
62.2 cm); sheet, 24½ × 29⅝ in.
(62.2 × 75.2 cm)
In graphite at lower left: 8/50
Bloch 941; MMA 21; Geiser/Baer
1224.II.B.a
The Mr. and Mrs. Charles Kramer
Collection, Gift of Mr. and Mrs.
Charles Kramer, 1979
1979.620.36

P163.

Picador Entering the Arena

1959

Printed by Hidalgo Arnéra
Published by Galerie Louise Leiris,
Paris
Linoleum cut
Block, 6½ × 8¼ in. (16.5 × 21 cm);
sheet, 14¾ × 18⅞ in. (37.5 × 47.9 cm)
In graphite at lower left: 3/50
Bloch 942; MMA 22; Geiser/Baer
1221.II.B.a
The Mr. and Mrs. Charles Kramer
Collection, Gift of Mr. and Mrs.
Charles Kramer, 1979
1979.620.37

P164.

Banderillas

1959

Printed by Hidalgo Arnéra
Published by Galerie Louise Leiris,
Paris
Linoleum cut
Block, 6½ × 8⅞ in. (16.5 × 22.5 cm);
sheet, 14⅞ × 25 in. (37.8 × 63.5 cm)
In graphite at lower left: 23/50
Bloch 943; MMA 23; Geiser/Baer
1222.II.B.a
The Mr. and Mrs. Charles Kramer
Collection, Gift of Mr. and Mrs.
Charles Kramer, 1979
1979.620.38

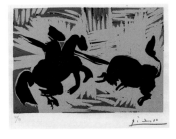 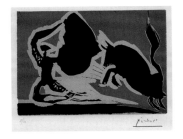

P165.

Lance I

1959

Printed by Hidalgo Arnéra
Published by Galerie Louise Leiris,
Paris
Linoleum cut
Block, 6½ × 8⅞ in. (16.5 × 22.5 cm);
sheet, 14⅞ × 18⅞ in. (37.8 × 47.9 cm)
In graphite at lower left: 42/50
Bloch 944; MMA 24; Geiser/Baer
1219.II.B.a
The Mr. and Mrs. Charles Kramer
Collection, Gift of Mr. and Mrs.
Charles Kramer, 1979
1979.620.39

P166.

Farol

1959

Printed by Hidalgo Arnéra
Published by Galerie Louise Leiris,
Paris
Linoleum cut
Block, 6½ × 8⅞ in. (16.5 × 22.5 cm);
sheet, 14¾ × 18⅞ in. (37.5 × 47.9 cm)
In graphite at lower left: 3/50
Bloch 945; MMA 25; Geiser/Baer
1223.II.B.a
The Mr. and Mrs. Charles Kramer
Collection, Gift of Mr. and Mrs.
Charles Kramer, 1979
1979.620.40

P167.

Before the Lance I

1959

Printed by Hidalgo Arnéra
Published by Galerie Louise Leiris,
Paris
Linoleum cut
Block, 6½ × 8⅞ in. (16.5 × 22.5 cm);
sheet, 14⅞ × 18⅞ in. (37.8 × 47.9 cm)
In graphite at lower left: 47/50
Bloch 946; MMA 26; Geiser/Baer
1220.II.B.a
The Mr. and Mrs. Charles Kramer
Collection, Gift of Mr. and Mrs.
Charles Kramer, 1979
1979.620.41

P168.

Flutist and Performing Goat

1959

Printed by Hidalgo Arnéra
Published by Galerie Louise Leiris,
Paris
Linoleum cut
Block, 8¼ × 4⅜ in. (21 × 11.1 cm);
sheet, 13¾ × 9¼ in. (34.9 × 23.5 cm)
In graphite at lower left: 11/50
Bloch 949; MMA 45; Geiser/Baer
1267.C.a.1
The Mr. and Mrs. Charles Kramer
Collection, Gift of Mr. and Mrs.
Charles Kramer, 1979
1979.620.44

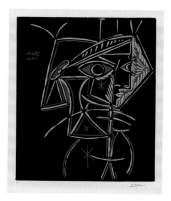

P169.

*Ceramics Exhibition,
Vallauris 1959*

1959

Printed by Hidalgo Arnéra
Published by Arnéra, Vallauris
Linoleum cut
Block, 25¼ × 20¾ in. (64.1 ×
52.7 cm); sheet, 30 × 22¼ in. (76.2 ×
56.5 cm)
In graphite at lower left: 119/175
Bloch 1286; Czwiklitzer 34; MMA
136; Geiser/Baer 1216.B.a
The Mr. and Mrs. Charles Kramer
Collection, Gift of Mr. and Mrs.
Charles Kramer, 1979
1979.620.125

P170.

Bulls in Vallauris 1959

1959

Printed by Hidalgo Arnéra
Published by Arnéra, Vallauris
Linoleum cut
Block, 25¼ × 21 in. (64.1 × 53.3 cm);
sheet, 30⅛ × 22¼ in. (76.5 × 56.5 cm)
In graphite at lower left: 60/190
Bloch 1287; Czwiklitzer 33; MMA
137; Geiser/Baer 1218.B
The Mr. and Mrs. Charles Kramer
Collection, Gift of Mr. and Mrs.
Charles Kramer, 1979
1979.620.126

P171.

*Picasso "Les Ménines,"
Galerie Louise Leiris*

1959

Printed by Fernand Mourlot
Published by Galerie Louise Leiris,
Paris
Lithograph
Sheet, 26³⁄₁₆ × 18⅞ in. (66.5 ×
47.9 cm)
Czwiklitzer 141
Gift of Galerie Louise Leiris, 1959
59.671

P172.

Bust of a Woman: Jacqueline

1959–60

Printed by Hidalgo Arnéra
Published by Galerie Louise Leiris,
Paris
Linoleum cut
Block, 25⅞ × 21¼ in. (65.7 × 54 cm);
sheet, 29¾ × 24½ in. (75.6 × 62.2 cm)
In graphite at lower left: 42/50
Bloch 947; MMA 6; Geiser/Baer
1213.II.B.a
The Mr. and Mrs. Charles Kramer
Collection, Gift of Mr. and Mrs.
Charles Kramer, 1979
1979.620.42

P173.

Plant with Little Bulls

1959–60

Printed by Hidalgo Arnéra
Published by Galerie Louise Leiris,
Paris
Linoleum cut
Block, 26 × 21¼ in. (66 × 54 cm);
sheet, 29¾ × 24½ in. (75.6 × 62.2 cm)
In graphite at lower left: 3/50
Bloch 948; MMA 48; Geiser/Baer
1214.II.B.a
The Mr. and Mrs. Charles Kramer
Collection, Gift of Mr. and Mrs.
Charles Kramer, 1979
1979.620.43

P174.

Small Bacchanal

1959–60

Printed by Hidalgo Arnéra
Published by Galerie Louise Leiris,
Paris
Linoleum cut
Block, 8⅝ × 10⅜ in. (21.8 ×
26.4 cm); sheet, 17¾ × 24¾ in.
(45.1 × 62.9 cm)
In graphite at lower left: 21/50
Bloch 1020; MMA 46; Geiser/Baer
1250
The Mr. and Mrs. Charles Kramer
Collection, Gift of Mr. and Mrs.
Charles Kramer, 1979
1979.620.45

P175.

Vallauris Exhibition 1960

1960

Printed by Hidalgo Arnéra
Published by Arnéra, Vallauris
Linoleum cut
Block, 25 × 20⅞ in. (63.5 × 53 cm);
sheet, 29⅝ × 24 in. (75.2 × 61 cm)
In graphite at lower left: 62/170
Bloch 1290; Czwiklitzer 37; MMA
139; Geiser/Baer 1268.B.a
The Mr. and Mrs. Charles Kramer
Collection, Gift of Mr. and Mrs.
Charles Kramer, 1979
1979.620.127

P176.

Bulls in Vallauris 1960

1960

Printed by Hidalgo Arnéra
Published by Arnéra, Vallauris
Linoleum cut
Block, 25⅛ × 20⅞ in. (63.8 × 53 cm);
sheet, 29⅝ × 24⅝ in. (75.2 × 62.5 cm)
In graphite at lower left: 178/185
Bloch 1291; Czwiklitzer 36; MMA
138; Geiser/Baer 1269.B
The Mr. and Mrs. Charles Kramer
Collection, Gift of Mr. and Mrs.
Charles Kramer, 1979
1979.620.128

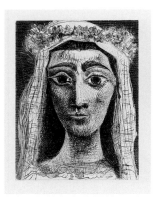

P177.

Jacqueline Dressed as a Bride Full Face I

1961

Printed by Jacques Frélaut
Aquatint and drypoint; eleventh state
Plate, 15⅝ × 11⅝ in. (39.7 × 29.5 cm);
sheet, 20¼ × 16 in. (51.4 × 40.6 cm)
Geiser/Baer 1089.XI
Purchase, Reba and Dave Williams
Gift, 1997
1997.90

P178.

Madoura

1961

Printed by Hidalgo Arnéra
Published by Galerie Madoura,
Cannes
Linoleum cut
Block, 3⅞ × 8⅝ in. (9.8 × 21.9 cm);
sheet, 4⅜ × 9⅛ in. (11.1 × 23.2 cm)
Bloch 1021; MMA 141; Geiser/Baer
1270.I.B
The Mr. and Mrs. Charles Kramer
Collection, Gift of Mr. and Mrs.
Charles Kramer, 1979
1979.620.46

P179.

Variation on Manet's "Le déjeuner sur l'herbe"

1961

Printed by Hidalgo Arnéra
Published by Galerie Louise Leiris,
Paris
Linoleum cut
Block, 20⅞ × 25¼ in. (53.1 ×
64.1 cm); sheet, 24½ × 29⅝ in.
(62.2 × 75.2 cm)
In graphite at lower left: 43/50
Bloch 1023; MMA 86; Geiser/Baer
1277.I.B.a
The Mr. and Mrs. Charles Kramer
Collection, Gift of Mr. and Mrs.
Charles Kramer, 1979
1979.620.47

P180.

Vallauris Exhibition 1961

1961

Printed by Hidalgo Arnéra
Published by Arnéra, Vallauris
Linoleum cut
Block, 25 × 20⅞ in. (63.5 × 53 cm);
sheet, 29½ × 24½ in. (74.9 × 62.2 cm)
In graphite at lower left: 111/175
Bloch 1295; Czwiklitzer 42; MMA
140; Geiser/Baer 1274.B.a
The Mr. and Mrs. Charles Kramer
Collection, Gift of Mr. and Mrs.
Charles Kramer, 1979
1979.620.129

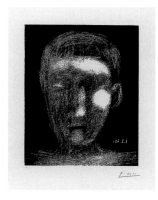

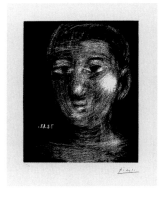

P181.

Madoura 1961

1961

Printed by Hidalgo Arnéra
Published by Galerie Madoura,
Cannes
Linoleum cut
Block, 25¼ × 21 in. (64.1 × 53.3 cm);
sheet, 29⅝ × 24½ in. (75.2 × 62.2 cm)
In graphite at lower left: 3/100
Bloch 1296; Czwiklitzer 41; MMA
142; Geiser/Baer 1272.B
The Mr. and Mrs. Charles Kramer
Collection, Gift of Mr. and Mrs.
Charles Kramer, 1979
1979.620.130

P182.

Head of a Boy II

1962

Printed by Hidalgo Arnéra
Published by Galerie Louise Leiris,
Paris
Linoleum cut
Block, 13¾ × 10⅝ in. (34.9 × 27 cm);
sheet, 24½ × 17½ in. (62.2 × 44.5 cm)
In graphite at lower left: 25/50
Bloch 1025; MMA 74; Geiser/Baer
1289.II.B.a
The Mr. and Mrs. Charles Kramer
Collection, Gift of Mr. and Mrs.
Charles Kramer, 1979
1979.620.48

P183.

Head of a Boy III

1962

Printed by Hidalgo Arnéra
Published by Galerie Louise Leiris,
Paris
Linoleum cut
Block, 13¾ × 10⅝ in. (34.9 × 27 cm);
sheet, 24¾ × 17½ in. (62.9 × 44.5 cm)
In graphite at lower left: 22/50
Bloch 1026; MMA 75; Geiser/Baer
1290.II.B.a
The Mr. and Mrs. Charles Kramer
Collection, Gift of Mr. and Mrs.
Charles Kramer, 1979
1979.620.49

P184.

Le déjeuner sur l'herbe, after Manet I

1962

Printed by Hidalgo Arnéra
Published by Galerie Louise Leiris,
Paris
Linoleum cut
Block, 20¹³⁄₁₆ × 25¼ in. (52.8 ×
64.1 cm); sheet, 24⅜ × 29⅝ in.
(61.9 × 75.2 cm)
In graphite at lower left: 50/50
Bloch 1027; MMA 87; Geiser/Baer
1287.V.B.a
The Mr. and Mrs. Charles Kramer
Collection, Gift of Mr. and Mrs.
Charles Kramer, 1979
1979.620.50

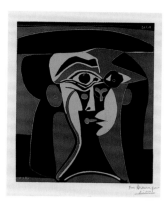

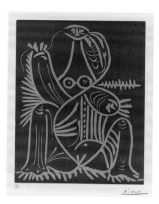

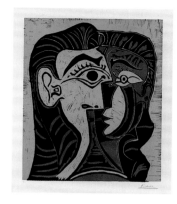

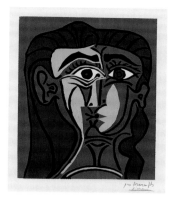

P185.

Jacqueline in a Black Hat
1962

Printed by Hidalgo Arnéra
Published by Galerie Louise Leiris,
Paris
Linoleum cut
Block, 25⅛ × 20⅝ in. (63.8 ×
52.4 cm); sheet, 29⅝ × 24½ in.
(75.2 × 62.2 cm)
In graphite at lower right: pour
Arnera frère/Picasso
Bloch 1028; MMA 59; Geiser/Baer
1311.III.A
The Mr. and Mrs. Charles Kramer
Collection, Gift of Mr. and Mrs.
Charles Kramer, 1979
1979.620.51

P186.

*Seated Woman in
Beachwear II*
1962

Printed by Hidalgo Arnéra
Published by Galerie Louise Leiris,
Paris
Linoleum cut
Block, 15⅜ × 11¾ in. (39.1 × 29.8 cm);
sheet, 21½ × 17 in. (54.6 × 43.2 cm)
In graphite at lower left: 94/100
Bloch 1062; MMA 83; Geiser/Baer
1276.B.a
The Mr. and Mrs. Charles Kramer
Collection, Gift of Mr. and Mrs.
Charles Kramer, 1979
1979.620.52

P187.

Jacqueline Full Face I
1962

Printed by Hidalgo Arnéra
Published by Galerie Louise Leiris,
Paris
Linoleum cut
Block, 25 1/16 × 20 11/16 in. (63.6 ×
52.5 cm); sheet, 29½ × 24½ in.
(74.9 × 62.2 cm)
In graphite at lower left: 26/50
Bloch 1064; MMA 61; Geiser/Baer
1278.III.B.a
The Mr. and Mrs. Charles Kramer
Collection, Gift of Mr. and Mrs.
Charles Kramer, 1979
1979.620.54

P188.

Jacqueline Full Face II
1962

Printed by Hidalgo Arnéra
Published by Galerie Louise Leiris,
Paris
Linoleum cut
Block, 25¼ × 20¾ in. (64.2 ×
52.7 cm); sheet, 29⅝ × 24⅜ in.
(75.2 × 61.9 cm)
In graphite at lower right: pour
Arnera fils/Picasso
Bloch 1063; MMA 60; Geiser/Baer
1280.IV.a
The Mr. and Mrs. Charles Kramer
Collection, Gift of Mr. and Mrs.
Charles Kramer, 1979
1979.620.53

P189.

Landscape with Bathers
1962

Printed by Hidalgo Arnéra
Linoleum cut
Block, 20 13/16 × 25 3/16 in. (52.8 ×
64 cm); sheet, 24 7/16 × 29⅝ in.
(62 × 75.2 cm)
Geiser/Baer 1284.III.B
The Mr. and Mrs. Charles Kramer
Collection, Gift of Mr. and Mrs.
Charles Kramer, 1988
1988.1101.1

P190.

Stylized Portrait of Jacqueline
1962

Printed by Hidalgo Arnéra
Published by Galerie Louise Leiris,
Paris
Linoleum cut
Block, 25¼ × 20¾ in. (64.1 ×
52.7 cm); sheet, 29⅝ × 24⅜ in.
(75.2 × 61.9 cm)
In graphite at lower left: 11/50
Bloch 1065; MMA 55; Geiser/Baer
1285.IV.B.a
The Mr. and Mrs. Charles Kramer
Collection, Gift of Mr. and Mrs.
Charles Kramer, 1979
1979.620.55

P191.

Jacqueline with Smooth Hair
1962

Printed by Hidalgo Arnéra
Published by Galerie Louise Leiris,
Paris
Linoleum cut
Block, 25¼ × 20¾ in. (64.1 ×
52.7 cm); sheet, 29⅝ × 24⅜ in.
(75.2 × 61.9 cm)
In graphite at lower left: 21/50
Bloch 1066; MMA 53; Geiser/Baer
1302.IV.B.a
The Mr. and Mrs. Charles Kramer
Collection, Gift of Mr. and Mrs.
Charles Kramer, 1979
1979.620.56

P192.

Jacqueline in a Straw Hat
1962

Printed by Hidalgo Arnéra
Published by Galerie Louise Leiris,
Paris
Linoleum cut
Block, 25¼ × 20⅞ in. (64.1 × 53 cm);
sheet, 29⅝ × 24⅜ in. (75.2 × 61.9 cm)
In graphite at lower left: 26/50
Bloch 1067; MMA 54; Geiser/Baer
1279.IV.B.a
The Mr. and Mrs. Charles Kramer
Collection, Gift of Mr. and Mrs.
Charles Kramer, 1979
1979.620.57

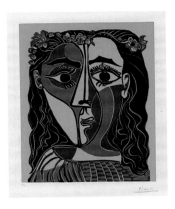

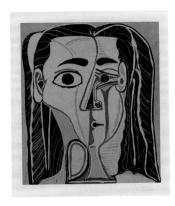

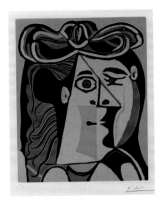

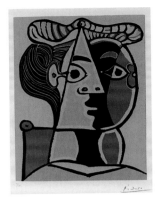

P193.

Small Head of a Woman with a Crown of Flowers

1962

Printed by Hidalgo Arnéra
Published by Galerie Louise Leiris, Paris
Linoleum cut
Block, 14⅜ × 11¾ in. (36.5 × 29.8 cm); sheet, 24⅝ × 17½ in. (62.5 × 44.5 cm)
In graphite at lower left: 2/50
Bloch 1068; MMA 70; Geiser/Baer 1305.III.B.a
The Mr. and Mrs. Charles Kramer Collection, Gift of Mr. and Mrs. Charles Kramer, 1979
1979.620.58

P194.

Jacqueline with a Headband, Full Face

1962

Printed by Hidalgo Arnéra
Published by Galerie Louise Leiris, Paris
Linoleum cut
Block, 25³⁄₁₆ × 20⅞ in. (64 × 53 cm); sheet, 29⅝ × 24⅜ in. (75.2 × 61.9 cm)
In graphite at lower left: 48/50
Bloch 1069; MMA 62; Geiser/Baer 1303.III.B.a
The Mr. and Mrs. Charles Kramer Collection, Gift of Mr. and Mrs. Charles Kramer, 1979
1979.620.59

P195.

Head of a Woman in a Hat

1962

Printed by Hidalgo Arnéra
Published by Galerie Louise Leiris, Paris
Linoleum cut
Block, 13¾ × 10⅝ in. (34.9 × 27 cm); sheet, 24¾ × 17½ in. (62.9 × 44.5 cm)
In graphite at lower left: 25/50
Bloch 1070; MMA 58; Geiser/Baer 1299.III.B.a
The Mr. and Mrs. Charles Kramer Collection, Gift of Mr. and Mrs. Charles Kramer, 1979
1979.620.60

P196.

Seated Woman with a Chignon

1962

Printed by Hidalgo Arnéra
Published by Galerie Louise Leiris, Paris
Linoleum cut
Block, 13¾ × 10⅝ in. (34.9 × 27 cm); sheet, 24⅝ × 17½ in. (62.5 × 44.5 cm)
In graphite at lower left: 14/50
Bloch 1071; MMA 57; Geiser/Baer 1298.III.B.a
The Mr. and Mrs. Charles Kramer Collection, Gift of Mr. and Mrs. Charles Kramer, 1979
1979.620.61

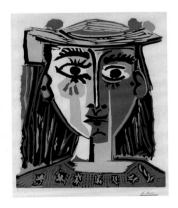

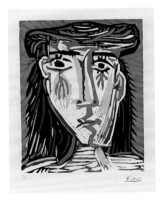

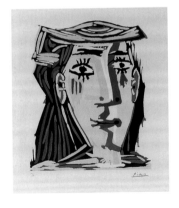

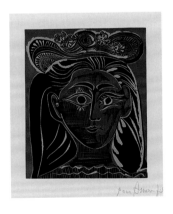

P197.

Woman in a Hat with Pom-poms and a Printed Blouse

1962

Printed by Hidalgo Arnéra
Published by Galerie Louise Leiris, Paris
Linoleum cut
Block, 24¾ × 20⅞ in. (62.9 × 53 cm); sheet, 30 × 24½ in. (76.2 × 62.2 cm)
In graphite at lower left: 50/50
Bloch 1072; MMA 50; Geiser/Baer 1318.V.B.a
The Mr. and Mrs. Charles Kramer Collection, Gift of Mr. and Mrs. Charles Kramer, 1985
1985.1079.4

P198.

Jacqueline in a Straw Hat

1962

Printed by Hidalgo Arnéra
Published by Galerie Louise Leiris, Paris
Linoleum cut
Block, 13¾ × 10⅝ in. (34.9 × 27 cm); sheet, 24¾ × 17½ in. (62.9 × 44.5 cm)
In graphite at lower left: 2/50
Bloch 1073; MMA 51; Geiser/Baer 1281.V.B.a
The Mr. and Mrs. Charles Kramer Collection, Gift of Mr. and Mrs. Charles Kramer, 1979
1979.620.62

P199.

Jacqueline in a Multicolored Straw Hat

1962

Printed by Hidalgo Arnéra
Published by Galerie Louise Leiris, Paris
Linoleum cut
Block, 13⅝ × 10⅝ in. (34.6 × 27 cm); sheet, 24¾ × 17½ in. (62.9 × 44.5 cm)
In graphite at lower left: 11/50
Bloch 1074; MMA 52; Geiser/Baer 1283.B.d.2.a
The Mr. and Mrs. Charles Kramer Collection, Gift of Mr. and Mrs. Charles Kramer, 1979
1979.620.63

P200.

Jacqueline in a Flowery Straw Hat

1962

Printed by Hidalgo Arnéra
Published by Galerie Louise Leiris, Paris
Linoleum cut
Block, 13¹¹⁄₁₆ × 10¹¹⁄₁₆ in. (34.8 × 27.2 cm); sheet, 24⅜ × 17⅜ in. (61.9 × 44.1 cm)
Bloch 1075; MMA 63; Geiser/Baer 1322.II.B.b
The Mr. and Mrs. Charles Kramer Collection, Gift of Mr. and Mrs. Charles Kramer, 1979
1979.620.64

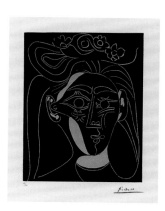

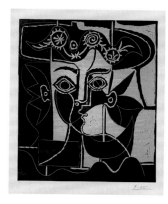

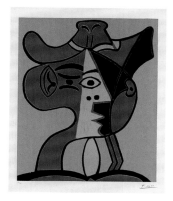

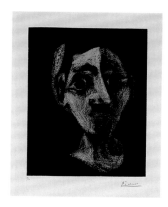

P201.

Jacqueline in a Flowered Hat I

1962

Printed by Hidalgo Arnéra
Published by Galerie Louise Leiris, Paris
Linoleum cut
Block, 13¾ × 10⅝ in. (34.9 × 27 cm); sheet, 24¾ × 17½ in. (62.9 × 44.5 cm)
In graphite at lower left: 20/50
Bloch 1076; MMA 64; Geiser/Baer 1304.I.A.b.1
The Mr. and Mrs. Charles Kramer Collection, Gift of Mr. and Mrs. Charles Kramer, 1979
1979.620.65

P202.

Large Head of Jacqueline in a Hat

1962

Printed by Hidalgo Arnéra
Published by Galerie Louise Leiris, Paris
Linoleum cut
Block, 25³⁄₁₆ × 20¹³⁄₁₆ in. (64 × 52.8 cm); sheet, 29⅝ × 24¼ in. (75.2 × 61.6 cm)
In graphite at lower left: 3/50
Bloch 1077; MMA 65; Geiser/Baer 1317.B.b.1
The Mr. and Mrs. Charles Kramer Collection, Gift of Mr. and Mrs. Charles Kramer, 1979
1979.620.66

P203.

Large Head of a Woman in a Hat

1962

Printed by Hidalgo Arnéra
Published by Galerie Louise Leiris, Paris
Linoleum cut
Block, 25¼ × 20⅞ in. (64.1 × 53 cm); sheet, 30⅝ × 24½ in. (77.8 × 62.2 cm)
In graphite at lower left: 48/50
Bloch 1078; MMA 56; Geiser/Baer 1293.IV.B.a
The Mr. and Mrs. Charles Kramer Collection, Gift of Mr. and Mrs. Charles Kramer, 1979
1979.620.67

P204.

Jacqueline with a Headband I

1962

Printed by Hidalgo Arnéra
Published by Galerie Louise Leiris, Paris
Linoleum cut
Block, 13¾ × 10⅝ in. (34.9 × 27 cm); sheet, 24¾ × 17½ in. (62.9 × 44.5 cm)
In graphite at lower left: 2/50
Bloch 1090; MMA 76; Geiser/Baer 1297.I.A.b.1
The Mr. and Mrs. Charles Kramer Collection, Gift of Mr. and Mrs. Charles Kramer, 1979
1979.620.79

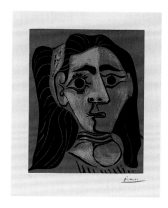

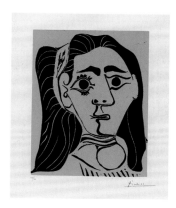

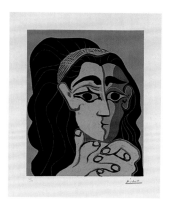

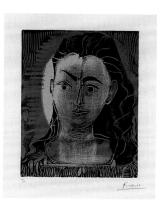

P205.

Jacqueline with a Headband II

1962

Printed by Hidalgo Arnéra
Published by Galerie Louise Leiris, Paris
Linoleum cut
Block, 13¹³⁄₁₆ × 10¹¹⁄₁₆ in. (35.1 × 27.1 cm); sheet, 24¾ × 17½ in. (62.9 × 44.5 cm)
In graphite at lower left: 48/50
Bloch 1080; MMA 67; Geiser/Baer 1297.III.A.b.1
The Mr. and Mrs. Charles Kramer Collection, Gift of Mr. and Mrs. Charles Kramer, 1979
1979.620.69

P206.

Jacqueline with a Headband III

1962

Printed by Hidalgo Arnéra
Published by Galerie Louise Leiris, Paris
Linoleum cut
Block, 13¹¹⁄₁₆ × 10⁹⁄₁₆ in. (34.8 × 26.8 cm); sheet, 24⅝ × 17⅜ in. (62.5 × 44.1 cm)
In graphite at lower left: 43/50
Bloch 1079; MMA 66; Geiser/Baer 1297.III.B.b.1
The Mr. and Mrs. Charles Kramer Collection, Gift of Mr. and Mrs. Charles Kramer, 1979
1979.620.68

P207.

Jacqueline Leaning on Her Elbows with a Headband

1962

Printed by Hidalgo Arnéra
Published by Galerie Louise Leiris, Paris
Linoleum cut
Block, 13¹³⁄₁₆ × 10¹¹⁄₁₆ in. (35.1 × 27.1 cm); sheet, 24⅞ × 17½ in. (63.2 × 44.5 cm)
In graphite at lower left: 49/50
Bloch 1081; MMA 68; Geiser/Baer 1306.III.B.a
The Mr. and Mrs. Charles Kramer Collection, Gift of Mr. and Mrs. Charles Kramer, 1979
1979.620.70

P208.

Jacqueline in a Printed Dress

1962

Printed by Hidalgo Arnéra
Published by Galerie Louise Leiris, Paris
Linoleum cut
Block, 13¾ × 10⅝ in. (35 × 27 cm); sheet, 24¾ × 17½ in. (62.9 × 44.5 cm)
In graphite at lower left: 47/50
Bloch 1082; MMA 78; Geiser/Baer 1300.B.b.1
The Mr. and Mrs. Charles Kramer Collection, Gift of Mr. and Mrs. Charles Kramer, 1979
1979.620.71

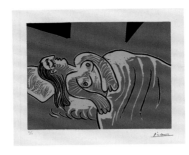

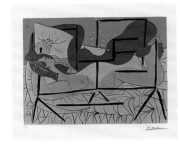

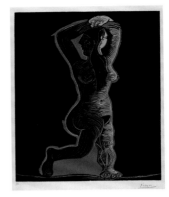

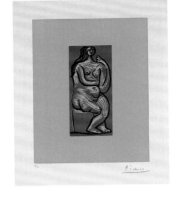

P209.

Sleeping Woman

1962

Printed by Hidalgo Arnéra
Published by Galerie Louise Leiris,
Paris
Linoleum cut
Block, 10⅝ × 13¾ in. (27 × 34.9 cm);
sheet, 17 × 20 in. (43.2 × 50.8 cm)
In graphite at lower left: 40/50
Bloch 1083; MMA 82; Geiser/Baer
1319.IV.B.a
The Mr. and Mrs. Charles Kramer
Collection, Gift of Mr. and Mrs.
Charles Kramer, 1979
1979.620.72

P210.

Danaë

1962

Printed by Hidalgo Arnéra
Published by Galerie Louise Leiris,
Paris
Linoleum cut
Block, 10⅝ × 13¾ in. (27 × 34.9 cm);
sheet, 17⅝ × 24⅝ in. (44.8 × 62.5 cm)
In graphite at lower left: 21/50
Bloch 1084; MMA 81; Geiser/Baer
1286.IV.B.a
The Mr. and Mrs. Charles Kramer
Collection, Gift of Mr. and Mrs.
Charles Kramer, 1979
1979.620.73

P211.

Large Dancing Nude

1962

Printed by Hidalgo Arnéra
Published by Galerie Louise Leiris,
Paris
Linoleum cut
Block, 25⅛ × 20¹³⁄₁₆ in. (63.8 ×
52.9 cm); sheet, 29⅝ × 24⅜ in.
(75.2 × 61.9 cm)
In graphite at lower left: 9/50
Bloch 1085; MMA 84; Geiser/Baer
1309.VI.B.a
The Mr. and Mrs. Charles Kramer
Collection, Gift of Mr. and Mrs.
Charles Kramer, 1979
1979.620.74

P212.

Seated Nude

1962

Printed by Hidalgo Arnéra
Published by Galerie Louise Leiris,
Paris
Linoleum cut
Block, 13¹¹⁄₁₆ × 10⁹⁄₁₆ in. (34.8 ×
26.9 cm); sheet, 24½ × 17⅜ in.
(62.2 × 44.1 cm)
In graphite at lower left: 22/50
Bloch 1086; MMA 85; Geiser/Baer
1330.II.B.a
The Mr. and Mrs. Charles Kramer
Collection, Gift of Mr. and Mrs.
Charles Kramer, 1979
1979.620.75

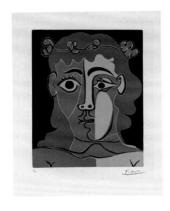

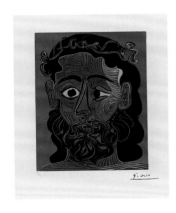

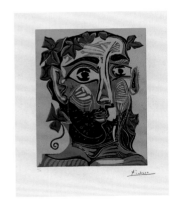

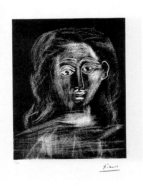

P213.

*Young Man with a Crown
of Leaves*

1962

Printed by Hidalgo Arnéra
Published by Galerie Louise Leiris,
Paris
Linoleum cut
Block, 13¹³⁄₁₆ × 10⅝ in. (35.1 × 27 cm);
sheet, 24¾ × 17½ in. (62.9 × 44.5 cm)
In graphite at lower left: 2/50
Bloch 1087; MMA 71; Geiser/Baer
1307.III.B.a
The Mr. and Mrs. Charles Kramer
Collection, Gift of Mr. and Mrs.
Charles Kramer, 1979
1979.620.76

P214.

*Bearded Man with a Crown
of Leaves and Vines*

1962

Printed by Hidalgo Arnéra
Published by Galerie Louise Leiris,
Paris
Linoleum cut
Block, 13¾ × 10⅝ in. (35 × 27 cm);
sheet, 24¾ × 17½ in. (62.9 × 44.5 cm)
In graphite at lower left: 21/50
Bloch 1088; MMA 72; Geiser/Baer
1308.V.B.a
The Mr. and Mrs. Charles Kramer
Collection, Gift of Mr. and Mrs.
Charles Kramer, 1979
1979.620.77

P215.

*Bearded Man with a Crown
of Vines*

1962

Printed by Hidalgo Arnéra
Published by Galerie Louise Leiris,
Paris
Linoleum cut
Block, 13¾ × 10½ in. (35 × 26.7 cm);
sheet, 24¾ × 17½ in. (62.9 × 44.5 cm)
In graphite at lower left: 23/50
Bloch 1089; MMA 73; Geiser/Baer
1310.VI.B.a
The Mr. and Mrs. Charles Kramer
Collection, Gift of Mr. and Mrs.
Charles Kramer, 1979
1979.620.78

P216.

Jacqueline with Soft Hair

1962

Printed by Hidalgo Arnéra
Published by Galerie Louise Leiris,
Paris
Linoleum cut
Block, 13¾ × 10⅝ in. (35 × 27 cm);
sheet, 24¾ × 17½ in. (62.9 × 44.5 cm)
In graphite at lower left: 1/50
Bloch 1091; MMA 79; Geiser/Baer
1295.B.a
The Mr. and Mrs. Charles Kramer
Collection, Gift of Mr. and Mrs.
Charles Kramer, 1979
1979.620.80

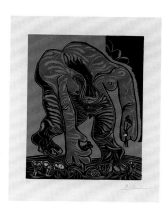

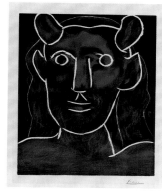

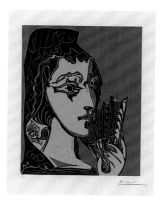

P217.

Nude Woman Picking Flowers
1962

Printed by Hidalgo Arnéra
Published by Galerie Louise Leiris,
Paris
Linoleum cut
Block, 13¾ × 10¹¹/₁₆ in. (35 ×
27.1 cm); sheet, 24⅝ × 17⅜ in.
(62.5 × 44.1 cm)
In graphite at lower left: 42/50
Bloch 1092; MMA 91; Geiser/Baer
1325.III.B.a
The Mr. and Mrs. Charles Kramer
Collection, Gift of Mr. and Mrs.
Charles Kramer, 1979
1979.620.81

P218.

Woman at the Spring
1962

Printed by Hidalgo Arnéra
Published by Galerie Louise Leiris,
Paris
Linoleum cut
Block, 20¹³/₁₆ × 25⅛ in. (52.8 ×
63.8 cm); sheet, 24½ × 29⅝ in.
(62.3 × 75.2 cm)
In graphite at lower left: 22/50
Bloch 1093; MMA 90; Geiser/Baer
1326.III.B.a
The Mr. and Mrs. Charles Kramer
Collection, Gift of Mr. and Mrs.
Charles Kramer, 1979
1979.620.82

P219.

Head of a Faun
1962

Printed by Hidalgo Arnéra
Published by Galerie Louise Leiris,
Paris
Linoleum cut
Image, 25¼ × 20¾ in. (64.1 ×
52.7 cm); sheet, 29⅝ × 24⅜ in.
(75.2 × 61.9 cm)
In graphite at lower left: 14/50
Bloch 1094; MMA 77; Geiser/Baer
1291.B.b.2.a
The Mr. and Mrs. Charles Kramer
Collection, Gift of Mr. and Mrs.
Charles Kramer, 1979
1979.620.83

P220.

Jacqueline as Carmen
1962

Printed by Hidalgo Arnéra
Published by Galerie Louise Leiris,
Paris
Linoleum cut
Block, 13¾ × 10⅝ in. (35 × 27 cm);
sheet, 24⅝ × 17⅜ in. (62.5 × 44.1 cm)
In graphite at lower left: 4/50
Bloch 1095; MMA 69; Geiser/Baer
1324.IV.B.a
The Mr. and Mrs. Charles Kramer
Collection, Gift of Mr. and Mrs.
Charles Kramer, 1979
1979.620.84

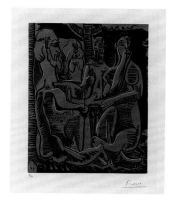

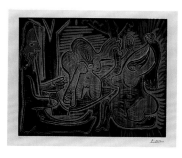

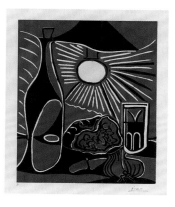

P221.

*Petit déjeuner sur l'herbe,
after Manet*
1962

Printed by Hidalgo Arnéra
Published by Galerie Louise Leiris,
Paris
Linoleum cut
Block, 13¹³/₁₆ × 10¹¹/₁₆ in. (35.1 ×
27.1 cm); sheet, 24⅝ × 17⅜ in.
(62.5 × 44.1 cm)
In graphite at lower left: 2/50
Bloch 1096; MMA 88; Geiser/Baer
1328.III.B.a
The Mr. and Mrs. Charles Kramer
Collection, Gift of Mr. and Mrs.
Charles Kramer, 1979
1979.620.85

P222.

*Le déjeuner sur l'herbe,
after Manet II*
1962

Printed by Hidalgo Arnéra
Published by Galerie Louise Leiris,
Paris
Linoleum cut
Block, 20⅞ × 25⅛ in. (53 × 63.8 cm);
sheet, 24½ × 29⅝ in. (62.2 × 75.2 cm)
In graphite at lower left: 23/50
Bloch 1097; MMA 89; Geiser/Baer
1329.IV.B.a
The Mr. and Mrs. Charles Kramer
Collection, Gift of Mr. and Mrs.
Charles Kramer, 1979
1979.620.86

P223.

Still Life with a Watermelon
1962

Printed by Hidalgo Arnéra
Published by Galerie Louise Leiris,
Paris
Linoleum cut
Block, 23¼ × 28⅜ in. (59.1 × 72 cm);
sheet, 24½ × 29⅝ in. (62.2 × 75.2 cm)
In graphite at lower left: 45/160
Bloch 1098; MMA 92; Geiser/Baer
1301.B.i.2.a
The Mr. and Mrs. Charles Kramer
Collection, Gift of Mr. and Mrs.
Charles Kramer, 1979
1979.620.87

P224.

Still Life with a Snack I
1962

Printed by Hidalgo Arnéra
Published by Galerie Louise Leiris,
Paris
Linoleum cut
Block, 25³/₁₆ × 20⅞ in. (64 × 53 cm);
sheet, 29⅝ × 24½ in. (75.2 × 62.2 cm)
In graphite at lower left: 3/50
Bloch 1100; MMA 94; Geiser/Baer
1315.IV.A.b.1
The Mr. and Mrs. Charles Kramer
Collection, Gift of Mr. and Mrs.
Charles Kramer, 1979
1979.620.89

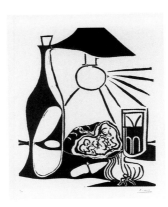

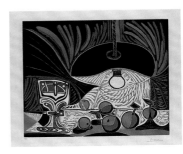

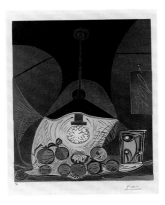

P225.

Still Life with a Snack II

1962

Printed by Hidalgo Arnéra
Published by Galerie Louise Leiris,
Paris
Linoleum cut
Block, 25³⁄₁₆ × 20⅞ in. (64 × 53 cm);
sheet, 29¼ × 24½ in. (74.3 × 62.2 cm)
In graphite at lower left: 21/50
Bloch 1099; MMA 93; Geiser/Baer
1315.IV.B.b.1
The Mr. and Mrs. Charles Kramer
Collection, Gift of Mr. and Mrs.
Charles Kramer, 1979
1979.620.88

P226.

Nude

1962

Printed by Hidalgo Arnéra
Linoleum cut; unfinished edition
Block, 20¾ × 25 in. (52.7 × 63.6 cm);
sheet, 24½ × 29¾ in. (62.2 × 75.6 cm)
Geiser/Baer 1316.III.b
Gift of Myra and Sanford
Kirschenbaum, 2004
2004.532

P227.

*Still Life with a Glass by
Lamplight*

1962

Printed by Hidalgo Arnéra
Published by Galerie Louise Leiris,
Paris
Linoleum cut
Block, 20⅞ × 25³⁄₁₆ in. (53 × 64 cm);
sheet, 24½ × 29⅝ in. (62.2 × 75.2 cm)
In graphite at lower left: 33/50
Bloch 1101; MMA 95; Geiser/Baer
1312.V.B.a
The Mr. and Mrs. Charles Kramer
Collection, Gift of Mr. and Mrs.
Charles Kramer, 1979
1979.620.90

P228.

Still Life with Hanging Lamp

1962

Printed by Hidalgo Arnéra
Published by Galerie Louise Leiris,
Paris
Linoleum cut
Block, 25³⁄₁₆ × 20¹³⁄₁₆ in. (64 ×
52.9 cm); sheet, 29⅝ × 24½ in.
(75.2 × 62.2 cm)
In graphite at lower left: 43/50
Bloch 1102; MMA 97; Geiser/Baer
1313.B.g.2.a
The Mr. and Mrs. Charles Kramer
Collection, Gift of Mr. and Mrs.
Charles Kramer, 1979
1979.620.91

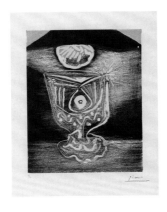

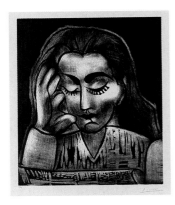

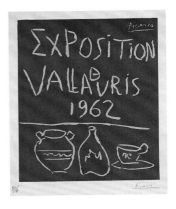

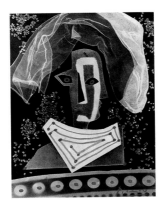

P229.

A Glass by Lamplight

1962

Printed by Hidalgo Arnéra
Published by Galerie Louise Leiris,
Paris
Linoleum cut
Block, 13⅞ × 10⅝ in. (35.2 × 27 cm);
sheet, 24¾ × 17½ in. (62.9 × 44.5 cm)
In graphite at lower left: 2/50
Bloch 1103; MMA 96; Geiser/Baer
1314.B.b.2.a
The Mr. and Mrs. Charles Kramer
Collection, Gift of Mr. and Mrs.
Charles Kramer, 1979
1979.620.92

P230.

Jacqueline Reading

1962

Printed by Hidalgo Arnéra
Published by Galerie Louise Leiris,
Paris
Linoleum cut
Block, 25¼ × 20⅞ in. (64 × 53 cm);
sheet, 29⅝ × 24½ in. (75.2 × 62.2 cm)
In graphite at lower left: 43/50
Bloch 1181; MMA 80; Geiser/Baer
1292.B.b.1
The Mr. and Mrs. Charles Kramer
Collection, Gift of Mr. and Mrs.
Charles Kramer, 1979
1979.620.105

P231.

Vallauris Exhibition 1962

1962

Printed by Hidalgo Arnéra
Published by Arnéra, Vallauris
Linoleum cut
Block, 25⅛ × 20⅞ in. (63.8 × 53 cm);
sheet, 29½ × 24½ in. (74.9 ×
62.2 cm)
In graphite at lower left: 170/175
Bloch 1299; Czwiklitzer 48; MMA
143; Geiser/Baer 1335.B.a
The Mr. and Mrs. Charles Kramer
Collection, Gift of Mr. and Mrs.
Charles Kramer, 1979
1979.620.131

P232.

The Bride As She Is

1962

From *Diurnes: Decoupages and
Photographs*
With André Villers; text by Jacques
Prévert
Printed by Atelier Daniel Jacomet
Published by Berggruen, Paris
Collotype with hand-colored
additions in wax crayon
Overall 15⅝ × 11⅝ in. (39.7 ×
29.5 cm)
Cramer 115
Gift of Olivier and Desiree
Berggruen, 2009
2009.534

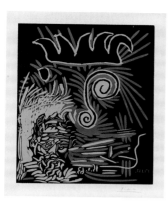

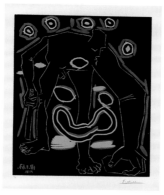

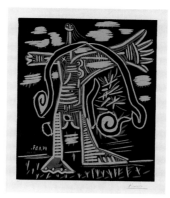

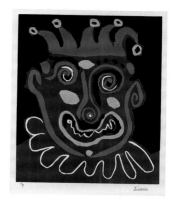

P233.

The Old Jester

1963

Printed by Hidalgo Arnéra
Published by Galerie Louise Leiris,
Paris
Linoleum cut
Block, 25¼ × 20⅞ in. (64.1 × 53 cm);
sheet, 29⅝ × 24½ in. (75.2 × 62.2 cm)
In graphite at lower left: 21/50
Bloch 1104; MMA 105; Geiser/Baer
1338.(2nd plate).II.B.a
The Mr. and Mrs. Charles Kramer
Collection, Gift of Mr. and Mrs.
Charles Kramer, 1979
1979.620.93

P234.

The Old Jester

1963

Printed by Hidalgo Arnéra
Published by Galerie Louise Leiris,
Paris
Linoleum cut
Block, 25¼ × 20⅞ in. (64.1 × 53 cm);
sheet, 29⅝ × 24½ in. (75.2 × 62.2 cm)
In graphite at lower left: 21/50
Bloch 1106; MMA 111; Geiser/Baer
1338.(3rd plate).II.B.a
The Mr. and Mrs. Charles Kramer
Collection, Gift of Mr. and Mrs.
Charles Kramer, 1979
1979.620.95

P235.

The Old Jester

1963

Printed by Hidalgo Arnéra
Published by Galerie Louise Leiris,
Paris
Linoleum cut
Block, 25¼ × 20⅞ in. (64.1 × 53 cm);
sheet, 29⅝ × 24½ in. (75.2 × 62.2 cm)
In graphite at lower left: 2/50
Bloch 1107; MMA 112; Geiser/Baer
1338.(4th plate).II.B.a
The Mr. and Mrs. Charles Kramer
Collection, Gift of Mr. and Mrs.
Charles Kramer, 1979
1979.620.96

P236.

The Old Jester

1963

Printed by Hidalgo Arnéra
Published by Galerie Louise Leiris,
Paris
Linoleum cut
Block, 25¼ × 20⅞ in. (64.1 × 53 cm);
sheet, 29⅝ × 24½ in. (75.2 × 62.2 cm)
In graphite at lower left: 41/160
Bloch 1152; MMA 104; Geiser/Baer
1338.B.i.3.a
The Mr. and Mrs. Charles Kramer
Collection, Gift of Mr. and Mrs.
Charles Kramer, 1979
1979.620.103

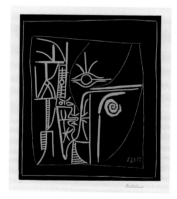

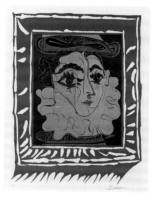

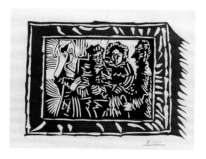

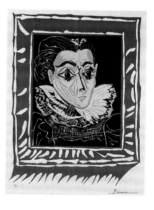

P237.

Face

1963

Printed by Hidalgo Arnéra
Published by Galerie Louise Leiris,
Paris
Linoleum cut
Block, 25¼ × 20⅞ in. (64.1 × 53 cm);
sheet, 29⅝ × 24½ in. (75.2 × 62.2 cm)
In graphite at lower left: 21/50
Bloch 1105; MMA 102; Geiser/Baer
1339.B.a
The Mr. and Mrs. Charles Kramer
Collection, Gift of Mr. and Mrs.
Charles Kramer, 1979
1979.620.94

P238.

*Jacqueline in a Flowery
Straw Hat*

1963

Printed by Hidalgo Arnéra
Published by Galerie Louise Leiris,
Paris
Linoleum cut
Block, 21⅛ × 15¾ in. (53.7 × 40 cm);
sheet, 24⅝ × 17½ in. (62.5 × 44.5 cm)
In graphite at lower left: 2/50
Bloch 1145; MMA 99; Geiser/Baer
1322.B.b.1
The Mr. and Mrs. Charles Kramer
Collection, Gift of Mr. and Mrs.
Charles Kramer, 1979
1979.620.97

P239.

Ingresque Family IV

1963

Printed by Hidalgo Arnéra
Published by Galerie Louise Leiris,
Paris
Linoleum cut
Block, 15¾ × 21 in. (40 × 53.3 cm);
sheet, 19⅞ × 25¾ in. (50.5 × 65.4 cm)
In graphite at lower left: 2/50
Bloch 1146; MMA 113; Geiser/Baer
1337.B.a
The Mr. and Mrs. Charles Kramer
Collection, Gift of Mr. and Mrs.
Charles Kramer, 1979
1979.620.98

P240.

Jacqueline with a Ruff

1963

Printed by Hidalgo Arnéra
Published by Galerie Louise Leiris,
Paris
Linoleum cut
Block, 21⅛ × 15¾ in. (53.7 × 40 cm);
sheet, 24½ × 17¼ in. (62.2 × 43.8 cm)
Bloch 1147; MMA 100; Geiser/Baer
1321.B.b.1
The Mr. and Mrs. Charles Kramer
Collection, Gift of Mr. and Mrs.
Charles Kramer, 1979
1979.664.1

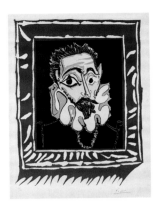

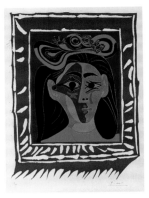

P241.

Man with a Ruff

1963

Printed by Hidalgo Arnéra
Published by Galerie Louise Leiris,
Paris
Linoleum cut
Block, 21⅛ × 15¾ in. (53.7 × 40 cm);
sheet, 24½ × 17⅜ in. (62.2 × 44.1 cm)
In graphite at lower left: 17/50
Bloch 1148; MMA 101; Geiser/Baer
1320.B.b.1
The Mr. and Mrs. Charles Kramer
Collection, Gift of Mr. and Mrs.
Charles Kramer, 1979
1979.620.99

P242.

*Jacqueline in a Flowered
Hat II*

1963

Printed by Hidalgo Arnéra
Published by Galerie Louise Leiris,
Paris
Linoleum cut
Block, 21⅛ × 15¾ in. (53.7 × 40 cm);
sheet, 24½ × 17½ in. (62.2 × 44.5 cm)
In graphite at lower left: 2/50
Bloch 1149; MMA 98; Geiser/Baer
1304.B.b.1
The Mr. and Mrs. Charles Kramer
Collection, Gift of Mr. and Mrs.
Charles Kramer, 1979
1979.620.100

P243.

Embrace I

1963

Printed by Hidalgo Arnéra
Published by Galerie Louise Leiris,
Paris
Linoleum cut
Block, 20⅞ × 25⅛ in. (53 × 63.8 cm);
sheet, 24½ × 29½ in. (62.2 × 74.9 cm)
In graphite at lower left: 23/50
Bloch 1150; MMA 114; Geiser/Baer
1343.B.a
The Mr. and Mrs. Charles Kramer
Collection, Gift of Mr. and Mrs.
Charles Kramer, 1979
1979.620.101

P244.

Embrace II

1963

Printed by Hidalgo Arnéra
Published by Galerie Louise Leiris,
Paris
Linoleum cut
Block, 21 × 25⅛ in. (53.3 × 63.8 cm);
sheet, 24⅜ × 28⅞ in. (61.9 × 73.3 cm)
In graphite at lower left: 2/50
Bloch 1151; MMA 115; Geiser/Baer
1344.B.a
The Mr. and Mrs. Charles Kramer
Collection, Gift of Mr. and Mrs.
Charles Kramer, 1979
1979.620.102

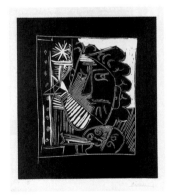

P245.

Painter and His Canvas

1963

Printed by Hidalgo Arnéra
Published by Galerie Louise Leiris,
Paris
Linoleum cut
Block, 25¼ × 20⅞ in. (64.1 × 53 cm);
sheet, 29⅝ × 24½ in. (75.2 × 62.2 cm)
In graphite at lower left: 80/150
Bloch 1153; MMA 103; Geiser/Baer
1342.B.a
The Mr. and Mrs. Charles Kramer
Collection, Gift of Mr. and Mrs.
Charles Kramer, 1979
1979.620.104

P246.

Vallauris Exhibition 1963

1963

Printed by Hidalgo Arnéra
Published by Arnéra, Vallauris
Linoleum cut
Block, 25⅛ × 20⅞ in. (63.8 × 53 cm);
sheet, 29⅝ × 24½ in. (75.2 × 62.2 cm)
Bloch 1300; Czwiklitzer 50; MMA
144; Geiser/Baer 1341.B.a
The Mr. and Mrs. Charles Kramer
Collection, Gift of Mr. and Mrs.
Charles Kramer, 1979
1979.620.132

P247.

*Painter and Model in an
Armchair*

1963

Printed by Hidalgo Arnéra
Linoleum cut; first state of two
Block, 20⅞ × 25³⁄₁₆ in. (53 × 64 cm);
sheet, 24⁷⁄₁₆ × 29⁹⁄₁₆ in. (62 × 75.1 cm)
Geiser/Baer 1347.I.3
The Mr. and Mrs. Charles Kramer
Collection, Gift of Mr. and Mrs.
Charles Kramer, 1988
1988.1101.2

P248.

Vallauris Exhibition 1964

1964

Printed by Hidalgo Arnéra
Published by Arnéra, Vallauris
Linoleum cut
Block, 25⅛ × 20⅞ in. (63.8 × 53 cm);
sheet, 29⅝ × 24½ in. (75.2 × 62.2 cm)
In graphite at lower left: 67/168
Bloch 1301; Czwiklitzer 52; MMA
145; Geiser/Baer 1354.B.a
The Mr. and Mrs. Charles Kramer
Collection, Gift of Mr. and Mrs.
Charles Kramer, 1979
1979.620.133

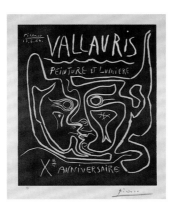

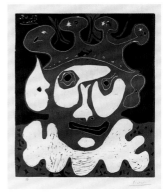

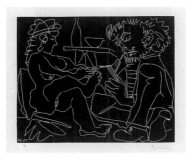

P249.

Vallauris Exhibition, "Painting and Light," Tenth Anniversary, 1964

1964

Printed by Hidalgo Arnéra
Published by Arnéra, Vallauris
Linoleum cut
Block, 25½ × 20⅞ in. (64.8 × 53 cm);
sheet, 29½ × 24⅜ in. (74.9 × 61.9 cm)
In graphite at lower left: 106/185
Bloch 1850; Czwiklitzer 51; MMA
146; Geiser/Baer 1353.II.B.a
The Mr. and Mrs. Charles Kramer
Collection, Gift of Mr. and Mrs.
Charles Kramer, 1979
1979.620.137

P250.

"Picasso Original Prints Exhibition," Galerie Nierendorf, Berlin 1964

1964

Printed by Schneider, Berlin
Published by Galerie Nierendorf,
Berlin
Linoleum cut
Block, 21⅛ × 15½ in. (53.7 × 39.4 cm);
sheet, 25 × 18¾ in. (63.5 × 47.6 cm)
Czwiklitzer 200; MMA 147
The Mr. and Mrs. Charles Kramer
Collection, Gift of Mr. and Mrs.
Charles Kramer, 1979
1979.620.140

P251.

Head of a Jester, Carnival 1965

1965

Printed by Hidalgo Arnéra
Published by Galerie Louise Leiris,
Paris
Linoleum cut
Block, 25½ × 20⅝ in. (64.8 ×
52.4 cm); sheet, 29½ × 24⅜ in.
(74.9 × 61.9 cm)
In graphite at lower left: 113/160
Bloch 1193; MMA 106; Geiser/Baer
1356.II.B.a
The Mr. and Mrs. Charles Kramer
Collection, Gift of Mr. and Mrs.
Charles Kramer, 1979
1979.620.106

P252.

Painter Sketching and Nude Model in a Hat

1965

Printed by Hidalgo Arnéra
Published by Galerie Louise Leiris,
Paris
Linoleum cut
Block, 20⅝ × 25 in. (52.4 × 63.5 cm);
sheet, 24¾ × 29½ in. (62.9 ×
74.9 cm)
In graphite at lower left: 66/160
Bloch 1194; MMA 116; Geiser/Baer
1357.B.a
The Mr. and Mrs. Charles Kramer
Collection, Gift of Mr. and Mrs.
Charles Kramer, 1979
1979.620.107

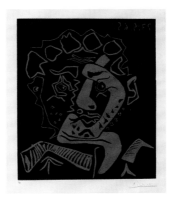

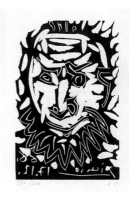

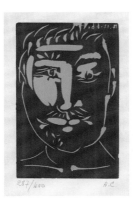

P253.

Head of an Actor

1965

Printed by Hidalgo Arnéra
Published by Galerie Louise Leiris,
Paris
Linoleum cut
Block, 25¼ × 20⅞ in. (64.1 × 53 cm);
sheet, 29⅝ × 14⅞ in. (75.2 × 37.8 cm)
In graphite at lower left: 4/200
Bloch 1849; MMA 107; Geiser/Baer
1360.B.a
The Mr. and Mrs. Charles Kramer
Collection, Gift of Mr. and Mrs.
Charles Kramer, 1979
1979.620.136

P254.

Head of a Man

1966

Printed by Hidalgo Arnéra
Published by Galerie Louise Leiris,
Paris
Linoleum cut
Block, 13⅜ × 11 in. (34 × 27.9 cm);
sheet, 17⅛ × 14¾ in. (43.5 × 37.5 cm)
In graphite at lower left: 5/150
Bloch 1230; MMA 108; Geiser/Baer
1848.B
The Mr. and Mrs. Charles Kramer
Collection, Gift of Mr. and Mrs.
Charles Kramer, 1979
1979.620.108

P255.

Head of a Bearded Man

1966

Printed by Hidalgo Arnéra
Published by Galerie Madoura,
Cannes
Linoleum cut
Block, 6⅞ × 4¼ in. (17.5 × 10.8 cm);
sheet, 8½ × 5¼ in. (21.6 × 13.3 cm)
In graphite at lower right: H.C.; at
lower left: 380/400
Bloch 1240; MMA 110; Geiser/Baer
1850.B.b
The Mr. and Mrs. Charles Kramer
Collection, Gift of Mr. and Mrs.
Charles Kramer, 1979
1979.620.109

P256.

Head of a Man with a Mustache

1966

Printed by Hidalgo Arnéra
Published by Galerie Madoura,
Cannes
Linoleum cut
Block, 6⅞ × 4½ in. (17.5 × 11.4 cm);
sheet, 8½ × 5¼ in. (21.6 × 13.3 cm)
In graphite at lower left: 287/400
Bloch 1853; MMA 109; Geiser/Baer
1851.B.b
The Mr. and Mrs. Charles Kramer
Collection, Gift of Mr. and Mrs.
Charles Kramer, 1979
1979.620.138

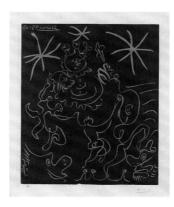

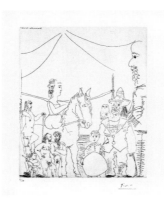

P257.

Carnival 1967

1967

Printed by Hidalgo Arnéra
Published by Galerie Louise Leiris,
Paris
Linoleum cut
Block, 25¼ × 20⅞ in. (64.1 × 53 cm);
sheet, 29½ × 24⅜ in. (74.9 × 61.9 cm)
In graphite at lower left: 13/160
Bloch 1242; MMA 117; Geiser/Baer
1852.B.a
The Mr. and Mrs. Charles Kramer
Collection, Gift of Mr. and Mrs.
Charles Kramer, 1979
1979.620.110

P258.

*Célestine with a Woman and
a Cavalier on Foot*

1968

Printed by Hidalgo Arnéra
Published by Galerie Madoura,
Cannes
Linoleum cut
Block, 6⅞ × 4½ in. (17.5 × 11.4 cm);
sheet, 8½ × 5¼ in. (21.6 × 13.3 cm)
In graphite at lower right: H.C.; at
lower left: 251/440
Bloch 1461; MMA 119; Geiser/Baer
1853.B.b
The Mr. and Mrs. Charles Kramer
Collection, Gift of Mr. and Mrs.
Charles Kramer, 1979
1979.620.134

P259.

*Célestine with a Woman, a
Cavalier, and His Valet*

1968

Printed by Hidalgo Arnéra
Published by Galerie Madoura,
Cannes
Linoleum cut
Block, 4⅝ × 6⅞ in. (11.7 × 17.5 cm);
sheet, 5¾ × 8½ in. (14.6 × 21.6 cm)
In graphite at lower right: H.C.; at
lower left: 9/450
Bloch 1462; MMA 118; Geiser/Baer
1854.B.b
The Mr. and Mrs. Charles Kramer
Collection, Gift of Mr. and Mrs.
Charles Kramer, 1979
1979.620.135

P260.

*At the Circus: Group with
Female Rider and Clown,*
from *347 Suite*

1968

Printed by Aldo and Piero
Crommelynck
Published by Galerie Louise Leiris,
Paris
Etching
Plate, 16⅝ × 13⅝ in. (42.2 ×
34.6 cm); sheet, 24⅛ × 19¹¹⁄₁₆ in.
(61.3 × 50 cm)
In graphite at lower left: 23/50
Bloch 1485; Geiser/Baer 1500.B.b.1
Gift of Reiss-Cohen Inc., 1985
1985.1165.1

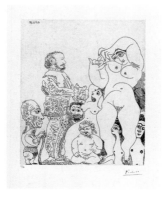

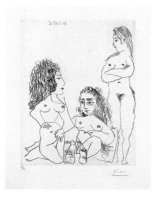

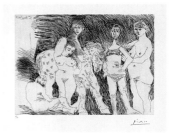

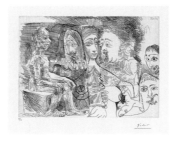

P261.

*Self-Portrait with a Cane,
with a Comedian in Costume,
Cupid, and Women,* from
347 Suite

1968

Printed by Aldo and Piero
Crommelynck
Published by Galerie Louise Leiris,
Paris
Etching
Plate, 16⅝ × 13⅝ in. (42.2 × 34.6 cm);
sheet, 24 × 19⅝ in. (61 × 49.8 cm)
In graphite at lower left: 23/50
Bloch 1488; Geiser/Baer 1503.B.b.1
Gift of Reiss-Cohen Inc., 1985
1985.1165.2

P262.

Three Women, from *347 Suite*

1968

Printed by Aldo and Piero
Crommelynck
Published by Galerie Louise Leiris,
Paris
Etching
Plate, 16⅜ × 12⅜ in. (41.6 × 31.5 cm);
sheet, 22¾ × 17⅝ in. (57.8 × 44.8 cm)
In graphite at lower left: 20/50
Bloch 1494; Geiser/Baer 1510.B.b.1
Gift of Mr. and Mrs. Isidore M.
Cohen, 1984
1984.1205.43

P263.

*Old Man Thinking of His
Youth: Boy on a Circus Horse
and Women,* from *347 Suite*

1968

Printed by Aldo and Piero
Crommelynck
Published by Galerie Louise Leiris,
Paris
Etching
Plate, 12½ × 16⅜ in. (31.7 ×
41.6 cm); sheet, 17¾ × 22³⁄₁₆ in.
(45.1 × 56.3 cm)
In graphite at lower left: 8/50
Bloch 1495; Geiser/Baer 1511.B.b.1
Gift of Reiss-Cohen Inc., 1985
1985.1165.3

P264.

*The Old Man's Fantasy:
Courtesan with Men in
Rembrandtesque Costume,*
from *347 Suite*

1968

Printed by Aldo and Piero
Crommelynck
Published by Galerie Louise Leiris,
Paris
Etching
Plate, 12⅜ × 16⁵⁄₁₆ in. (31.5 ×
41.5 cm); sheet, 17¹¹⁄₁₆ × 22³⁄₁₆ in.
(45 × 56.4 cm)
In graphite at lower left: 20/50
Bloch 1496; Geiser/Baer 1512.B.b.1
Gift of Mr. and Mrs. Isidore M.
Cohen, 1984
1984.1205.42

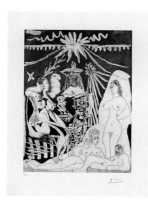

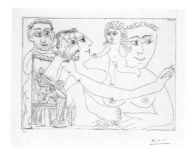

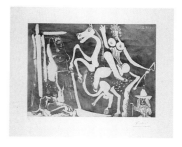

P265.

An Elongated Man with Two Women Telling Tales of an Old Clown and a Young Girl, from *347 Suite*

1968

Printed by Aldo and Piero Crommelynck
Published by Galerie Louise Leiris, Paris
Aquatint and etching
Plate, 14 13/16 × 10 13/16 in. (37.6 × 27.5 cm); sheet, 21 5/8 × 16 3/4 in. (54.9 × 42.5 cm)
In graphite at lower left: 6/50
Bloch 1498; Geiser/Baer 1514.B.b.1
Gift of Isidore M. Cohen, 1986
1986.1236.3

P266.

Figures with a Man in an Armchair Daydreaming about Love, from *347 Suite*

1968

Printed by Aldo and Piero Crommelynck
Published by Galerie Louise Leiris, Paris
Etching
Plate, 12 3/8 × 16 5/16 in. (31.5 × 41.5 cm); sheet, 17 13/16 × 22 3/16 in. (45.3 × 56.3 cm)
In graphite at lower left: 45/50
Bloch 1501; Geiser/Baer 1517.B.b.1
Gift of Reiss-Cohen Inc., 1986
1986.1236.4

P267.

At the Circus: The Strong Man, from *347 Suite*

1968

Printed by Aldo and Piero Crommelynck
Published by Galerie Louise Leiris, Paris
Etching
Plate, 2 3/8 × 4 11/16 in. (6 × 11.9 cm); sheet, 9 1/8 × 13 in. (23.2 × 33 cm)
In graphite at lower left: 29/50
Bloch 1506; Geiser/Baer 1522.B.b.1
Gift of Reiss-Cohen Inc., 1985
1985.1165.4

P268.

Painter and Model, from *347 Suite*

1968

Printed by Aldo and Piero Crommelynck
Published by Galerie Louise Leiris, Paris
Aquatint and etching
Plate, 12 3/8 × 16 3/8 in. (31.5 × 41.6 cm); sheet, 17 11/16 × 22 3/16 in. (45 × 56.4 cm)
In graphite at lower left: 20/50
Bloch 1516; Geiser/Baer 1532.B.b.1
Gift of Reiss-Cohen Inc., 1986
1986.1236.5

P269.

Harlequin and Characters, from *347 Suite*

1968

Printed by Aldo and Piero Crommelynck
Published by Galerie Louise Leiris, Paris
Etching
Plate, 12 1/2 × 15 1/2 in. (31.8 × 39.4 cm); sheet, 18 11/16 × 22 1/4 in. (47.5 × 56.5 cm)
In graphite at lower left: 18/50
Bloch 1517; Geiser/Baer 1533.B.b.1
Gift of Reiss-Cohen Inc., 1985
1985.1165.5

P270.

Painter with Couple and Child, from *347 Suite*

1968

Printed by Aldo and Piero Crommelynck
Published by Galerie Louise Leiris, Paris
Etching
Plate, 11 × 15 5/16 in. (28 × 38.9 cm); sheet, 17 13/16 × 21 5/16 in. (45.3 × 54.2 cm)
In graphite at lower left: 8/50
Bloch 1526; Geiser/Baer 1542.B.b.1
Gift of Reiss-Cohen Inc., 1985
1985.1165.6

P271.

Painter, Model, and Spectator, from *347 Suite*

1968

Printed by Aldo and Piero Crommelynck
Published by Galerie Louise Leiris, Paris
Etching
Plate, 4 13/16 × 3 9/16 in. (12.2 × 9 cm); sheet, 12 13/16 × 9 15/16 in. (32.6 × 25.2 cm)
In graphite at lower left: 31/50
Bloch 1530; Geiser/Baer 1546.B.b.1
Gift of Reiss-Cohen Inc., 1985
1985.1165.7

P272.

Woman on a Roman Chariot Harnessed to a Half-Human Horse, from *347 Suite*

1968

Printed by Aldo and Piero Crommelynck
Published by Galerie Louise Leiris, Paris
Etching
Plate, 11 × 15 1/4 in. (28 × 38.7 cm); sheet, 17 3/4 × 21 3/8 in. (45.1 × 54.3 cm)
In graphite at lower left: 18/50
Bloch 1533; Geiser/Baer 1549.B.b.1
Gift of Reiss-Cohen Inc., 1985
1985.1165.8

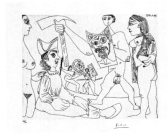
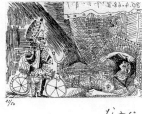

P273.

Fantasy, in the Style of Fuseli's "Dream," with a Voyeur under the Bed, from *347 Suite*
1968

Printed by Aldo and Piero Crommelynck
Published by Galerie Louise Leiris, Paris
Etching
Plate, 11 × 15⁵⁄₁₆ in. (28 × 38.9 cm); sheet, 17¹³⁄₁₆ × 21⁷⁄₁₆ in. (45.2 × 54.4 cm)
In graphite at lower left: 18/50
Bloch 1536; Geiser/Baer 1552.II.B.b.1
Gift of Reiss-Cohen Inc., 1985
1985.1165.9

P274.

Gladiators' Spectacle, from *347 Suite*
1968

Printed by Aldo and Piero Crommelynck
Published by Galerie Louise Leiris, Paris
Etching
Plate, 12½ × 15⁷⁄₁₆ in. (31.8 × 39.2 cm); sheet, 18⅝ × 22⅜ in. (47.3 × 56.8 cm)
In graphite at lower left: 17/50
Bloch 1538; Geiser/Baer 1554.B.b.1
Gift of Reiss-Cohen Inc., 1986
1986.1236.6

P275.

Gladiators' Spectacle, from *347 Suite*
1968

Printed by Aldo and Piero Crommelynck
Published by Galerie Louise Leiris, Paris
Etching
Plate, 12⁷⁄₁₆ × 15½ in. (31.6 × 39.3 cm); sheet, 18⁹⁄₁₆ × 22⁵⁄₁₆ in. (47.2 × 56.7 cm)
In graphite at lower left: 23/50
Bloch 1538; Geiser/Baer 1554.B.b.1
Gift of Reiss-Cohen Inc., 1985
1985.1165.10

P276.

A Jester with a Bicycle, Odalisque, and Owl, from *347 Suite*
1968

Printed by Aldo and Piero Crommelynck
Published by Galerie Louise Leiris, Paris
Etching
Plate, 3½ × 4⅞ in. (8.9 × 12.4 cm); sheet, 9¹³⁄₁₆ × 12⅞ in. (25 × 32.7 cm)
In graphite at lower left: 23/50
Bloch 1540; Geiser/Baer 1556.B.b.1
Gift of Reiss-Cohen Inc., 1985
1985.1165.11

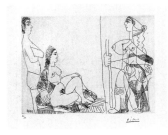
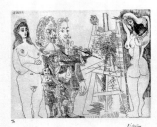
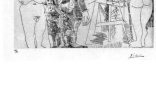
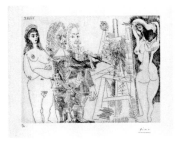
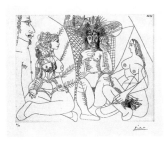

P277.

A Couple and Traveler, from *347 Suite*
1968

Printed by Aldo and Piero Crommelynck
Published by Galerie Louise Leiris, Paris
Etching
Plate, 8¾ × 11⁷⁄₁₆ in. (22.2 × 29 cm); sheet, 13¾ × 16⁹⁄₁₆ in. (34.9 × 42 cm)
In graphite at lower left: 23/50
Bloch 1543; Geiser/Baer 1559.B.b.1
Gift of Reiss-Cohen Inc., 1985
1985.1165.12

P278.

The Studio with an Owl and Official Envoy, from *347 Suite*
1968

Printed by Aldo and Piero Crommelynck
Published by Galerie Louise Leiris, Paris
Etching
Plate, 12¾ × 15¾ in. (32.4 × 40 cm); sheet, 17¾ × 21⁷⁄₁₆ in. (45.1 × 54.4 cm)
In graphite at lower left: 45/50
Bloch 1545; Geiser/Baer 1561.B.b.1
Gift of Reiss-Cohen Inc., 1985
1985.1165.13

P279.

The Studio with an Owl and Official Envoy, from *347 Suite*
1968

Printed by Aldo and Piero Crommelynck
Published by Galerie Louise Leiris, Paris
Etching
Plate, 12¾ × 15¾ in. (32.4 × 40 cm); sheet, 17¾ × 21⁷⁄₁₆ in. (45.1 × 54.4 cm)
In graphite at lower left: 17/50
Bloch 1545; Geiser/Baer 1561.B.b.1
Gift of Reiss-Cohen Inc., 1986
1986.1236.7

P280.

Three Women Passing the Time with a Stern Spectator, from *347 Suite*
1968

Printed by Aldo and Piero Crommelynck
Published by Galerie Louise Leiris, Paris
Etching
Plate, 12¾ × 15¾ in. (32.4 × 40 cm); sheet, 17¹³⁄₁₆ × 21⁷⁄₁₆ in. (45.3 × 54.4 cm)
In graphite at lower left: 23/50
Bloch 1548; Geiser/Baer 1563.B.b.1
Gift of Reiss-Cohen Inc., 1986
1986.1236.8

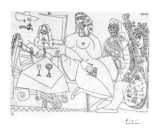 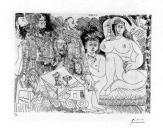 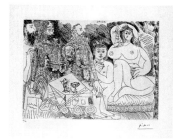 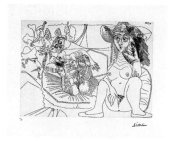

P281.

Discussing Music at Célestine's, from *347 Suite*
1968

Printed by Aldo and Piero Crommelynck
Published by Galerie Louise Leiris, Paris
Etching
Plate, 12⅜ × 16⅜ in. (31.5 × 41.6 cm); sheet, 17¹³⁄₁₆ × 22¹⁄₁₆ in. (45.2 × 56 cm)
In graphite at lower left: 18/50
Bloch 1549; Geiser/Baer 1565.B.b.1
Gift of Reiss-Cohen Inc., 1985
1985.1165.14

P282.

About Célestine: Conferring in the Garden with Young Bacchus, from *347 Suite*
1968

Printed by Aldo and Piero Crommelynck
Published by Galerie Louise Leiris, Paris
Etching
Plate, 12⅜ × 16⁵⁄₁₆ in. (31.4 × 41.4 cm); sheet, 17⅞ × 22³⁄₁₆ in. (45.4 × 56.3 cm)
In graphite at lower left: 47/50
Bloch 1550; Geiser/Baer 1566.B.b.1
Gift of Reiss-Cohen Inc., 1985
1985.1165.15

P283.

About Célestine: Conferring in the Garden with Young Bacchus, from *347 Suite*
1968

Printed by Aldo and Piero Crommelynck
Published by Galerie Louise Leiris, Paris
Etching
Plate, 12⅜ × 16⁵⁄₁₆ in. (31.4 × 41.4 cm); sheet, 18 × 22¼ in. (45.7 × 56.4 cm)
In graphite at lower left: 20/50
Bloch 1550; Geiser/Baer 1556.B.b.1
Gift of Reiss-Cohen Inc., 1986
1986.1236.9

P284.

A Young Woman in a Hat, from *347 Suite*
1968

Printed by Aldo and Piero Crommelynck
Published by Galerie Louise Leiris, Paris
Etching
Plate, 12⅜ × 16⁷⁄₁₆ in. (31.5 × 41.7 cm); sheet, 17¹¹⁄₁₆ × 22⅛ in. (45 × 56.2 cm)
In graphite at lower left: 45/50
Bloch 1551; Geiser/Baer 1567.B.b.1
Gift of Reiss-Cohen Inc., 1985
1985.1165.16

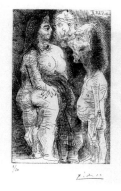 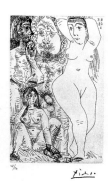 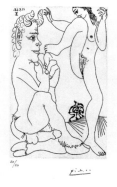 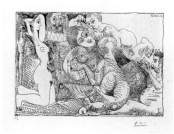

P285.

Fat Courtesan with an Old Man and a Spectator in Costume, from *347 Suite*
1968

Printed by Aldo and Piero Crommelynck
Published by Galerie Louise Leiris, Paris
Etching
Plate, 7⅜ × 4⁹⁄₁₆ in. (18.7 × 11.6 cm); sheet, 12⅞ × 9⅞ in. (32.7 × 25.1 cm)
In graphite at lower left: 8/50
Bloch 1552; Geiser/Baer 1568.III.B.b.1
Gift of Mr. and Mrs. Isidore M. Cohen, 1984
1984.1205.12

P286.

Two Couples in Varying Styles, from *347 Suite*
1968

Printed by Aldo and Piero Crommelynck
Published by Galerie Louise Leiris, Paris
Etching
Plate, 7½ × 4½ in. (19.1 × 11.4 cm); sheet, 12¹¹⁄₁₆ × 9¹³⁄₁₆ in. (32.3 × 25 cm)
In graphite at lower left: 47/50
Bloch 1556; Geiser/Baer 1572.B.b.1
Gift of Mr. and Mrs. Isidore M. Cohen, 1984
1984.1205.5

P287.

Faun and Bacchante, with Battle of Fauns in the Distance, from *347 Suite*
1968

Printed by Aldo and Piero Crommelynck
Published by Galerie Louise Leiris, Paris
Etching
Plate, 7⅜ × 4⁹⁄₁₆ in. (18.7 × 11.6 cm); sheet, 12⅞ × 9⅞ in. (32.7 × 25.1 cm)
In graphite at lower left: 20/50
Bloch 1557; Geiser/Baer 1573.B.b.1
Gift of Mr. and Mrs. Isidore M. Cohen, 1984
1984.1205.10

P288.

La vie en rose ("Quand . . . Il me parle tout bas"), from *347 Suite*
1968

Printed by Aldo and Piero Crommelynck
Published by Galerie Louise Leiris, Paris
Etching
Plate, 10¹³⁄₁₆ × 14¾ in. (27.5 × 37.5 cm); sheet, 16⁹⁄₁₆ × 19¹¹⁄₁₆ in. (42.1 × 50 cm)
In graphite at lower left: 23/50
Bloch 1560; Geiser/Baer 1576.B.b.1
Gift of Reiss-Cohen Inc., 1985
1985.1165.17

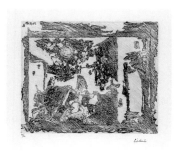

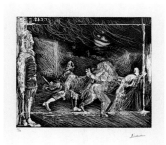

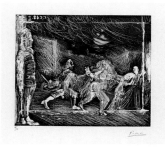

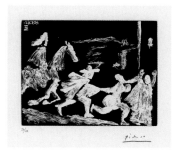

P289.

A Scene from "La Celestina": The Gentleman Is Led Toward the Den, from *347 Suite*
1968

Printed by Aldo and Piero Crommelynck
Published by Galerie Louise Leiris, Paris
Etching
Plate, 11⅝ × 13¾ in. (29.5 × 34.9 cm); sheet, 17⅞ × 20⁹⁄₁₆ in. (45.4 × 52.2 cm)
In graphite at lower left: 20/50
Bloch 1565; Geiser/Baer 1581.B.b.1
Gift of Mr. and Mrs. Isidore M. Cohen, 1984
1984.1205.41

P290.

Theater or Television: Cape and Sword, from *347 Suite*
1968

Printed by Aldo and Piero Crommelynck
Published by Galerie Louise Leiris, Paris
Aquatint and drypoint
Plate, 11⅝ × 13⅝ in. (29.5 × 34.6 cm); sheet, 17⅞ × 20½ in. (45.4 × 52.1 cm)
In graphite at lower left: 23/50
Bloch 1567; Geiser/Baer 1583.III.B.b.1
Gift of Reiss-Cohen Inc., 1985
1985.1165.18

P291.

Theater or Television: Cape and Sword, from *347 Suite*
1968

Printed by Aldo and Piero Crommelynck
Published by Galerie Louise Leiris, Paris
Aquatint and drypoint
Plate, 11⅝ × 13⁹⁄₁₆ in. (29.5 × 34.5 cm); sheet, 17⅞ × 20½ in. (45.4 × 52.1 cm)
In graphite at lower left: 18/50
Bloch 1567; Geiser/Baer 1583.III.B.b.1
Gift of Reiss-Cohen Inc., 1986
1986.1236.1

P292.

Cape and Sword: Pursuit I, from *347 Suite*
1968

Printed by Aldo and Piero Crommelynck
Published by Galerie Louise Leiris, Paris
Aquatint
Plate, 6½ × 8⅛ in. (16.5 × 20.7 cm); sheet, 11⅛ × 13³⁄₁₆ in. (28.3 × 33.5 cm)
In graphite at lower left: 17/50
Bloch 1568; Geiser/Baer 1584.B.b.1
Gift of Reiss-Cohen Inc., 1985
1985.1165.19

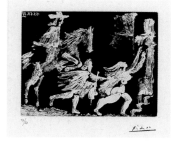

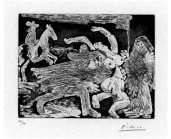

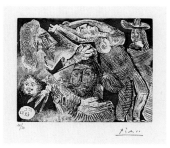

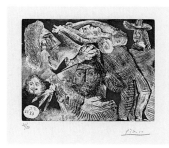

P293.

Cape and Sword: Pursuit II, from *347 Suite*
1968

Printed by Aldo and Piero Crommelynck
Published by Galerie Louise Leiris, Paris
Aquatint
Plate, 6⅝ × 8⅛ in. (16.8 × 20.6 cm); sheet, 11⅛ × 13¹⁄₁₆ in. (28.3 × 33.2 cm)
In graphite at lower left: 17/50
Bloch 1569; Geiser/Baer 1585.B.b.1
Gift of Mr. and Mrs. Isidore M. Cohen, 1984
1984.1205.16

P294.

Célestine, Abduction, from *347 Suite*
1968

Printed by Aldo and Piero Crommelynck
Published by Galerie Louise Leiris, Paris
Aquatint
Plate, 6⁹⁄₁₆ × 8⅛ in. (16.7 × 20.6 cm); sheet, 11⅛ × 13⅛ in. (28.3 × 33.3 cm)
In graphite at lower left: 47/50
Bloch 1570; Geiser/Baer 1586.B.b.1
Gift of Mr. and Mrs. Isidore M. Cohen, 1984
1984.1205.15

P295.

The Three Musketeers: Abduction, from *347 Suite*
1968

Printed by Aldo and Piero Crommelynck
Published by Galerie Louise Leiris, Paris
Aquatint
Plate, 6½ × 8⅛ in. (16.5 × 20.6 cm); sheet, 11⅛ × 13⅛ in. (28.3 × 33.3 cm)
In graphite at lower left: 23/50
Bloch 1571; Geiser/Baer 1587.B.b.1
Gift of Reiss-Cohen Inc., 1985
1985.1165.20

P296.

The Three Musketeers: Abduction, from *347 Suite*
1968

Printed by Aldo and Piero Crommelynck
Published by Galerie Louise Leiris, Paris
Aquatint, etching, and drypoint
Plate, 6½ × 8⅛ in. (16.5 × 20.6 cm); sheet, 11⅛ × 13⅛ in. (28.2 × 33.3 cm)
In graphite at lower left: 20/50
Bloch 1571; Geiser/Baer 1587.B.b.1
Gift of Reiss-Cohen Inc., 1986
1986.1236.10

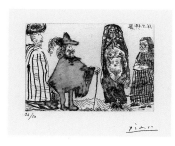 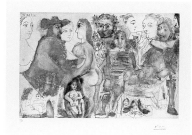

P297.

"A Thousand and One Nights" and Célestine: The Young Slave, from *347 Suite*
1968

Printed by Aldo and Piero Crommelynck
Published by Galerie Louise Leiris, Paris
Etching
Plate, 3⁹⁄₁₆ × 4¹⁵⁄₁₆ in. (9 × 12.5 cm); sheet, 9¹⁵⁄₁₆ × 12¹⁵⁄₁₆ in. (25.3 × 32.8 cm)
In graphite at lower left: 23/50
Bloch 1574; Geiser/Baer 1590.B.b.1
Gift of Reiss-Cohen Inc., 1985
1985.1165.21

P298.

A Musketeer Seated at the Table with a Young Boy Recalling His Life, from *347 Suite*
1968

Printed by Aldo and Piero Crommelynck
Published by Galerie Louise Leiris, Paris
Aquatint
Plate, 13¼ × 24⅛ in. (33.7 × 61.3 cm); sheet, 19¾ × 25¹¹⁄₁₆ in. (50.2 × 65.3 cm)
In graphite at lower left: 45/50
Bloch 1577; Geiser/Baer 1593.VI.B.b.1
Gift of Reiss-Cohen Inc., 1986
1986.1236.11

P299.

Abduction with Célestine, a Ruffian, a Girl, and a Lord with His Valet, from *347 Suite*
1968

Printed by Aldo and Piero Crommelynck
Published by Galerie Louise Leiris, Paris
Aquatint
Plate, 11⅝ × 13⅝ in. (29.5 × 34.6 cm); sheet, 17⅞ × 20½ in. (45.4 × 52.1 cm)
In graphite at lower left: 45/50
Bloch 1578; Geiser/Baer 1594.B.b.1
Gift of Reiss-Cohen Inc., 1985
1985.1165.22

P300.

Célestine Presenting Her Two Pensioners to Two Clients, from *347 Suite*
1968

Printed by Aldo and Piero Crommelynck
Published by Galerie Louise Leiris, Paris
Etching
Plate, 3½ × 4⅞ in. (8.9 × 12.4 cm); sheet, 9¹⁵⁄₁₆ × 12⅞ in. (25.2 × 32.7 cm)
In graphite at lower left: 23/50
Bloch 1581; Geiser/Baer 1597.III.B.b.1
Gift of Reiss-Cohen Inc., 1985
1985.1165.23

 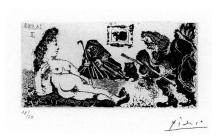 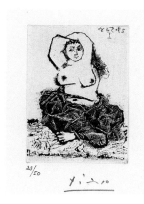

P301.

Patron and His Retinue Visiting the Studio of an Old Painter, from *347 Suite*
1968

Printed by Aldo and Piero Crommelynck
Published by Galerie Louise Leiris, Paris
Sugar-lift aquatint and drypoint
Plate, 9³⁄₁₆ × 13 in. (23.4 × 33 cm); sheet, 14⅜ × 18½ in. (36.5 × 47 cm)
In graphite at lower left: 23/50
Bloch 1590; Geiser/Baer 1606.B.b.1
Gift of Reiss-Cohen Inc., 1985
1985.1165.24

P302.

An Old Beau Greeting Célestine's Pupil, from *347 Suite*
1968

Printed by Aldo and Piero Crommelynck
Published by Galerie Louise Leiris, Paris
Aquatint
Plate, 2⅜ × 4⅝ in. (6 × 11.7 cm); sheet, 9¹³⁄₁₆ × 12¹⁵⁄₁₆ in. (25 × 32.9 cm)
In graphite at lower left: 18/50
Bloch 1593; Geiser/Baer 1609.B.b.1
Gift of Reiss-Cohen Inc., 1986
1986.1236.12

P303.

Odalisque, from *347 Suite*
1968

Printed by Aldo and Piero Crommelynck
Published by Galerie Louise Leiris, Paris
Sugar-lift aquatint
Plate, 3⅜ × 2⅜ in. (8.5 × 6 cm); sheet, 13 × 10 in. (33 × 25.4 cm)
In graphite at lower left: 29/50
Bloch 1601; Geiser/Baer 1620.B.b.1
Gift of Reiss-Cohen Inc., 1985
1985.1165.26

P304.

Maja and Célestine, from *347 Suite*
1968

Printed by Aldo and Piero Crommelynck
Published by Galerie Louise Leiris, Paris
Sugar-lift aquatint
Plate, 4¹¹⁄₁₆ × 2⅜ in. (11.9 × 6 cm); sheet, 12¹³⁄₁₆ × 10 in. (32.5 × 25.4 cm)
In graphite at lower left: 29/50
Bloch 1602; Geiser/Baer 1617.B.b.1
Gift of Mr. and Mrs. Isidore M. Cohen, 1984
1984.1205.4

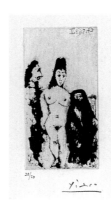

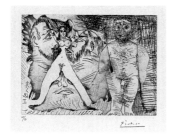

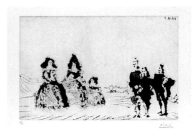

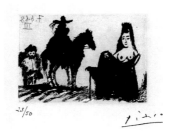

P305.

Célestine, Maja, and Male Accomplice, from *347 Suite*
1968

Printed by Aldo and Piero Crommelynck
Published by Galerie Louise Leiris, Paris
Sugar-lift aquatint
Plate, 4¹¹⁄₁₆ × 2⅜ in. (11.9 × 6 cm); sheet, 12¹³⁄₁₆ × 9¹⁵⁄₁₆ in. (32.6 × 25.2 cm)
In graphite at lower left: 29/50
Bloch 1603; Geiser/Baer 1618.B.b.1
Gift of Reiss-Cohen Inc., 1985
1985.1165.25

P306.

Nude Couple, from *347 Suite*
1968

Printed by Aldo and Piero Crommelynck
Published by Galerie Louise Leiris, Paris
Etching
Plate, 7¹³⁄₁₆ × 10⅛ in. (19.8 × 25.7 cm); sheet, 12¹⁵⁄₁₆ × 15¾ in. (32.8 × 40 cm)
In graphite at lower left: 45/50
Bloch 1613; Geiser/Baer 1629.III.B.b.1
Gift of Reiss-Cohen Inc., 1985
1985.1165.27

P307.

Las Meninas and Gentlemen in the Sierra, from *347 Suite*
1968

Printed by Aldo and Piero Crommelynck
Published by Galerie Louise Leiris, Paris
Sugar-lift aquatint
Plate, 13¼ × 19⁷⁄₁₆ in. (33.7 × 49.4 cm); sheet, 19¾ × 25¹¹⁄₁₆ in. (50.2 × 65.3 cm)
In graphite at lower left: 23/50
Bloch 1614; Geiser/Baer 1630.B.b.1
Gift of Reiss-Cohen Inc., 1985
1985.1165.28

P308.

Cavalier and His Valet, Célestine, and Maja, from *347 Suite*
1968

Printed by Aldo and Piero Crommelynck
Published by Galerie Louise Leiris, Paris
Sugar-lift aquatint
Plate, 2⅜ × 3⁵⁄₁₆ in. (6 × 8.4 cm); sheet, 9⅞ × 12¹³⁄₁₆ in. (25.1 × 32.5 cm)
In graphite at lower left: 23/50
Bloch 1625; Geiser/Baer 1641.B.b.1
Gift of Reiss-Cohen Inc., 1985
1985.1165.29

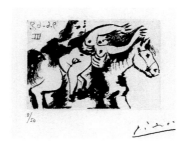

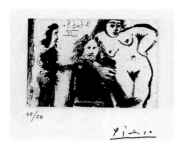

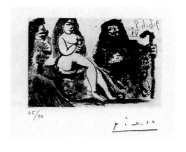

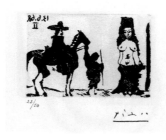

P309.

The Abduction by Horse, from *347 Suite*
1968

Printed by Aldo and Piero Crommelynck
Published by Galerie Louise Leiris, Paris
Sugar-lift aquatint
Plate, 2⅜ × 3⁵⁄₁₆ in. (6 × 8.4 cm); sheet, 9¹⁵⁄₁₆ × 12⅞ in. (25.3 × 32.7 cm)
In graphite at lower left: 8/50
Bloch 1628; Geiser/Baer 1644.B.b.1
Gift of Mr. and Mrs. Isidore M. Cohen, 1984
1984.1205.1

P310.

"Mon dieu, quel homme, qu'il est petit . . . ," from *347 Suite*
1968

Printed by Aldo and Piero Crommelynck
Published by Galerie Louise Leiris, Paris
Sugar-lift aquatint
Plate, 2⅜ × 3⁵⁄₁₆ in. (6 × 8.4 cm); sheet, 9¹⁵⁄₁₆ × 12⅞ in. (25.2 × 32.7 cm)
In graphite at lower left: 45/50
Bloch 1629; Geiser/Baer 1645.B.b.1
Gift of Reiss-Cohen Inc., 1986
1986.1236.13

P311.

Visitor with a "Bourbon Nose" at Célestine's Home, from *347 Suite*
1968

Printed by Aldo and Piero Crommelynck
Published by Galerie Louise Leiris, Paris
Sugar-lift aquatint
Plate, 2⅜ × 3⁵⁄₁₆ in. (6 × 8.4 cm); sheet, 9¹⁵⁄₁₆ × 12¾ in. (25.2 × 32.4 cm)
In graphite at lower left: 45/50
Bloch 1631; Geiser/Baer 1647.B.b.1
Gift of Reiss-Cohen Inc., 1986
1986.1236.14

P312.

Maja and a Horseman, from *347 Suite*
1968

Printed by Aldo and Piero Crommelynck
Published by Galerie Louise Leiris, Paris
Etching
Plate, 2⅜ × 3⅜ in. (6 × 8.5 cm); sheet, 10 × 12⅝ in. (25.4 × 32 cm)
In graphite at lower left: 23/50
Bloch 1636; Geiser/Baer 1652.B.b.1
Gift of Reiss-Cohen Inc., 1985
1985.1165.30

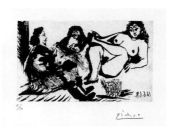

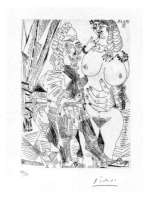

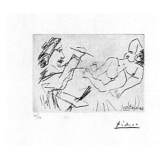

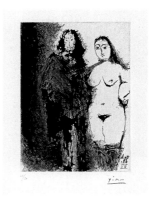

P313.

Cavalier Visiting a Girl with Célestine and a Little Dog, from *347 Suite*
1968

Printed by Aldo and Piero Crommelynck
Published by Galerie Louise Leiris, Paris
Sugar-lift aquatint
Plate, 3⅞ × 6⁵⁄₁₆ in. (9.8 × 16 cm); sheet, 9⅞ × 12¹⁵⁄₁₆ in. (25.1 × 32.9 cm)
In graphite at lower left: 8/50
Bloch 1642; Geiser/Baer 1658.B.b.1
Gift of Reiss-Cohen Inc., 1985
1985.1165.31

P314.

Fat Courtesan and Old Beau, from *347 Suite*
1968

Printed by Aldo and Piero Crommelynck
Published by Galerie Louise Leiris, Paris
Etching
Plate, 8¼ × 5¹³⁄₁₆ in. (21 × 14.8 cm); sheet, 13¹¹⁄₁₆ × 11³⁄₁₆ in. (34.8 × 28.4 cm)
In graphite at lower left: 18/50
Bloch 1645; Geiser/Baer 1661.B.b.1
Gift of Reiss-Cohen Inc., 1986
1986.1236.15

P315.

Painter and Model on a Bed, from *347 Suite*
1968

Printed by Aldo and Piero Crommelynck
Published by Galerie Louise Leiris, Paris
Drypoint
Plate, 3⁹⁄₁₆ × 4⅞ in. (9 × 12.4 cm); sheet, 9¹⁵⁄₁₆ × 12¹³⁄₁₆ in. (25.3 × 32.5 cm)
In graphite at lower left: 20/50
Bloch 1651; Geiser/Baer 1667.B.b.1
Gift of Reiss-Cohen Inc., 1985
1985.1165.32

P316.

Prostitute and Reiter, from *347 Suite*
1968

Printed by Aldo and Piero Crommelynck
Published by Galerie Louise Leiris, Paris
Sugar-lift aquatint
Plate, 8¼ × 5¹³⁄₁₆ in. (21 × 14.8 cm); sheet, 13¹¹⁄₁₆ × 11³⁄₁₆ in. (34.8 × 28.4 cm)
In graphite at lower left: 45/50
Bloch 1653; Geiser/Baer 1669.B.b.1
Gift of Reiss-Cohen Inc., 1986
1986.1236.16

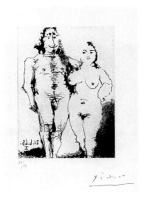

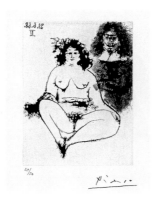

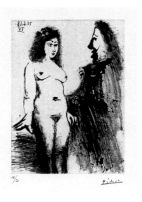

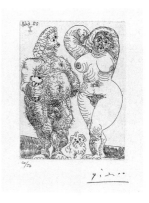

P317.

Nude Couple Posing, from *347 Suite*
1968

Printed by Aldo and Piero Crommelynck
Published by Galerie Louise Leiris, Paris
Sugar-lift aquatint
Plate, 4⅞ × 3⁷⁄₁₆ in. (12.4 × 8.8 cm); sheet, 12⅞ × 9¹⁵⁄₁₆ in. (32.7 × 25.2 cm)
In graphite at lower left: 29/50
Bloch 1654; Geiser/Baer 1670.B.b.1
Gift of Reiss-Cohen Inc., 1985
1985.1165.33

P318.

Fat Prostitute and Musketeer, from *347 Suite*
1968

Printed by Aldo and Piero Crommelynck
Published by Galerie Louise Leiris, Paris
Sugar-lift aquatint
Plate, 4¹⁵⁄₁₆ × 3⁹⁄₁₆ in. (12.5 × 9 cm); sheet, 12⅞ × 9¾ in. (32.7 × 24.8 cm)
In graphite at lower left: 29/50
Bloch 1655; Geiser/Baer 1671.B.b.1
Gift of Mr. and Mrs. Isidore M. Cohen, 1984
1984.1205.9

P319.

Young Prostitute and Musketeer, from *347 Suite*
1968

Printed by Aldo and Piero Crommelynck
Published by Galerie Louise Leiris, Paris
Sugar-lift aquatint
Plate, 8¼ × 5⅞ in. (21 × 15 cm); sheet, 13 11/16 × 11¼ in. (34.7 × 28.5 cm)
In graphite at lower left: 18/50
Bloch 1656; Geiser/Baer 1673.B.b.1
Gift of Reiss-Cohen Inc., 1985
1985.1165.34

P320.

Fat Couple and Little Shaggy Dog, from *347 Suite*
1968

Printed by Aldo and Piero Crommelynck
Published by Galerie Louise Leiris, Paris
Etching
Plate, 4¹³⁄₁₆ × 3⁹⁄₁₆ in. (12.2 × 9 cm); sheet, 12¹³⁄₁₆ × 9¹³⁄₁₆ in. (32.5 × 24.9 cm)
In graphite at lower left: 20/50
Bloch 1658; Geiser/Baer 1674.B.b.1
Gift of Mr. and Mrs. Isidore M. Cohen, 1984
1984.1205.11

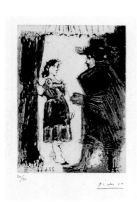

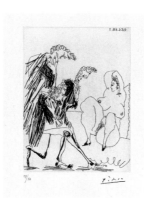

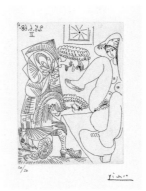

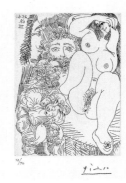

P321.

Lovers, from *347 Suite*
1968

Printed by Aldo and Piero
Crommelynck
Published by Galerie Louise Leiris,
Paris
Sugar-lift aquatint
Plate, 8¼ × 5⅞ in. (21 × 15 cm);
sheet, 13¾ × 11⅛ in. (35 × 28.3 cm)
In graphite at lower left: 20/50
Bloch 1659; Geiser/Baer 1675.B.b.1
Gift of Reiss-Cohen Inc., 1985
1985.1165.35

P322.

*Fat Courtesan Greeted
by Three Gentlemen*, from
347 Suite
1968

Printed by Aldo and Piero
Crommelynck
Published by Galerie Louise Leiris,
Paris
Etching
Plate, 8¼ × 5⅞ in. (21 × 15 cm);
sheet, 13¾ × 11⅛ in. (35 × 28.3 cm)
In graphite at lower left: 17/50
Bloch 1663; Geiser/Baer 1679.B.b.1
Gift of Reiss-Cohen Inc., 1985
1985.1165.36

P323.

*Young Woman with Two
Bowing Courtiers*, from
347 Suite
1968

Printed by Aldo and Piero
Crommelynck
Published by Galerie Louise Leiris,
Paris
Etching
Plate, 4⅞ × 3½ in. (12.4 × 8.9 cm);
sheet, 12¹³⁄₁₆ × 9¹⁵⁄₁₆ in. (32.5 ×
25.2 cm)
In graphite at lower left: 20/50
Bloch 1664; Geiser/Baer 1680.B.b.1
Gift of Mr. and Mrs. Isidore M.
Cohen, 1984
1984.1205.3

P324.

*Young Courtesan with a
Gentleman, a Sculptor, and
an Old Seducer*, from
347 Suite
1968

Printed by Aldo and Piero
Crommelynck
Published by Galerie Louise Leiris,
Paris
Etching
Plate, 4⅞ × 3½ in. (12.4 × 8.9 cm);
sheet, 12¹³⁄₁₆ × 9¹⁵⁄₁₆ in. (32.5 ×
25.2 cm)
In graphite at lower left: 18/50
Bloch 1665; Geiser/Baer 1681.B.b.1
Gift of Reiss-Cohen Inc., 1986
1986.1236.17

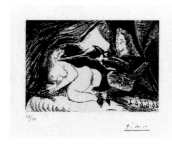

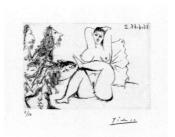

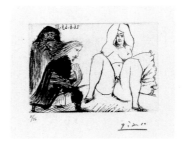

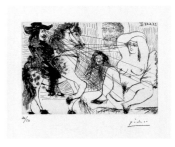

P325.

*Painter Painting the Nape
of His Young Model*, from
347 Suite
1968

Printed by Aldo and Piero
Crommelynck
Published by Galerie Louise Leiris,
Paris
Sugar-lift aquatint
Plate, 3½ × 4⅞ in. (8.9 × 12.4 cm);
sheet, 9¹⁵⁄₁₆ × 12¾ in. (25.3 × 32.4 cm)
In graphite at lower left: 47/50
Bloch 1668; Geiser/Baer 1684.B.b.1
Gift of Mr. and Mrs. Isidore M.
Cohen, 1984
1984.1205.2

P326.

*Three Musketeers Greet
a Woman in Bed*, from
347 Suite
1968

Printed by Aldo and Piero
Crommelynck
Published by Galerie Louise Leiris,
Paris
Sugar-lift aquatint
Plate, 3½ × 4¹³⁄₁₆ in. (8.9 × 12.2 cm);
sheet, 9⅞ × 12¾ in. (25.1 × 32.4 cm)
In graphite at lower left: 8/50
Bloch 1669; Geiser/Baer 1685.B.b.1
Gift of Reiss-Cohen Inc., 1986
1986.1236.18

P327.

*Célestine, Her Protégée, and
a Young Gentleman*, from
347 Suite
1968

Printed by Aldo and Piero
Crommelynck
Published by Galerie Louise Leiris,
Paris
Sugar-lift aquatint
Plate, 3½ × 4¹³⁄₁₆ in. (8.9 × 12.2 cm);
sheet, 10 × 12¾ in. (25.4 × 32.4 cm)
In graphite at lower left: 8/50
Bloch 1670; Geiser/Baer 1686.B.b.1
Gift of Mr. and Mrs. Isidore M.
Cohen, 1984
1984.1205.13

P328.

Exchange of Glances, from
347 Suite
1968

Printed by Aldo and Piero
Crommelynck
Published by Galerie Louise Leiris,
Paris
Sugar-lift aquatint and drypoint
Plate, 5¹³⁄₁₆ × 8³⁄₁₆ in. (14.8 ×
20.8 cm); sheet, 11⅛ × 13¾ in.
(28.2 × 34.9 cm)
In graphite at lower left: 20/50
Bloch 1671; Geiser/Baer 1687.II.B.b.1
Gift of Mr. and Mrs. Isidore M.
Cohen, 1984
1984.1205.33

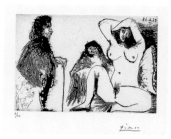 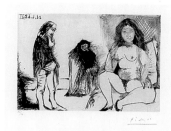

P329.

Visitor and His Dog at the Home of a Young Woman and Célestine, from *347 Suite*

1968

Printed by Aldo and Piero Crommelynck
Published by Galerie Louise Leiris, Paris
Sugar-lift aquatint
Plate, 5¹³⁄₁₆ × 8¼ in. (14.8 × 21 cm); sheet, 11⅛ × 13¾ in. (28.2 × 34.9 cm)
In graphite at lower left: 8/50
Bloch 1672; Geiser/Baer 1688.B.b.1
Gift of Reiss-Cohen Inc., 1985
1985.1165.37

P330.

Pensive Man with a Young Woman and Célestine, from *347 Suite*

1968

Printed by Aldo and Piero Crommelynck
Published by Galerie Louise Leiris, Paris
Sugar-lift aquatint and drypoint
Plate, 5¹³⁄₁₆ × 8³⁄₁₆ in. (14.8 × 20.8 cm); sheet, 11⅛ × 13¹⁵⁄₁₆ in. (28.3 × 35.4 cm)
In graphite at lower left: 29/50
Bloch 1673; Geiser/Baer 1689.IV.B.b.1
Gift of Mr. and Mrs. Isidore M. Cohen, 1984
1984.1205.17

P331.

Furniture Moving, or Revolutionary Cart, from *347 Suite*

1968

Printed by Aldo and Piero Crommelynck
Published by Galerie Louise Leiris, Paris
Etching and sugar-lift aquatint
Plate, 11¹⁄₁₆ × 15⁵⁄₁₆ in. (28.1 × 38.9 cm); sheet, 17⅞ × 21⅜ in. (45.4 × 54.3 cm)
In graphite at lower left: 20/50
Bloch 1677; Geiser/Baer 1693.II.B.b.1
Gift of Reiss-Cohen Inc., 1986
1986.1236.2

P332.

Rembrandtesque Man Seated with Girls, from *347 Suite*

1968

Printed by Aldo and Piero Crommelynck
Published by Galerie Louise Leiris, Paris
Sugar-lift aquatint
Plate, 5⅞ × 8³⁄₁₆ in. (14.9 × 20.8 cm); sheet, 11⅛ × 13⅝ in. (28.2 × 34.6 cm)
In graphite at lower left: 47/50
Bloch 1679; Geiser/Baer 1695.B.b.1
Gift of Mr. and Mrs. Isidore M. Cohen, 1984
1984.1205.18

 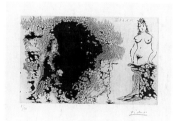 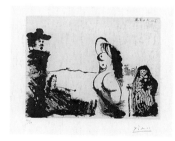

P333.

Artist Thinking of a Fighting Woman, with Musketeer, Cupid, and Small Characters, from *347 Suite*

1968

Printed by Aldo and Piero Crommelynck
Published by Galerie Louise Leiris, Paris
Sugar-lift aquatint
Plate, 8³⁄₁₆ × 5¹³⁄₁₆ in. (20.8 × 14.8 cm); sheet, 13⅝ × 11⅛ in. (34.6 × 28.2 cm)
In graphite at lower left: 47/50
Bloch 1680; Geiser/Baer 1696.B.b.1
Gift of Mr. and Mrs. Isidore M. Cohen, 1984
1984.1205.14

P334.

Célestine, Maja, and Two Gentlemen, from *347 Suite*

1968

Printed by Aldo and Piero Crommelynck
Published by Galerie Louise Leiris, Paris
Sugar-lift aquatint
Plate, 5¹³⁄₁₆ × 8¾ in. (14.8 × 22.2 cm); sheet, 11⅛ × 14¼ in. (28.3 × 36.2 cm)
In graphite at lower left: 31/50
Bloch 1687; Geiser/Baer 1703.B.b.1
Gift of Mr. and Mrs. Isidore M. Cohen, 1984
1984.1205.6

P335.

Serenade by Flute, from *347 Suite*

1968

Printed by Aldo and Piero Crommelynck
Published by Galerie Louise Leiris, Paris
Sugar-lift aquatint
Plate, 5⅞ × 8¹¹⁄₁₆ in. (14.9 × 22.1 cm); sheet, 11⅛ × 14⁵⁄₁₆ in. (28.2 × 36.3 cm)
In graphite at lower left: 8/50
Bloch 1688; Geiser/Baer 1704.B.b.1
Gift of Mr. and Mrs. Isidore M. Cohen, 1984
1984.1205.23

P336.

Le déjeuner sur l'herbe, in the Style of Rembrandt, with Maja and Célestine, from *347 Suite*

1968

Printed by Aldo and Piero Crommelynck
Published by Galerie Louise Leiris, Paris
Sugar-lift aquatint
Plate, 6⁵⁄₁₆ × 8¾ in. (16 × 22.2 cm); sheet, 12⁵⁄₁₆ × 14⁵⁄₁₆ in. (31.3 × 36.4 cm)
In graphite at lower left: 17/50
Bloch 1689; Geiser/Baer 1707.B.b.1
Gift of Mr. and Mrs. Isidore M. Cohen, 1984
1984.1205.26

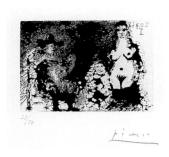
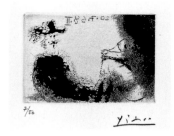

P337.
Seated Man with Pipe, Maja, and Célestine, from *347 Suite*
1968

Printed by Aldo and Piero Crommelynck
Published by Galerie Louise Leiris, Paris
Sugar-lift aquatint
Plate, 2⅜ × 3⁵⁄₁₆ in. (6 × 8.4 cm); sheet, 9⅞ × 12⅞ in. (25.1 × 32.7 cm)
In graphite at lower left: 29/50
Bloch 1690; Geiser/Baer 1705.B.b.1
Gift of Reiss-Cohen Inc., 1985
1985.1165.38

P338.
Conversation, from *347 Suite*
1968

Printed by Aldo and Piero Crommelynck
Published by Galerie Louise Leiris, Paris
Etching
Plate, 2⅜ × 3⁵⁄₁₆ in. (6 × 8.4 cm); sheet, 9¹³⁄₁₆ × 12¹³⁄₁₆ in. (25 × 32.6 cm)
In graphite at lower left: 7/50
Bloch 1691; Geiser/Baer 1706.B.b.1
Gift of Reiss-Cohen Inc., 1985
1985.1165.39

P339.
Jacqueline as Nude Maja, with Célestine and Two Musketeers, from *347 Suite*
1968

Printed by Aldo and Piero Crommelynck
Published by Galerie Louise Leiris, Paris
Sugar-lift aquatint
Plate, 6⁵⁄₁₆ × 8¾ in. (16 × 22.2 cm); sheet, 12¼ × 14⁵⁄₁₆ in. (31.1 × 36.3 cm)
In graphite at lower left: 17/50
Bloch 1692; Geiser/Baer 1708.B.b.1
Gift of Mr. and Mrs. Isidore M. Cohen, 1984
1984.1205.25

P340.
Painter and Model in Stockings, with a Spectator, from *347 Suite*
1968

Printed by Aldo and Piero Crommelynck
Published by Galerie Louise Leiris, Paris
Etching
Plate, 3⁹⁄₁₆ × 4⅝ in. (9 × 11.7 cm); sheet, 9¹⁵⁄₁₆ × 12¹⁵⁄₁₆ in. (25.2 × 32.8 cm)
In graphite at lower left: 20/50
Bloch 1693; Geiser/Baer 1709.B.b.1
Gift of Reiss-Cohen Inc., 1986
1986.1236.19

P341.
A Buffoon and Dwarf, Roman and Old Man before a Dancing Odalisque, from *347 Suite*
1968

Printed by Aldo and Piero Crommelynck
Published by Galerie Louise Leiris, Paris
Etching
Plate, 5¹³⁄₁₆ × 8¾ in. (14.8 × 22.2 cm); sheet, 11 × 14⁵⁄₁₆ in. (28 × 36.3 cm)
In graphite at lower left: 8/50
Bloch 1696; Geiser/Baer 1712.B.b.1
Gift of Mr. and Mrs. Isidore M. Cohen, 1984
1984.1205.22

P342.
Two Women with an Owl, Don Quixote, and a Conquistador, from *347 Suite*
1968

Printed by Aldo and Piero Crommelynck
Published by Galerie Louise Leiris, Paris
Etching
Plate, 6⅞ × 10¼ in. (17.5 × 26 cm); sheet, 11 × 14¹⁵⁄₁₆ in. (28 × 38 cm)
In graphite at lower left: 45/50
Bloch 1712; Geiser/Baer 1730.B.b.1
Gift of Mr. and Mrs. Isidore M. Cohen, 1984
1984.1205.27

P343.
Itinerant Players with Owl and Jester Embracing a Woman, from *347 Suite*
1968

Printed by Aldo and Piero Crommelynck
Published by Galerie Louise Leiris, Paris
Etching and drypoint
Plate, 12½ × 12⅜ in. (31.8 × 31.4 cm); sheet, 19⁷⁄₁₆ × 17¹⁵⁄₁₆ in. (49.3 × 45.5 cm)
In graphite at lower left: 23/50
Bloch 1713; Geiser/Baer 1729.II.B.b.1
Gift of Reiss-Cohen Inc., 1986
1986.1236.20

P344.
Painter and Model, from *347 Suite*
1968

Printed by Aldo and Piero Crommelynck
Published by Galerie Louise Leiris, Paris
Aquatint
Plate, 6¾ × 10⁵⁄₁₆ in. (17.1 × 26.2 cm); sheet, 11³⁄₁₆ × 15¹⁄₁₆ in. (28.4 × 38.3 cm)
In graphite at lower left: 45/50
Bloch 1714; Geiser/Baer 1731.B.b.1
Gift of Reiss-Cohen Inc., 1986
1986.1236.21

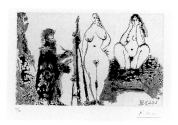

P345.

Bearded Painter in a Dressing Gown with Two Nude Women and a Visitor, from *347 Suite*
1968

Printed by Aldo and Piero Crommelynck
Published by Galerie Louise Leiris, Paris
Sugar-lift aquatint
Plate, 6¾ × 10⁵⁄₁₆ in. (17.1 × 26.2 cm); sheet, 11⅛ × 14⅞ in. (28.3 × 37.8 cm)
In graphite at lower left: 47/50
Bloch 1715; Geiser/Baer 1732.B.b.1
Gift of Mr. and Mrs. Isidore M. Cohen, 1984
1984.1205.28

P346.

A Woman in a Hat with a Man in a Turban, Clown, Putto and Spectator, from *347 Suite*
1968

Printed by Aldo and Piero Crommelynck
Published by Galerie Louise Leiris, Paris
Etching
Plate, 6¾ × 10⁵⁄₁₆ in. (17.1 × 26.2 cm); sheet, 11¹⁄₁₆ × 14⅞ in. (28.1 × 37.8 cm)
In graphite at lower left: 45/50
Bloch 1716; Geiser/Baer 1733.B.b.1
Gift of Reiss-Cohen Inc., 1986
1986.1236.22

P347.

Belly Dancer in the Desert with a Stout Spectator, from *347 Suite*
1968

Printed by Aldo and Piero Crommelynck
Published by Galerie Louise Leiris, Paris
Etching
Plate, 6¾ × 10⁵⁄₁₆ in. (17.1 × 26.2 cm); sheet, 11⅛ × 14¾ in. (28.2 × 37.4 cm)
In graphite at lower left: 8/50
Bloch 1717; Geiser/Baer 1734.B.b.1
Gift of Mr. and Mrs. Isidore M. Cohen, 1984
1984.1205.29

P348.

Oasis with Flutist and Dancers, from *347 Suite*
1968

Printed by Aldo and Piero Crommelynck
Published by Galerie Louise Leiris, Paris
Etching
Plate, 6⅞ × 10⁵⁄₁₆ in. (17.5 × 26.2 cm); sheet, 11 × 14¹³⁄₁₆ in. (28 × 37.7 cm)
In graphite at lower left: 47/50
Bloch 1718; Geiser/Baer 1735.B.b.1
Gift of Mr. and Mrs. Isidore M. Cohen, 1984
1984.1205.30

P349.

Seated Old Man with a Woman and Dancer, from *347 Suite*
1968

Printed by Aldo and Piero Crommelynck
Published by Galerie Louise Leiris, Paris
Etching
Plate, 6¾ × 10¼ in. (17.1 × 26 cm); sheet, 11 × 14¾ in. (28 × 37.4 cm)
In graphite at lower left: 17/50
Bloch 1719; Geiser/Baer 1736.B.b.1
Gift of Mr. and Mrs. Isidore M. Cohen, 1984
1984.1205.31

P350.

About Ingres's Turkish Bath, from *347 Suite*
1968

Printed by Aldo and Piero Crommelynck
Published by Galerie Louise Leiris, Paris
Etching
Plate, 7¾ × 12¹³⁄₁₆ in. (19.7 × 32.5 cm); sheet, 13 × 17⅞ in. (33 × 45.4 cm)
In graphite at lower left: 47/50
Bloch 1722; Geiser/Baer 1739.B.b.1
Gift of Mr. and Mrs. Isidore M. Cohen, 1984
1984.1205.38

P351.

Two Spectators, One in a Rembrandtesque Hat, Admiring a Painting of Bacchantes, from *347 Suite*
1968

Printed by Aldo and Piero Crommelynck
Published by Galerie Louise Leiris, Paris
Etching
Plate, 7¹³⁄₁₆ × 12¹³⁄₁₆ in. (19.8 × 32.5 cm); sheet, 12½ × 17⅞ in. (31.8 × 45.4 cm)
In graphite at lower left: 20/50
Bloch 1723; Geiser/Baer 1740.B.b.1
Gift of Mr. and Mrs. Isidore M. Cohen, 1984
1984.1205.40

P352.

The Nightmare, from *347 Suite*
1968

Printed by Aldo and Piero Crommelynck
Published by Galerie Louise Leiris, Paris
Sugar-lift aquatint
Plate, 7⅞ × 12⅞ in. (20 × 32.7 cm); sheet, 13 × 17⅞ in. (33 × 45.4 cm)
In graphite at lower left: 20/50
Bloch 1730; Geiser/Baer 1747.B.b.1
Gift of Reiss-Cohen Inc., 1985
1985.1165.40

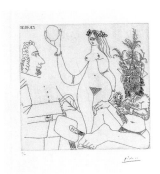
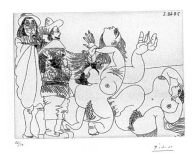
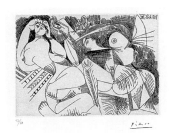
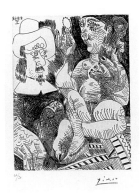

P353.

A Painter before One of Raphael's Three Graces and a Woodsman in a Party Hat, from *347 Suite*

1968

Printed by Aldo and Piero Crommelynck
Published by Galerie Louise Leiris, Paris
Etching
Plate, 12½ × 12⁷⁄₁₆ in. (31.8 × 31.6 cm); sheet, 19⁷⁄₁₆ × 17¹³⁄₁₆ in. (49.3 × 45.3 cm)
In graphite at lower left: 18/50
Bloch 1731; Geiser/Baer 1748.B.b.1
Gift of Reiss-Cohen Inc., 1986
1986.1236.23

P354.

Young Nobleman with a Reiter and Two Female Nudes, from *347 Suite*

1968

Printed by Aldo and Piero Crommelynck
Published by Galerie Louise Leiris, Paris
Etching
Plate, 8⅛ × 10⁹⁄₁₆ in. (20.6 × 26.8 cm); sheet, 12¹⁵⁄₁₆ × 15⅞ in. (32.9 × 40.3 cm)
In graphite at lower left: 23/50
Bloch 1734; Geiser/Baer 1751.B.b.1
Gift of Reiss-Cohen Inc., 1986
1986.1236.24

P355.

The Siesta, from *347 Suite*

1968

Printed by Aldo and Piero Crommelynck
Published by Galerie Louise Leiris, Paris
Etching
Plate, 6¹⁄₁₆ × 8¼ in. (15.4 × 21 cm); sheet, 11¹⁄₁₆ × 13⅝ in. (28.1 × 34.6 cm)
In graphite at lower left: 17/50
Bloch 1736; Geiser/Baer 1753.B.b.1
Gift of Reiss-Cohen Inc., 1986
1986.1236.25

P356.

Woman with Her Mirror and Man in a Rembrandtesque Hat, from *347 Suite*

1968

Printed by Aldo and Piero Crommelynck
Published by Galerie Louise Leiris, Paris
Etching
Plate, 8³⁄₁₆ × 6 in. (20.8 × 15.3 cm); sheet, 13¾ × 11⅛ in. (34.9 × 28.3 cm)
In graphite at lower left: 47/50
Bloch 1738; Geiser/Baer 1755.B.b.1
Gift of Reiss-Cohen Inc., 1985
1985.1165.41

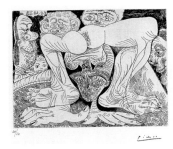
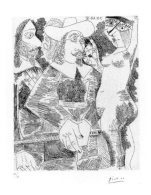
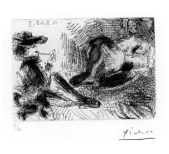
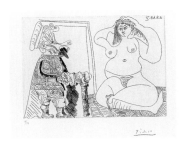

P357.

Female Acrobat with Face Makeup and Spectators, from *347 Suite*

1968

Printed by Aldo and Piero Crommelynck
Published by Galerie Louise Leiris, Paris
Etching
Plate, 7¹⁄₁₆ × 8¾ in. (17.9 × 22.2 cm); sheet, 12³⁄₁₆ × 14¼ in. (31 × 36.2 cm)
In graphite at lower left: 20/50
Bloch 1739; Geiser/Baer 1756.B.b.1
Gift of Mr. and Mrs. Isidore M. Cohen, 1984
1984.1205.24

P358.

Young Woman Pulling the Mustache of a Gentleman, from *347 Suite*

1968

Printed by Aldo and Piero Crommelynck
Published by Galerie Louise Leiris, Paris
Etching
Plate, 10½ × 8¼ in. (26.6 × 21 cm); sheet, 16⅜ × 12¾ in. (41.6 × 32.4 cm)
In graphite at lower left: 23/50
Bloch 1742; Geiser/Baer 1759.B.b.1
Gift of Reiss-Cohen Inc., 1985
1985.1165.42

P359.

Gentleman with a Pipe and Nude Maja, from *347 Suite*

1968

Printed by Aldo and Piero Crommelynck
Published by Galerie Louise Leiris, Paris
Etching
Plate, 3⁷⁄₁₆ × 4⅝ in. (8.8 × 11.8 cm); sheet, 9¹³⁄₁₆ × 12¾ in. (25 × 32.4 cm)
In graphite at lower left: 18/50
Bloch 1751; Geiser/Baer 1768.B.b.1
Gift of Reiss-Cohen Inc., 1986
1986.1236.26

P360.

Seated Female Nude, from *347 Suite*

1968

Printed by Aldo and Piero Crommelynck
Published by Galerie Louise Leiris, Paris
Etching
Plate, 6¹⁄₁₆ × 8¼ in. (15.4 × 21 cm); sheet, 11 × 13¹¹⁄₁₆ in. (28 × 34.7 cm)
In graphite at lower left: 8/50
Bloch 1757; Geiser/Baer 1773.B.b.1
Gift of Mr. and Mrs. Isidore M. Cohen, 1984
1984.1205.19

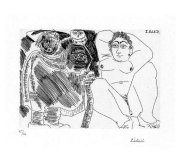
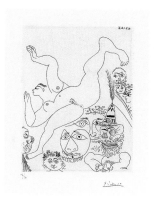
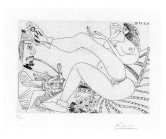
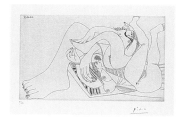

P361.

Fat Prostitute, Sorceress with a Barn Owl, and Traveler in Clogs, from *347 Suite*
1968

Printed by Aldo and Piero Crommelynck
Published by Galerie Louise Leiris, Paris
Etching
Plate, 6¹⁄₁₆ × 8¼ in. (15.4 × 21 cm); sheet, 11⅛ × 13¹¹⁄₁₆ in. (28.2 × 34.8 cm)
In graphite at lower left: 45/50
Bloch 1760; Geiser/Baer 1777.B.b.1
Gift of Reiss-Cohen Inc., 1985
1985.1165.43

P362.

Television: Gymnastics with Spectators, from *347 Suite*
1968

Printed by Aldo and Piero Crommelynck
Published by Galerie Louise Leiris, Paris
Etching
Plate, 8¼ × 6¹⁄₁₆ in. (21 × 15.4 cm); sheet, 13¹¹⁄₁₆ × 11⅛ in. (34.8 × 28.3 cm)
In graphite at lower left: 18/50
Bloch 1763; Geiser/Baer 1780.B.b.1
Gift of Reiss-Cohen Inc., 1986
1986.1236.27

P363.

Opium Smoker with Woman in Slippers on Her Bed and a Little Dog, from *347 Suite*
1968

Printed by Aldo and Piero Crommelynck
Published by Galerie Louise Leiris, Paris
Etching
Plate, 6¹⁄₁₆ × 8¼ in. (15.4 × 21 cm); sheet, 11⅛ × 13¹¹⁄₁₆ in. (28.2 × 34.7 cm)
In graphite at lower left: 8/50
Bloch 1764; Geiser/Baer 1781.B.b.1
Gift of Mr. and Mrs. Isidore M. Cohen, 1984
1984.1205.21

P364.

Two Women Romping on a Beach Mat, from *347 Suite*
1968

Printed by Aldo and Piero Crommelynck
Published by Galerie Louise Leiris, Paris
Etching
Plate, 7¾ × 12¾ in. (19.7 × 32.4 cm); sheet, 12⅜ × 17¹³⁄₁₆ in. (31.5 × 45.2 cm)
In graphite at lower left: 8/50
Bloch 1765; Geiser/Baer 1782.B.b.1
Gift of Mr. and Mrs. Isidore M. Cohen, 1984
1984.1205.39

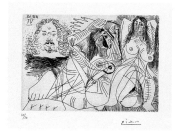
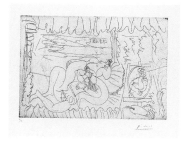
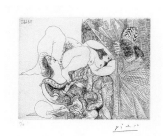
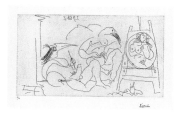

P365.

Rembrandtesque Man and Two Female Nudes, from *347 Suite*
1968

Printed by Aldo and Piero Crommelynck
Published by Galerie Louise Leiris, Paris
Etching
Plate, 6 × 8¼ in. (15.3 × 21 cm); sheet, 11¹⁄₁₆ × 13¾ in. (28.1 × 34.9 cm)
In graphite at lower left: 45/50
Bloch 1767; Geiser/Baer 1784.B.b.1
Gift of Reiss-Cohen Inc., 1986
1986.1236.28

P366.

Raphael and the Fornarina I, from *347 Suite*
1968

Printed by Aldo and Piero Crommelynck
Published by Galerie Louise Leiris, Paris
Etching
Plate, 11 × 15¼ in. (27.9 × 38.7 cm); sheet, 17¾ × 21⅜ in. (45.1 × 54.3 cm)
In graphite at lower left: 8/50
Bloch 1776; Geiser/Baer 1793.B.b.1
Gift of Reiss-Cohen Inc., 1986
1986.1236.29

P367.

Raphael and the Fornarina III, from *347 Suite*
1968

Printed by Aldo and Piero Crommelynck
Published by Galerie Louise Leiris, Paris
Etching
Plate, 6⅝ × 8¼ in. (16.8 × 21 cm); sheet, 11 × 13⅛ in. (28 × 33.3 cm)
In graphite at lower left: 7/50
Bloch 1778; Geiser/Baer 1795.B.b.1
Gift of Mr. and Mrs. Isidore M. Cohen, 1984
1984.1205.20

P368.

Raphael and the Fornarina VI, from *347 Suite*
1968

Printed by Aldo and Piero Crommelynck
Published by Galerie Louise Leiris, Paris
Etching
Plate, 11¹¹⁄₁₆ × 20³⁄₁₆ in. (29.7 × 51.3 cm); sheet, 17⅜ × 25¹¹⁄₁₆ in. (44.1 × 65.3 cm)
In graphite at lower left: 20/50
Bloch 1781; Geiser/Baer 1798.B.b.1
Gift of Reiss-Cohen Inc., 1986
1986.1236.30

P369.
Raphael and the Fornarina VIII, from *347 Suite*
1968

Printed by Aldo and Piero Crommelynck
Published by Galerie Louise Leiris, Paris
Etching
Plate, 5¹³⁄₁₆ × 8³⁄₁₆ in. (14.8 × 20.8 cm); sheet, 11¹⁄₁₆ × 13¹¹⁄₁₆ in. (28.1 × 34.7 cm)
In graphite at lower left: 20/50
Bloch 1783; Geiser/Baer 1800.B.b.1
Gift of Reiss-Cohen Inc., 1986
1986.1236.31

P370.
Raphael and the Fornarina IX, from 347 Suite
1968

Printed by Aldo and Piero Crommelynck
Published by Galerie Louise Leiris, Paris
Etching
Plate, 5⅞ × 8¹⁄₁₆ in. (15 × 20.5 cm); sheet, 11 × 8¼ in. (28 × 21 cm)
In graphite at lower left: 7/50
Bloch 1784; Geiser/Baer 1801.B.b.1
Gift of Mr. and Mrs. Isidore M. Cohen, 1984
1984.1205.7

P371.
Raphael and the Fornarina X, from 347 Suite
1968

Printed by Aldo and Piero Crommelynck
Published by Galerie Louise Leiris, Paris
Etching
Plate, 5¹³⁄₁₆ × 8¼ in. (14.8 × 21 cm); sheet, 11 × 13¾ in. (27.9 × 34.9 cm)
In graphite at lower left: 18/50
Bloch 1785; Geiser/Baer 1802.B.b.1
Gift of Reiss-Cohen Inc., 1986
1986.1236.32

P372.
Raphael and the Fornarina XI, from 347 Suite
1968

Printed by Aldo and Piero Crommelynck
Published by Galerie Louise Leiris, Paris
Etching
Plate, 5¾ × 8³⁄₁₆ in. (14.6 × 20.8 cm); sheet, 11⅛ × 13¾ in. (28.3 × 34.9 cm)
In graphite at lower left: 29/50
Bloch 1786; Geiser/Baer 1803.B.b.1
Gift of Reiss-Cohen Inc., 1986
1986.1236.33

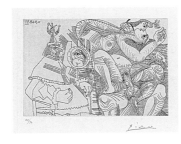 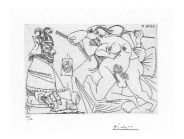 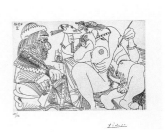 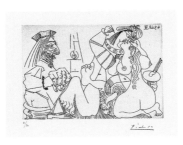

P373.
Raphael and the Fornarina XII, from 347 Suite
1968

Printed by Aldo and Piero Crommelynck
Published by Galerie Louise Leiris, Paris
Etching
Plate, 5⅞ × 8¹⁄₁₆ in. (15 × 20.5 cm); sheet, 11 × 13⁹⁄₁₆ in. (28 × 34.4 cm)
In graphite at lower left: 47/50
Bloch 1787; Geiser/Baer 1804.B.b.1
Gift of Mr. and Mrs. Isidore M. Cohen, 1984
1984.1205.32

P374.
Raphael and the Fornarina XV, from 347 Suite
1968

Printed by Aldo and Piero Crommelynck
Published by Galerie Louise Leiris, Paris
Etching
Plate, 5³⁄₁₆ × 8¼ in. (13.2 × 21 cm); sheet, 11 × 13¹¹⁄₁₆ in. (28 × 34.7 cm)
In graphite at lower left: 18/50
Bloch 1790; Geiser/Baer 1807.B.b.1
Gift of Reiss-Cohen Inc., 1986
1986.1236.34

P375.
Raphael and the Fornarina XVI, from 347 Suite
1968

Printed by Aldo and Piero Crommelynck
Published by Galerie Louise Leiris, Paris
Etching
Plate, 5⅞ × 8¼ in. (14.9 × 21 cm); sheet, 11¹⁄₁₆ × 13¾ in. (28.1 × 34.9 cm)
In graphite at lower left: 20/50
Bloch 1791; Geiser/Baer 1808.B.b.1
Gift of Reiss-Cohen Inc., 1986
1986.1236.35

P376.
Raphael and the Fornarina XVII, from 347 Suite
1968

Printed by Aldo and Piero Crommelynck
Published by Galerie Louise Leiris, Paris
Etching
Plate, 5¾ × 8¼ in. (14.6 × 21 cm); sheet, 11 × 13¹¹⁄₁₆ in. (28 × 34.7 cm)
In graphite at lower left: 7/50
Bloch 1792; Geiser/Baer 1809.B.b.1
Gift of Reiss-Cohen Inc., 1986
1986.1236.36

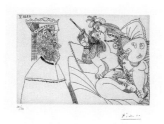 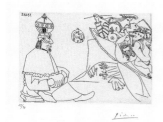 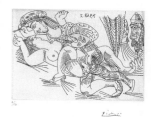 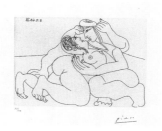

P377.

Raphael and the Fornarina XVIII, from *347 Suite*
1968

Printed by Aldo and Piero Crommelynck
Published by Galerie Louise Leiris, Paris
Etching
Plate, 5¹³⁄₁₆ × 8¼ in. (14.8 × 21 cm); sheet, 11 × 13¹¹⁄₁₆ in. (28 × 34.8 cm)
In graphite at lower left: 20/50
Bloch 1793; Geiser/Baer 1810.B.b.1
Gift of Reiss-Cohen Inc., 1986
1986.1236.37

P378.

Raphael and the Fornarina XIX, from *347 Suite*
1968

Printed by Aldo and Piero Crommelynck
Published by Galerie Louise Leiris, Paris
Etching
Plate, 5¹³⁄₁₆ × 8¼ in. (14.8 × 21 cm); sheet, 11⅛ × 13¹¹⁄₁₆ in. (28.2 × 34.8 cm)
In graphite at lower left: 29/50
Bloch 1794; Geiser/Baer 1811.B.b.1
Gift of Reiss-Cohen Inc., 1986
1986.1236.38

P379.

Raphael and the Fornarina XX, from *347 Suite*
1968

Printed by Aldo and Piero Crommelynck
Published by Galerie Louise Leiris, Paris
Etching
Plate, 5¹³⁄₁₆ × 8³⁄₁₆ in. (14.8 × 20.8 cm); sheet, 11³⁄₁₆ × 13⅝ in. (28.4 × 34.6 cm)
In graphite at lower left: 7/50
Bloch 1795; Geiser/Baer 1812.B.b.1
Gift of Reiss-Cohen Inc., 1986
1986.1236.39

P380.

Raphael and the Fornarina XXIII, from *347 Suite*
1968

Printed by Aldo and Piero Crommelynck
Published by Galerie Louise Leiris, Paris
Etching
Plate, 5¾ × 8³⁄₁₆ in. (14.6 × 20.8 cm); sheet, 11 × 13¹⁵⁄₁₆ in. (27.9 × 35.4 cm)
In graphite at lower left: 23/50
Bloch 1798; Geiser/Baer 1815.B.b.1
Gift of Reiss-Cohen Inc., 1985
1985.1165.44

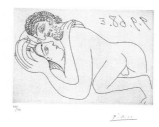 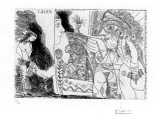 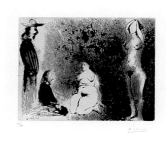

P381.

Amorous Couple: Raphael and the Fornarina, End, from *347 Suite*
1968

Printed by Aldo and Piero Crommelynck
Published by Galerie Louise Leiris, Paris
Etching
Plate, 5¹³⁄₁₆ × 8¼ in. (14.8 × 21 cm); sheet, 11⅛ × 13¹¹⁄₁₆ in. (28.3 × 34.8 cm)
In graphite at lower left: 47/50
Bloch 1800; Geiser/Baer 1817.B.b.1
Gift of Reiss-Cohen Inc., 1986
1986.1236.40

P382.

A Writer and His Female Adviser Working on the Story "A Thousand and One Nights," from *347 Suite*
1968

Printed by Aldo and Piero Crommelynck
Published by Galerie Louise Leiris, Paris
Etching
Plate, 5⅞ × 8³⁄₁₆ in. (15 × 20.8 cm); sheet, 11⅛ × 13¾ in. (28.3 × 34.9 cm)
In graphite at lower left: 8/50
Bloch 1801; Geiser/Baer 1818.B.b.1
Gift of Mr. and Mrs. Isidore M. Cohen, 1984
1984.1205.8

P383.

Landscape Painters with Two Nude Models, from *347 Suite*
1968

Printed by Aldo and Piero Crommelynck
Published by Galerie Louise Leiris, Paris
Sugar-lift aquatint
Plate, 8¼ × 10⁷⁄₁₆ in. (21 × 26.5 cm); sheet, 12¹⁵⁄₁₆ × 15¹³⁄₁₆ in. (32.9 × 40.2 cm)
In graphite at lower left: 47/50
Bloch 1807; Geiser/Baer 1824.B.b.1
Gift of Mr. and Mrs. Isidore M. Cohen, 1984
1984.1205.36

P384.

Landscape Painters: Déjeuner sur l'herbe Impressioniste, from *347 Suite*
1968

Printed by Aldo and Piero Crommelynck
Published by Galerie Louise Leiris, Paris
Sugar-lift aquatint
Plate, 8¼ × 10½ in. (21 × 26.7 cm); sheet, 12⅞ × 15¹³⁄₁₆ in. (32.7 × 40.2 cm)
In graphite at lower left: 8/50
Bloch 1808; Geiser/Baer 1825.B.b.1
Gift of Mr. and Mrs. Isidore M. Cohen, 1984
1984.1205.34

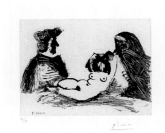 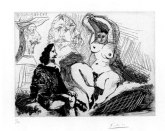 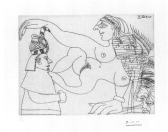 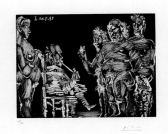

P385.

Célestine, Client, and Small Faceless Nude Maja, from *347 Suite*
1968

Printed by Aldo and Piero Crommelynck
Published by Galerie Louise Leiris, Paris
Sugar-lift aquatint
Plate, 8⅛ × 10⁹⁄₁₆ in. (20.6 × 26.8 cm); sheet, 12⅞ × 15⅞ in. (32.7 × 40.3 cm)
In graphite at lower left: 23/50
Bloch 1809; Geiser/Baer 1826.B.b.1
Gift of Reiss-Cohen Inc., 1986
1986.1236.41

P386.

Seated Man near a Woman Combing Her Hair, from *347 Suite*
1968

Printed by Aldo and Piero Crommelynck
Published by Galerie Louise Leiris, Paris
Sugar-lift aquatint and drypoint with scraper
Plate, 8³⁄₁₆ × 10½ in. (20.8 × 26.7 cm); sheet, 12⅞ × 15¹³⁄₁₆ in. (32.7 × 40.1 cm)
In graphite at lower left: 8/50
Bloch 1810; Geiser/Baer 1827.II.B.b.1
Gift of Reiss-Cohen Inc., 1986
1986.1236.42

P387.

Egyptian and Women, from *347 Suite*
1968

Printed by Aldo and Piero Crommelynck
Published by Galerie Louise Leiris, Paris
Etching
Plate, 8⅛ × 10⁹⁄₁₆ in. (20.6 × 26.8 cm); sheet, 12⅞ × 15¾ in. (32.7 × 40 cm)
In graphite at lower left: 47/50
Bloch 1811; Geiser/Baer 1828.B.b.1
Gift of Mr. and Mrs. Isidore M. Cohen, 1984
1984.1205.37

P388.

Three Old Friends Visiting: Man Smoking, Woman Keeping Watch, from *347 Suite*
1968

Printed by Aldo and Piero Crommelynck
Published by Galerie Louise Leiris, Paris
Aquatint
Plate, 8⅛ × 10⅝ in. (20.6 × 27 cm); sheet, 12¹³⁄₁₆ × 15⅞ in. (32.6 × 40.3 cm)
In graphite at lower left: 45/50
Bloch 1820; Geiser/Baer 1837.II.B.b.1
Gift of Reiss-Cohen Inc., 1986
1986.1236.43

P389.

The Bust of a Dead Painter Crowned by the Academy, from *347 Suite*
1968

Printed by Aldo and Piero Crommelynck
Published by Galerie Louise Leiris, Paris
Etching
Plate, 8⅛ × 10⁹⁄₁₆ in. (20.6 × 26.8 cm); sheet, 12⅞ × 15⅞ in. (32.7 × 40.3 cm)
In graphite at lower left: 47/50
Bloch 1822; Geiser/Baer 1839.B.b.1
Gift of Mr. and Mrs. Isidore M. Cohen, 1984
1984.1205.35

Ceramics

This checklist is organized chronologically, following the sequence of the related linoleum cuts in the checklist of prints (cats. P184, P193, P200, P202, P206, P208, P229, P256, P258, P259).

TECHNICAL NOTE

These terracotta reliefs were made from molds taken from Picasso's linoleum cuts. The reliefs are thus positive clay versions of the linoleum cuts but negatives of the prints. The edges in the design areas are somewhat rounded, suggesting that they were cast from a clay slurry rather than tamped into a mold in a more solid state. The ends and sides also show a wood grain pattern, indicating that a wood frame was built around the relief mold in order to hold the slurry while it dried. As the clay dried to a leather-hard state, it shrank just enough to be easily removed from the mold.

The reverse sides of the reliefs have squares cut out of the back (like windowpanes) that served to thin them sufficiently to prevent cracking during drying or firing but also ensured enough support to prevent or reduce warpage. The uniform depth of the cutout areas suggests that a production system was used to remove the clay within each bay (with a sharp flat tool) and to finish the edges; the exposed surface was smoothed with a rib tool.

The surface decoration is a thin black slip apparently applied with a roller before firing, as indicated by the fabric-like marks on the recessed areas, a roller line in the hair of one face (cat. C3), and the absence of slip in the recessed corners. The slip was thin enough to flow into the shallow incisions, and there is evidence that some of these areas were reworked with a sharp tool to re-expose the clay within the incised lines (cats. C1, C4, C6). In one (cat. C3), the surface was worked with a comb to introduce lines into the hair that are not present in the linoleum cut.

Most of the linoleum cuts comprise two or three colors, and the molds for the reliefs were taken from the final state. An exception is *Le déjeuner sur l'herbe, after Manet I* (cat. C1), where the plaster mold was evidently taken from the first state of the linoleum cut, printed in yellow ink. KR

C1.

Le déjeuner sur l'herbe, after Manet I
1964

Terracotta with black slip
19¾ × 23½ × 1⅛ in.(50.2 × 59.7 × 2.9 cm)
Published by Galerie Madoura, Vallauris
Stamped twice on verso, along central horizontal axis: MADOURA PLEIN FEU / EMPREINTE ORIGINALE DE PICASSO / MADOURA PLEIN FEU / EMPREINTE ORIGINALE DE PICASSO
Numbered (etched) on verso, at center: 22/50
The Mr. and Mrs. Charles Kramer Collection, Gift of Mr. and Mrs. Charles Kramer, 1980
1980.481.1

Positive clay version of the 1962 linoleum cut of the same title (see cat. P184)

EXHIBITION
New York (MMA/Kramer) 1985, pp. 11, 150 (pl. 149)

REFERENCES [not specific to number 22/50]
Bloch 1972, p. 141 (ill.), no. 163; Ramié 1974, pp. 257 (ill.), 290, no. 640; Ramié 1976, pp. 257 (ill.), 290, no. 640; Kosme de Barañano and C. Sylvia Weber in Künzelsau 1999, p. 51 (ill.); Anne Fréling and Isabelle Mancarella in Vallauris 2001, pp. 10 (ill.), 92, no. 39; Paul Bourassa et al. in Quebec–Toronto–Antibes 2004–5, pp. 145–47 (ill.), no. 82; Christie's sale 2009, p. 19 (ill.), no. 30

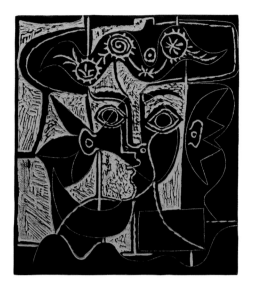

C2.

Small Head of a Woman with a Crown of Flowers
1964

Terracotta with black slip
13 × 10 × ⅞ in. (33 × 25.4 × 2.2 cm)
Published by Galerie Madoura, Vallauris
Stamped on verso, upper left: Madoura Plein
Feu / Empreinte originale de Picasso
Numbered (etched) on verso, upper left: 92/100
The Mr. and Mrs. Charles Kramer Collection,
Gift of Mr. and Mrs. Charles Kramer, 1980
1980.481.5

Positive clay version of the 1962 linoleum cut of the
same title (see cat. P193)

Exhibition
New York (MMA/Kramer) 1985, pp. 11, 154 (pl. 153)

References [not specific to number 92/100]
Bloch 1972, p. 146 (ill.), no. 168; Ramié 1974, pp. 254
(ill.), 290, no. 636; Ramié 1976, pp. 254 (ill.), 290,
no. 636; Anne Fréling and Isabelle Mancarella in
Vallauris 2001, p. 92, no. 38, ill.; Paul Bourassa et al. in
Quebec–Toronto–Antibes 2004–5, pp. 146, 149 (ill.),
265 (ill.), no. 84; Salvador Haro and Harald Theil in
Málaga 2007–8, pp. 115 (ill.), 137 (ill.), no. 33

C3.

Jacqueline in a Flowery Straw Hat
1964

Terracotta with black slip
12⅞ × 10 × ⅞ in. (32.7 × 25.4 × 2.2 cm)
Published by Galerie Madoura, Vallauris
Inscribed and numbered on verso in black, upper
right: Empreinte originale / de Picasso /
91/100 / Madoura
The Mr. and Mrs. Charles Kramer Collection,
Gift of Mr. and Mrs. Charles Kramer, 1985
1985.233

Positive clay version of the 1962 linoleum cut of the
same title (see cat. P200)

Exhibition
New York (MMA/Kramer) 1985, pp. 11, 149 (pl. 148)

References [not specific to number 91/100]
Bloch 1972, p. 145 (ill.), no. 167; Ramié 1974, pp. 254
(ill.), 290, no. 635; Ramié 1976, pp. 254 (ill.), 290,
no. 635; Anne Fréling and Isabelle Mancarella in
Vallauris 2001, p. 92, nos. 38, 43; Paul Bourassa et al.
in Quebec–Toronto–Antibes 2004–5, pp. 146, 148
(ill.), 265 (ill.), no. 83

C4.

Large Head of Jacqueline in a Hat
1964

Terracotta with black slip
23¾ × 19¾ × 1 in. (60.3 × 50.2 × 2.5 cm)
Published by Galerie Madoura, Vallauris
Stamped on verso, along central vertical axis:
Empreinte originale de Picasso /
Madoura Plein Feu
Numbered (etched) on verso, at center: 18/50
The Mr. and Mrs. Charles Kramer Collection,
Gift of Mr. and Mrs. Charles Kramer, 1980
1980.481.2

Positive clay version of the 1962 linoleum cut of the
same title (see cat. P202)

Exhibition
New York (MMA/Kramer) 1985, pp. 11, 151 (pl. 150)

References [not specific to number 18/50]
Bloch 1972, p. 142 (ill.), no. 164; Ramié 1974, pp. 255
(ill.), 290, no. 639; Ramié 1976, pp. 255 (ill.), 290,
no. 639; Hunter-Stiebel 1981, pp. 68–69 (ill.)

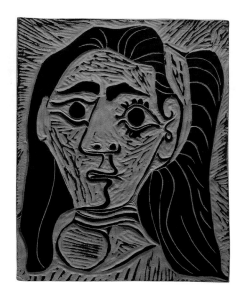 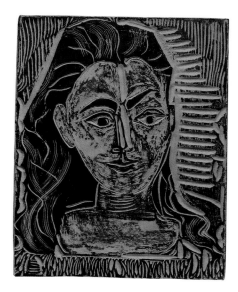 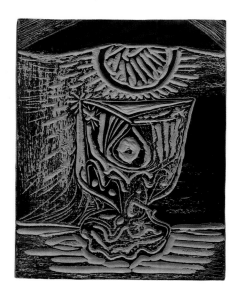

C5.

Jacqueline with a Headband III
1964

Terracotta with black slip
12¾ × 9⅞ × ⅞ in. (32.4 × 25.1 × 2.2 cm)
Published by Galerie Madoura, Vallauris
Stamped on verso, lower right (upside down):
EMPREINTE ORIGINALE DE PICASSO /
MADOURA PLEIN FEU
Numbered (etched) on verso, lower right: 3/100
The Mr. and Mrs. Charles Kramer Collection,
Gift of Mr. and Mrs. Charles Kramer, 1980
1980.481.4

Positive clay version of the 1962 linoleum cut of the
same title (see cat. P206)

EXHIBITION
New York (MMA/Kramer) 1985, pp. 11, 153 (pl. 152)

REFERENCES [not specific to number 3/100]
Bloch 1972, p. 144 (ill.), no. 166; Ramié 1974, pp. 253
(ill.), 290, no. 634; Ramié 1976, pp. 253 (ill.), 290,
no. 634

C6.

Jacqueline in a Printed Dress
1964

Terracotta with black slip
13 × 10⅛ × ¾ in. (33 × 25.7 × 1.9 cm)
Published by Galerie Madoura, Vallauris
Stamped on verso, upper left: MADOURA PLEIN
FEU / EMPREINTE ORIGINALE DE PICASSO
Numbered (etched) on verso, upper left: 71/100
The Mr. and Mrs. Charles Kramer Collection,
Gift of Mr. and Mrs. Charles Kramer, 1980
1980.481.6

Positive clay version of the 1962 linoleum cut of the
same title (see cat. P208)

EXHIBITION
New York (MMA/Kramer) 1985, pp. 11, 152 (pl. 151)

REFERENCES [not specific to number 71/100]
Bloch 1972, p. 147 (ill.), no. 169; Ramié 1974, pp. 252
(ill.), 290, no. 633; Ramié 1976, pp. 252 (ill.), 290,
no. 633

C7.

A Glass by Lamplight
1964

Terracotta with black slip
12¾ × 10 × ⅞ in. (32.4 × 25.4 × 2.2 cm)
Published by Galerie Madoura, Vallauris
Stamped on verso, upper left: MADOURA PLEIN
FEU / EMPREINTE ORIGINALE DE PICASSO
Numbered (etched) on verso, upper left: 28/100
The Mr. and Mrs. Charles Kramer Collection,
Gift of Mr. and Mrs. Charles Kramer, 1980
1980.481.3

Positive clay version of the 1962 linoleum cut of the
same title (see cat. P229)

EXHIBITION
New York (MMA/Kramer) 1985, pp. 11, 155 (pl. 154)

REFERENCES [not specific to number 28/100]
Bloch 1972, p. 143 (ill.), no. 165; Ramié 1974, pp. 255
(ill.), 290, no. 638; Ramié 1976, pp. 255 (ill.), 290,
no. 638

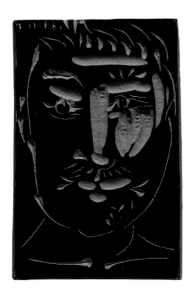

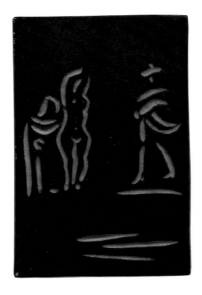

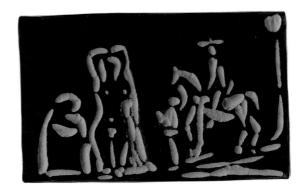

C8.

Head of a Man with a Mustache
1966

Terracotta with black slip
6½ × 3⅞ × ⅞ in. (16.5 × 9.8 × 2.2 cm)
Published by Galerie Madoura, Vallauris
Stamped on verso: Madoura Plein Feu /
Empreinte originale de Picasso
Numbered (inscribed in black, at center): J. 148/
355/500
The Mr. and Mrs. Charles Kramer Collection,
Gift of Mr. and Mrs. Charles Kramer, 1980
1980.481.7

Positive clay version of the 1966 linoleum cut of the
same title (see cat. P256)

Exhibition
New York (MMA/Kramer) 1985, pp. 11, 156 (pl. 155)

References [not specific to number 355/500]
Bloch 1972, p. 158 (ill.), no. 180; Ramié 1974, pp. 267
(ill.), 291, no. 653; Ramié 1976, pp. 267 (ill.), 291,
no. 653; Trinidad Sánchez-Pacheco in Valentano 1989,
no. 23, ill.; Anne Fréling and Isabelle Mancarella in
Vallauris 2001, p. 93, no. 47, ill.

C9.

*Célestine with a Woman and a Cavalier
on Foot*
1968

Terracotta with black slip
6½ × 4⅛ × ⅞ in. (16.5 × 10.5 × 2.2 cm)
Published by Galerie Madoura, Vallauris
Stamped on verso: Madoura Plein Feu /
Empreinte originale de Picasso
Numbered (incised against black slip rectangular
background): J. 150 / 239/500
The Mr. and Mrs. Charles Kramer Collection,
Gift of Mr. and Mrs. Charles Kramer, 1980
1980.481.8

Positive clay version of the 1968 linoleum cut of the
same title (see cat. P258)

Exhibition
New York (MMA/Kramer) 1985, pp. 11, 157 (pl. 156)

References [not specific to number 239/500]
Bloch 1972, p. 158 (ill.), no. 181; Ramié 1974, pp. 267
(ill.), 291, no. 653; Ramié 1976, pp. 267 (ill.), 291,
no. 653; Trinidad Sánchez-Pacheco in Valentano 1989,
no. 30, ill.; Christie's sale 1990, pp. 30 (ill.), 31, no. 34;
Anne Fréling and Isabelle Mancarella in Vallauris 2001,
pp. 92–93, nos. 42 (ill.), 49

C10.

*Célestine with a Woman, a Cavalier,
and His Valet*
1968

Terracotta with black slip
4¼ × 6½ × ⅞ in. (10.8 × 16.5 × 2.2 cm)
Published by Galerie Madoura, Vallauris
Stamped on verso: Madoura Plein Feu /
Empreinte originale de Picasso
Numbered (incised against black slip rectangular
background): J. 149 / 230/500
The Mr. and Mrs. Charles Kramer Collection,
Gift of Mr. and Mrs. Charles Kramer, 1980
1980.481.9

Positive clay version of the 1968 linoleum cut of the
same title (see cat. P259)

Exhibition
New York (MMA/Kramer) 1985, pp. 11, 158 (pl. 157)

References [not specific to number 230/500]
Bloch 1972, p. 158 (ill.), no. 182; Ramié 1974, pp. 267
(ill.), 291, no. 653; Ramié 1976, pp. 267 (ill.), 291,
no. 653; Trinidad Sánchez-Pacheco in Valentano 1989,
no. 29, ill.; Anne Fréling and Isabelle Mancarella in
Vallauris 2001, pp. 92–93, nos. 41, 48, ill.

Bibliography

KEY TO ABBREVIATED CATALOGUES RAISONNÉS

DB Daix and Boudaille 1967

DR Daix and Rosselet 1979

GB Geiser and Baer 1933–96

MP Bernadac, Richet, and Seckel 1985–87

OPP On-line Picasso Project 2009

P Palau i Fabre 1981b

PF Palau i Fabre 1990

PP Chipp and Wofsy 1995–2009

S Spies 2000

Z Zervos 1932–78

EXHIBITIONS CITED

1900–1909

Barcelona 1900. Exhibition of drawings by Pablo Picasso. Els Quatre Gats, Barcelona, February 1900. No catalogue published.

Barcelona 1901. Exhibition of drawings by Pablo Picasso and Ramon Casas organized by Miguel Utrillo, sponsored by the periodical *Pèl & ploma*. Sala Parés, Barcelona, June 1–14, 1901. No catalogue published.

Paris 1901. *Exposition de tableaux de F. Iturrino et de P.-R. Picasso.* Galerie Vollard, Paris, June 25–July 14, 1901. Catalogue preface by Gustave Coquiot. Paris, 1901.

Paris (Salon d'Automne) 1904. "Salon d'Automne." Grand Palais des Champs-Élyseés, Paris, October 15–November 15, 1904. *Catalogue des ouvrages de peinture, sculpture, dessin, gravure, architecture et art décoratif.* Paris, 1904.

Paris (Salon d'Automne) 1905. "Salon d'Automne." Grand Palais des Champs-Élyseés, Paris, October 18–November 25, 1905. *Catalogue des ouvrages de peinture, sculpture, dessin, gravure, architecture et art décoratif.* Paris, 1905.

Paris (Serrurier) 1905. *Exposition d'oeuvres des peintres Trachsel, Gérardin, Picasso.* Galeries Serrurier, Paris, February 25–March 6, 1905. Catalogue preface by Charles Morice. Paris, 1905.

Paris 1906. *Société des Artistes Indépendants: 22e exposition.* Grandes Serres de la Ville de Paris (Cours-la-Reine), Paris, March 20–April 30, 1906. Catalogue. Paris, 1906.

Paris (Salon d'Automne) 1907. "Salon d'Automne." Grand Palais des Champs-Élyseés, Paris, October 1–22, 1907. *Catalogue des ouvrages de peinture, dessin, sculpture, gravure, architecture et art décoratif.* Paris, 1907.

1910–1919

Paris 1910. Exhibition of works by Pablo Picasso organized by Wilhelm Uhde. Galerie Notre-Dame-des-Champs, Paris, May 1910. No catalogue published.

Paris 1910–11. "Picasso." Galerie Vollard, Paris, December 20, 1910–late February 1911. No catalogue published.

Amsterdam 1911. *Moderne Kunst Kring: Internationale tentoonstelling van moderne kunst.* Stedelijk Museum, Amsterdam, October 6–November 5, 1911. Catalogue. Amsterdam, 1911.

Berlin 1911. *XXII Ausstellung der Berliner Secession.* Ausstellungshaus der Secession, Berlin, 1911. Catalogue. Berlin, 1911.

New York 1911. "Exhibition of Early and Recent Drawings and Water-Colors by Pablo Picasso of Paris." 291, New York, March 28–April 25, 1911 (extended to May). No catalogue published.

Barcelona 1912. "Exposició Picasso." Galeries Dalmau, Barcelona, February–March 1912. No catalogue published.

Cologne 1912. *Internationale Kunst-Ausstellung des Sonderbundes Westdeutscher Kunstfreunde und Künstler.* Städtische Ausstellungshalle am Aachener Tor, Cologne, May 25–September 30, 1912. Catalogue foreword by Dr. R[iehart] Reiche. Cologne, 1912.

Berlin 1913. *Herbstausstellung.* Austellungshaus der Kurfürstendamm, Berlin, December 1913. Catalogue. Berlin, 1913.

Cologne 1913. *Pablo Picasso.* Rheinische Kunstsalon (Otto Feldmann), Cologne, March–April 1913. Catalogue. Cologne, 1913.

Munich 1913. *Ausstellung Pablo Picasso.* Moderne Galerie (Heinrich Thannhauser), Munich, February 1913. Catalogue introduction by Justin K. Thannhauser. Munich, 1913.

New York–Chicago–Boston 1913. *International Exhibition of Modern Art* [The Armory Show]. Armory of the 69th Regiment, New York, February 17–March 15, 1913; The Art Institute of Chicago, March 24–April 16, 1913; and Copley Hall, Copley Society of Boston, April 28–May 19, 1913. Catalogue and supplement. New York, 1913. Other eds.: Chicago and Boston, 1913.

Prague 1913. *III. Výstava Skupiny výtvarných umelcu.* Obecní Dum, Prague, 1913. Catalogue. Prague, 1913.

Berlin–Dresden 1913–14. Exhibition of works by Pablo Picasso organized by Daniel-Henry Kahnweiler. Neue Galerie (Otto Feldmann), Berlin, November 1913, and Kunstsalon Emil Richter, Dresden, January 1914. No catalogue published. Other venues: see Basel 1914, Vienna 1914, and Zürich 1914.

Basel 1914. "Pablo Picasso." Kunsthalle, Basel, May 1914. No catalogue published. Other venues: see Berlin–Dresden 1913–14, Vienna 1914, and Zürich 1914.

Vienna 1914. *Pablo Picasso.* Galerie Miethke, Vienna, February–March 1914. Catalogue. Vienna, 1914. Other venues: see Berlin–Dresden 1913–14, Basel 1914, and Zürich 1914.

Zürich 1914. *Sonder-Ausstellung Pablo Picasso.* Moderne Galerie (Gottfried Tanner), Zürich, April 4, 1914. Catalogue. Zürich, 1914. Other venues: see Berlin–Dresden 1913–14, Basel 1914, and Vienna 1914.

New York 1914–15. "Exhibition of Recent Drawings and Paintings by Picasso and by Braque, of Paris." 291, New York, December 9, 1914–January 11, 1915. No catalogue published; no checklist.

New York 1915. Untitled exhibition of nine works by Pablo Picasso from the collection of Adolphe Basler. 291, New York, January 12–26, 1915. No catalogue published.

Basel 1916. *Ausstellung neuerer Kunst aus Basler Privatsammlungen.* Kunsthalle, Basel, April 9–30, 1916. Catalogue. Basel, 1916.

Hannover 1919. *Französische Malerei bis 1914 und Deutsche Künstler des Café du Dôme, Gemälde, Graphik: XXVII.–XXVIII. Sonderausstellung.* Kestner-Gesellschaft, Hannover, September 7–November 12, 1919. Catalogue. Hannover, [1919].

1920–1929

Philadelphia 1920. *Exhibition of Paintings and Drawings by Representative Modern Masters.* Pennsylvania Academy of the Fine Arts, Philadelphia, April 17–May 9, 1920. Catalogue. Philadelphia, 1920.

Brooklyn 1921. *Paintings by Modern French Masters Representing the Post Impressionists and Their Predecessors.* Brooklyn Museum, March 26–April 1921. Catalogue. Brooklyn, 1921.

New York 1921. *Loan Exhibition of Impressionist and Post-Impressionist Paintings.* The Metropolitan Museum of Art, New York, May 3–September 15, 1921. Catalogue introduction by Bryson Burroughs. New York, 1921.

Munich 1922. *Pablo Ruiz Picasso.* Moderne Galerie (Heinrich Thannhauser), Munich, [1922]. Catalogue preface by Paul Rosenberg. Munich, [1922].

Prague 1923. *Výstava francouzského umění XIX. a XX. století.* Obecní Dum, Prague, May–June 1923. Catalogue. Prague, 1923.

New York 1924. *Original Paintings, Drawings and Engravings Being Exhibited with the Dial Folio "Living Art."* Montross Gallery, New York, January 26–February 14, 1924. Catalogue. New York, 1924.

Northampton 1924. "The Dial Collection." Hillyer Art Gallery, Smith College, Northampton, Mass., spring 1924. No catalogue published.

Rochester 1924. *The Dial Portfolio of "Living Art."* Memorial Art Gallery, Rochester, N.Y., February–March, 1924. *Catalogue of Paintings by Allen Tucker and Samuel Halpert, the Dial Portfolio of "Living Art." Woodblock Prints by Charles Bartlett. "The Holy Experiment" by Violet Oakley.* Rochester, 1924.

Worcester 1924. *Exhibition of the Dial Collection of Paintings, Engravings, and Drawings by Contemporary Artists.* Worcester Art Museum, Mass., March 5–30, 1924. Catalogue foreword by Raymond Henniker-Heaton. Worcester, Mass., 1924.

Brooklyn 1926. "Special Loan Exhibition of Paintings by Modern French and American Artists." Brooklyn Museum, June 12–October 14, 1926. No catalogue published.

New York 1926. "Exhibition of Prints, Paintings and Sculpture from the John Quinn Collection including Rousseau's Jungle." Brummer Galleries, New York, March 1926. No catalogue published.

Paris 1926. *Salon du Franc* ("L'Art français au service du Franc," exhibition of foreign artists living in Paris in aid of the Franc, followed by an auction). Musée Galliéra, Paris, October 22–31, 1926, and sale October 29, 1926. Catalogue. Paris, 1926.

Paris (Rosenberg) 1926. *Exposition d'oeuvres récentes de Picasso.* Galerie Paul Rosenberg, Paris, June 15–July 1926. Catalogue. Paris, 1926.

Berlin 1927. "Sonderausstellung." Künstlerhaus, Berlin, 1927. No catalogue published.

Glasgow 1927. *A Century of French Painting.* McLellan Galleries, Glasgow, May 1927; organized by The Lefevre Gallery (Alex. Reid & Lefevre), London. Catalogue. Glasgow, 1927.

New York 1927. *Modern French Paintings, Water Colors, and Drawings.* C. W. Kraushaar Art Galleries, New York, October 8–22, 1927. Catalogue. New York, 1927.

Paris 1927. *Exposition de cent dessins par Picasso chez Paul Rosenberg.* Galerie Paul Rosenberg, Paris, June–July 1927. Catalogue. Paris, 1927.

Paris 1929. *La Grande Peinture contemporaine à la Collection Paul Guillaume.* Galerie Bernheim-Jeune, Paris, May 25–June 27, 1929. Catalogue by Waldemar George. Paris, 1929.

1930–1939

New York 1930. *Summer Exhibition: Retrospective.* The Museum of Modern Art, New York, June 15–September 28, 1930. Catalogue. New York, 1930.

New York (MoMA) 1930. *Painting in Paris from American Collections.* The Museum of Modern Art, New York, January 18–February 16, 1930 (extended to March 2). Catalogue foreword signed A[lfred] H. B[arr]. New York, 1930.

Paris 1930. *Cent ans de peinture française.* Galerie Georges Petit, Paris, June 15–30, 1930. Catalogue introduction by Josse Bernheim-Jeune, Gaston Bernheim-Jeune, and Etienne Bignou. Paris, 1930.

Andover 1931. *The Collection of Miss Lizzie P. Bliss: Fourth Loan Exhibition.* Addison Gallery of American Art, Andover, Mass., October 17–December 15, 1931. Catalogue. Andover, Mass., 1931.

London 1931. *Thirty Years of Pablo Picasso.* Alex. Reid & Lefevre Ltd., London, June 1931. Catalogue preface by Maud Dale. London, 1931.

New York (MoMA) 1931. *Memorial Exhibition: The Collection of the Late Miss Lillie P. Bliss, Vice-President of the Museum.* The Museum of Modern Art, New York, May 17–September 27, 1931 (extended to October 6). Catalogue. New York, 1931.

New York (Valentine) 1931. *Abstractions of Picasso.* Valentine Gallery, New York, January 5–February 7, 1931. Catalogue. New York, 1931.

Paris 1931. *Henri Matisse.* Galerie Georges Petit, Paris, June 16–July 25, 1931. Catalogue. Paris, 1931.

Indianapolis 1932. *Modern Masters from the Collection of Miss Lizzie P. Bliss.* John Herron Art Institute, Indianapolis, Ind., January 1932. Catalogue foreword by Alfred H. Barr Jr. Indianapolis, Ind., 1932.

New York 1932. "Summer Exhibition: Painting and Sculpture." The Museum of Modern Art, New York, June 7–October 30, 1932. No catalogue published.

Paris 1932. *Exposition Picasso.* Galerie Georges Petit, Paris, June 16–July 30, 1932. Catalogue introduction by Charles Vrancken. Paris, 1932. Second venue: see Zürich 1932.

Zürich 1932. *Picasso Retrospective, 1901–1931.* Kunsthaus Zürich, September 11–October 30, 1932 (extended to November 13). Catalogue by Charles Vrancken and W. Wartmann. Zürich, 1932. First venue: see Paris 1932.

Chicago 1933. *A Century of Progress: Exhibition of Paintings and Sculpture Lent from the American Collections.* The Art Institute of Chicago, June 1–November 1, 1933. Catalogue edited by Daniel Catton Rich. Chicago, 1933.

New York (MoMA/Summer) 1933. "Summer Exhibition: Painting and Sculpture." The Museum of Modern Art, New York, July 10–September 30, 1933. No catalogue published.

New York (MoMA) 1933. "Modern European Art." The Museum of Modern Art, New York, October 3–27, 1933; organized by Stephen C. Clark. No catalogue published.

New York (Valentine) 1933. "Exhibition of 7 Outstanding Paintings by Picasso." Valentine Gallery, New York, March 6–April 1, 1933. Catalogue, *Exhibition Picasso.* New York 1933. Unpaginated.

Buenos Aires 1934. *Exposición Pablo Ruiz Picasso.* Galería Müller, Buenos Aires, October 1934. Catalogue preface by Federico C. Müller. Buenos Aires, 1934.

Hartford 1934. *Pablo Picasso.* Wadsworth Atheneum, Hartford, Conn., February 6–March 1, 1934. Catalogue. [Hartford], 1934.

New York 1934. *The Lillie P. Bliss Collection.* The Museum of Modern Art, New York, May 14–September 12, 1934. Catalogue. New York, 1934.

New York 1934–35. *Modern Works of Art: Fifth Anniversary Exhibition.* The Museum of Modern Art, New York, November 19, 1934–January 20, 1935. Catalogue. New York, 1934.

New York 1935. "Summer Exhibition: The Museum Collection and a Private Collection on Loan." The Museum of Modern Art, New York, June 4–September 24, 1935. No catalogue published; unnumbered typed checklist.

Saint Louis–Pittsburgh–Northampton 1935. "Paintings from the Lillie P. Bliss Collection, lent by The Museum of Modern Art." City Art Museum of Saint Louis, February 4–March 4, 1935; Carnegie Institute, Pittsburgh, March 13–April 10, 1935; and Smith College Museum of Art, Northampton, Mass., April 18–May 19, 1935. No catalogue published.

Barcelona–Bilbao–Madrid 1936. *Picasso.* Adlan (Amigos de las Artes Nuevas, Madrid), Sala Esteva, Barcelona, January 13–February 28, 1936; Galeria Arte, Bilbao, February–March 1936; and Centro de la Construcción, Madrid, March 1936. Catalogue by Guillermo de Torre. Madrid, 1936.

Cambridge 1936. "Harvard Tercentenary Exhibition." Harvard University, Cambridge, Mass., June 5–October 7, 1936. No catalogue published.

Dallas 1936. "Texas Centennial Exhibition: Exhibition of Paintings, Sculptures, Graphic Arts." Dallas Museum of Fine Arts, June 6–November 29, 1936. *Catalogue of the Exhibition of Paintings, Sculptures, Graphic Arts.* Dallas, 1936.

New York (MMA) 1936. "De Groot Loans Exhibition." The Metropolitan Museum of Art, New York, October 1936. No catalogue published; unnumbered typed checklist.

New York (MoMA) 1936. *Cubism and Abstract Art.* The Museum of Modern Art, New York, March 2–April 19, 1936. Catalogue by Alfred H. Barr Jr., Dorothy C. Miller, and Ernestine M. Fantl. New York, 1936.

New York (Seligmann) 1936. *Picasso: "Blue" and "Rose" Periods, 1901–1906: Loan Exhibition.* Jacques Seligmann & Co., New York, November 2–26, 1936. Catalogue. New York, 1936.

New York (Valentine) 1936. *Picasso, 1901–1934: Retrospective Exhibition.* Valentine Gallery, New York, October 26–November 21, 1936. Catalogue. New York, 1936.

Paris 1936. *Exposition d'oeuvres récentes de Picasso.* Galerie Paul Rosenberg, Paris, March 3–31, 1936. Catalogue. Paris, 1936.

Washington–Detroit 1936. "Paintings from the Lillie P. Bliss Collection, Lent by The Museum of Modern Art." Studio House, Washington, D.C., January 5–19, 1936, and Society of Arts and Crafts, Detroit, February 3–24, 1936. No catalogue published.

Chicago (Art Institute) 1937. *Sixteenth International Watercolor Exhibition.* The Art Institute of Chicago, March 18–May 16, 1937. Catalogue. Chicago, 1937.

Chicago (Chrysler) 1937. *Exhibition of the Walter P. Chrysler, Jr., Collection.* Arts Club of Chicago, January 8–31, 1937. Catalogue. Chicago, 1937.

Detroit 1937. *Selected Exhibition of the Walter P. Chrysler. Jr. Collection.* Detroit Institute of Arts, October 1937. Catalogue foreword by Walter P. Chrysler, Jr. Detroit, 1937.

London (Rosenberg & Helft) 1937. *Recent Works of Picasso.* Rosenberg & Helft, London, April 1–30, 1937. Catalogue. London, 1937.

London (Zwemmer) 1937. *Chirico—Picasso.* Zwemmer Gallery, London, June 1–30, 1937. Catalogue. London, 1937.

New York (American Place) 1937. *Beginnings and Landmarks: "291," 1905–1917.* An American Place, New York, October 27–December 27, 1937. Catalogue. New York, 1937.

New York (Perls) 1937. *For the Young Collector: Exhibition of Paintings, Watercolors, and Drawings by Picasso, Utrillo, Raoul Dufy, Rouault and Other Modern French Painters.* Perls Galleries, New York, October–November 1937. Catalogue. New York, 1937.

New York (Seligmann) 1937. *20 Years in the Evolution of Picasso, 1903–1923: Loan Exhibition.* Jacques Seligmann & Co., New York, November 1–20, 1937. Catalogue. New York, 1937.

Paris (Perls) 1937. *Picasso, 1900 à 1910: Exposition de tableaux, aquarelles, dessins.* Galerie Käte Perls, Paris, June 15–July 15, 1937. Catalogue. Paris, 1937.

Paris (Petit Palais) 1937. *Les Maîtres de l'art indépendant.* Musée du Petit Palais, Paris, June–October 1937. Catalogue. Paris, 1937.

Philadelphia 1937. "Exhibition of French Paintings." Philadelphia Museum of Art, March 20–April 18, 1937. No catalogue published; unnumbered checklist.

Boston 1938. *Picasso—Henri Matisse.* Boston Museum of Modern Art, October 19–November 11, 1938. Catalogue. Boston, 1938.

New York 1938. *The School of Paris: Modern French Paintings "for the Young Collector."* Perls Galleries, New York, September 12–October 22, 1938. Catalogue. New York, 1938.

Toronto 1938. *Paintings of Women from the Fifteenth to the Twentieth Century.* Art Gallery of Toronto, October 14–November 14, 1938. Catalogue. Toronto, 1938.

Washington 1938. *Picasso and Marin.* Phillips Memorial Gallery, Washington, D.C., April 10–May 1, 1938. Catalogue. Washington, D.C., 1938.

Boston 1939. *The Sources of Modern Painting: A Loan Exhibition Assembled from American Public and Private Collections.* Museum of Fine Arts, Boston, March 2–April 9, 1939. Catalogue by James Plaut. Boston, 1939.

Chicago 1939. *The Eighteenth International Exhibition, Water Colors, Pastels, Drawings, and Monotypes.* The Art Institute of Chicago, March 23–May 14, 1939. Catalogue. Chicago, 1939.

London 1939. *Picasso in English Collections.* London Gallery, May 16–June 3, 1939. Catalogue edited by E. L. T. Mesens and Roland Penrose, published in *London Bulletin* 2, no. 15–16 (May 15, 1939).

New York (Harriman) 1939. *Picasso: Figure Paintings.* Marie Harriman Gallery, New York, January 30–February 18, 1939. Brochure. New York, 1939.

New York (MoMA) 1939. *Art in Our Time, an Exhibition to Celebrate the Tenth Anniversary of the Museum of Modern Art and the Opening of Its New Building, Held at the Time of the New York World's Fair.* The Museum of Modern Art, New York, May 10–September 30, 1939. Catalogue by Alfred H. Barr Jr. New York, 1939. Reprinted 1972.

New York (Wildenstein) 1939. *The Sources of Modern Painting: A Loan Exhibition Assembled from American Public and Private Collections by The Institute of Modern Art.* Wildenstein & Co., New York, April 25–May 20, 1939. Catalogue by James Plaut. New York, 1939.

New York and other cities 1939–41. *Picasso: Forty Years of His Art.* The Museum of Modern Art, New York, November 15, 1939–January 7, 1940; The Art Institute of Chicago, February 1–March 5, 1940; City Art Museum of Saint Louis, March 16–April 14, 1940; Museum of Fine Arts, Boston, April 26–May 25, 1940; San Francisco Museum of Art, June 25–July 22, 1940; Cincinnati Art Museum, September 28–October 27, 1940; The Cleveland Museum of Art, November 7–December 8, 1940; Isaac Delgado Museum, New Orleans, December 20, 1940–January 17, 1941; Minneapolis Institute of Art, February 1–March 2, 1941; and Carnegie Institute, Department of Art, Pittsburgh, March 15–April 13, 1941. Catalogue edited by Alfred H. Barr Jr. New York, 1939. See also Utica and other cities 1941–43.

1940–1949

Washington 1940. *Exhibition of Modern Paintings, Drawings, and Primitive African Sculpture from the Collection of Helena Rubinstein.* Mayflower Hotel, Washington, D.C., March 5–6, 1940. Catalogue. Washington, D.C., 1940.

New York 1940–41. *Landmarks in Modern Art.* Pierre Matisse Gallery, New York, December 30, 1940–January 25, 1941. Brochure. New York, 1940.

Cambridge 1941. "Classicism in Western Art." Fogg Art Museum, Harvard University, Cambridge, Mass., July 1–August 17, 1941. No catalogue published.

Los Angeles 1941. *Aspects of French Painting from Cézanne to Picasso.* Los Angeles County Museum, January 15–March 2, 1941. Catalogue. [Los Angeles, 1940.]

New York (American Place) 1941. *Exhibition of Four Americans: Dove, Marin, O'Keeffe, Stieglitz, and Picasso.* An American Place, New York, October 17–November 27, 1941. Catalogue. New York, 1941.

New York (Bignou) 1941. *Picasso: Early and Late.* Bignou Gallery, New York, February 10–March 1, 1941. Brochure. New York, 1941.

New York (MoMA) 1941. "Masterpieces of Picasso." The Museum of Modern Art, New York, July 16–September 7, 1941. No catalogue published; typed checklist.

New York (MoMA Collection) 1941. "Painting and Sculpture from the Museum Collection." The Museum of Modern Art, New York, May 6–April 30, 1941. No catalogue published.

Richmond–Philadelphia 1941. *Collection of Walter P. Chrysler Jr.* Virginia Museum of Fine Arts, Richmond, January 16–March 4, 1941, and Philadelphia Museum of Art, March 29–May 11, 1941. Catalogue essay by Henry McBride. Richmond, 1941.

Worcester 1941. *The Art of the Third Republic: French Painting 1870–1940.* Worcester Art Museum, Worcester, Mass., February 22–March 16, 1941. Catalogue. Worcester, Mass., 1941.

Utica and other cities 1941–43. *Picasso: Forty Years of His Art.* Munson-Williams-Proctor Institute, Utica, N.Y., November 1–24, 1941; Duke University, Durham, N.C., November 29–December 20, 1941; William Rockhill-Nelson Art Gallery, Kansas City, January 24–February 14, 1942; Milwaukee Art Institute, February 20–March 13, 1942; Grand Rapids Art Gallery, Grand Rapids, Mich., March 23–April 13, 1942; Dartmouth College, Hanover, N.H., April 27–May 18, 1942; Vassar College, Poughkeepsie, N.Y., May 20–June 15, 1942; Wellesley College, Wellesley, Mass., September 27–October 18, 1942; Sweet Briar College, Sweet Briar, Va., October 28–November 18, 1942; Williams

College, Williamstown, Mass., November 28–December 19, 1942; Indiana University, Bloomington, January 1–22, 1943; Monticello College, Alton, Ill., February 5–26, 1943; and Portland Art Museum, Portland, Ore., April 1–30, 1943. Catalogue (produced for New York and other cities 1939–41) edited by Alfred H. Barr Jr. New York, 1939.

New York (MoMA) 1942. *20th Century Portraits.* The Museum of Modern Art, New York, December 9, 1942–January 24, 1943. Catalogue by Monroe Wheeler. New York, 1942.

New York (MoMA/New Acquisitions) 1942. "Cubist and Abstract Art: New Acquisitions and Extended Loans." The Museum of Modern Art, New York, March 25–May 3, 1942. No catalogue published; typed checklist.

New York (Rosenberg) 1942. *Loan Exhibition of Masterpieces by Picasso (from 1919 to 1926).* Paul Rosenberg & Co., New York, February 11–March 7, 1942. Brochure. New York, 1942.

New York (Valentine) 1942. *Picasso & Miró.* Valentine Gallery, New York, November 2–28, 1942. Catalogue. New York, 1942.

New York 1942–43. "Painting and Sculpture from the Museum Collection." The Museum of Modern Art, New York, July 28, 1942–July 21, 1943. No catalogue published.

New York 1943. *Picasso.* Pierre Matisse Gallery, New York, November 30–December 30, 1943. Brochure. New York, 1943.

Mexico City 1944. *Picasso: Primera exposición de la Sociedad de Arte Moderno.* Sociedad de Arte Moderno, Mexico City, June 26–September 10, 1944. Organized by Circulating Exhibitions, The Museum of Modern Art, New York. Catalogue by Jose Moreno Villa, Agustin Lazo, Carlos Merida, Jose Renau, and John McAndrew. Mexico, 1944.

New York 1944. *Modern Drawings.* The Museum of Modern Art, New York, February 16–May 10, 1944. Catalogue edited by Monroe Wheeler. New York, 1944.

New York (Art in Progress) 1944. *Art in Progress: Fifteenth Anniversary Exhibition.* The Museum of Modern Art, New York, May 24–October 15, 1944. Catalogue by George Amberg, Iris Barry, Serge Chermayeff, Elodie Courtier, Victor d'Amico, René d'Harnoncourt, Elizabeth Mock, Nancy Newhall, James Thrall Soby, and Monroe Wheeler. New York, 1944.

New York (MoMA) 1944. "Painting and Sculpture from the Museum Collection." The Museum of Modern Art, New York, January 15–May 16, 1944. No catalogue published.

New York (Valentine) 1944. *Modern Paintings: The Lee Ault Collection.* Valentine Gallery, New York, April 10–29, 1944. Catalogue. New York, 1944.

Philadelphia 1944. *History of an American, Alfred Stieglitz: "291" and After, Selections from the Stieglitz Collection.* Philadelphia Museum of Art, July 1–November 1, 1944. Catalogue. Philadelphia, 1944.

New York 1944–45. "Painting, Sculpture, Graphic Arts from the Museum Collection." The Museum of Modern Art, New York, November 15, 1944–May 30, 1945. No catalogue published.

Denver 1945. *A Retrospective Exhibition of Paintings, Drawings, Sculpture, and Prints by Picasso.* Denver Art Museum, April 12–May 12, 1945. Catalogue. Denver, 1945.

New York (Buchholz) 1945. *Picasso: Exhibition of Paintings and Drawings from a Private Collection* [Mrs. Meric Callery]. Buchholz Gallery, New York, February 27–March 17, 1945. Catalogue by Pablo Picasso and Paul Éluard. New York, 1945.

New York (Wildenstein) 1945. *The Child through Four Centuries: Portraits of Children, 17th to 20th Centuries.* Wildenstein & Co., New York, March 1–28, 1945. Catalogue. New York, 1945.

Philadelphia 1945. *The Callery Collection: Picasso—Léger.* Philadelphia Museum of Art, January 10–February 20, 1945. Catalogue published in *Philadelphia Museum Bulletin* 40, no. 204 (January 1945), pp. 35–48.

New York 1945–46. "The Museum Collection of Painting and Sculpture." The Museum of Modern Art, New York, June 20, 1945–January 13, 1946. No catalogue published.

Boston 1946. *Four Spaniards: Dali, Gris, Miro, Picasso.* Institute of Modern Art, Boston, January 24–March 3, 1946. Catalogue. Boston, 1946.

Chicago 1946. *Variety in Abstraction.* Arts Club of Chicago, March 5–30, 1946. Brochure. Chicago, 1946.

New York 1946. "The Museum Collection of Painting." The Museum of Modern Art, New York, February 19–May 5, 1946. No catalogue published.

New York (MoMA) 1946. "Painting, Sculpture, Graphic Arts from the Museum Collection." The Museum of Modern Art, New York, July 2–September 26, 1946. [MoMA exh. no. 324.] No catalogue published.

London 1947. *The Cubist Spirit in Its Time.* London Gallery, March 18–May 3, 1947; organized by E. L. T. Mesens. Catalogue by Robert Melville and E. L. T. Mesens. London, 1947.

New York (Knoedler) 1947. *Picasso before 1907: Loan Exhibition for the Benefit of the Public Education Association.* Knoedler Galleries, New York, October 15–November 8, 1947. Catalogue. New York, 1947.

New York (MoMA) 1947. "Alfred Stieglitz Exhibition: His Collection." The Museum of Modern Art, New York, June 10–August 31, 1947. No catalogue published; typed checklist.

Philadelphia 1947. *Masterpieces of Philadelphia Private Collections.* Philadelphia Museum of Art, May 20–September 15, 1947. Catalogue published in *Philadelphia Museum Bulletin* 42, no. 214 (May 1947).

Stockholm 1947. *Rolf de Marés Samling: Franska kubister.* Exhibition, Föreningen för Nutida Konst, Stockholm, February 22–March 25, 1947. Catalogue by Nils Dardel. Stockholm, 1947.

Chicago 1948. "Alfred Stieglitz: His Photographs and His Collection." The Art Institute of Chicago, February 2–29, 1948. No catalogue published; typed checklist.

Newark 1948. "Seeing Modern Art." Newark Museum, Newark, N.J., January 5–February 24, 1948. No catalogue published.

New York 1948. "Portrait of Gertrude Stein by Picasso." The Museum of Modern Art, New York, January 22–March 12, 1948. No catalogue published.

New York (MoMA) 1948. "Painting, Sculpture, Graphic Arts from the Museum Collection." The Museum of Modern Art, New York, October 8–November 10, 1948. [MoMA exh. no. 324.] No catalogue published.

New York (MoMA/Private Collections) 1948. "New York Private Collections." The Museum of Modern Art, New York, July 20–September 12, 1948. No catalogue published.

San Francisco–Portland (Ore.) 1948. *Picasso, Gris, Miró: The Spanish Masters of Twentieth Century Painting.* San Francisco Museum of Art, September 14–October 17, 1948, and Portland Art Museum, Portland, Ore., October 26–November 28, 1948. Catalogue preface by Richard B. Freeman; essays by Donald Gallup and Sidney Janis. San Francisco, 1948.

New York 1949. "Painting, Sculpture, Graphic Arts from the Museum Collection." The Museum of Modern Art, New York, January 4–February 23, 1949. [MoMA exh. no. 324.] No catalogue published.

New York (MoMA) 1949. "Painting, Sculpture, Graphic Arts from the Museum Collection." The Museum of Modern Art, New York, March 28–April 15, 1949. [MoMA exh. no. 324.] No catalogue published.

Princeton 1949. *Loan Exhibition of Picasso Drawings.* Art Museum, Princeton University, January 10–31, 1949. Catalogue. Princeton, N.J., 1949.

Toronto 1949. *Picasso.* Art Gallery of Toronto, April 1949. Brochure. Toronto, 1949.

New York and other cities 1949–52. "Three Modern Styles." The Museum of Modern Art, New York, July 11–September 5, 1950, and twenty other U.S. venues, October 24, 1949–May 12, 1952. No catalogue published; typed checklist.

1950–1959

New York (MMA) 1950. "Paintings from Private Collections, Summer Loan Exhibition." The Metropolitan Museum of Art, New York, summer 1950. No catalogue published.

Paris 1950. *Cent portraits de femmes du XVe siècle à nos jours.* Galerie Charpentier, Paris, 1950. Catalogue preface by Henry de Montherlant. Paris, 1950.

Venice 1950. *XXV Biennale Internazionale d'Arte.* Venice, 1950. Catalogue introduction on Cubism by Douglas Cooper. Venice, 1950.

Philadelphia 1950–51. *Masterpieces of Drawing, Diamond Jubilee Exhibition.* Philadelphia Museum of Art, November 4, 1950–February 11, 1951. Catalogue. Philadelphia, 1950.

London 1951. *Drawings and Watercolours since 1893: Homage to Picasso on His 70th Birthday.* Institute of Contemporary Arts, London, October 11–November 24, 1951. Catalogue by Roland Penrose and Paul Éluard. London, 1951.

New Haven–Baltimore 1951. *Pictures for a Picture of Gertrude Stein as a Collector and Writer on Art and Artists.* Yale University Art Gallery, New Haven, February 11–March 11, 1951, and The Baltimore Museum of Art, March 21–April 21, 1951. Catalogue. [New Haven], 1951.

New York 1951. "From the Alfred Stieglitz Collection: An Extended Loan from the Metropolitan Museum of Art." The Museum of Modern Art, New York, May 22–August 12, 1951. No catalogue published; typed checklist.

Santa Barbara 1951. "French Paintings of the 19th and 20th Centuries Lent by California Museums and Private Collections." Santa Barbara Museum of Art, September 6–30, 1951. No catalogue published.

Worcester 1951–52. "The Practice of Drawing." Worcester Art Museum, Worcester, Mass., November 17, 1951–January 6, 1952. Checklist published in *Worcester Art Museum News Bulletin and Calendar* 17, no. 3 (December 1951), p. 5.

Hempstead 1952. "Metropolitan Museum Masterpieces." Hofstra College, Hempstead, N.Y., June 26–September 1, 1952. No catalogue published; typed checklist.

New York (MoMA) 1952. "Works from the Museum Collection." The Museum of Modern Art, New York, August 12–September 21, 1952. No catalogue published.

New York (Perls) 1952. *The Perls Galleries Collection of Modern French Paintings.* Perls Galleries, New York, March 3–April 5 and April 7–May 10, 1952. Catalogue. New York, 1952.

New York 1952–54. "Painting, Sculpture, Graphic Arts from the Museum Collection." The Museum of Modern Art, New York, November 25, 1952–January 6, 1954. [MoMA exh. no. 324.] No catalogue published.

Philadelphia–New York 1952–53. *Sculpture of the Twentieth Century.* Philadelphia Museum of Art, October 11–December 7, 1952, and The Museum of Modern Art, New York, April 28–September 7, 1953. Catalogue by Andrew Carnduff Ritchie. New York, 1952.

London 1953. *The Art of Drawing, 1500–1950.* Wildenstein & Co., London, May 14–July 4, 1953. Catalogue. London, 1953.

Lyons 1953. *Picasso.* Musée de Lyon, July 1–September 27, 1953. Catalogue by Jean Cassou, Daniel-Henry Kahnweiler, Christian Zervos, René Jullian, and Marcel Michaud. Lyons, 1953.

Milan 1953. *Pablo Picasso.* Palazzo Reale, Milan, September 23–December 31, 1953. Catalogue essay by Franco Russoli. Milan, 1953.

Milan (Palazzo Reale) 1953. *Pablo Picasso.* Palazzo Reale, Milan, September–November 1953. Catalogue essay by Franco Russoli, preface by Caio Mario Cattabeni. Milan, 1953.

New York (Perls) 1953. *The Perls Galleries Collection of Modern French Paintings.* Perls Galleries, New York, March 9–April 11 and April 13–May 16, 1953. Catalogue. New York, 1953.

New York (Perls/Picasso) 1953. *Picasso: The Thirties.* Perls Galleries, New York, January 5–February 7, 1953. Brochure. New York, 1953.

Paris 1953. *Le Cubisme, 1907–1914.* Musée National d'Art Moderne, Paris, January 30–April 9, 1953. Catalogue essay by Jean Cassou; catalogue by Gabrielle Vienne; chronology by Bernard Dorival. Paris, 1953.

Rome 1953. *Mostra di Pablo Picasso.* Galleria Nazionale, Rome, 1953. Catalogue by Lionello Venturi, with Eugenio Battisti and Nello Ponente. Rome, 1953.

São Paulo 1953–54. *Exposição Picasso.* 2a Bienal do Museu de Arte Moderna, São Paulo, December 13, 1953–February 20, 1954. Catalogue introduction by Maurice Jardot. São Paulo, [1953].

London 1954. *Collectors Choice IV.* Gimpel Fils, London, November–December 1954. Catalogue. London, 1954.

New York (Perls) 1954. *The Perls Galleries Collection of Modern French Paintings.* Perls Galleries, New York, March 8–April 10 and April 12–May 15, 1954. Catalogue. New York, 1954.

New York (Perls/Cubism) 1954. *Picasso, Braque, Gris: Cubism to 1918.* Perls Galleries, New York, January 4–February 6, 1954. Catalogue. New York, 1954.

New York (Valentin) 1954. *In Memory of Curt Valentin, 1902–1954: An Exhibition of Modern Masterpieces Lent by American Museums.* Valentin Gallery, New York, October 5–30, 1954. Catalogue introduction by Perry T. Rathbone. New York, 1954.

New York 1954–55. "Paintings From the Museum Collection: Twenty-Fifth Anniversary Exhibition." The Museum of Modern Art, New York, October 9, 1954–February 6, 1955. No catalogue published; unnumbered typed checklist.

Atlanta–Birmingham 1955. *French Painting: David to Rouault.* Atlanta Art Association Galleries, September 20–October 4, 1955, and Birmingham Museum of Art, October 16–November 5, 1955. Catalogue. Atlanta, 1955.

Barcelona 1955. *III Bienal Hispanoamericana de Arte: Forerunners and Masters of Contemporary Spanish Art.* Palacio de la Virreina y Museo de Arte Moderno, Barcelona, September 24–October 24, 1955. Catalogue. Barcelona, 1955.

Chicago 1955. *An Exhibition of Cubism on the Occasion of the Fortieth Anniversary of the Arts Club of Chicago.* Arts Club of Chicago, October 3–November 4, 1955. Catalogue by Forbes Watson. Chicago, [1955].

New York (MoMA) 1955. *Paintings from Private Collections: A 25th Anniversary Exhibition.* The Museum of Modern Art, New York, May 31–September 5, 1955. Catalogue by Alfred H. Barr Jr. New York, 1955. See also Barr 1955 for checklist and installation photograph.

New York (Perls) 1955. *The Perls Galleries Collection of Modern French Paintings.* Perls Galleries, New York, March 14–April 23, 1955. Catalogue. New York, 1955.

New York (Rosenberg) 1955. *Loan Exhibition of Paintings by Picasso.* Paul Rosenberg & Co., New York, January 17–February 12, 1955. Catalogue. New York, 1955.

Paris 1955. *Picasso: Peintures, 1900–1955.* Musée des Arts Décoratifs, Paris, June 6–October 15, 1955. Catalogue. Paris, 1955.

London 1956. *Picasso Himself.* Institute of Contemporary Arts, London, October–December 1956. Catalogue [by Roland Penrose]. London, 1956.

New York (Kootz) 1956. *Picasso.* Kootz Gallery, New York, March 12–April 7, 1956. Catalogue. New York, 1956.

New York (MMA) 1956. "Paintings from Private Collections, Summer Loan Exhibition." The Metropolitan Museum of Art, New York, June 19–October 1, 1956. No catalogue published.

New York (Perls) 1956. *The Perls Galleries Collection of Modern French Paintings.* Perls Galleries, New York, January 3–February 5, 1956. Catalogue. New York, 1956.

Oslo 1956. *Picasso: Malerier, tegninger, frafikk, skulptur, keramikk.* Kunstnernes Hus, Oslo, November–December 1956. Catalogue. Oslo, 1956.

New York (Fine Arts Associates) 1957. *Picasso, Sculpture.* Fine Arts Associates, New York, January 15–February 9, 1957. Catalogue by Daniel-Henry Kahnweiler. New York, 1957.

New York (MMA) 1957. "Paintings from Private Collections, Summer Loan Exhibition." The Metropolitan Museum of Art, New York, July 11–September 3, 1957. No catalogue published; typed checklist.

New York (Perls) 1957. *Maîtres de la première génération du vingtième siècle: A Group of Paintings in the Collection of Peter and Elizabeth Rübel, New York.* Perls Galleries, New York, March 13–April 13, 1957; organized by the Swiss Institute for Art Research, Zürich. This exhibition later traveled to several cities in the United States. Catalogue by Silva Sulzer-Jäggli and Georg Schmidt. Zürich, 1957.

New York–Chicago 1957. *Picasso: 75th Anniversary Exhibition.* The Museum of Modern Art, New York, May 4–September 8, 1957, and The Art Institute of Chicago, October 29–December 8, 1957. Catalogue by Alfred H. Barr Jr. New York, 1957. Third venue: see Philadelphia 1958.

New York (MMA) 1958. "Paintings from Private Collections, Summer Loan Exhibition." The Metropolitan Museum of Art, New York, July 2–September 1, 1958. No catalogue published; typed checklist.

New York (Perls) 1958. *Masterpieces from the Collection of Adelaide Milton de Groot.* Perls Galleries, New York, April 14–May 3, 1958. Catalogue foreword by Theodore Rousseau. New York, 1958.

Paris 1958. *De Clouet à Matisse, dessins français des collections américaines.* Musée de l'Orangerie, Paris, October–November 15, 1958, Catalogue. Paris, 1958. Other venues: see Rotterdam 1958 and New York 1959.

Philadelphia 1958. *Picasso: A Loan Exhibition of His Paintings, Drawings, Sculpture, Ceramics, Prints and Illustrated Books.* Philadelphia Museum of Art, January 8–February 23, 1958. Catalogue preface by Henry Clifford; essay by Carl Zigrosser. Philadelphia, 1958. Earlier venues: see New York–Chicago 1957.

Rotterdam 1958. *Van Clouet tot Matisse, Tentoonstelling van franse tekeningen uit amerikaanse collecties.* Museum Boymans, Rotterdam, July 31–September 28, 1958. Catalogue. Rotterdam, 1958. Other venues: see Paris 1958 and New York 1959.

Columbus 1958–59. *Masterpieces from the Adelaide Milton de Groot Collection.* Columbus Gallery of Fine Arts, Columbus, Ohio, December 2, 1958–March 1, 1959. Catalogue note by Mahonri Sharp Young. Columbus, Ohio, 1958.

Marseilles 1959. *Picasso.* Musée Cantini, Marseilles, May 11–July 31, 1959. Catalogue by Douglas Cooper. Marseilles, 1959.

New York 1959. *French Drawings from American Collections: Clouet to Matisse.* The Metropolitan Museum of Art, New York, February 3–March 15, 1959. Catalogue by Jacqueline Bouchot-Saupique. New York, 1959. Other venues: see Rotterdam 1958 and Paris 1958.

Worcester 1959. *The Dial and the Dial Collection.* Worcester Art Museum, Worcester, Mass., April 30–September 8, 1959. Catalogue by Louisa Dresser; essay by Daniel Catton Rich. Worcester, Mass., 1959.

1960–1969

London 1960. *Pablo Picasso.* Tate Gallery, London, July 6–September 18, 1960. Catalogue by Roland Penrose. London, 1960.

New York (Baker) 1960. *Master Drawings in the Collection of Walter C. Baker.* The Metropolitan Museum of Art, New York, June 1–September 6, 1960. Catalogue published as: Claus Virch. "The Walter C. Baker Collection of Master Drawings." *MMA Bulletin* 18, no. 10 (June 1960), pp. 309–17.

New York (MMA) 1960. "Paintings from Private Collections: Summer Loan Exhibition." The Metropolitan Museum of Art, New York, July 6–September 6, 1960. No catalogue published; typed checklist.

Prague 1960. *Dar dr. Vincence Kramáre Národní Galerii v Praze.* Národní Galerie, Prague, 1960. Catalogue by Jiří Šetlík. Prague, 1960.

Zürich and other cities 1960–61. *Dalla collezione Thompson: Esposizione, collezione G. David Thompson, Pittsburgh, USA.* Kunsthaus Zürich, October 15–November 27, 1960; Solomon R. Guggenheim Museum, New York, May 25–September 30, 1961; Galleria Civica d'Arte Moderna Torino, Turin, October–November 1961; and two other museums. Catalogue by Alfred H. Barr Jr., G. David Thompson, and E. V. Viale. Turin, 1961.

Los Angeles 1961. *"Bonne fête" Monsieur Picasso: From Southern California Collectors; an Exhibition of Paintings, Drawings, and Prints."* UCLA Art Galleries, Los Angeles, October 25–November 12, 1961. Catalogue essay by Daniel-Henry Kahnweiler. Los Angeles, 1961.

New York (MMA) 1961. "Paintings from Private Collections: Summer Loan Exhibition." The Metropolitan Museum of Art, New York, June 30–August 20, 1961. No catalogue published; typed checklist.

New York (Perls) 1961. *21 Major Acquisitions.* Perls Galleries, New York, October 10–November 25, 1961. Catalogue. New York, 1961. Unpaginated.

New York (Perls/Twenties) 1961. *Trends of the Twenties in the School of Paris.* Perls Galleries, New York, January 10–February 18, 1961. Catalogue. New York, 1961.

New York 1962. *Picasso, an American Tribute: Benefit Exhibition for the Public Education Association.* Held simultaneously at nine New York galleries: Knoedler and Co., Saidenberg Gallery, Paul Rosenberg Galleries, Duveen Bros., Perls Galleries, Staempfli Gallery, Cordier-Warren Gallery, The New Gallery, Otto Gerson Gallery, April 25–May 12, 1962. Catalogue edited by John Richardson. New York, 1962. Unpaginated.

New York (MMA) 1962. "Paintings from Private Collections: Summer Loan Exhibition." The Metropolitan Museum of Art, New York, June 3–September 3, 1962. No catalogue published; typed checklist.

New York (MoMA) 1962. "Picasso in the Museum of Modern Art: 80th Birthday Exhibition. The Museum's Collection, Present and Future." The Museum of Modern Art, New York, May 15–September 18, 1962. No catalogue published; unnumbered typed checklist.

New York 1962–63. "Painting, Sculpture, Graphic Arts from the Museum Collection." The Museum of Modern Art, New York, October 27, 1962–November 3, 1963 (1999.363.65 withdrawn February 1, 1963). No catalogue published.

New York (Knoedler) 1963. *Twentieth-Century Masters from the Bragaline Collection for the Benefit of the Museum of Early American Folk Art.* M. Knoedler & Co., New York, November 6–23, 1963. Catalogue. New York, 1963.

New York (MMA) 1963. "Paintings from Private Collections: Summer Loan Exhibition." The Metropolitan Museum of Art, New York, July 12–September 3, 1963. No catalogue published; typed checklist.

Utica–New York 1963. *1913 Armory Show: 50th Anniversary Exhibition.* Munson-Williams-Proctor Institute, Utica, N.Y., February 17–March 31, 1963, and Armory of the 69th Regiment, New York, April 6–28, 1963. Catalogue. New York and Utica, 1963.

Pittsburgh 1963–64. "Works of Art from the Collection of The Museum of Modern Art." Carnegie Institute, Museum of Art, Pittsburgh, December 17, 1963–February 9, 1964. No catalogue published.

New York (MMA) 1964. "Paintings from Private Collections: Summer Loan Exhibition." The Metropolitan Museum of Art, New York, summer 1964. No catalogue published.

Prague 1964. *Picasso, Braque, Derain, Kubista, Filla ze sbírky dr. Vincence Kramáre.* Galerie Vincence Kramáre, Prague, September 27–November 15, 1964. Catalogue preface by Frantisek Dolezal; introduction by Lubos Hlavácek. Prague, 1964.

Tokyo–Kyoto–Nagoya 1964. *Pikaso/Picasso.* National Museum of Modern Art, Tokyo, May 23–July 5, 1964; National Museum of Modern Art, Kyoto, July 10–August 2, 1964; and Prefectural Museum of Art, Nagoya, August 7–18, 1964. Catalogue by Daniel-Henry Kahnweiler and Alfred H. Barr Jr. Tokyo, 1964.

Toronto–Montreal 1964. *Picasso and Man.* Art Gallery of Toronto, January 11–February 16, 1964, and Montreal Museum of Fine Arts, February 28–March 31, 1964. Some pieces also traveled to Tokyo–Kyoto–Nagoya 1964. Catalogue by Jean Sutherland Boggs. Toronto, 1964.

New York 1964–69. "Painting and Sculpture from the Museum Collection." The Museum of Modern Art, New York, May 27, 1964–May 11, 1969. No catalogue published.

Frankfurt–Hamburg 1965. *Picasso: 150 Handzeichnungen aus sieben Jahrzehnten.* Frankfurter Kunstverein, May 29–July 4, 1965, and Kunstverein in Hamburg, July 24–September 5, 1965. Catalogue by Ewald Rathke and Sylvia Rathke-Köhl. Frankfurt am Main and Hamburg, 1965.

Nashville 1965. *36th Annual Festival of Music and Art.* Fisk University, Nashville, April 28–May 2, 1965 (extended to June 10). Catalogue. Nashville, 1965.

New York (MMA) 1965. "Summer Loan Exhibition." The Metropolitan Museum of Art, New York, summer 1965. No catalogue published.

New York (Perls) 1965. *Pablo Picasso: Highlights in Retrospect.* Perls Galleries, New York, October 12–November 20, 1965. Catalogue. New York, 1965.

Toulouse 1965. *Picasso et le théâtre.* Musée des Augustins, Toulouse, June 22–September 15, 1965. Catalogue preface by Jean Cassou; essays by Robert Mesuret, Douglas Cooper, and Denis Milhau. Toulouse, 1965.

Worcester 1965. "Selections from the Dial Collection." Worcester Art Museum, Worcester, Mass., November 13–30, 1965. No catalogue published; unnumbered typed checklist.

New York and other cities 1965–66. *The School of Paris: Paintings from the Florene May Schoenborn and Samuel A. Marx Collection.* The Museum of Modern Art, New York, November 1, 1965–January 2, 1966; The Art Institute of Chicago, February 11–March 27, 1966; City Art Museum of Saint Louis, April 16–June 13, 1966; Museo de Are Moderno, Mexico City, July 2–August 7, 1966; and San Francisco MoMA of Art, September 2–October 2, 1966. Catalogue preface by Alfred H. Barr Jr.; introduction by James Thrall Soby; notes by Lucy R. Lippard. New York, 1965.

Bordeaux 1966. *La Peinture française: Collections américaines.* Musée des Beaux-Arts, Bordeaux, May 13–September 15, 1966. Catalogue by Gilberte Martin-Méry. Bordeaux, 1966.

Cleveland 1966. *Fifty Years of Modern Art, 1916–1966.* The Cleveland Museum of Art, June 15–July 31, 1966. Catalogue by Edward B. Henning. Cleveland, 1966.

New York (MMA) 1966. "Summer Loan Exhibition: Paintings, Drawings, and Sculpture from Private Collections." The Metropolitan Museum of Art, New York, July 8–September 6, 1966. No catalogue published; typed checklist.

Paris 1966. *Picasso: Dessins & aquarelles, 1899–1965.* Galerie Knoedler, Paris, 1966. Catalogue preface by Daniel-Henry Kahnweiler. Paris, 1966.

Prague 1966. *Sbírka francouzského umení 19. a 20. století.* Národní Galerie, Prague, 1966. Catalogue by Olga Macková. Prague, 1966.

Washington 1966. *Five Years: The Friends of the Corcoran, "The Contemporary Spirit."* Corcoran Gallery of Art, Washington, D.C., October 7–30, 1966. Catalogue. Washington, D.C., 1966.

Jerusalem and other cities 1966–67. *Paintings from the Collection of Joseph H. Hazen.* Israel Museum, Jerusalem, May–September 1966; Fogg Art Museum, Harvard University, Cambridge, Mass., October 19–December 1, 1966; UCLA Art Galleries, January–February 1967; University of California, Berkeley Art Museum, February–March 1967; The Museum of Fine Arts, Houston, April–March 1967; and Honolulu Academy of Arts, June–August 1967. Catalogue preface by John Coolidge. Jerusalem, 1966. Fogg Art Museum supplement. Hebrew ed.: *Tsiyurim me-ospo shel G'osef H. Hezn.*

Paris 1966–67. *Hommage à Pablo Picasso.* Grand Palais, Paris, November 20, 1966–February 28, 1967. Catalogue by Jean Leymarie. Paris, 1966.

Amsterdam 1967. *Picasso.* Stedelijk Museum, Amsterdam, March 4–April 30, 1967. Catalogue. Amsterdam, 1967.

Fort Worth–Dallas 1967. *Picasso: Two Concurrent Retrospective Exhibitions.* Fort Worth Art Center Museum and Dallas Museum of Fine Arts, February 8–March 26, 1967. Catalogue by Douglas Cooper. [Fort Worth], 1967.

London 1967. *Picasso: Sculpture, Ceramics, Graphic Work.* Tate Gallery, London, June 9–August 13, 1967. Catalogue by Roland Penrose. London, 1967.

New York 1967. "Drawings from the Alfred Stieglitz Collection." The Metropolitan Museum of Art, New York, September 9–November 12, 1967. No catalogue published; unnumbered typed checklist.

New York 1967–68. *The Sculpture of Picasso.* The Museum of Modern Art, New York, October 11, 1967–January 1, 1968. Catalogue by Roland Penrose; chronology by Alicia Legg. New York, 1967.

Buenos Aires–Santiago–Caracas 1968. *De Cézanne a Miró, una exposición organizada bajo los auspicios del International Council of the Museum of Modern Art, New York.* Museo Nacional de Bellas Artes, Buenos Aires, May 15–June 5, 1968; Museo de Arte Contemporáneo de la Universidad de Chile, Santiago, June 26–July 17, 1968; and Museo de Bellas Artes, Caracas, August 4–26, 1968. Catalogue by Monroe Wheeler and Lucy R. Lippard. New York, 1968.

Chicago 1968. *Picasso in Chicago: Paintings, Drawings, and Prints from Chicago Collections.* The Art Institute of Chicago, February 3–March 31, 1968. Catalogue. Chicago, 1968.

Humlebaek 1968. *Picasso.* Louisiana Museum for Moderne Kunst, Humlebaek, Denmark, September 20–November 10, 1968. Catalogue published in *Louisiana Revy* 9, no. 1–2 (September 1968).

New York 1968. *New York Collects.* The Metropolitan Museum of Art, New York, July 3–September 2, 1968. Catalogue. New York, 1968.

New York (MMA) 1968. "Summer Loan Exhibition." The Metropolitan Museum of Art, New York, summer 1968. No catalogue published.

Vienna 1968. *Pablo Picasso.* Österreichisches Museum für Angewandte Kunst, Vienna, April 24–June 30, 1968. Catalogue by Heribert Hutten; contributions by Gertrude Sandner. Vienna, 1968.

New York 1969. *Twentieth-Century Art from the Nelson Aldrich Rockefeller Collection.* The Museum of Modern Art, New York, May 26–September 1, 1969. Catalogue essay by William S. Lieberman. New York, 1969.

New York 1969–70. *A Selection of Drawings, Pastels and Watercolors from the Collection of Mr. & Mrs. Lester Francis Avnet.* New York Cultural Center in association with Fairleigh Dickinson University, New York, December 9, 1969–January 25, 1970. Catalogue. New York, 1970.

1970–1979

Berkeley 1970. *Excellence: Art from the University Community.* University of California, Berkeley Art Museum, September 1970. Catalogue foreword by Peter Selz. Berkeley, 1970.

Boston 1970. *Masterpieces of Painting in the Metropolitan Museum of Art.* Museum of Fine Arts, Boston, September 16–November 1, 1970. Catalogue by Edith A. Standen and Thomas M. Folds; introduction by Claus Virch. [Greenwich, Conn.], 1970.

Kaiserslautern 1970. *Hommage à Kahnweiler.* Pfalzgalerie, Kaiserslautern, February 15–March 15, 1970. Catalogue preface by Daniel-Henry Kahnweiler. Kaiserslautern, 1970.

New York 1970. "Painting and Sculpture from the Museum Collection." The Museum of Modern Art, New York, February 3–April 10, 1970. No catalogue published.

Portland (Ore.) 1970. *Picasso for Portland.* Portland Art Museum, Portland, Ore., September 21–October 25, 1970. Catalogue by Robert Pierce. Portland, Ore., 1970.

Los Angeles–New York 1970–71. *The Cubist Epoch.* Los Angeles County Museum of Art, December 15, 1970–February 21, 1971, and The Metropolitan Museum of Art, New York, April 7–June 7, 1971. Catalogue by Douglas Cooper. New York, 1970.

New York (MMA) 1970–71. *Masterpieces of Fifty Centuries.* The Metropolitan Museum of Art, New York, November 14, 1970–June 1, 1971. Catalogue introduction by Kenneth Clark. New York, 1970.

New York–Baltimore–San Francisco 1970–71. *Four Americans in Paris: The Collections of Gertrude Stein and Her Family.* The Museum of Modern Art, New York, December 19, 1970–March 1, 1971; The Baltimore Museum of Art, April 4–June 13, 1971; and San Francisco Museum of Art, September 9–October 31, 1971. Catalogue edited by Margaret Potter; essays by Irene Gordon, Lucile M. Golson, Leon Katz, Douglas Cooper, and Ellen B. Hirschland. New York, 1970.

New York 1971. *Homage to Picasso for His 90th Birthday: Joint Exhibition of Paintings and Works on Paper.* Marlborough Gallery and Saidenberg Gallery, New York, October 1–31, 1971. Catalogue by John Richardson. New York, 1971.

Ottawa 1971. *Gertrude Stein and Picasso and Juan Gris.* National Gallery of Canada, Ottawa, June 25–August 15, 1971. Catalogue by Jean Sutherland Boggs et al. [Ottawa, 1971.]

Tokyo–Kurume 1971. *From Cézanne through Picasso: 100 Drawings from the Collection of The Museum of Modern Art, New York, An Exhibition Organized under the Auspices of The International Council of the Museum of Modern Art.* National Museum of Western Art, Tokyo, May 1–June 20, 1971, and Ishibashi Museum, Kurume, July 1–August 1, 1971. Catalogue introduction by William S. Lieberman. Tokyo, 1971. Japanese title: *Yoroppa kyosho suisai sobyoten Sezannu kara Picaso made.* Later venues: see Auckland–Melbourne–Sydney 1971–72.

Worcester 1971. "The Dial Revisited." Worcester Art Museum, Worcester, Mass., June 29–August 22, 1971. No catalogue published; typed checklist.

Auckland–Melbourne–Sydney 1971–72. *From Cézanne through Picasso: 100 Drawings from the Collection of The Museum of Modern Art, New York, an Exhibition Organized under the Auspices of The International Council of the Museum of Modern Art.* Auckland City Art Gallery, September 7–October 17, 1971; National Gallery of Victoria, Melbourne, November 11, 1971–January 2, 1972; and Farmer's Blaxland Gallery, Sydney, January 17–February 5, 1972. Catalogue introduction by William S. Lieberman. Auckland, 1971. Earlier venues: see Tokyo–Kurume 1971.

New Haven 1971–72. *Picasso Drawings from the Collection of Mr. and Mrs. Walter Bareiss.* Yale University Art Gallery, New Haven, November 4, 1971–January 2, 1972. Catalogue preface by Walter Bareiss. New Haven, 1971.

Honolulu–San Francisco 1972. "From Cézanne through Picasso: 100 Drawings from the Collection of The Museum of Modern Art, New York." Honolulu Academy of Arts, February 18–March 26, 1972, and California Palace of the Legion of Honor, San Francisco, April 15–June 4, 1972. No catalogue published.

London 1972. *Summer Exhibition: Paintings and Sculpture of the Nineteenth and Twentieth Centuries.* O'Hana Gallery, London, May 17–September 15, 1972. Catalogue. London, 1972.

New York 1972. *Picasso in the Collection of The Museum of Modern Art.* The Museum of Modern Art, New York, February 3–April 2, 1972. Catalogue edited by William Rubin; essays by Rubin, Elaine L. Johnson, and Riva Castleman. New York, 1972.

Tokyo–Kyoto 1972. *Treasured Masterpieces of The Metropolitan Museum of Art.* Tokyo National Museum, August 10–October 1, 1972, and Kyoto Municipal Museum, October 8–November 26, 1972. Catalogue. Tokyo, 1972. Japanese ed.: *Nyuyoku Metoroporitan Bijutsukan ten.* Tokyo, 1972.

London 1973. *Pioneers of Modern Sculpture.* Hayward Gallery, London, July 20–September 23, 1973. Catalogue by Albert E. Elsen. London, 1973.

London (O'Hana) 1973. *Summer Exhibition: Paintings and Sculpture of the Nineteenth and Twentieth Centuries Including a Collection of Paintings by Eugène Galien-Laloue.* O'Hana Gallery, London, May 24–September 15, 1973. Catalogue. London, 1973.

New York 1973. *The World of Balenciaga.* The Metropolitan Museum of Art, New York, March 21–July 1, 1973. Catalogue. New York, 1973.

Norfolk 1973. "Picasso Retrospective." Chrysler Museum, Norfolk, Va., June 17–July 21, 1973. No catalogue published; typed checklist.

Otterlo 1973. *Honderd tekeningen uit het Museum of Modern Art, New York/Hundred Drawings from the Museum of Modern Art, New York.* Rijksmuseum Kröller-Müller, Otterlo, April 15–June 18, 1973. Catalogue introduction by William S. Lieberman. [Otterlo], 1973.

Sheffield 1973. *One Hundred European Drawings from The Museum of Modern Art, New York.* Graves Art Gallery, Sheffield, U.K., September 22–November 4, 1973. Catalogue introduction by William S. Lieberman. [Sheffield, U.K.], 1973.

Milan 1973–74. *Disegni di artisti europei del Museum of Modern Art di New York.* Rotonda di via Besana, Milan, November 30, 1973–January 6, 1974. Catalogue introduction by William S. Lieberman. Milan, 1973.

Paris 1973–74. *Dessins français du Metropolitan Museum of Art, New York: De David à Picasso.* Musée du Louvre, Paris, October 25, 1973–January 7, 1974. Catalogue by Jacob Bean, Linda Boyer Gillies, and Cynthia Lambros. Paris, 1973.

Lisbon 1974. *100 desenhos europeus do Museu de Arte Moderna de Nova Iorque.* Fundação Calouste Gulbenkian, Lisbon, February–March 1974. Catalogue introduction by William S. Lieberman. Lisbon, 1974.

Menton 1974. *Dixième Biennale Internationale d'Art de Menton.* Palais de l'Europe, Menton, July–September 1974. Catalogue introduction by Émile Marze. Menton, 1974.

Richmond 1974. "Picasso: Painting and Prints." Virginia Museum of Fine Arts, Richmond, November 18–December 22, 1974. No catalogue published.

Leningrad–Moscow 1975. *100 kartin iz Muzeia Metropoliten, Soedinennye Shtaty Ameriki* (100 Paintings from The Metropolitan Museum of Art, New York). The State Hermitage Museum, Leningrad, May 22–July 27, 1975, and The Pushkin State Museum of Fine Arts, Moscow, August 28–November 2, 1975. Catalogue edited by Albert G. Kostenevich. Moscow, 1975.

Montauban 1975. *Picasso (nus, portaits, compositions).* Musée Ingres, Montauban, June 27–September 7, 1975. Catalogue by Pierre Barousse and Hélène Parmelin. Montauban, 1975.

New York 1975. *Picasso: A Loan Exhibition for the Benefit of Cancer Care, Inc., The National Cancer Foundation.* Acquavella Galleries, New York, April 15–May 17, 1975. Catalogue. New York, 1975.

Toronto 1975. *Puvis de Chavannes and the Modern Tradition.* Art Gallery of Ontario, Toronto, October 24–November 30, 1975. Catalogue by Richard J. Wattenmaker. Toronto, 1975.

Basel 1976. *Picasso aus dem Museum of Modern Art New York und Schweizer Sammlungen.* Kunstmuseum Basel, June 15–September 12, 1976. Catalogue by Franz Meyer, William Rubin, Zdenek Felix, and Reinhol Hohl. Basel, 1976.

New York 1976. *Modern Portraits: The Self and Others; an Exhibition Organized by the Department of Art History and Archaeology of Columbia University in the City of New York.* Wildenstein & Co., New York, October 20–November 28, 1976. Catalogue by Kirk Varnedoe et al. New York, 1976.

Tokyo–Kyoto 1976. *Kyubizumu ten/Cubism.* National Museum of Modern Art, Tokyo, October 2–November 14, 1976, and National Museum of Modern Art, Kyoto, November 23–December 19, 1976. Catalogue. Tokyo, 1976.

Bellingham 1976–77. *5000 Years of Art: An Exhibition from the Collections of The Metropolitan Museum of Art.* Whatcom Museum of History and Art, Bellingham, Wash., November 1976–September 1977. Catalogue by Thomas Schlotterback. Bellingham, Wash., 1976.

Norfolk–Nashville 1977. *Treasures from the Chrysler Museum at Norfolk and Walter P. Chrysler, Jr.* Chrysler Museum, Norfolk, Va., 1977, and Tennessee Fine Arts Center at Cheekwood, Nashville, June 12–September 5, 1977. Catalogue by Mario Amaya and Eric Zafran. Norfolk, Va., 1977.

Paris 1977. *Paris—New York.* Centre Pompidou, Paris, June 1–September 19, 1977. Catalogue. Paris, 1977.

Worcester 1977. "The Model in Art." Worcester Art Museum, Worcester, Mass., August 31–October 18, 1977. No catalogue published.

New York and other cities 1977–78. "Impresario Ambroise Vollard." The Museum of Modern Art, New York, June 9–September 7, 1977; Art Gallery of Ontario, Toronto, October 22–December 4, 1977; Krannert Art Museum, University of Illinois at Champaign, January 15–February 19, 1978; and Toledo Museum of Art, Toledo, Ohio, March 19–April 23, 1978. Catalogue, *Ambroise Vollard, Éditeur: Prints, Books, Bronzes,* by Una E. Johnson. New York, 1977. *Impresario Ambroise Vollard* (brochure), by Riva Castleman. New York, 1977.

Tokyo and other cities 1977–78. *Exposition Picasso: Japon 1977–78.* Museum of the City of Tokyo, October 15–December 4, 1977; Prefectural Museum of Art, Nagoya, December 13–26, 1977; Cultural Center, Fukuoka, January 5–22, 1978; and National Museum of Modern Art, Kyoto, January 28–March 5, 1978. Catalogue by Roland Penrose, Pontus Hulten, and Dominique Bozo. [Tokyo], 1977.

London 1978. *20th Century Portraits.* National Portrait Gallery, London, June 9–September 17, 1978. Catalogue by Robin Gibson. London, 1978.

Princeton–Washington 1978. *Els Quatre Gats: Art in Barcelona around 1900.* Art Museum, Princeton University, January 29–March 26, 1978, and Hirshhorn Museum and Sculpture Garden, Washington, D.C., April 14–June 26, 1978. Catalogue by Marilyn McCully. Princeton, N.J., 1978.

Washington 1978. "The Noble Buyer": John Quinn, Patron of the Avant-Garde. Hirshhorn Museum and Sculpture Garden, Washington, D.C., June 15–September 4, 1978. Catalogue by Judith Zilczer. Washington, D.C., 1978.

Wellesley 1978. *One Century: Wellesley Families Collect.* Wellesley College Museum, Jewett Arts Center, Wellesley, Mass., April 15–May 30, 1978. Catalogue by Ann Gabhart, Judith Hoos Fox, and Elisabeth Thresher Scharlack. Wellesley, Mass., 1978.

Athens 1979. *Thesauroi apo to Mētropolitiko Mouseio Technēs tēs Neas Hyorkēs/Treasures from The Metropolitan Museum of Art, New York: Memories and Revivals of the Classical Spirit.* National Pinakothiki Alexander Soutzos Museum, Athens, September 3–December 2, 1979. Catalogue. Athens, 1979.

Bielefeld 1979. *Zeichnungen und Collagen des Kubismus: Picasso, Braque, Gris.* Kunsthalle Bielefeld, March 11–April 29, 1979. Catalogue by Ulrich Weisner. Bielefeld, 1979.

Cleveland 1979. *The Spirit of Surrealism.* The Cleveland Museum of Art, October 3–November 25, 1979. Catalogue by Edward B. Henning. Cleveland, 1979.

New York and other cities 1979–80. *Master Drawings and Watercolors of the Nineteenth and Twentieth Centuries.* Solomon R. Guggenheim Museum, New York, August 24–October 7, 1979; Des Moines Art Center, November 19, 1979–January 6, 1980; Art Museum of South Texas, Corpus Christi, February 8–March 16, 1980; The Museum of Fine Arts, Houston, May 1–June 22, 1980; Denver Art Museum, July 12–August 24, 1980; organized by The Baltimore Museum of Art and the American Federation of Arts. Catalogue by Carol Hynning Smith. New York, 1979.

1980–1989

Kyoto–Tokyo 1980. *Eien no meiga hizo-ten: Goya kara Sezannu, Pikaso made/The Joan Whitney Payson Collection: From Goya to Wyeth.* Kyoto Municipal Museum, September 13–October 12, 1980, and Isetan Museum of Art, Tokyo, October 17–December 9, 1980. Catalogue by François Daulte. Tokyo, 1980.

London 1980. *Abstraction: Towards a New Art, Painting 1910–20.* Tate Gallery, London, February 5–April 8, 1980. Catalogue. London, 1980.

New York 1980. *Pablo Picasso: A Retrospective.* The Museum of Modern Art, New York, May 22–September 16, 1980. Catalogue edited by William Rubin; introduction by Dominique Bozo; chronology by Jane Fluegel. New York, 1980. Supplement of works added after the catalogue went to press.

Rome 1980–81. *Apollinaire e l'avanguardia.* Galleria Nazionale d'Arte Moderna, Rome, November 30, 1980–January 4, 1981. Catalogue by Michel Décaudin, P. A. Jannini, Daniel Abadie, and Bruno Mantura. Rome, 1980.

Turin 1980–81. *Kupka Gutfreund & C. in the National Gallery in Prague/Kupka Gutfreund & C. nella Galleria Nazionale di Praga.* Mole Antonelliana, Turin, November 15, 1980–January 11, 1981. Catalogue by Jiří Kotalík. Venice, 1980.

Washington 1980–81. *Picasso: The Saltimbanques.* National Gallery of Art, Washington, D.C., December 14, 1980–March 15, 1981. Catalogue by E. A. Carmean Jr. Washington, D.C., 1980.

Basel 1981. *Pablo Picasso: Das Spätwerk, Themen 1964–1972.* Kunstmuseum Basel, September 6–November 8, 1981. Catalogue by Christian Geelhaar, Richard Häsli, Dieter Koepplin, Kim Levin, and Franz Meyer. Basel, 1981.

Bordeaux 1981. *Profil du Metropolitan Museum of Art de New York: De Ramsès à Picasso.* Galerie des Beaux-Arts, Bordeaux, May 15–September 1, 1981. Catalogue edited by Philippe de Montebello and Gilberte Martin-Méry. Bordeaux, 1981.

Cambridge–Chicago–Philadelphia 1981. *Master Drawings by Picasso.* Fogg Art Museum, Harvard University, Cambridge, Mass.; The Art Institute of Chicago, April 30–June 14, 1981; and Philadelphia Museum of Art, 1981. Catalogue by Gary Tinterow. Cambridge, Mass., 1981.

Florence 1981. *Arte maestra: Da Monet a Picasso; cento capolavori della Galleria Nazionale di Praga/Monet to Picasso; a Hundred Masterpieces from the National Gallery in Prague.* Palazzo Pitti, Florence, June 27–September 20, 1981. Catalogue by Achille Bonito Oliva and Jiří Kotalík. Florence, 1981.

Saint-Paul 1981. *Sculpture du XXe siècle, 1900–1945: Tradition et ruptures.* Fondation Maeght, Saint-Paul, July 4–October 4, 1981. Catalogue by Jean-Louis Prat. Saint-Paul, 1981.

Venice 1981. *Picasso: Opere dal 1895 al 1971 dalla Collezione Marina Picasso.* Centro di Cultura di Palazzo Grassi, Venice, May 3–July 26, 1981. Catalogue by Giovanni Carandente and Werner Spies. Florence, 1981.

Worcester 1981. *The Dial: Arts and Letters in the 1920s.* Worcester Art Museum, Worcester, Mass., March 7–May 10, 1981. Catalogue edited by Gaye L. Brown. Toronto, 1981.

Hamburg 1981–82. *Der zerbrochene Kopf: Picasso zum 100. Geburtstag.* Hamburger Kunsthalle, Hamburg, December 11, 1981–February 21, 1982. Catalogue edited by Helmut R. Leppien. Hamburg, 1981.

Madrid–Barcelona 1981–82. *Picasso, 1881–1973: Exposición antológica.* Museo Español de Arte Contemporáneo, Madrid, November 5–December 27, 1981, and Museu Picasso, Barcelona, January 11–February 28, 1982. Catalogue by Javier Tusell, Narcís Serra i Serra, Ana Beristain, Rosa M. Subirana, José Milicua, Alicia Suárez, Alvaro Martinez Novillo, et al. Barcelona, 1981.

Munich and other cities 1981–82. *Pablo Picasso: Eine Ausstellung zum hundertsten Geburtstag. Werke aus der Sammlung Marina Picasso.* Haus der Kunst, Munich, February 14–August 11, 1981; Kunsthalle, Cologne, August 11–October 11, 1981; Städtische Galerie, Frankfurt am Main, October 22, 1981–January 10, 1982; and Kunsthaus Zürich, January 29–March 28, 1982. Catalogue edited by Werner Spies. Munich, 1981.

Toronto 1981–82. *Gauguin to Moore: Primitivism in Modern Sculpture.* Art Gallery of Ontario, Toronto, November 7, 1981–January 3, 1982. Catalogue by Alan G. Wilkinson. Toronto 1981.

Cologne 1982. *Kubismus: Künstler, Themen, Werke, 1907–1920.* Kunsthalle, Cologne, May 26–July 25, 1982. Catalogue by Siegfried Gohr. Cologne, 1982.

New York 1982. *The Sculpture of Picasso.* Pace Gallery, New York, September 16–October 23, 1982. Catalogue by Robert Rosenblum. New York, 1982.

Saitama 1982. *Inshoha kara eicoru do Pari e: Saitama no kindai bijutsu o meguru kaikan kinen ten/From Impressionism to École de Paris: Its Passion and Struggle.* The Museum of Modern Art, Saitama, November 3–December 12, 1982. Catalogue by Masayoshi Homma and Shuji Takashina. Saitama, 1982.

Mexico City 1982–83. *Los Picassos de Picasso en México: Una exposición retrospectiva.* Museo Rufino Tamayo, Mexico City, November 1982–January 1983. Catalogue edited by William S. Lieberman. Mexico City, 1982.

Paris 1982–83. *Paul Éluard et ses amis peintres, 1895–1952.* Centre Pompidou, Paris, November 4, 1982–January 17, 1983. Catalogue. Paris, 1982.

Paris–Washington 1982–83. *Georges Braque: The Papiers collés.* Centre Pompidou, Paris, June 17–September 27, 1982, and National Gallery of Art, Washington, D.C., October 31, 1982–January 16, 1983. Catalogue by Isabelle Monod-Fontaine, with E. A. Carmean Jr. Washington, D.C., 1982. French ed.: *Georges Braque: Les Papiers collés,* by Isabelle Monod-Fontaine. Paris, 1982.

London 1983. *The Essential Cubism: Braque, Picasso and Their Friends, 1907–1920.* Tate Gallery, London, April 27–July 10, 1983. Catalogue by Douglas Cooper and Gary Tinterow. London 1983.

New York 1983. *Picasso: The Primacy of Design, Major Drawings in Black and Colored Media from the Marina Picasso Collection, in Association with Galerie Jan Krugier, Geneva.* Paul Rosenberg & Co., New York, October 26–December 3, 1983. Catalogue. New York, 1983.

Tokyo–Kyoto 1983. *Picasso: Masterpieces from Marina Picasso Collection and from Museums in the U.S.A. and U.S.S.R.* National Museum of Modern Art, Tokyo, April 2–May 29, 1983, and Kyoto Municipal Museum, June 10–July 24, 1983. Catalogue by Kenji Adachi, Werner Spies, Kunio Motoé, and Masanori Ichikawa. Tokyo, 1983.

Berlin–Düsseldorf 1983–84. *Pablo Picasso: Das Plastische Werk: Werkverzeichnis der Skulpturen.* Nationalgalerie Berlin, Staatliche Museen Preussischer Kulturbesitz, October 7–November 27, 1983, and Kunsthalle Düsseldorf, December 11, 1983–January 29, 1984. Catalogue by Werner Spies and Christine Piot. Stuttgart, 1983.

Dallas and other cities 1983–84. *Picasso the Printmaker: Graphics from the Marina Picasso Collection.* Dallas Museum of Art, September 11–October 30, 1983; Brooklyn Museum, November 23, 1983–January 8, 1984; and two other museums. Catalogue by Brigitte Baer. Dallas, 1983.

Basel 1984. *Skulptur im 20. Jahrhundert.* Merian-Park, Basel, June 3–September 30, 1984. Catalogue by Theodora Vischer. Basel, 1984.

Bordeaux 1984. *50 ans d'art espagnol, 1880–1936.* Galerie des Beaux-Arts, Bordeaux, May 11–September 1, 1984. Catalogue by Gilberte Martin-Méry. Bordeaux, 1984.

Melbourne–Sydney 1984. *Picasso: Works from the Marina Picasso Collection in Collaboration with Galerie Jan Krugier, Geneva, with Loans from Museums in Europe and the United States of America and Private Collections.* National Gallery of Victoria, Melbourne, July 29–September 23, 1984, and Art Gallery of New South Wales, Sydney, October 10–December 2, 1984. Catalogue edited by Patrick McCaughey and Judith Ryan. Sydney, 1984.

Mexico City 1984. *Picasso: Su última década, 1963–1973.* Museo Rufino Tamayo, Mexico City, June–July 1984. Catalogue preface by Robert R. Littman; essays by Gert Schiff, John Richardson, and David Hockney; translated by Flora Botton-Burlá et al. Mexico City, 1984. First venue: see New York (Guggenheim) 1984.

New York (Guggenheim) 1984. "Picasso: The Last Decade." Solomon R. Guggenheim Museum, New York, March 2–May 13, 1984; organized by the Grey Art Gallery and Study Center, New York University. Catalogue, *Picasso: The Last Years, 1963–1973,* by Gert Schiff and Isa van Eeghen. New York, 1983. Second venue: see Mexico City 1984.

New York (MMA) 1984. "Exceptional Acquisitions." The Metropolitan Museum of Art, New York, May 8–September 2, 1984. No catalogue published.

Bern 1984–85. *Der Junge Picasso: Frühwerk und Blaue Periode.* Kunstmuseum Bern, December 6, 1984–February 17, 1985. Catalogue edited by Jürgen Glaesemer; contributions by Marilyn McCully, Stefan Frey, et al. Bern, 1984.

New York–Detroit–Dallas 1984–85. *"Primitivism" in 20th Century Art: Affinity of the Tribal and the Modern.* The Museum of Modern Art, New York, September 27, 1984–Jaunuary 15, 1985; Detroit Institute of Arts, February 23–May 19, 1985; and Dallas Museum of Art, June 15–September 8, 1985. Catalogue edited by William Rubin. 2 vols. New York, 1984.

Paris 1984–85. *Donation Louise et Michel Leiris: Collection Kahnweiler-Leiris.* Centre Pompidou, Paris, November 22, 1984–January 28, 1985. Catalogue by Isabelle Monod-Fontaine et al. Paris, 1984.

Paris (Kahnweiler) 1984–85. *Daniel-Henry Kahnweiler: Marchand, éditeur, écrivain.* Centre Pompidou, Paris, November 22, 1984–January 28, 1985. Catalogue edited by Isabelle Monod-Fontaine and Claude Laugier. Paris, 1984.

Charleroi 1985. *Picasso, Miró, Dalí: Évocations d'Espagne.* Palais des Beaux-Arts, Charleroi, September 24–December 22, 1985. Catalogue by Werner Spies (Picasso), Jacques Dupin (Miró), and Renilde Hammacher-van den Brande (Dalí). Charleroi, 1985.

Madrid 1985. *Juan Gris (1887–1927).* Salas Pablo Ruiz Picasso, Madrid, September 20–November 24, 1985. Catalogue by Gary Tinterow. Madrid, 1985.

New York (Beadleston) 1985. *Through the Eye of Picasso, 1928–1934: The Dinard Sketchbook and Related Paintings and Sculpture.* William Beadleston, Inc., New York, October 31–December 14, 1985. Catalogue by John Richardson. New York, 1985.

New York (MMA) 1985. "Selection Two: Twentieth-Century Art." The Metropolitan Museum of Art, New York, June 2–September 3, 1985. No catalogue published.

New York (MMA/Kramer) 1985. *Picasso Linoleum Cuts: The Mr. and Mrs. Charles Kramer Collection in the Metropolitan Museum of Art.* The Metropolitan Museum of Art, New York, March 7–May 12, 1985. Catalogue by William S. Lieberman; catalogue entries by L. Donald McVinney. New York, 1985.

Tokyo 1985. *Roransan/Laurencin.* Art Gallery Shueisha, Tokyo, 1985. Catalogue by Haruki Yaegashi et al. Tokyo, 1985.

London 1985–86. *Homage to Barcelona: The City and Its Art, 1888–1936.* Hayward Gallery, London, November 14, 1985–February 23, 1986. Catalogue edited by Michael Raeburn. London, 1985.

Canberra–Brisbane 1986. *20th Century Masters from The Metropolitan Museum of Art.* National Gallery of Australia, Canberra, March 1–April 27, 1986, and Queensland Art Gallery, Brisbane, May 7–July 1, 1986. Catalogue by Michael Lloyd et al. Canberra, 1986.

New York 1986. *Je suis le cahier: The Sketchbooks of Pablo Picasso.* Pace Gallery, New York, May 2–August 1, 1986. Catalogue edited by Arnold Glimcher and Marc Glimcher. New York, 1986.

Paris 1986. *Qu'est-ce que la sculpture moderne?* Centre Pompidou, Paris, July 3–October 13, 1986. Catalogue edited by Margit Rowell. Paris, 1986.

Toronto and other cities 1986. *Picasso Head of a Woman (Fernande).* Art Gallery of Ontario, Toronto, and other cities in Ontario, 1986. Catalogue by Alan G. Wilkinson. Masterpiece Exhibition Series, no. 3. Toronto, 1986.

Tübingen–Düsseldorf 1986. *Picasso: Pastelle, Zeichnungen, Aquarelle.* Kunsthalle, Tübingen, April 5–May 25, 1986, and Kunstsammlung Nordrhein-Westfalen, Düsseldorf, June 6–July 27, 1986. Catalogue by Werner Spies. Stuttgart, 1986.

Hannover 1986–87. *Picasso im Sprengel Museum Hannover: Druckgraphik, illustrierte Bücher, Zeichnungen, Collagen und Gemälde.* Sprengel Museum Hannover, December 7, 1986–March 15, 1987. Catalogue edited by Magdalena M. Moeller. Hannover, 1986.

Madrid 1986–87. *Picasso en Madrid: Colección Jacqueline Picasso.* Museo Español de Arte Contemporáneo, Madrid, October 25, 1986–January 10, 1987. Catalogue edited by Aurelio Torrente Larrosa. Madrid, [1986].

Düsseldorf 1987–88. *Positionen unabhängiger Kunst in Europa um 1937: "Und nicht die leiseste Spur einer Vorschrift."* Kunstsammlung Nordrhein-Westfalen, Düsseldorf, December 4, 1987–January 31, 1988. Catalogue by Thomas Brandt, Freya Mülhaupt, et al. Düsseldorf, 1987.

Düsseldorf–Münster 1987–88. *Alfred Flechtheim, Sammler, Kunsthändler, Verleger.* Kunstmuseum Düsseldorf, September 20–November 1, 1987, and Westfälisches Landesmuseum für Kunst und Kulturgeschichte, Münster, November 29, 1987–January 17, 1988. Catalogue by Hans-Albert Peters and Stephan von Wiese, with Monika Flacke-Knoch and Gerhard Leistner. Düsseldorf, 1987.

Bielefeld 1988. *Picassos Klassizismus: Werke von 1914–1934.* Kunsthalle Bielefeld, April 17–July 31, 1988. Catalogue edited by Ulrich Weisner. Bielefeld, 1988.

Cologne 1988. *Picasso im Zweiten Weltkrieg, 1939 bis 1945.* Museum Ludwig, Cologne, April 27–June 19, 1988. Catalogue by Siegfried Gohr, Brigitte Baer, Pierre Daix, Franz Meyer, Laurence Bertrand Dorléac, Leo Steinberg, Remo Guidieri, Wilfried Wiegand, Christian Zervos, Harriet Janis, and Sidney Janis. Cologne, 1988.

London 1988. *Late Picasso: Paintings, Sculpture, Drawings, Prints, 1953–1972.* Tate Gallery, London, June 23–September 18, 1988. Catalogue by Michel Leiris,

Marie-Laure Bernadac, John Richardson, Brigitte Baer, and David Sylvester. London, 1988. Other venues: see Paris (Pompidou) 1988 and Humlebaek 1988–89.

Lugano 1988. *Il cubismo nella scultura.* Galleria Pieter Coray, Lugano, April–May 1988. Catalogue introduction by Nicole Barbier. Milan, 1988.

Paris (Pompidou) 1988. *Le Dernier Picasso, 1953–1973.* Centre Pompidou, Paris, February 17–May 16, 1988. Catalogue by Michel Leiris, Marie-Laure Bernadac, John Richardson, Brigitte Baer, Guy Scarpetta, and David Sylvester. Paris, 1988. Later venues: see London 1988 and Humlebaek 1988–89.

Paris–Barcelona 1988. *Les Demoiselles d'Avignon.* Musée Picasso, Paris, January 26–April 18, 1988, and Museu Picasso, Barcelona, May 10–July 14, 1988. Catalogue (2 vols.) by William Rubin, Hélène Seckel, and Judith Cousins. Paris, 1988. English rev. ed.: see Rubin, Seckel, and Cousins 1994.

Humlebaek 1988–89. *Picasso: 1960–1973.* Louisiana Museum for Moderne Kunst, Humlebaek, Denmark, October 8, 1988–January 15, 1989. Catalogue by Rolf Laessoe, John Richardson, and Christian Geelhaar; published in *Louisiana Revy* 29, no. 1 (October 1988). Earlier venues: see Paris (Pompidou) 1988 and London 1988.

New York 1988–89. *Umberto Boccioni.* The Metropolitan Museum of Art, New York, September 15, 1988–January 8, 1989. Catalogue by Ester Coen; translated by Robert Eric Wolf. New York, 1988.

Stockholm 1988–89. *Pablo Picasso.* Moderna Museet, Stockholm, October 15, 1988–January 8, 1989. Catalogue by Olle Granath et al. Stockholm, 1988.

Balingen 1989. *Picasso: Portrait, Figurine, Skulptur.* Stadthalle, Balingen, June 17–August 20, 1989. Catalogue by Roland Doschka. Balingen, 1989.

Valentano 1989. *Picasso nella ceramica: Carreaux di Madoura.* Museo Rocca Farnese, Valentano, November 4–30, 1989. Catalogue by Trinidad Sánchez-Pacheco. Viterbo, 1989.

Yokohama 1989. *Treasures from the Metropolitan Museum of Art: French Art from the Middle Ages to the Twentieth Century.* Yokohama Museum of Art, March 25–June 4, 1989. Catalogue edited by Denys Sutton. [Tokyo], 1989.

New York 1989–90. *Picasso and Braque: Pioneering Cubism.* The Museum of Modern Art, New York, September 24, 1989–January 16, 1990. Catalogue by William Rubin; chronology by Judith Cousins. New York, 1989.

New York–London 1989–90. *Twentieth-Century Modern Masters: The Jacques and Natasha Gelman Collection.* The Metropolitan Museum of Art, New York, December 12, 1989–April 1, 1990, and Royal Academy of Arts, London, April 19–July 15, 1990. Catalogue edited by William S. Lieberman; catalogue by Sabine Rewald; contributions by Dawn Ades, John Ashbery, Jacques Dupin, John Golding, Lawrence Gowing, William S. Lieberman, Philippe de Montebello, Pierre Schneider, and Gary Tinterow. New York, 1989.

Philadelphia–Washington–Los Angeles–New York 1989–91. *Masterpieces of Impressionism and Post-Impressionism: The Annenberg Collection.* Philadelphia Museum of Art, May 21–September 17, 1989; National Gallery of Art, Washington, D.C., May 6–August 5, 1990; Los Angeles County Museum of Art, August 16–November 11, 1990; and The Metropolitan Museum of Art, New York, June 4–October 13, 1991. Catalogue by Colin B. Bailey, Joseph J. Rishel, and Mark Rosenthal; with Veerle Thielemans. 3rd ed. Philadelphia, 1989; enl. ed., 1991.

1990–1999

Barcelona–Madrid 1990. *Cubismo en Praga: Obras de la Galería Nacional.* Museu Picasso, Barcelona, February 20–April 29, 1990, and Fundación Juan March, Madrid, May 11–July 8, 1990. Catalogue by Jiří Kotalík, Ivan Neumann, and Jiřii Šetlik. Madrid, 1990.

London 1990. *On Classic Ground: Picasso, Léger, De Chirico and the New Classicism, 1910–1930.* Tate Gallery, London, June 6–September 2, 1990. Catalogue by Elizabeth Cowling and Jennifer Mundy. London, 1990.

New York (MMA) 1990. "Summer Loan Exhibition." The Metropolitan Museum of Art, New York, summer 1990. No catalogue published.

Okayama and other cities 1990. *Paburo Pikaso ten/Exposition Pablo Picasso, autour des portraits.* Okayama Prefectural Museum of Art, May 29–June 24, 1990; Kumamoto Prefectural Museum of Art, June 29–July 25, 1990; Shizuoka Prefectural Museum of Art, July 31–August 26, 1990; Nabio Museum of Art, Osaka, August 31–September 27, 1990; and Museum of of Fine Arts, Gifu, October 2–28, 1990. Catalogue by Jean Clair, Jean-Louis Prat, Pierre Daix, Georges Boudaille, and Solange Auzias de Turenne. Tokyo, 1990.

London 1990–91. *Impressionism.* The National Gallery, London, November 28, 1990–April 21, 1991. Catalogue by David Bomford, Jo Kirby, John Leighton, and Ashok Roy; contributions by Raymond White and Louise Williams. Art in the Making. London, 1990.

New York 1990–91. "60 Drawings." The Metropolitan Museum of Art, New York, October 23, 1990–January 15, 1991. No catalogue published.

New York and other cities 1990–91. *Gertrude Stein: The American Connection.* Sid Deutsch Gallery, New York, November 3–December 8, 1990; Terra Museum of American Art, Chicago, January 12–March 10, 1991; University Art Museum, University of Minnesota, Minneapolis, April 14–May 24, 1991; Butler Institute of American Art, Youngstown, Ohio, June 23–August 2, 1991; and Kalamazoo Institute of Arts, Kalamazoo, Mich., September 3–October 27, 1991. Catalogue by Gail Stavitsky. New York, 1990.

New York–Chicago–Los Angeles 1990–91. *High and Low: Modern Art and Popular Culture.* The Museum of Modern Art, New York, October 7, 1990–January 15, 1991; The Art Institute of Chicago, February 20–May 12, 1991; and The Museum of Contemporary Art, Los Angeles, June 21–September 15, 1991. Catalogue by Kirk Varnedoe and Adam Gopnik. New York, 1990.

Boston–New York 1991. *Pleasures of Paris: Daumier to Picasso.* Museum of Fine Arts, Boston, June 5–September 1, 1991, and IBM Gallery of Science and Art, New York, October 15–December 28, 1991. Catalogue by Barbara Stern Shapiro with the assistance of Anne E. Havinga; essays by Susanna Barrows, Phillip Dennis Cate, and Barbara K. Wheaton. Boston, 1991.

Atlanta and other cities 1991–93. *Max Weber: The Cubist Decade, 1910–1920.* High Museum of Art, Atlanta, December 11, 1991–February 9, 1992; The Museum of Fine Arts, Houston, March 8–May 3, 1992; Corcoran Gallery of Art, Washington, D.C., May 31–August 9, 1992; Albright-Knox Art Gallery, Buffalo, September 12–October 25, 1992; Brooklyn Museum, November 13, 1992–January 10, 1993; and Los Angeles County Museum of Art, February 18–April 25, 1993. Catalogue essay by Percy North; introduction by Susan Krane. Atlanta, 1991.

London 1991–95. *Van Gogh to Picasso: The Berggruen Collection at the National Gallery.* The National Gallery, London, five-year loan exhibition, 1991–95. Catalogue by Richard Kendall; essays by Lizzie Barker and Camilla Cazalet. London, 1991.

Paris–Nantes 1991–92. *Picasso, Jeunesse et genèse: Dessins, 1893–1905.* Musée Picasso, Paris, September 17–November 25, 1991, and Musée des Beaux-Arts, Nantes, December 6, 1991–February 16, 1992. Catalogue edited by Brigitte Léal. Paris, 1991.

Barcelona–Bern 1992. *Picasso, 1905–1906: De l'epoca rosa als ocres de Gósol.* Museu Picasso, Barcelona, February 5–April 19, 1992, and Kunstmuseum Bern, May 8–June 26, 1992. Catalogue by Núria Rivero, Teresa Llorens, et al. Barcelona, 1992. English ed.: *Picasso, 1905–1906: From the Rose Period to the Ochres of Gósol.* Translated by Richard Rees. Barcelona, 1992.

Cleveland–Philadelphia–Paris 1992. *Picasso & Things: The Still-Lifes of Picasso.* The Cleveland Museum of Art, February 26–May 3, 1992; Philadelphia Museum of Art, June 7–August 23, 1992; and Grand Palais, Paris, September 22–December 28, 1992. Catalogue by Jean Sutherland Boggs; essays by Brigitte Léal and Marie-Laure Bernadac. Cleveland, 1992. French ed.: *Picasso et les choses: Les Natures mortes.* Paris, 1992.

Mexico City 1992. *La colección de pintura mexicana de Jacques y Natasha Gelman.* Centro Cultural Arte Contemporáneo, Mexico City, June 23–October 11, 1992. Catalogue essay by Sylvia Navarrete. Mexico City, 1992.

New York 1992. *The William S. Paley Collection.* The Museum of Modern Art, New York, February 2–May 7, 1992. Catalogue by William Rubin and Matthew Armstrong. New York, 1992.

Málaga 1992–93. *Picasso clasico.* Palacio Episcopal, Málaga, October 10, 1992–January 11, 1993. Catalogue edited by Gary Tinterow. Málaga, 1992.

Canberra–Brisbane–Sydney 1993. *Surrealism: Revolution by Night.* National Gallery of Australia, Canberra, March 12–May 2, 1993; Queensland Art Gallery, Brisbane, May 21–July 11, 1993; and Art Gallery of New South Wales, Sydney, July 30–September 19, 1993. Catalogue by Michael Lloyd, Ted Gott, and Christopher Chapman. Canberra, 1993.

New York 1993. "Nudes: A Selection from the Bequest of Scofield Thayer." The Metropolitan Museum of Art, New York, February 12–October 1993. No catalogue published.

Bielefeld 1993–94. *Picasso, letzte Bilder: Werke 1966–1972.* Kunsthalle Bielefeld, October 17, 1993–January 31, 1994. Catalogue edited by Ulrich Weisner. Bielefeld, 1993.

London 1994. *Picasso: Sculptor/Painter.* Tate Gallery, London, February 16–May 8, 1994. Catalogue edited by Elizabeth Cowling and John Golding; essays by Pepe Karmel, Peter Read, Marilyn McCully, Claude Ruiz-Picasso, Elizabeth Cowling, and Christine Piot. London, 1994.

Martigny 1994. *De Matisse à Picasso: Collection Jacques et Natasha Gelman.* Fondation Pierre Gianadda, Martigny, June 18–November 1, 1994 (extended to November 13). Catalogue forewords by Philippe de Montebello, Léonard Gianadda, and Sabine Rewald; introduction by William S. Lieberman; essays by Lawrence Gowing, Pierre Schneider, Gary Tinterow, John Golding, Dawn Ades, Jacques Dupin, and John Ashbery; catalogue by Sabine Rewald. Martigny, 1994.

Paris 1994. *Picasso photographe, 1901–1916.* Musée Picasso, Paris, June 1–July 17, 1994. Catalogue by Anne Baldassari. Paris, 1994.

Quimper–Paris 1994. *Max Jacob et Picasso.* Musée des Beaux-Arts, Quimper, June 21–September 4, 1994, and Musée Picasso, Paris, October 4–December 12, 1994. Catalogue edited by Hélène Seckel. Paris, 1994.

West Palm Beach 1994. *Pablo Picasso: A Vision.* Norton Gallery of Art, West Palm Beach, Fla., March 2–April 3, 1994. Catalogue by David F. Setford. West Palm Beach, Fla., 1994.

Barcelona 1994–95. *Picasso Landscapes, 1890–1912: From the Academy to the Avant-Garde.* Museu Picasso, Barcelona, November 1994–February 1995. Catalogue edited by Maria Teresa Ocaña. Boston, 1994.

Los Angeles–New York–Chicago 1994–95. *Picasso and the Weeping Women: The Years of Marie-Thérèse Walter and Dora Maar.* Los Angeles County Museum of Art, February 10–May 8, 1994; The Metropolitan Museum of Art, New York, June–September 14, 1994; and The Art Institute of Chicago, October 6, 1994–January 8, 1995. Catalogue by Judi Freeman. Los Angeles and New York, 1994. MMA brochure and checklist.

Burlington 1995. *Picasso: Inside the Image. Prints from the Ludwig Museum, Cologne.* Robert Hull Fleming Museum, University of Vermont, Burlington, March 4–June 4, 1995. Catalogue edited by Janie Cohen. Burlington, Vt., 1995.

Munich 1995. *Pierrot: Melancholie und Maske.* Haus der Kunst, Munich, September 15–December 3, 1995. Catalogue by Thomas Kellein. Munich, 1995.

New York 1995. *Image and Eye: The Art of Goya and Picasso.* New York Studio School, October 24–November 11, 1995. Catalogue by Karen Wilkin. New York, 1995. Unpaginated.

New York (Pace Wildenstein) 1995. *Picasso and Drawing.* Pace Wildenstein, New York, April 28–June 2, 1995. Catalogue by Bernice Rose. New York, 1995.

Barcelona 1995–96. *Picasso i els 4 Gats: La clau de la modernidad.* Museu Picasso, Barcelona, November 1995–February 1996. Catalogue by Maria Teresa Ocaña. English ed.: *Picasso and els 4 Gats: The Key to Modernity.* Barcelona, 1995.

San Francisco 1995–96. *Picasso the Sculptor.* California Palace of the Legion of Honor, Fine Arts Museums of San Francisco, November 11, 1995–March 10, 1996. Catalogue by Steven A. Nash. San Francisco, 1995.

Berlin 1996. *Picasso und seine Zeit: Die Sammlung Berggruen.* Staatliche Museen zu Berlin, Preussischer Kulturbesitz, Berlin, 1996. Catalogue by Peter-Klaus Schuster, Angela Schneider, Hans Jürgen Papies, and Roland März. Berlin, 1996. English ed.: *Picasso and His Time: The Berggruen Collection.* Berlin, 1998.

London–Chicago 1996–97. *Degas: Beyond Impressionism.* The National Gallery, London, May 22–August 26, 1996, and The Art Institute of Chicago, September 28, 1996–January 5, 1997. Catalogue by Richard Kendall. London, 1996.

New York–Paris 1996–97. *Picasso and Portraiture: Representation and Transformation.* The Museum of Modern Art, New York, April 28–September 17, 1996, and Grand Palais, Paris, October 15, 1996–January 20, 1997. Catalogue edited by William Rubin; essays by Anne Baldassari, Pierre Daix, Michael C. FitzGerald, Brigitte Léal, Marilyn McCully, Robert Rosenblum, William Rubin, Hélène Seckel, and Kirk Varnedoe. New York, 1996. French ed.: *Picasso et le portrait.* Paris, 1996.

San Francisco–New York 1996–97. *A Century of Sculpture: The Nasher Collection.* California Palace of the Legion of Honor, Fine Arts Museums of San Francisco, October 1996–January 1997, and Solomon R. Guggenheim Museum, New York, February–April 1996. Catalogue by Carmen Giménez and Steven A. Nash. New York, 1996.

Céret 1997. *Picasso: Dessins et papiers collés, Céret, 1911–1913.* Musée d'Art Moderne, Céret, June 29–September 14, 1997. Catalogue by Pepe Karmel, Anne Baldassari et al. Céret, 1997.

New York (MMA) 1997. *Picasso the Engraver: Selections from the Musée Picasso, Paris.* The Metropolitan Museum of Art, New York, September 18–December 21, 1997. Catalogue by Brigitte Baer; translated by Iain Watson and Judith Schub. New York, 1997.

New York (MMA/Schoenborn) 1997. "The Florene M. Schoenborn Bequest: 12 Artists of the School of Paris." The Metropolitan Museum of Art, New York, February 11–May 4, 1997 (extended to August 31). No catalogue published; brochure.

Paris 1997. *Le Miroir noir: Picasso, sources photographiques, 1900–1928.* Musée Picasso, Paris, March 12–June 9, 1997. Catalogue by Anne Baldessari. Paris, 1997. Later venues: see Houston–Munich 1997–98.

Paris (Warhol) 1997. *Andy Warhol: Heads (after Picasso).* Galerie Thaddaeus Ropac, Paris, May 3–July 14, 1997. Catalogue. Paris, 1997.

Seattle 1997. "Matisse, Picasso, and Friends." Seattle Art Museum, February 20–April 20, 1997. No catalogue published.

Grenoble 1997–98. *Francis Picabia: Les Nus et la méthode.* Musée de Grenoble, October 17, 1997–January 3, 1998. Catalogue by Serge Lemoine et al. Paris, 1998.

Houston–Munich 1997–98. *Picasso and Photography: The Dark Mirror.* The Museum of Fine Arts, Houston, November 16, 1997–February 1, 1998, and Fotomuseum, Münchner Stadtmuseum, Munich, spring 1998. Catalogue by Anne Baldassari; translated from French by Deke Dusinberre. Paris and New York, 1997. First venue: see Paris 1997.

Lisbon 1997–98. *Picasso e o Mosqueteiro: 1967–1972.* Museu do Chiado, Lisbon, October 28, 1997–February 1, 1998. Catalogue by Michele Moutashar, Raquel Henriques Da Silva, and Eduardo Lourenco. Lisbon, 1997.

Washington–Boston 1997–98. *Picasso: The Early Years, 1892–1906.* National Gallery of Art, Washington, D.C., March 30–July 27, 1997, and Museum of Fine Arts, Boston, September 10, 1997–January 4, 1998. Catalogue edited by Marilyn McCully; contributions by Natasha Staller, Jeffrey Weiss, et al. Washington, D.C., 1997.

Atlanta–Ottawa–Los Angeles 1997–99. *Picasso, Masterworks from The Museum of Modern Art.* High Museum of Art, Atlanta, November 8, 1997–February 15, 1998; National Gallery of Canada, Ottawa, April 3–July 12, 1998; and Los Angeles County Museum of Art, September 6, 1998–January 4, 1999. Catalogue by Kirk Varnedoe and Pepe Karmel. New York, 1997.

Barcelona 1998. *Joan González 1868–1908: Pintures, escultures, dibuixos.* Museu Nacional d'Art de Catalunya, Barcelona, 1998. Catalogue by Mercè Doñate, Cristina Mendoza, and Cecília Vidal Maynou. Barcelona, 1998.

Geneva 1998. *Picasso l'Africain.* Musée Barbier-Müller, Geneva, May 7–September 15, 1998. Catalogue by Pierre Daix. Geneva, 1998.

New York 1998. "Bathers" (1998 Annual Benefit). New York Studio School, October 13–November 14, 1998. No catalogue published.

Tokyo–Nagoya 1998. *Pikaso ten: Kaikan 10-shunen kinen/Pablo Picasso: 10th Anniversary.* Bunkamura Museum of Art, Tokyo, July 4–September 6, 1998, and Nagoya City Art Museum, September 12–November 29, 1998. Catalogue [by William S. Lieberman] in Japanese and English. Nagoya, 1998.

Venice 1998. *Picasso 1917–1924: Il viaggio in Italia.* Palazzo Grassi, Venice, March 14–July 12, 1998. Catalogue edited by Jean Clair, with Odile Michel. Milan, 1998. English ed.: *Picasso: The Italian Journey, 1917–1924.* Milan, 1998. French ed.: *Picasso, 1917–1924: Le Voyage d'Italie.* Paris, 1998.

London–New York 1998–99. *Picasso: Painter and Sculptor in Clay.* Royal Academy of Arts, London, September 17–December 16, 1998, and The Metropolitan Museum of Art, New York, March 3–June 6, 1999. Catalogue edited by Marilyn McCully. New York and London, 1998.

Paris 1998–99. *Picasso 1901–1909: Chefs d'oeuvre du Metropolitan Museum of Art, New York.* Musée Picasso, Paris, October 21, 1998–January 25, 1999. Catalogue by Brigitte Léal. Paris, 1998. Unpaginated.

San Francisco–New York 1998–99. *Picasso and the War Years, 1937–1945.* California Palace of the Legion of Honor, Fine Arts Museums of San Francisco, October 10, 1998–January 3, 1999, and Solomon R. Guggenheim Museum, New York, February 5–April 26, 1999. Catalogue edited by Stephen A. Nash, with Robert Rosenblum et al. New York and San Francisco, 1998.

Tacoma 1998–99. *Picasso: A Dialogue with Ceramics, Ceramics from the Marina Picasso Collection.* Tacoma Art Museum, Tacoma, Wash., September 27, 1998–January 10, 1999. Catalogue. Tacoma, Wash., 1998.

Künzelsau 1999. *Picasso, Sein Dialog mit der Keramik: Werke aus der Sammlung Mariana Picasso.* Museum Würth, Künzelsau, June 4–September 12, 1999. Catalogue by Kosme de Barañano and C. Sylvia Weber. Künzelsau, 1999.

Portland (Maine) 1999. "Picasso's Human Vision." Portland Museum of Art, Portland, Maine, May 29–September 6, 1999. No catalogue published; typed checklist.

Schwerin 1999. *Pablo Picasso: Der Reiz der Fläche/The Appeal of Surface.* Staatliches Museum, Schwerin, July 3–September 26, 1999. Catalogue edited by Kornelia von Berswordt-Wallrabe. Ostfildern-Ruit, 1999.

Vallauris 1999. *L'Homme au mouton, Picasso.* Musée Magnelli, Musée de la Céramique, Vallauris, July 4–October 4, 1999. Catalogue. Paris, 1999.

Villeneuve d'Ascq 1999. *Les Années cubistes: Collections du Centre Georges Pompidou, Musée National d'Art Moderne et du Musée d'Art Moderne de Lille Métropole.* Musée d'Art Moderne de Lille Métropole, Villeneuve d'Ascq, March 13–July 18, 1999. Catalogue by Isabelle Monod-Fontaine et al. Paris and Villeneuve d'Ascq, 1999.

London–Washington–New York 1999–2000. *Portraits by Ingres: Image of an Epoch.* The National Gallery, London, January 27–April 25, 1999; National Gallery of Art, Washington, D.C., May 23–August 22, 1999; and The Metropolitan Museum of Art, New York, October 5, 1999–January 2, 2000. Catalogue edited by Gary Tinterow and Philip Conisbee. New York, 1999.

2000–2009

Balingen 2000. *Pablo Picasso: Metamorphoses des Menschen; Arbeiten auf Papier, 1895–1972.* Stadthalle Balingen, Germany, June 20–September 24, 2000. Catalogue edited by Roland Doschka; essays by Anne Baldassari, Roland Doschka, and Marilyn McCully. Munich, 2000. English ed.: *Pablo Picasso: Metamorphoses of the Human Form, Graphic Works, 1895–1972.* Munich, 2000.

Hannover–Berlin 2000. *Picasso: Die Umarmung. Spanischen Pavillons der Expo 2000.* Kestner Gesellschaft, Hannover, August 29–September 30, 2000, and Neue Nationalgalerie, Berlin, October 3–December 10, 2000. Catalogue by Claude Picasso and Sylvie Vautier. Berlin, 2000.

New York 2000. *Painters in Paris, 1895–1950.* The Metropolitan Museum of Art, New York, March 8–December 31, 2000. Catalogue by William S. Lieberman. New York, 2000.

Paris 2000. *Picasso: Sculpteur.* Centre Pompidou, Paris, June 7–September 25, 2000. Catalogue by Werner Spies, with Christine Piot. Paris, 2000.

Tokyo 2000. *Picasso's World of Children.* National Museum of Western Art, Tokyo, March 14–June 18, 2000. Catalogue. Tokyo, 2000.

Washington 2000. *Modern Art and America: Alfred Stieglitz and His New York Galleries.* National Gallery of Art, Washington, D.C., January 28–April 22, 2000. Catalogue edited by Sarah Greenough. Washington, D.C., 2000.

Liège 2000–2001. *Pablo Picasso.* Salle Saint-Georges, Liège, October 6, 2000–January 31, 2001. Catalogue edited by Régine Rémon; texts by Anne Baldassari, Roland Doschka, Françoise Dumont, Dominique Dupuis-Labbé, Régine Rémon, and Jean-Marc Gay. Munich, 2000.

Montreal–Fort Worth 2000–2001. *From Renoir to Picasso: Masterpieces from the Musée de l'Orangerie.* Montreal Museum of Fine Arts, June 1–October 15, 2000, and Kimbell Art Museum, Fort Worth, November 12, 2000–February 25, 2001. Catalogue by Pierre Georgel. Montreal, 2000.

Vienna–Tübingen 2000–2002. *Picasso, Figur und Porträt: Hauptwerke aus der Sammlung Bernard Picasso.* Kunstforum, Vienna, September 7, 2000–January 7, 2001, and Kunsthalle Tübingen, February 2–June 16, 2002. Catalogue edited by Götz Adriani, Evelyn Benesch, and Ingried Brugger. Vienna, 2000.

Vallauris 2001. *Picasso à Vallauris: Linogravures.* Musée National Picasso La Guerre et La Paix and Musée Magnelli, Musée de la Céramique, Vallauris,

June 16–November 19, 2001. Curated by Sandra Benadretti-Pellard; catalogue by Anne Fréling and Isabelle Mancarella. Paris, 2001.

London–New York 2001–2. *Surrealism: Desire Unbound.* Tate Modern, London, September 20, 2001–January 1, 2002, and The Metropolitan Museum of Art, New York, February 6–May 12, 2002. Catalogue edited by Jennifer Mundy. London, 2001.

Madrid 2001–2. *Forma: El ideal clásico en el arte moderno.* Museo Thyssen-Bornemisza, Madrid, October 9, 2001–January 13, 2002. Catalogue by Tomàs Llorens. Madrid, 2001.

Madrid–Las Palmas de Gran Canaria 2001–2. *Rumbos de la escultura española en el siglo XX.* Fundación Santander Central Hispano, Madrid, October 2–November 18, 2001, and Centro Atlántico de Arte Moderno, Las Palmas de Gran Canaria, December 13, 2001–February 10, 2002. Catalogue edited by Ana Vázquez de Parga. Madrid, 2001.

Milan 2001–2. *Picasso: 200 capolavori dal 1898 al 1972.* Palazzo Reale, Milan, September 15, 2001–January 27, 2002. Catalogue edited by Bernice B. Rose and Bernard Ruiz Picasso; additional essays by Pepe Karmel and Naomi Spector. Milan, 2001. English ed.: *Picasso: 200 Masterworks from 1898 to 1972.* Boston, 2002.

New York 2001–2. "The Jacques and Natasha Gelman Collection: Bonnard to Balthus." The Metropolitan Museum of Art, New York, June 1, 2001–February 3, 2002. No catalogue published; typed checklist.

New York (Hollis Taggart) 2001–2. *Inheriting Cubism: The Impact of Cubism on American Art, 1909–1936.* Hollis Taggart Galleries, New York, November 28, 2001–January 12, 2002. Catalogue by Stacey B. Epstein. New York, 2001.

Paris–Montreal–Barcelona 2001–2. *Picasso érotique.* Galerie Nationale du Jeu de Paume, Paris, February 19–May 20, 2001; Montreal Museum of Fine Arts, June 14–September 16, 2001; and Museu Picasso, Barcelona, October 15, 2001–January 27, 2002. Catalogue by Gérard Régnier and Dominique Dupuis-Labbé. Paris, 2001.

Madrid 2002. *Las formas del cubismo: Escultura, 1909–1919.* Museo Nacional Centro de Arte Reina Sofía, Madrid, February 12–April 22, 2002. Catalogue edited by José Francisco Yvars; catalogue by Lucía Ybarra and Macarena Mora. Madrid, 2002.

Paris 2002. *Montmartre: Bals et cabarets au temps de Bruant et Lautrec.* Musée de Montmartre, Paris, 2002. Catalogue by Daniel Bonthoux and Bernard Jégo. Paris, 2002.

Chemnitz 2002–3. *Picasso and Women—Picasso et les femmes.* Kunstsammlungen Chemnitz, October 20, 2002–January 19, 2003. Catalogue by Pierre Daix et al. Heidelberg, 2002.

Copenhagen 2002–3. *The Avant-Garde in Danish and European Art, 1909–19.* Statens Museum for Kunst, Copenhagen, September 7, 2002–January 19, 2003. Catalogue by Dorthe Aagesen. Copenhagen, 2002.

Kyoto–Tokyo 2002–3. *Picasso and the School of Paris: Paintings from The Metropolitan Museum of Art.* Kyoto Municipal Museum, September 14–November 24, 2002, and Bunkamura Museum of Art, Tokyo, December 7, 2002–March 9, 2003. Catalogue in Japanese and English edited by William S. Lieberman. N.p., 2002.

London–Paris–New York 2002–3. *Matisse—Picasso.* Tate Modern, London, May 11–August 18, 2002; Grand Palais, Paris, September 25, 2002–January 6, 2003; and The Museum of Modern Art, New York, February 13–May 19, 2003. Catalogue by John Golding, Anne Baldassari, John Elderfield, Elizabeth Cowling, Isabelle Monod-Fontaine, Kirk Vanedoe, and Claude Laugier. London, 2002. French ed.: Paris, 2002.

Sydney 2002–3. *Picasso: The Last Decades.* Art Gallery of New South Wales, Sydney, November 9, 2002–February 16, 2003. Catalogue by Terence Maloon. Sydney, 2002.

New York (C&M Arts) 2003. *Picasso: The Classical Period.* C&M Arts Gallery, New York, October 1–December 6, 2003. Catalogue. New York, 2003.

New York (Gagosian) 2003. *The Sculptures of Picasso.* Gagosian Gallery, New York, April 3–May 10, 2003. Catalogue by Diana Widmaier Picasso and Robert Rosenblum. New York, 2003.

New York (Whitney) 2003. *Elie Nadelman: Sculptor of Modern Life.* Whitney Museum of American Art, New York, April 3–July 20, 2003. Catalogue by Barbara Haskell. New York, 2003.

Paris–Boston 2003–4. *Gauguin, Tahiti.* Grand Palais, Paris, September 20, 2003–January 19, 2004, and Museum of Fine Arts, Boston, February 29–June 20, 2004. Catalogue by George T. M. Schackelford and Claire Frèches-Thory. Boston, 2004.

Vienna 2003–4. *Die Galerie Miethke: Eine Kunsthandlung im Zentrum der Moderne.* Jüdisches Museum Wien, Vienna, November 19, 2003–February 8, 2004. Catalogue by Tobias G. Natter. Vienna, 2003.

Washington–Dallas 2003–4. *Picasso: The Cubist Portraits of Fernande Olivier.* National Gallery of Art, Washington, D.C., October 1, 2003–January 18, 2004, and Nasher Sculpture Center, Dallas, February 15–May 9, 2004. Catalogue by Jeffrey Weiss, Valerie J. Fletcher, and Kathryn A. Tuma. Washington, D.C., 2003.

Münster 2004. *Pablo Picasso and Marie-Thérèse Walter: Between Classicism and Surrealism.* Graphikmuseum Pablo Picasso Münster, May 7–August 8, 2004. Catalogue edited by Marcus Müller. Bielefeld, 2004.

Paris–Montauban 2004. *Picasso—Ingres.* Musée Picasso, Paris, March 16–June 21, 2004, and Musée Ingres, Montauban, July 8–October 3, 2004. Catalogue edited by Laurence Madeline. Paris, 2004.

Paris–Ottawa 2004. *The Great Parade: Portrait of the Artist as a Clown.* Grand Palais, Paris, March 12–May 31, 2004, and National Gallery of Canada, Ottawa, June 25–September 19, 2004. Organized by Pierre Théberge; catalogue edited by Jean Clair. New Haven, 2004.

Ferrara 2004–5. *Il Cubismo: Revoluzione e tradizione.* Palazzo dei Diamanti, Ferrara, October 3, 2004–January 9, 2005. Catalogue by Marilyn McCully and Michael Raeburn. Ferrara, 2004.

Madrid (Prado) 2004–5. *The Spanish Portrait: From El Greco to Picasso.* Museo Nacional del Prado, Madrid, October 20, 2004–February 6, 2005. Catalogue edited by Javier Portús Pérez. Madrid, 2004. Spanish ed.: *El retrato español: Del Greco a Picasso.* Madrid, 2004.

Madrid (Thyssen-Bornemisza) 2004–5. *Gauguin and the Origins of Symbolism.* Museo Thyssen-Bornemisza, Madrid, and Fundación Caja Madrid, September 28, 2004–January 9, 2005. Catalogue edited by Guillermo Solana; texts by Richard Shiff, Guy Cogeval, and María Dolores Jiménez-Blanco. London, 2004. Spanish ed.: *Gauguin y los orígenes del Simbolismo.* Madrid, 2004.

Paris–Madrid 2004–5. *New York et l'art moderne: Alfred Stieglitz et son cercle (1905–1930).* Musée d'Orsay, Paris, October 18, 2004–January 16, 2005, and Museo Nacional Centro de Arte Reina Sofia, Madrid, February 10–May 16, 2005. Catalogue by Danielle Tilkin, et al.; essay by Sarah Greenough. Paris, 2004.

Quebec–Toronto–Antibes 2004–5. *Picasso and Ceramics.* Musée National des Beaux-Arts du Québec, May 6–August 29, 2004; Gardiner Museum of Ceramic Art, University of Toronto, September 28, 2004–January 23, 2005; and Musée Picasso, Antibes, February 12–May 29, 2005. Catalogue by Paul Bourassa, Léopold L. Foulem, John R. Porter, Line Ouellet, Alexandra Montgomery, Susan Jefferies, and Jean-Louis Andral; translated by Charles Penwarden and John Tittensor. Paris, 2004. French ed.: *Picasso et la céramique.* Paris, 2004.

Basel 2005. *Picasso surreal—Picasso surréaliste— The Surrealist Picasso.* Fondation Beyeler, Reihen/Basel, June 12–September 12, 2005. Catalogue edited by Anne Baldassari. Reihen/Basel, 2005.

New York 2005. *Jewish Women and Their Salons: The Power of Conversation.* The Jewish Museum, New York, March 4–July 10, 2005. Catalogue by Emily D. Bilski and Emily Braun; with contributions by Leon Botstein et al. New Haven, 2005.

Paris 2005. *Bacon—Picasso: La Vie des images.* Musée Picasso, Paris, March 1–May 30, 2005. Catalogue by Anne Baldassari. Paris, 2005. English ed.: *Bacon—Picasso: The Life of Images.* Translated by David Radzinowicz. Paris, 2005.

Stuttgart 2005. *Picasso: Badende.* Staatsgalerie Stuttgart, June 18–October 16, 2005. Catalogue edited by Ina Conzen, with contributions by Anke Spötter and Guido Messling. Stuttgart, 2005. English ed.: *Picasso: Bathers.* Translated by Bronwen Saunders and Brian Currid. Stuttgart, 2005.

Washington–Chicago 2005. *Toulouse-Lautrec and Montmartre.* National Gallery of Art, Washington, D.C., March 20–June 12, 2005, and The Art Institute of Chicago, July 16–October 10, 2005. Catalogue. Washington, D.C., 2005.

Madrid 2005–6. *Celebración del arte: Medio siglo de la Fundación Juan March.* Fundación Juan March, Madrid, October 7, 2005–January 15, 2006. Catalogue by Juan Manuel Bonet et al. Madrid, 2005. English ed.: *Celebration of Art: A Half Century of the Fundación Juan March.* Madrid, 2005.

Kanagawa 2006. *Pikaso: Itsutsu no tema/Picasso: Five Themes.* Pola Museum of Art, Kanagawa, March 18–September 17, 2006. Catalogue by Imai Keiko et al. Kanagawa, 2006.

Madrid 2006. *Picasso: Tradition and Avant-Garde.* Museo Nacional del Prado and Museo Nacional Centro de Arte Reina Sofía, Madrid, June–September 4, 2006. Catalogue by Francisco Calvo Serraller, Carmen Giménez, José Álvarez Lopera, et al. Madrid, 2006.

Barcelona–Martigny 2006–7. *Picasso y el circo.* Museu Picasso, Barcelona, November 15, 2006–February 18, 2007, and Fondation Pierre Gianadda, Martigny, March 9, 2007–June 10, 2007. Catalogue by Jean Clair, Maria Teresa Ocaña, Zeev Gourarier, Brigitte Léal, Genís Matabosch, Markus Müller, and Michèle Moutashar. Barcelona, 2006. French ed.: *Picasso et le cirque.* Martigny, 2007.

Cleveland–New York 2006–7. *Barcelona and Modernity: Picasso, Gaudí, Miró, Dalí.* The Cleveland Museum of Art, October 15, 2006–January 7, 2007, and The Metropolitan Museum of Art, New York, March 7–June 3, 2007. Catalogue by William H. Robinson, Carmen Belen Lord, Jordi Falgàs, Magdalena Dabrowski, Jared Goss, et al. Cleveland, 2006.

Frankfurt 2006–7. *Picasso und das Theater/Picasso and the Theater.* Schirn Kunsthalle Frankfurt, October 21, 2006–January 21, 2007. Catalogue edited by Olivier Berggruen and Max Hollein. Ostfildern, 2006.

Málaga 2006–7. *Picasso: Musas y modelos/Muses and Models.* Museo Picasso Málaga, February 10, 2006–February 28, 2007. Catalogue edited by Bernardo Laniado-Romero, texts by Estrella de Diego and Robert S. Lubar. Málaga, 2006.

New York 2006–7. *Spanish Painting from El Greco to Picasso.* Solomon R. Guggenheim Museum, New York, November 17, 2006–March 28, 2007. Catalogue edited by Carmen Giménez and Francisco Calvo Serraller. Alcobendas and New York, 2006. Spanish ed.: *Pintura española de El Greco a Picasso.* Madrid, 2006.

New York–Chicago–Paris 2006–7. *Cézanne to Picasso: Ambroise Vollard, Patron of the Avant-Garde.* The Metropolitan Museum of Art, New York, September 13, 2006–January 7, 2007; The Art Institute of Chicago, February 17–May 13, 2007; and Musée d'Orsay, Paris, June 11–September 16, 2007. Catalogue edited by Rebecca Rabinow; essays by Douglas W. Druick, Ann Dumas, Gloria Groom, Anne Roquebert, Gary Tinterow, et al. New York, 2006. French ed.: *De Cézanne à Picasso: Chefs-d'oeuvre de la Galerie Vollard.* Paris, 2007.

New York–San Francisco–Minneapolis 2006–7. *Picasso and American Art.* Whitney Museum of American Art. New York, September 28, 2006–January 28, 2007; San Francisco Museum of Modern Art, February 25–May 28, 2007; and Walker Art Center, Minneapolis, June 17–September 9, 2007. Catalogue by Michael C. FitzGerald; chronology by Julia May Boddewyn, New York, 2006.

Vienna–Düsseldorf 2006–7. *Picasso: Malen gegen die Zeit.* Albertina, Vienna, September 21, 2006–January 14, 2007, and Kunstsammlung Nordrhein-Westfalen, Düsseldorf, February 2–May 28, 2007. Catalogue edited by Werner Spies. Düsseldorf, 2006.

Williamstown–New York 2006–7. *The Clark Brothers Collect: Impressionist and Early Modern Paintings.* Sterling and Francine Clark Art Institute, Williamstown, Mass., June 4–September 4, 2006, and The Metropolitan Museum of Art, May 22–August 19, 2007. Catalogue by Michael Conforti et al. Williamstown, Mass., 2006.

Berlin 2007. *Französische Meisterwerke des 19. Jahrhunderts aus dem Metropolitan Museum of Art, New York.* Neue Nationalgalerie, Berlin, May 31–October 7, 2007. Catalogue edited by Angela Schneider, Anke Daemgen, and Gary Tinterow. Berlin, 2007.

Copenhagen 2007. *Andre Derain: An Outsider in French Art.* Statens Museum for Kunst, Copenhagen, February 10–May 13, 2007. Catalogue by Isabelle Monod-Fontaine; contributions by Sibylle Pieyre de Mandiargues et al. Copenhagen, 2007.

Edinburgh 2007. *Picasso on Paper.* Scottish National Gallery of Modern Art, Edinburgh, July 14–September 23, 2007. Catalogue by Patrick Elliott. Edinburgh, 2007.

Houston 2007. *The Masterpieces of French Painting from The Metropolitan Museum of Art, 1800–1920.* The Museum of Fine Arts, Houston, February 4–May 6, 2007. Catalogue introduction by Gary Tinterow; texts by Kathryn Calley Galitz, Sabine Rewald, Susan Alyson Stein, and Gary Tinterow. New York, 2007.

Madrid–Fort Worth 2007. *The Mirror and The Mask: Portraiture in the Age of Picasso.* Museo Thyssen-Bornemisza, Madrid, and Fundación Caja Madrid, February 6–May 20, 2007, and Kimbell Art Museum, Fort Worth, June 17–September 16, 2007. Catalogue edited by Paloma Alarcó and Malcolm Warner. Fort Worth, 2007. Spanish ed.: *El espejo y la mascara: El retrato en el siglo de Picasso.* Madrid, 2007.

New York 2007. *Picasso, Braque, and Early Film in Cubism.* Pace Wildenstein, New York, April 20–June 23, 2007. Catalogue edited by Bernice B. Rose; essays by Tom Gunning, Bernice Rose, and Jennifer Wild. New York, 2007.

Amsterdam 2007–8. *Barcelona 1900.* Van Gogh Museum, Amsterdam, September 21, 2007–January 20, 2008. Catalogue edited by Teresa-M. Sala. Amsterdam, 2007.

London 2007–8. *Seduced: Art and Sex from Antiquity to Now.* Barbican Art Gallery, London, October 12, 2007–January 27, 2008. Catalogue by Marina Wallace, Martin Kemp, and Joanne Bernstein. London, 2007.

Málaga 2007–8. *Picasso: Objeto e imagen/Picasso: Object and Image.* Museo Picasso Málaga, October 22, 2007–January 27, 2008. Catalogue by Salvador Haro and Harald Theil. Málaga, 2007.

Paris 2007–8. *Picasso cubiste.* Musée National Picasso, Paris, September 19, 2007–January 7, 2008. Catalogue by Anne Baldassari et al. Paris, 2007. Eng. ed.: *Cubist Picasso.* Paris, 2007.

Williamstown–New Haven–Dallas 2007–8. *Making It New: The Art and Style of Sara and Gerald Murphy.* Williams College Museum of Art, Williamstown, Mass., July 8–November 11, 2007; Yale University Art Gallery, New Haven, February 26–May 4, 2008; and Dallas Museum of Art, June 8–September 15, 2008. Catalogue edited by Deborah Rothschild. Berkeley, 2007.

Greenwich 2008–9. *Paris Portraits: Artists, Friends, and Lovers.* Bruce Museum, Greenwich, Conn., September 27, 2008–January 4, 2009. Catalogue by Kenneth E. Silver. New Haven and London, 2008.

Munich 2008. *Die "Moderne Galerie" von Heinrich Thannhauser/The "Moderne Galerie" of Heinrich Thannhauser.* Jüdisches Museum München, January 30–May 25, 2008. Catalogue by Emily D. Bilski. Munich, 2008.

Naples (Fla.) 2008. "Picasso: Preoccupations and Passions." Naples Museum of Art, Naples, Fla., January 29–May 18, 2008. No catalogue published; brochure.

New York 2008. *Picasso's Marie-Thérèse.* Acquavella Galleries, New York, October 15–November 29, 2008. Catalogue by Michael FitzGerald and Elizabeth Cowling. New York, 2008.

Barcelona 2008–9. *Objetos vivos: Figura y naturaleza muerta en Picasso.* Museu Picasso, Barcelona, November 20, 2008–March 1, 2009. Catalogue by Christopher Green. Barcelona, 2008. English ed.: *Life and Death in Picasso: Still Life/Figure, c. 1907–1933.* London, 2009.

Madrid 2008–9. *A.C.: La revista del G.A.T.E.P.A.C., 1931–1937.* Museo Nacional Centro de Arte Reina Sofía, Madrid, October 28, 2008–January 5, 2009. Catalogue by Enrique Granell et al. Madrid, 2008.

New York 2008–9. *The Philippe de Montebello Years.* The Metropolitan Museum of Art, New York, October 20, 2008–February 1, 2009. Online cat., http://www.metmuseum.org/special/philippe_de_montebello_years/index.aspx.

Paris 2008–9. *Picasso et les maîtres.* Grand Palais, Paris, October 8, 2008–February 2, 2009, and Musée du Louvre, Paris, October 8, 2008–February 2, 2009. Catalogue by Anne Baldassari et al. Paris, 2008. Second venue: see London 2009.

Rome 2008–9. *Picasso Harlequin, 1917–1937.* Complesso del Vittoriano, Rome, October 11, 2008–February 8, 2009. Catalogue edited by Yve-Alain Bois; translated by Simon Turner. Milan, 2008.

London 2009. *Picasso: Challenging the Past.* The National Gallery, London, February 25–June 7, 2009. Catalogue edited by Christopher Riopelle and Anne Robbins; contributions by Elizabeth Cowling et al. London, 2009. First venue: see Paris 2008–9.

New York 2009. *Picasso: Mosqueteros.* Gagosian Gallery, New York, March 26–June 6, 2009. Catalogue by John Richardson et al. New York, 2009.

Philadelphia 2009. *Cézanne and Beyond.* Philadelphia Museum of Art, February 26–May 17, 2009. Catalogue edited by Joseph J. Rishel and Katherice Sachs. Philadelphia, 2009.

Williamstown 2009. *Dove, O'Keeffe: Circles of Influence.* Sterling and Francine Clark Art Institute, Williamstown, Mass., June 7–September 7, 2009. Catalogue by Debra Bricker Balken. Williamstown, Mass., 2009.

New Haven–Durham 2009–10. *Picasso and the Allure of Language.* Yale University Art Gallery, New Haven, January 27–May 24, 2009, and Nasher Museum of Art, Duke University, Durham, N.C., August 20, 2009–January 3, 2010. Catalogue by Susan Greenberg Fisher, with Mary Ann Caws et al. New Haven, 2009.

2010–2019

Liverpool 2010. "Picasso: Peace and Freedom." Tate Liverpool, May 21–August 30, 2010. Forthcoming.

Zürich 2010–11. "Picasso." Kunsthaus Zürich, October 15, 2010–January 30, 2011. Forthcoming.

PUBLICATIONS CITED

Acton 1970. Harold Acton. *More Memoirs of an Aesthete.* London, 1970.

Adam 1963. Antoine Adam. *The Art of Paul Verlaine.* Translated by Carl Morse. New York, 1963.

Alexandre 1905. Arsène Alexandre. *Jean Dominique Ingres: Master of Pure Draughtsmanship.* Edited by Walter Shaw Sparrow. London, 1905.

Alley 1967. Ronald Alley. *Picasso, The Three Dancers: The 48th Charlton Lecture.* Newcastle upon Tyne, 1967.

Alley 1986. Ronald Alley. *Picasso: The Three Dancers.* Tate Modern Masterpieces. London, 1986.

Andre 1997. Mila Andre. "Bien merci, Mme Schoenborn" (review of New York [MMA/Schoenborn] 1997). *Daily News,* February 14, 1997.

Andreotti 1994. Margherita Andreotti. "The Joseph Winterbotham Collection." *Art Institute of Chicago Museum Studies* 20, no. 2 (1994), pp. 111–81, 189–92.

Anon., October 5, 1902. Anonymous. "Fiestas de la Merced." *El Liberal* 2, no. 540 (October 5, 1902), p. 1.

Anon., October 3, 1911. Anonymous. "Le Premier 'Picassolâtre.'" *Le Figaro,* October 3, 1911, p. 1.

Anon., February 18, 1913. F. W. "Kunst: Moderne Galerie (München, Theatinerstrasse)" (review of Munich 1913). *Münchner Augsburger Abendzeitung,* no. 40 (February 18, 1913), p. 11.

Anon., March 27, 1913. Anonymous. "Kunst Wissenschaft und Leben: Bildende Kunst in Köln" (review of Cologne 1913). *Kölnische Zeitung,* March 27, 1913, p. 1.

Anon., January 13, 1917. Anonymous. "Les Deux Picassos." *Le Bonnet rouge,* January 13, 1917, p. 2. Reproduced in Quimper–Paris 1994, pp. 134, 140 n. 59.

Anon., November 22, 1921. Anonymous. "Revue des ventes: Séquestre Kahnweiler, 2me vente." *Gazette de l'Hôtel Drouot* 30, no. 123 (November 22, 1921).

Anon., April 22, 1922. Anonymous. "Pari-Mutuel Inventor: Death of Joseph Oller." *The Times* (London), April 22, 1922, p. 12.

Anon., May 10, 1923. Anonymous. "Chronique des ventes: Hôtel Drouot, Séquestre Kahnweiler." *Gazette de l'Hôtel Drouot* 32, no. 56 (May 10, 1923), p. 1.

Anon., May 17, 1923. Anonymous. "Chronique des ventes: Hotel Drouot, Séquestre Kahnweiler." *Gazette de l'Hôtel Drouot* 32, no. 59 (May 17, 1923), unpaginated.

Anon., January 25, 1930. Anonymous. "Modern Museum Exhibition of Painting in Paris" (review of New York [MoMA] 1930). *Art News* (New York) 28, no. 17 (January 25, 1930), pp. 3–4, 12.

Anon., July 12, 1930. Anonymous. "Modern Museum Holds Summer Exhibition" (review of New York [MoMA] 1930). *Art News* 28, no. 38 (July 12, 1930), pp. 3, 6.

Anon., June 3, 1931. Anonymous. "The Bathing Beauty as Pablo Picasso Sees Her" (review of London 1931). *The Sketch* (London) 154, no. 2001 (June 3, 1931), p. 381.

Anon., May 1938. Anonymous. "Pablo Picasso, *Woman in White.*" *Art Trade Journal* (London), May 1938, p. 109.

Anon., January 1939. Anonymous. "Picasso's 'Le Jardin de Paris' (Courtesy of the Perls Galleries)." *Arts and Decoration* 49, no. 4 (January 1939), p. 7.

Anon., February 4, 1939. M. D. "An Illuminating Survey of Picasso's Figure Pieces" (review of New York [Harriman] 1939). *Art News* 37, no. 19 (February 4, 1939), p. 13.

Anon., March 13, 1939. Anonymous. "Moderns' Debt to Antiquity Shown at Boston Exhibition" (review of Boston 1939). *Newsweek* 13, no. 11 (March 13, 1939), p. 37.

Anon., April 1, 1939. Anonymous. "Modern Art Confesses All" (review of Boston 1939). *Art Digest* 13, no. 13 (April 1, 1939), pp. 8–9, 29.

Anon., November 18, 1939. Anonymous. Review of Boston 1939. *Evening Transcript* (Boston), November 18, 1939.

Anon., February 1, 1941. Anonymous. "Pablo Picasso." *Virginia Museum Bulletin* (Richmond) 1, no. 5 (February 1, 1941), p. 1.

Anon., August 5, 1944. Anonymous. "Picasso en Mexico" (review of Mexico City 1944). *Nosotros* (Mexico City) 1, no. 16 (August 5, 1944), pp. 60–63.

Anon., March 26, 1945. Anonymous. "French Modern Art." *Senior Scholastic* (New York) 46, no. 8 (March 26, 1945), p. 8.

Anon., [August 1946]. Anonymous. "Gertrude Stein Estate Goes to Alice B. Toklas." *Herald Tribune,* [August 1946].

Anon., August 11, 1946. Anonymous. "Alice Toklas Heir of Gertrude Stein: A Portrait of Picasso Is Left to Metropolitan Museum, Manuscripts to Yale." *New York Times,* August 11, 1946, p. 46.

Anon., February 21, 1947. Anonymous. Review of Stockholm 1947. *Dagens Nyheter,* February 21, 1947, unpaginated.

Anon., February 28, 1947. Anonymous. Review of Stockholm 1947. *Svenska Dagbladet,* February 28, 1947, unpaginated.

Anon., August 22, 1947. Anonymous. "Stein Portrait on View Today." *New York Times,* August 22, 1947, p. 17.

Anon., August 24, 1947. Anonymous. "Stein in Valhalla." *New York Times,* August 24, 1947, p. X8.

Anon., September 22, 1947. Anonymous. "3 Museums to Exchange Art to 'Clarify Modern Trends.'" *New York Times,* September 22, 1947, pp. 1, 24.

Anon., January 22, 1948. Anonymous. "Museums Start Exchange of Art: Metropolitan's Gertrude Stein by Picasso to Be Shown in Modern Gallery" (review of New York 1948). *New York Times,* January 22, 1948, p. 25.

Anon., summer 1948. Anonymous. "Review of the Year 1947." *Metropolitan Museum of Art Bulletin* 7, no. 1 (summer 1948), pp. 10–28.

Anon., June 20, 1955. Anonymous. "People" (review of Paris 1955). *Time Magazine,* June 20, 1955, p. 36.

Anon., June 27, 1955. Anonymous. "Art" (review of Paris 1955). *Time Magazine,* June 27, 1955, p. 75.

Anon., May 27, 1957. Anonymous. "Picasso: Protean Genius of Modern Art." *Time,* May 27, 1957, pp. 80–81.

Anon., August 1970. Anonymous. "Conseils aux acheteurs: Le Cubisme a la grande cote." *Connaissance des arts* 222 (August 1970), p. 79.

Anon., October 1971. Anonymous. "Acquisitions by Museums of Works by Picasso: Supplement." *Burlington Magazine* 113, no. 823 (October 1971), pp. 625–[33].

Anon., May 19, 1972. Anonymous. "2 Shoot a Museum Guard and Flee with 4 Paintings in Worcester." *New York Times,* May 19, 1972, pp. 1 (ill.), 38.

Anon., July 1973. Anonymous. "Picasso Retrospective" (review of Norfolk 1973). *Chrysler Museum Bulletin* 2, no. 5 (July 1973), p. 2.

Anon., October 26, 1991. Anonymous. "Lives of the Artists: Strong Gazing" (review of Richardson 1991–2007, vol. 1). *The Economist,* October 26, 1991, p. 148.

Anon., March 1992a. Anonymous. "Pablo Picasso: Der Aufbruch eines Genies" (review of Barcelona–Bern 1992). *Pan: Zeitschrift für Kunst und Kultur,* March 1992, p. 36.

Anon., March 1992b. Anonymous. "Picasso, 1905–1906" (review of Barcelona–Bern 1992). *Punt Presencia,* March 1992.

Anon., July 23, 1993. Anonymous. "Nudes, Erotic and Chaste, at the Met" (review of New York 1993). *Northport NY Journal,* July 23, 1993.

Anon., May 21, 1996. Anonymous. "Treasures for Met." *Los Angeles Times,* May 21, 1996, p. F2.

Anon., September 3, 2001. Anonymous. "Erotic Picasso in Montreal." *Maverick Arts,* September 3, 2001. http://www.maverick-arts.com/cgi-bin/MAVERICK?action=article&issue=031.

Anon., October 27, 2005. Anonymous. "Deaths: Haupt, Enid A." *New York Times,* October 27, 2005, p. B13.

Antliff and Leighten 2001. Mark Antliff and Patricia Leighten. *Cubism and Culture.* London and New York, 2001.

Apollinaire 1905. Guillaume Apollinaire. "Les Jeunes: Picasso, peintre" (review of Paris [Serrurier] 1905). *La Plume,* no. 372 (May 15, 1905), pp. 480–82. Reprinted in *La Plume: Littéraire, artistique, philosophique* (Geneva, 1969), pp. 482–83. Full translation in Eberiel 1987, pp. 156–57.

Apollinaire 1913. Guillaume Apollinaire. "Première Exposition de sculpture futuriste du peintre et sculpteur futuriste Boccioni" (review of Boccioni exhibition at Galerie La Boétie in Paris). *L'Intransigeant,* June 21, 1913. Reprinted in Breunig 1960, pp. 409–10; Breunig 1988, pp. 320, 501 n. 48; and Caizergues and Décaudin 1991, p. 599.

Apollinaire 1913a. Guillaume Apollinaire. "Die moderne Malerei." *Der Sturm,* February 1913, p. 272.

Apollinaire 1913b. Guillaume Apollinaire. "Picasso et les papiers collés." *Montjoie!,* no. 3 (March 14, 1913), p. 6. Translation in Schiff 1976, pp. 50, 52.

Appignanesi 2004. Lisa Appignanesi. *The Cabaret.* Rev. ed. New Haven and London, 2004.

Aragon and Breton 1928. Louis Aragon and André Breton. "Le Cinquantenaire de l'hystérie, 1878–1928." *La Révolution surréaliste* 4, no. 11 (March 15, 1928), pp. 20–22.

Argan 1953. Giulio Carlo Argan. *Scultura di Picasso.* Venice, 1953.

Arnason 1968. H. Harvard Arnason. *History of Modern Art: Painting, Sculpture, Architecture.* New York, 1968.

Arnason 1977. H. Harvard Arnason. *History of Modern Art: Painting, Sculpture, Architecture.* 2nd ed. Englewood Cliffs, N.J., 1977.

Arnason 1986. H. Harvard Arnason. *History of Modern Art: Painting, Sculpture, Architecture.* 3rd ed. revised by Daniel Wheeler. New York, 1986.

Arnason 1998. H. Harvard Arnason. *History of Modern Art: Painting, Sculpture, Architecture.* 4th ed. revised by Marla F. Prather. New York, 1998.

Asher 1999. Michael Asher. *Painting and Sculpture from The Museum of Modern Art: Catalog of Deaccessions, 1929 through 1998.* New York, 1999.

Asplund 1923. Karl Asplund, with essay by Maurice Raynal. *Rolf de Marés tavelsamling: Några anteckningar.* Stockholm, 1923.

Assouline 1990. Pierre Assouline. *An Artful Life: A Biography of D. H. Kahnweiler, 1884–1979.* Translated by Charles Ruas. New York, 1990.

Baacke 1980. Rolf-Peter Baacke, with Jens Kwasny, eds. *Carl Einstein: Werke,* vol. 1, *1908–1918.* Berlin, 1980.

Bacou 1973. Roseline Bacou. "Dessins français du Metropolitan Museum de Art, New York, de David à Picasso." *Revue du Louvre* 23, no. 4–5 (1973), pp. 309–12.

Baer 1988. Brigitte Baer. "Seven Years of Printmaking: The Theatre and Its Limits." In *Late Picasso* (London 1988), pp. 95–135.

Baldassari 1996. Anne Baldassari. "'Heads, Faces and Bodies': Picasso's Uses of Portrait Photographs." In *Picasso and Portraiture: Representation and Transformation* (New York–Paris 1996–97), pp. 203–23.

Baldassari 2000. Anne Baldassari. *Picasso Working on Paper.* Translated by George Collins. London, 2000.

Baldassari 2003. Anne Baldassari. *Picasso: Papiers, journaux.* Paris, 2003.

Barbier 1988. Nicole Barbier. "Il cubismo nella scultura." In *Il cubismo nella scultura* (Lugano 1988), pp. 9–15.

Barkan and Bush 1995. Elazar Barkan and Ronald Bush, eds. *Prehistories of the Future: The Primitivist Project and the Culture of Modernism.* Stanford, 1995.

Barkham 1973. John Barkham. "The Literary Scene: Staying on Alone" (review of Burns 1973). *New York Post,* December 12, 1973.

Barnes Foundation 1993. *Great French Paintings from the Barnes Foundation: Impressionist, Post-impressionist, and Early Modern.* New York, 1993.

Barr 1933. Alfred H. Barr Jr. "Who's Crazy Now?" *Park Avenue Social Review* (New York), November 1933, pp. 11, 34.

Barr 1942. Alfred H. Barr Jr., ed. *Painting and Sculpture in The Museum of Modern Art.* New York, 1942.

Barr 1946. Alfred H. Barr Jr. *Picasso: Fifty Years of His Art.* New York, 1946. Reprinted New York, 1974.

Barr 1948. Alfred H. Barr Jr., ed. *Painting and Sculpture in the Museum of Modern Art.* [New ed.] New York, 1948.

Barr 1951. Alfred H. Barr Jr. *Matisse: His Art and His Public.* New York, 1951.

Barr 1955. Alfred H. Barr Jr. "Paintings from Private Collections" (about New York [MoMA] 1955). *Bulletin of the Museum of Modern Art* 22, no. 4 (summer 1955), pp. 3–36.

Barr 1958. Alfred H. Barr Jr. *Painting and Sculpture in The Museum of Modern Art: A Catalog.* New York, 1958.

Barr 1974. Alfred H. Barr Jr. *Picasso: Fifty Years of His Art.* [Reprint of Barr 1946.] New York, 1974.

Basler 1928. Adolphe Basler. *La Sculpture moderne en France.* Paris, 1928.

Bataille 1930. Georges Bataille, ed. "Hommage à Picasso." *Documents* 2, no. 3 (1930).

Batchelor 1993. David Batchelor. "'This Liberty and This Order': Art in France after the First World War." In *Realism, Rationalism, Surrealism: Art between the Wars,* by Briony Fer, David Batchelor, and Paul Wood, pp. 2–86. New Haven, 1993.

Baumann 1976. Felix Andreas Baumann. *Pablo Picasso: Leben und Werk.* Stuttgart, 1976.

Bean 1964. Jacob Bean. *100 European Drawings in the Metropolitan Museum of Art.* New York, 1964.

Bean and McKendry 1968. Jacob Bean and John J. McKendry. "A Rich Harvest." *Metropolitan Museum of Art Bulletin* 26, no. 7 (March 1968), pp. 300–305.

Bee and Elligott 2004. Harriet S. Bee and Michelle Elligott, eds. *Art in Our Time: A Chronicle of the Museum of Modern Art.* New York, 2004.

Bell 1922. Clive Bell. *Since Cézanne.* New York, 1922.

Bell 1924. Clive Bell. "Modern Art, and How to Look at It: A Critical Appreciation of 'The Dial' Portfolio, 'Living Art', with Certain Instructive Remarks" (review of Thayer 1923). *Vanity Fair,* April 1924, pp. 56, 88.

Belloli 1999. Lucy Belloli. "The Evolution of Picasso's Portrait of Gertrude Stein." *Burlington Magazine* 141 (January 1999), pp. 12–18.

Belloli 2005. Lucy Belloli. "Lost Paintings beneath Picasso's *La Coiffure*." *Metropolitan Museum Journal* 40 (2005), pp. 151–61.

Benet 1953. Rafael Benet, with Jorge Benet Aurell. *Simbolismo.* Barcelona, 1953.

Benjamin 2001. Roger Benjamin. "Ingres chez les Fauves." In *Fingering Ingres,* edited by Susan L. Siegfried and Adrian Rifkin, pp. 93–121. Malden, Mass., 2001.

Benoist 1926. Luc Benoist. "Les Ventes" (review of Paris 1926). *Beaux-Arts: Revue d'information artistique* (Paris) 4, no. 18 (November 1, 1926), p. 288.

Berger 1965. John Berger. *The Success and Failure of Picasso.* Harmondsworth and Baltimore, 1965.

Berggruen 1997. Heinz Berggruen. *J'étais mon meilleur client: Souvenirs d'un marchand d'art.* Translated from German by Laurent Muhleisen. Paris, 1997.

Berkow 1998. Ira Berkow. "Jewels in the Desert." *Artnews* 97, no. 5 (May 1998), pp. 144–49.

Bernadac and Du Bouchet 1986. Marie-Laure Bernadac and Paule du Bouchet. *Picasso, le sage et le fou*. Paris, 1986.

Bernadac, Richet, and Seckel 1985–87. Marie-Laure Besnard-Bernadac, Michèle Richet, and Hélène Seckel. *Musée Picasso: Catalogue sommaire des collections*. 2 vols. Paris, 1985–87.

Bernadac, Richet, and Seckel 1986. Marie-Laure Besnard-Bernadac, Michèle Richet, and Hélène Seckel. *The Picasso Museum, Paris: Paintings, Papiers collés, Picture Reliefs, Sculptures, and Ceramics*. New York, 1986.

Bernier 1991. Rosamond Bernier. *Matisse, Picasso, Miro as I Knew Them*. New York, 1991.

Billy 1945. André Billy. *Max Jacob*. Paris, 1945.

Blistène 1999. Bernard Blistène. *Une Histoire de l'art du XXe siècle*. Paris, 1999.

Blizzard 2004. Allison Blizzard. *Portraits of the 20th Century Self: An Interartistic Study of Gertrude Stein's Literary Portraits and Early Modernist Portraits by Paul Cézanne, Henri Matisse, and Pablo Picasso*. European Universities Studies, series XVI, Anglo-Saxon Language and Literature, vol. 406. Frankfurt am Main, 2004.

Bloch 1971. Georges Bloch. *Pablo Picasso: Catalogue de l'oeuvre gravé et lithographié, 1904–1967*. 2nd ed. 2 vols. Bern, 1971.

Bloch 1972. Georges Bloch. *Pablo Picasso*. Vol. 3, *Catalogue of the Printed Ceramics, 1949–1971*. Bern, 1972.

Blunt 1968. Anthony Blunt. "Picasso's Classical Period (1917–1925)." *Burlington Magazine* 110 (April 1968), pp. 187–94. Spanish translation in Combalía Dexeus 1981, pp. 146–50.

Blunt and Pool 1962. Anthony Blunt and Phoebe Pool. *Picasso, the Formative Years: A Study of His Sources*. London, 1962.

Boardingham 1997. Robert Boardingham. *The Young Picasso*. New York, 1997.

Boeck and Sabartés 1955. Wilhelm Boeck and Jaime Sabartés. *Picasso*. New York, 1955.

Bois 1988. Yve-Alain Bois. "Painting as Trauma." *Art in America* 76, no. 6 (June 1988), pp. 130–41, 172–73. Translation of French version in *Critique* 497 (October 1988), pp. 834–57.

Bois 1992. Yve-Alain Bois. "The Semiology of Cubism." In *Picasso and Braque: A Symposium* (Rubin and Zelevansky 1992), pp. 169–208, "discussion," pp. 209–20.

Bolger 1988. Doreen Bolger. "Hamilton Easter Field and His Contribution to American Modernism." *American Art Journal* 20, no. 2 (1988), pp. 79–107.

Bonduelle-Reliquet 1997. Scarlett Bonduelle-Reliquet. "Henri-Pierre Roché, collectionneur (1879–1959)." Doctoral diss., A.N.R.T., Université de Lille III, 1997.

Bonfante and Ravenna 1945. Egidio Bonfante and Juti Ravenna. *Arte cubista, con le "Méditations esthétiques sur la peinture" di Guillaume Apollinaire*. Venice, 1945.

Boone 1989. Danièle Boone. *Picasso*. Paris, 1989. English ed.: Translated by John Greaves. London, 1989.

Boone 1993. Danièle Boone. *Picasso*. Translated by John Greaves. Rev. ed. London, 1993.

Borel 1968. Jacques Borel, ed. *Verlaine: Oeuvres poétiques complètes*. Text établi et annoté par Y.-G. Le Dantec. Paris, 1968.

Boudaille 1969. Georges Boudaille. *Picasso: Première époque, 1881–1906: Périodes bleue et rose*. Paris, 1969.

Boudaille 1987. Georges Boudaille, with Marie-Laure Bernadac and Marie-Pierre Gauthier. *Picasso*. Secaucus, N.J., 1987.

Bouillon 1973. Jean-Paul Bouillon. "Le Cubisme et l'avant-garde russe." In "Actes du premier Colloque d'Histoire de l'Art Contemporain tenu au Musée d'Art et d'Industrie, Saint-Étienne, les 19, 20, 21 novembre 1971," *Le Cubisme*, C.I.E.R.E.C. [Centre Interdisciplinaire d'Études et de Recherche sur l'Expression Contemporaine], Travaux IV, Université de Saint-Étienne, pp. 153–223. Saint-Étienne, 1973.

Bouret 1950. Jean Bouret. *Picasso: Dessins*. Paris, 1950.

Bouyer 1905. Raymond Bouyer. "Salon d'Automne." *Bulletin de l'art ancien et moderne*, no. 275 (October 28, 1905), pp. 269–71.

Bowers 1994. Jane P. Bowers. "Experimentation in Time and Process of Discovery: Picasso Paints Gertrude Stein—Gertrude Stein Makes Sentences." In "Literature and the Visual Arts from the Pre-Raphaelites to Warhol," *Harvard Library Bulletin* 5, no. 2 (summer 1994), pp. 5–30.

Bowness 1973. Alan Bowness. "Picasso's Sculpture." In Penrose and Golding 1973, pp. 122–55.

Brassaï 1966. Brassaï. *Picasso and Company*. Translated by Francis Price; introduction by Roland Penrose. Garden City, N.Y., 1966.

Brassaï 1971. Brassaï. "The Master at 90: Picasso's Great Age Seems Only to Stir up the Demons Within." *The New York Times Magazine*, October 24, 1971, pp. 30–31, 96–102.

Brassaï 1999. Brassaï. *Conversation with Picasso*. Translated by Jane-Marie Todd. Chicago and London, 1999.

Breeskin 1952. Adelyn D. Breeskin. "Early Picasso Drawings in the Cone Collection." *Magazine of Art* 45, no. 3 (March 1952), pp. 104–9.

Brenner 1939. Anita Brenner. "Picasso versus Picasso." *New York Times*, magazine section, November 12, 1939, p. 13.

Brenson 1982. Michael Brenson. "Met Museum Given Major Private Collection." *New York Times*, August 25, 1982, pp. A1, C18.

Brenson 1996. Michael Brenson. "Insight and Form." In *A Century of Sculpture: The Nasher Collection* (San Francisco–New York 1996–97), pp. 39–57.

Breunig 1960. LeRoy C. Breunig, ed. *Chroniques d'art, 1902–1918*. Paris, 1960.

Breunig 1988. LeRoy C. Breunig, ed. *Apollinaire on Art: Essays and Reviews, 1902–1918*. Translated by Susan Suleiman. New York, 1988.

Brock 2000. Charles Brock. "Pablo Picasso, 1911: An Intellectual Cocktail." In *Modern Art and America: Alfred Stieglitz and His New York Galleries* (Washington 2000), pp. 117–26.

Broude 1972. Norma F. Broude. "Picasso's Drawing, *Woman with a Fan*: The Role of Degas in Picasso's Transition to His 'First Classical Period.'" *Allen Memorial Art Museum Bulletin* 29, no. 2 (winter 1972), pp. 78–89.

F. Brown 1968. Frederick Brown. *An Impersonation of Angels: A Biography of Jean Cocteau*. New York, 1968.

M. Brown 1963. Milton W. Brown. *The Story of the Armory Show*. Greenwich, Conn., 1963.

M. Brown 1988. Milton W. Brown. *The Story of the Armory Show*. 2nd ed. New York, 1988.

Brusendorff and Henningsen 1969. Ove Brusendorff and Poul Henningsen. *Love's Picture Book: The History of Pleasure and Moral Indignation*. Vol. 2, *From the French Revolution to the Present Time*. Translated by Elsa Gress. New York, 1969.

Buchheim 1959. Lothar-Günther Buchheim. *Picasso: A Pictorial Biography*. Translated by Michael Heron. New York, 1959.

Bulliet 1937. C. J. Bulliet. Review of Chicago 1937. *Chicago Daily News*, January 9, 1937, sect. 3, p. 2.

Burns 1970. Edward Burns, ed. *Gertrude Stein on Picasso*. New York, 1970.

Burns 1973. Edward Burns, ed. *Staying on Alone: Letters of Alice B. Toklas*. New York, 1973.

Burns 1985. Edward Burns, ed. *Gertrude Stein, Picasso: The Complete Writings*. Reprint of Burns 1970. Boston, 1985.

Burns 1986. Edward Burns, ed. *The Letters of Gertrude Stein and Carl Van Vechten, 1913–1946*. 2 vols. New York, 1986.

Cabanne 1975a. Pierre Cabanne. *Le Siècle de Picasso, I: La Jeunesse, le cubisme, le théâtre, l'amour, 1881–1937*. Paris, 1975.

Cabanne 1975b. Pierre Cabanne. *Le Siècle de Picasso, I: La Naissance du cubisme, 1881–1912*. Paris, 1975.

Cabanne 1977. Pierre Cabanne. *Pablo Picasso: His Life and Times*. Translated by Harold J. Salemson. New York, 1977.

Cabanne 1981. Pierre Cabanne. *Picasso: Pour le centenaire de sa naissance*. Neuchâtel, 1981.

Cabanne 1992. Pierre Cabanne. *Le Siècle de Picasso*. New ed. 4 vols. Paris, 1992.

Cahn 2007. Isabelle Cahn. *Ambroise Vollard: Un Marchand d'art et ses trésors*. Paris, 2007.

Caizergues and Décaudin 1991. Pierre Caizergues and Michel Décaudin, eds. *Apollinaire: Oeuvres en prose complètes II*. Paris, 1991.

Caizergues and Seckel 1992. Pierre Caizergues and Hélène Seckel. *Picasso/Apollinaire Correspondance*. Paris, 1992.

Calado 1994. Jorge Calado. "As Lágrimas de Picasso" (review of Los Angeles–New York–Chicago 1994–95). *Expresso* (Portugal), August 1994, p. 64.

Camón Aznar 1956. José Camón Aznar. *Picasso y el cubismo*. Madrid, 1956.

Canaday 1972. John Canaday. "Very Quiet and Very Dangerous." *New York Times*, February 27, 1972, p. D21.

Carco 1919. Francis Carco. "Préface." In Francis Carco et al., *Les Veillées du "Lapin Agile,"* pp. v–xix. Paris, 1919.

Carco 1928. Francis Carco. *The Last Bohemia: From Montmartre to the Quartier Latin*. Translated by Madeleine Boyd. New York, 1928.

Cardwell 1994. Richard A. Cardwell. "Picasso's Harlequin: Icon of the Art of Lying." In *Leeds Papers on Symbol and Image in Iberian Arts*, edited by Margaret A. Rees, pp. 249–81. Leeds, 1994.

Carey 1915. Elizabeth Luther Carey. "Art at Home and Abroad: News and Comment" (review of New York 1914–15). *New York Times*, January 24, 1915, p. SM11. Reprinted in *Camera Work*, no. 48 (October 1916), p. 18.

Carey 1924. Elizabeth Luther Carey. "The World of Art: Modern Art of One Kind or Another" (review of Thayer 1923). *New York Times Magazine*, January 27, 1924, p. SM10.

Carey 1926. Elizabeth Luther Carey. "Art of the Moderns in a Notable Show" (review of Brooklyn 1926). *New York Times*, July 4, 1926, p. SM24. Reprinted in *Brooklyn Museum Quarterly* 13, no. 4 (October 1926), p. 136.

Carlson 1976. Victor I. Carlson. *Picasso: Drawings and Watercolors, 1899–1907, in the Collection of the Baltimore Museum of Art*. Baltimore, 1976.

Cassou 1940. Jean Cassou. *Picasso*. English translation by Mary Chamot. London, Paris, and New York, 1940.

Cassou 1949. Jean Cassou. *Picasso*. Paris, 1949.

Cassou 1975. Jean Cassou, ed. *Pablo Picasso*. Paris, 1975.

Cassou and Sabartés 1950. Jean Cassou and Jaime Sabartés. *Two French Masters of Contemporary Art: Matisse—Picasso*. Paris, [1950].

Caws 2000. Mary Ann Caws. *Picasso's Weeping Woman: The Life and Art of Dora Maar*. Boston, 2000.

Champris 1960. Pierre de Champris. *Picasso: Ombre et soleil*. Paris, 1960.

Chapin 2005. Mary Weaver Chapin. "The Chat Noir & The Cabarets." In *Toulouse-Lautrec and Montmartre* (Washington–Chicago 2005), pp. 89–107.

Cheney 1924. Sheldon Cheney. *A Primer of Modern Art*. New York, 1924.

Cheney 1941. Sheldon Cheney. *The Story of Modern Art*. New York, 1941.

Chevalier 1978. Denys Chevalier. *Picasso: The Blue and Rose Periods*. Translation by Stéphanie Winston. New York, 1978. First published New York, 1969.

Chevalier 1991. Denys Chevalier. *Picasso: The Blue and Rose Periods*. Translation by Stéphanie Winston. New York, 1991. First published New York, 1969.

Chipp and Wofsy 1995–2009. Herschel Chipp and Alan Wofsy, eds. *The Picasso Project: Picasso's Paintings, Watercolours, Drawings and Sculpture, A Comprehensive Illustrated Catalogue 1885–1973*. Catalogue by Mariel Jardines. 21 vols. San Francisco, 1995–2009.

Christ 1980. Ronald Christ. "Picasso's Hands: The Mutability of Human Form." *ArtsCanada*, no. 236–37 (September–October 1980), pp. 19–30.

Christie's sale 1988. "*Femme à la mandoline* by Pablo Picasso, Property of Hester Diamond," supplement. Sale, Christie's, New York, November 15, 1988.

Christie's sale 1990. *Picasso Editions*. Sale, Christie's, London, October 18, 1990.

Christie's sale 2004. *Impressionist and Modern Art*. Sale, Christie's, New York, November 3, 2004.

Christie's sale 2009. *Picasso Editions*. Sale, Christie's, London, October 29, 2009.

Cirici-Pellicer 1946. Alexandre Cirici-Pellicer. *Picasso antes de Picasso*. Barcelona, 1946.

Cirlot 1972. Juan-Eduardo Cirlot. *Picasso, Birth of a Genius*. New York and Washington, D.C., 1972.

Coates 1957. Robert M. Coates. "The Art Galleries: Picasso" (review of New York–Chicago 1957). *The New Yorker*, June 8, 1957, pp. 124–29.

Cocteau 1926. Jean Cocteau. *Le Rappel à l'ordre*. Paris, 1926.

Cocteau and Fraigneau 1988. Jean Cocteau and André Fraigneau. *Entretiens*. Monaco, 1988.

Cogniat 1959. Raymond Cogniat. *Picasso: Figures*. Lausanne, 1959.

Cohen 1983. Janie L. Cohen. "Picasso's Exploration of Rembrandt's Art, 1967–1972." *Arts Magazine* 58, no. 2 (October 1983), pp. 119–26.

Coignard 1991. Jérôme Coignard. "Le Salon de peinture de Mr. and Mrs. Annenberg." *Beaux Arts*, no. 92 (July–August 1991), pp. 62–73.

Combalía Dexeus 1981. Victoria Combalía Dexeus, ed. *Estudios sobre Picasso*. Barcelona and Madrid, 1981.

D. Cooper 1958. Douglas Cooper. *Picasso: Carnet catalan*. Facsimile of 1906 notebook with preface and notes by Douglas Cooper. Paris, 1958.

D. Cooper 1963. Douglas Cooper. *Great Private Collections*. New York, 1963.

D. Cooper 1968. Douglas Cooper. *Picasso Theatre*. New York, 1968.

D. Cooper 1976. Douglas Cooper. *Alex Reid & Lefevre: 1926–1976*. London, 1976.

H. Cooper 2002. Harry Cooper. "Matisse Picasso, Tate Modern, London" (review of London–Paris–New York 2002–3). *Artforum* 41, no. 2 (October 2002), pp. 146–48.

Cope 1993. Karin Marie Cope. "Gertrude Stein, Pablo Picasso, and the Love of Error." Ph.D. diss., Johns Hopkins, Baltimore, 1993.

Cordova 1998. Ruben Charles Cordova. "Primitivism and Picasso's Early Cubism." Ph.D. diss., University of California, Berkeley, 1998.

Cork 1994. Richard Cork. "Genius in a New Dimension" (review of London 1994). (*London*) *Times*, February 15, 1994.

J. Corredor-Matheos 1981. J. Corredor-Matheos. "La escultura de Picasso." Reprinted in *Picasso, 1881–1973: Exposición antológica* (Madrid–Barcelona 1981–82), p. 385. Originally published in *Bellas artes*, año 5, no. 30 (February 1974), pp. 10–15.

Cortenova 2005. Giorgio Cortenova. *Pablo Picasso, su vida, su obra*. Barcelona, 2005.

Costello 2008. Kevin Costello. "Exhibit Offers Glimpse of a Picasso's Passions and His Vast Creativity" (review of Naples [Fla.] 2008). *Herald Tribune*, March 23, 2008, p. E1.

Cott 1948. Perry B. Cott, ed. *Art through Fifty Centuries from the Collections of the Worcester Art Museum*. Worcester, Mass., 1948.

Cousins 1989. Judith Cousins, with the collaboration of Pierre Daix. "Documentary Chronology." In *Picasso and Braque: Pioneering Cubism* (New York 1989–90), pp. 335–445.

Cowling 1985. Elizabeth Cowling. "Proudly We Claim Him as One of Us: Breton, Picasso, and the Surrealist Movement." *Art History* 8, no. 1 (March 1985), pp. 82–104.

Cowling 2002. Elizabeth Cowling. *Picasso: Style and Meaning*. London, 2002.

Cowling 2006. Elizabeth Cowling. *Visiting Picasso: The Notebooks and Letters of Roland Penrose*. London, 2006.

Cox 1991. Neil Cox. "La Morale des lignes: Picasso, 1907–1910; Modernist Reception; the Subversion of Content; and the Lesson of Caricature." 2 vols. Ph.D. diss., University of Essex, 1991.

Crase 2004. Douglas Crase. *Both: A Portrait in Two Parts*. New York, 2004.

Crastre 1950. Victor Crastre. *Naissance du cubisme: Céret 1910*. Geneva, 1950.

Crastre 2006. Victor Crastre. *Manolo*. Céret, 2006.

Craven 1924. Thomas Craven. "Living Art" (review of Thayer 1923). *The Dial* 76, no. 2 (February 1924), pp. 180–83.

Crespelle 1969. Jean-Paul Crespelle. *Picasso and His Women.* New York, 1969. Translation by Robert Baldick of *Picasso: Les Femmes, les amis, l'oeuvre* (1967).

Crespelle 1978. Jean-Paul Crespelle. *La Vie quotidienne à Montmartre au temps de Picasso, 1900–1910.* Paris, 1978.

Crespo de la Serna 1944. Jorge I. Crespo de la Serna. "Picasso y la eternidad" (review of Mexico City 1944). *Arte y plata* (Mexico), July 1944, p. 25.

Crommelynck 1995. Aldo Crommelynck. "Recollections on Printmaking with Picasso." In *Picasso: Inside the Image: Prints from the Ludwig Museum-Cologne,* pp. 12–17. Burlington, 1995.

Czwiklitzer 1981. Christophe Czwiklitzer. *Pablo Picasso, Plakate, 1923–1973: Werkverzeichnis.* Munich, 1981.

Daix 1975. Pierre Daix. "Picasso et l'invention de la sculpture moderne." In Cassou 1975, pp. 123–44.

Daix 1977. Pierre Daix. *La Vie de peintre de Pablo Picasso.* Paris, 1977.

Daix 1982a. Pierre Daix. "Braque and Picasso at the Time of the *Papiers collés.*" In *Georges Braque: The Papiers collés* (Paris–Washington 1982–83), pp. 23–43. Also in French ed., *Georges Braque: Les Papiers collés.*

Daix 1982b. Pierre Daix. *Cubists and Cubism.* New York, 1982.

Daix 1982c. Pierre Daix. "Éluard et Picasso." In *Paul Éluard et ses amis peintres, 1895–1952* (Paris 1982–83), pp. 25–35.

Daix 1983. Pierre Daix. "On a Hidden Portrait of Marie-Thérèse." *Art in America* 71, no. 8 (September 1983), pp. 124–29.

Daix 1987a. Pierre Daix. *Picasso créateur: La Vie intime et l'oeuvre.* Paris, 1987.

Daix 1987b. Pierre Daix. "Picasso's Time of Decisive Encounters," translated by Tom Repensek. *Art News* 86, no. 4 (April 1987), pp. 136–41.

Daix 1988. Pierre Daix. "'Die Rückkehr' Picassos zum Portrait (1912–1923)." In *Picassos Klassizismus: Werke von 1914–1934* (Bielefeld 1988), pp. 137–43.

Daix 1992a. Pierre Daix. "L'Entrée de Picasso dans l'avant-garde (1905–1906)." *Connaissance des Arts,* no. 481 (March 1992), pp. 54–64.

Daix 1992b. Pierre Daix. "The Years of Great Transformation." In *Picasso, 1905–1906: De l'epoca rosa als ocres de Gósol* (Barcelona–Bern 1992), pp. 29–50.

Daix 1993. Pierre Daix. *Picasso: Life and Art.* Translated by Olivia Emmet. New York, 1993.

Daix 1995. Pierre Daix. *Dictionnaire Picasso.* Paris, 1995.

Daix 1996. Pierre Daix. "Portraiture in Picasso's Primitivism and Cubism." In *Picasso and Portraiture: Representation and Transformation* (New York–Paris 1996–97), pp. 255–95.

Daix 2000. Pierre Daix. "Picasso sculpte." *Connaissance des arts,* no. 573 (June 2000), pp. 110–17.

Daix 2002. Pierre Daix. "Matisse–Picasso: Rivalité ou communion?" *Connaissance des arts,* no. 598 (October 2002), pp. 36–49.

Daix 2007. Pierre Daix. *Pablo Picasso.* Paris, 2007.

Daix and Boudaille 1967. Pierre Daix and Georges Boudaille, with Joan Rosselet. *Picasso: The Blue and Rose Periods: A Catalogue Raisonné of the Paintings, 1900–1906.* Translated by Phoebe Pool. [Rev. ed.] Greenwich, Conn., 1967.

Daix and Boudaille 1988. Pierre Daix and Georges Boudaille, with Joan Rosselet. *Picasso, 1900–1906: Catalogue raisonné de l'oeuvre peint.* New ed. Neuchâtel, 1988.

Daix and Rosselet 1979. Pierre Daix and Joan Rosselet. *Le Cubisme de Picasso: Catalogue raisonné de l'oeuvre peint, 1907–1916.* Neuchâtel, 1979. English ed.: *Picasso: The Cubist Years, 1907–1916: A Catalogue Raisonné of the Paintings and Related Works.* Translated by Dorothy S. Blair. Boston, 1979.

Dale 1930. Maud Dale. *Modern Art: Picasso.* New York, 1930.

Daulte 1966. François Daulte. *Picasso.* Geneva, 1966.

Daulte 1971. François Daulte. *Auguste Renoir: Catalogue raisonné de l'oeuvre peint.* Lausanne, 1971.

Daval 1973. Jean-Luc Daval. *Journal de l'art moderne, 1884–1914: Texte, notices explicatives, déroulement synoptique à travers le témoignage des contemporains.* Geneva, 1973.

Desnos 1923. Robert Desnos. "La Dernière Vente Kahnweiler." *Paris-Journal,* May 1923. Reprinted in Paris (Kahnweiler) 1984–85, p. 138.

Devree 1939a. Howard Devree. "Ten Ring Circus: Picasso Exhibit Shows Diversity and Shallowness of Modern Art" (review of New York and other cities 1939–41). *Boston Evening Transcript,* November 18, 1939, p. 7.

Devree 1939b. Howard Devree. "Work by Dutch and French Masters" (review of New York [Harriman] 1939). *New York Times,* February 5, 1939, sect. 9, p. X9.

Dobrzynski 1998. Judith H. Dobrzynski. "20th-Century Art Treasures Left to Met." *New York Times,* May 6, 1998, pp. A1, B6.

Donker 1982. Peter P. Donker. "Museum Losing Dial Art: Collection Going to New York." *Worcester Telegram,* August 11, 1982, p. 1.

Dorival 1943–46. Bernard Dorival. *Les Étapes de la peinture française contemporaine.* 3 vols. Paris, 1943–46.

Doucet 1905. Jérôme Doucet. *Les Peintres français: Fantin-Latour, Corot, les trois Vernet, Ingres, J.-P. Laurens, Bouguereau, Puvis de Chavannes, Jules Breton, Meissonier, Fromentin, Yvon, Millet.* Paris, 1905.

Drath 1996. Viola Herms Drath. "Nobles Geschenk." *Handelsblatt* (Düsseldorf and Frankfurt), May 24, 1996, p. g04.

Drutt 2001. Matthew Drutt, ed. *The Thannhauser Collection of the Guggenheim Museum.* New York, 2001.

Dubnick 1984. Randa K. Dubnick. *The Structure of Obscurity: Gertrude Stein, Language, and Cubism.* Urbana and Chicago, 1984.

Dupuis-Labbé 2001. Dominique Dupuis-Labbé. "Sous le signe d'Éros" (review of Paris–Montreal–Barcelona 2001–2). In "Picasso érotique," *Connaissance des arts,* 160 (February 2001), pp. 32–41.

Dupuis-Labbé and Enshaian 2005. Dominique Dupuis-Labbé and Marie-Christine Enshaian. "Les 39 dessins du 'Mystère Picasso' Genèse d'une création, évolution d'un projet de conservation-restauration." *Techné,* no. 22 (2005), pp. 88–95.

Duret 1894. Théodore Duret. "Degas." *The Art Journal* (London), n.s., July 1894, pp. 204–8.

Durrant 2007. Nancy Durrant. "Under the Fig Leaf" (review of London 2007–8). *(London) Times,* September 29, 2007.

Dydo 2003. Ulla E. Dydo, with William Rice. *Gertrude Stein: The Language That Rises, 1923–1934.* Evanston, Ill., 2003.

Eberiel 1987. Rosemary Eberiel. "Clowns: Apollinaire's Writings on Picasso." *RES,* no. 14 (autumn 1987), pp. 143–59.

Eddy 1914. Arthur Jerome Eddy. *Cubists and Post-Impressionism.* Chicago, 1914.

Edgerton 1980. Anne Carnegie Edgerton. "Picasso's 'Nude Woman' of 1910." *Burlington Magazine* 122, no. 928 (July 1980), pp. 498–503.

Edgü 1996. Ferit Edgü. "EL." *P: sanat, kültür, antika* (Istanbul), Sayi 2 (Yaz 1996), p. 33.

Einstein 1913. Carl Einstein. "Herbstaustellung am Kurfürsterdamm" (review of Berlin 1913, including mention of the Picasso gallery). *Die Aktion* 3 (1913), pp. 1186–89. Reprinted in Baacke 1980, pp. 184–87.

Einstein 1926. Carl Einstein. *Die Kunst des 20. Jahrhunderts.* Propyläen-Kunstgeschichte, vol. 16. Berlin, 1926.

Einstein 1928. Carl Einstein. *Die Kunst des 20. Jahrhunderts.* 2nd ed. Propyläen-Kunstgeschichte, vol. 16. Berlin, 1928.

Einstein 1931. Carl Einstein. *Die Kunst des 20. Jahrhunderts.* 3rd ed. Propyläen-Kunstgeschichte, vol. 16. Berlin, 1931.

Einstein 1934. Carl Einstein. *Georges Braque.* Paris, 1934.

Einstein 1996. Carl Einstein. *Die Kunst des 20. Jahrhunderts.* Reprint of 3rd ed., edited by Uwe Fleckner and Thomas W. Gaehtgens. Berlin, 1996.

Elderfield 1978. John Elderfield, with William S. Lieberman and Riva Castleman. *Matisse in the Collection of the Museum of Modern Art, including Remainder-Interest and Promised Gifts.* New York, 1978.

Elderfield 2004. John Elderfield, ed. *Modern Painting and Sculpture, 1880 to the Present at The Museum of Modern Art.* New York, 2004.

Elderfield 2009. John Elderfield. "Picasso's Extreme Cézanne." In *Cézanne and Beyond* (Philadelphia 2009), pp. 207–25, 550–52.

Elgar 1956. Frank Elgar. *Picasso: Blue, Pink Periods.* New York, 1956.

Elgar and Maillard 1955. Frank Elgar and Robert Maillard. *Picasso: Étude de l'oeuvre.* Paris, 1955.

Elgar and Maillard 1956. Frank Elgar and Robert Maillard. *Picasso: A Study of His Work.* English translation by Francis Scarfe. New York, 1956.

Elgar and Maillard 1972. Frank Elgar and Robert Maillard. *Picasso: Study of His Work.* Rev. and enl. ed. English translation by Francis Scarfe. New York, 1972.

Elsen 1969. Albert E. Elsen. "The Many Faces of Picasso's Sculpture." *Art International* 13, no. 6 (summer 1969), pp. 24–34.

Elsen 1974. Albert E. Elsen. *Origins of Modern Sculpture: Pioneers and Premises.* New York, 1974.

Éluard 1927. Paul Éluard. "Poèmes: Défense de savoir." *La Révolution surréaliste* 3, nos. 9–10 (October 1, 1927), pp. 18–20. Reprinted in *La Révolution surréaliste.* New York, 1968.

Éluard 1932. Paul Éluard. "Pablo Picasso." *Cahiers d'art* 7 (1932), p. 154.

Éluard 1935. Paul Éluard. "Je parle de ce qui est bien." *Cahiers d'art* 10 (1935), pp. 165–68.

Éluard 1945. Paul Éluard. *À Pablo Picasso.* Geneva and Paris, 1945.

Éluard 1947. Paul Éluard. *Pablo Picasso.* Translated by Joseph T. Shipley. New York, 1947.

Engelhard sale 1996. *Property from the Collection of Mr. and Mrs. Charles W. Engelhard.* Sale, Christie, Manson & Woods International, New York, November 13, 1996.

Estrada 1936. Genaro Estrada. *Genio y figura de Picasso.* Mexico, 1936.

Fagus 1901. Félicien Fagus [Georges-Eugène Faillet]. "Gazette de l'art. L'Invasion espagnole: Picasso." *La Revue blanche* 25, no. 195 (July 15, 1901), pp. 464–65.

Falgàs 2006–7. Jordi Falgàs. "Picasso in Gósol: Savoring the Secrets of the Mysterious Land." In *Barcelona and Modernity: Picasso, Gaudí, Miró, Dalí* (Cleveland–New York 2006–7), pp. 236–48.

Farr 1983. Dennis Farr. "Quintessential Cubism: A New Look" (review of London 1983). *Apollo* 117, no. 256 (June 1983), pp. 508–9.

B. Farrell 1968. Barry Farrell. "His Women." In "Special Double Issue: Picasso," *Life Magazine* 65, no. 26 (December 27, 1968), pp. 64–68, 70–76, 78–82.

K. Farrell 1992. Kate Farrell. *Art and Nature: An Illustrated Anthology of Nature Poetry.* New York, 1992.

Feliciano 1997. Hector Feliciano. *The Lost Museum: The Nazi Conspiracy to Steal the World's Greatest Works of Art.* New York, 1997.

Feller 1986. Robert L. Feller, ed. *Artist's Pigments: A Handbook of Their History and Characteristics.* Vol. 1. Cambridge, 1986.

Fels 1950. Florent Fels. *L'Art vivant: De 1900 à nos jours.* Geneva, 1950.

Fermigier 1969. André Fermigier. *Picasso.* Paris, 1969.

Fischl 1980. Eric Fischl. "Picasso: A Symposium." *Art in America* 68, no. 10, special issue (December 1980), p. 17.

FitzGerald 1995. Michael C. FitzGerald. *Making Modernism: Picasso and the Creation of the Market for Twentieth-Century Art.* New York, 1995.

FitzGerald 1996. Michael C. FitzGerald. "The Modernists' Dilemma: Neoclassicism and the Portrayal of Olga Khokhlova." In *Picasso and Portraiture: Representation and Transformation* (New York–Paris 1996–97), pp. 297–335.

FitzGerald 1998. Michael C. FitzGerald. "Reports from the Home Fronts: Some Skirmishes over Picasso's Reputation." In *Picasso and the War Years, 1937–1945* (San Francisco–New York 1998–99), pp. 113–21.

Flam 1986. Jack Flam. *Matisse: The Man and His Art, 1869–1918.* Ithaca and London, 1986.

Flam 2003. Jack Flam. *Matisse and Picasso: The Story of Their Rivalry and Friendship.* Cambridge, Mass., 2003.

Flechtheim 1972. Alfred Flechtheim. "Tagebuchblätter 1913." *Neue deutsche Hefte* 135/19, no. 3 (1972), pp. 44–60.

Fletcher 2003. Valerie J. Fletcher. "Process and Technique in Picasso's *Head of a Woman (Fernande)*." In *Picasso: The Cubist Portraits of Fernande Olivier* (Washington–Dallas 2003–4), pp. 165–91.

Flint 1930. Ralph Flint. "The Current American Art Season" (includes review of New York [MoMA] 1930). *Art and Understanding* (Phillips Memorial Gallery, Washington D.C.) 1, no. 2 (March 1930), pp. 177–224.

Forbes 1935–36. Edward W. Forbes. "Report of the Fogg Art Museum, 1935–36." *Annual Report (Fogg Art Museum)*, no. 1935–36 (1935–36), pp. 1–26.

H. Foster et al. 2004. Hal Foster, Rosalind Krauss, Yve-Alain Bois, and Benjamin H. D. Buchloh. *Art since 1900: Modernism, Antimodernism, Postmodernism.* London, 2004.

S. Foster 1979. Stephen C. Foster. "Picasso's Sculpture of 1907–1908: Some Remarks on Its Relation to Earlier and Later Work." *Art Journal* 38, no. 4 (summer 1979), pp. 267–72.

Fougstedt 1916. Arvid Fougstedt. "Une Visite chez Pablo Picasso." *Svenska Dagbladet*, January 9, 1916, p. 10. Reproduced in *Picasso—Ingres* (Paris–Montauban 2004), p. 168.

Franck 2001. Dan Franck. *The Bohemians: The Birth of Modern Art, Paris, 1900–1930.* Translated by Cynthia Hope Liebow. London, 2001. First published Paris, 1998.

Frank et al. 1934. Waldo Frank, Lewis Mumford, Dorothy Norman, Paul Rosenfeld, and Harold Rugg, eds. *America and Alfred Stieglitz: A Collective Portrait.* Garden City, N.Y., 1934.

Frank et al. 1979. Waldo Frank, Lewis Mumford, Dorothy Norman, Paul Rosenfeld, and Harold Rugg, eds. *America and Alfred Stieglitz: A Collective Portrait.* Rev. ed. Millerton, N.Y., 1979.

Frankfurter 1939a. Alfred M. Frankfurter. "Picasso in Retrospect: 1939–1900: The Comprehensive Exhibition in New York and Chicago" (review of New York and other cities 1939–41). *Art News* 38, no. 7 (November 18, 1939), pp. 11–21, 26–30.

Frankfurter 1939b. Alfred M. Frankfurter. "The Sources of Modern Painting: A Concrete Exposition by the Boston Institute of Modern Art" (review of Boston 1939). *Art News* 37, no. 24 (March 11, 1939), pp. 9–13.

Frankfurter 1941. Alfred M. Frankfurter. "341 Documents of Modern Art: The Chrysler Collection" (review of Richmond–Philadelphia 1941). *Art News* 39, no. 16 (January 18, 1941), pp. 9–19.

Frère 1956. Henri Frère. *Conversations de Maillol.* Geneva, 1956.

E. Fry 1988. Edward F. Fry. "Picasso, Cubism, and Reflexivity." *Art Journal* 47, no. 4 (winter 1988), pp. 296–310.

R. Fry 1917. Roger Fry. "The New Movement in Art in Its Relation to Life: A Lecture Given at the Fabian Society Summer School." *Burlington Magazine* 31, no. 175 (October 1917), pp. 162–68.

R. Fry 1926. Roger Fry. *Transformations: Critical and Speculative Essays on Art.* New York, 1926.

Gaffé 1947–48. René Gaffé. "Sculpteur, Picasso?" *Artes* (Antwerp) 2, nos. 3–4 (1947–48), pp. 36–37.

Gaffé 1963. René Gaffé. *À la verticale: Réflexions d'un collectionneur.* Brussels, 1963.

Gallup 1953. Donald Gallup, ed. *The Flowers of Friendship: Letters Written to Gertrude Stein.* New York, 1953.

Gallwitz 1985. Klaus Gallwitz. *Picasso, the Heroic Years.* New York, 1985.

Garcia 1992. Josep Miquel Garcia. "Picasso a Gosol estiu del 1906" (review of Barcelona–Bern 1992). *Segre: Diario independiente*, March 1, 1992.

Gardner 1936. Helen Gardner. *Art through the Ages.* New York, 1936.

Gardner 1948. Helen Gardner. *Art through the Ages.* 3rd ed. New York, 1948.

Gardner 1970. Helen Gardner. *Art through the Ages.* 5th ed., revised by Horst de la Croix and Richard G. Tansey. New York, 1970.

Gascoigne 1986. Bamber Gascoigne. *How to Identify Prints: A Completed Guide to Manual and Mechanical Processes from Woodcut to Ink Jet.* New York, 1986.

Gasman 1981. Lydia Gasman. "Mystery, Magic and Love in Picasso, 1925–1938: Picasso and the Surrealist Poets." 4 vols. Ph.D. diss., Columbia University, New York, 1981.

Gasser 1958. Manuel Gasser. "Picasso Taurómaco." *Du* (Zürich) 18, no. 8 (August 1958), pp. 11–29.

Gautier et al. 2009. G. Gautier, A. Bezur, K. Muir, F. Casadio, and I. Fiedler. "Chemical Fingerprinting of Ready-Mixed House Paints of Relevance to Artistic Production in the First Half of the Twentieth Century. Part I: Inorganic and Organic Pigments." *Applied Spectroscopy* 63, no. 6 (2009), pp. 597–603.

Gaya Nuño 1950. Juan Antonio Gaya Nuño. *Picasso.* Barcelona, 1950.

Gedo 1980. Mary Mathews Gedo. *Picasso: Art as Autobiography.* Chicago, 1980.

Gee 1981. Malcolm Gee. *Dealers, Critics, and Collectors of Modern Painting: Aspects of the Parisian Art Market Between 1910 and 1930.* New York and London, 1981.

Geelhaar 1993. Christian Geelhaar. *Picasso: Wegbereiter und Förderer seines Aufstiegs, 1899–1939.* Zürich, 1993.

Geiser and Baer 1933–96. Bernhard Geiser and Brigitte Baer. *Picasso: Peintre-graveur.* 7 vols., and suppl. Bern, 1933–96.

Genauer 1939. E[mily] G[enauer]. "Ten Paintings Throw Light on Picasso's Development" (review of New York [Harriman] 1939). *New York World Telegram*, February 4, 1939, p. 13.

Giedion-Welcker 1937. Carola Giedion-Welcker. *Modern Plastik: Elemente der Wirklichkeit. Masse und Auflockerung.* Zürich, 1937.

Giedion-Welcker 1955. Carola Giedion-Welcker. Translation. *Contemporary Sculpture: An Evolution in Volume and Space.* New York, 1955.

Giedion-Welcker 1960. Carola Giedion-Welcker. *Contemporary Sculpture: An Evolution in Volume and Space.* 3rd ed. New York, 1960.

Gieure 1951. Maurice Gieure. *Initiation à l'oeuvre de Picasso.* Paris, 1951.

Gikandi 2003. Simon Gikandi. "Picasso, Africa, and the Schemata of Difference." *Modernism/Modernity* 10, no. 3 (September 2003), pp. 455–80.

Gilot and Lake 1964. Françoise Gilot and Carlton Lake. *Life with Picasso.* New York, 1964.

Giraudon 1993. Colette Giraudon. *Paul Guillaume et les peintres du XXe siècle: De l'art nègre à l'avant-garde.* Paris, 1993.

Girieud [1936–48]. Pierre Girieud. "Souvenirs d'un vieux peintre." Unpaginated manuscript, [1936–48]. Available in an electronic ed.: http://www.pgirieud.asso.fr (accessed June 26, 2009). See also Véronique Serrano, "Pierre Girieud, *Souvenirs d'un vieux peintre*, manuscrit inédit écrit entre 1936 et 1948" (Doctoral diss., Université de Paris I Panthéon-Sorbonne, 1995).

Giroud 2007. Vincent Giroud. "Picasso and Gertrude Stein." *Metropolitan Museum of Art Bulletin* 64, no. 3 (winter 2007), pp. 6–54.

Glozer 1988. Laszlo Glozer. *Picasso: Les Chefs-d'oeuvre de la Période bleue, 38 tableaux.* Munich, 1988.

Glueck 1971. Grace Glueck. "Trendless but Varied, the Season Starts: New York" (review of New York 1971). *Art in America* 59, no. 5 (September–October 1971), pp. 118–23.

Glueck 1980. Grace Glueck. "How Picasso's Vision Affects American Artists." *New York Times*, June 22, 1980, sect. 2, pp. 1, D7, D25.

Golding 1958. John Golding. "The 'Demoiselles d'Avignon.'" *Burlington Magazine* 100, no. 662 (May 1958), pp. 155–63.

Golding 1959. John Golding. *Cubism: A History and an Analysis, 1907–1914.* New York, 1959.

Golding 1968. John Golding. *Cubism: A History and an Analysis, 1907–1914.* 2nd ed. London, 1968.

Golding 1973. John Golding. "Picasso and Surrealism." In Penrose and Golding 1973, pp. 77–121.

Golding 1988. John Golding. *Cubism: A History and an Analysis, 1907–1914.* 3rd ed. Cambridge, Mass., 1988.

Golding 1991. John Golding. "Book Review: *A Life of Picasso*, vol. 1, by John Richardson." *Burlington Magazine* 133, no. 1064 (November 1991), pp. 783–86.

Golding 1994. John Golding. "Picasso: A New Dimension." *Prestige Magazine* (London) (1994), pp. 44–47.

Goldstein 2007. Andrew M. Goldstein. "Met's Secret, Sexy Picasso Is Bared in London" (review of London 2007–8). *New York Magazine*, November 26, 2007, pp. 29–30.

Goldwater 1969. Robert Goldwater. *What Is Modern Sculpture?* New York, 1969.

Gómez de la Serna 1945. Ramón Gómez de la Serna. *Completa y verídica historia de Picasso y el cubismo.* Turin, 1945.

Gómez Sicre 1947. José Gómez Sicre. "Barr y Picasso." *El Nacional* (Caracas) 4, no. 1 (January 12, 1947), p. 9.

Gómez Sicre 1948. José Gómez Sicre. "Picasso" (about the Picassos at MoMA). *Norte* 8, no. 6 (March 1948), pp. 13, 17.

González 1936. Julio González. "Picasso Sculpteur." *Cahiers d'Art* 11, no. 6–7 (January 1936), pp. 189–92.

González López 2004. Francisco González López. *La vejez y la enfermedad en el arte.* Caldas, 2004.

Goodrich 1931. Lloyd Goodrich. "Exhibitions: Picasso's Latest" (review of New York [Valentine] 1931). *The Arts* (New York) 17, no. 6 (March 1931), pp. 413–14.

Goodyear 1943. A. Conger Goodyear. *The Museum of Modern Art: The First Ten Years.* New York, 1943.

Gopnik 1983. Adam Gopnik. "High and Low: Caricature, Primitivism, and the Cubist Portrait." *Art Journal* 43, no. 4 (winter 1983), pp. 371–76.

Gordon 1974. Donald E. Gordon. *Modern Art Exhibitions, 1900–1916: Selected Catalogue Documentation.* 2 vols. Munich, 1974.

Gormley 1980. Lane Gormley. "Artists and Models: Women in French Art from 1880 to 1930." *Frontiers: A Journal of Women Studies* 5, no. 1 (spring 1980), pp. 40–47.

Gossa 1984. S. Gossa. "Kubistische Konstruktionen und kubistische Stilrichtungen." In *Skulptur im 20. Jahrhundert* (Basel 1984), pp. 45–56.

Gottlieb 1981. Carla Gottlieb. "Picasso as a Self-Portraitist." *Colóquio: Artes*, ser. 2, 23, no. 50 (September 1981), pp. 14–23.

Grafe 1978. Friede Grafe. "Zwei Jahre aus meinem Leben mit Gertrude Stein." *Die Republik* (1978), pp. 134–463.

Graham-Dixon 1994. Andrew Graham-Dixon. "Rough Cuts" (review of London 1994). *British Vogue* (February 1994), pp. 110–11.

Graulich 1999. Gerhard Graulich. "Between Surface and Space: Picasso's Late Surface Sculpture." In *Pablo Picasso: Der Reiz der Fläche/The Appeal of Surface* (Schwerin 1999), pp. 112–29.

C. Green 2001. Christopher Green, ed. *Picasso's Les Demoiselles d'Avignon.* Cambridge, 2001.

C. Green 2005. Christopher Green. *Picasso: Architecture and Vertigo.* New Haven and London 2005.

M. Green and Swan 1986. Martin Green and John Swan. *The Triumph of Pierrot: The Commedia dell'Arte and the Modern Imagination.* New York, 1986.

Greenfeld 1987. Howard Greenfeld. *The Devil and Dr. Barnes: Portrait of an American Art Collector.* New York, 1987.

Greenough 2002. Sarah Greenough. *Alfred Stieglitz: The Key Set. The Alfred Stieglitz Collection of Photographs.* 2 vols. Washington, D.C., and New York, 2002.

Gregory 1948. Alyse Gregory. *The Day Is Gone.* New York, 1948.

Griffey 2001. Randall R. Griffey. "Marsden Hartley's Lincoln Portraits." *American Art* 15, no. 2 (summer 2001), pp. 34–51.

Grimes 2008. William Grimes. "Klaus Perls, Art Dealer Who Gave Picassos to the Met, Dies at 96." *New York Times*, June 5, 2008, p. B6.

Guiette 1947–48. René Guiette. "Peinture magique." *Artes* (Antwerp) 2, nos. 3–4 (1947–48), p. 42.

Hadler and Perls 1993. Mona Hadler. "Oral History Interview with Klaus G. Perls," January 19, 1993. Archives of American Art, Smithsonian Institution. http://www.aaa.si.edu/collections/oralhistories/transcripts/perls93.htm.

Haesaerts 1938. Paul Haesaerts. *Picasso et le goût du paroxysme.* Antwerpen and Amsterdam, 1938.

Hamilton 1970. George Heard Hamilton. "The Alfred Stieglitz Collection." *Metropolitan Museum Journal* 3 (1970), pp. 371–92.

Hammacher 1969. Abraham Marie Hammacher. *The Evolution of Modern Sculpture: Tradition and Innovation.* New York, 1969. Reprinted New York, 1988.

Hammacher 1988. Abraham Marie Hammacher. *Modern Sculpture: Tradition and Innovation.* Rev. and enl. ed. New York, 1988.

Harmon 1962. Harry Harmon. *Picasso for Children.* New York, 1962.

D. Hart 2009. Dakin Hart. "Peace and Love in Picasso." In *Picasso: Mosqueteros* (New York 2009), pp. 239–71.

T. Hart and Rojas 1966. Thomas R. Hart and Carlos Rojas, eds. *La España moderna; vista y sentida por los españoles.* Englewood Cliffs, N.J., 1966.

Hausenstein 1916. Wilhelm Hausenstein. *Modernen Galerie Heinrich Thannhauser, München. Nachtragswerk I zur grossen Katalogausgabe 1916.* Munich, 1916.

Henderson 1983. Linda Dalrymple Henderson. *The Fourth Dimension and Non-Euclidean Geometry in Modern Art.* Princeton, 1983.

Henkes 1997. Robert Henkes. *Portraits of Famous American Women: An Analysis of Various Artists' Renderings of 13 Admired Figures.* Jefferson, N.C., and London, 1997.

Hess 1955–56. Walter Hess. "Picasso und die anderen." *Das Kunstwerk* 9, no. 3 (1955–56), pp. 8–18.

Higgins 2007a. Charlotte Higgins. "The Best-Hung Show in London" (review of London 2007–8). *Sydney Morning Herald*, February 23, 2007. http://www.smh.com.au/news/arts/the-best-hung-show-in-london/2007/02/22/1171733953319.html.

Higgins 2007b. Charlotte Higgins. "Removing the Fig Leaf: Barbican's Scholarly Sex Show, for over-18s Only" (review of London 2007–8). *The Guardian* (London), February 22, 2007. http://www.guardian.co.uk/uk/2007/feb/22/artnews.art.

Hildebrandt 1913. Hans Hildebrandt. "Die Frühbilder Picassos" (review of Munich 1913 and Cologne 1913). *Kunst und Künstler* 11 (1913), pp. 376–78.

Hillairet 1997. Jacques Hillairet. *Dictionnaire historique des rues de Paris.* 10th ed. 2 vols. Paris, 1997.

Hilton 1975. Timothy Hilton. *Picasso.* London, 1975.

Hobhouse 1975. Janet Hobhouse. *Everybody Who Was Anybody: A Biography of Gertrude Stein.* New York, 1975.

[Hoeber] 1911. [Arthur Hoeber.] "Art and Artists." *The Globe and Commercial Advertiser* (New York), April 21, 1911, p. 12.

Hoenigswald 1994. Ann Hoenigswald. "Reworking Finished Paintings: Gauguin and Van Gogh, a Comparison." In *Van Gogh: The Songlines of Legend*, edited by Felicity St. John Moore, pp. 40–43. Melbourne, [1994].

Hoffman 1989. Katherine Hoffman, ed. *Collage Critical Views.* Ann Arbor, 1989.

Hoffmann 1958. Edith Hoffmann. "Current and Forthcoming Exhibitions: New York." *Burlington Magazine* 100 (May 1958), pp. 184–86.

Hohl 1986. Reinhold Hohl. "Widerspruch als Stilprinzip." In *Picasso im Sprengel Museum Hannover: Druckgraphik, illustrierte Bücher, Zeichnungen, Collagen und Gemälde* (Hannover 1986–87), pp. 19–27.

Holloway 2006. Memory Holloway. *Making Time: Picasso's Suite 347.* American University Studies 20, Fine Arts, vol. 35. New York, 2006.

Holtmann, Herzog, and Jacobs van Renswou 2006. Heinz Holtmann, Günter Herzog, and Brigitte Jacobs van Renswou. *Thannhauser: Händler, Sammler, Stifter.* Special issue of *Sediment: Mitteilungen zur Geschichte des Kunsthandels, Zentralarchiv des Internationalen Kunsthandels ZADIK* 11. Nuremberg, 2006.

Homer 1977. William Innes Homer. *Alfred Stieglitz and the American Avant-Garde.* Boston, 1977.

Hoog 1984. Michel Hoog, ed., with the collaboration of Hélène Guicharnaud and Colette Giraudon. *Musée de l'Orangerie. Catalogue de la collection Jean Walter et Paul Guillaume.* Paris, 1984.

Hoyle 2007. Ben Hoyle. "The Art of Seduction Spanning 2,000 Years" (review of London 2007–8). *The Times Online* (London), February 22, 2007. http://entertainment.timesonline.co.uk/tol/arts_and_entertainment/visual_arts/article1421346.ece.

Huffington 1988. Arianna Stassinopoulos Huffington. *Picasso: Creator and Destroyer.* New York, 1988.

Hunter 1957. Sam Hunter. *Picasso (Born 1881): Cubism to the Present.* New York, 1957.

Hunter-Stiebel 1981. Penelope Hunter-Stiebel. "Pablo Picasso, *Lady with a Flowered Hat.*" In *Notable Acquisitions, 1980–1981: The Metropolitan Museum of Art* (1981), pp. 68–69.

Hurd 2004. Pippa Hurd. *Icons of Erotic Art.* Munich, London, and New York, 2004.

Huth 1996. Marta Huth, photographer, edited by Jan T. Köhler, Jan Maruhn, and Nina Senger. *Berliner Lebenswelten der zwanziger Jahre: Bilder einer unterge- gangenen Kultur.* Frankfurt am Main, 1996.

Itsuki and Yaegashi 1978. H. Itsuki and H. Yaegashi. *The Book of Great Masters 32: Picasso.* Tokyo, 1978.

Jacob 1911. Max Jacob. *Saint Matorel.* Paris: Daniel-Henry Kahnweiler, 1911.

Jacob 1927. Max Jacob. "Souvenirs sur Picasso contés par Max Jacob." *Cahiers d'art* 2 (1927), pp. 199–203.

Jaffé 1964. Hans Ludwig C. Jaffé. *Pablo Picasso.* Translated by Norbert Guterman. New York, 1964.

Jaffé 1967. Hans Ludwig C. Jaffé. *Pablo Picasso.* Translated by Lucienne Netter. Paris, 1967.

Jaffé 1981. Hans Ludwig C. Jaffé. *Picasso.* Cologne, 1981.

Jaffé 1988. Hans Ludwig C. Jaffé. *Pablo Picasso.* Concise ed. London, 1988.

Janis and Janis 1946. Harriet Janis and Sidney Janis. *Picasso: The Recent Years, 1939–1946.* Garden City, N.Y., 1946.

Januszczak 1994. Waldemar Januszczak. "Mating Games" (review of London 1994). (*London*) *Sunday Times*, February 20, 1994.

Jardot 1959. Maurice Jardot. *Pablo Picasso Drawings.* New York, 1959.

Jeffett 2002. William Jeffett. "Una lectura de Kahnweiler y Breton: La escul- tura 'cubista' de Picasso y los orígenes del objecto surrealista." In *Las formas del Cubismo escultural, 1909--1919* (Madrid 2002), pp. 103–16.

Johnson 1971. Ronald Johnson. "The Early Sculpture of Picasso, 1901–1914." Ph.D. diss., University of California, Berkeley, 1971.

Johnson 1975. Ronald Johnson. "Primitivism in the Early Sculpture of Picasso." *Arts Magazine* 49, no. 10 (June 1975), pp. 64–68.

Johnson 1976. Ronald Johnson. *The Early Sculpture of Picasso, 1901–1914.* Outstanding Dissertations in the Fine Arts. New York and London 1976. Originally the author's Ph.D. diss., University of California, Berkeley, 1971.

Johnson 1977. Ronald Johnson. "Picasso's Parisian Family and the 'Saltimbanques.'" *Arts Magazine* 51, no. 5 (January 1977), pp. 90–95.

R. Johnson 1997. Richard Johnson. "Secret of Met's X-Rated Picasso." *New York Post*, March 10, 1997, p. 8.

Joost 1964. Nicholas Joost. *Scofield Thayer and The Dial: An Illustrated History.* Carbondale, Ill., 1964.

Joost 1971. Nicholas Joost. "The Dial Collection: Tastes and Trends of the Twenties." *Apollo* 94, no. 118 (December 1971), pp. 488–95.

Jouvet 1982. Jean Jouvet, ed., with essays by Werner Spies, Maurice Jardot, and Richard Häsli. *Pablo Picasso, der Zeichner: Dreihundert Zeichnungen und Graphiken, 1893–1972.* Zürich, 1982.

Jouvet 1989. Jean Jouvet, ed., with essays by Werner Spies, Maurice Jardot, and Richard Häsli. *Pablo Picasso, der Zeichner: Dreihundert Zeichnungen und Graphiken, 1893–1972.* New ed. Zürich, 1989.

Junkin 1941. Marion Junkin. "The Chrysler Collection" (review of Richmond–Philadelphia 1941). *Art in America* 29 (1941), pp. 105–6.

Justice 1973. Cornelia Justice. "Picasso's Art Sheds Life" (review of Norfolk 1973). *Ledger Star*, June 16, 1973, p. A7.

Kachur 1988. Lewis C. Kachur. "Themes in Picasso's Cubism, 1907–1918." Ph.D. diss., Columbia University, New York, 1988.

Kachur 1997. Lewis Kachur. "Review: Early Picasso, Boston and Chicago" (review of Washington–Boston 1997–98). *Burlington Magazine* 139 (September 1997), pp. 657–59.

E. Kahn 2003. Elizabeth Louise Kahn. *Marie Laurencin: "Une femme inadaptée" in Feminist Histories of Art.* Burlington, 2003.

G. Kahn 1905. Gustave Kahn. "Ingres et Manet." *La Nouvelle Revue* 33 (March–April 1905), pp. 556–57.

Kahnweiler 1948. Daniel-Henry Kahnweiler, with Brassaï. *Les Sculptures de Picasso.* Paris, 1948.

Kahnweiler 1949a. Daniel-Henry Kahnweiler. *The Rise of Cubism.* Translated by Henry Aronson. New York, 1949.

Kahnweiler 1949b. Daniel-Henry Kahnweiler, with Brassaï. *The Sculptures of Picasso.* Translated by A. D. B. Sylvester. London, 1949.

Kahnweiler 1950. Daniel-Henry Kahnweiler. *Les Années héroiques du cubisme.* Paris, 1950.

Kahnweiler 1971. Daniel-Henry Kahnweiler. *My Galleries and Painters.* Translated by Helen Weaver. New York, 1971. French ed.: *Mes Galleries et mes peintres.* Paris, 1961.

Kahnweiler 2005. Daniel-Henry Kahnweiler. *The Sculptures of Picasso.* Photographs by Brassaï; foreword by Diana Widmaier Picasso. New York, 2005.

Kahnweiler sales 1921–23. *Vente de biens allemands ayant fait l'objet d'une mesure de Séquestre de Guerre: Collection Henry Kahnweiler.* Hôtel Drouot, Paris, four sales, March 13–14, 1921, November 17–18, 1921, July 4, 1922, May 7–8, 1923.

Kantor 2002. Sybil Gordon Kantor. *Alfred H. Barr Jr. and the Intellectual Origins of the Museum of Modern Art.* Cambridge, Mass., 2002.

Karmel 1992. Pepe Karmel. "Notes on the Dating of Works." In *Picasso and Braque: A Symposium* (Rubin and Zelevansky 1992), pp. 322–40.

Karmel 1993. Joseph Low (Pepe) Karmel. "Picasso's Laboratory: The Role of His Drawings in the Development of Cubism, 1910–14." 6 vols. Ph.D. diss., New York University, Institute of Fine Arts, 1993.

Karmel 2000. Pepe Karmel. "Pablo Picasso and Georges Braque, 1914–1915: Skeletons of Thought." In *Modern Art and America: Alfred Stieglitz and His New York Galleries* (Washington 2000) pp. 184–201.

Karmel 2003. Pepe Karmel. *Picasso and the Invention of Cubism.* New Haven and London, 2003.

Karpel 1972. Bernard Karpel and Walt Kuhn, eds. *The Armory Show, International Exhibition of Modern Art, 1913.* 3 vols. New York, 1972.

Karshan 1968. Donald H. Karshan. *Picasso Linocuts, 1958–1963.* New York, 1968.

Kaufman 1996. J[ason] E[dward] K[aufman]. "Perls Adds Gems to the Met." *Art Newspaper*, no. 61 (July–August 1996), p. 14.

Kay 1965. Helen Kay. *Picasso's World of Children.* New York, 1965.

Kenner 1991. Hugh Kenner. "Think of Me." *Art and Antiques* 8 (summer 1991), p. 120.

Kimmelman 1994a. Michael Kimmelman. "At the Met with Elizabeth Murray, Looking for the Magic in Painting." *New York Times*, October 21, 1994, pp. C1, C28.

Kimmelman 1994b. Michael Kimmelman. "A Face in the Gallery of Picasso's Muses Is Given a New Name." *New York Times*, April 21, 1994, pp. C19 (ill.), C22. Reprinted as: Michael Kimmelman. "A Secret Picasso Muse—Jazz-Age Luminary Linked to Paintings." *International Herald Tribune*, April 23–24, 1994, p. 6.

Kimmelman 1994c. Michael Kimmelman. "Who Was Picasso's Mona Lisa?" *New York Times*, April 24, 1994, p. 127.

Kimmelman 2003. Michael Kimmelman. "The Saint" (review of Kantor 2002). *The New York Review of Books* 50, no. 18 (November 20, 2003), p. 12.

Kirstein 1973. Lincoln Kirstein. *Elie Nadelman.* New York, 1973.

Klein 2007. John Klein. "The Mask as Image and Strategy." In *The Mirror and The Mask: Portraiture in the Age of Picasso* (Madrid–Fort Worth 2007), pp. 25–35.

Kleinfelder 1993. Karen L. Kleinfelder. *The Artist, His Model, Her Image, His Gaze: Picasso's Pursuit of the Model.* Chicago, 1993.

Klingsor 1902. Tristan Klingsor. "André Methey." *L'Art moderne* (Brussels) 22, no. 25 (June 22, 1902), p. 213.

Kodansha 1981. Kodansha, ed. *Pablo Picasso.* 5 vols. In Japanese; captions in English. Tokyo, 1981.

Koenig 1992. Hertha Koenig, edited by Joachim W. Storck. *Erinnerungen an Rainer Maria Rilke sowie Rilkes Mutter.* Bielefeld, 1992.

Korn 2004. Madeleine Korn. "Collecting Paintings by Matisse and by Picasso in Britain before the Second World War." *Journal of the History of Collections* 16, no. 1 (2004), pp. 111–29.

Kostenevich 2008. Albert G. Kostenevich. *Iskusstvo Frantsii, 1860–1950, Zhivopis, risunok, skulptura.* 2 vols. St. Petersburg: The State Hermitage Museum, 2008.

Kozloff 1973. Max Kozloff. *Cubism/Futurism.* New York, 1973.

Kramer 1991. Hilton Kramer. "John Richardson's 'Picasso'" (book review). *New Criterion* 9, no. 6 (February 1991), pp. 4–7.

Kramer 1996. Hilton Kramer. "Picasso: Portraits or Masks?" (review of New York–Paris 1996–97). *New Criterion* 14, no. 10 (June 1996), pp. 5–8.

Kramer 1997. Hilton Kramer. "Picasso: The Early Years—Not Quite a Major Event" (review of Washington–Boston 1997–98). *New York Observer* (May 19, 1997), p. 33.

Krauss 1998. Rosalind E. Krauss. *The Picasso Papers.* New York, 1998.

Lafond 1906a. Paul Lafond. "Domenikos Theotokopuli dit Le Greco." *Les Arts*, no. 58 (October 1906), pp. 2–32.

Lafond 1906b. Paul Lafond. "La Chapelle San José de Tolède et ses peintures du Greco." *Gazette des beaux-arts*, ser. 3, 36 (November 1906), pp. 382–92.

Lapuze 1905a. Henry Lapuze. "Le 'Bain Turc' d' Ingres, d'après des documents inédits." *La Revue d'art ancient et moderne*, vol. 18 (July–December 1905), pp. 383–96.

Lapuze 1905b. Henry Lapuze. *Mélanges sur l'art français.* Paris, 1905.

Larson 1986. Kay Larson. "The Met Goes Modern." *New York Magazine* 19, no. 49 (December 15, 1986), pp. 40–48.

Lassaigne 1949. Jacques Lassaigne. *Picasso.* Paris, 1949.

Lassaigne et al. 1937. J. Lassaigne et al. "Les Maîtres de l'art indépendant au Petit Palais" (review of Paris [Petit Palais] 1937). *Beaux-Arts* 75, n.s., no. 235 (July 2, 1937), pp. 2, 8.

Laurvik 1913. J. Nilson Laurvik. "The Coming Cubists Explain Their Picture Puzzles" (review of the Armory Show). *Boston Evening Transcript*, April 12, 1913, part 3, p. 2.

Léal 1992. Brigitte Léal. "The Sketchbooks from the Rose Period." In *Picasso, 1905–1906: De l'epoca rosa als ocres de Gósol* (Barcelona–Bern 1992), pp. 97–105.

Léal 1994. Brigitte Léal. "Landscapes During the Pink Period." In *Picasso Landscapes, 1890–1912: From the Academy to the Avant-Garde* (Barcelona 1994–95), pp. 243–57.

Léal 1996. Brigitte Léal. *Carnets: Catalogue des dessins.* Musée Picasso. 2 vols. Paris, 1996.

Léal, Piot, and Bernadac 2000. Brigitte Léal, Christine Piot, and Marie-Laure Bernadac. *Picasso Total, 1881–1973.* Barcelona 2000. English ed.: Brigitte Léal, Christine Piot, and Marie-Laure Bernadac. *The Ultimate Picasso.* Translated by Molly Stevens and Marjolin de Jager. New York, 2000.

Lecaldano 1968. Paolo Lecaldano. *L'opera completa di Picasso blu e rosa.* Preface by Alberto Moravia. Milan, 1968. Eng. ed.: *The Complete Paintings of Picasso: Blue and Rose Periods.* Introduction by Denys Sutton. New York, 1968.

Lecaldano 1971. Paolo Lecaldano. *The Complete Paintings of Picasso: Blue and Rose Periods*. Introduction by Denys Sutton. London, 1971. Reprint of 1968 ed.

Lecaldano 1979. Paolo Lecaldano. *L'opera completa di Picasso blu e rosa*. Milan, 1979. Reprint of 1968 ed.

Leclerc 1947. André Leclerc. *Picasso*. New York, [1947].

Leepa 1957. Allen Leepa. *The Challenge of Modern Art*. Rev. ed. New York, 1957.

Leighten 1983. Patricia Dee Leighten. "Picasso: Anarchism and Art, 1897–1914." Ph.D. diss., Rutgers, State University of New Jersey, New Brunswick, 1983.

Leighten 1985. Patricia Leighten. "Picasso's Collages and the Threat of War, 1912–13." *Art Bulletin* 67 (1985), pp. 653–72. Reprinted in *Collage, Critical Views*, edited by Katherine Hoffman, pp. 121–70. Ann Arbor and London, 1989.

Leighten 1989. Patricia Leighten. *Re-Ordering the Universe: Picasso and Anarchism, 1897–1914*. Princeton, 1989.

Leja 1985. Michael Leja. "'Le Vieux Marcheur' and 'Les Deux Risques': Picasso, Prostitution, Venereal Disease, and Maternity, 1899–1907." *Art History* 8, no. 1 (March 1985), pp. 66–81.

Lenz 1977. Christian Lenz. "Max Beckmann in seinem Verhältnis zu Picasso." *Niederdeutsche Beiträge zur Kunstgeschichte* 16 (1977), pp. 239–50.

Level 1928. André Level. *Picasso*. Paris, 1928.

Lewis-Jones 2007. Huw Lewis-Jones. "Sex Sells Erotic Art in London: The Barbican's 'Seduced' Exhibition Wrenches the Fig-leaf off Works of Art from Ancient Rome to the Present Day" (review of London 2007–8). *Apollo* 166, no. 549 (December 2007), pp. 110–12.

Leymarie 1967. Jean Leymarie. *Picasso: Dessins*. Geneva, 1967. English ed.: *Picasso Drawings*. Translated by Stuart Gilbert. Geneva, 1967.

Leymarie 1971a. Jean Leymarie. *Picasso: The Artist of the Century*. New York, 1971.

Leymarie 1971b. Jean Leymarie. *Picasso: Métamorphoses et unité*. Geneva, 1971.

Leymarie 1972. Jean Leymarie. *Picasso: The Artist of the Century*. Translated by James Emmons. New York, 1972.

Licht 1967. Fred Licht. *Sculpture, 19th and 20th Centuries*. Greenwich, Conn., 1967.

Lieberman 1952. William S. Lieberman. "Picasso: His Graphic Art." *Bulletin of the Museum of Modern Art* 19, no. 2 (winter 1952), p. 3–17.

Lieberman 1954. William S. Lieberman. *Pablo Picasso: Blue and Rose Periods*. New York, 1954.

Lieberman 1981. William S. Lieberman. *The Nelson A. Rockefeller Collection: Masterpieces of Modern Art*. Introduction by Nelson A. Rockefeller; essay Alfred H. Barr Jr. New York, 1981.

Lieberman 1984. William S. Lieberman. "Pablo Picasso, *The Peasant Woman* and *Two Players at a Table*." In *Notable Acquisitions, 1983–1984: The Metropolitan Museum of Art* (1984), p. 106.

Lieberman 1997. William S. Lieberman. "Pablo Picasso, *Girl Reading*." In "Recent Acquisitions: A Selection, 1996–1997," *Metropolitan Museum of Art Bulletin*, n.s., 55, no. 2 (autumn 1997), pp. 76–77.

Lipton 1976. Eunice Lipton. "Picasso Criticism, 1901–1939: The Making of the Artist-Hero." Ph.D. diss., New York University, 1976.

Littlewood 1988. Ian Littlewood. *Paris: A Literary Companion*. New York, 1988.

Llorens Serra 2001. Tomàs Llorens Serra. *Nacimiento y desintegración del cubismo: Apollinaire y Picasso*. Pamplona, 2001.

Loeb sale 1997. *The John and Frances L. Loeb Collection*. Sale, Christie's, New York, May 12, 1997.

Loize 1966. Jean Loize. "Frank Burty." *Reflets du Roussillon* 13 (spring 1966), pp. 27–32.

Lombard 1990. Richard Lombard, ed. "The Portrait of Gertrude Stein." *The Column* (MMA) 4, no. 1 (January–February 1990), p. 4.

Lord 1994. James Lord. *Six Exceptional Women: Further Memoirs*. New York, 1994.

Lubar 1996. Robert S. Lubar. "Narrating the Nation: Picasso and the Myth of El Greco." In *Picasso and the Spanish Tradition*, edited by Jonathan Brown, pp. 27–60. New Haven and London, 1996.

Lubar 1997. Robert S. Lubar. "Unmasking Pablo's Gertrude: Queer Desire and the Subject of Portraiture." *Art Bulletin* 79 (March 1997), pp. 56–84.

Luce 1947. Henry R. Luce, ed. "Speaking of Pictures: Gertrude Stein Left a Hodgepodge Behind Her." *Life Magazine*, August 18, 1947, p. 15.

Lucie-Smith 1984. Edward Lucie-Smith. *The Thames and Hudson Dictionary of Art Terms*. London, 1984.

Lyttle 1989. Richard B. Lyttle. *Pablo Picasso: The Man and the Image*. New York, 1989.

MacIntyre 1994. Ben MacIntyre. "Art Expert Frames the Real Madame Picasso." (London) *Times*, April 22, 1994.

Mackenzie 1940. Helen F. Mackenzie. *Understanding Picasso: A Study of His Styles and Development*. Chicago, 1940.

Macleod 2008. Dianne Sachko Macleod. *Enchanted Lives, Enchanted Objects*. Berkeley, 2008.

Madacsi 2007. David Madacsi. "Fragile Light: Confluence of Art and Science." In *Proceedings, Starlight: International Conference in Defense of the Quality of the Night Sky and the Right to Observe the Stars*, pp. 89–95. Santa Cruz de la Palma, April 19–20, 2007, http://www.starlight2007.net/proculture.htm.

Madeline 2005. Laurence Madeline, ed. *Pablo Picasso—Gertrude Stein: Correspondance*. Paris, 2005.

Madeline 2006. Laurence Madeline. "Portrait de Gertrude Stein par Pablo Picasso." *Connaissance des arts*, no. 634 (January 2006), pp. 98–101.

Madeline 2008. Laurence Madeline, ed. *Pablo Picasso—Gertrude Stein: Correspondence*. Translated by Lorna Scott Fox. London, 2008.

Mahar 1972. William John Mahar. "Neo-Classicism in the Twentieth Century: A Study of the Idea and Its Relationship to Selected Works of Stravinsky and Picasso." Ph.D. diss., Syracuse University, 1972.

Mailer 1995. Norman Mailer. *Portrait of Picasso as a Young Man: An Interpretive Biography*. New York 1995.

Mailer 2002. Norman Mailer. "Fernande Olivier." In *Picasso and Women—Picasso et les femmes* (Chemnitz 2002–3), pp. 70–89.

Maison de la Chimie sale 1998. *Pablo Picasso et Dora Maar, une histoire, des oeuvres: Succession de Madame Dora Markovitch, 1907–1997. Importantes Photographies de 1906 à 1946*. Sale, Maison de la Chimie, Paris, October 28–29, 1998 (exhibited in New York at Philips, September 25–28, 1998).

Malcolm 2003. Janet Malcolm. "Gertrude Stein's War: The Years in Occupied France." *The New Yorker*, June 2, 2003, pp. 58–81.

Malraux 1995. André Malraux. *Picasso's Mask*. Translated and annotated by June Guicharnaud, with Jacques Guicharnaud. New York, 1995.

Marc 1989. Henri Marc. *Aristide Bruant: Le Maître de la rue*. Paris, 1989.

Marks 2006. Peter Marks. "'Picasso's Closet': An Artist with No Place to Hide." *Washington Post*, June 27, 2006. http://www.washingtonpost.com/wp-dyn/content/article/2006/06/26/AR2006062601490.html.

Marrinan 1977. Michael Marrinan. "Picasso as an 'Ingres' Young Cubist." *Burlington Magazine* 119, no. 896 (November 1977), pp. 756–63.

Marsan 1906. Eugène Marsan [Sandricourt, pseud.]. *Sandricourt: Au pays des firmans; histoire d'un gouvernement*. Paris, 1906.

Martí 1998. Octavi Martí. "Paris exhibe los inquietos Picassos de la juventud viajera del pintor" (review of Paris 1998–99). *El País* (Madrid), November 2, 1998, p. 39.

Martínez Blasco and Martínez Blasco 1995. Tomás Martínez Blasco and Manuel Martínez Blasco. *Mediterráneo Picasso*. Alicante, 1995.

Mather 1913. F. Jewett Mather, Jr. "Newest Tendencies in Art." *The Independent*, March 6, 1913, p. 504. Article reprinted in Karpel 1972, vol. 3, doc. 5.

R. Mayer 1969. Ralph Mayer. *A Dictionary of Art Terms and Techniques*. New York, 1969.

S. Mayer 1980. Susan Mayer. "Ancient Mediterranean Sources in the Works of Picasso, 1892–1937." Ph.D. diss., New York University, New York, 1980.

Mayor 1979. A. Hyatt Mayor. *The Metropolitan Museum of Art: Favorite Paintings*. New York 1979.

Mayor 1983. A. Hyatt Mayor. *A. Hyatt Mayor: Selected Writings and a Bibliography*. New York, 1983.

McBride 1924. Henry McBride. "Modern Art" (review of Thayer 1923). *The Dial* 76, no. 2 (February 1924), pp. 207–9.

McBride 1951. Henry McBride. "Pictures for a Picture of Gertrude" (review of New Haven–Baltimore 1951). *Artnews* 49, no. 10 (February 1951), pp. 16–18, 63. Reprinted in *The Flow of Art: Essays and Criticisms of Henry McBride*, edited by Daniel Catton Rich, pp. 429–32. New York, 1975.

McCausland 1934. Elizabeth McCausland. "Picasso" (review of Hartford 1934). *The Springfield Republican* (Mass.), February 7, 1934, unpaginated. Reprinted in McCausland 1944, p. 15.

McCausland 1939. Elizabeth McCausland. "Picasso" (review of New York and other cities 1939–41). *The Springfield Republican* (Mass.), November 19, 1939, unpaginated.

McCausland 1944. Elizabeth McCausland. *Picasso*. New York, 1944. Includes "Ten Years in Review," reprints of exhibition reviews published in *The Springfield Republican* (Mass.), 1934–44.

McCully 1993. Marilyn McCully. *Picasso: A Private Collection*. London, 1993.

McCully 1996. Marilyn McCully. "To Fall 'Like a Fly Into the Trap of Picasso's Stare': Portraiture in the Early Work." In *Picasso and Portraiture: Representation and Transformation* (New York–Paris 1996–97), pp. 225–53.

Mellow 1968. James R. Mellow. "The Stein Salon Was the First Museum of Modern Art." *New York Times Magazine*, December 1, 1968, sect. 6, pp. 48–51, 182–87, 190–91.

Mellow 1974. James R. Mellow. *Charmed Circle: Gertrude Stein and Company*. New York, 1974.

Melville 1939. Robert Melville. *Picasso: Master of the Phantom*. London, 1939.

Mendoza 2006. Cristina Mendoza. "Quatre Gats and the Origins of Picasso's Career." In *Barcelona and Modernity: Picasso, Gaudí, Miró, Dalí* (Cleveland–New York 2006–7), pp. 79–91.

Menier 1999. Mady Menier. "Un Sculpteur nommé Picasso." In *L'Homme au mouton, Picasso* (Vallauris 1999), pp. 12–13.

Merli 1942. Joan Merli. *Picasso, el artista y la obra de nuestro tiempo*. Buenos Aires, 1942.

Merli 1948. Joan Merli. *Picasso, el artista y la obra de nuestro tiempo*. 2nd ed. Buenos Aires, 1948.

Messinger 1982. Lisa M. Messinger. "Twentieth Century Art." In *Notable Acquisitions, 1981–1982: The Metropolitan Museum of Art* (1982), pp. 56–64.

Messinger 1983. Lisa M. Messinger. "Twentieth Century Art." In *Notable Acquisitions, 1982–1983: The Metropolitan Museum of Art* (1983), pp. 60–72.

Messinger 1985. Lisa M. Messinger, with Sabine Rewald and R. Craig Miller. "Twentieth-Century Art: The Scofield Thayer Bequest." In *Notable Acquisitions, 1984–1985: The Metropolitan Museum of Art* (1985), pp. 44–61. (Picasso entries by Lisa M. Messinger.)

Messinger 1986. Lisa M. Messinger. "Picasso Portrait Drawings: Barcelona, 1899–1900." *Drawing: The International Review published by the Drawing Society* 8, no. 4 (November–December 1986), pp. 73–77.

Messinger 1997. Lisa M. Messinger. "Pablo Picasso, *Harlequin*." In "Recent Acquisitions: A Selection, 1996–1997," *Metropolitan Museum of Art Bulletin*, n.s., 55, no. 2 (autumn 1997), pp. 68–69.

Methey 1907. André Methey. "La Renaissance de la faïence stannifère." *La Grande revue* 10 (October 10, 1907), pp. 746–49.

Michel 1913–14. Wilhelm Michel. "Schwankungen und Entscheidungen." *Deutsche Kunst und Dekoration* (Darmstadt) 33 (October 1913–March 1914), pp. 371–74.

A. Miller 2001. Arthur I. Miller. *Einstein, Picasso: Space, Time, and the Beauty That Causes Havoc*. New York, 2001.

S. Miller 2002. Sanda Miller. "From an Aesthetic Point of View." In *Las formas del Cubismo: Escultura, 1909–1919* (Madrid 2002), pp. 204–71.

Millier 1961. Arthur Millier. *The Drawings of Picasso*. Los Angeles, 1961.

Moeller 1987. Magdalena Moeller. "Alfred Flechtheim und die Vermittlung französischer Kunst vor 1914." In *Alfred Flechtheim, Sammler, Kunsthändler, Verleger* (Düsseldorf–Münster 1987–88), pp. 37–43.

Moffitt 1995. John F. Moffitt. *Art Forgery: The Case of the Lady of Elche*. Gainesville, Fla., 1995.

Mollet 1963. Jean Mollet. *Les Mémoires du Baron Mollet*. Preface by Raymond Queneau. Paris, 1963.

Monnier and Rose 1979. Geneviève Monnier and Bernice Rose, with introduction by Jean Leymarie. *Drawing: History of an Art*. New York, 1979.

Mourlot 1950–64. Fernand Mourlot. *Picasso: Lithographe*. 4 vols. Monte Carlo, 1950–64.

Mourlot 1970. Fernand Mourlot. *Picasso Lithographs*. Translated by Jean Didry. Boston, 1970.

Muñoz Molina 2005. Antonio Muñoz Molina. "The *Musée imaginaire* and the Real Presence of Art." In *Celebration of Art: A Half Century of the Fundación Juan March* (Madrid 2005–6), pp. 184–91.

Munsterberg 1951. Hugo Munsterberg. *Twentieth-Century Painting*. New York, 1951.

Národní Galerie 1966. Národní Galerie, Prague. *Francouzské sochařství ze sbírek Národní Galerie*. Prague, 1966.

Näslund 2008. Erik Näslund. *Rolf de Maré: Fondateur des ballets suédois, collectionneur d'art, créateur de musée*. Arles and Stockholm, 2008.

Nef 1953. John U. Nef, ed. *Elinor Castle Nef: Letters and Notes*. Vol. 1. Los Angeles, 1953.

Nikodem 1936. V[iktor] Nikodem. *Pablo Picasso*. Prague, 1936.

Norman 1960. Dorothy Norman. *Alfred Stieglitz: An American Seer*. New York, 1960.

Norman 1973. Dorothy Norman. *Alfred Stieglitz: An American Seer*. New York, 1973.

M. North 1994. Michael North. *The Dialect of Modernism: Race, Language, and Twentieth-Century Literature*. New York and Oxford, 1994.

P. North 2000. Percy North. "Bringing Cubism to America: Max Weber and Pablo Picasso." *American Art* 14, no. 13 (autumn 2000), pp. 58–77.

O'Brian 1976. Patrick O'Brian. *Pablo Ruiz Picasso: A Biography*. New York, 1976.

O'Brien 2007. Liz O'Brien. *Ultramodern: Samuel Marx, Architect, Designer, Art Collector*. New York, 2007.

Olds 1998. Marshall C. Olds. "Future Mallarmé (Present Picasso): Portraiture and Self-Portraiture in Poetry and Art." *Romance Quarterly* 45, no. 3 (summer 1998), pp. 168–77.

Olivier 1933. Fernande Olivier. *Picasso et ses amis*. [Paris, 1933]. Reprinted [2nd ed.] Paris, 1945.

Olivier 1964. Fernande Olivier. *Picasso and His Friends*. Translation of Olivier 1933 by Jane Miller. London, 1964.

Olivier 1988. Fernande Olivier. *Souvenirs intimes: Écrits pour Picasso*. Geneva, 1988.

Olivier 2001a. Fernande Olivier. *Loving Picasso: The Private Journal of Fernande Olivier*. Translated by Christine Baker and Michael Raeburn; notes by Marilyn McCully; epilogue by John Richardson. New York, 2001.

Olivier 2001b. Fernande Olivier. *Picasso et ses amis*. Edited by Hélène Klein. Paris, 2001.

On-line Picasso Project 2009. On-line Picasso Project. Created and directed by Enrique Mallen, 1997–2009. http://picasso.tamu.edu.

d'Ors 1930. Eugenio d'Ors. *Pablo Picasso*. Paris, 1930.

d'Ors [1946]. Eugenio d'Ors. *Pablo Picasso en tres revisiones*. Madrid, n.d. [1946].

Otero 1974. Roberto Otero. *Forever Picasso: An Intimate Look at His Last Years*. Translated by Elaine Kerrigan. New York, 1974.

Pace 1994. Eric Pace. "Alexander L. Levine, Developer and Philanthropist, Dies at 82." *New York Times*, September 6, 1994, p. B6.

Padrta 1960. Jiří Padrta. *Picasso: The Early Years*. New York, 1960.

Page 1998. Amy Page. "Americans Abroad" (series on famous women collectors). *Elle Decor*, [February 11], 1998, p. 106.

Paine 2008. Janice T. Paine. "There Might Not Be Anything New to Say about Picasso, but There's Still Plenty Worth Repeating" (review of Naples [Fla.] 2008). *NaplesNews.com*, February 20, 2008. http://www.naplesnews.com/ news/2008/feb/20/janice-t-paine-there-might-not-be-anything-new-say/.

Palau i Fabre 1966. Josep Palau i Fabre. *Picasso en Cataluña*. Barcelona, 1966.

Palau i Fabre 1970. Josep Palau i Fabre. *Picasso por Picasso*. Barcelona, 1970.

Palau i Fabre 1971. Josep Palau i Fabre. "1900: A Friend of His Youth." In "Homage to Picasso," special issue, *XXe siècle* (1971), pp. 3–12.

Palau i Fabre 1981a. Josep Palau i Fabre. *Picasso, Barcelona, Catalunya*. Barcelona, 1981.

Palau i Fabre 1981b. Josep Palau i Fabre. *Picasso: The Early Years, 1881–1907*. Translated by Kenneth Lyons. New York, 1981. First published Barcelona, 1980.

Palau i Fabre 1985. Josep Palau i Fabre. *Picasso*. New York, 1985.

Palau i Fabre 1990. Josep Palau i Fabre. *Picasso: Cubism, 1907–1917*. New York, 1990.

Palau i Fabre 1999. Josep Palau i Fabre. *Picasso: From the Ballets to Drama (1917–1926)*. Translated by Richard-Lewis Rees. Barcelona, 1999.

Palau i Fabre 2006. Josep Palau i Fabre. *Picasso i els seus amics catalans*. Rev. ed. Barcelona, 2006. Originally published 1971.

Palmgren 1947. Nils Palmgren. Review of Stockholm 1947. *Aftonbladet*, February 27, 1947, unpaginated.

Papanikolas 2007. Zeese Papanikolas. *American Silence*. Lincoln, Neb., and London 2007.

Parmelin 1959. Hélène Parmelin. *Picasso sur la place*. Paris, 1959.

Parmelin 1963. Hélène Parmelin. *Picasso Plain: An Intimate Portrait*. Translated by Humphrey Hare. New York, 1963.

Parmelin [1967?]. Hélène Parmelin. *Picasso: Women, Cannes and Mougins, 1954–1963*. Translated by Humprey Hare. Paris and Amsterdam, n.d. [1967?].

Parmelin 1969. Hélène Parmelin. *Picasso Says*. Translated by Christine Trollope. London, 1969.

Paudrat 1984. Jean-Louis Paudrat. "From Africa." In *"Primitivism" in 20th Century Art: Affinity of the Tribal and the Modern*, edited by William Rubin (New York–Detroit–Dallas 1984–85), vol. 1, pp. 124–75.

Payró 1957. Julio E. Payró. *Picasso y el ambiente artístico-social contemporáneo*. Buenos Aires, 1957.

Peignot 1969. Jérôme Peignot. "Les Premiers Picasso de Gertrude Stein." *Connaissance des arts*, no. 213 (November 1969), pp. 122–31.

Pène du Bois 1931. Guy Pène du Bois. "The Lizzie P. Bliss Collection." *The Arts* 17, no. 9 (June 1931), pp. 601–12.

Penrose 1957. Roland Penrose. *Portrait of Picasso*. New York, 1957.

Penrose 1958. Roland Penrose. *Picasso: His Life and His Work*. New York, 1958.

Penrose 1959. Roland Penrose. *Picasso: His Life and His Work*. New York, 1959.

Penrose 1961. Roland Penrose. *Picasso: Four Themes*. London, 1961.

Penrose 1967. Roland Penrose. *The Eye of Picasso*. New York and Toronto, 1967.

Penrose 1971a. Roland Penrose. *Picasso*. London, 1971.

Penrose 1971b. Roland Penrose. *Portrait of Picasso*. 2nd rev. ed. New York, 1971.

Penrose 1973. Roland Penrose. *Picasso: His Life and Work*. Rev. ed. New York, 1973.

Penrose 1974. Roland Penrose. "Picasso's Portrait of Kahnweiler." *Burlington Magazine* 116 (March 1974), pp. 124–31, 133. Reprinted in Michael Levey, ed., *The Burlington Magazine, A Centenary Anthology*. New Haven and London, 2003.

Penrose 1981. Roland Penrose. *Picasso: His Life and His Work*. 3rd ed. Berkeley, 1981.

Penrose and Golding 1973. Roland Penrose and John Golding. *Picasso in Retrospect*. New York, 1973.

Perry 1982. Jacques Perry. *Yo Picasso*. Paris, 1982.

Persin 1990. Patrick-Gilles Persin. *Daniel-Henry Kahnweiler: L'Aventure d'un grand marchand*. Paris, 1990.

Petrová 1981. Eva Petrová. *Picasso v Ceskoslovensku*. Prague, 1981.

Petrová 1984. Eva Petrová. *Picasso: Sein Werk in den Prager Sammlungen*. Translated by Lenka Reinerová. Bayreuth, 1984.

Picasso 1989. Pablo Picasso. *Picasso: Écrits*. Edited by Marie-Laure Bernadac and Christine Piot. Paris, 1989. English ed.: *Picasso: Collected Writings*. Translated by Carol Volk and Albert Bensoussan. New York, 1989.

Pierpont 1998. Claudia Roth Pierpont. "The Mother of Confusion: How Did Gertrude Stein Become the First True Voice of Modern Literature." *The New Yorker* (May 11, 1998), pp. 80–89.

Pijoán 1938. José Pijoán. *An Outline History of Art*. Vol. 3, *Art of the European Renaissance, Baroque, and Modern Art*. Chicago, 1938.

Pincell 1901. Pincell [Miguel Utrillo]. "Pablo R. Picasso" (review of Barcelona 1901). *Pèl & ploma*, June 1901, pp. 15–17.

Piot 1981. Christine Piot. "Décrire Picasso." Thèse de doctorat de 3e cycle, Université de Paris I, Panthéon-Sorbonne, 1981.

Platt 1988. Susan Noyes Platt. "Modernism, Formalism, and Politics: The 'Cubism and Abstract Art' Exhibition of 1936 at the Museum of Modern Art." *Art Journal* 47, no. 4 (Winter 1988), pp. 284–95.

Plieger 2000. Cornelia Plieger. "Picasso und das Figurenbild im Kubismus." In *Picasso, Figur und Porträt: Hauptwerke aus der Sammlung Bernard Picasso* (Vienna–Tübingen 2000–2002), pp. 11–21.

Podoksik 1989. Anatoli Podoksik. *Picasso: La Quête perpétuelle*. Paris, 1989.

Podoksik 1996. Anatoli Podoksik. *Pablo Picasso and the Creative Eye, from 1881 to 1914*. Translated by Vladimir Pozner. Bournemouth, 1996.

Poggi 1992. Christine Poggi. *In Defiance of Painting: Cubism, Futurism, and the Invention of Collage*. New Haven, 1992.

Pool 1959. Phoebe Pool. "Sources and Background of Picasso's Art, 1900–6." *Burlington Magazine* 101, no. 674 (May 1959), pp. 176–82.

Pool 1960. Phoebe Pool. "The Picasso Exhibition: The Most Important Four Rooms" (review of London 1960). *Burlington Magazine* 102, no. 690 (September 1960), pp. 386–92.

Pool 1965. Phoebe Pool. "Picasso's Neo-Classicism: First Period, 1905–6." *Apollo*, n.s., 81, no. 36 (February 1965), pp. 123–25. Reprinted in *Estudios sobre Picasso*, edited by Victoria Combalía Dexeus. Barcelona and Madrid, 1981.

Pophanken and Billeter 2001. Andrea Pophanken and Felix Billeter. *Die Moderne und ihre Sammler: Französische Kunst in Deutschem Privatbesitz vom Kaiserreich zur Weimarer Republik*. Berlin, 2001.

Porzio and Valsecchi 1974. Domenico Porzio and Marco Valsecchi. *Understanding Picasso*. New York, 1974.

Prampolini 1953. Enrico Prampolini. "Incontro di Picasso con Roma." In *La Biennale di Venezia* nos. 13–14 (1953), pp. 53–54.

Prideaux 1968. Tom Prideaux. "Terrible Ladies of Avignon—Cubism." In "Special Double Issue: Picasso," *Life Magazine* 65, no. 26 (December 27, 1968), pp. 58–63.

Rabinow 2000. Rebecca A. Rabinow. "Modern Art Comes to the Metropolitan: The 1921 Exhibition of 'Impressionist and Post-Impressionist Paintings.'" *Apollo* 152, no. 464 (2000), pp. 3–12.

Ramié 1974. Georges Ramié. *Céramique de Picasso*. Paris, 1974.

Ramié 1976. Georges Ramié. *Picasso's Ceramics*. Translated by Kenneth Lyons. New York, 1976.

Rapoport 2009. Maria Rapoport, ed. "A New Artist for a New Century." *Scholastic Art* 39, no. 5 (March 2009), pp. 1–5.

Ratcliff 1977. Carter Ratcliff. "Picasso's 'Harlequin': Remarks on the Modern's 'Harlequin.'" *Arts Magazine* 51, no. 5 (January 1977), pp. 124–26.

Raynal 1921. Maurice Raynal. *Picasso.* Translated from the French manuscript by Ludwig Gorm. Munich, 1921.

Raynal 1922. Maurice Raynal. *Picasso.* Paris, 1922.

Raynal 1959. Maurice Raynal. *Picasso.* Translated by James Emmons. Geneva, 1959.

H. Read 1948. Herbert Read. *Art Now: An Introduction to The Theory of Modern Painting and Sculpture.* 3rd ed. London, 1948.

H. Read 1956. Herbert Read. *The Art of Sculpture.* New York, 1956.

H. Read 1964. Herbert Read. *A Concise History of Modern Sculpture.* New York, 1964.

H. Read 1985. Herbert Read. *A Concise History of Modern Sculpture.* New ed. New York, 1985.

P. Read 1995. Peter Read. *Picasso et Apollinaire: Les Métamorphoses de la mémoire, 1905–1973.* Paris, 1995.

P. Read 1997. Peter Read. "'Au rendez-vous des poètes': Picasso, French Poetry, and Theater, 1900–1906." In *Picasso: The Early Years, 1892–1906* (Washington–Boston 1997–98), pp. 210–23.

P. Read 2008. Peter Read. *Picasso and Apollinaire: The Persistence of Memory.* Berkeley, 2008.

Redmond and Easby 1948. Roland L. Redmond and Dudley T. Easby Jr. "Report of the Trustees for the Year 1947." *Metropolitan Museum of Art Bulletin* 7, no. 1 (summer 1948), pp. 7–9.

Reff 1966. Theodore Reff. Review of Blunt and Pool 1962. *Art Bulletin* 48, no. 2 (June 1966), pp. 263–67.

Reff 1971. Theodore Reff. "Harlequins, Saltimbanques, Clowns, and Fools." *Artforum* 10 (October 1971), pp. 30–43.

Reff 1973. Theodore Reff. "Themes of Love and Death in Picasso's Early Work." In Penrose and Golding 1973, pp. 11–47.

Reff 1976. Theodore Reff. "Picasso and the Circus." In *Memoriam Otto J. Brendel: Essays in Archaeology and the Humanities,* edited by Larissa Bonfante and Helga von Heintze, pp. 237–48. Mainz, 1976.

Reid 1968. Benjamin Lawrence Reid. *The Man from New York: John Quinn and His Friends.* New York, 1968.

Reif 1989a. Rita Reif. "A Rose-Period Picasso Is to Be Auctioned." *The New York Times,* September 8, 1989, p. c16.

Reif 1989b. Rita Reif. "Walter Annenberg Buys a Picasso Painting for $40.7 Million." *The New York Times,* November 16, 1989, p. c23.

Reinach 1897–1931. Salomon Reinach. *Répertoire de la statuaire grecque et romaine.* 6 vols. Paris, 1897–1931.

Reliquet and Reliquet 1999. Scarlet Reliquet and Philippe Reliquet. *Henri-Pierre Roché: L'Enchanteur collectionneur.* Paris, 1999.

J. Rewald 1987. John Rewald. *Cézanne, the Steins, and Their Circle.* New York, 1987.

S. Rewald 1993. Sabine Rewald. "Pablo Picasso, *At the Lapin Agile.*" In "Recent Acquisitions: A Selection, 1992–1993," *Metropolitan Museum of Art Bulletin,* n.s., 51, no. 2 (autumn 1993), p. 63.

S. Rewald 1997. Sabine Rewald. "Pablo Picasso, *Harlequin.*" In "Recent Acquisitions: A Selection, 1996–1997," *Metropolitan Museum of Art Bulletin,* n.s., 55, no. 2 (autumn 1997), p. 76.

S. Rewald 2000. Sabine Rewald. "Pablo Picasso, *The Scream.*" In "Recent Acquisitions: A Selection, 1999–2000," *Metropolitan Museum of Art Bulletin,* n.s., 58, no. 2 (autumn 2000), p. 59.

Reynolds 2007. Nigel Reynolds. "Under-18s Are Banned from X-Rated Exhibition" (review of London 2007–8). *Telegraph* (February 22, 2007). http://www.telegraph.co.uk/news/uknews/1543427/Under-18s-are-banned-from-x-rated-exhibition.html.

Rich 1933. Daniel Catton Rich. "The Exhibition of French Art, Art Institute of Chicago" (review of Chicago 1933). *Formes* (American edition, Philadelphia) 33 (1933), pp. 381–83.

Richardson 1980. John Richardson. "Your Show of Shows" (review of New York 1980). *New York Review of Books* 27, no. 12 (July 17, 1980). www.nybooks.com/articles/7342.

Richardson 1984. John Richardson. "The Catch in the Late Picasso." *New York Review of Books* 31, no. 12 (July 19, 1984). http://www.nybooks.com/articles/article-preview?article_id=5785.

Richardson 1987. John Richardson. "Rediscovering an Early Modern Vision: The Dial Collection Recalls the Life and Times of Scofield Thayer." *House and Garden* 159, no. 2 (February 1987), pp. 158–63, 215–16.

Richardson 1988. John Richardson. "L'Époque Jacqueline." In *Late Picasso* (London 1988), pp. 16–48.

Richardson 1991. John Richardson. "Picasso and Gertrude Stein: Mano a Mano, Tête à Tête." *New York Times,* February 10, 1991, pp. 31, 36.

Richardson 1991–2007. John Richardson, with Marilyn McCully. *A Life of Picasso.* 3 vols. to date. New York, 1991–2007.

Richardson 1994. John Richardson. "Picasso und Deutschland vor 1914." In *Kunst des 20. Jahrhunderts; 20 Jahre Wittrock Kunsthandel; 20 Werke,* edited by Heiko Andreas and Wolfgang Wittrock, pp. 10–24. Düsseldorf, [1994].

Richardson 2001. John Richardson. "The Madness of Scofield Thayer." In John Richardson, *Sacred Monsters, Sacred Masters: Beaton, Capote, Dali, Picasso, Freud, Warhol, and More,* pp. 19–28. New York, 2001.

Richardson 2009. John Richardson. "Great Late Picasso." In *Picasso: Mosqueteros* (New York 2009), pp. 15–35.

Riding 2001. Alan Riding. "Picasso's Carnal Carnival" (review of Paris–Montreal–Barcelona 2001–2). *New York Times,* March 22, 2001, p. E1–E2.

Rilke 2009. Rainer Maria Rilke. *Briefe an Hertha Koenig, 1914–1921.* Edited by Theo Neteler. Bielefeld, 2009.

Risatti and Colosimo 2000. Howard Risatti and Christina L. Colosimo. "Classicism, Iberianism, and Primitivism in Picasso, 1906–1907." *Southeastern College Art Conference* Review 13, no. 5 (2000), pp. 445–58.

Roché 1959. Henri-Pierre Roché. "Adieu, brave petite collection!" *L'Oeil,* no. 51 (March 1959), pp. 34–40. Reprinted in Roché 1998.

Roché 1998. Henri-Pierre Roché. *Écrits sur l'art.* Edited by Serge Fauchereau. Marseilles, 1998.

Rodriguez 1984–85. Jean-François Rodriguez. "Picasso à la Biennale de Venise (1905–1948): Sur deux letters de Picasso à Ardengo Soffici." *Atti dell'Instituti Veneto di Scienze, Lettere ed Arti* 143 (1984–85), pp. 27–63.

Rodriguez 2001. Jean-François Rodriguez. "*Le Cafard après la fête . . .*": *Naturisme e rappel à l'ordre tra Francia e Italia nelle lettere di Louis Rouart, Eugène Montfort e Adolphe Basler ad Ardengo Soffici, 1910–1932.* Padua, 2001.

Rodríguez Codolà 1900. [Rodríguez Codolà.] "Els IV Gats: Exposición Ruiz Picazzo [sic]" (review of Barcelona 1900). *La Vanguardia,* February 3, 1900. Reprinted in Palau i Fabre 2006, pp. 265–66.

Rogers et al. 1936. John Williams Rogers et al. "Dallas Exhibit Reveals World's Art and Significance of Southwest" (review of Dallas 1936). In "Texas Centennial Special Number," *Art Digest* (New York) 10, no. 17 (June 1, 1936), pp. 9–32.

Rohe 1913. M[aximilian] K. Rohe. "Pablo Picasso" (review of Munich 1913). *Die Kunst für Alle* 28 (1913), pp. 377–84.

Rose 1993. Barbara Rose. "Jasper Johns: The 'Tantric Details.'" *American Art* 7, no. 4 (autumn 1993), pp. 47–71.

Rosenbaum 1996. Lee Rosenbaum. "Visual Reality." *www.artnet.com,* December 20, 1996.

Rosenberg 1959. Jakob Rosenberg. *Great Draughtsmen from Pisanello to Picasso.* Cambridge, Mass., 1959.

Rosenberg 1974. Jakob Rosenberg. *Great Draughtsmen from Pisanello to Picasso.* Rev. ed. New York, 1974.

Rosenblum 1960. Robert Rosenblum. *Cubism and Twentieth-Century Art.* New York, 1960.

Rosenblum 1967. Robert Rosenblum. *Jean-Auguste-Dominique Ingres.* New York, 1967.

Rosenblum 1970. Robert Rosenblum. "Picasso and the Anatomy of Eroticism." In *Studies in Erotic Art*, edited by Theodore Bowie and Cornelia V. Christenson, pp. 337–50. New York, 1970.

Rosenblum 1971. Robert Rosenblum. "Picasso and the Coronation of Alexander III: A Note on the Dating of Some Papiers Collés." *Burlington Magazine* 113 (October 1971), pp. 602, 604–7.

Rosenblum 1976. Robert Rosenblum. *Cubism and Twentieth-Century Art*. Rev. ed. New York, 1976.

Rosenblum 1997. Robert Rosenblum. "Picasso in Gósol: The Calm Before the Storm." In *Picasso, The Early Years, 1892–1906* (Washington–Boston 1997–98), pp. 263–75.

Rosenblum 1999. Robert Rosenblum. "Ingres's Portraits and Their Muses." In *Portraits by Ingres: Image of an Epoch* (London–Washington–New York 1999–2000), pp. 3–23.

Rosenthal 1951. G[ertrude] R[osenthal]. "Portraits of Gertrude Stein in the Collections of the Baltimore Museum." *Baltimore Museum of Art News* 13, no. 7 (April 1951), pp. 1–4.

Rosenthal 1967. Gertrude Rosenthal. *Paintings, Sculpture and Drawings in the Cone Collection*. Baltimore, 1967.

Roussard 2001. André Roussard. *Dictionnaire des lieux à Montmartre*. Paris, 2001.

Rousseau 1952. Theodore Rousseau Jr. "Reports of the Departments: Paintings." In "Eighty-Second Annual Report, . . ." *Metropolitan Museum of Art Bulletin*, n.s., 11, no. 1 (1952), pp. 32–33.

Rousseau 1954. Theodore Rousseau Jr. "A Guide to the Picture Galleries." *Metropolitan Museum of Art Bulletin*, n.s., 12, no. 5, part 2 (January 1954).

Rowell 1986. Margit Rowell. "Note liminaire." In *Qu'est-ce que la sculpture moderne?* (Paris 1986), pp. 15–23, 431, no. 5.

Rubin 1972. William Rubin. *Picasso in the Collection of The Museum of Modern Art, including Remainder-Interest and Promised Gifts*. Additional texts by Elaine L. Johnson and Riva Castleman. New York, 1972. Published to accompany New York 1972.

Rubin 1979. William Rubin. "Pablo and Georges and Leo and Bill." *Art in America* 67 (March–April 1979), pp. 128–47.

Rubin 1984. William Rubin. "Picasso." In *"Primitivism" in 20th Century Art: Affinity of the Tribal and the Modern* (New York–Detroit–Dallas 1984–85), vol. 1, pp. 241–343.

Rubin 1994. William Rubin. "The Pipes of Pan: Picasso's Aborted Love Song to Sara Murphy." *Artnews* 93, no. 5 (May 1994), pp. 138–47.

Rubin 1996. William Rubin. "Reflections on Picasso and Portraiture." In *Picasso and Portraiture: Representation and Transformation* (New York–Paris 1996–97), pp. 13–109.

Rubin 1996a. William Rubin. "The Jacqueline Portraits in the Pattern of Picasso's Art." In *Picasso and Portraiture: Representation and Transformation* (New York–Paris 1996–97), pp. 447–84.

Rubin, Seckel, and Cousins 1994. William Rubin, Hélène Seckel, and Judith Cousins. *Les Demoiselles d'Avignon*. Studies in Modern Art, 3. New York, 1994. Rev. ed. of Paris–Barcelona 1988.

Rubin and Zelevansky 1992. William Rubin, organizer, and Lynn Zelevansky, ed. *Picasso and Braque: A Symposium*. Moderated by Kirk Varnedoe. New York, 1992.

Ruchon 1947. François Ruchon, ed. *Verlaine: Documents Iconographiques*. Geneva, 1947.

Russell 1983. John Russell. "70 Drawings by Picasso: Picasso Drawings and Sculpture Shown" (review of New York 1983). *New York Times*, November 4, 1983, pp. C1, C20.

Russell 1994. John Russell. "Art View: Picasso's Studios Disgorge His Inspirations." *New York Times*, March 27, 1994, pp. 42–43.

Russell 1998. John Russell. "Natasha Gelman, Collector of 20th-Century Fine Art, 86." *New York Times*, May 6, 1998, p. D23.

Russoli and Minervino 1972. Franco Russoli and Fiorella Minervino. *L'opera completa di Picasso cubista*. Milan, 1972.

Saarinen 1958. Aline B[ernstein] Saarinen. *The Proud Possessors: The Lives, Times and Tastes of Some Adventurous American Art Collectors*. New York, 1958.

Sabartés 1946a. Jaime Sabartés. *Paintings and Drawings of Picasso*. Paris, 1946. French ed.: *Picasso*. Paris, 1946.

Sabartés 1946b. Jaime Sabartés. *Picasso: Portraits & Souvenirs*. Translated by Paule-Marie Grand and André Chastel. Paris, 1946.

Sabartés 1948. Jaime Sabartés. *Picasso: An Intimate Portrait*. Translated from 1946 Spanish edition by Angel Flores. New York, 1948.

Sabartés 1953. Jaime Sabartés. *Picasso: Retratos y recuerdos*. Madrid, 1953.

Sabartés 1954. Jaime Sabartés. *Picasso: Documents iconographiques*. Geneva, 1954.

Sabin 2002. Stefana Sabin. "Refracted Perspective: Gertrude Stein, Pablo Picasso and Artistic Experimentation." In *Picasso and Women—Picasso et les femmes* (Chemnitz 2002–3), pp. 90–101.

Safran 1989. Rose Safran. "Picasso and Ogunquit's Hamilton Easter Field" (review of New York 1989–90). *York Weekly* (Maine), December 13, 1989.

Salber 2007. Linde Salber. *Geniale Geschwister: Elisabeth Und Friedrich Nietzsche, Getrude und Leo Stein, Ana María und Salvador Dalí, Erika und Klaus Mann*. Munich, 2007.

Salmon 1906. André Salmon. *Poèmes*. Paris, 1906.

Salmon 1955–61. André Salmon. *Souvenirs sans fin*. 3 vols. Paris, 1955–61.

Salmon 2004. André Salmon. *Souvenirs sans fin (1903–1940)*. Paris, 2004.

Saltzman 1998. Cynthia Saltzman. *Portrait of Dr. Gachet: The Story of a Van Gogh Masterpiece. Modernism, Money, Politics, Collectors, Dealers, Taste, Greed, and Loss*. New York, 1998.

Sanouillet 1966. Michel Sanouillet. *Francis Picabia et 391*. Paris, 1966.

Schaeffner 1930. André Schaeffner. "L'Homme à la clarinette." In Bataille 1930, pp. 160–65.

Schama 1988. Simon Schama. *The Embarrassment of Riches: An Interpretation of Dutch Culture in the Golden Age*. Berkeley, 1988.

Schapiro 1937. Meyer Schapiro. "The Nature of Abstract Art." *Marxist Quarterly* 1, no. 1 (January–March 1937), pp. 77–98.

Schapiro 1976. Meyer Schapiro. "Picasso's *Woman with a Fan*: On Transformation and Self-Transformation." In *Essays in Archaeology and the Humanities*, edited by Larissa Bonfante and Helga von Heintze, pp. 249–54. Mainz, 1976. Reprinted in Schapiro 1978.

Schapiro 1978. Meyer Schapiro. "Picasso's *Woman with a Fan*: On Transformation and Self-Transformation." In Meyer Schapiro, *Modern Art, 19th and 20th Centuries: Selected Papers*, pp. 111–20. New York, 1978.

Schapiro 2000. Meyer Schapiro. *The Unity of Picasso's Art*. New York, 2000.

Scheffler 1913. Karl Scheffler. "Die Letzte Austellung der Berliner Sezession" (review of Berlin 1913). *Kunst und Künstler* 12 (December 1, 1913), pp. 199–207.

Schiff 1976. Gert Schiff, ed. *Picasso in Perspective*. Englewood Cliffs, N.J., 1976.

Schneider 1947–48. Daniel E. Schneider. "The Painting of Pablo Picasso: A Psychoanalytic Study." *College Art Journal* 7, no. 2 (winter 1947–48), pp. 81–95.

Schürer 1927. Oskar Schürer. *Pablo Picasso*. Berlin and Leipzig, 1927.

Seckel 1992. Hélène Seckel. *Picasso: Les Chefs-d'oeuvre de la période rose. Quarante tableaux*. Munich and Paris, 1992.

Seckel and Weiss 1993. Hélène Seckel and Jeffrey S. Weiss. "Picasso." In *Great French Paintings from the Barnes Foundation: Impressionist, Post-impressionist, and Early Modern*, pp. 190–207. New York, 1993.

Seckel-Klein 1999. Hélène Seckel-Klein. "Deux jalons historiques de l'oeuvre graphique de Picasso entrent dans les collections publiques grâce à la dation Dora Maar: Le Portrait de Max Jacob, 1915; Dora et le Minotaure (Composition), 1936." *Revue du Louvre: La Revue des Musées de France* 49 (October 1999), pp. 20–23.

Seghers 1970. Lode Seghers. "Mercado de las artes en el extranjero." *Goya* (Madrid), no. 94 (January–February 1970), pp. 256–58.

Shapiro 1999. Norman R. Shapiro, trans. *One Hundred and One Poems by Paul Verlaine: A Bilingual Edition*. Chicago and London, 1999.

Shoolman and Slatkin 1942. Regina Shoolman and Charles E. Slatkin. *The Enjoyment of Art in America.* Philadelphia and New York, 1942.

Shubinski 2007. Julianna Shubinski. "From Exception to Norm: Deaccessioning in Late Twentieth-Century American Art Museums." M.A. thesis, Graduate School of the University of Kentucky, Lexington, 2007.

Sieberling 1968. Dorothy Sieberling, ed. "Picasso: His Disguises." In "Special Double Issue: Picasso," *Life Magazine* 65, no. 26 (December 27, 1968), pp. 122–34.

Silver 1988. Kenneth E. Silver. "Der politische Bezug in Picassos Neoklassizismus." In *Picassos Klassizismus: Werke von 1914–1934* (Bielefeld 1988), pp. 77–88.

Silver 1989. Kenneth E. Silver. *Esprit de Corps: The Art of the Parisian Avant-Garde and the First World War, 1914–1925.* Princeton, 1989.

Simon 1977. Linda Simon. *The Biography of Alice B. Toklas.* Garden City, N.Y., 1977.

Simon 1994. Linda Simon. *Gertrude Stein Remembered.* Lincoln, Neb., and London, 1994.

Skidelsky 1939. Sibilla Skidelsky. "Autumn Forecast: A Preview of Exhibitions Scheduled for the Artistic Season" (announcing New York and other cities 1939–41). *Mademoiselle* (New York), October 1939, p. 55.

Skira 1921. Albert Skira, ed. *Picasso.* Geneva, 1921.

Soby 1939. James Thrall Soby. "Picasso: A Critical Estimate" (review of New York and other cities 1939–41). *Parnassus* 11, no. 8 (December 1939), pp. 8–12.

Sotheby's sale 1989. "Pablo Picasso, *Au Lapin Agile,* The Property of Mrs. Vincent de Roulet." Sale, Sotheby's, New York, November 15, 1989. Issued separately from rest of sale: *Impressionist and Modern Paintings and Sculpture.*

Sotheby's sale 2006. *Pablo Picasso: Works from an Important Sketchbook of 1905, Lots 123–144 in the Sale of Impressionist & Modern Art Works on Paper.* Sale, Sotheby's, London, February 8, 2006.

Spies 1971. Werner Spies. *Sculpture by Picasso, with a Catalogue of the Works.* Translated by J. Maxwell Brownjohn. New York, 1971.

Spies 2000. Werner Spies, with Christine Piot. "Catalogue Raisonné of the Sculptures." In *Picasso: Sculpteur* (Paris 2000), pp. 345–424.

Staller 1986. Natasha Staller. "Early Picasso and the Origins of Cubism." *Arts Magazine* 61, no. 1 (September 1986), pp. 80–91.

Staller 1989. Natasha Staller. "Méliès' 'Fantastic' Cinema and the Origins of Cubism." *Art History* 12, no. 2 (June 1989), pp. 202–32.

Staller 2001. Natasha Staller. *A Sum of Destructions: Picasso's Cultures and the Creation of Cubism.* New Haven and London, 2001.

Steegmuller 1973. Francis Steegmuller. *Cocteau: A Biography.* Paris, 1973.

G. Stein 1912. Gertrude Stein. "Pablo Picasso." *Camera Work,* August 1912, special number, pp. 29–30.

G. Stein 1924. Gertrude Stein. "If I Told Him: A Completed "Portrait" of Pablo Picasso, in an Eccentric Modern Manner." *Vanity Fair* 21, no. 8 (April 1924), p. 40.

G. Stein 1933. Gertrude Stein. *The Autobiography of Alice B. Toklas.* New York, 1933.

G. Stein 1934. Gertrude Stein. "L'Atelier de Gertrude Stein." *Gazette des beaux-arts,* ser. 6, 11, 76e année (1934), pp. 232–43.

G. Stein 1937. Gertrude Stein. *Everybody's Autobiography.* New York, 1937. Reprinted Cambridge, 1993.

G. Stein 1938a. Gertrude Stein. *Picasso.* Anciens et modernes, 14. Paris, 1938.

G. Stein 1938b. Gertrude Stein. *Picasso.* London and New York, 1938. Reprinted London and New York, 1946.

G. Stein 1954. Gertrude Stein. *As Fine as Melanctha, 1914–1930.* New Haven, 1954.

G. Stein 1955. Gertrude Stein, with an introduction by Daniel-Henry Kahnweiler. *Painted Lace and Other Pieces, 1914–1937.* New Haven, 1955.

G. Stein 1998a. Gertrude Stein. *Writings: 1903–1932.* New York, 1998.

G. Stein 1998b. Gertrude Stein. *Writings: 1932–1946.* New York, 1998.

L. Stein 1947. Leo Stein. *Appreciation: Painting, Poetry and Prose.* New York, 1947.

L. Stein 1950. *Journey into the Self: Being the Letters, Papers, and Journals of Leo Stein.* Edited by Edmund Fuller; introduction by Van Wyck Brooks. New York, 1950.

L. Stein 1996. Leo Stein. *Appreciation: Painting, Poetry and Prose.* New ed.; introduction by Brenda Wineapple. Lincoln, Neb., 1996.

S. Stein and Miller 2009. Susan Alyson Stein and Asher Ethan Miller, eds. *Masterpieces of Impressionism and Post-Impressionism: The Annenberg Collection.* Texts by Colin B. Bailey, Joseph J. Rishel, Mark Rosenthal, and Susan Alyson Stein. New ed. New York, 2009.

Steinberg 1978. Leo Steinberg. "Resisting Cézanne: Picasso's *Three Women.*" *Art in America* 66, no. 6 (November–December 1978), pp. 114–33.

Steinberg 1979. Leo Steinberg. "The Polemical Part." *Art in America* 67, no. 2 (March–April 1979), pp. 114–27.

Steinberg 1981. Leo Steinberg. "El burdel filosófico." In Combalía Dexeus 1981, pp. 99–135.

Steinberg 1988. Leo Steinberg. "Kvinnorna i Alger och Picasso i stort." In *Pablo Picasso* (Stockholm 1988–89), pp. 121–222.

Steinberg 2007. Leo Steinberg. "Resisting Cézanne: Picasso's *Three Women.*" In *Cubist Picasso* (Paris 2007–8), pp. 71–101. French ed.: "La Résistance à Cézanne: Les *Trois femmes* de Picasso" (translated by Jean-Louis Houdebine).

Steiner 1987. Wendy Steiner. "Postmodernist Portraits." *Art Journal* 46, no. 3 (autumn 1987), pp. 173–77.

Stendhal 1989. Renate Stendhal, ed. *Gertrude Stein: Ein Leben in Bildern und Texten.* Zürich, 1989.

Stendhal 1994. Renate Stendhal, ed. *Gertrude Stein in Words and Pictures: A Photobiography.* Chapel Hill, N.C., 1994. Translation of the 1989 ed.

Sterling and Salinger 1967. Charles Sterling and Margaretta M. Salinger. *French Paintings: A Catalogue of the Collection of the Metropolitan Museum of Art.* Vol. 3. New York, 1967.

Steward 1977. Samuel Steward, ed. *Dear Sammy: Letters from Gertrude Stein and Alice B. Toklas.* Boston, 1977.

Stieglitz 1911. Alfred Stieglitz. "Post-Impressionism in America." *The Evening Sun,* December 18, 1911.

Stieglitz 1939. Alfred Stieglitz. "Under Postage: [Letter] to the Art Editor." *New York Times,* December 24, 1939, p. 91.

Stieglitz 1997. *Alfred Stieglitz. Camera Work: The Complete Illustrations, 1903–1917.* Edited by Simone Philippi and Ute Kieseyer. Cologne, 1997.

Story 1994. Richard David Story. "The Tops in Town this Week" (review of Los Angeles–New York–Chicago 1994–95). *New York Magazine,* June 20, 1994, p. 33.

Sutton 1948. Denys Sutton. *Picasso, Peintures: Époques bleue et rose.* Paris, 1948. English ed.: *Picasso: Blue and Pink Periods.* London, 1948.

Sutton 1955. Denys Sutton. *Picasso, Peintures: Époques bleue et rose.* [2nd ed.] Paris, 1955.

Sutton 1972. Denys Sutton, ed. *The Letters of Roger Fry.* 2 vols. New York, 1972.

Sweeney 1941. James Johnson Sweeney. "Picasso and Iberian Sculpture." *Art Bulletin* 23 (September 1941), pp. 190–98.

Sweet 1940. Frederick A. Sweet. "Picasso: Forty Years of His Art" (review of New York and other cities 1939–41). *Bulletin of the Art Institute of Chicago* 34, no. 2 (February 1940), pp. 21–24.

Tait 1994. Simon Tait. "Seen through the Eyes of a Sculptor" (review of London 1994). *(London) Times,* January 31, 1994.

Von Tavel 1992. Hans Christoph von Tavel. "Man and Woman in Picasso's Work in 1905 and 1906." In *Picasso, 1905–1906: De l'epoca rosa als ocres de Gósol* (Barcelona–Bern 1992), pp. 89–96.

B. Taylor 2004. Brandon Taylor. *Collage: The Making of Modern Art.* London and New York, 2004.

F. Taylor 1932. F[rancis] H[enry] T[aylor]. "Modern French Paintings in the Museum." *Bulletin of The Worcester Art Museum* 22, no. 4 (January 1932), pp. 64–72.

Ténèze, Enshaïan, and Hincelin 2009. Annabelle Ténèze, Marie-Christine Enshaïan, and Emmanuel Hincelin. "First Steps toward a Study of Papers and Watermarks in the Drawings of Picasso." *Master Drawings* 47, no. 1 (spring 2009), pp. 17–52.

Thayer 1923. Scofield Thayer, ed. *Living Art: Twenty Facsimile Reproductions after Paintings, Drawings and Engravings and Ten Photographs after Sculpture by Contemporary Artists.* New York: Dial Pub. Co., 1923.

Thayer 1927. Scofield Thayer, ed. "Collection John Quin [*sic*]." *The Dial* 82 (June 1927), p. 5.

Thomas 1975. Denis Thomas. *Picasso and His Art.* London, 1975.

Thornley 1889. George William Thornley. *Quinze lithographies d'après Degas.* Paris, 1889.

Tinterow 1987. Gary Tinterow. *Modern Europe: The Metropolitan Museum of Art.* New York, 1987.

Tinterow 1991. Gary Tinterow. "Miracle au Met." *Connaissance des arts,* no. 472 (June 1991), pp. 32–40.

Tinterow 2006. Gary Tinterow. "Vollard and Picasso." In *Cézanne to Picasso: Ambroise Vollard, Patron of the Avant-Garde* (New York–Chicago–Paris 2006–7), pp. 101–17.

Tinterow 2007. Gary Tinterow. "Treasured Paintings Travel from the Metropolitan Museum of Art to the MFAH: Remarks Delivered at the Exhibition Opening Reception." In *The Museum of Fine Arts, Houston: Annual Report for the Fiscal Year July 1, 2006–June 30, 2007,* pp. 43–45. Houston, 2007.

Tinterow et al. 2007. Gary Tinterow, ed. *Masterpieces of European Painting, 1800–1920, in The Metropolitan Museum of Art.* Texts by Kathryn Calley Galitz, Asher Ethan Miller, Rebecca A. Rabinow, Sabine Rewald, Susan Alyson Stein, and Gary Tinterow. New York, 2007.

Toklas 1963. Alice B. Toklas. *What Is Remembered.* New York, 1963.

Tomkins 1970. Calvin Tomkins. *Merchants and Masterpieces: The Story of the Metropolitan Museum of Art.* New York, 1970.

Tomkins 1989. Calvin Tomkins. *Merchants and Masterpieces: The Story of the Metropolitan Museum of Art.* Rev. ed. New York, 1989.

Topalian 1986. Elyse Topalian. "Modern Art in the Met." *Apollo* 124, no. 296 (October 1986) pp. 362–63.

Trincia 1997. Stefano Trincia. "Che scandalo: Il Metropolitan censura un Picasso 'a luci rosse.'" *Il Messagero,* March 11, 1997, p. 20.

Trog 1914. [Hans] T[rog]. "Kunstchronik, Pablo Picasso" (review of Zürich 1914). *Neue Zürcher Zeitung* 135, no. 586 (April 17, 1914), p. 1.

Tuchman 1994. Phyllis Tuchman. "A Sweeping Look at Picasso" (review of London 1994). *New York Newsday,* May 3, 1994.

Tucker 1982. Paul Hayes Tucker. "Picasso, Photography, and the Development of Cubism." *Art Bulletin* 64 (June 1982), pp. 288–99.

Tuma 2003. Kathryn A. Tuma. "La Peau de chagrin." In *Picasso: The Cubist Portraits of Fernande Olivier* (Washington–Dallas 2003–4), pp. 127–63.

Utley 2000. Gertje R. Utley. *Picasso, the Communist Years.* London and New Haven, 2000.

Utrillo 1906. Miguel Utrillo. *Komenikos Theotokopulos, "Le Greco."* Barcelona, [1906].

Vaill 1998. Amanda Vaill. *Everybody Was So Young: Gerald and Sara Murphy, a Lost Generation Love Story.* Boston, 1998.

Vallan 1994. Guilia d'Agnolo Vallan. "Se habla de Picasso" (review of Los Angeles–New York–Chicago 1994–95). *Vogue España,* August 1994, p. 39.

Vallentin 1957. Antonina Vallentin. *Pablo Picasso.* Paris, 1957.

Vallier 1954. Dora Vallier. "Braque: La Peinture et nous." *Cahiers d'art* (Paris) 29, no. 1 (October 1954), pp. 13–26.

Varnedoe 1995. Kirk Varnedoe. "The Evolving Torpedo: Changing Ideas of the Collection of Painting and Sculpture of the Museum of Modern Art." In *Studies in Modern Art,* no. 5: *The Museum of Modern Art at Mid-Century: Continuity and Change,* pp. 12–73. New York, 1995.

Varnedoe 1996. Kirk Varnedoe. "Picasso's Self-Portraits." In *Picasso and Portraiture: Representation and Transformation* (New York–Paris 1996–97), pp. 111–79.

Vauxcelles 1937. Louis Vauxcelles. "Verlaine." In *Éditions originales et autographes de Charles Baudelaire, Paul Verlaine, Arthur Rimbaud.* Paris, 1937.

Van Vechten 1914. Carl Van Vechten. "How to Read Gertrude Stein." *The Trend* (August 1914), pp. 553–57. Reprinted in Simon 1994.

Verdet 2000. André Verdet. "Autour du cubisme." In André Verdet, *Entretiens, notes et écrits sur la peinture: Braque, Léger, Matisse, Picasso, Chagall. Essai.* Nantes, 2000.

Vigne 1995. Georges Vignes. *Dessins d'Ingres: Catalogue raisonné des dessins du Musée de Montauban.* Paris, 1995.

Vinchon 1951. Jean Vinchon. "Les Mythes du taureau et du cheval dans les arts normaux et pathologiques." *Art d'aujourd'hui* 2, no. 8 (October 1951), pp. 14–16.

Virch 1962. Claus Virch. *Master Drawings in the Collection of Walter C. Baker.* New York, 1962.

Vogel 1996a. Carol Vogel. "Met is Given 13 Works Worth Over $60 Million." *New York Times,* May 20, 1996, pp. C11–12.

Vogel 1996b. Carol Vogel. "32 Works of Art by Masters Left to Met and the Modern." *New York Times,* November 25, 1996, pp. A1, C12.

Vollard 1936. Ambroise Vollard. *Recollections of a Picture Dealer.* Translated by Violet M. Macdonald. Boston, 1936. Reprinted New York, 1978.

Volta 1998. Ornella Volta. "Picasso and Italy: The Last Memories of His Journey." In *Picasso: The Italian Journey, 1917–1924* (Venice 1998), pp. 87–92.

Waldemar George 1924. Waldemar George. *Pablo Picasso.* Rome, 1924.

Waldemar George 1926. Waldemar George. *Picasso, dessins.* Paris, 1926.

Waldemar George 1932. Waldemar George. "Aut Caesar aut Nihil: The Picasso Exhibition" (review of Paris 1932). *Formes* (Paris and Philadelphia), no. 25 (May 1932), pp. 268–71.

Waldman 1992. Diane Waldman. *Collage, Assemblage, and the Found Object.* New York, 1992.

Warncke 1992. Carsten-Peter Warncke. *Pablo Picasso, 1881–1973.* 2 vols. Cologne, 1992.

Warncke 1993. Carsten-Peter Warncke. *Pablo Picasso, 1881–1973.* 2 vols. Cologne, 1993.

Warnod 1972. Jeanine Warnod. *Washboat Days.* Translated by Carol Green. New York, 1972.

Warnod 1975. Jeanine Warnod. *Le Bateau Lavoir, 1892–1914.* Paris, 1975.

Warnod 1986. Jeanine Warnod. *Le Bateau Lavoir.* Paris, 1986.

Wasserstrom 1963. William Wasserstrom, ed. *A Dial Miscellany.* Syracuse, 1963.

F. Watson 1926. Forbes Watson, ed. *John Quinn, 1870–1925 [sic]: Collection of Paintings, Water Colors, Drawings and Sculpture.* Huntington, N.Y., 1926.

S. Watson 1998. Steven Watson. *Prepare for Saints: Gertrude Stein, Virgil Thomson, and the Mainstreaming of American Modernism.* New York, 1998.

Wattenmaker 1975. Richard J. Wattenmaker. *Puvis de Chavannes and the Modern Tradition.* Toronto, 1975.

Weiss 1995. Andrea Weiss. *Paris Was a Woman: Portraits from the Left Bank.* London, 1995.

Widmaier Picasso 2004. Diana Widmaier Picasso. "Marie-Thérèse Walter and Pablo Picasso: New Insights into a Secret Love." In *Pablo Picasso and Marie-Thérèse Walter: Between Classicism and Surrealism* (Münster 2004), pp. 27–35.

Widmaier Picasso 2006. Diana Widmaier Picasso. "Vollard and the Sculptures of Picasso." In *Cézanne to Picasso: Ambroise Vollard, Patron of the Avant-Garde* (New York–Chicago–Paris 2006–7), pp. 182–88.

Wight 1951. Frederick S. Wight. "The Eclipse of the Portrait." *Magazine of Art* 44, no. 4 (April 1951), pp. 129–31.

Wilenski 1940. R[eginald] H[oward] Wilenski. *Modern French Painters.* New York, 1940. Reprinted New York, 1954.

Wilkin 2008. Karen Wilkin. "Homage at the Metropolitan." *The New Criterion* 27 (December 2008), pp. 4–8.

Will-Levaillant 1971. Françoise Will-Levaillant. "La Lettre dans la peinture cubiste." In *Travaux IV: Le Cubisme, Actes du premier colloque d'Histoire de l'Art Contemporain tenu au Musée de l'art et de l'industrie, Saint-Étienne, les 19, 20, 21 novembre 1971, Centre Interdiscipliniare d'Études et de Recherche sur l'Expression Contemporaine.* Saint Étienne, 1971.

E. Wilson 1973. Ellen Wilson. *They Named Me Gertrude Stein.* New York, 1973.

F. Wilson 2007. Frances Wilson. "Reader, She ****** Him!" (review of London 2007–8). *Times Literary Supplement* (London), October 24, 2007.

K. Wilson 2009. Kristina Wilson. *The Modern Eye: Stieglitz, MoMA, and the Art of the Exhibition, 1925–1934.* New Haven and London, 2009.

Wineapple 1996. Brenda Wineapple. *Sister, Brother: Gertrude and Leo Stein.* New York, 1996.

Wood 1983. Jeremy Wood. "London, Tate Gallery Exhibition: The Essential Cubism, Braque, Picasso, & Their Friends, 1907–1920" (review of London 1983). *Pantheon* (Munich) 41, no. 3 (July–September 1983), pp. 204–27.

Woodward 2009. Richard B. Woodward. "A Modernist's Look Back" (review of London 2009). *Wall Street Journal,* April 29, 2009, p. B15.

de Zayas 1911. Marius de Zayas. "Pablo Picasso." *Camera Work,* no. 34–35 (April–July 1911), pp. 65–67.

de Zayas 1923. [Marius de Zayas]. "Picasso Speaks: A Statement by the Artist." *The Arts* 3 (May 1923), pp. 315–26. Reprinted in Barr 1946, pp. 270–71.

de Zayas 1996. Marius de Zayas, edited by Francis M. Naumann. *How, When, and Why Modern Art Came to New York.* Cambridge, Mass., 1996.

Zennström 1948. Per-Olov Zennström. *Pablo Picasso.* Stockholm, 1948.

Zervos 1926a. Christian Zervos. *Picasso: Oeuvres, 1920–1926.* Paris, 1926.

Zervos 1926b. Christian Zervos. "Oeuvres récentes de Picasso" (announcing Paris [Rosenberg] 1926). *Cahiers d'art* (Paris), no. 1 (1926), p. 91.

Zervos 1928a. Christian Zervos. "Picasso: Oeuvres inédites anciennes." *Cahiers d'art* 3, no. 5–6 (1928), pp. 204–27.

Zervos 1928b. Christian Zervos. "Sculptures des peintres d'aujourd'hui." *Cahiers d'art* 3, no. 7 (1928), pp. 276–89.

Zervos 1930. Christian Zervos. "De l'importance de l'objet dans la peinture d'aujourd'hui, III." *Cahiers d'Art* (Paris) 5, no. 6 (1930), pp. 281–94.

Zervos 1932–78. Christian Zervos. *Pablo Picasso.* 33 vols. Paris and New York, 1932–78.

Zervos 1935a. Christian Zervos. *Picasso: 1930–1935.* Paris, 1935.

Zervos 1935b. Christian Zervos. "Fait social et vision cosmique." *Cahiers d'art* 10 (1935), nos. 7–10 (1935), pp. 145–61.

Zervos 1935c. Christian Zervos. "Conversation avec Picasso." *Cahiers d'art* 10, no. 10 (1935), pp. 173–78.

Zervos 1938a. Christian Zervos. *Histoire de l'art contemporain.* Paris, 1938.

Zervos 1938b. Christian Zervos. "Tableaux magiques de Picasso," and a poem by Paul Éluard, "A Pablo Picasso." *Cahiers d'art* 13, nos. 3–10 (1938), pp. 73–136 and 137–96.

Zervos 1946. Christian Zervos, ed. "Peintures de Picasso et de Matisse." *Cahiers d'art* 20–21 (1946), p. 428.

Zervos et al. 1932. Christian Zervos et al. "Picasso" (special issue coinciding with Paris 1932). *Cahiers d'art* 7, nos. 3–5 (1932).

Zervos et al. 1935. Christian Zervos et al. "Picasso." *Cahiers d'art* 10, nos. 7–10 (1935).

Ziffer 1992. Alfred Ziffer, ed. *Bruno Paul: Deutsche Raumkunst und Architektur zwischen Jugendstil und Moderne.* Munich, 1992.

Index

354

Photograph Credits

Unless otherwise specified, all photographs were supplied by the owners of the works of art, who hold the copyright thereto, and are reproduced with permission. We have made every effort to obtain permissions for all copyright-protected images. If you have copyright-protected work in this publication and you have not given us permission, please contact the Metropolitan Museum's Editorial Department. Photographs of works in the Metropolitan Museum's collection are by the Photograph Studio, The Metropolitan Museum of Art; new photography is by Katherine Dahab, Mark Morosse, and Juan Trujillo, the Photograph Studio, The Metropolitan Museum of Art. Technical photography of works in the Metropolitan Museum is courtesy the Sherman Fairchild Centers for Paintings and Paper Conservation. Additional credits are as follows:

Images of works of art by Pablo Picasso © 2010 Estate of Pablo Picasso / Artists Rights Society (ARS), New York

Alinari / Art Resource, NY: fig. 68.3

© The Art Institute of Chicago: figs. 12, 26.2, 37.1

© Artists Rights Society (ARS), New York / SOMAAP, Mexico City: fig. 15

Baldassari 2000, pp. 68–69, fig. 59: fig. 58.1

© Banco de México Diego Rivera Frida Kahlo Museums Trust, Mexico, D.F. / Artists Rights Society (ARS), New York: fig. 14

© 2009 reproduced with the Permission of The Barnes Foundation, Merion, Pennsylvania: figs. 22.1, 30.3, 30.4, 36.1

Christie's: figs. 13.1, 94.1

© Lucien Clergue 2010: fig. 94.2

© The Cleveland Museum of Art: fig. 22.4

Cowling 2002, p. 416, fig. 371: fig. 68.2

Daix and Rosselet 1979, p. 245, no. 296: fig. 49.1; p. 260, no. 370: fig. 53.1

Galerie Schmit, Paris: fig. 14.3

Gallwitz 1985, p. 175, no. 285: fig. 93.2

© Getty Images: fig. 88.1

Houston–Munich 1997–98, p. 136: fig. 62.2; p. 137: fig. 62.3; p. 166: fig. 62.7; p. 190: fig. 75.1

Erich Lessing / Art Resource, NY: figs. 14.2, 20.1, 56.1, 65.2, 82.2

© Man Ray Trust / Artists Rights Society (ARS), NY / ADAGP, Paris / Telimage: fig. 2

© Estate Ugo Mulas: fig. 13

© Museu Picasso, Barcelona 2009, Foto Gasull Fotografia: figs. 6.1, 22.3, 30.6

Digital Images © The Museum of Modern Art / Licensed by SCALA / Art Resource, NY: figs. 29.2, 34.1, 40.1, 62.1, 68.1, 91.1

Images courtesy of the Board of Trustees, National Gallery of Art, Washington, D.C.: figs. 18.1, 26.1

© 1947 Arnold Newman: fig. 7

Otto / Getty Images: fig. 88.1

Pace Wildenstein, New York: fig. 19.1; photograpy by Claude Germain: fig. 87.2

Princeton–Washington 1978, p. 18: fig. 8.1

© Edward Quinn: fig. 90.1

Réunion des Musées Nationaux / Art Resource, NY: figs. 1.1, 52.2, 63.1; photography by Michèle Bellot: figs. 20.2, 78.1; photography by Christian Jean: fig. 38.2; photography by Thierry Le Mage: figs. 39.1, 42.1, 43.2, 45.1, 48.2, 65.1; photography by Hervé Lewandowski: figs. 30.1, 93.3

© Rheinisches Bildarchiv, Cologne: fig. 46.1

Scala / Art Resource, NY: figs. 12.1, 14.4, 23.2, 31.1, 36.2

© The State Hermitage Museum, Saint Petersburg: figs. 21.1, 43.1, 44.1, 45.2, 46.3

Johanna T. Steichen: fig. 5

Estate of Gertrude Stein, through its Literary Executor, Stanford Gann, Jr., of Levin and Gann, P.A.: fig. 38.4

Malcolm Varon: fig. 15

© Dominique Vorillon: fig. 11

Zervos 1932–78, supplement vol. 22, p. 87, no. 240: fig. 27.1; vol. 16, p. 142, no. 394: fig. 90.2; vol. 19, p. 116, no. 387: fig. 92.1; vol. 19, p. 119, no. 398: fig. 92.2